COMPENDIUM
Nikon System from 1917

Simon Stafford
Hillebrand & Hauschild

First English Edition 1993
Reprint English Edition 1998
Second English Edition 2003

Published by
Hove Books Ltd
30 The Industrial Estate, Small Dole
West Sussex BN5 9XR UK

Fax: 01273 494992
www. hovebooks.com
E-mail: info@hovebooks.com

ISBN 1-897 802-16-1

Design Tony Truscott

Printed by Die Keure NL, Belgium

British Library Cataloguing in Publication
Date
A catalogue record for this book is available from the British Library

Acknowledgements

I have accrued a great deal of experience, over a period of more than twenty years, from using Nikon cameras, lenses and accessories, and have also been very fortunate in having an extensive amount of equipment and other material made available to me. The new Nikon Compendium is the culmination of my knowledge, much research, and wide discussion with many others about the world's foremost camera system.

Founded on the original book by authors, Rudolf Hilliebrand and Hans-Joachim Hauschild, I could not have completed the project without the help and advice of numerous people. In particular I wish to acknowledge the following for their assistance. At Grays of Westminster, the exclusively Nikon dealer, to my very dear friends Gray Levett, Nick Wynne, and Uri Zakay, I would like to express my deep gratitude for your unstinting support, encouragement, and providing unique access to so many treasures. At Nikon Corporation (Japan) I would like to thank Mr Tetsuro Goto and Dr Zhehong Chen for their informed commentary and technical information. At Nikon U.K. Limited I wish express my thanks to Yojiro Yamguchi, Simon Coleman, Kevin Jordan, Mark Fury, and Jeremy Gilbert for their support; to Elaine Swift and Charley Hayes for loaning equipment; to Mike Burnhill for his information and technical support. I would like to thank Mike Allen and Richard Kirkwood at Fixation (London) for their information and loan of equipment. At the London Camera Exchange and West End Cameras (London), my thanks for the loan of equipment.

The following acknowledgement is reproduced from the original book in recognition of the assistance rendered to the authors, Rudolf Hilliebrand and Hans-Joachim Hauschild.

"This Nikon Compendium is the result of extensive research on the basis of the material made available to us. We would like to express our gratitude to a number of people who have contributed to the realisation of this book: Dietrich Exner, Rolf Krueger, and especially Daniela Glauerdt from Nikon Germany in Dusseldorf who were a great help in gathering data and information, as well as Renato Gerussi and Marco Rosenfelder from Nikon Switzerland in Ksnacht. Jochen Beyss and Peter Braczko readily allowed us to photograph parts of their collections. We owe special thanks to Rosmarie and Adrian Bircher for their creative assistance and much more."

The following publisher's note is reproduced from the original book in recognition of the work done in providing an English language version of the original book.

"The publisher would like to specifically thank Rolf Krueger for his English translation and for his help in supplying the additional material, which brings the book right up to date."

Dedication
To my wife Kate and daughter Holly.

Trademark Information
Nikon, Nikkor, Nikkormat, Speedlight, Nikon View, and Nikon Capture are trademarks of the Nikon Corporation (Japan). Machintosh, is a registered trademark of the Apple Computer Inc. Microsoft, and Windows, are registered trademarks of the Microsoft Corporation. IBM and Microdrive are registered trademarks of the International Business Machine Corporation. SanDisk and CompactFlash are the registered trademarks of the SanDisk Corporation. Lexar Media is a registered trademark of the Lexar Media Corporation. All other product names are trademarks of their respective owners.

Please note neither the Nikon Corporation, nor Nikon U.K. Limited sponsor this book. The information, specifications, data, and procedures are correct to the best of the author and publisher's knowledge; all other liability is expressly disclaimed. A manufacturer may change product specifications without giving notice, therefore, the contents of this book may not necessarily concur with changes made after publication.

Contents

Introduction

Nikon have provided photographers with a series of indispensable photographic tools for over half a century. Renown for its innovation this comprehensive system of cameras, lenses, and accessories has evolved continuously, adapting to new technologies in a considered and calculated way.

The world wide reputation enjoyed, past and present, by Nikon stems from the quality of their rangefinder cameras like this Nikon S2 and Nikkor 5cm f1.4 lens which date from the mid-1950's.

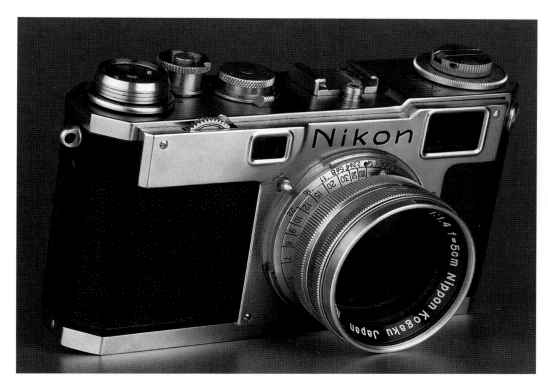

The corner stone of the Nikon system we see to day was laid a long time ago during the second decade of the last century. Over the next forty years, following the formation of Nippon Kogaku K.K. in July 1917, the company accrued a great deal of experience producing camera lenses and optical instruments. At the out break of World War II the company was selected by the Japanese government to act as the principle supplier of optical equipment to the Japanese armed forces. By the time of the cessation of hostilities the company had almost ceased to exist, but under the super-

vision of the occupying Allied forces the remnants were reorganised and resumed production of civilian optical equipment for the Japanese home market. The aspirations of Nippon Kogaku K.K. soon turned to the manufacture of a camera, and initially two models were considered; a medium format twin lens reflex (TLR) design and a 35mm rangefinder type. In one of those fateful decisions, the significance of which is never appreciated at the time, the TLR design was abandoned and work commenced on the small format camera. At some point during its development the name

Nikon was coined from NIppon KOgaku, and during 1948 the first production camera, the Nikon I, was introduced.

The accolades received for their products from photojournalists covering the Korean War brought international recognition to the company, and during the 1950's they continued to develop their rangefinder system. It was the philosophy behind the introduction of the Nikon F SLR, during 1959, that consolidated Nikon's position as a manufacturer of a fully specified camera system made to exacting standards. A system designed without compro-

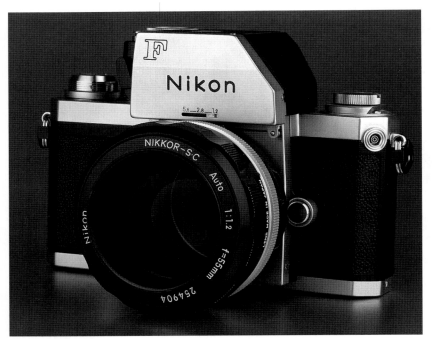

The Nikon F Photomic TN was the pinnacle of design and development of the original Nikon F camera.

grow, which is reflected by the fact that less than a year after its launch the D100 has become Nikon's biggest selling SLR camera!

Regardless of the medium used record images the Nikon system has stood the test of time. Its components are practicable and efficient; they have a well-deserved reputation for being robust, reliable, and able to survive in the most rugged, and hostile environments, which is born out of the system's use from the depths of the oceans to the weightlessness of space. Through the numerous technological revolutions in camera design, including autofocusing and digital imaging, Nikon have sought to retain the widest possible compatibility from the earliest to the latest cameras and lenses. Nikon products have become increasingly diverse with the passage of time, to the extent that these days they cater for every photographer from the newest beginner to the most seasoned professional.

mise to satisfy the diverse needs of the professional and keen enthusiast photographer. Now, over four decades later, as then, Nikon continue to develop and manufacture products that allow a degree of flexibility and adaptability, which enables photographers to accomplish virtually any photographic task. Some, such as the AF Micro-Zoom 70-180mm f4.5-5.6D, and Defocus Control Nikkor lenses are unique to the Nikon system. The alliance between Nikon and Kodak during the early 1990's was aimed at producing a usable digital SLR camera for press photographers. The collaboration turned out to be a key factor in the eventual acceptance of digital imaging technology for newsgathering. Since those early days, over a decade ago, probably the most influential photographic product to have been introduced is the Nikon D1 camera. Almost overnight it alone convinced a broad base of photographers, across a variety of disciplines, that there

was an affordable alternative of sufficient quality to film. The popularity of digital imaging continues to

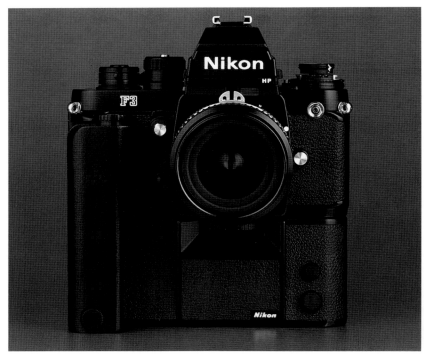

In its day the Nikon F3P and MD-4 motor drive represented the epitome of a camera designed and built for the professional photographer.

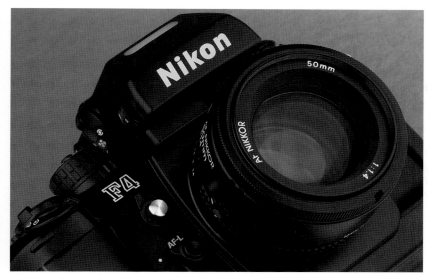

Nikon took the advent of auto focusing in their stride and at the same time retained the Nikon 'F' lens mount. The Nikon F4 was the first camera in the F series to feature AF technology.

I make no differentiation between a professional and the committed enthusiast photographer in terms of their motivation, dedication, ability, and the expectations they have of their camera equipment. Around the globe, day-in-day-out, Nikon cameras can be seen in their hands as they contribute to the visual heritage of our world: journalists, naturalists, artists, teachers, explorers, medical experts, aviators, divers, travellers, scientists, law enforcement officers, and military personnel to name a few. What better endorsement can there be for a camera system?

My aim with this book is to provide a general overview of the key components of the Nikon camera system. I started by completely revising the original book, and correcting its factual errors. Then I worked through all the relevant products released during the past twelve years to bring the new book right up to date. I set myself several objectives for the photographic practitioner; to facilitate an understanding of the products; to show how they can be combined; and to share my own experiences gained from using the equipment. For the collector of photographic equipment my objective is to provide a record of the system and a history of its development. I have included plenty of technical information, much of it in a tabulated form, and photographed Nikon equipment, old and new, extensively to provided a comprehensive reference to the system. Ultimately I hope the book will assist you in making informed decisions about selecting and using your own Nikon equipment.

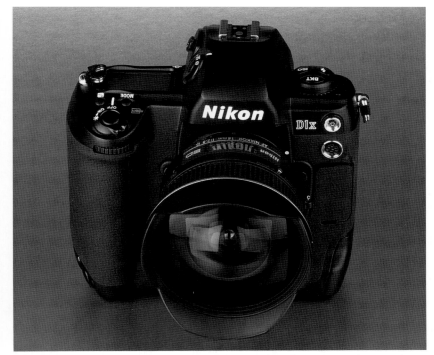

The Nikon D1X is a fully featured digital SLR whose heritage can be traced back to the original Nikon F introduced during 1959.

The Early Years 1917 - 1958

Nikon, formally Nippon Kogaku KK, has been involved in the development, design, and manufacture of high-grade optical devices for the past eight-five years. Created during 1917 the company did not produce its first camera until 1948.

The Nikon story began on 25th July 1917 when, with the support of the Japanese industrial giant, the Mitsubishi Group, and the Imperial Japanese Navy a new company called 'Nippon Kogaku K.K' was formed. The brand name 'Nikon' was subsequently derived from the company's name, which translated means 'Japanese Optical Company'. Over the next few months three Japanese optical companies, Keiki Seisaku Sho, Iwaki Glass Manufacturing, and Fujii Lens Seisaku Sho, were amalgamated into 'Nippon Kogaku K.K'.

Today the Nikon Corporation has its headquarters in the Fuji Building in Chiyoda-ku, in central Tokyo, and has numerous manufacturing plants both within Japan and several other countries including Thailand, the Philippines and South Korea. The origins of the present modern international corporation can be traced back to the early part of the twentieth century.

Apparently Nippon Kogaku K.K. officially opened for business on 1st January 1918 and established a production site at the Ohi plant in the Shinagawa district of Tokyo. Initial orders were received from the Imperial Japanese Army for binoculars and telescopes and soon afterwards the company signed a contract with the Imperial Japanese Navy to supply telescopes. Events did not bode well for the fledgling company as optical glass was in very short supply due to the wartime blockade of Germany, the world's principle manufacturer of the material. Unable to fulfill the Navy's order for telescopes the company faced bankruptcy, however, an extension of the contract was negotiated, and during 1919 eight German technicians were hired to assist training the 200 staff working at Nippon Kogaku and begin a research programme for the production of optical devices.

The Germans finally arrived in Tokyo during 1921, the same year that the Imperial Japanese Navy established its Institute of Optical Weapons. A year later the Navy began experimenting with the production of optical glass, but fate was about to take a hand. On 1st September 1923, an earthquake devastated Tokyo and the Navy's experimental glass plant was destroyed. As a result Nippon Kogaku were contracted by the Japanese government to continue the Navy's optical glass research and development programme. The Naval contract significantly increased the company's requirement for special types of glass, which its small-scale manufacturing facility could not satisfy. Under the leadership of Mr. Jinpachi Ohara, Nippon Kogaku set about an expansion of their glass making

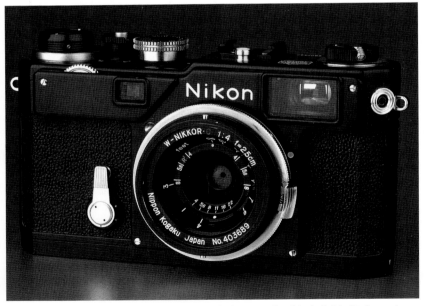

The object of many photographers desires in the late 1950's a black finish S3 shown here with a 2.5cm f4 lens. Today such a camera is highly sought after by collectors.

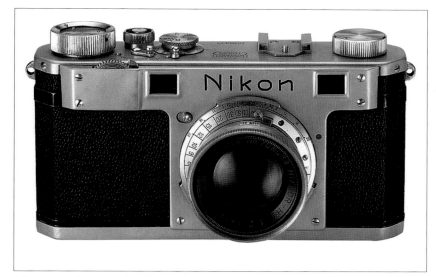

The camera that started it all the Nikon I

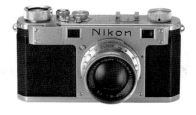

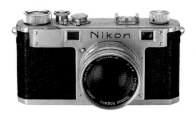

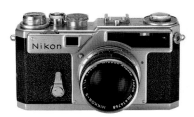

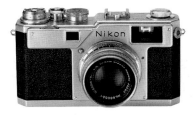

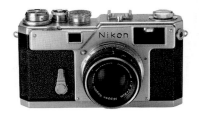

capability to ensure their independence in both supply and optical technology. Independence maintained to this day.

The Way It All Began

The first non-military products, three telescopes with effective diameters of 5, 7.5, and 10cm, were introduced in 1921. The early microscopes, manufactured from 1925, were sold under the brand name 'Nikko', but when production of the first camera lenses began in 1932, they carried the name 'Nikkor', and continue to do so to the present day. They were supplied to camera manufacturers in various focal lengths between 50mm and 700mm and included quite fast designs for their time, such as the 500mm f4.8 made for plate cameras. During 1937, in response to an order from another then new company, the 'Seiki Kogaku Precision Optical Research Institute', which was looking for top-quality lenses for its 'Hansa Kwanon' small format 35mm camera, Nippon Kogaku developed a number of 50mm lenses with maximum apertures between f4.5 and f2.0. Today that company is known as 'Canon', Nikon's principle

rival in the professional camera market.

During the ensuing years before and during the Second World War the company's production was almost entirely devoted to the needs of the Japanese armaments industry. During the war years, at the height of its production, Nippon Kogaku employed nearly 30,000 people in 24 plants throughout Japan. By the end of the war, however, most of Japan's industrial infrastructure, and with it its economy had been destroyed and, with the exception of its main production site at Ohi, Nippon Kogaku had to close down all of its remaining factories and reduce its workforce to less than 3,000.

During October 1945 the company was given permission by the occupying Allied Command to resume the production of binoculars, telescopes, and microscopes. Consequently Nippon Kogaku's re-establishment was initially founded on sale of these optical instruments. As the consolidation and re-building programme continued the company decided to begin the manufacture of cameras as well as lenses. Initially two different formats were considered; a twin-lens reflex (TLR)

Nikon's worldwide reputation was built initially on the quality of its rangefinder cameras and their lenses. At the top the Nikon M, followed by the Nikon S, the Nikon SP, the S4, and the last in the line of the rangefinder series the half-frame S3M.

6x6cm roll film camera and a 35mm rangefinder model. Around this time the Allied Command responsible for the administration of postwar Japan ordered Japanese film manufacturers to cease the production of roll film in order that they could concentrate on the production of X-ray film required for the health care of the indigenous population. It is likely that this action contributed in some way to Nippon Kogaku's decision to opt for the development of a 35mm camera rather than the TLR model. A decision that, as we now know, would subsequently set in train Nikon's immeasurable contribution to photography.

The Rangefinder Cameras

The Nikon I was introduced during 1948 with a film-format of 24x32mm in an attempt to get away from the more common 3:2 aspect ratio of the 24x36mm format of other contemporary cameras and provide a more balanced frame dimension. The reduction in frame length also allowed for forty exposures on a standard 36-exposure length film.

The external appearance of the Nikon I camera has a strong resemblance to that of the Zeiss Contax II, and has the same bayonet lens mount. Internally though the Nikon I bears far more similarity to the Leica IIIa, especially the shutter mechanism. It came equipped with a standard Nikkor 5cm lens, with either an f2 or f3.5 maximum aperture, and a split-image rangefinder. The rangefinder of the Nikon I is incorporated into the viewfinder so, unlike many of its contemporaries, you do not have to focus first before determining your final composition through a separate finder. Besides the 50mm lenses, two more focal lengths where made available for the Nikon I: a four-element 3.5cm f3.5 and a 13.5cm f4.

Shutter speeds from 1 sec. to 1/500 sec. can be set via a double-dial on the top plate, and turning a knob positioned to the right of the shutter speed dial advances the film; the rapid wind-on lever was only devised later. The camera did not have a self-timer or flash socket. It is believed that no more than 739 examples of the Nikon I were produced of which approximately 400 were delivered with the rest being converted to Nikon M models. As a result it is a true rarity these days that can command very high prices from collectors, almost regardless of condition.

Nikon M

In 1949 Nikon's second model was introduced. Rather than carrying the number "II" as might have been expected, it was named the Nikon M. Since Nikon's adoption of the 24x32mm format had not met with any measurable degree of success they decided to enlarge the film format of the new model by stretching it 2mm to give a film frame of 24x34mm. Except for a few details, its features are the same as those of the Nikon I. Later models of the M have a film rewind crank with a

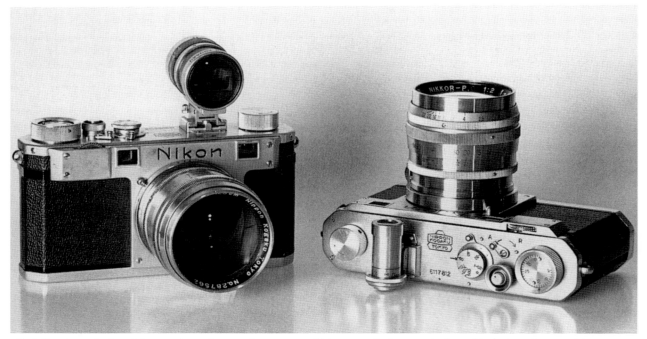

The Nikon M and Nikon S have a picture format of 24x34mm, which eventually became obsolete with the introduction of the S2.

higher profile, with sprung retaining rails and flash synchronization incorporated in the accessory shoe. Production of the M ceased during December 1950, by which time another lens, the 8.5cmf2, had been introduced. Nikon's first 50mm f1.4 lens also appeared that same year and, to due its extremely fast maximum aperture, it opened up new possibilities in available light photography.

Word about the quality of the Nikkor lenses quickly spread through the ranks of professional and enthusiast photographers. It is now recognized as historical fact that their acceptance of the Nikon M, and the 8.5cm f2 lens in particular, was one of the principle reasons behind Nikon gaining a high reputation at an early stage.

At the beginning of the 1950's David Douglas Duncan, probably one of the best-known photojournalists of this era was working for Life magazine covering the Korean War. He and most of his contemporaries used either Leica or Contax cameras and would periodically return to Tokyo to file their pictures and have their cameras serviced. Shrewdly Nikon offered their lenses in both Leica and Contax mounts, either the Nikon/Contax bayonet, or the Leica 39mm screw thread. It was during such a visit to Tokyo that Duncan came across the Nikkor 8.5cm f2 and decided to put it to the test. His high regard for the lens' optical quality was endorsed when he received a telegram from staff at Life magazine commenting on the outstanding quality of the prints he had sent them, but asking why he was shooting pictures of a war on a plate camera!

The rest as they say is history; within a very short time all the staff photographers from Life were equipped with Nikkor lenses, and it was not long before various

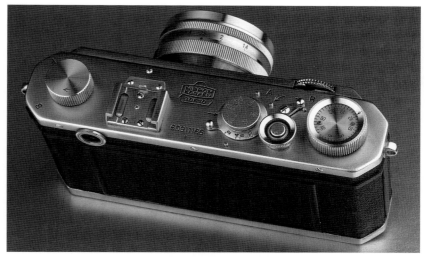

Nikon's first rangefinder camera to be produced in significant numbers the S.

American newspapers and magazines began to run stories about the new Nikon optical phenomenon alongside the picture stories of the war photographed using its equipment. The Nikon legend had been born.

Nikon S

After the production of a little over 3200 units the Nikon S replaced the Nikon M in 1951. Like the later M models this camera had sprung retaining rails and flash synchronization incorporated in the accessory shoe, but now as standard fitting. Some researchers believe the 'S' nomenclature may be derived from the word 'series', whilst others say it comes from 'synchronization'; whatever the case this is not the standard

A Nikon S rangefinder camera together with a 5cm f1.4 lens.

flash sync terminal we are familiar with today but a special one with two sockets. It was designed to work with flash bulbs because electronic flash units were not yet available. The Nikon S was Nippon Kogaku's first model made for the export market and within three years almost 37,000 units were produced; a measure of its success and proof of the fact that Nippon Kogaku had entered the world of volume production.

During 1953, in addition to two new optical masterpieces, a 2.8cm f3.5 and a 8.5cm f1.5, the first subsidiary company, Nippon Kogaku (U.S.A.) was founded in New York. By 1954, despite the success of the S model, the time had come for Nikon to bow to the popularity of the

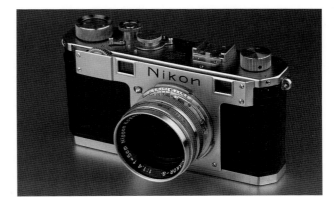

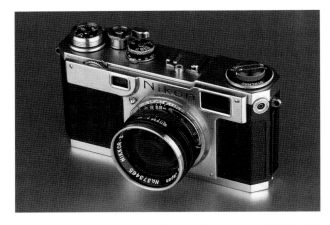

A Nikon S2 (Black Dial) rangefinder camera.

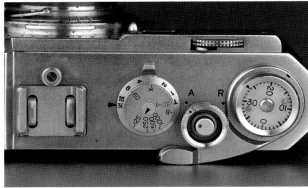

The double shutter speed dial arrangement of the Nikon S2.

24x36mm format with the introduction of the Nikon S2, which also featured a number of other modifications. The most obvious, as well as most practical, is the film wind-on lever that replaced the winding-knob, thus making film advance much quicker and more convenient.

Film rewinding was made faster too, with a folding rewind crank situated on the opposite side of the body.

The shutter speed range was extended to 1/1000 sec. Thanks to the new flash terminal it became possible to use electronic flash units, and the shutter speed dial is marked with an 'X' for the maximum sync speed of 1/50 sec. The viewfinder was also improved with an extremely large eyepiece to facilitate viewing and better control of the split-image rangefinder. The Nikon S2 was the first camera that Nippon Kogaku offered in a choice of either chrome or black finish. S2 production was prolific compared with earlier models and all together some 50,000 were built making it the most numerous Nikon rangefinder camera.

The range of lenses also continued to grow with the addition of a 10.5cm f2.5, a 2.5cm wide-angle, and two longer lenses, a 18cm f2.5 and a 50cm f5. The camera's viewfinder cannot be used with these long focal lengths and it was necessary to mount a reflex mirror-box between the lens and camera to control framing and focusing. By now, even allowing for the awkward handling of the long lenses, the variety of Nikkor lenses left little to be desired by comparison with other manufacturers. Nikon did not rest on their laurels and constantly sought to expand the lens range with ever more innovative designs, and in 1956 two really fast lenses appeared, a 3.5cm f1.8 and a 5cm f1.1. Close focusing was made more accessible with the introduction of the first Micro-Nikkor 5.5cm f3.5, which had a minimum focus distance of 0.45m; a real sensation at the time since most lenses could not focus closer than about 1m. A very rare Nikkor lens is the Stereo-Nikkor 3.5cm f3.5, which yields two 17x24mm pictures on one

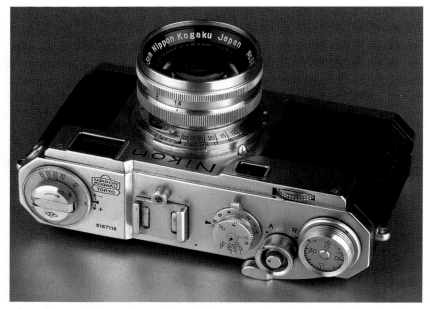

The Nikon S2 with 5cm f1.4 the first Nikon with the 24x36mm film format.

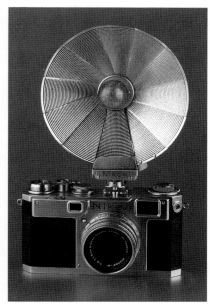

A Nikon S2 with the BC-5 collapsible fan-flash reflector for use with flash bulbs.

24x36mm frame. A special viewfinder was available as well as a stereo viewing device.

Nikon SP

The Nikon SP was introduced in 1957. The 'P' stands for 'professional' and the camera was clearly aimed at this sector of the market. To many the Nikon F that appeared just two years later is nothing more than an SP with a built-in mirror-box. The similarity of the controls on the top plate could certainly support this theory, as they are nearly identical.

There is only one dial for all the shutter speeds from 1 sec. to 1/1000sec., and the exposure counter resets to zero automatically whenever the camera back is opened eliminating a potential error that could easily happen when working quickly. For the first time in a Nikon camera body the shutter curtains were made from titanium foil.

The most exiting new feature, without doubt, was the first battery-powered motor drive, which could advance film through the SP, contin-

uously, up to a rate of 3 frames per second. Known as the S-36 it later became the F-36 for the Nikon F. It has been suggested by some that a bulk-film camera back for up to 250 exposures existed for the SP, however this has not been verified.

Also new was a selenium cell exposure meter that mounted on the top of the camera and connected with the shutter speed dial. The sync-speed was raised slightly from 1/50 sec. to 1/60 sec. and the SP was also equipped with another first for a Nikon camera - a self-timer.

The viewfinder has frames for focal lengths between 28mm and 135mm as a standard feature. The finder frames for 50mm, 85mm, 105mm and 135mm can be selected by means of a dial located beneath the rewind crank. Furthermore, a separate optical finder can be fitted to display frames for 35mm and 28mm focal lengths. A finder illuminator was also available as an accessory to facilitate shooting in low light conditions.

To succeed the S2 a lower priced version of the SP, known as the Nikon S3, was introduced in 1958. The complexity of the selectable

finder frames contributed to the high cost of the SP so they were omitted in favour of fixed frames for 35mm, 50mm and 105mm. Otherwise the two cameras share the same features.

Despite the sophistication of cameras like the Nikon SP, the dominance of rangefinder camera was coming to an end due to the increasing demand for the single lens reflex (SLR) design. The legendary Nikon F SLR finally appeared in 1959 at the same time as a less expensive rangefinder, the Nikon S4; it is a simplified S3 in which the self-timer, motor drive coupling, and the automatic resetting frame counter were omitted. Unfortunately the S4 was not destined to enjoy any great success, possibly because the American subsidiary of Nikon did not include it in its catalogue. A mere 6000 customers chose an S4 in preference to either the SP, or F models.

Nikon's last rangefinder camera is also the most rare, as only about 200 examples of the Nikon S3M were produced between April 1960 and April 1961. Based on the S3 it has a half frame format of 18x24mm, and

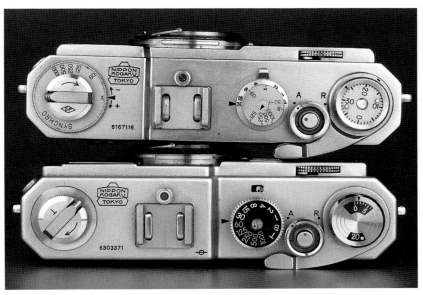

The top plates of the S2 (above) and the S3; the S3 has a single shutter speed dial.

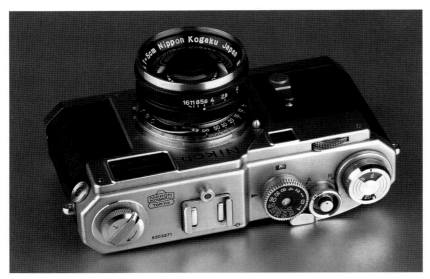

The Nikon S3 is a simpler version of the professional specification of the SP.

due to its shorter frame dimension it can achieve a maximum continuous film advance speed of 6 fps, a very respectable speed for the time, with the assistance of the S-72 motor drive, which was derived from the S-36. The viewfinder has frames for 35mm, 50mm, and 105mm focal lengths.

By now there were twenty different lenses in the range, with focal lengths from 25mm to 500mm. The rangefinder lens system was completed with the introduction of a further four models; a 21mm f4 super wide-angle, a 105mm f4, a telephoto 350mm f4.5 and a 1000mm f6.3 mirror lens, that had initially been designed for the SLR camera.

In the twelve years of production over 140,000 rangefinder cameras had been produced. Besides the extensive and versatile lens system, the mirror-box attachment, and the motor drive, Nikon offered a comprehensive list of accessories, including different viewfinders, a bellows attachment, a reproduction stand, a microscope adapter, close-up lenses, and lots more.

Technologically of course there is a world of difference between pre-sent Nikon cameras and those of forty to fifty years ago, so naturally Nikon rangefinder models are of less interest as contemporary photographic tools, however, the precision of the mechanical engineering and construction employed in these early Nikon cameras gives them an appeal beyond photographers with an interest in the history of the marque, and examples in good condition continue to attract ever-higher prices from collectors.

In March 2000, some forty years after Nikon's last rangefinder cameras were made; the company announced that it would produce a special limited edition of its 1958 vintage S3 model to celebrate the millennium. Although rangefinder cameras have enjoyed something of a renaissance in recent years with Cosina producing the Voigtländer range of cameras with their Leica-fit lenses, and Konica introducing the Hexar RF model, this re-issued Nikon S3 is obviously intended to appeal to the collector rather than the practitioner.

The S3-2000 is available in chrome, or black finish. It comes complete with a Nikkor 50mm f1.4 lens that has a black finish which, unlike its predecessor that had a single coating on its elements, benefits from Nikon's modern multi-coating process. The lens hood and front cap are replicas of the original accessories, as is the box in which the camera is presented, except that it has "Year 2000 Limited Edition" printed on its side. Initially Nikon stated that only 3000 units would be made, however, in response to the unprecedented demand it is possible

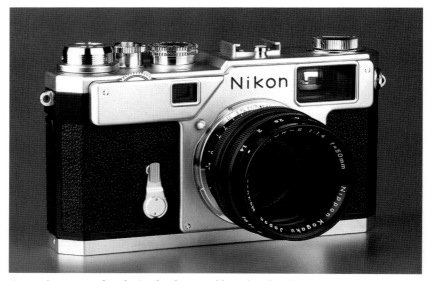

A surprise to many but destined to be owned by only a few the Year 2000 Limited Edition Nikon S3.

that as many as 5000 have been produced. Whether you are fortunate enough to own one of the new S3's, or an original Nikon rangefinder, you may be interested to know that a range of lenses designed to work with Nikon S series rangefinders and pre-war Contax cameras has been introduced under the Voigtländer brand that includes focal lengths of 21mm, 25mm, and 35mm.

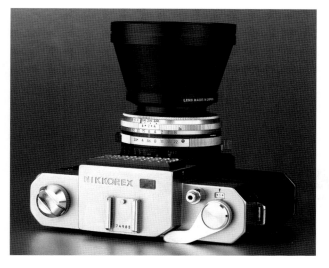

The Nikkorex 35 with the wide-angle lens attachment that provided an effective focal length of 35mm.

The Nikkorex Series

The Nikkorex series of cameras are an almost unknown backwater in the history of Nikon. They go to show that models like the EM, F-301, and FM-10 were not Nikon's only attempts at producing a mass-market product. Just as the S3 and S4 rangefinder models were intended as less expensive alternatives to the SP, Nikon wanted to position a more affordable camera next to their professional SLR the Nikon F.

These days it is rare to find a reference to the Nikkorex series possibly because they were produced in co-operation with Mamiya, and their design and manufacture was not exclusive to Nikon. A reputation of relatively poor quality can have done little to enhance the standing of these cameras over the years. The principle behind the Nikkorex design was to produce an inexpensive SLR with a fixed lens. In 1960 the first model the Nikkorex 35 appeared with the 5cm f2.5 Nikkor. It featured a lens with a shutter made by Citizen, a company better known as a manufacturer of wrist-watches and office machines!

Immediately above the lens of the Nikkorex 35 is a window with a honeycomb structure behind which is the built-in exposure meter. The metering range stretches from EV6.5 to 18 and a needle on the top plate indicates the 'correct' shutter speed/aperture combination. All of the exposure controls are situated on the lens, together with the focusing ring and the film speed setting that has a range from ISO100 to 1600. Shutter speeds run from 1 sec. to 1/500 sec. while apertures can be set from f/2.5 to f/22. The finder eyepiece is located slightly off-centre to the left and the rather dim focusing screen makes the split-image rangefinder an absolute necessity. The Porro-type finder design used in this camera, which does not employ a reflective prism, as is usual to deliver an image that is upright and the right way about, is partly responsible for the poor viewing quality. Nikon compensated for the disadvantage of the non-interchangeable lens by offering supplementary lenses as accessories. The wide-angle attachment increases the angle of view to 60°, corresponding to a focal length of 35mm, but this reduces the maximum aperture to f/5.6. The use of the tele-photo-attachment, which increases the focal length to 90mm, results in the same loss of speed. Image quality also deteriorates considerably

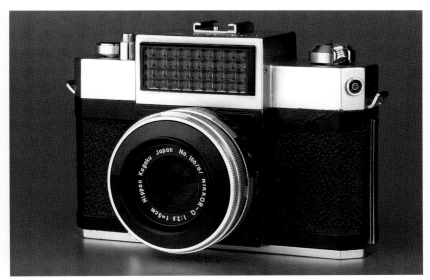

The original Nikkorex 35, from 1960, with a fixed 5cm f2.5 lens that contained a leaf shutter.

The Nikkorex 35 with the accessory wide-angle attachment.

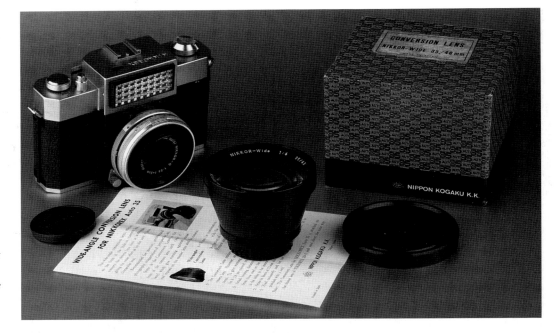

The Nikkorex F with its F-bayonet lens mount was the least expensive route in to the Nikon system.

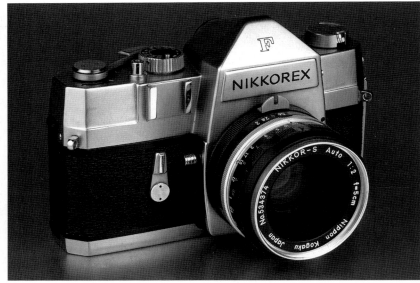

The Nikkorex F with Nikkor 3.5cm f2.8 lens.

with these attachments. In addition, a supplementary lens of 1.5 dioptres reduces the closest focusing distance from 60cm to 35cm. A year after its introduction the Nikkorex 35 was modified to become the Nikkorex 35-2. It has a new shutter supplied by Seikosha and an enlarged film-advance lever.

The next addition to the Nikkorex range, the Nikkorex F, was far more important as it offered the facility to change lenses using the F-type bayonet. It represented a very economical route in to the wider Nikon system. It is also notable as the first Nikon to have a focal plane shutter, supplied by Copal, with metal blades that travel vertically. The shutter speed dial is located on the top plate to the right of the prism-head, however, the camera does not have an integral exposure meter. If required, a selenium cell unit, which couples with the shutter speed dial as well as the meter-coupling pin of the lens can be fitted. The Nikkorex F's features are comparable to those of the Nikkormat FS model introduced later, but in common with the other Nikkorex models it lacks any

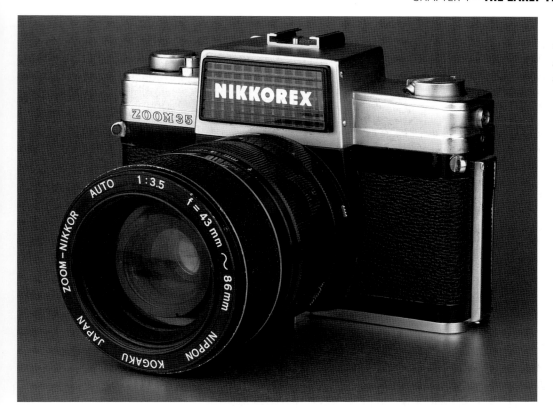

The Nikkorex Zoom 35 has a fixed 43-86mm f3.5 lens.

Nikon Rangefinder Cameras

Camera	Framesize (mm)	Year of release	Number produced	Shutter Speeds (sec)	Viewfinder magnification	Finder frames(mm)	Film advance	Sync- terminal	Self-timer	Motor drive
Nikon I	24x32	1948	739	1 – 1/500	0.6x	50	Windingknob	X	X	X
Nikon M	24x34	1949	3200	1 – 1/500	0.6x	50	Windingknob	X*	X	X
Nikon S	24x34	1951	35,200	1 – 1/500	0.6x	50	Windingknob	M	X	X
Nikon S2	24x36	1954	56,715	1- 1/1000	1.0x	50	Windingknob	M +x1/50	Y	S-36
Nikon SP	24x36	1957	22,350	1- 1/1000	1.0x	28/35, 50, 85, 105, 135	Advance lever	M +x1/60	Y	S-36
Nikon S3	24x36	1958	14,310	1- 1/1000	1.0x	35, 50, 105	Advance lever	M +x1/60	Y	S-36
Nikon S4	24x36	1959	5,900	1- 1/1000	1.0x	50, 135	Advance lever	M +x1/60	X	X
NikonS3M	24x36	1960	200	1- 1/1000	1.0x	35, 50, 135	Advance lever	M +x1/60	Y	S-72
Nikon S3 - 2000	24x36	2000	3000**	1- 1/1000	1.0x	35, 50, 135	Advance lever	M +x1/60	Y	S-36

* Fitted later to some models X-Not available
** Not confirmed Y-Available

of that customary feeling of a traditional, rugged, robust, and well built Nikon camera.

The Nikkorex F model was followed by the Nikkorex Zoom 35, which, with its integrated zoom lens that has a focal length range from 43mm to 86mm represented something of a novelty. The lens is in fact the same design as the Zoom-Nikkor 43-86mm f3.5 introduced during the early 1960's.

The last camera in the Nikkorex series is also Nikon's first camera with an automatic exposure mode.

Equipped with a Seikosha lens shutter, it features a shutter-priority auto-exposure mode within the aperture range of f2.0 to f16 as the built-in 48mm lens has a maximum aperture of f/2. In this mode the aperture selected by the camera is displayed in the viewfinder by a needle. In the manual mode the camera controls must be adjusted so that a second needle coincides with the first to provide a 'correct' exposure.

The camera body has rounded edges reflecting the prevailing trend in design at that time. Its most distinctive feature is the shutter release button located on the front plate next to the lens, as opposed to the more traditional position on the top plate. In the case of a few examples this Nikkorex is the only one in the series that carries the Nikon logo.

Nikon Rangefinder Lenses

Lens (focal length: mm)	Bayonet/Thread	Year released	Minimum aperture	Minimum focus (m)	Elements/ Groups	Filter Thread (mm)	Weight (g)
21 f4	B	1959	16	.90	8/4	43	140
25 f4	B/T	1953	22	.90	4/4	X	140
28 f3.5	B/T	1952	22	.90	6/4	43	155
35 f3.5	B/T	1948	22	.90	4/3	43	200
35 f3.5 Stereo	B	1956	16	.90	4/3	40.5	185
35 f2.5	B/T	1952	22	.90	6/4	43	220
35 f1.8	B/T	1956	22	.90	7/5	43	170
50 f3.5 Micro	B/T	1956	22	.45	5/4	34.5	145
50 f3.5	B/T	1945	16	.90	4/3	X	170
50 f2	B/T	1946	16	.90	6/3	40.5	185
50 f1.5	B/T	1950	11	.90	7/5	40.5	205
50 f1.4	B/T	1950	16	.90	7/3	43	210
50 f1.1	B/T	1956	22	.90	9/6	62	435
85 f2	B/T	1948	16	1.0	5/3	48	465
85 f1.5	B/T	1951	32	1.0	7/3	60	600
105 f4	B	1959	22	1.2	3/3	34.5	280
105 f2.5	B/T	1953	32	1.2	5/3	52	570
135 f4	B/T	1947	16	1.5	4/3	40.5	560
135 f3.5	B/T	1950	16	1.5	4/3	43	520
180 f2.5*	B/T	1953	32	2.1	6/4	82	1860
250 f4*	B/T	1951	32	3.0	4/3	68	1240
350 f4.5*	B	1959	22	4.0	3/3	82	1830
500 f5*	B/T	1952	45	7.5	3/3	110	8600
1000 f6.3*	B	1959	6.3	30	3/2	52	9980

* Usable only with a reflex mirror box

The Professional F-Series

Nikon introduced their first SLR camera, the Nikon F, in 1959. Building on the reputation that they had established with their rangefinder models the F quickly consolidated Nikon's position as the first choice for the professional photographer. Along with the new camera came a new lens mount, the F-type bayonet, which has remained virtually unchanged to this day capable even of accommodating the latest autofocus lenses.

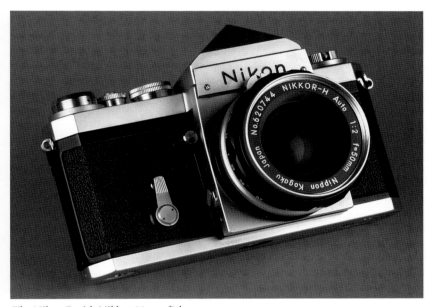

The Nikon F with Nikkor 50mm f2 lens.

the present day. A feat no other camera manufacturer has achieved. So photographers can still use their trusted and treasured manual focus lenses on the most recent AF cameras such as the F5, or digital D1X, although of course some of the camera functions cease to be available. Equally most current AF-D and AF-S series lenses can be fitted to a vintage Nikon F body.

Looking at the Nikon F from above, apart from the prism finder, it shows a great similarity to the SP and S3 rangefinder models. The film counter is located concentric with the advance lever. Next to it is the shutter release button, which is situated towards the rear edge of the top

Nikon F

In 1959 at a time when most camera manufacturers were still equipping their SLR models with the laboriously slow M42-thread lens mount, the engineers at Nikon conceived and designed the F-type bayonet, which provided a method of changing lenses with unprecedented ease and speed. In spite of all the technological advances in camera and lens design Nikon have retained, in essence, the same F-type mount throughout their camera system to

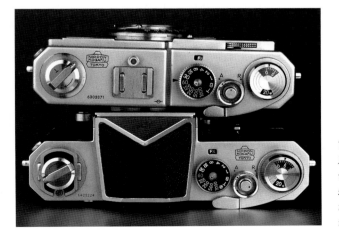

The heritage of the Nikon F is clear when you see it side by side with the Nikon S3 rangefinder.

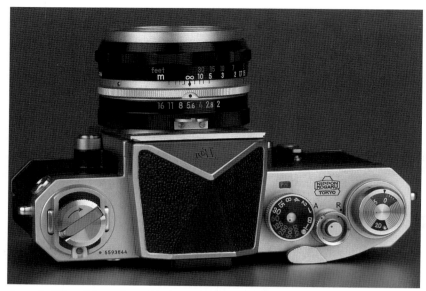

An early Nikon F from the 65-block serial number.

case of flash bulbs, one of the three coloured dots should be chosen according to the desired shutter speed. The corresponding speeds are marked with the respective colours, white, red, and green. To use electronic flash units the FX setting should be chosen. Each marked shutter speed has a positive click-stop position, but the dial can also be set to intermediate values within the range of 1/1000 to 1/125sec.

The standard prism finder can be removed and replaced with a variety of different heads: the Photomic metering head, a waist-level finder, or an action finder that provides a much greater eye relief distance. To change the fitted head you must press in the locking button positioned next to the finder eyepiece. Pressing the button again will

plate compared to later models in the F-series. The reason for this is the fixed connection with the take-up spool. Around the shutter release button is a collar marked with two positions 'A' and 'R'. The 'A' stands for advance, in order to rewind the film the collar has to be lifted slightly and turned to 'R', which unlocks the take-up spool. This collar also serves as the mount for a female-threaded 'Leica bell' cable release.

To the left of the release button is the shutter speed dial with settings from 1 second to 1/1000sec, as well as Bulb (B) and Time (T). The 'T' position, which is rarely incorporated in modern cameras, was used for making long exposures. On depressing the shutter release when the dial is set to 'T' the shutter remains open; moving the dial to another position terminates the exposure. In the centre a black dot indicates whether or not the shutter is cocked, and small pin protrudes above the surface of the shutter speed dial for connection to the Photomic metering head when it is mounted.

A window in front of the shutter speed dial shows the selected type of flash synchronization. The collar of

the dial must be lifted and turned to switch from one to the other. In the

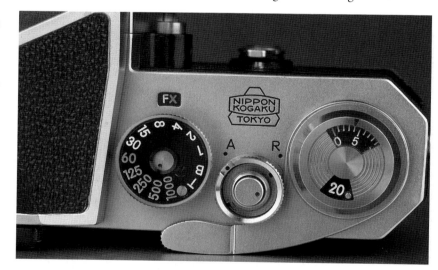

Early Nikon F cameras have the Nippon Kogaku badge on their top plate. Note the position of the shutter release button toward the rear edge.

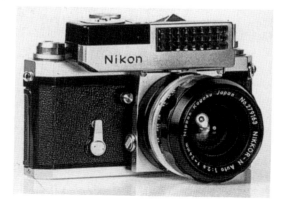

The Nikon F with the clip-on exposure meter seen from the front.

On the Nikon F Photomic the standard eye-level finder is replaced with a metering head. It does not offer TTL metering, because the meter cell is external; it is mounted on the side of the head.

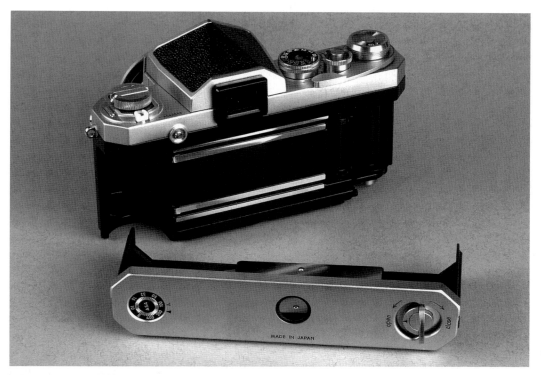

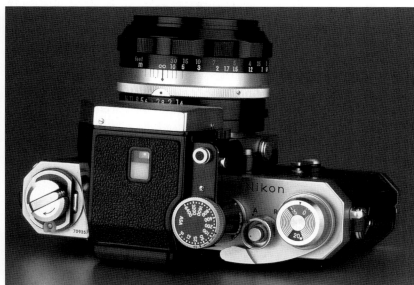

A Nikon FTN with 50mm f1.4 lens.

release the focusing screen. If you then invert the camera the screen will drop out. When first introduced there were just four types of focus screen available for the F, by the end of its production run this had risen to 15.

The Nikon F was the very first SLR to have a viewfinder frame that showed 100% of the actual image. Even today many cameras still only show 93% - 96% of the image area, consequently the frame area of the film records more than the photographer sees in the viewfinder at the time the exposure is made. The 100% finder image has been a consistent feature throughout every model in the Nikon professional F-series up to and including the F5. The rewind crank is situated in the usual place to the left, and beneath it the special accessory-shoe with its central contact designed for flash units. The additional viewfinders for the fisheye lenses and the then remarkable super-wide-angle Nikkor 21mm lens can also be mounted here since none of them can be focused with the reflex mirror in it normal position. It must be locked in the up position before the lenses are attached. The serial number, which also indicates the position of the film plane, is engraved between the rewind crank and the prism head.

The F-mount bayonet dominates the front view of the camera body. Its inner diameter of 44mm, designed to provide plenty of space for light to pass through even the fastest lenses without the risk of vignetting the image. The lenses are

secured by the three inward-pointing claws positioned every 120° so that a 60° turn is sufficient to lock the lens into place.

The mirror lock-up function is a two-stage process that is somewhat impractical. Its design was modified in the F's successor the F2. First a knob next to the lens mount throat has be rotated through 45°, and then the shutter must be released, after which the mirror swings up and remains in that position. This results in one frame being lost each time the function is used. It can be avoided by pressing the release button just halfway instead of all the way so that the mirror swings up without tripping the shutter.

The Nikon F has a depth-of–field preview button as well as a self-timer both of which are positioned on the right side of the body next the lens mount. The shutter release button does not activate the latter; it is operated by pressing a small button under the self-timer lever which is unlocked whenever the lever is set to a value between three and ten seconds. You can use the self-timer in combination with the Bulb (B) setting to achieve an accurate two-second-exposure time.

In common with the design of the Nikon rangefinder cameras the back of the Nikon F is not hinged. Designed to be removed completely it has to be pulled down off the camera after turning a flush mounted locking catch in the base plate, which is on the same side as the rewind crank. Once unlocked the back tends to spring up as the tension on the film back plate springs is released. You must take care not to pull the back away from the body at an angle or else you risk damaging the film guide rails on the main camera body. This is particularly important when using the F-36 motor drive in which the camera back forms an integral part.

The F-36 was the first electric motor drive for a standard 35mm SLR camera and was the most significant component of the Nikon F system that contributed to its overwhelming success. It is capable of achieving a maximum firing rate of up to 4 fps; faster than the current MD-12 model for the FM3A. A couple of modified versions of the F/F-36 combination were made in very limited numbers for Olympic games. The first for the Winter Olympics held in Sapporo, Japan, in 1972, had separate battery pack and accessory viewfinder for focal lengths of 135, 180, 200, and 300mm, since to attain its high frame cycle rate of 7fps the camera's mirror had to be locked in the up position. Four years later Nikon produced an even faster F/F-36 combination capable of 9fps for the 1976 Olympics held in Montreal, Canada.

Unlike later Nikon camera body and motor drive combinations whose design allowed them to be attached to each other conveniently by the photographer, a technician must modify the standard F body before the F-36 can be fitted. The camera's internal base-plate has to be replaced with a motor drive version which is drilled out for the release-pin. This plate also carries the tripod mount.

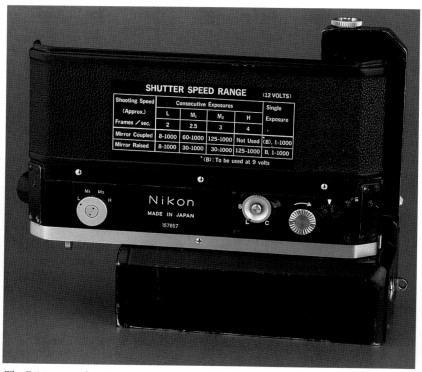

The Nikon F Photomic with F36 motor drive and the first super wide Nikkor 20mm f3.5 UD.

The F-36 motor-drive unit with its integral camera back plate.

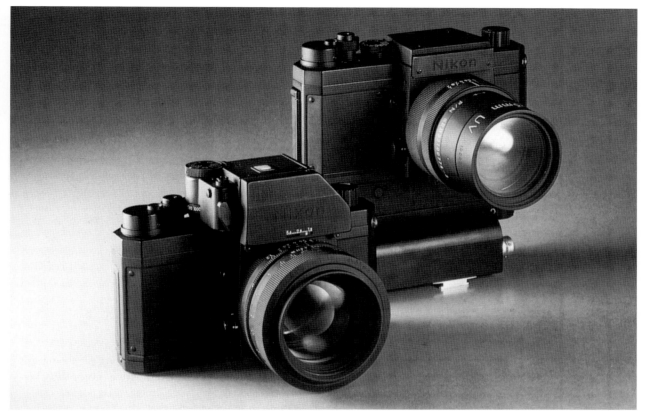

Nikon produced a variety of special version of the Nikon F. NASA used these two during the early days of the American space programme.

The Nikon F shutter curtains are made of the same titanium foil used in the SP rangefinder model. They take some 12msec to travel across the film gate from right-to-left, which results in the F having a flash synchronization speed of 1/60sec.

The Nikon F, during the course of the 11 years of its production, became the hub of one the most versatile professional camera systems. In addition to the ever expanding range of Nikkor lenses photographers had the choice of four different viewfinder finder systems, fifteen focusing screens, the F-36 motor drive, a 250 exposure camera back, and a host of other accessories.

The Nikon F design not only laid the foundations of the professional F-series cameras, but it has stood the test of time. Over thirty years

after production of the Nikon F ceased, and long after Nikon finished making new spare parts for the camera, photographers continue to use them as working tools. To help keep an old F in working order a number of accessories from the F2 system, which are fully compatible, can be fitted. These include focusing screens, viewfinders, with the exception of the Photomic prism models, although the F nameplate must be removed before attaching an F2 finder head, and the flash adapters.

Nikon F Serial Numbers

In recent years collecting early Nikon cameras has become increasingly popular, this applies not only to the rangefinder series but also to the Nikon F series. However, a number of myths have grown up surrounding early Nikon equipment

and without question the most misleading is the notion that the first two digits of the Nikon F serial number represent the camera's year of manufacture. Put bluntly this simply is not true!

Nippon Kogaku (Nikon) produced nearly one million Nikon F's between 1959 and 1974. Serial numbering began with 6400001 and by the time production ceased had reached 74xxxxx. Generally collectors are most interested in cameras from the first serial number block which is prefixed with '64'. This is due to the fact that early production examples have a wide variety of different external markings and features that make some particular models very rare.

Matters are further complicated by the fact that within each serial number block Nikon would produce

a quantity of extra camera top plates for spare part stock. It is quite possible, therefore, to find a camera made in 1966 fitted, as a result of a repair, with a top plate bearing a serial number from the '72' block. This makes original documentation and packaging a valuable asset in determining the provenance of a specific camera.

The serial number of certain Nikon F cameras is prefixed with a red dot to indicate the body has been factory modified to accept the Photomic metering head.

Nikon F Serial Numbers

Serial Number Block	Number Produced (approx.)	Production Dates
64	100,000	June 1959 – June 1963
65	100,000	June 1964 – June 1965
66	3,000	July 1965
67	95,000	Aug 1965 – July 1966
68	95,000	Aug 1966 – Nov 1967
69	95,000	Dec 1968 – Dec 1969
70	95,000	Jan 1970 – Dec 1971
71	95,000	Jan 1971 – Dec 1972
72	90,000	Jan 1972 – Dec 1973
73	95,000	Jan 1973 – Dec 1973
74	50,000	Jan 1974 – Jun 1975

Notes to table:

1. Nikon F bodies in the 64, 65, and 66 blocks cannot accept the Photomic T finder without modification.

2. Some F's in the 64, 65, and 66 blocks are marked with a red dot prefix to their serial number to indicate that the body has been factory modified to accept the Photomic T finder.

3. Production of F's in the 67 serial number block, commencing with 6700001, coincides with the introduction of the Photomic T finder in August 1965.

4. Production of F's in the 69 serial number block, commencing with 6900001, coincides with the introduction of the Photomic FTN finder in December 1968.

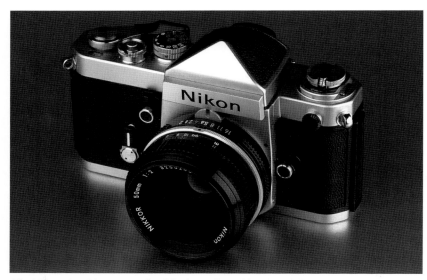

The Nikon F2 with DE-1 eyelevel finder and a Nikkor 50mm f2.

Nikon F2

During the course of the 1960's the Nikon F's increasing reputation as a rugged reliable camera gained it the position, particularly in the U.S.A., as the first choice of many professional photographers. In Europe, though, the F remained rather unknown until the end of that decade, and it was the F's successor, the Nikon F2, that was principally responsible for raising the marque's profile.

Introduced in 1971, in essence it is an F with a number of general modifications and improvements. The body has rounded edges and fits into the hand even more snugly. The basic construction remained almost identical to that of the F, but some design details were changed and improved. The film advance lever operates with a single 120° stroke and, at the 20° position, switches on the exposure meter in those bodies fitted with a Photomic head. The shutter release button was moved across the top plate to the front edge to improve the ergonomics. The collar located around it now has different functions compared to the Nikon F. Turned to the right to 'L' it locks the shutter release button to prevent accidental release.

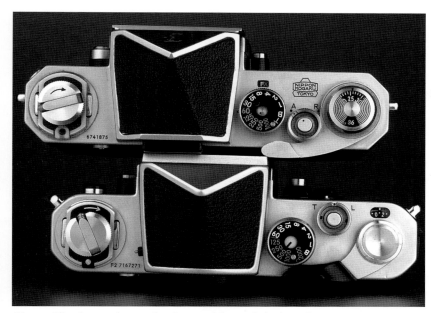

The modifications to the top plate layout of the F2 (below) can be seen in comparison to the Nikon F.

Turned in the opposite direction to 'T', for time, long exposures can be made in combination with the Bulb (B) setting of the shutter speed dial. Pressing the release button opens the shutter and setting the collar back to its normal position terminates the exposure.

The F2 has a fastest shutter speed of 1/2000sec, which was achieved by reducing the running time of the curtains to 10 ms as well as reducing the width of the slit. As a consequence the flash synchronization speed is increased to 1/80sec.

The attachment system for the

viewfinder finder heads remained the same as in the F, so that focusing screens and finders, with the exception of the Photomic heads, are compatible. There is one major difference between the F and F2 series metering heads; in the F series heads the battery is situated within the finder, whereas in the F2 series it is housed in the base of the camera body. There are two contacts to the left and right of the F2 Photomic heads that provide the necessary connection to the batteries in the camera.

The F2's rewind crank can be pulled up out of the body by about 6mm to facilitate rewinding film, while the accessory shoe beneath the crank is identical to that of the F.

In order to improve durability to meet the demands of everyday professional work the bayonet and the parts of the shutter that are subjected to heavy strain are made of a chrome-nickel-steel alloy, and additional clusters of ball bearings were incorporated within the shutter mechanism to improve its performance. Compared to the F, the reflex mirror is longer, to avoid vignetting in the viewfinder when using very long telephoto lenses or lens extensions such as bellows attachments. The depth-of-field preview button is located in the same place as on the F, concentric with it is the mirror lockup lever which, unlike the F, now works independently of the shutter function and therefore without the loss of a film frame. The self-timer has its own release button similar to the F. The 'T' position, however, opens up additional possibilities: if the shutter speed dial is simultaneously set to 'B', long exposures from 2 to 10 seconds can be controlled with it.

A further improvement seen in the F2 is the fitting of the now familiar hinged camera back. It is removable to allow the attachment

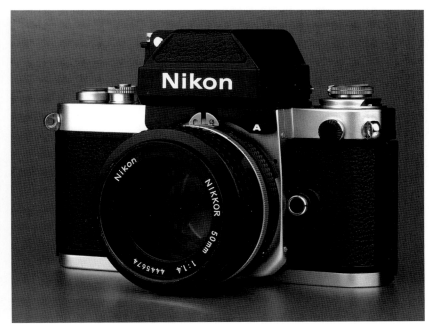

The Nikon F2A with a Nikkor 50mm f1.4.

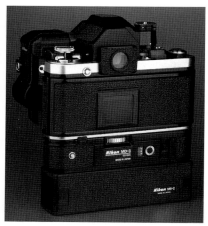

A Nikon F2 S with the MD-3 motor-drive unit, MB-2 battery pack, and DS-1 aperture control unit.

rewind-spindle access to the film cassette. To prevent losing the removed Open/Close key it can be stored in the grip section of the motor drive. If there is film in the camera the motor drive should only be attached or removed in subdued light, because removal of the catch leaves a hole in the camera base plate through which light can enter. The motor drive coupling is located on the opposite side of the base-

of bulk film backs for 250 or 750 exposures, or alternatively the MF-3 back, which prevents the film leader from being wound back into the cassette when the motorized film rewind function of the MD-2 motor drive is used.

In continuous shooting mode the MD-1 and MD-2 motor drives are capable of cycling the F2 at speeds of 4 to 5 fps provided the mirror is locked in the up position. They can rewind a 36-exposure film completely in only 7 seconds, a feature much appreciated by press and sports photographers.

Turning a catch that is recessed into the base-plate opens the back of the camera. This has to be removed when MD-1 or MD-2 motor drive is attached in order to allow the drive's

The base plate of the F2 has a recessed catch for opening the back and coupling for the motor drive.

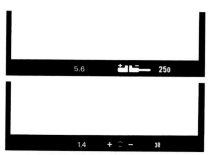

Two different viewfinder displays: the DP-11 (above) with its needle system and the DP-12 that uses LEDs.

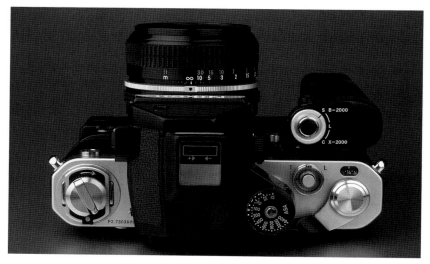

A Nikon F2 S with MD-3 seen from above.

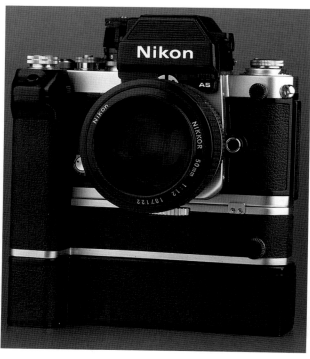

A Nikon F2 AS and MD-1 motor drive.

plate together with the rewind release button and the motor drive release coupling.

The Nikon F2, with the exception of a few small internal modifications, remained practically unchanged throughout its production life, despite the variety of different versions that were manufactured. The Photomic exposure metering heads on the other hand were updated to keep pace as technology advanced. As the F had done beforehand the F2, with its system of viewfinders, motor drives, focusing screens, camera backs and of course the Nikkor lenses, provided one of the most comprehensive camera systems of its time and made Nikon a bye word for professional 35mm photography. If the versatility and adaptability of the F2 in its standard form could not cope with a specific task then it was likely that one of the special versions would.

Nikon F2 Titan

Introduced in 1978, this version of the F2 demonstrated quite clearly Nikon's determination to produce the most durable cameras that will work faultlessly in even the most extreme adverse conditions. Previously Nikon had only used titanium for the shutter curtains of the F and F2 models. In these cameras that were designed to withstand the rigours of hard professional use those areas and parts most likely to be subjected to the greatest amount of stress such as the base-plate, the back, the bayonet mount, and the prism cover, were made of titanium.

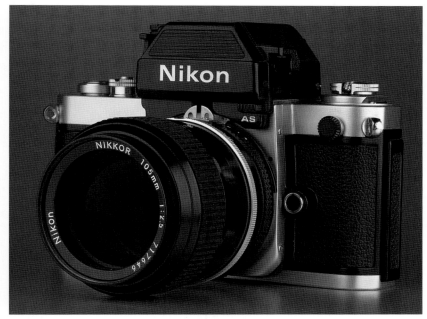

The Nikon F2 AS is the last standard variant of the F2 series. It is shown here with a classic Nikkor lens the 105mm f2.5.

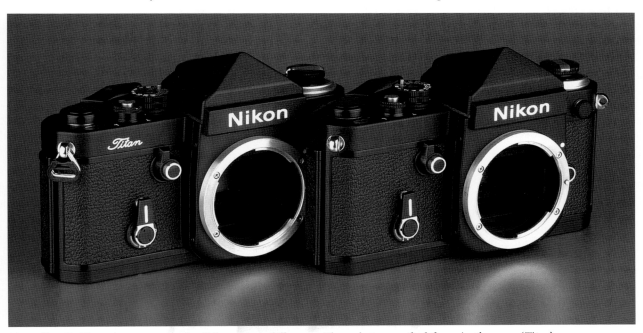

Two Nikon F2 Titan cameras: notice the slight cosmetic differences. The early type on the left carries the name 'Titan'.

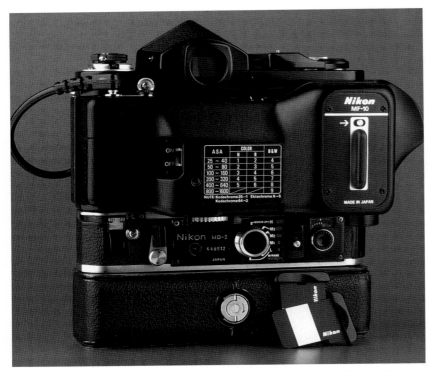

The Nikon F2 Data seen from behind gives some indication of the complex precision mechanical engineering that this ancestor of today's electronic equivalents used to achieve its functions. Note the spare data cards resting against the battery pack.

The earlier cameras in the Titan series have the name conspicuously displayed on the front of the camera below the shutter release button, later models simply have a rather discreet 'T' as a prefix to their serial number. The Titan's were generally finished in a distinctive hammered metal matt black finish, however, a few examples were produced in a chrome finish and were the last F2's ever made. Otherwise, apart from being 5 grams lighter, the F2 Titan is identical to the standard F2.

Nikon F2 Data

These days a databack accessory is available for most cameras, and many point-and-shoot compact cameras, both film and digital, have a data recording facility included in their specification as a matter of course, however, this was not the case in the days of the F2 series.

At that time a special version of

the F2, the F2 Data, was required. It is equipped with a special back that can imprint various kinds of information onto the lower left corner of the frame, simultaneously with the exposure, by means of a tiny built-in electronic flash unit. The film is illuminated from the rear via a 10mm f1.8 lens that incorporates an iris diaphragm for control of the exposure to match the sensitivity of the film in use! The flash unit could only re-cycle at the rate of one frame per second so when used with a motor drive the unit imprinted data intermittently with 2 to 5 frames between each data marked frame.

The information that can be recorded includes: the time via a removable time piece unit, the month and year via a removable dating unit, and finally customized information that has to be hand written onto a 12mm x 21mm area

of a memo plate that is then inserted into the databack. Each databack was supplied with a set of ten memo plates. In order to prevent this area of the film from being included in the main exposure, a small masking plate is situated directly in front of the film at the edge of the picture frame. The special S-type focusing screen was provided with the databack, with markings to denote the imprinting area. The F2 Data was available either with the MF-10 databack for a 36-exposure film, or the MF-11 databack with a 250-exposure bulk-film capability. If the masking-plate is removed from the film frame and the standard camera back is attached the F2 Data is converted into a normal F2 and can then only be identified by the word 'Data' above the serial number.

Nikon F2 H

As mentioned before, the F2 is capable of a maximum firing rate of 5 fps with either the MD-1 or MD-2 motor drive. Some professional / scientific applications require a higher frame rate, so Nikon designed an extremely fast, special version of the F2 for these purposes, the F2 H. 'H' stands for High Speed and the camera is capable of cycling at the rate of 10 fps. It was to become a favourite piece of equipment with sports photographers who could shoot three or four frames of an incident in a fraction of a second and then be in a position to offer different clients similar but not identical shots. Since it is not possible to construct a mirror mechanism to operate at these speeds the F2 H employs a fixed, partially transparent, pellicle mirror that allows 65% of the light to pass through to the film and reflects the remaining 35% upwards into the viewfinder. The film transport system was modified and the maximum shutter speed was reduced to

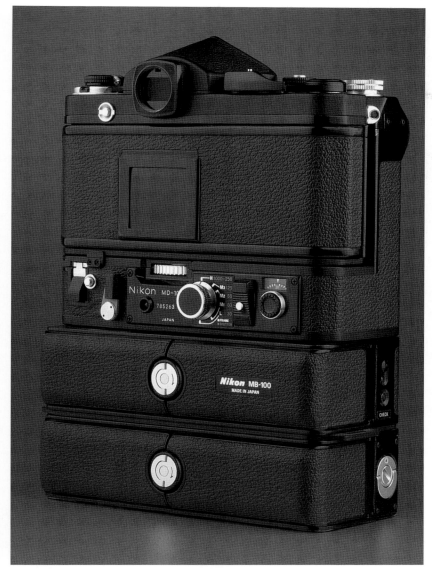

The F2H with the MD-100 motor drive could achieve 10 fps by using a fixed reflex mirror and a preset 'stopped-down' aperture.

1/1000sec. In later cameras of the 'H' series the 'T' and 'B' settings, which are unlikely to be used in such a camera, were omitted. At the time the F2 H was introduced in 1976 it was not possible to design a mechanism capable of opening and closing the lens diaphragm at a frequency of 10 fps consequently metering in the F2H is done with the lens stopped down to its shooting aperture.

The F2 H is driven by a modified

MD-2, known as the MD-100. The increased requirement for power is provided by the MB-100, which comprises two MB-1 type battery packs coupled together. This provides the motor with 30 volts enabling it to transport a 36-exposure film in just 3.6 seconds. The standard F2 H was equipped with the normal style prism finder that has a top made from titanium. You can also fit one of the Photomic finders as long as the film speed is

reduced by 1EV to compensate for the loss of light through the pellicle mirror.

The F2 was discontinued in 1980 to make way for its successor the F3. There was a huge outcry from Nikon users, both professional and enthusiasts alike, who were not willing to trust the new electronically controlled camera, preferring the mechanical reliability and ruggedness of their F2's. However, despite the conservative nature of many photographers when it comes to equipment, in time many would go on to use the F3 for years, some even to this day.

Nikon F3

The purely mechanical systems of the F2 impose a number of shortcomings from a technical point of view compared to a camera that uses electronics to control some of its functions. The mechanical control of the F2's shutter employs numerous gear trains, control levers, and pawls, which are subject to the effects abrasion as well as also being susceptible to dust and grit. Their reaction times and running speeds change with differing temperatures and their physical dimensions determine the location of the controls as well as their design.

The experience Nikon gained with models such as the Nikkormat EL, the Nikon EL-2, and the Nikon FE was applied to the new 'flagship' model. In the Nikon F3 the film transport and mirror-box, for example, are still mechanically operated, only the shutter speeds are electronically controlled. Introduced in 1980, it has little more in common with the F2 than the F-mount bayonet, and although many had expected a multi-mode camera the new model only offers an aperture priority exposure mode in addition to manual exposure control.

The F3's external styling was the

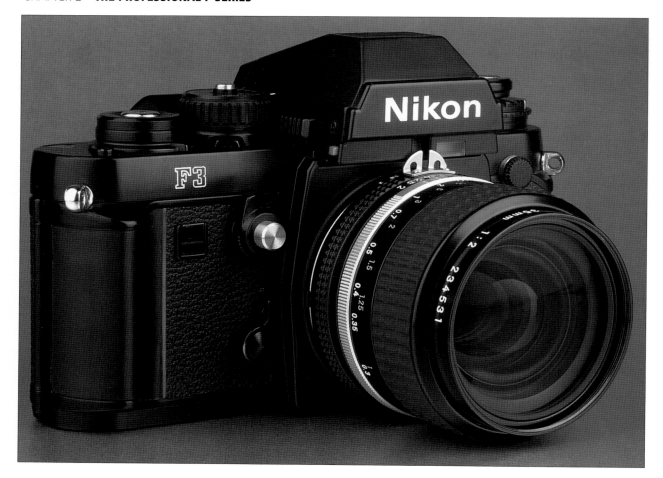

The Nikon F3: use of an electronically controlled shutter represented a significant change over its predecessors.

work of the Italian industrial designer Giorgetto Giugiaro who had already show his abilities with the Nikon EM body. Its die-cast body is made of a copper silumin alloy, which is more resistant to corrosion than the materials that had been used previously. The thickness of the body's wall varies between 1.4mm and 2mm providing an extremely rigid chassis, whilst the top plate cover and the back are made of brass.

The main power switch of the F3 is set around the film advance lever; lightly pressing the release button activates the meter for 16 seconds, but only if the film counter has reached '1'; before this point the shutter operates at 1/80sec to speed up film loading. For the first time on a Nikon the shutter release but-

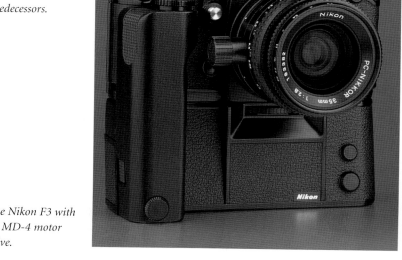

The Nikon F3 with an MD-4 motor drive.

ton is situated at the central axis of the film advance lever and works as a two-stage switch. In the first stage lightly pressing the release button activates the exposure meter, pressing the button down further trips the shutter release mechanism. The design of the F3's shutter release greatly reduces the danger of camera shake. A screw thread within the release button allows the use of standard ISO-type cable releases.

The camera's mechanical film transport system had received special attention during the design stage, although some users have criticised the amount of play in the plastic tipped advance lever in practice it is of no consequence. The new mechanism employs several clusters of ball bearings, which drastically reduced the torque required to cock the shutter. So much so that when you operate the advance lever it is difficult to tell the difference between an empty camera and one loaded with film. This also makes it easier for the MD-4 motor drive, designed especially for the F3, to transport film through the camera up to 6 fps.

Another small lever located next to the film advance lever allows multiple exposures. It features a click-stop position and returns to its initial setting after the shutter is released and re-cocked for the second exposure. If a multiple exposure of more than two shots is required the lever must be reset for each additional exposure.

Located next to the prism head is the shutter speed dial with its 18 click stop positions from 8sec to 1/2000sec, plus B and T settings, a 1/60sec flash sync position marked with an 'X', and an 'A' position for aperture priority automatic exposure mode. The shutter speed dial locks at any of the special positions such as 'X', but by pressing the lock button on top of the dial any of the

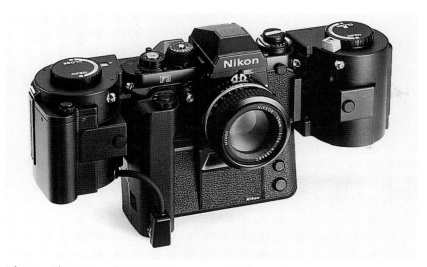

The F3 with MD-4 and MF-17 250 exposure bulk film back.

manual speeds can be set. A quartz oscillator resonating at a frequency of exactly 32,768Hz precisely controls shutter times, provided the camera is loaded with the appropriate batteries. The quartz control circuit is 100% reliable and calculates shutter speeds very precisely, for example if you set a shutter speed of 1/2sec the shutter receives the signal to close again after exactly 16,384 oscillations. This degree of precision is far beyond the capability of a mechanical device. The 'T' setting is also released electronically, but terminated mechanically in order to keep power consumption down to a minimum during extremely long exposures. The 'X' setting on the shutter speed dial is meant for those electronic flash units not capable of setting the synchronization speed on the F3 automatically. Another lever beneath the shutter speed dial activates the electronically controlled self-timer. After starting it with the release button a red LED blinks every 1/2sec for a total of 8 seconds, then the frequency is raised to 8Hz during the last two seconds to indicate the imminent operation of the function, can be deactivated at any time by setting the lever back to its original position.

The Electronics of the F3

Along with the standard DE-3 prism finder the, DW-3 waist-level finder, DE-2 action finder, and DW-4 6x magnifying finder were introduced with the F3, but unlike the F and F2 cameras, where depending on the model, the metering system and/or the camera's power supply was integrated in the Photomic metering prism finders, the F3 has its electronics built into the camera body. This design eliminated what was probably the weakest point of the F2: the mechanical construction of the metering and display systems, which made the F2 Photomic heads rather sensitive to knocks.

The F3 features an LCD located

The inner core of the F3: the shutter, shutter release, and film transport mechanism.

on the front edge of the mirror-box to display the exposure data. It is reflected into every type of finder above the image frame by a system of mirrors. The F3 was, in fact, Nikon's first camera employing an LCD display. Its advantages are a low rate of power consumption and the ease of viewing even for protracted periods. There are, of course, some disadvantages too. Since LCD's do not emit light themselves they have to be equipped with separate illumination in low light conditions. The F3 features a small red button on the outside of the prism that activates a light for this purpose. However, it is not very easy to operate and number of professionals had their illuminators modified by Nikon so that it operated in tandem with the metering system. Other shortcomings of LCD's include their sensitivity to temperature as they become sluggish below 0° and turn black above 60°, but recover again in normal temperatures, and after a period of years their contrast deteriorates and they have to be replaced.

When set to automatic exposure the viewfinder of the F3 displays information about the shutter speed in whole increments, so a display of 1/250sec may well represent a speed of 1/225sec At the limit of the camera's sensitivity overexposure is indicated by '+2000', and underexposure by '-8'. In manual mode a plus sign in addition to the small 'M' in front of the shutter speed display indicates overexposure, a minus sign underexposure, and when + and - are displayed simultaneously this indicates a 'correct' exposure within a tolerance of +/-1/5EV. The viewfinder display also serves as a battery check: when the display disappears immediately after pressing the shutter release it is time to replace the batteries.

The aperture set on the lens is visible in the centre of the viewfinder

A diagram showing the standard viewfinder image of the F3: 1 - shutter speed, 2 – aperture via the ADR window, 3 – flash ready signal.

via the ADR window, but only with AI standard lenses or lenses converted to the AI standard. The small scale on the aperture ring is absent on other lens versions so that the display window remains blank when they are in use. A red LED in the viewfinder serves as a flash-ready signal.

The F3 offers a 100% view of the image area like its predecessor the F and F2, however, the F3 screens deliver an image about 1/3EV brighter and are mounted in a different type of frame with a small lip on the edge to facilitate lifting the screen out of the camera, rather than having to invert it and let the screen drop out. There are 22 different screen versions available, and because the exposure is no longer metered off the focusing screen, but from a metering cell located in the mirror box you do not have to apply exposure compensation when using any of the screens, including the special versions.

The SPD metering cell is also responsible for flash metering which will be described later. This is how the exposure metering of the F3 works: the centre of the reflex mirror is perforated, allowing about 8% of the light to pass through and be reflected down by a secondary mirror, hinged to the main one, onto the metering cell in the base of the

camera. In is location the F3's metering cell is protected from any extraneous light, which allows the centre-weighted metering pattern to be more concentrated. For the first time the F3's metering features an 80:20 ratio compared to the 60:40 ratio usual up to then. This greater concentration makes it possible to meter a certain portion of the subject with more precision. The perforation of the mirror avoids the problems that come with partly reflective systems: on the one hand it allows the complete spectral range of the light to pass through evenly, and on the other hand the angle of the light entering is irrelevant. This system also allows the use of a normal linear polarizing filter instead of a circular version.

The film speed dial, situated on the left side of the top plate has a range of ISO12 to 6400, and is set by pulling up the outer collar. Next to it there is an exposure compensation scale marked in increments of 1/3EV. The F3's special accessory shoe is also located here, integrated below the rewind crank, for attaching the appropriate Speedlights. A small cam on the ISO dial conveys the film speed to the flash unit mechanically. This is the reason why the F3's TTL-flash metering, the first in a Nikon camera, which uses the cell in the mirror box base, does not work with flash units that have ISO-type hot shoes. The disadvantage of mounting the flash unit in this position, as had been done with the earlier F and F2, is that the rewind crank and camera back lock are covered. So the flash must be removed before the film can be changed. Later, The AS-7 flash adapter, introduced later, allows the film to be rewound and the back to be opened with a flash attached.

A normal PC (pin-cylinder) sync socket is located on the front of the body beneath the rewind crank.

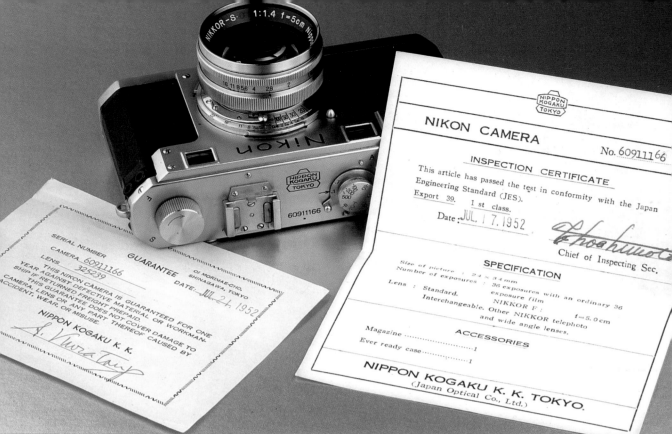

A 1952 Nikon S rangefinder complete with its quality control inspection certificate and guarantee card, both signed in ink.

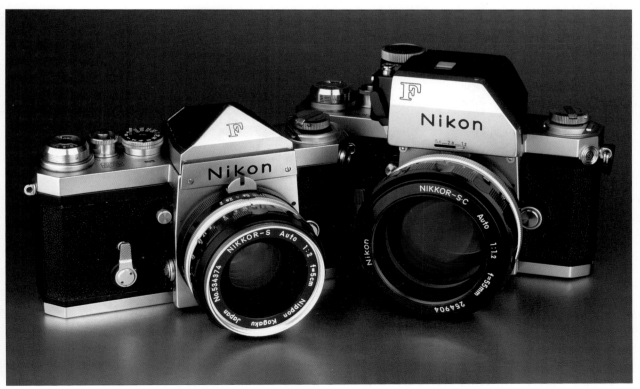

An early Nikon F with eye-level finder together with the last standard version of the camera, the Nikon F Photomic FTN.

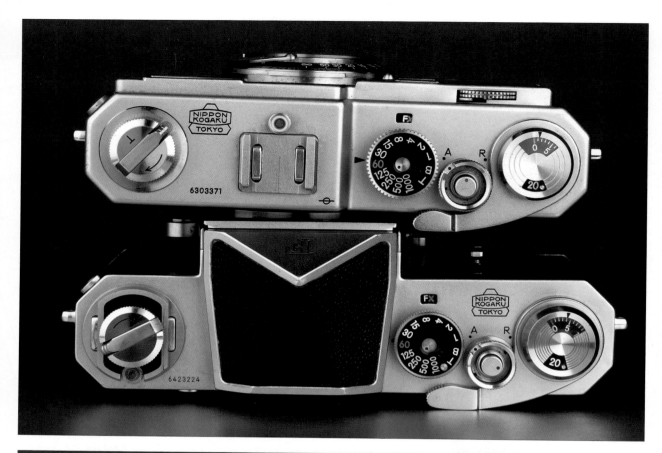

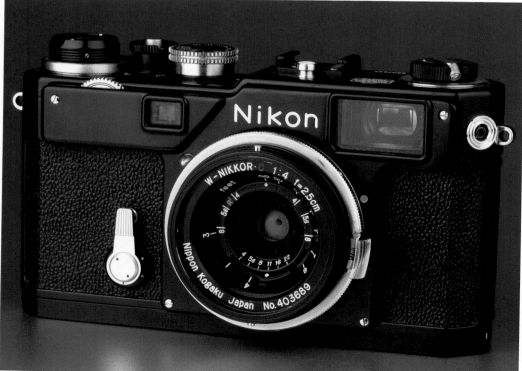

Above:
The heritage of the Nikon F can be seen clearly when compared to the Nikon S3 rangefinder above.

Left:
A Nikon S3 rangefinder with the Nikkor 25mm f/4 lens.

Page iii
A Nikon F with a range of early Nikkor lenses.

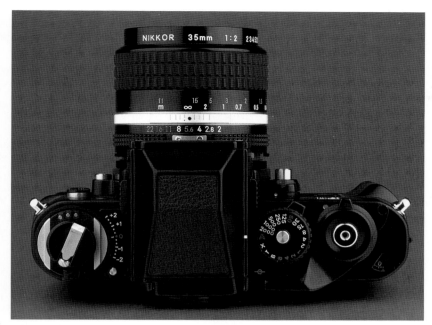

The top plate of the Nikon F3: the special flash foot attachment rails can be seen around the rewind crank.

In view of the F3's dependency on electronics the camera was given a mechanical shutter release, which is operated by the lever next to the lens mount.

Situated around the bayonet is the all-metal meter coupling lever, which can be swung up in order to allow the use of non-AI standard lenses.

To the left of the bayonet where the self-timer is usually found on other Nikon cameras, the F3 has a small lever that operates the mechanical shutter release in case the batteries fail. The auto-exposure lock button is positioned in the centre of this lever's axis, and for some years it proved to be something of a weak spot for the F3, as it would occasionally fall out. The design was eventually changed and the problem was solved.

To improve handling without the motor drive attached Giugiaro designed the F3 with a bulge on the front of the body to act as a finger grip. Opening the back of the camera reveals further improvements of the internal design; the take-up spool is equipped with six slots to allow faster film loading, and a roller next to the left of the film gate improves film guidance, ensuring optimal flatness even when using the motor drive.

Two gold contacts below the film guide rails provide connection between the camera and an attached databack. In order to mount the MD-4 motor drive the threaded cover plate set in to the base plate must be removed to allow the rewind spindle access to the film cassette. To prevent its loss the plate can be secured in a compartment on the MD-4.

There are seven contact pins situated round the rewind spindle via which the F3 controls the MD-4. This is a major improvement over its predecessor the F2 where the motor drive frequency had to be synchronized with the shutter speed first. The MD-4 also takes over the power supply for the F3's electronics.

In spite of the obvious advantages of the F3's electronics compared to the earlier mechanical camera designs, and its enormous popularity among so many photographers, the F3 has still not achieved quite the same legendary status of the F or F2. Regardless of this fact the F3

The base plate of the F3 with the motor drive coupling cover removed to show the electrical contacts. The MD-4 provides power to the F3 as well as advancing the film.

33

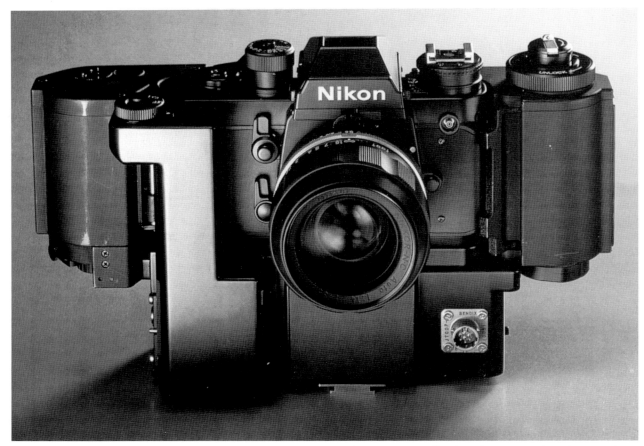

Nikon maintained its involvement with NASA during the production of the F3 with specially adapted cameras such as this example.

would ultimately out survive its successor the F4, and remain in concurrent production with the F5 until 2001, when in its 22nd year of manufacture Nikon decided it was finally time to discontinue this stalwart camera; a true testament to the F3's qualities and reputation.

Nikon F3 HP

For those photographers who wear glasses seeing in to the extreme corners of the image area in the viewfinder is often a problem since they cannot position their eye close enough to the eyepiece. Normal viewfinders are designed for an eye relief distance of about 17mm between eyepiece and eye. As this distance increases the corners of the finder image begin to be obscured. In order to solve this problem

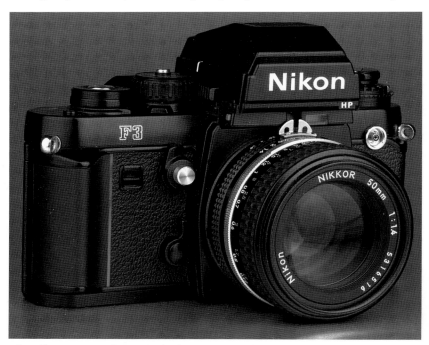

The Nikon F3 HP with its DE-4 high-eyepoint viewfinder.

Nikon developed a special viewfinder for the F3, the High-eyepoint (HP) finder, which has an eye relief distance of 25mm allowing a complete view of the finder image that suffices for most glass wearers.

The HP viewfinder, known as the DE-3, turns a normal F3 into an F3 HP, increasing the camera's weight from 700 to 745 grams. It is not just those with glasses who have come to appreciate the F3 HP, photographers with normal vision can benefit from the more comfortable viewing afforded by this finder, so much so that in the latter years of its production the F3 was invariably delivered as the HP version.

Nikon F3 T

Following the precedent set by the earlier F2 Titan, Nikon introduced a titanium version of the F3, the F3/T, in 1982 to emphasize its professional status. All the usually vulnerable parts are made of titanium and it was supplied with the titanium DE-4 HP type finder. Initially the camera was only available in a silver coloured finish, although a black

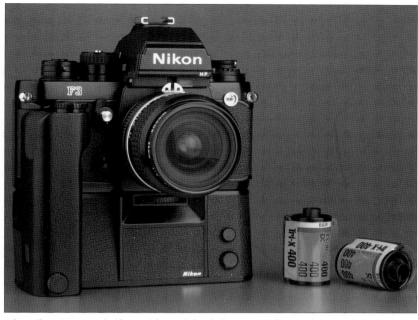

The Nikon F3 P was built to withstand the daily rigours of press photography.

version was offered later. The camera can be identified by the addition of a 'T' after the F3 logo on the front of the camera, and its serial number is prefixed with a 'T', otherwise all specifications were identical to the standard F3 HP, except for its weight which was reduced by 20g.

Nikon F3 P

In spite of the apparent paradox Nikon responded to demands from professional photographers to produce a professional version of their professional camera. Professionals' needs differ; a fashion photographer has different equipment requirements compared to one working for the press, and this is exactly the group the F3 P - 'P' as in press, was made for. The user requirement of the F3 P was developed in conjunction with the Japanese press agency Kyodo. This special version of the camera can be distinguished from the standard F3 by the conspicuous ISO type accessory shoe, with hot shoe contact, mounted on an HP finder that has a titanium housing. The shutter speed dial and the release button have a significantly higher profile to facilitate handling, and the latter has a silicone rubber cover to prevent the entry of water, but lacks the cable release thread. Inside the F3 P there are a number of rubber seals to protect the camera whilst working in damp conditions including high humidity or

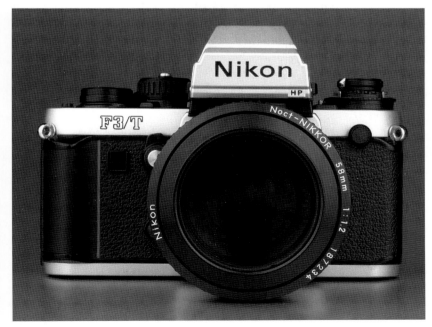

The Nikon F3 T has titanium outer body panels.

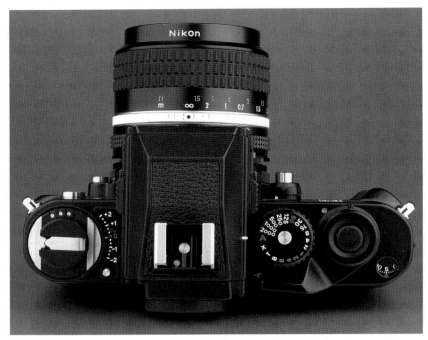

The F3 P has enhanced protection against moisture and dust; note the rubber seal over the shutter release button. Modifications included the provision of an ISO hotshoe on the viewfinder head.

exposure mode is always active instead of being activated once the frame counter has reach '1'. The lens mount of the F3 P is made of stainless steel and the camera is delivered with the B-type focusing screen as well as the MF-6B back that prevents the MD-4's motorized rewind taking the film leader back into the film cassette.

As mentioned before, these features were based on the feedback Nikon received from Japanese press photographers. Perhaps the design may have differed if sports photographers or photojournalists from other countries had been consulted. Whatever the case, in some European countries at least, supply of the F3 P was restricted to 'bona fide' professional photographers who were required to present their press identity cards before delivery of the camera.

torrential rain. Certain features considered to be superfluous in everyday press photography, were omitted: the self-timer, the eyepiece shutter, the lever for multiple exposures, and the security-catch on the camera back lock.

Further differences include the enlarged film counter window for easier viewing, and the automatic

Nikon F3 AF

These days we take automatic focusing for granted; in 1985 when the Minolta 7000 was introduced it was ground breaking technology. So why did Nikon present its first autofocus model two years earlier in 1983, and as a professional version? Given the high cost of development manufacturers tend to introduce new technology in to their enthusiast cameras first, before entrusting their professional model with it. Nikon decision to do things the other way round was based on the unit construction of the F3, which was suited to the development of an autofocus version of the existing camera without having to start from scratch. So the F3 AF body, except for the finder, is almost identical to the normal F3. The only differences are an additional row of electrical contacts on the finder mount and bayonet, which relay the signals from the AF finder to the AF lenses. Control of the autofocus is carried

The Nikon F3 AF: its autofocus system is housed in the DX-1 viewfinder head.

The Nikon F3 High Speed with its dedicated MD-4H motor drive is capable of 13fps.

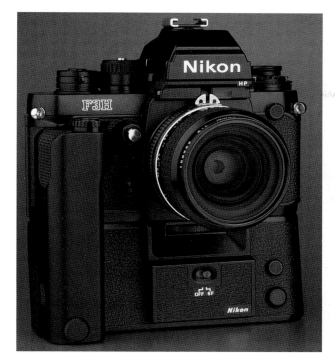

The Nikon F3 H and MD-4H.

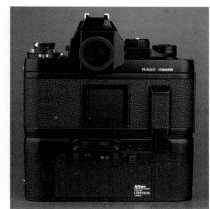

out in the DX-1 AF finder head. It is a self-contained system with a fixed focusing screen and its own power supply.

Within the finder two portions of the light rays in the central area of the finder image are separated out and directed at two silicon photo diodes. Similar to a split image rangefinder of a focusing screen, the system recognizes whether or not the parts of the subject centered in the focusing zone are in or out of focus. Depending on whether the subject is in front of, or behind, the correct focus plane the system sends the autofocus lens different signals telling the built-in motor which way to turn it in order to achieve correct focus. The focus indicators in the viewfinder, two red arrows, indicate the direction in which the lens is turning. Both light up simultaneously to confirm that correct focus has been achieved. Alternatively a red 'X' indicates that the system is not capable of focusing correctly; for example when there is insufficient contrast within the focusing zone.

The DX-1 AF-finder can be attached to any standard F3, with the exception of the F3 P, and serve as a focusing aid with the normal Nikkor lenses provided they have a maximum aperture of f3.5 or greater. Two autofocus lenses were introduced with the F3 AF, a 80mm f2.8 and a 200mm f3.5 IF-ED. The TC-16 teleconverter, that appeared later, remained the only supplement to the system. The converter's motor drives its own optical system, to providing an AF capability with a normal manual focus Nikkor lens.

Again, because of the –1/3EV light loss caused by the TC-16 and the need for a bright viewfinder image to ensure the AF system could function the attached lens must have a maximum aperture of at least f/2. The TC-16 is something of a stopgap since the focusing range of the lenses used with it is restricted, especially on telephoto lenses. Commercially the F3 AF was never a success, but then Nikon did not expect it to be, it served the more useful purpose of testing the market and allowed the company to gain valuable experience for the future.

Nikon F3 Limited

This special version of the F3 camera was released exclusively to the Japanese domestic market in October 1993. It is similar to the F3 P in both appearance and specifications, including a titanium covered HP style finder with ISO accessory shoe and hot shoe contact, the high profile shutter speed dial and shutter release button, which has the same rubber cover and no cable release thread, and fixed B type focusing screen. The viewfinder eyepiece blind and multiple exposure-lever have also been omitted. Externally the camera can be distinguished by the word 'Limited' next to the normal 'F3' badge on the front.

F3 High Speed

Yet another variant of the F3 P this camera in combination with its dedicated MD-4H motor drive can cycle at an incredible 13 fps! Like the earlier F2 H it uses a fixed pellicle reflex mirror that transmits 70% of the light through it to the film and reflects the remaining 30% into the viewfinder. To cope with the very high frame rate the lens must be preset to the shooting aperture, and metering is done with the lens stopped down. The depth-of-field

preview button is used to open the aperture to its maximum to facilitate viewing. The camera has the familiar titanium HP finder with ISO accessory shoe and a B-type focusing screen is supplied as standard. The multiple exposure lever and mechanical shutter release button have both been omitted.

Nikon F4

During the 1980's camera technology developed at an ever-quicker pace. At the time the first F3's appeared a programmed automatic exposure mode was considered an extremely advanced feature, today it is commonplace. Multi-pattern metering was introduced in 1983 with the Nikon FA and then in 1985 the Minolta 7000 headed the breakthrough in autofocus technology for SLR cameras.

By incorporating more and more microelectronics there seemed to be nothing that camera designers and engineers could not achieve. There was however a price to be paid, quite literally, since almost all manufacturers abandoned their existing lens mount design and adopted a new one to accommodate the AF technology. As well as a new camera their customers had no option but

to purchase a new set of lenses. This may be acceptable for the enthusiast, but for the professional it meant a considerable investment, especially if they were to upgrade their expensive, fast optics.

Nikon looked to protect the loyalty of its clients and set about designing a camera that maintained compatibility with its F-mount, which had existed since 1959, and combining it with the latest advanced technology - an extremely difficult task but one that Nikon mastered. The result was the Nikon F4. This fascinating, hybrid camera contains a whole host of innovative features allied to some tried and tested ones. It is beyond the scope of this book to examine all of them in detail; therefore, I will limit myself to the most important.

The external design is once again the result of cooperation between Nikon and the Italian stylist Giorgetto Giugiaro. At 1,100g the F4 cannot be described as a lightweight by any stretch of the imagination, but this is compensated for, especially when the camera is used with long and heavy telephoto lenses, by the comfortable and secure handling afforded by ergonomic design. The shutter release button is located on the slanted top of the protruding right hand grip. The film advance mode dial is built around the release button. In addition to a single frame advance mode, two continuous modes are available. The CH position allows firing rates of up to 4 fps when the F4 is equipped with the MB-20 battery pack, the F4S with the more powerful MB-21 battery pack and the F4E with the MB-23 pack are capable of 5.7 fps. The F4 is equipped with no less than four internal motors; one is used exclusively to transport the film, the second is responsible for cocking the shutter and driving the mirror-box mechanics, the third for film

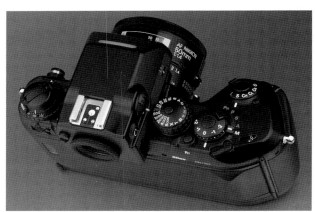

The Nikon F4 was the first camera in the professional F-series to have a built-in motor drive. Hence it does not have a film advance lever.

The Nikon F4 has a highly ergonomic design.

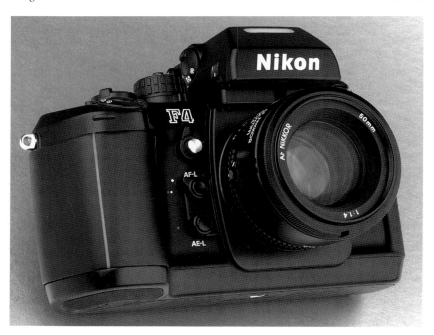

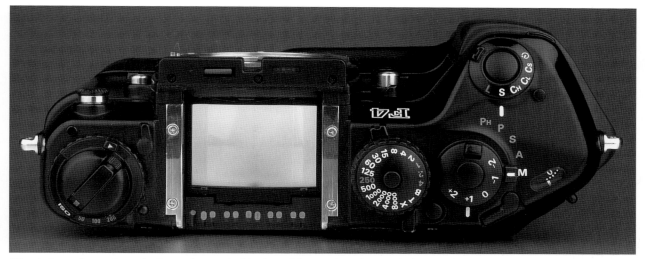

The plethora of controls on the F4 can be seen in this view of the top plate along with the row of electrical contacts for the viewfinder head.

rewinding, and the fourth motor is for driving the lens focusing mechanism.

The CL position offers a lower firing rate of 3.4 fps, whilst the CS setting is available for those situations when the normal noise level of the motor drive could be intrusive. The CS function advances film at a rate of one picture a second but because the motor is switched to operate intermittently the camera operates extremely quietly. The last position on the dial activates the electronically controlled self-timer.

An exposure compensation dial is located next to the classically designed shutter speed dial instead of in its usual place concentric with the film speed dial. A lever below this dial acts as a switch for the different exposure modes: two program versions (normal and high-speed), aperture and shutter priority modes, as well as manual. Note that the program and shutter priority modes are only available with AF lenses equipped with a CPU.

The multiple-exposure control lever, and the first rewind release lever are located on the rear edge of the F4's body behind the top plate dials. Following on from the F3 P

the F4's shutter speed dial has a high profile to facilitate handling, even when wearing gloves. There are 19 click-stops for speeds between 4sec and 1/8000sec, 'B', 'T', and the 'X' flash synchronization speed of 1/250sec It would not be possible to achieve such high speeds with a horizontally traveling shutter as fitted in the F. F2, and F3. For this reason the F4 has a shutter whose blades, which are made out of a carbon fibre reinforced epoxy material, travel vertically, similar to other Nikon cameras like the F-801, FM2N, and contemporary cameras such as the F100.

Although the F4 is equipped with a tungsten alloy balancer to reduce vibration caused by the shutter, as with earlier professional F-series Nikon's the mirror of the F4 can be locked in the up position to further reduce internal camera vibration. However, in this configuration there is a risk of light finding its way past the edges of the individual shutter blades. In order to prevent this a second set of aluminium shutter blades sit in front of the first with its epoxy blades. As in every model of the F-series the shutter of the F4 is designed to withstand a minimum of 150,000 cycles.

The standard DP-20 finder is removable, and as with other F-series models there is a waist-level finder, the DW-20, a 6x-magnifying finder, the DW-21, and an action finder, the DA-20. The F4 comprises

A diagram of the F4's viewfinder image: the AF sensor area is defined by the square brackets at the centre.

The Matrix metering mode divides the frame area in to five separate segments.

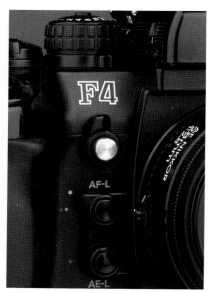

The depth-of-field preview button and mirror lock-up lever are located above the AF and AE lock buttons.

over 1700 separate parts and in order to create sufficient room for them some of the electronics were built in to the finder, including its 4-bit and 8-bit microcomputers and the controlling Integrated Circuits. The standard prism finder, the DP-20, offers the same matrix metering

The metering mode selector switch on the side of the DP-20 finder head.

as the Nikon F-801, which in turn was developed from the multi-pattern metering of the Nikon FA. The F4, however, has an innovative addition in the form of two tiny mercury switches that register whether the camera is being held vertically or horizontally so that the electronics can change the metering segment orientation accordingly. Furthermore, the DP-20 finder features a built-in dioptre correction and a compensation scale for the F4's different focusing screens.

The dial for the three metering modes is located on the right side of the finder housing. In addition to the matrix-metering mode mentioned above, there is a centre-weighted mode with the classic 60:40 ratio, as well as for the first time in a Nikon camera, a spot meter mode. The spot meter sensor is situated on top of the AF module in the bottom of the camera and covers an area represented by the 5mm circle in the centre of the finder screen; as such spot metering is possible with any finder and even without one. The 60:40 centre weighted metering is available with both the DP-20 and DA-20 heads, whilst the matrix metering is only possible with the DP-20 head attached. The complete viewfinder information is also only available with the standard DP-20 prism finder, which includes a display of the aperture and shutter speed, the metering mode, the exposure mode, an indicator that exposure compensation factor is in use, and the frame counter. The finders are mounted by sliding them onto the guide rails and are connected to the camera's electronics by a row of contacts behind the focusing screen. A separate lever under the shutter speed dial allows the finder illumination to be activated along with the exposure meter.

An ISO type accessory shoe, with

hot-shoe contact is mounted on both the DP-20 and DA-20, which in the case of the DP-20 means you can perform matrix-balanced fill-flash with an appropriate Nikon Speedlight. In order to protect the camera's electronics from flash units that use too high trigger voltage a special semiconductor-switch is incorporated.

Besides the standard bright B type focusing screen a further twelve versions are available for the F4, but unlike those for earlier models that feature interchangeable screens, they are generally not used as frequently because of the F4's autofocus.

The F4 and Autofocus

The F4 should be considered as a hybrid camera that bridged the divide between the manual focus era and the new AF technology. If you disregard Nikon's first foray into auto focus with the F3 AF camera in 1983, the F4 represents Nikon's first fully-fledged professional system, AF camera. It uses the AM200 AF-module with its 200 CCDs, which was also fitted to both the F-401x and F-801s. Its sensitivity range stretches from EV -1 to EV18.

In combination with a coreless motor the autofocus system achieves a response speed that, for the time, was very respectable. The autofocus system will only function with lenses that have a maximum aperture of f5.6, or greater, or if used in combination with the AF-teleconverter TC-16A, of at least f3.5. Additionally, the system offers a focus-tracking mode for moving subjects. This technology was introduced first in the Minolta 7000i and works by focus being determined at least twice before shutter release occurs. The camera computes the difference between the determined values and from this the distance the subject will have moved at the moment the shutter opens. Focus is

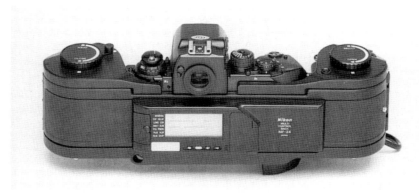

The MF-24 Multi-control bulk film back attached to an F4.

then preset to this distance to achieve a sharp image.

A filter is situated in front of the AF module to remove infrared light, but when an AF Speedlight is attached that has an AF illuminator using infrared light, a second filter is switched in that only lets IR light pass. The F4 even has an automatic mechanism that removes dust from the surfaces of these filters. By attaching either MF-23, or MF-24 Multi-control camera backs another AF function, known as the 'Freeze-focus' becomes available. In this mode the focus is set manually to a predetermined distance and as soon as a subject passes through this point of focus the camera releases the shutter automatically.

Once the film has been finished an LED, located to the left of the finder, lights up as a warning. The photographer then has the choice of either having the camera rewind the film automatically, which takes 8 seconds, or conserving battery power and resorting to manual rewind crank. This warning LED is also activated when the film speed has been set to DX but a non-DX coded film has been loaded. The film speed range runs from ISO6 to ISO6400.

The autofocus mode selector is situated below the lens release button. Inside the bayonet you will find the electrical contacts for the AF lenses and a complete set of control pins and levers, which ensure compatibility with almost all types of Nikkor lenses. As stated previously the Program and Shutter priority automatic exposure modes are only available with AF lenses, or manual lenses that contain a CPU, but the aperture priority and manual modes will work with any type of lens.

Function of the Matrix metering system is dependent on either an AF, or AI lens with a CPU. The centre-weighted metering is usable with almost all types of lenses, and spot metering is possible with all lenses, except the Reflex-Nikkors and PC-Nikkor lenses.

The depth-of-field preview button and mirror lock-up lever are situated on the front of the camera to the right of the bayonet, and below it is the AF lock button, which can also work simultaneously as an exposure lock if preferred. Lower down, beneath the AF lock, is another button that operates an exposure lock.

Nikon F4S and F4E

For a camera that is totally dependent on batteries the power supply of the F4 is of a vital importance. Power can be provided from a variety of different sources. The most

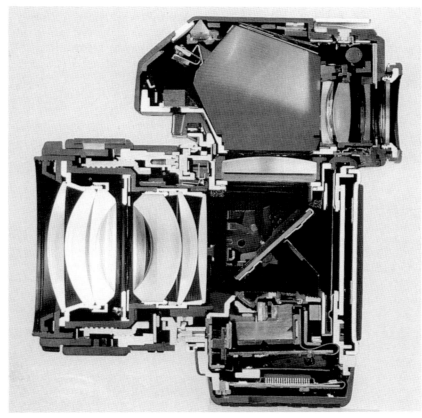

The complexity of the F4 is clearly shown by this cross-section.

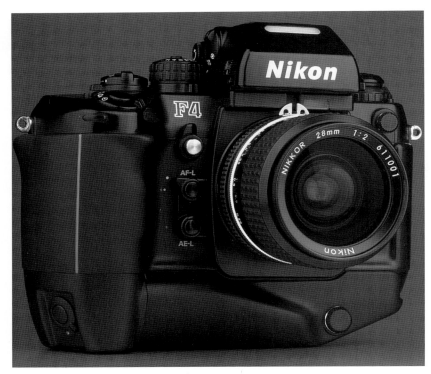

The Nikon F4 with MB-21 becomes the F4S.

The F4 represented such a radical change and significant advance over earlier F-series cameras that immediately after its introduction Nikon were literally overwhelmed by the demand for its new camera. They simply did not predict the F4's popularity, and for a long time deliveries were very slow, forcing camera stores to record waiting lists of their customers.

On one occasion during an interview a Nikon engineer expressed his astonishment at how he and his colleagues had managed to incorporate so many functions and features into the F4. Although unsubstantiated by Nikon it is my understanding from several well-informed sources that in excess of four hundred modifications were carried out on the F4 during the course of its production life. Serial numbers for the camera begin at 2000201 and, as far as I can determine, all of the principle modifications were completed in cameras issued with a serial number of 2450001 or higher. Prospective pur-

compact battery box, the MB-20, takes four AA sized 1.5v cells and fits inside the right-hand grip of the basic F4 body. The MB-21 takes six AA, or rechargeable 1.5v cells, and provides an additional shutter release button for more convenient operation when the camera is held vertically, as well as a terminal for remote control equipment. The camera equipped with the MB-21 is known as the F4S. The MB-22 consists of a grip section shaped exactly like that of the MB-21 and is required when external power supplies are used. The MB-23 is a one-piece battery pack that can be loaded with either AA size cells, or Nikon's rechargeable battery the MN-20. The camera with the MB-23 pack is known as the F4E. The shooting capacity of these battery packs vary between 30 films with the MB-20 and 150 films with the MB-23 equipped with the MN-20. The standard F4 with MB-20 does not have an electric remote control terminal,

however you can still use a conventional mechanical cable-release via the socket on the base-plate.

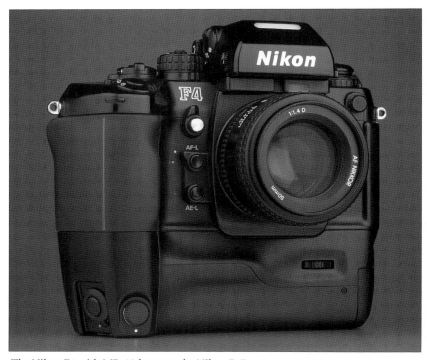

The Nikon F4 with MB-23 becomes the Nikon F4E.

The Nikon F4 serial number is located on the rear of the camera beside the first rewind switch.

chasers of a second-hand F4 would be well advised to consider a camera with the highest available serial number.

Nikon F5

During June 1996 the world's photographic press were invited to Sweden to the unveiling of Nikon's new flagship professional 35mm SLR camera - the F5. Although its existence was one of the worst kept secrets in the history of photography and rumours about the camera had been rife for months beforehand when it was finally revealed

the breadth of the specification and innovation of its component functions left many photographers spell bound. The F5 equipped photographer can monitor the effect of the camera's 36 control buttons and dials on one of three LCD's in thirty-eight separate areas of information. Further flexibility is offered by the 24 in-built custom settings (CS), which alter aspects of the camera's performance, and two sets of CS combinations can be memorised for specific shooting conditions.

Yet again the innate good looks and ergonomic style of the F5 are

the work of the design guru Giorgio Giugiaro. Inside the cast aluminium body, which is finished with a tough metallic coating, and the titanium prism head, are some of the most revolutionary developments in camera technology since the arrival of the original Nikon F. Two features were particularly innovative; the three dimensional, multi-sensor, colour sensitive light meter, and the AF system capable of tracking a moving subject whilst the camera shutter cycles at 8 fps.

Although the F5 maintains Nikon's famed retrospective compatibility with Nikkor lens by virtue of the Nikon F mount it is with the newer AF-D, AF-I, AF-S, and AF-G series lenses that the camera shows its true metering capabilities. The F5 has a 1,005-pixel Red-Green-Blue sensitive CCD that evaluates a scene's brightness, contrast and colour. Used with these lens types further information is gathered including the selected focus area, focal length, lens aperture, and focus distance. All of this data is analysed by a microprocessor, which holds a database of over 30,000 specimen exposures complied from photographs of real subjects. The RGB sensor is capable of detecting different light sources and can differentiate between tungsten, fluorescent, and daylight, as well as varying levels of individual colour saturation. Combined with its high sensitivity range from EV0 to EV20, at ISO100 with a 50mm f1.4 lens, the 3D

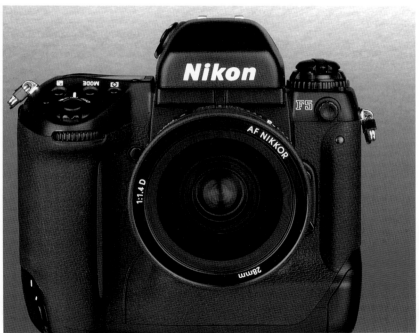

The Nikon F5 with Nikkor 28mm f1.4. Its specification took camera design forward by a quantum leap.

The metering mode selector switch is located on the side of the finder head.

43

matrix-metering mode is the most sophisticated TTL meter in any 35mm SLR camera to date.

The F5 also offers centre-weighted and spot metering modes. The centre-weighted meter has a 75:25 ratio whereby at the normal factory set default 75% of its sensitivity is concentrated within the 12mm circle at the centre of the viewfinder image. By using CS-14 you can redefine the size of this metering circle to 8mm, 12mm, 15mm, 20mm, or you can select a simple full-frame averaging meter. The spot meter is linked to the five AF sensors. To choose the 4mm diameter spot meter area you want to use you just manually select the corresponding AF sensor.

The F5 also releases Nikon photographers from the shackles of a centrally located AF sensor as seen in the F4, F-801, and the F90X. As good as these systems were photographers who wished to use AF were constrained by the fact that they had

to place their principle subject at the centre of the image frame to ensure it was covered by the AF sensor area. The F5 has five AF sensors arranged in what Nikon calls a 'wide-cross array' allowing for far more dynamic compositions, which at the same time permit the camera to track moving subjects. Nikon developed a new AF sensor the Multi-CAM 1300 that has the five CCD sensors incorporated in the module covering five areas – centre, left, right, top and bottom. The active sensor is selected by pressing the large rocker pad on the camera's back. On the standard EC-B plain matt focus screen, and EC-E grid pattern screen, the selected AF area brackets become darker to distinguish them from the inactive areas. On other screens you have to look at the small orange arrowheads that appear just outside the viewfinder image area to identify which sensor has been selected. In addition to 'seeing' more of the

frame area these AF sensors have an increased sensitivity range from EV-1 to EV19.

There are two distinct AF modes; in single area AF mode the photographer selects one of the five AF areas corresponding to the sets of brackets in the viewfinder to become the active AF sensor and aligns this with a static subject, for shooting a moving subject the F5 has a dynamic AF mode that automatically expands the coverage of the selected AF sensor area so that if the subject moves out of this area the focus priority is shifted to one of the other four areas to keep the subject in focus. Dynamic AF allows the photographer to follow a moving subject, subjects that change speed, and subjects that alter their direction. The F5's focus tracking operates in all AF modes, even at the camera's highest frame rate of 8fps. There is one other new feature to the AF system that Nikon calls Lock-On. This software ensures that provided you have a subject in focus and the shutter release still depressed the focus will remain locked even if, momentarily, something should come between the camera and subject; the software causes the AF system to ignore the interfering object.

As with previous Nikon AF bodies there is small switch on the front of the camera body beside the lens mount allows selection of either Single Servo (S) or Continuous Servo (C) modes. In either mode both focus tracking and Lock-On operate automatically. The same switch is used to select Manual focus (M). The F5 has an electronic range finder similar to other Nikon AF cameras, with a central green dot confirming focus and the two red arrowheads either side of this indicating the direction in which the focus ring should be turned to obtain focus. The F5 has two AF-

The F5 has the now familiar toggle switch located on the camera back to select the AF sensor area.

The main LCD panel of the F5 displays all the relevant exposure information.

ON buttons placed for horizontal and vertical shooting that allow the photographer to operate the AF without pressing the shutter release. Nikon claim that the F5 auto focus system is 15% faster than any previous Nikon body, and I can certainly vouch for its performance when used in combination with AF-S type lenses with their internal focusing motors.

The main On/Off power switch is placed around the primary shutter release button and has a separate lock button to prevent accidental movement. A secondary shutter release, with a lock button, for vertical shooting is positioned at the base of the right side grip. Rotating the dial to the right switches on the illuminator for the top and rear LCD panels, and repeating this step switches them off. The F5 has a double-bladed shutter construction with six blades made from an epoxy-carbon fibre mix and the other two from aluminium alloy. The shutter has a self-diagnostic feature so that every time it fires the system monitors the shutter speed. If it drifts from the calibrated speed the camera automatically compensates to maintain correct exposure. The shutter and mirror, which has a sophisticated damper and balancer to reduce vibration to a minimum, are mounted in a floating mechanism to lower noise levels.

The F5 offers program, shutter-

priority, and aperture-priority automatic exposure, or a full manual mode, these are chosen by depressing the mode button behind the shutter release and turning the main command dial on the rear of the camera. To the right of the mode button is the exposure compensation button; compensation can be set in increments of 1/3EV across a range of –5 to +5EV. To the left of the exposure mode button is the AF mode switch, and behind this is the button used to set the multiple exposure function. The large top plate LCD shows: exposure mode, exposure compensation, multiple exposure, shutter speed, shutter speed lock, aperture, aperture lock, focus area, AF mode, focus area lock, exposure bracketing, flash exposure bracketing, battery level, and frame counter.

The F5 comes with the DP-30 multi-meter finder, however there are three other viewfinders available.

The DA-30 action finder that provides five-segment matrix, centre-weighted, and spot metering. The DW-31 high-magnification finder offers a magnification of x6 of the central viewfinder image, and the DW-30 waist level finder both provide spot metering only. All finders afford virtually 100% viewing.

On the right side of the DP-30 is the meter mode switch, which has a large central lock button. Behind this is the viewfinder eyepiece dioptre adjustment with setting from –3 to +1m -1. The eyepiece has a curtain to prevent stray light entering when the camera is used remotely. On top of the prism housing is a standard ISO accessory shoe with hot shoe contact for the dedicated TTL flash control system. The viewfinder shows a wealth of information including: exposure mode, shutter speed, aperture, exposure compensation, frame counter, flash ready, focus status, and retains an ADR window to display lens apertures of all AI, AI-S, and AF Nikkor lenses.

The F5 had a conventional manual rewind crank with a lock button. Set around the crank is the film advance mode selector that offers: single, continuous low, continuous high, continuous silent, or self-timer. Custom Settings can be used to vary the frame rate in each of the continuous modes, and the continuous silent mode, which operates at 1

The F5 offers both manual and powered film rewinding. The conventional rewind crank can be seen here above the second auto-rewind switch.

The rear LCD panel of the Nikon F5 displays a variety of information.

fps, and whilst not totally silent does reduce the overall noise of the film advance and shutter action. For those in a hurry the F5 has motorised film rewind that returns a 36-exposure film to its cassette in just 4 seconds when powered by the MN-30 battery pack. Although the F5 can be set-up to advance film to the first frame automatically as soon as the camera back is closed curiously there is no automatic rewind once the end of the film has been reached. Equally if you wish to have the film leader left out of the cassette with auto-rewind an authorised Nikon engineer must adapt the camera.

The LCD panel on the rear of the F5 is used to set, custom settings, film speed, exposure bracketing, flash exposure bracketing, flash sync mode, and the locking of camera settings. In addition to DX coding (ISO25 to 5000) the film speed can be set manually from ISO6 to ISO 6400.

The F5, used in conjunction with appropriate lenses and Speedlights, offers a very sophisticated TTL flash control system. Flash modes include front curtain sync, rear curtain sync, and slow sync. In auto-exposure modes with front curtain sync the shutter speed range is restricted to 1/60 to 1/250sec. In

slow or rear curtain sync the range is extended from 30 seconds to 1/250sec. It should be noted that in rear curtain sync the Monitor Pre-flash exposure system of compatible Nikon Speedlights is switched off and flash exposure defaults to standard TTL control. In manual and shutter priority exposure mode the F5 has a maximum sync sped of 1/300sec that is set by CS-20. Exposure bracketing can be set in increments of 1/3, 2/3, or 1EV, and in two or three frame configurations. The lock function that can be applied to the shutter speed, aperture value, or AF sensor selection will only work with lenses containing a CPU, and the word LOCK appears against the appropriate control in the top LCD. Pressing the button marked CSM accesses the Custom Function menu; to scroll through the menu you rotate the main command dial and lock the chosen CS with the sub-command dial. For special or frequently experienced shooting conditions you have the option of programming the F5 with two sets of Custom Settings, labelled either A, or B, that can be quickly accessed.

Unlike the F models beforehand the motor drive of the F5 is integral as is the battery box. The camera is supplied with the MS-30 battery

holder that accepts eight AA size cells, which can be standard alkaline, nickel-metal hydride (Ni-MH), or lithium (Li). The maximum frame rate with these batteries is 7.4fps. To achieve the full 8fps you must use the MN-30 Ni-MH battery unit, which has its own dedicated charger, the MH-30, that includes a refresh function to completely discharge the MN-30 before putting it through a recharge cycle.

The F5 has a removable back which can be replaced with either the MF-27 Data Back for the imprinting of time (minute/hour) and day, month, and year, or the MF-28 Multi-Control Back, which can imprint data both in the frame area and between frames. In addition to time/date information the MF-28 can record the frame number, and a six-digit number in the frame area. It can record the same information between frames as well as a caption up 22 characters long including the copyright symbol (, the shutter speed/aperture, compensation value in Auto-bracketing, or a caption with 18 characters plus a four digit year.

When the F4 was launched during 1988 auto focus technology was still in its infancy and regarded by many photographers as something of a novelty. The F4 was a hybrid camera that embraced both the new generation of AF and earlier manual focus lenses, with which it retained full exposure metering functionality including matrix metering.

By the time the F5 arrived eight years later all this had changed. AF systems were considerably quicker and more reliable. The advances AF lens design meant that they supplied far more information to the camera for the purposes of calculating both ambient and flash exposures. Hence the F5, with its sophisticated metering and auto focus systems, is a very significant advance on the F4.

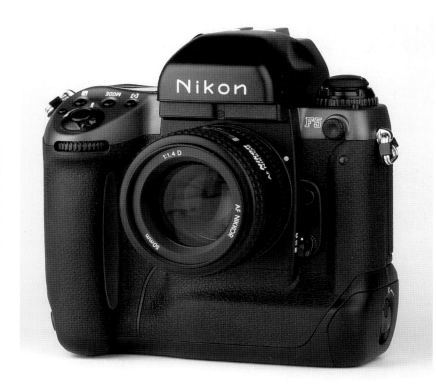

The Nikon F5 Anniversary was issued to mark the 50th anniversary of 35mm camera production.

The F5 Anniversary has a number of distinctive features including the 'Nippon Kogaku – 50' logo on the rear.

Thanks to the retention of the Nikon F lens mount bayonet, and despite the increased use of complex electronics, the F5 can still be used with most manual focus Nikkor lenses, however, it can only support centre weighted and spot metering and does not provide all of the features available with AF lenses.

For many the F5 approaches the pinnacle of design for a 35mm film camera. Although, based on experiences with the F5 a few handling improvements appeared two years later in the F100, it is unlikely that we will ever see an F6 due to the dawn of the digital age. It is a great testament to the F5 that a lot of its features can be seen in the highly successful D1, D1X, and D1H digital SLRs, which have now firmly established themselves in many areas of professional photography.

Nikon F5 Anniversary Edition

To celebrate the fiftieth anniversary of the introduction of the first Nikon 35mm camera, the Nikon I, a special version of the F5 was introduced. Production was limited to about 3000 units, and even though it is a fully functioning camera, it was principally aimed at collectors. The Nikon name badge on the front of the DP-30 finder replicates the lettering style of the Nikon I. On the back, near the rear LCD is the old triangular 'Nippon Kogaku' trademark logo with the figure '50' below it. The top plate is finished in elegant looking slate grey coloured titanium, and the stripe on the inside of the finger grip is grey, as is the special BF-1A body cap. The camera was supplied in a high quality presentation box together with a commemorative strap embroidered with the inscription ' 50 Year Nikon 1948–1998 – F5'.

The Nikkormat Series

In the 1960's many photographers who aspired to own a Nikon did not require the level of sophistication offered by the professional F model. The company responded to this demand by introducing the simpler, more affordable Nikkormat series.

By 1965 the Nikon F was well on its way to establishing itself as the professional photographer's first choice for a 35mm SLR. Even so, many professional as well as accomplished enthusiast photographers felt the need for a simpler second body. They were prepared to go without some specialist features, such as a removable penta-prism, in return for a camera with a more moderate price.

Nikkormat FT

The Nikkormat FT was introduced to fill this niche. Equipped with a TTL-exposure meter, a fast shutter with speeds ranging from 1 to 1/1000sec., a flash sync speed of 1/125sec., and capable of accepting every one of the then current Nikkor lenses, including the specialist ones, it met all the most important criteria. It was more compact and lighter than its cousin, the F, and was intended to allow the proficient enthusiast access to the Nikon system.

The Nikkormat FT features a fixed prism finder along with a fixed

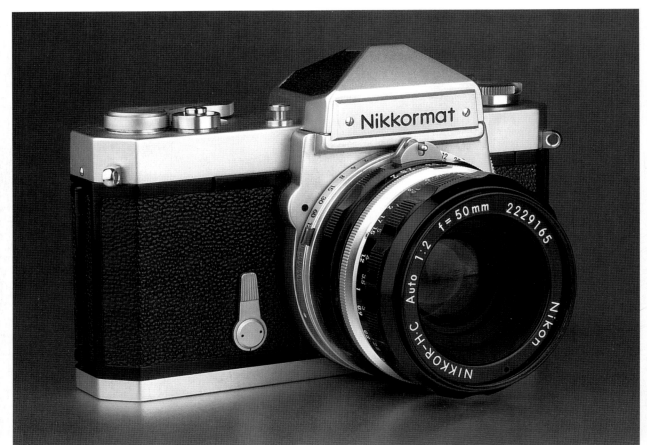

The Nikkormat FT represented a more affordable alternative to the Nikon F.

The final version of the Nikon F2 the F2 AS.

The mirror lock-up sliding switch: a feature of early Nikkormats.

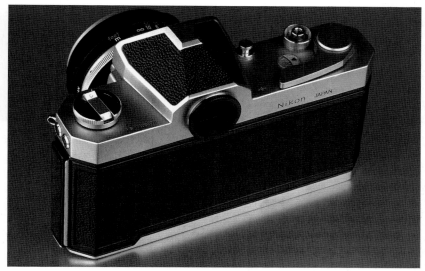

The Nikkormat FS lacked the exposure meter and mirror lock-up of the FT.

viewfinder screen. To switch on the exposure meter the film advance lever is turned 20° out to its stand off position. A full stroke of 135° cocks the shutter and transports the film to the next frame; contrary to the F or F2, it is not possible to do this with several half-strokes. The film counter and depth-of-field preview button are situated next to the release button with its normal, as well as Leica 'bell-type', thread for cable releases.

The shutter speed dial is not on the top of the camera, but is located around the lens bayonet. The set speed can be seen on the ring, which is operated with a lever located on its opposite side. The meter-coupling prong is also found around the bayonet. The camera's exposure meter must be informed about the preset as well as the lens' maximum aperture. To ensure this occurs the ISO-film speed has to be turned to the mark corresponding to the latter. This proved to be a time consuming and awkward procedure.

The mirror lock-up slider, which many photographers consider to be rather difficult to use, is situated immediately above the lens release button. Regardless of this it is a very useful feature that unfortunately many modern cameras, particularly AF types, no longer have. Of course, the Nikkormat FT also has the obligatory self-timer with a running time of about eight seconds. The fixed screen in the viewfinder, which is comparatively dim by current

standards, has a micro-prism area. The exposure meter needle is displayed to the right outside the finder image. Whenever the needle is centred within the bracketing frame the resulting exposure will be 'correct'. In addition the exposure setting can be monitored from outside the camera. On the top-plate, located between the prism and the rewind crank, is a small window with its own needle, so that the exposure can be controlled without having to look through the viewfinder. This practical feature is very useful, for example, when you want to shoot without raising the camera to the eye.

The FT metering system incorporating two CDS cells to the left and right of the eyepiece, that cover the whole frame without favouring any particular area, work within the range of EV 3 to17 at ISO100. Just like the Nikon F, the Nikkormat also uses a single 1.35v button-size battery that is housed in the base of the camera. The Nikkormat FT has two different sync-terminals labeled: 'X' for electronic units and 'M' for flashbulbs.

Besides the fixed finder there is another important difference to the

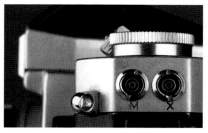

The M and X flash sync terminals of a Nikkormat FS.

Nikon F: the Nikkormat has no motor coupling. Nikon sacrificed these two features to permit a simpler design and thus a lower the price. As an extra, a separate accessory shoe was available which could be mounted on the eyepiece protection lens. This shoe also allowed the attachment of special viewfinders for fisheye lenses but does not provide a hot-shoe contact for triggering flash units.

The FT was made available in chrome or black finish, and formed the starting point of the Nikkormat series. The first design under went a series of modifications, represented by the following models, the FS, FTN, FT-2, and FT-3, which together spanned a total production life of 12 years between 1965 and 1977. The length of this period of produc-

tion exceeded one or two of the F-series models.

Nikkormat FS

A sister model to the Nikkormat FT, the FS was introduced at the same time. Its features are nearly identical to those of the FT except that the exposure meter and the mirror lock-up-slider were omitted. These days, although not commonplace, good quality examples of second-hand Nikkormat FT's can still be found, the FS however, is very much a rarity.

Nikkormat FTN

The best-known Nikkormat model, the FTN, was introduced in 1967 as the successor to the FT. Although eventually replaced by the FT-2 in 1975 it was a successful design that remained popular for many years thereafter. Compared to the FT it was improved in several areas that were very useful in everyday work. Its exposure meter is centre-weighted, with a 60:40% ratio, a characteristic that was to remain a standard in many Nikon cameras during subsequent years. The viewfinder image was brightened somewhat and the Nikkormat FTN could be supplied with one of two different focusing screens: the A-type with a split-image rangefinder or, the J-type with micro-prisms. However, you had to decide which screen you required before purchase because it was fixed in the factory and could not be removed by the photographer. The last series of FTN models was supplied with the K type screen that combined the features of the A and J types.

The display of the shutter speeds in the viewfinder was new and a real benefit in practical terms. There are always three speeds visible simultaneously: the preset speed is displayed in the middle, with the next faster and slower speeds to the left and right. The bracket for the

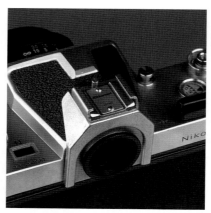

The standard FTN lacked a built in accessory shoe, however one could be attached via the finder eyepiece.

metering needle was equipped with plus and minus symbols to make it easier to discern between over or under exposure.

The FTN was the first model to be equipped with the semi-automatic maximum aperture indexing of the mounted lens as a coupling between the exposure meter and the lens. To do this, the meter-coupling prong must be turned to the left in the direction of the rewind crank and the lens set to f/5.6. The lens is then attached and, after it clicks into its proper position, the aperture ring must be turned once all the way to the left and once to the right. This procedure, which may seem tedious at first, and was often criticised by the users of other makes, is soon something the photographer does almost instinctively. A habit that long-time Nikon users still practiced unnecessarily even after the change to the Automatic Indexing (AI) system that was introduced during 1977.

A scale for the maximum aperture of the mounted lens is included in the aperture ring at about the height of the mirror lock-up slider. It is advisable to get into the routine of occasionally checking the mechanics, consisting of three metal rings running within each other, as they

The FT has an all-metal depth-of-field lever, and the shutter speed is set via a ring around the outside of the lens mount.

On the Nikkormat FT the film speed is set via a ring around the lens mount.

are susceptible to the ingress of moisture and dust, which can impede their movement resulting in overexposure. Initially this defect was not identified since it occurred intermittently and only with certain lenses that otherwise worked perfectly. The most vexatious element of FTN handling is without doubt setting the film speed. Achieved by means of a tiny metal lever in the lower part of the shutter speed dial it is rather difficult to handle, and must have been responsible for countless broken fingernails over the years. Otherwise it is difficult to criticize the handling of this popular Nikkormat model.

Nikkormat FT- 2

After a production period of eight years the Nikkormat FTN became due for a number of modifications, and it metamorphosed into the FT-2. The most obvious feature that distinguishes it from its predecessor is the accessory shoe, with its flash-

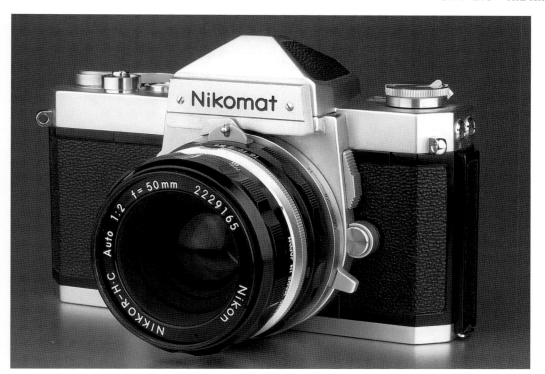

The Nikkormat FTN, the most popular model in the series, was introduced during 1967.

A view of the FT-2's top plate: showing the built-in accessory shoe and small plastic inlet in the depth-of-field button.

The exposure meter window, next to the rewind crank, can be seen in this view of the FTN top plate.

sync contact, mounted on top of the penta-prism. The plastic-covered film advance lever made the film winding action more comfortable to handle and further improvements enhanced the FT-2's looks as well as its operation. For example, a new leather surface on the front and rear plates, a plastic-coated self-timer lever, and small plastic inlets in the depth-of-field button and lens release buttons. The ISO setting had become distinctly easier to operate and was equipped with a lock on the shutter speed lever, so Nikkormat users had no need to complain about broken fingernails anymore. The proven "Copal Square" shutter construction was modified by including an automatically switching sync-contact, so that the FT-2 only needed one sync-terminal, another distinctive feature. Plus and minus symbols were added to the exposure meter window on the top of the camera as signs for over and under exposure, and the power was now supplied by a 1.5v battery.

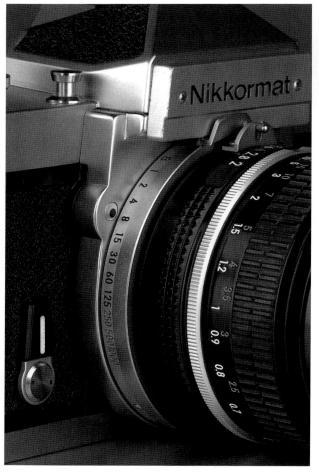

The maximum aperture scale set around the lens mount of the FT-2.

The shutter speed ring of the FT-2: notice the plastic covered self-timer lever.

The successor to the Nikkormat FTN was the FT-2. New innovations included the accessory shoe, fitted as standard, and the plastic tip to the film advance lever.

Nikkormat FT- 3

In 1977 Nikon introduced the Automatic Indexing (AI) control system, which automatically indicated the lens' maximum aperture to the exposure metering system, so the FT-2 was updated to become the FT-3. The only difference between the two models is the AI aperture coupling. However as the demand for a more modern camera gathered pace the reign of the Nikkormat was drawing to a close.

Nikon discontinued the Nikkormat series in the same year that the FT-3 was released and replaced them with the more compact and efficient FM. Even so, countless Nikon photographers, professionals as well as enthusiasts, had come to value their Nikkormats as reliable and rugged photographic tools, which continued to provide sterling service for many years to come. Collectors of this series of cameras may be interested to know that those models manufactured for the Japanese market carried the name Nikomat rather than Nikkormat. The latter name was used for export models only.

Nikkormat EL

This was not Nikon's first camera with an automatic exposure mode; that particular honour belongs to the Nikkorex Auto 35. The latter, a little known and rather esoteric camera from the Nikon stable, had

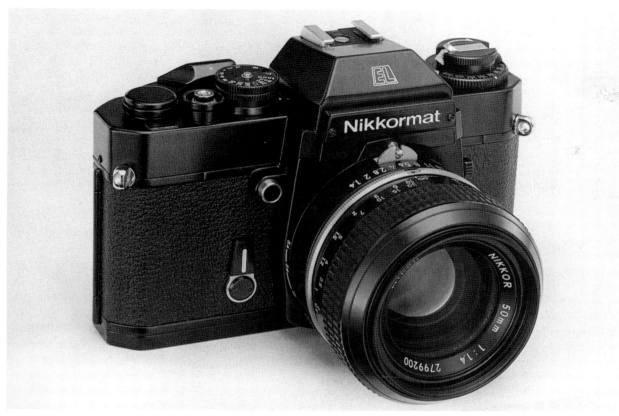

The Nikkormat EL with automatic aperture priority exposure control.

neither TTL-metering nor inter-changeable lenses. Nikon's first true system camera with aperture priori-ty automatic exposure mode, the Nikkormat EL appeared on the mar-ket in 1972. Considering that Konica had introduced an automatic system SLR four years before with the Autoreflex T, although it featured a shutter priority mode, the Nikkormat EL was long over due.

In terms of design the EL is a completely different camera, which bears no more in common with the mechanical Nikkormat models that had been produced up to that date than the name. It was equipped with the proven 60:40% centre-weighted metering system and, for the time, a revolutionary single Integrated Circuit (IC) that electronically con-trolled the Copal shutter. Two CDS cells serve as metering sensors. Their sluggish performance in low light is

readily apparent. Pointed at a dark subject immediately after a bright one it takes 1 to 2 seconds for the metering needle to settle on an exposure value. This so-called mem-ory-effect is more or less typical of all CDS-metering systems and not peculiar to the EL.

That brings us to the viewfinder display. Within the EL's fixed prism finder a shutter speed scale is locat-ed on the left with a range from 1/1000 to 4 sec. A black needle moves over this scale and indicates the shutter speed chosen by the automatic exposure system. When set to manual mode a green needle marks the preset shutter speed while the black one still indicates the meter's selection as a comparison. This match-needle system is a very practical method of assessing expo-sure values, which enables you to meter the brightest and the darkest

subject details in order to evaluate the degree of contrast. When set to automatic mode the green needle moves to the "A" at the top of the speed scale. An almost identical arrangement was later used in the Nikon FE, FE2, and FM3A cameras. The Nikkormat EL is equipped with an auto-exposure lock function, which is activated with the self-timer lever. As long as it is pressed in the direction of the bayonet the value displayed will remain locked.

The viewfinder had either the A type (split-image rangefinder) or the J-type (micro-prism) focusing screen built in. They are not inter-changeable. The last models pro-duced during 1976 were equipped with the K type screen that com-bines both features.

A 6v silver-oxide battery serves as the power supply, and Nikon gave it a very peculiar place in the camera's

The battery check button and the warning LED on a Nikkormat EL.

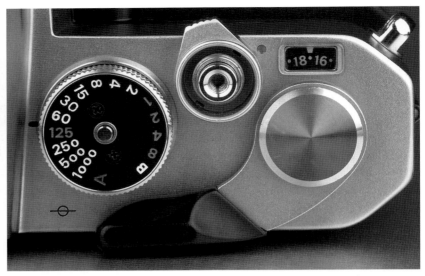

The Nikkormat EL-2 has a long shutter speed of 8 sec. Note the inclusion of the additional meter power switch set around the shutter release.

body. You will find it in the mirror box where the mirror has to be locked in its upper position and the battery compartment's cover unlocked before it can be exchanged. A procedure that requires some dexterity! A button to the left of the eyepiece operates a battery test function with an LED that illuminates to indicate that there is sufficient power in the battery. If the battery output falls below 4.5v the shutter will revert to its mechanical speed of 1/90 sec. The B position, however, will not work if the battery fails.

The exposure meter is activated when the film advance lever is moved out to its stand off position; this simultaneously unlocks the shutter release button. The switch for the type of flash synchronization is located within the shutter speed dial and operates by lifting the outer collar of the dial: a red arrow for X (electronic flash units), a white bulb

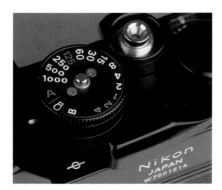

The bulb symbol for M-type synchronization can be seen inside the shutter speed dial of this ELW.

symbol for the M-type synchronization of flash bulbs.

The EL's built-in accessory shoe represents another first for a Nikon camera model since it provides a hot-shoe contact as a standard. An example of Nikon's attention to detail is the switch located in the accessory shoe that only activates the central X sync contact when a flashgun is attached.

The procedure of opening the EL's back by lifting up the rewind crank is another first for a Nikon, and is a significant improvement in handling over the earlier key arrangement in the base-plate. The top plate mounted film speed dial located beneath the rewind crank, yet another new innovation for Nikon, has a range from ISO25 to ISO1600.

In the EL, the information about the chosen film speed and aperture set on the lens is relayed to the camera's electronics by means of a resistor plate. Depending on the ISO and aperture values a tracing brush touches a certain section of the plate. These resistor elements used to be made of graphite with the disadvantage that any ingress of dust or moisture could cause poor

contact. The problem would often manifest itself by the meter needle moving erratically. In the EL an Functional Resistance Element (FRE) was employed which uses a hard glass base plate onto which the resistors are fastened thus eliminating the problem. Another advantage of the EL is the rotation of the reflex mirror around an asymmetrical axis. This allows the use of an elongated mirror that provides a brighter viewfinder image, and reduces the effects of vignetting with long telephoto lenses and in high magnification close-up photography.

Nikkormat ELW

Not long after the appearance of the EL photographers began to ask for a motorized film transport system to compliment its automatic exposure mode. As the original EL had not been designed for the attachment of such an accessory it was necessary to develop an appropriately modified successor, the Nikkormat ELW, with the W standing for winder. It was introduced in 1976 and only available in black finish. It is practically identical with an EL with the excep-

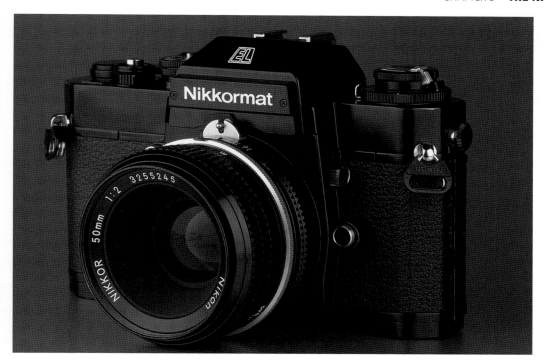

The Nikkormat ELW permitted the attachment of the AW-1 Film winder for automatic film advance.

tion of some additional electrical contacts and a mechanical coupling in the camera base-plate for the motor winder.

The AW-1 motor winder produced for the ELW has dimensions almost equal to those of the camera base plate and is a mere 4cm high. It is controlled by the camera release button and runs at about 2fps. Although there is no continuous shooting mode the winder improves handling by allowing consecutive exposures to be made without having to take the eye from the viewfinder. The ELW was equipped with a separate switch, situated around the shutter release button, to activate the exposure meter so that the film transport lever does not have to remain at the stand off position. To prevent battery drain you must remember to turn this switch to its 'off' position when the camera is not in use.

It is worth noting that the EL cannot be converted into an ELW, of which only a small number were produced, since its successor, the

EL-2 was already on the drawing board and released just one year later.

Nikkormat EL-2

In comparison to the EL, two major differences stand out on the EL-2,

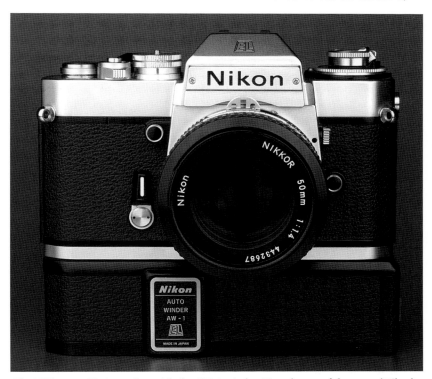

The Nikkormat EL-2 together with the AW-1 winder. Note the use of the name 'Nikon' in place of 'Nikkormat'.

The EL-2 has the AI standard lens coupling introduced during 1977.

The battery chamber in the Nikkormat EL, ELW, and EL-2 models is in the floor of the mirror box, and is accessed through the lens mount flange.

which was the first in this series of cameras to carry the name Nikon instead of Nikkormat. In 1977 all Nikon cameras and lenses were equipped with the AI system for automatic maximum aperture indexing. The days of having to set the aperture ring to f/5.6 before mounting a lens, the prong to its normal position, and after securing the lens turning the aperture ring back and forth once were gone. The AI system reduces lens changing to one single, simple, and quick operation with the help of the lens' meter coupling ridge that automatically brings the body's prong into the proper position.

The second major modification concerns the electronics. Instead of the relatively sluggish CDS-cells, the EL-2 works with very much more responsive silicon photo diode (SPD) cells. All the electronics are integrated into one flexible printed circuit board with far fewer soldered connections making them far more durable and reliable. There are also improvements to details in the EL-2. For long exposures the shutter speed range is extended to 8 sec. and the film speed range is expanded from ISO12 to 3200. Another useful feature is the ability to set exposure compensation factors from +2 EV to -1 EV in increments of 1/2 EV. The

self-timer lever, which also serves as the auto-exposure lock lever, was shaped more ergonomically to prevent the finger from slipping off. As the immediate successor to the ELW the EL-2 was also designed to accept the AW-1 motor winder. Though the standard K-type focusing screen (split-image rangefinder and microprisms) is still fixed. The EL-2 was available either in chrome or black finish but only for a short while. In 1978, having used the EL-2 as a test bed for its electronics, Nikon introduced the compact FE.

The Compact F Series

By the late 1970's the popularity of the Nikkormat series had convinced Nikon of the demand for a compact, robust, and fully specified camera to compliment its professional 'flagship' model, the F2. The design concept, introduced in Nikon FM during 1977, has been so successful that it continues to be used today in the current model the FM3A.

At the time of its launch it is unlikely that Nikon ever anticipated how successful their new camera design, the Nikon FM, would be. By using the same dimensions throughout this series of lightweight, compact bodies, which comprises the FM, FE, FM2, FM2N, FE2, and the currently available FM3A, and the same system accessories, including the MD-11 and MD-12 motor-drives, which fit all models, Nikon gave rise to one of the most ubiquitous camera types ever made.

Nikon had offered the Nikkormat series alongside their F and F2 cameras since 1965. Aimed at professional and enthusiast photographers alike, many of whom purchased a Nikkormat as a second body, the series enjoyed a rapid growth in popularity. This was based, principally, on their qualities of reliability and ruggedness, which were found to be comparable to the F and F2. However, in spite of constant improvements from the first FT to the FTN, FT-2, and finally the FT-3

with its AI-coupling system, the calls for a new type of camera had grown.

Nikon FM

In 1977 Nikon introduced a completely new design of camera - the FM. Even though its dimensions are almost identical to the tried and tested Nikkormat it weighs about 200g less. From the first moment you pick up an FM and stroke the film advance lever through its extremely smooth action you realise

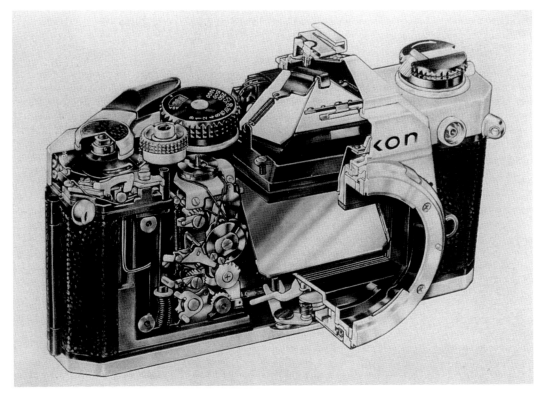

A cut-away drawing of the Nikon FM: successor to the mechanical models of the Nikkormat series.

The FM viewfinder image with the aperture displayed via the ADR window.

that the camera has only one thing in common with an FTN, or its successors, the Nikon F bayonet.

Look through the viewfinder and you will see the three LEDs used to indicate the result of the proven 60:40% centre-weighted metering system. The circle in the centre indicates a 'correct' exposure with a maximum deviation of +/- 1/5 EV. In addition if the +/- LEDs light up, this indicates over, or under exposure of up to 1 EV. If only + or - light up the difference from a 'correct' exposure amounts to 1 EV or more. Nikon designers chose the extremely responsive gallium arsenide photo diodes for the light metering cells. The metering range extends from EV1 (1 sec. at f/1.4) to EV18 (1/1000 sec. at f/16) with ISO100. The film speed is set inside the shutter speed dial and covers an impressive range from ISO12 to 3200. Besides the shutter speed, the preset aperture is also displayed in the viewfinder via a small window on the underside of the penta-prism. A system Nikon refer to as the Aperture Direct Readout (ADR). All AI type lenses, and those modified to this standard, carry a second scale of aperture markings close to the rear edge of the aperture ring for this purpose.

The FM has a fixed K-type focusing screen as standard. In order to avoid vignetting when using extremely long telephoto lenses or in close-up photography the FM was given a larger mirror. The vibration resulting from the movement of the mirror, just prior to the opening of the shutter, is reduced by a pneumatic damper unit, which is built into the mirror-box. Nikon decided that this system obviated the need for a mirror lock so it was omitted. There is a depth-of-field preview lever situated on the right side of the lens mount (as viewed from behind the camera). The AI coupling lever can be swung out of the way to permit the use of non-AI lenses.

Common to both the FM and FE the AI coupling lever pivots to allow use of non-AI lenses.

The internal mechanical construction was greatly improved, which has the benefit of reducing the amount of usual lubricating oils and greases that need to be used. The design allows this completely mechanical camera to operate throughout an enormous temperature range from -40°C to +50°C without any difficulties. The FM was the first Nikon to be equipped with a multiple exposure facility as a standard feature.

Positioned around the shutter release button is a rotating collar, which acts as a switch for the camera's TTL meter when the MD-11, or later MD-12, motor drives are fitted. This prevents having to have the film advance lever in the stand off position to activate the exposure meter. The MD-11 and MD-12 can advance film through the FM at a rate of nearly 3.5 fps. Since this compact combination weighs 500g less than a motorized F2 it quickly won the favour with many sports and press photographers. The shutter is a Copal CCS with a sync-speed of 1/125 sec. that represented the state of the art at the time and unlike all previous Nikon cameras it travels vertically rather than horizontally. The mechanical self-timer, which can be cancelled after it is set, was also new. The FM's back, which has a clip for the film box end, as a reminder of the type of film loaded is removable and can be replaced by the MF-12 data back.

The FM was available in chrome and black versions. During 1977 to celebrate the 60th anniversary of Nippon Kogaku K.K. Nikon introduced a limited edition with a body and Nikkor 50mm f1.4 in gold finish. Designed as a 'workhorse camera' the FM has become a collectable classic. Its successor, the FM2, was

The double action lever on the Nikon FE: pushed towards the lens it operates the auto-exposure lock, and moved in the opposite direction it will activate the self-timer.

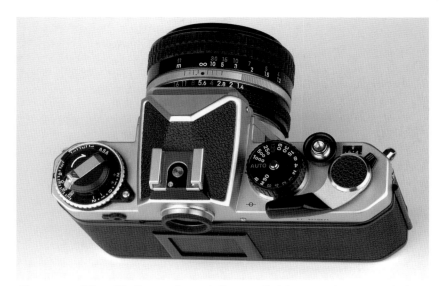

The compact Nikon FE offers an electronically controlled shutter and aperture priority auto-exposure.

finally discontinued during 2001 after one of the longest production life spans of any Nikon camera.

Nikon FE

Introduction of the new all-mechanical FM brought about a replication of the demand, first seen with the Nikkormat series, for an electronic version. Nikon responded during 1978 by combining the mechanics of the FM with the electronics of the Nikkormat EL-2 to produce the Nikon FE.

The FE offered several benefits over the FM in terms of its operation and handling. First of all the electronic system was converted to work on a 3v system in order to allow the choice between two 1.5v silver oxide batteries or one 3v lithium battery.

Many photographers appreciated the option to change the focusing screen themselves. A facility that is unavailable with the FM. Due to the fixed penta-prism screens have to be changed through the lens bayonet opening. Besides the standard K-type screen with split-image rangefinder and micro-prism ring, the plain field B-type, and grid pattern E-type were available. Nikon supplies a pair of tweezers with these screens in order to make it easier to remove and replace them without damaging them or the mirror. The procedure is straight forward, but since most photographers change screens infrequently a little practice always helps. As a practical

tip the FE viewfinder can be made a little brighter by fitting the FE-2/FA 'Briteview' Type II screens, the K2, B2, and E2. The resulting increase in brightness, by 1/3 EV, also affects the FE's metering cell, and you need to compensate for this by adjusting the film speed down by the same factor. So using an ISO100 film you should set the camera to ISO80.

Other modifications in the FE are a flash-ready light in the viewfinder and the automatic switch to the sync-speed of 1/125 sec. whenever a flash unit is attached. An additional contact in the accessory shoe next to the one in the centre allows Nikon Speedlights, as well as compatible units of other brands, to do this by supplying the ready light in the viewfinder with power. In the aperture priority mode attachment of a flash unit causes the camera to set a sync speed of 1/90 sec. When shooting with flash if the shutter is inadvertently set to a speed faster than 1/125 sec. the flash ready LED blinks as a warning.

The FE inherited the exposure

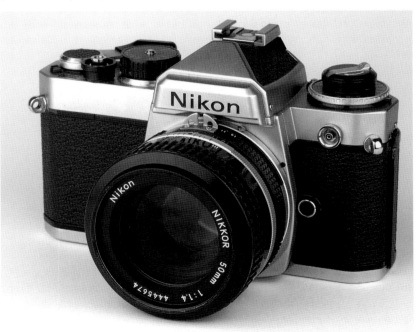

The FE has the same dimensions as the FM and shares the same system accessories.

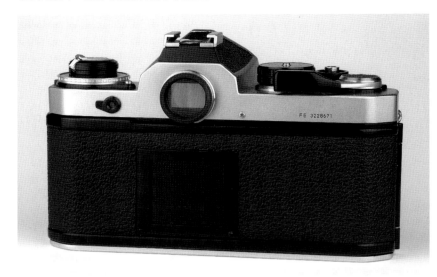

The Nikon FE has a battery check button on the rear plate to the left of the viewfinder eyepiece. The small red LED in the centre of the button lights to confirm that sufficient battery power is available.

metering display of the Nikkormat EL, with the addition of the 'M' position that represents the mechanically controlled 1/90 sec., which provides a back-up shutter release should the camera batteries fail. If the batteries are exhausted and the shutter is released the mirror locks in the up position and can only be returned to its normal viewing position by turning the shutter speed dial to the mechanical 1/90 sec.

The FE has an extended film speed range up to ISO4000. The multiple exposure-lever was placed directly beneath the film advance lever in order to facilitate easier handling when used in combination with a motor drive. In another attention to detail the viewfinder eyepiece was fitted with a rubber rim so as not to scratch spectacle lenses. Due to the compact design of the FM and FE attachment to a tripod head with a broad surface could sometimes result in the aperture ring of the lens being obstructed. Nikon therefore supplied a black rubber disc to act as a spacer between the camera base plate and the tripod, a practice that continues to this day with the FM3A.

Nikon FM2

In 1982 Nikon caused a sensation in camera design innovation: the FM was modified and received a new shutter capable of 1/4000 sec. the fastest then available in any 35mm SLR camera. It is mounted in a two-piece, die-cast body chassis made of copper silinium aluminium alloy, which is both extremely rigid and very resistant to corrosion. An additional benefit of the new shutter, which many photographers found more enticing, was its fast 1/200 sec. flash sync-speed. In the later FM2N this was increased to 1/250 sec. Shutter speeds can be increased to a certain degree by reducing the width of the slit between the shutter blades or curtains, but to attain a greater flash sync-speed the shutter's running speed has to be increased in order that it stays completely open for about 1/1000 sec.

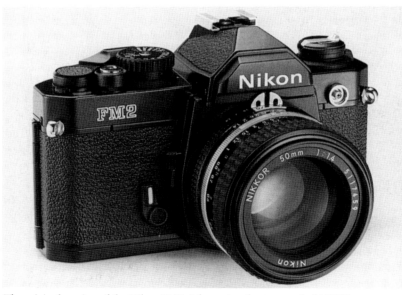

The original version of the Nikon FM2: it has a top shutter speed of 1/4000sec.

The blades of the first shutter design used in the FM2 and FM2N have a honeycomb pattern. Later cameras, introduced since 1989, have the shutter from the F801, which has blades with a smooth finish.

Nikon, in cooperation with Copal the manufacturer of the shutter, managed to achieve both design criteria. To do so, this advanced mechanical construction accelerates the shutter blinds to an average speed of about 25 km/h. This is an impressive performance when you realize that the start, the acceleration phase, and the retardation all take place within a mere 24mm. The designers used an oil-less, self-lubricating metal in the bearings of the shutter to reduce friction, and improve performance at very low temperatures. Nikon developed shutter blades made of extremely light and mechanically sturdy titanium foil. A honeycomb pattern was etched into them in order to further decrease their weight by nearly 60% and increase their stiffness. The mass of a normal shutter blade accelerated and decelerated at this rate would have caused vibrations that would probably have prevented

Externally the FM2N can be identified by the 'N' prefix to the serial number.

the camera from recording any picture sharply. The end result of all this work is a shutter in which the blade travel time is reduced to only 3.3 milliseconds. Since 1989 the FM2N has been equipped with the shutter used in the F801, which can be identified by the smooth finish of the blades rather than the earlier honeycomb pattern.

Nikon were very conscious that many more conservative photographers still missed the purely mechanical F2. Bearing this fact in mind they introduced other modifi-

The FM2 allows photographers to change focusing screens through the throat of the lens mount. A dedicated pair of tweezers is supplied with each screen to facilitate this operation.

cations in the FM2. The photographer can change the focusing screens, at first those of the FE were used, but later the camera was fitted with the "Briteview II" versions from the FE2. The mirror mount, made of titanium, and its retarding mechanism were also changed.

The film transportation system is now mounted on five clusters of ball bearings. The film speed dial was enlarged and the film speed setting range extended up to ISO6400. The two metering cells employed are silicon photodiodes (SPD) that work three times faster than the gallium arsenide type formerly used in the FM.

On the original FM2 there was a design error on the shutter speed dial, because when it was moved to the flash sync-speed, marked x200,

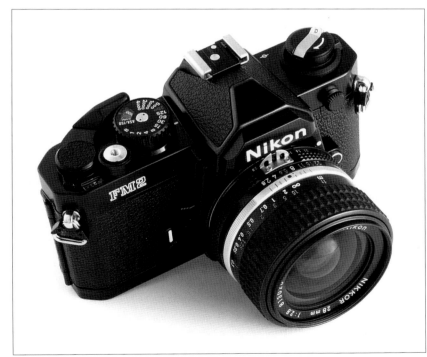

The re-designed FM2 was given the suffix 'N' to identify it from the original camera. Basic dimensions are exactly the same but a number of improvements were incorporated.

Introduced in 1982 the first FM2 has a flash sync-speed of 1/200 sec., but setting the shutter speed dial to the x200 position switched off the exposure meter.

The FM2N has a new layout to its shutter speed dial that shows the higher 1/250sec. sync speed.

the metering system is switched off. This was a real handicap, especially shooting with fill-in flash when the fast sync-speed is most likely to be used. Luckily this was rectified in the FM2N. It is a little known fact, but the original FM2 can be used successfully with flash at speeds up to 1/250 sec., although the flash ready light blinks indicating that too fast a speed has been selected.

To switch on the exposure meter the film advance lever has to be pulled out to the stand off position and the shutter release pressed lightly. The meter is activated for about 30 seconds before it shuts off automatically to conserve battery power. The metering symbols in the

viewfinder comprise plus, minus, and zero shaped characters, which are displayed by red LEDs. The multiple-exposure lever is situated directly beneath the film-advance lever as in the FE/FE2. The release button itself was enlarged so that only cable releases with an ISO type

thread can be employed. Unlike its predecessor the AI-coupling lever is fixed so non-AI standard lenses cannot be used on the FM2/FM2N. The two gold-plated contacts located under the film guide rails provide the necessary connections for the MF-16 data back.

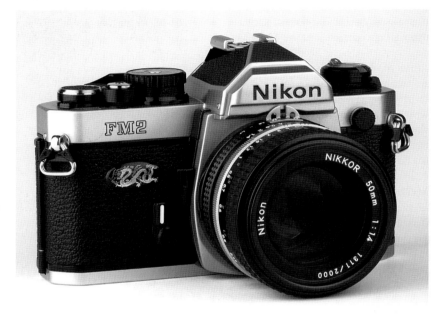

The 'Year of the Dragon' – Millennium 2000 version of the FM-2N: the small enamelled badge is visible on the front plate.

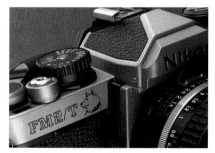

Introduced in 1994 the special limited edition 'Year of the Dog' Nikon FM2/T was designed to appeal to collectors.

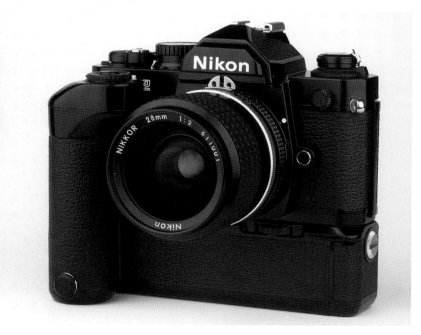

The FM2N and MD-12 have proved to be one of the most enduring combinations produced by Nikon.

FM2/T

The FM2/FM2N's reputation as a tough, rugged, and reliable camera was further enhanced when, during late 1993, Nikon introduced the FM2/T. It is identical to the standard FM2N, including its aluminium alloy chassis, except that titanium is used for the top and base plates and the camera back. No other specifications were changed and the FM2/T accepts all the same accessories. There have also been a couple of special limited editions of the camera; the 'Year of the Dog' version, of which only 300 units were produced was released in 1994 and has a picture of a dog's head engraved on the front plate next the FM2/T badge. The 'Year of the Dragon' Millennium 2000 edition can be identified by the small enameled badge showing a dragon which is set on the front plate below the camera badge. Although both are fully functional cameras they were principally produced to appeal to the collector market.

FE2

A year after the introduction of the FM2, the FE received an update and became the FE2. It adopted the new fast shutter with the 1/4000 sec. top speed and 1/250 sec. sync-speed. At the same time Nikon released three new focusing screens, the K2, B2, and E2 that are about 1/3 EV brighter than the earlier versions. To further reduce the vibrations caused by the reflex mirror movement a counter-rotating plate was incorporated.

The FE2 also possesses TTL flash control circuitry, which is effective within a film speed range of ISO 25 to 400. If a film speed below or above this range is selected the FE-2's flash ready light blinks as a warning. If a shutter speed higher than 1/250 sec. is set manually the electronic system automatically reverts

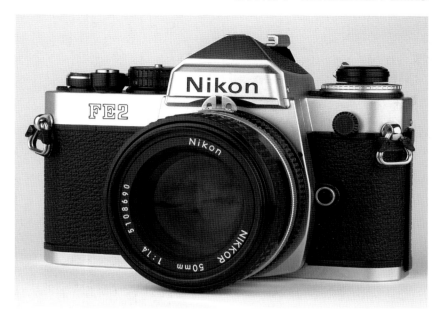

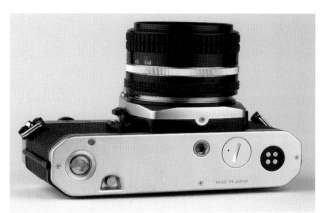

The FE2 was also available in a chrome finish.

The electrical and mechanical connections for the MD-12 motor drive are incorporated at either end of the base plate of the FE-2.

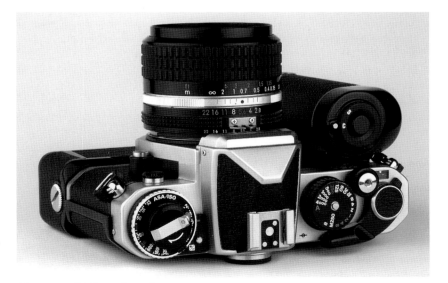

The FE2 and MD-12 from above.

To quicken film loading with the FE2 the light meter is only activated once the frame counter has reached '1'.

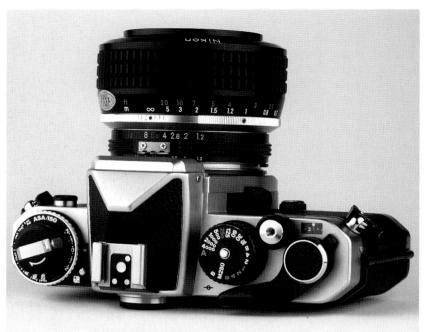

Seen from above the FE2 with Nikkor 58mm f1.2 Noct lens.

to a default setting of 1/250 sec. Unlike the first version of the FM2 the metering system remains activated when shooting at the dedicated top sync-speed, which is particularly useful in day light fill-flash situations, since it allows incident light and flashlight to be balanced perfectly. The same two SPD cells that had already proven themselves in the EL-2 and FE are employed in the metering system.

If the batteries fail the photographer still has the mechanical shutter speed, marked on the shutter speed dial M250, and the B position at their disposal. Whilst advancing the film to the first frame the FE2 uses the 1/250 sec. speed to prevent long exposure times selected by the automatic metering from slowing the process. Unlike the FE, it is not equipped with a battery condition check facility.

Exposure compensation factors can be set in increments of 1/3 EV, and an LED in the viewfinder informs the photographer when this function is being used. In spite of the many modifications and improvements incorporated in the FE2 its strong heritage with the Nikkormat EL allowed photographers to switch seamlessly between the two types of camera. In 1987 Nikon announced that production of the FE2 would cease; this precipitated a huge outcry from the thousands of photographers who trea-

sured the qualities of a camera that belonged to the ever dwindling group of traditional SLRs constructed from metal that did not have built-in motor drives, multi-mode automatic exposure control, and auto-focus. It would be another fourteen years before Nikon introduced a camera with similar features – the FM3A. Subsequently the cost of previously owned FE2 cameras has soared, sometimes to the point where they command a higher price than when new.

Nikon FA

By 1983 the FM2/FE2 were firmly established, but rather than rest on their laurels Nikon took a completely fresh look at the traditional 60:40 ratio centre weighted metering system they had used in cameras to that time and came up with yet another world first in camera design: the automatic multi-pattern (AMP) metering system, which they fitted to their latest camera the Nikon FA.

In a body practically identical to

that of the FE2, the FA incorporates a system that does not evaluate the reflected incident light indiscriminately over the whole frame area, but divides the viewfinder into five segments and surveys them separately. Depending on the brightness distribution in the frame an evaluation system computes the correct exposure in several steps. Whilst not foolproof this multi-pattern metering is superior to other systems, even in situations with strong contrast such as shooting against the light. The FA is equipped with a comprehensive exposure control system including: program, aperture priority, and shutter priority automatic modes, making it Nikon's first true multi-mode camera.

The program mode offers two versions 'normal' and 'fast'. The latter is biased in favour of faster shutter speeds at the expense of the aperture by 1.5EV. The program version is chosen automatically by the camera depending on the focal length of the lens in use. All AF, AI-S, and E series lenses with a focal

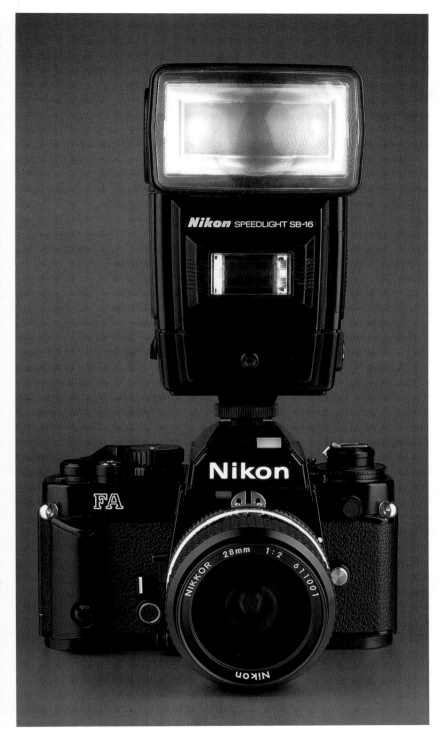

A world first: the AMP multi pattern metering system fitted to the Nikon FA. Combined with the SB-16B Speedlight, that offers TTL control, the FA was a powerful and sophisticated photographic tool.

The shutter priority mode also possessed a new feature that Nikon refers to as 'cybernetic override'. Whenever the aperture range does not permit a 'correct' exposure in combination with the selected shutter speed, the camera changes the shutter speed automatically.

This feature can be used to create a kind of personal, pseudo-program mode. Let us say for example that you want to shoot some portrait photographs with a 105mm lens. In shutter priority mode you select a shutter speed of 1/125 sec. and an aperture of f5.6. The FA will now set the lens aperture anywhere between f5.6 and the lens' maximum aperture value in combination with the preset shutter speed of 1/125 sec.

If the light deteriorates beyond the point where the maximum aperture has been reached the 'cybernetic control' will begin to select slower shutter speeds. If, however, the light level increases the aperture will only be stopped down to minimum of f5.6, thereafter the 'cybernetic control' will begin to select shutter speeds faster than 1/125 sec.

In addition to the program and shutter priority modes the FA has aperture priority and manual exposure modes. Like the FG, the FA also has a removable finger grip. The top plate is made of a plastic as opposed to metal in the FM2/FE2 and is a lot wider above the prism than these cameras in order to make room for the comprehensive electronics for the AMP metering and the finder display.

The main LCD in the top left corner of the viewfinder shows a variety of information depending on

length of 135mm or greater, and Zoom-Nikkors with ranges above this, have a focal length indicator ridge on the rear face of the lens mount. This ridge depresses the focal length indexing pin mounted in the mirror box of the FA, which in turn operates a switch that causes the program mode to shift to the 'fast' setting.

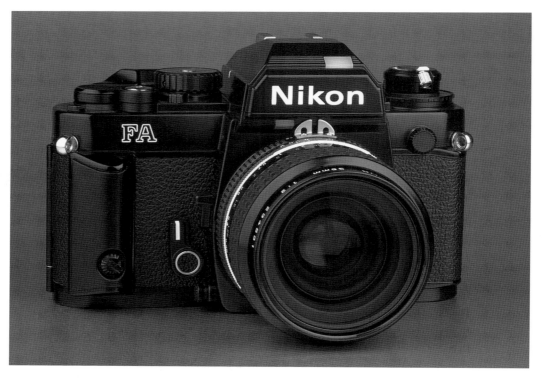

The distinctive appearance of the Nikon FA: the button for changing the metering mode can be seen below the self-timer lever to the lower left of the lens mount.

The design of the Nikon FA raised the integration of electronics to a new level, including a world first with its multi-segment metering pattern.

the exposure mode in use; this includes the chosen exposure mode, the shutter speed, the aperture, and any appropriate warning signals. When using manual and aperture priority exposure modes the preset aperture on AI, AI-S, and AF lenses is visible in the top centre of the viewfinder via the ADR window. In the program mode the lens must be set to its minimum aperture and the working aperture value is displayed in the main LCD. In shutter priority mode the preset speed appears in a small window to the top right side of the viewfinder. If exposure compensation is set the signal alerting the photographer to this fact is also displayed here, as is the flash-ready light. The focusing screens are the same as in the FE2/FM2N. The FA meters the light on the screen with two SPD sensors placed to the right and left of the viewfinder eyepiece, but these were divided into three segments each. As a result, the centre of the frame is the only part that is covered by two segments. When using the FA remotely with one of the automatic exposure modes there is an eyepiece shutter, operated by a small lever on the rear of the pentaprism, to exclude light that might otherwise affect the exposure computations.

Besides the AMP metering the FA also has the conventional 60:40% centre weighted metering mode. If desired this mode can be switched on with the button below the self-timer lever. The FA switches to this metering system automatically in manual mode, and when a lens that has been modified to the AI-standard is used because the cam, which transmits the maximum f/stop, is missing.

Besides the above-mentioned

focal length indexing switch, there is another new feature on the FA; a small switch that is operated by a pin situated slightly above the lens release pin. The FA recognizes AI-S, E-Series, and AF Nikkors, which all have a small notch milled out of the bayonet flange, because the pin sits inside this notch the switch is not activated. On older lenses that lack this notch the pin is depressed and the switch is activated telling the FA that it is operating with a nonlinear diaphragm mechanism and must take more time, about 20ms, to control the actual size of the aperture. Whilst the EL only needed one Integrated Circuit and a couple of transistors, the FA requires a microprocessor to cope with this additional information and the various permutations of lens types and metering modes.

Thus FA was the first Nikon to use a fully digital system to collate, analyse, and calculate an exposure setting from information based on the lens aperture range, the preset aperture, the focal length in use, and the film speed. The days of metering faults arising because there was dust on a resistor plate where gone. In spite of all these high-tech features the FA retains the appearance of a traditional camera. However, it also has some advanced mechanical features such as the 1/4000 sec. top shutter speed, and its electromechanical shutter release, which

On the FA the switch around the shutter speed dial is used to select exposure modes.

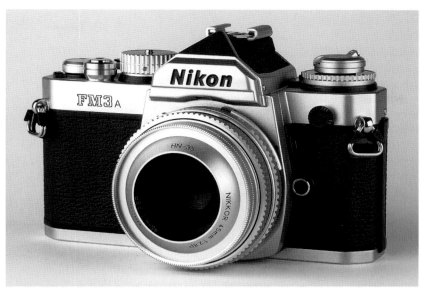

The FM-3A together with the 45mm f2.8P lens introduced at the same time as the camera.

combined with the damper unit fitted to the mirror mechanism, allows extremely smooth and vibration-free operation.

The MD-15, a new dedicated motor drive, was introduced with the FA. Once fitted, which requires the finger grip on the camera body to be removed, it supplies power to the camera allowing the button cells in the camera base plate to be removed. As an alternative the MD-11 and MD-12 motor drives can be used: however, they do not provide power to the camera, and the maximum frame is restricted to 2.7 fps, because they can only release the camera mechanically via a pin protruding into its base plate.

The technical innovation of the FA marks a significant point in the evolutionary tree of camera design. A fact recognized by the jury of the Japanese "Grand Prix Executive Committee" who awarded it the "Camera Grand Prix 1984". Nikon celebrated this accolade by producing a special, fully functioning version of the FA plated in 24-carat gold and finely textured crocodile skin leather.

The FA's time in the limelight was short lived. Initial supplies could not meet the very high demand for the camera, and by the time production levels where increased the competition had taken another quantum leap forward. During 1985 the world's first fully-fledged AF camera, the Minolta 7000 AF, was introduced. As a consequence the FA was not a commercial success for Nikon, but its technology broke new ground and laid a corner stone for future developments.

FM3A

By the dawn of the twenty first century the FM2 in its various guises had been in production for almost twenty years, and in the face of the inexorable rise of the digital camera many photographers assumed its days were numbered. Their assumption was not misplaced because Nikon finally Nikon announced in 2001 that the camera was to be discontinued, however, the tremendous disappointment felt by Nikon enthusiasts worldwide was tempered by even more extraordinary news. To accompany sophisticated film

cameras like the F5 and F100, and in the same year that it released its second generation digital SLR's represented by the D1X and D1H, the Nikon Corporation announced the launch of a 35mm film, single lens reflex camera designed along traditional lines - the FM-3A.

In short it is an amalgam of the best features of the FM2N and FE2. Demand has been unprecedented as it offers both full manual and aperture priority control based around a hybrid electo-mechanical shutter, and in addition to the traditional qualities of those earlier cameras, it incorporates some additional features such as TTL flash control with a compensation function and DX film code reading.

To ensure rugged durability Nikon have chosen to make the die-cast camera chassis from the same copper silumin aluminium alloy used for the FM2N. The new camera retains a top shutter speed of 1/4000 sec in both mechanical and electronic operation. The new hybrid shutter has blades made from an aluminium alloy to reduce their mass at the same time as increasing their strength and durability. Film advance is by a traditional wind on lever that has a 30(stand off position and a 135(wind on position. The short stroke, combined with four clusters of ball bearings and a low winding torque, make the film advance both swift and very smooth. A large pressure plate, together with guide rails that extend the full width from the film chamber to the take-up spool chamber provide further assistance to the film transport system. There is also an anti-curl roller on the film chamber side to assure film flatness.

The FM3A is manual focus only. Nikon have released three new brighter interchangeable focusing screens. The camera is supplied with a K3-type, which has a split image

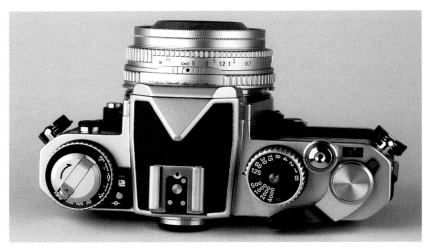

The best qualities of the FM2 and FE2 are combined in the new FM-3A.

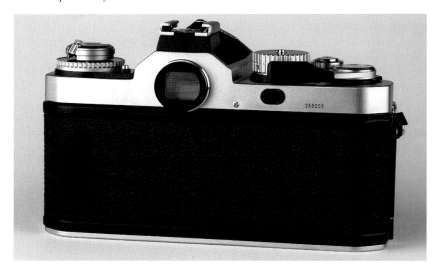

A rear view of the FM3A: the back plate has a small window to view the film cassette directly replacing the film box end holder of the FM2/FE2.

and micro prism collar. Also available is the B3-type matt screen with focusing spot, and the E3-type matt screen with etched grid lines. To identify the various versions of focus screens available for the FM - FE family look at the small tongue on the edge of the screen: the original Type I for the FE has a solid tongue, the Type II screens for the FE2/FM2/FA have a small notch in the tongue, and finally the Type III screens for the FM3A have their designation etched on the tongue. Type II and Type III screens are interchangeable between the FE2, FM2N,

and FM3A, without any exposure compensation being required. The viewfinder coverage represents about 93% of the full frame area, and has a magnification of approximately 0.80x with a 50mm lens set to infinity. Along the top edge of the viewfinder there is the traditional ADR window that displays the preset aperture, and two LED's that show flash ready and exposure compensation warning signals respectively.

The FM3A's large reflex mirror is mounted in a titanium frame to provide a light, smooth and accurate

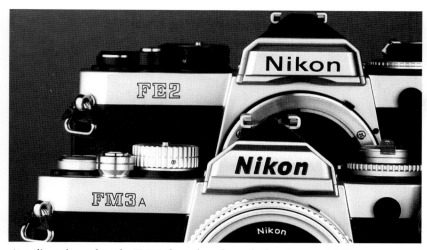

The hybrid shutter of the FM3A is controlled from the conventional style dial on the top plate.

As a direct descendent the FM3A draws heavily on the long lamented FE2.

movement. Its size helps reduce the effect of vignetting, even when shooting on very long lenses. A new design of control gear further reduces the effects of vibration and bounce caused by mirror movement. The camera is compatible with all AI, AI-S, E series, and AF Nikkor lenses, as well as modified non-AI lenses, but like its predecessors the FM2N and FE2, the AI coupling lever is fixed preventing non-AI standard lenses from being used.

The FM3A is designed to provide the photographer with either full manual or aperture priority automatic exposure control. It employs a pair of Silicon Photo Diodes (SPD) to measure the light level and offers a traditional centre weighted metering system, whereby 60% of the meters sensitivity is confined within the 12mm circle defined in the centre of the focus screen. The remaining 40% of the reading is taken from the area outside of this circle. The metering range is EV1 to EV20 at ISO100, with a 50mm f1.4 lens. Film speed is set automatically when using DX-coded film, or manually with a range of ISO12 to 6400.

The meter display is of the match needle type similar to the FE2. The shutter speed range from 1 sec. to 1/4000 sec. plus a Bulb (B) setting is listed down the left hand side of the viewfinder. A blue needle overlays and highlights the selected shutter speed. To obtain the metered exposure value you either adjust the shutter speed dial or, the aperture ring of the lens, until the black needle overlays the blue needle. If you wish to deviate from this reading the amount of under or over exposure is indicated by position of the black needle relative to the blue one. Alternatively, you can use the aperture priority auto exposure control by setting the shutter speed dial to 'A'; then preset the aperture and the FM3A automatically selects an appropriate shutter speed. Again, if you wish to deviate from this meter reading, and provided the exposure is within the camera's EV range, there is an exposure compensation dial positioned around the rewind crank, which allows compensation of up to +/- 2 stops in 1/3 stop increments. The camera also has an Auto Exposure lock button positioned on the back plate just below the wind on lever. It falls naturally under the photographers' right thumb and is easy to operate with bare hands however, with anything but the thinnest of gloves it becomes rather difficult to depress.

The most innovative feature of the FM3A is its hybrid shutter control. In the auto exposure mode the shutter speeds are controlled electronically. By switching the camera to manual exposure mode the shutter operation becomes mechanical so even if the batteries fail the camera continues to function with just the loss of the built in metering system. Either, a 3.0v lithium battery, two 1.55v silver oxide batteries or, two 1.5v alkaline batteries can power the camera.

Externally, apart from the camera badge and the adoption of the slanted script for the Nikon logo as used on modern AF cameras, there is little to distinguish the FM3A from its predecessors. The layout of the top plate will be familiar to users of both the FM2N and FE2. The knurled edged of the large shutter speed dial provides a positive grip and it moves in increments of whole stops with a very firm click stop at each speed. At the 'A' position it locks in place to prevent accidental changing from Auto exposure to manual control. A small button in the centre of the dial disengages this lock to allow manual selection of shutter speeds. The shutter release button is toward the front edge of the top plate next to the shutter speed dial. It operates in two stages, first a light pressure activates the camera meter and, second, depressing it further releases the shutter. The centre of the button has an ISO standard thread for a mechanical cable release. A multiple exposure

button is positioned around the wind on lever.

Like the FE2 the FM3A has TTL flash control. The camera's TTL flash sensor measures the amount of flash illumination off the film during the exposure and quenches the flash output once it has determined sufficient light has been emitted from the flash. The FM3A is compatible with all Nikon Speedlight units that offer TTL control including the SB-24, 25, 26, 27, and 28, as well as the recently released SB-50DX and SB-80DX. It has a flash sync speed of 1/250 second, which is highlighted on the shutter speed dial in red. A standard accessory shoe on top of the pentaprism has a flash hot shoe contact. Another new feature is the TTL flash compensation button. Situated on the front of the camera around the lens mount below the rewind crank, it allows you to reduce the flash output by up to one stop to give a more balanced fill-flash effect or, avoid overexposure when shooting with flash against a dark or distant background.

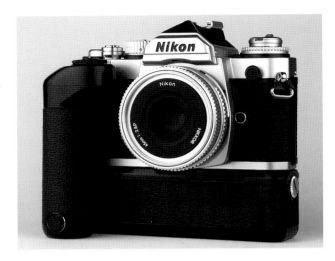

The FM3A can utilise the same system accessories as the earlier FM2N and FE2, including the MD-12 motor drive, which offers a maximum shooting rate of 3.2fps.

Other features include a metal camera back with a film cassette confirmation window, a pin cylinder (PC) socket for attaching a flash sync lead, a depth of field preview button, a 1/4" tripod socket on the base plate and a mechanically controlled self timer with a variable delay of between 4 and 10 seconds, which like the FM2N, activates the mirror lock-up facility when it operates. Curiously the rewind crank lock featured on the FM2N is omitted in the new camera.

Accessories available for the FM3A include the MD-12 motor drive for single frame advance or sequential shooting at 3.2 frames per second (fps) and, the MF-16 Data Back for recording date and time within the film frame area. Nikon's introduction of the FM3A represents a steadfast commitment to the traditional film based camera user that is the envy of many photographers using different marques. Only time will tell how long it can withstand the digital tide.

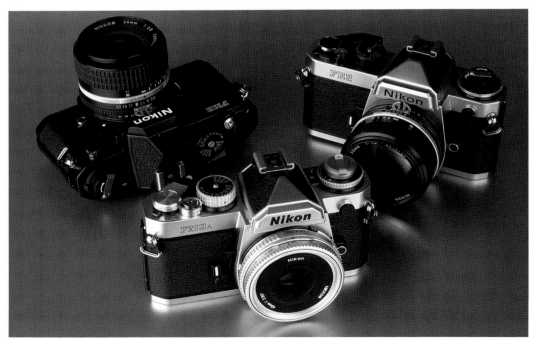

Left to right, the FM2N, FM3A, and FE-2: a distinguished family of Nikon cameras, built along traditional lines, that continue to serve photographers worldwide.

Popular Nikons

As the 1970's progressed the costs involved in developing new designs to sate the demand of customers for cameras with more features became increasingly prohibitive. Manufacturers, including Nikon, were forced to diversify their product range to include models, which appealed to the mass-market sector.

By 1979, twenty years after the introduction of the Nikon F, the brand name Nikon had become synonymous with professional 35mm photography. However, the of selling a relatively small number of high quality cameras when set against the ever increasing costs of new product development meant Nikon could not sustain its position in the market place, unless they could broaden their client base significantly.

During the 1970's there was a constant demand for new cameras that offered ever more sophisticated features and functions using microelectronics. Camera manufacturers were forced to invest increasing sums of money in the design and production of their products in an effort to stay ahead of their rivals and keep pace with advances in technology. Consequently the production life span of a camera

became shorter as the frequency of new model launches increased, and their predecessors were rendered obsolete.

Despite their very high reputation as a manufacturer of professional equipment Nikon required a camera, which through high volume sales, would generate sufficient capital to fund their research and development programme. They could not hope to achieve this with the expen-

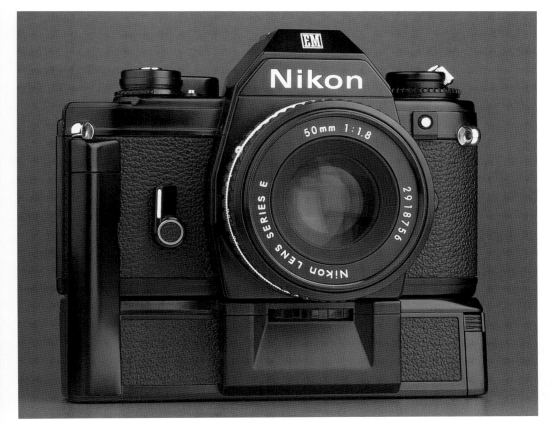

The Nikon EM with MD-E motor winder, designed with mass-market appeal in mind.

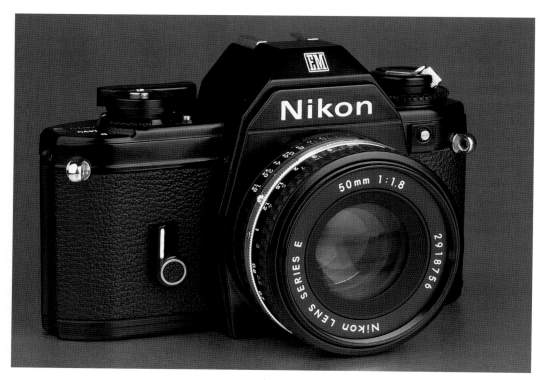

The Nikon EM with 50mm f1.8E series lens provided an economical entry point to the Nikon System for many.

sive F2 or FM as one of the principle criteria for a camera aimed at the enthusiast sector is the price point. In an effort to reduce production costs and offer good value for money the new camera had to have a lower specification. Its design needed to reflect the use to which it would be put, namely the occasional use by people interested in shooting family celebrations, holiday pictures, or a record of their children, and who had no need of features such as 5fps motor drive, interchangeable viewfinders and focusing screens.

Although Nikon had always had more moderately priced models in their range, for example the rangefinder S3 and S4 models in the 1950's, the Nikkorex series, and the Nikkormat models in the 1960's, the introduction of the Nikon EM, a beginner's camera with a plastic body that lacked a manual mode and sold for less than £200 complete with lens, sent shock waves through the ranks of loyal Nikon devotees, many of whom believed the

rumours about a new Nikon camera concerned the successor to the F2. Some diehards expressed strong opinions about the wisdom of Nikon entering the world of the mass market given its connotations with lower quality. If, however, they had stopped to consider the commercial realities of producing a range of cameras to suit the needs of both professionals and enthusiasts they would have soon realised Nikon had no other option. Nikon's philosophy of providing the best possible product remained resolute; the EM is not just a cheaper version of a camera with a better specification. Described as the "people's Nikon", it was designed from the outset as an independent, entry-level model to the Nikon system, which would meet the needs of novice photographers.

Nikon EM

Making his debut with the Nikon brand the Italian designer Giorgetto Giugiario produced an elegant,

compact body with a rounded profile. Weighing a mere 460g the top-plate, base-plate, and the lens bayonet surround were produced using plastic. The chassis is made of the same die-cast aluminium found in other Nikon SLRs.

The viewfinder has a fixed K-type focus screen, and the familiar shutter speed scale taken from the Nikkormat EL and FE. For reasons of cost an aperture display was omitted from the finder. Whenever the prevailing light level would cause overexposure, with even the fastest shutter speed of 1/1000 sec., or at speeds lower than 1/30 sec. when camera shake might cause blurred pictures, the EM emits an audible warning signal that beeps quietly but clearly. Although useful many found this feature a nuisance, as it cannot be cancelled.

Next to the film advance lever there is a blue button; this operates the battery condition test. The shutter release button and the exposure mode switch with its three posi-

tions, 'Auto' for aperture priority exposure mode, 'M90' for the mechanically controlled shutter speed of 1/90 sec., and 'B' (Blub) for long exposures without using battery power, are placed concentrically to the advance lever. Nikon introduced a new feature with the EM whereby the exposure meter is only switched on when the film counter has reached the figure '1'. This is designed to speed up film loading by preventing slow shutter speeds, as determined by the automatic exposure, causing a delay in advancing film to the first frame. The same system was adopted in later cameras such as the FE2, FA, and F3.

After the release button is pressed the exposure meter will stay activated for approximately 20 seconds. The film speed dial is located on the other side of the prism and has a range of ISO25 to 1600. Below this, on the front plate, is the backlight switch, which when depressed sets an exposure compensation of +2EV. On the first version of the EM this button is blue; on the second version introduced after March 1980 it has a chrome finish. Unfortunately,

as another concession to cost saving, there is no exposure-lock feature.

This sums up most of the EM's controls except for the self-timer, which can also be used to good effect when shooting at slow shutter speeds since it causes the mirror to lock in the up position before it operates. This removes any risk of camera shake being induced by 'mirror bounce'. Officially Nikon stated the slowest shutter speed attainable with the EM is 1 sec. but in practice exposure times of five minutes can be achieved without any difficulty. Of course, reciprocity failure must be taken into account when shooting at such slow speeds and compensated for by adjusting the exposure values accordingly.

A Silicon Photo Diode (SPD) sensor situated above the viewfinder eyepiece performs TTL exposure metering. The metering is centre-weighted, but in the EM the traditional 60:40 ratio used in many other Nikon cameras is reversed as the central 12mm circle on the focusing screen defines the area where 40% of the measurement is concentrated, the rest of the frame

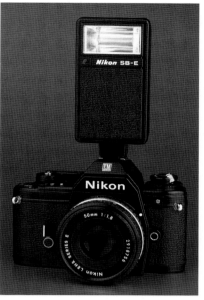

The EM and Speedlight SB-E offered three automatic shooting ranges with AI or E series lenses.

accounts for the remaining 60%.

The camera can be fitted with one of two dedicated motor drives, either the MD-E, or the MD-14, which was introduced later with the Nikon FG. Both are operated by the camera's shutter release button. The larger grip of the MD-14 offers the

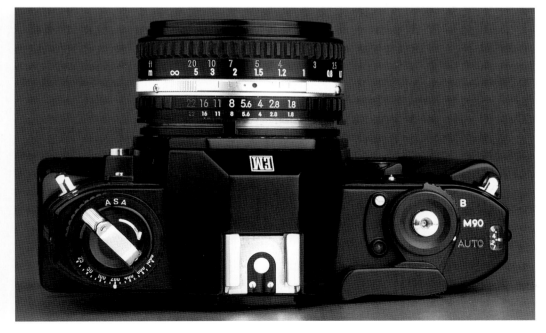

The extremely simple, and uncluttered layout of the top plate on the EM was designed with the beginner in mind.

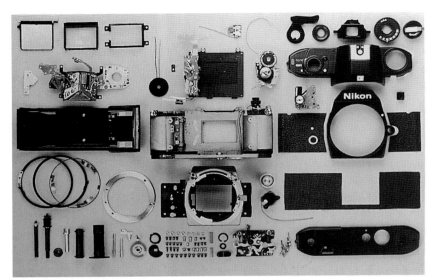

The component parts of a completely disassembled EM reveal how complex even a seemingly simple camera can be.

best handling of the two options. The EM employs a Seiko focal plane shutter, with metal blades that travel vertically. It proved be very reliable, even when cycled at a rate of three frames a second by the MD-14 motor drive.

The SB-E Speedlight was introduced to compliment the EM. In combination with the camera and either an AI, or E series lens, it offers automatic shooting for a range of three different apertures, which must be set directly on the lens. If any aperture other than the three is chosen the flash ready light situated in the viewfinder will start to flash. The flash sync-speed of 1/90 sec. is set automatically by the SB-E.

In addition to the dedicated flash and motor drive accessories, and as a measure of Nikon's efforts to produce a complete camera system a new line of lenses, designated the E series, was introduced with the EM. As well as the 50mm f1.8E, which was supplied with the camera, initially there was the fast wide-angle 35mm f2.5E, and the telephoto 100mm f2.8E. Despite the fact that the barrel and focusing helicoid of these lenses was made of plastic, and

the complex and expensive multi-coating process was not applied to the fixed focal length lenses, Nikon manufactured them all. The E series range was subsequently expanded to include a 135mm f2.8E, a 28mm f2.8E, and three zooms, the 36-72mm f3.5E, a 75-150mm f3.5E,

and 70-210mm f4E. As another concession to reducing manufacturing costs the AI coupling lever on the EM body is fixed, which prevents the use of non-AI standard lenses with this camera.

Unfortunately, and in spite of Nikon's best efforts to persuade their customers otherwise, the E Series lenses never enjoyed a particularly good reputation, with many photographers considering them to be cheap optics that turned in an inferior performance compared with mainstream Nikkors. The whole series was eventually discontinued. Instead, Nikon began to introduce less expensive lenses within the Nikkor range. Those photographers who dismiss the EM, with its modest features, forget that without Nikon's entry into the mass market the company would never have achieved the economic foundation it required to be able to afford to develop cameras such as the FA, or the F-801, forerunners to today's AF masterpieces.

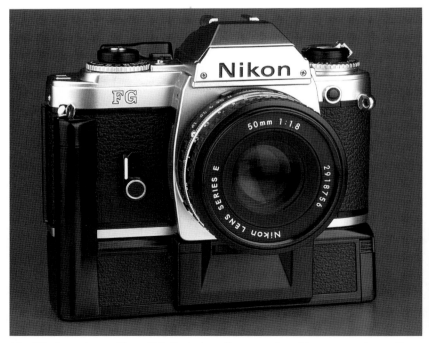

The FG, shown here with an MD-E winder, offers a number of improvements over the EM, including manually selected shutter speeds and a program exposure mode.

Nikon FG

In 1982 the EM was joined by another model in this class of compact cameras – the FG. Essentially it was an EM body with more features. Although 30g heavier than the EM externally the most obvious difference, apart from the badge, is the finger grip fastened with a screw, which provides this small camera with improved handling. It must be removed though when the motor winder MD-14, introduced with the FG, or the MD-E is to be attached. The improvements included a manual exposure mode, TTL-flash metering, and for the first time in a Nikon SLR, a program exposure mode.

Until this time an automatic exposure mode in a Nikon had been synonymous with aperture priority exposure, with the exception of the DS aperture control unit made for the F2, which provided shutter priority automatic exposure control. It had proved to be immensely difficult to construct an aperture control device that worked in conjunction with the diaphragm stop-down lever, which operated with the required precision. When the Nikon F-bayonet and the mechanics of the Nikkor lenses were designed towards the end of the 1950's the idea of a program mode had not been conceived.

To achieve a fast firing rate with a motor drive the stop-down lever had to be designed with a high leverage, and could only travel through a short arc of 5mm between the maximum and minimum aperture. On many lenses, in the course of this movement, the lever must cover a range of six, or seven stops. So moving it a mere 0.3 mm can make a difference of 1/3 EV. No mechanical construction is capable of working this precisely, especially since it has to operate with almost all system lenses as well as those types modified to the Al standard.

To overcome this problem the program mode uses a combination of shutter speed and aperture control. Assume, for example, the program mode selects an exposure of 1/125 sec. at f/5.6 for the prevailing light conditions. When the shutter release is pressed the lens diaphragm is stopped down to the calculated value then, just before the mirror swings up, the FG measures the actual dimension of the stopped-down diaphragm and, if necessary, corrects the shutter speed accordingly. If the camera determines that the effective aperture value is not f/5.6, but f/6 instead, this second meter reading causes an appropriately slower shutter speed to be set. Even if the stop-down lever malfunctioned it would not necessarily lead to an incorrect exposure. This method allowed the program mode to be included in the Nikon system without jeopardizing the compatibility of the F-mount. Whilst the program mode was designed to change shutter speeds and aperture values evenly, it has a drawback in that it assumes the photographer is shooting a static subject and prefers a mid-range aperture setting.

In addition to the program exposure mode the FG has both a manual and an aperture priority mode with quartz-controlled shutter speeds from 1/1000 to 1 sec., as well as Bulb (B) and the 1/90 sec.

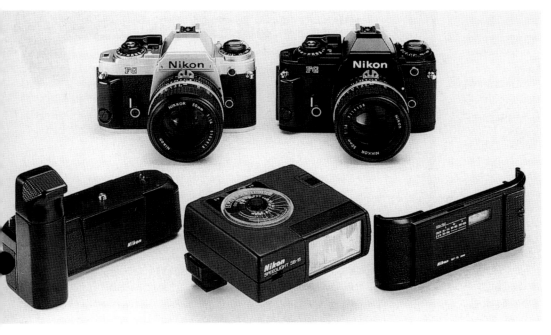

The Nikon FG was available in chrome or black finish, with three principle accessories the MD-14 motor winder, SB-15 Speedlight, and MF-15 Databack.

Shutter speeds can be set manually on the FG.

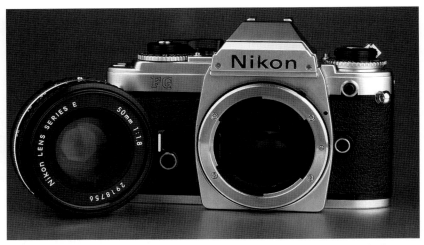

An FG with Nikkor 50mm f1.8E lens; the camera is considerably more versatile than the earlier EM model.

mechanical shutter speed, neither of which draw any power from the battery. There is a new shutter speed dial set around the shutter release that can be operated by one finger. The audible warning for under/overexposure can be cancelled and exposure compensation of +/-2 EV in increments of 1/2EV is incorporated on the film speed dial that has a range of ISO12 to 3200. The viewfinder has a fixed K-type focusing screen and a sequence of red LEDs positioned to the right of the image frame, which show the shutter speed selected by the automatic exposure modes. In manual mode one LED highlights the preset speed while one or two flashing LEDs indicate the exposure meter's suggested values. Under, or overexposure is signalled by LEDs below the 1 sec. and above the 1/1000 sec. marks respectively. In Program mode both of these LEDs flash as a warning that the lens' smallest aperture has not been selected. This warning operates whenever the lens is set to apertures larger than f/11. Just like the EM, the FG has a backlight button and a depth-of-field preview facility, but no automatic exposure lock function.

For its day the FG has a well-specified 'off-the-film' (OFT) TTL flash control system with the TTL sensor mounted in the base of the mirror box. Nikon introduced two other accessories with the FG, the MD-15

motor winder with a maximum speed of 3.2 fps, and the MF-15 data back.

During this era, with SLR sales in decline, the market for the first time SLR buyer was highly competitive. Regardless of the full range of features offered by the FG it could not match the image and status enjoyed by cameras such as the Canon AE1, or Minolta XD-7, due to its similarity to the EM.

On the FG the exposure compensation and film speed are set via a dial around the rewind crank.

Nikon FG-20

In 1984 the EM was succeeded by the FG-20. A more appropriate name would have been the EM-20, since it bears more of a resemblance to the EM than the FG. It does not have program exposure, or TTL flash control, although it does have more technical features compared to the EM. The most significant modification was the inclusion of a manual exposure mode with shutter speeds from 1/1000 sec. to 1 sec. It also has an aperture priority mode, automatic flash control, and a flash ready display.

An LED in the viewfinder shows an 'M' when shooting in manual mode, however the quartz-controlled shutter speeds are not displayed, as they are in the aperture priority mode, a feature that definitely undermines the camera's handling. The fixed K-type focusing screen is brighter than earlier versions with the effect that the split-image rangefinder only darkens with apertures of f/5.6 or smaller. This new screen is a predecessor to the 'Brite-View' range of screens that would be introduced later in the F-301 and continue to be fitted to Nikon SLR's to this day. As with the FG, the FG-20's audible warning

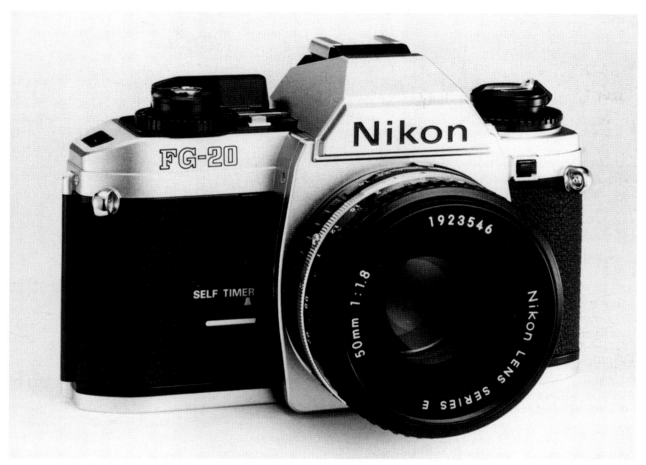

Successor to the EM the FG-20 offered aperture priority and manual exposure modes.

for exposure error can be switched off. The film speed range has been extended to ISO3200.

Otherwise, compared to the EM, internally everything else remained unchanged with one exception; in the EM the lens aperture value is transmitted by the meter-coupling lever to an unprotected resistor track where even the tiniest dust particles could disrupt the contact. This would cause the metering needle to tremble or jump erratically whenever the aperture ring was rotated. In the FG-20 the problem was solved by the use of a Functional Resistance Element (FRE). The FG-20 was not destined

On the FG-20 the backlight exposure compensation button is square and located beneath the rewind crank.

The shutter speed dial of the FG-20: the marking for the audible warning, that could be cancelled, can be seen against the index mark.

to have a very bright future though, and after less than a year its production was discontinued. Very few Nikon traditionalists mourned the end of the EM, FG, and FG-20, but they had left an important legacy: these cameras had introduced countless photographers around the world to the Nikon system.

FM-10

More than ten years after the introduction of the Nikon FG-20, Nikon once again responded to the dynamics of the world's consumer demand when, during 1995, it introduced the FM-10 specifically for the rapidly expanding Asian markets. This is a camera with all the hallmarks of a design from the 1970's that was manufactured with the materials and techniques of the 1990's. Nikon's aim was to produce a camera that was simple to operate and capable of withstanding the climatic extremes, including high humidity, of countries in the Indian sub-continent and Pacific ring. At only 420g it is even lighter than the earlier EM, however, it lacks quite a number of features. It has no matrix metering, or TTL flash control, there is no flash cable (PC) socket, or flash ready light, and no facility to attach a motor winder.

The shutter speed range runs from 1 sec. to 1/2000 sec., with flash synchronization at 1/125 sec. The film speed scale is set within the shutter speed dial and has a range from ISO25 to 3200, but there is no automatic DX coding system. The shutter release button incorporates a threaded cable release socket. The film advance lever acts as an ON/OFF switch for the camera's TTL meter and switches the metering on when it is moved to the stand off position. There is a secondary meter switch located around the lens mount above the lens release button. The metering range is EV2

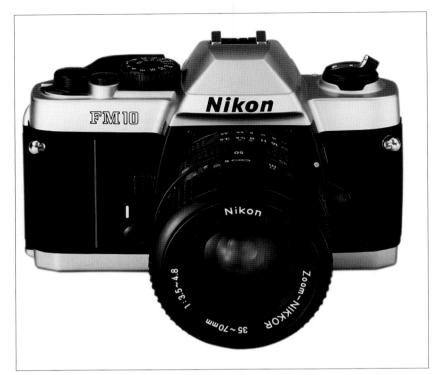

The FM-10 was introduced to appeal to the consumer mass market.

to EV19 (ISO100). A switch around the film advance lever operates the multiple-exposure function. The camera has a self-timer lever on the front plate next to the lens mount and just above this is a lens aperture stop-down lever.

The fixed prism head has a standard built-in ISO accessory shoe with a hot shoe contact, but it does not support full compatibility with Nikon's more advanced dedicated TTL flash units. The viewfinder, which covers 92% of the image area, has a fixed K type focusing screen, but there is no display of the shutter speed or aperture values, instead it has a series of red LED's to indicate under / over exposure, and a green LED to indicate 'correct' exposure. The non-removable camera back has a small window through which the film cassette can be observed to confirm the film type in use. There is a standard tripod socket in the base plate. Power is provided by two AA size batteries housed in the

right-hand side of the camera body. Externally the most distinguishing features are the titanium-like finish to the surface of the top and bottom plates and the distinctive red stripe along the edge of the finger grip. The camera was supplied as a kit including a Nikkor 35-70mm f3.5-4.8 zoom lens and camera case.

FE-10

In 1996 Nikon released the FE-10, which in contrast to the all-manual FM-10, has aperture priority exposure mode. Initially only destined for the Asian market the camera was made available in Europe and the U.S.A during 1997.

The automatic exposure can be adjusted in increments of 1/3 stop to +/-2EV using a dial set concentrically to the film rewind crank. There is also an auto-exposure lock button on the front plate of the camera just below the shutter speed dial. The specification is identical to the FM-10 with the exception of the follow-

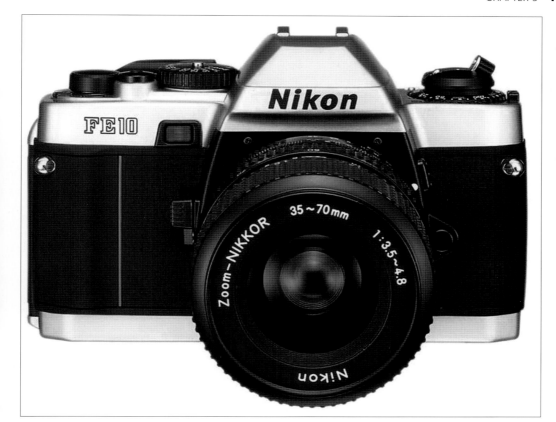

As the FE had followed the FM beforehand the FE-10 was introduced on the heels of the FM-10 to provide an alternative body with aperture priority automatic exposure control.

ing: the shutter speed range in auto (A) mode extends from 1/2000 sec. to 8 sec. The flash sync speed is lowered to 1/90 sec. in 'A' mode, and 1/60 sec. in manual mode. The camera will automatically switch to the x90 setting if a shutter speed between1/2000 sec. and 1/125 sec. is selected. The self-timer lever on the front plate of the FM-10 has been removed as this function is now electronically controlled. The

viewfinder information includes indicators for the shooting modes, the x90 sync speed and B (bulb). Additionally the display shows the selected and/or recommended shutter speed in manual mode. Finally the weight has been reduced to just 400g without batteries.

Even though Nikon aimed the FM-10 and FE-10 squarely at the consumer looking for an entry-level camera to the Nikon system, many

keen enthusiasts and professionals have exploited their qualities of lightweight, and compact size. For example, whilst participating in adventure sports when other heavier more bulky cameras would be less suitable. Given the rigours of such pursuits there is a further bonus in that should disaster strike, and the camera be badly damaged, the financial loss is reduced due to their relatively lower cost.

The Early AF Generation

The introduction of the Nikon EM, in 1979, launched Nikon into the mass consumer market were a product's ease of handling is of paramount importance. In 1985, after only 3 years of production, its successor the FG was discontinued and replaced the Nikon F-301. Later, an autofocus system was incorporated in the same body and became the F-501.

Nikon Model Names

The introduction of the F-301 marked the start of a new practice for Nikon whereby camera models were assigned a name for the North American market that was different to the one used for the rest of the world. The specification for each model, however, is identical. For those models discussed in this chapter the equivalent Nikon names are given in the table below.

Outside USA/Canada	Within USA/Canada
F301	N2000
F501	N2020
F401	N4004
F401s	N4004s
F401x	N5005
F601M	N6000
F601	N6006
F801	N8008
F801s	N8008s

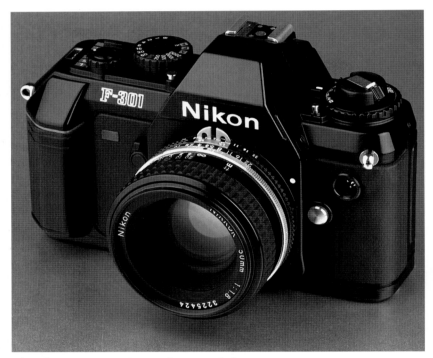

The Nikon F-301: a new concept in camera design.

A New Concept

Throughout the first thirty years of camera production by Nikon their design was determined by the mechanical systems they contained. The general philosophy was to include innovative features in each successive flagship camera, and then at a later date share some with less sophisticated models. Nikon's introduction of its EM model in 1979 changed all this, as it was a purpose built camera conceived for a specific market from the first stage of its design.

The process continued with the EM's successors. The first model in this completely new class of camera was the F-301, into which, two years later, Nikon fitted an AF system to produce the F-501. Since then Nikon camera design has undergone a continuous process of evolution culminating in the F65, F80, and F100 models of today.

Nikon F-301/N2000

The F-301 was the first Nikon SLR with a built-in motor drive, which although no faster than an FG and motor drive combination, has real advantages in its easy handling for an inexperienced photographer. A fully-fledged Nikon the F-301 can be used with almost all AI-type lenses as well as those modified to this standard. The automatic film advance, at up to 2.5 fps, means the F-301 depends on battery power. Four AAA-size batteries are fitted beneath the base plate, and provide sufficient power for approximately 50 rolls of film, which should be more than enough for most users. Alternatively you can fit the larger

Right:
Nikon's first foray into the world of the auto focus SLR: the Nikon F3 AF with its dedicated AF-Nikkor 80mm f/2.8.

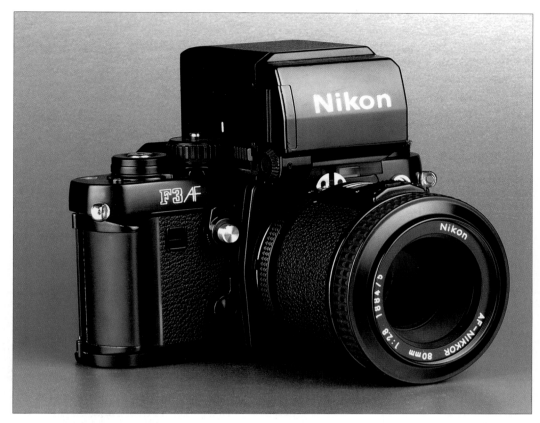

Below:
The F3 High-Speed is capable of 13fps. The camera is based on the F3 P and has a fixed pellicle mirror with a modified MD-4 motor drive.

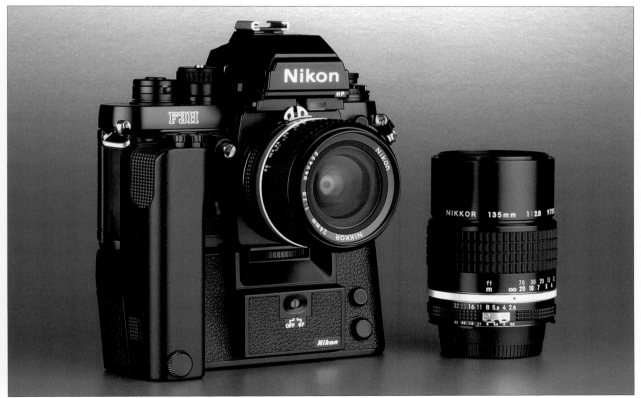

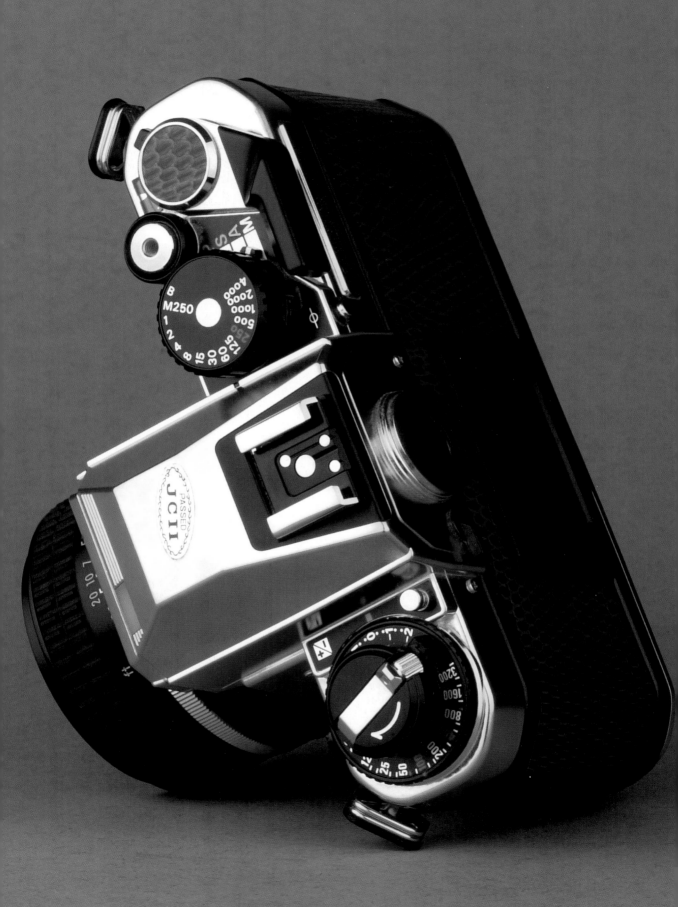

The shutter speed dial of the Nikon F-301

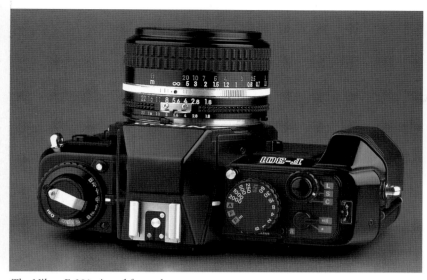

The Nikon F-301 viewed from above.

MB-3 battery pack, which replaces the standard base plate and accepts the ubiquitous AA size cells that offer greater capacity and improved performance in low temperatures. It is also possible to use rechargeable batteries in MB-3.

Film loading has been simplified, since the photographer only has to pull the leader to the red index mark located next to the take-up spool. On closing the back a spring-suspended roller presses the film against the spool, and a single press of the shutter release button causes the film to be advanced automatically to the first frame. An indicator on the camera back confirms film advance, adopted from the Nikon AF-compact cameras, it rotates as long as the film is running through the camera correctly. The F-301 is ready to shoot.

The deep finger grip on the front of the F-301 aids handling by providing a secure, comfortable grip even with long and heavy telephoto lenses. The top-plate is well arranged with the shutter release button ergonomically located directly behind the front edge, together with the dial for single or continuous film advance mode. The switch

for the acoustic warning signal, which operates with shutter speeds above 1/2000sec and below 1/30sec, when the self-timer is functioning, or when a non-DX coded film is loaded, is immediately behind it.

The F-301 has an exposure mode dial rather than an LCD display. Besides the manual shutter speeds from 1sec to 1/2000sec plus 'B', the camera has a standard aperture priority mode as well as the two program modes P and P Hi. Set to the

P position the camera selects a shutter speed/aperture combination, which is generally more appropriate for static subjects. P-Hi on the other hand applies a bias toward faster shutter speeds, which is useful for moving subjects or when shooting quickly in 'snapshot' situations. Compared to shutter speeds in the P mode those in P-Hi are approximately one stop faster and consequently the lens aperture is one stop larger. A quartz oscillator controls the manual shutter speeds. The locking button for the exposure mode dial is situated in front of it. The safety catch and button to release the film for rewind, which still has to be done with the conven-

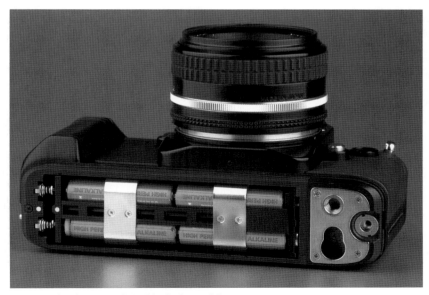

Batteries for the F-301 fit inside the base of the camera.

tional crank, is immediately behind the dial.

The viewfinder benefits from a newly developed fixed focusing screen that gives a brilliant image with hardly any visible grain. This new "Brite View" screen has the distinct advantage that its split-image rangefinder does not darken with lenses slower than f/4 as with earlier screen designs, but only from around f/11, making the use of slow zoom lenses and Reflex-Nikkor lenses far more convenient.

The shutter speed chosen by the camera is indicated in the viewfinder by a row of LEDs on the right side. In manual mode the preset speed is illuminated and a flashing LED indicates the speed suggested by the camera. Two triangle shaped symbols above the 1/1000sec and below the one second markings flash to indicate lighting situations that exceed the metering range. Since the design of the F-301 is primarily for use with one of the two program modes the preset aperture is not displayed in the viewfinder. An SPD cell is responsible for the centre-weighted metering with Nikon's familiar 40:60 ratio. A second SPD cell in the bottom of the camera's mirror box is used for the TTL-flash control, which operates within a range from ISO25 to 1000.

The F-301 has a new feature, a flash program mode, which with the camera set to P or P-Hi automatically chooses an appropriate aperture for flash photography. For ISO100 film the aperture is set at f/5.6; with a faster or slower film the aperture is correspondingly smaller or larger. Nikon based the flash program mode on the assumption that most enthusiast photographers use smaller flash units, with guide number between 25 and 30 (ISO100), mounted on the camera, and that their subject is usually within a range of two to five metres. The

photographer can of course select the flash aperture for themselves in both the aperture priority and manual modes. The camera will then display the shutter speed that would be 'correct' for the prevailing ambient light in the normal fashion, which is useful for fill-in flash photography. It should be noted that the flash program mode is only available when AI-S specification lenses are used.

In order to prevent stray light from entering through the eyepiece during remote camera operation Nikon supply the DK-5 eyepiece cover with the camera. The attachment of either a right-angled viewer, or eyepiece magnifier requires the

The exposure compensation dial is set around the rewind crank

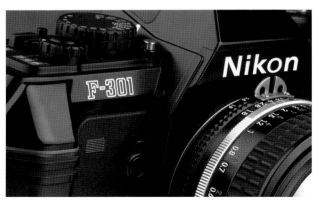

use of an adaptor. A red LED, positioned next to the prism housing, lights up when the film reaches the end of the roll. It has a secondary function to warn, by flashing, if a non-DX coded film has been loaded.

Because people often forget to reset the film speed on their meters when changing from one type of film to another, Kodak developed the DX code system and introduced it at the beginning of the 1980's. It has since become a worldwide standard. The film cassette is marked with a barcode that identifies the speed of the film. A row of contact pins located in the camera's film chamber make an electrical contact with this barcode allowing the camera to read the relevant film speed rating. The DX code enables speeds from ISO25 to 5000 to be identified. The F-301 has a DX-range from ISO25 to 4000, and film speeds from ISO12 to 3200 can be set manually. When the dial is rotated beyond the ISO12 position the DX mark appears on a red background. Concentric to the film speed dial is the exposure compensation dial, which allows values of +/- 2 stops in increments of 1/3EV to be set.

The F-301 does not have a conventional threaded cable release socket, but a two-pin terminal for electric remote release accessories such as the MC-12A cable. The terminal does accept the MR-3 adaptor

The finger grip and shutter release button of the F-301

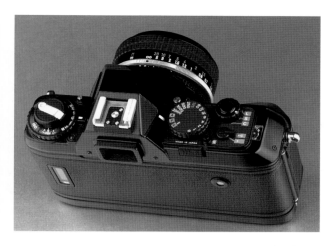

The Nikon F-301

The F-501, Nikon's first mass produced AFSLR camera, when combined with the TC16A teleconverter, provides a limited AF function with manual focus Nikkor lenses.

NIKON F-501/N2020

In 1985 a new chapter in the history of SLR cameras began with the introduction of the first mass-produced autofocus SLR, the Minolta 7000. Although the Nikon F3 AF had appeared two years earlier it was a special version of the camera developed within the F3 series, for which only two AF lenses where ever released, and the limited numbers sold reflected its high price. Nikon's very first autofocus lens was introduced in 1972 as a prototype

for a standard mechanical cable release to be fitted. Like the FA the F-301 has a second pin, situated just above the lens release pin, which identifies whether or not the lens in use is an AI-S type. If it isn't, the stop-down mechanism is given some more time to set the correct aperture during program mode. The self-timer, which is controlled electronically, is located to the left of the lens bayonet and an LED positioned next to it indicates its operation. The auto-exposure lock button is set at the central axis of the self-timer lever.

Some photographers found the F-301's off-centre tripod bush rather awkward, however, the AH-3 tripod adaptor can be fitted to overcome this problem. The last principle accessory for the camera is the MF-19 Multi-Control back that can be used to imprint the date, the time, or a sequential number. It also allows interval and timer operation and includes an alarm clock.

In an effort to reduce the manufacturing costs of the F-301 a depth-of-field preview button and a mirror lockup were omitted. At a time when the autofocus camera was in its ascendancy the F-301 still became popular with many photographers because of its numerous features, lightweight, and easy handling.

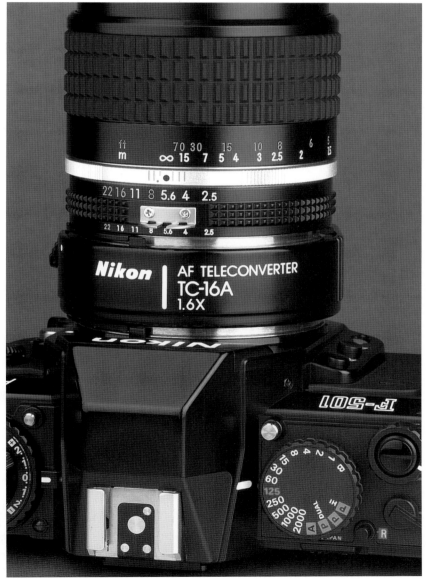

that never went into production. It weighted almost 3kg, was 30cm long, and for its 80mm focal length had a modest maximum aperture of f4.5. The autofocus action between one metre and infinity was ponderously slow.

Shortly after the Minolta 7000 appeared Nikon introduced their first SLR with an active autofocus system, the F-501. At first sight you might think you were handling an F-301 since the two cameras share the same body, except for a few minor details.

On the F-501 the shutter speed dial has an additional program, 'P-Dual'. This operates an automatic selection of either a normal or high-speed program mode depending on the focal length of lens in use. Similar to the system used in the

Nikon FA, whereby AI-S and AF type lenses with a focal length of 135mm or more activate the high-speed program by pressing in a pin protruding from the bayonet flange.

Unlike the F-301 focusing screens can be inter-changed, and in addition to the standard B-type screen, the E-type with an etched grid, and the J-type with micro-prisms to assist manual focusing were also available. The range of the automatic DX-coding was extended from ISO 25 to 5000, and the auto-exposure lock button was changed slightly.

In respect of the AF system the obvious difference is the AF drive coupling that can be seen in the lens mount flange. It is amazing that in the face of such a far-reaching development as autofocus the designers and engineers at Nikon succeeded in retaining the original Nikon F-mount used since 1959. As a result every AI, and non-AI lens modified to that standard, can be used on the F-501.

Pressure on the shutter release button also activates the AF system. A switch marked with the positions 'S', 'C', and 'M' is located below the

lens release button. In the 'S' position the shutter release button is locked until the AF system has attained focus; a function that Nikon refer to as 'Release Priority'.

In the 'C' position the AF system works continuously and if the subject moves it will attempt to correct the focus setting. In this mode it is possible to release the shutter at any time, even if critical focus has not been attain by the AF system; a function that Nikon refer to as 'Focus Priority'. In general everyday use the Release Priority should be used for static subjects while Focus Priority is more appropriate for moving subjects.

At the 'M' position the AF drive coupling is retracted to allow manual focusing with AF lenses. The AF system also offers an electronic rangefinder that is displayed in the viewfinder to facilitate manual focusing. The green circle in the centre confirms focus, while the red arrows to the left and right indicate direction in which to rotate focusing ring of the lens. If a red 'X' appears the camera is unable to confirm a focus point. This can happen, for example, when there is insufficient

The focus mode selector switch of the F-501 bears a strong resemblance to the same control of modern AF Nikon cameras.

A Nikon F-501 with an original type AF Nikon 28mm f2.8.

The F-501 can be distinguished from the F-301 by the additional Program-Dual mode on the shutter speed dial.

contrast in the subject, or when the AF sensor area is aimed at a highly reflective surface. The brackets in the centre of the focusing screen define the AF sensor area. If the main subject is not located at the centre of the image area the autofocus must be locked in a similar way to auto-exposure. In the 'S' mode the focus is locked whilst the shutter release button is half depressed. In the 'C' mode the AF lock button, situated beneath the exposure-lock button, must be held down. So in the AF mode, with a subject that is not at the exact centre of the frame, the photographer must first acquire sharp focus with the AF system then lock focus, re-compose the picture, and finally release the shutter. An effective system for its day, but it is a far cry from the high-speed predictive AF systems of current cameras like the F80 and F100.

Initially only three autofocus lenses were offered when the F-501 appeared at the beginning of 1986. In order to encourage Nikon photographers to enter the autofocus era an AF teleconverter, the TC-16A was released. The AF motor in the camera body drives the optical system of the TC-16A via its drive-coupling spindle. This allowed conventional manual focus Nikkor lenses, from the fisheye 6mm f2.8 to the 400mm f2.8, to have a limited autofocus capability. Use of the teleconverter means that the lens must have a maximum aperture of least f2.8,

because the effective aperture is reduced by a factor of 1.3 EV, whilst the effective focal length is increased by a factor of 1.6x. To use long focal length lenses at short range it is also necessary to preset the approximate focus distance manually, and thereafter the TC-16A can complete focus automatically.

The F-501 became one of the biggest selling Nikon-SLRs. Introducing a viable AF system at the same time as retaining the proven F-mount bayonet has proved to be one of Nikon's greatest technological achievements. The retro-compatibility of the Nikon 35mm camera system is unique, and something that no other camera manufacturer has been able to match. It has been much appreciated by

countless photographers, who having not had to re-invest in a completely new AF system, can continue to match their tried and trusted Nikon cameras and manual focus Nikkor lenses with most of those from the new AF generation. It is only with the very latest G-series Nikkors, which lack an aperture ring, that this compatibility has finally been lost over forty years after the Nikon F-mount was first introduced.

Nikon F-401/N4004
A year after the arrival of the F-501 expectations were running high that Nikon would introduce another autofocus model with faster focusing and film advance, and more professional features.

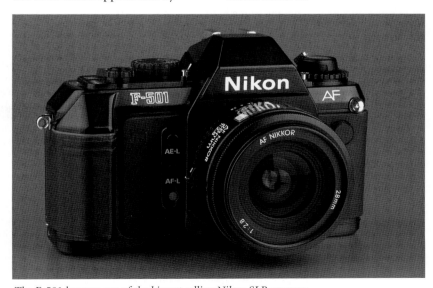

The F-501 became one of the biggest selling Nikon SLR cameras.

However, like the EM before it the F-401 was a complete enigma to most Nikon devotees. Whilst it does have the Nikon F-mount lens bayonet it does not even offer exposure metering unless an AF Nikkor lens is used. It was conceived as a response to the dwindling market share for an entry level SLR, which since the early 1980's had been steadily usurped by the AF compact cameras that had become increasingly well featured. The F-401 was designed to lure back those photographers who were tempted by the automation and ease of handling of the compact 'point and shoot' class of camera.

The F-401 has a very distinctive body due to its large grip, rounded corners and edges, and the small

Despite its relatively low output the built-in flash of the F-401 is a useful feature.

The two control dials of the Nikon F-401 are located beneath a tinted transparent cover.

pop-up flash unit built into the viewfinder prism. The shutter release button is recessed into the slanted top of the grip. The camera has two control dials one for the shutter speed and another for aperture values. Only the edges of these dials are accessible as they protrude out from under a grey tinted plastic cover plate.

Turning the shutter speed dial from the 'L' position switches on the F-401. The program mode is switched on by turning the shutter dial to the 'A' position and the aperture dial to the 'S' position. The camera has normal and high-speed program modes, the latter is activated when an AF lens is used that has a focal length of 135mm or more, or a zoom is set to a focal length beyond 135mm. If aperture priority auto-exposure is selected the aperture value is set via the dial and not the aperture ring of the lens. The aperture ring must be set to the minimum aperture value and locked in this position. The AF lenses have a small lock button adjacent to their aperture ring for this purpose. In shutter priority mode the preset shutter speed is selected with the aperture control dial positioned at 'S'. Even with this total automation the F-401 can be used manually by selecting settings with both dials.

The rewind button together with its lock button is situated next to the aperture dial, depressing both initiates the motorized film rewind, which takes about 25 seconds.

A 'Brite View' B-type focusing screen that is devoid of any manual focusing aids is fixed in the viewfinder. The viewfinder display is rudimentary comprising only + /– symbols, and a circle icon to indicate exposure values. No shutter speed or aperture values appear. If the circle icon blinks it is an indication that the shutter speed has fallen below 1/30sec and camera shake

The battery chamber of the F-401

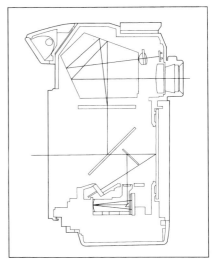

This diagram shows the light path inside the F-401.

may spoil the results. If either of the +/- symbols blink it indicates over, or underexposure. If the + and - symbols blink alternately this is a warning that the aperture ring has not been set to its minimum value. A green LED, next to those that provide exposure information, lights up when critical focus is attained. There is a flash-ready light, which in the F-401 also has another function; normally the camera evaluates the exposure with a three segment multi-metering pattern. However, if this system registers a subject with high contrast, for example in backlit situations, the camera's electronics prompt the photographer to switch on the built-in flash by getting the flash ready light to blink. If this suggestion is followed the result will be a balanced fill-flash picture. The

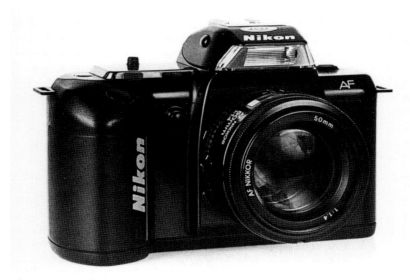

The F-401 is easily distinguished by its integral flash unit in the prism head.

built-in flash is switched on by pressing the locking buttons on the left and the right of the prism housing, which causes the reflector to pop up. It has a modest guide number of 12 (ISO100, m), which is perfectly adequate if the subject is within a range of two to five metres. The flash's proximity to the axis of the lens means that there is a strong probability of the red-eye effect showing up in pictures of people and animals. To avoid this and improve the quality of the lighting a separate flash unit should be used, either mounted on the camera or triggered via the SC-17 remote lead. In manual metering mode the camera defaults to a conventional centre-weighted configuration with the normal 60:40 ratio pattern.

Except for the button to activate the self-timer there is no other control on the top plate to the left of the viewfinder. The focus mode switch on the front has only two positions: one for 'S' (single servo autofocus) with focus priority, and 'M' for manual focusing.

The F-401 has a very annoying idiosyncrasy in its handling. Once the AF system has confirmed critical focus it can sometimes take up to 1 second before the shutter release will operate. This is in spite of the fact that the camera is equipped with the same AM-200 AF module used in the F801 and F4. The 200 sensors on the CCD of the AM-200 compare very favourably to the 96 of the F-501, and ensure that the F-401's AF-system registers a lot more information to achieve focus, even on finely textured surfaces such as a carpet. In addition some of the sensors are arranged diagonally so that horizontal structures or round objects are recognized more reliably. Compared to the F-501, the sensitivity of the F-401's AF system was expanded by 2 EV at the lower end, and in the later models, such as the F-801s, F-401s/x, F-601, F-90, and F4, even further to -1 EV.

Apart from the stop down lever and AF drive spindle the F-401 does not possess any other mechanical links in its lens bayonet. All other communication between the body and the lens takes place via the microchip (CPU) incorporated into the AF lenses. This is the reason why non-AF lenses can be attached but no metering functions operate, although manual focusing works normally and shutter speeds can be

in the usual way. The TC-16A AF teleconverter is not compatible with the F-401.

The auto-exposure lock button is situated all by itself next to the grip. The battery compartment is accessible after opening a flap in the camera's base plate, and accepts four AA size batteries, which in normal conditions are sufficient for about 20 rolls of film assuming the flash is used 50% of the time.

An alternative version of the F-401, the F-401 QD, which has a permanently attached databack to imprint either date or time was also available. Although somewhat unjustified, the F-401 struggled throughout its production life to gain any credence with owners of more traditional Nikon models. The reality is that it was never designed with their photographic needs in mind and should be seen for what it was – a highly automated camera aimed at the beginner and enthusiast photographer market.

Nikon F-401s/N4004s

In 1989, less than two years after the introduction of the F-401, a modified model identified by a 'S' suffix was launched. Externally the camera differs by the larger Nikon logo on the finger grip, and the model number on the front. The numerals for the shutter speeds and aperture values on the dials are larger, while the plastic cover plate above them is now completely transparent instead of being tinted. The 'A', 'S', 'P' (A+S), and 'L' positions can be locked and only altered by depressing a lock button to prevent any accidental changes. The shutter release button has a higher profile and the operating range of the AF-system begins at -1 EV. In addition the AF motor has a higher torque resulting in faster and more powerful focusing. A databack version called the F-401s QD was also available.

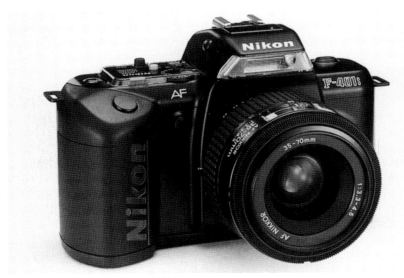

The F-401S introduced a number of improvements to the handling of the camera compared to the F-401.

Nikon F-401x/N5005

The F-401 was updated once again in 1991 to match some of the specifications of the more recent Nikon models, particularly in respect of the AF and metering systems. The 'Focus Tracking' function from the F4 was included, and the sensitivity

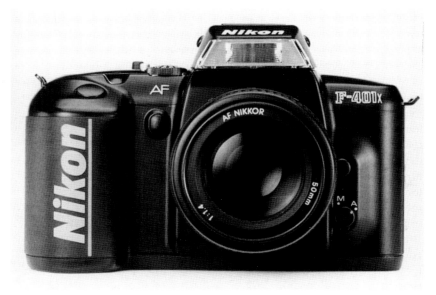

The LCD display of the F-401 QD camera

of the AF module was extended by 2EV to 19EV at the high end. The Nikon F-401x also received the same Matrix exposure metering and control circuitry as the other AF-SLRs, which is based on five rather than three segments and with its sensitivity range extended to 0EV. This probably had as much to do with rationalizing production as it did

with increasing the specification.

The camera's shutter range was extended with speeds down to 8 seconds in program mode, and 30 seconds in the aperture priority automatic mode. Unlike the earlier dual dial selection of the P-Hi program mode on the F-401 the F-401x is equipped with an Auto Multi-Program that will not set shutter speeds slower than the reciprocal of the

focal length until the lens diaphragm is fully opened, thus maximizing the potential of achieving sharp pictures when shooting hand-held. The additional 'T' position on the F-401x makes up for the absence of a cable release socket in earlier models when shooting long exposures. In manual mode, and set to 'T', the shutter is only activated 1/2 second after your finger is removed from the shutter release button and remains open until pressed again.

The flash system of the F401x has a number of improvements; the sync speed is increased to 1/125sec, and the built-in flash unit covers the picture angle of a 28mm lens. It retains the same GN12, but TTL control is extended to film speeds of ISO800 for the internal Speedlight, and ISO1000 for an external unit. The F-401x features Nikon's acclaimed Matrix Balanced Fill-Flash mode as well as a Centre-weighted fill-flash option. The threshold contrast to activate the flash signal in the viewfinder is reached when the central segment of the metering pattern is at least 2EV

The F401x has a more ergonomic shape to its finger grip. The cover over the control dials was also omitted.

darker than the outer four segments, which must register at least 10EV themselves. In the former arrangement the difference was only one EV, which could cause the portion of the photograph lit by flash to look unnaturally bright. The exposure information for the prevailing ambient light is also displayed to allow precise control and manual override if desired.

One of the major benefits of the new electronics is their greater efficiency since, according to the official Nikon specification the F401x manages up to 50% more films per battery-set. This third generation F-401 is easily recognized by its rounder grip and no cover plate over the shutter speed and aperture dials. A QD-model with an integrated databack was also available.

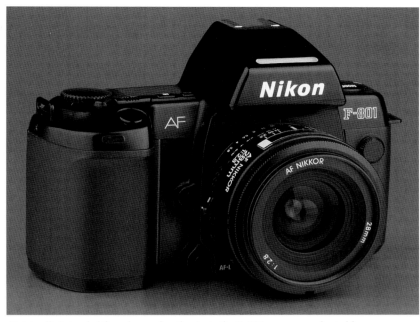

Originally intended for advanced enthusiasts the F-801 was soon adopted by many professionals. This example has the first version of the AF Nikkor 28mm f2.8 lens attached: note its very narrow focusing ring.

Nikon F-801/N8008

Nikon introduced their top AF model for advanced enthusiast photographers in 1988. It was so well received that before long many professionals adopted it, often as a back-up body to their F4 cameras. The F801 came with such an abundance of technical refinements that even today it retains its popularity with many photographers. It is quite apparent that Nikon took as much care with the many manual features, as well as the automatic focusing and exposure functions, to ensure they produced an all-round performer that was convenient to use. In addition to the motor for driving the AF system the F-801 has two further motors; one is responsible for winding and rewinding the film, the other cocks the shutter and the mirror mechanism.

The F-801 was the first SLR camera with the sensationally fast shutter speed of 1/8000sec, and for the time, at 3.3fps, had the fastest integrated motor drive. Another first for a Nikon SLR was the use of an LCD

and function buttons in place of the more familiar conventional dial type controls. Like the shutter speed dial of earlier cameras the F-801 has one principle control, the Main Command Dial, though it performs a more diverse role. The information is displayed in the LCD, but the settings are changed with this dial, which is located on the rear edge of the camera to the right hand side where it falls naturally under the photographer's right thumb. It is used in combination with one of the

seven function buttons to set many different camera operations.

A sliding switch behind the shutter release button activates the F-801, which is on the slanted top of the large finger grip. Some photographers find the that the smooth surface of the camera back does not provide sufficient grip and detracts from the camera's handling

The LCD communicates all the relevant information about the camera's operational state clearly and concisely. The exposure control and

Introduced in 1988 the layout of the controls on the F-801 conforms to a design style still used today in modern Nikon AF cameras: note the main command dial and LCD.

metering modes and any compensation factor set are displayed in the top row. The film speed, the shutter speed, and the aperture value can be seen in the central row, and at the bottom are the film-advance control symbol, the multiple exposure setting, and the frame counter. To avoid confusion these are not all displayed simultaneously; when switched on the LCD only shows the exposure control and metering mode, the film advance control symbol, and the frame counter. Depressing the shutter release button halfway causes the shutter speed and aperture values to appear.

In terms of exposure control the F801 offers everything a photographer could wish for: shutter and aperture priority modes, three program modes, normal, high-speed, and dual, including automatic switching from one program configuration to another depending on the focal length in use, as in the F-501. The program-shift function is new: the shutter speed/aperture combination chosen by the camera can be changed any time, via the command dial, to meet personal requirements, and if this option is chosen the 'P' icon blinks as a reminder. In shutter priority mode the speed is set with the command dial. If selected speed dictates an aperture value not available with the lens in use, 'HI' or 'Lo' appear in place of the aperture value. The LCD the displays the number of steps the speed should be corrected by.

In aperture priority mode the aperture ring on the lens is used to set the required value. Settings exceeding the available range are indicated in top plate LCD in the same manner as in shutter priority mode. In manual mode the aperture is set with the lens aperture ring and the speed with the command dial.

The LCD is a positive mine of

information and in addition to the shutter speed and aperture, it also shows any deviations from the preset combination of values in increments of 1/3EV. In practice this is just as informative as the match needle displays in the EL and FE/FE-2. The shutter speed range runs from 30secs to 1/1000sec. The F-801 offers a modified version of the AMP multi-pattern metering of the Nikon FA, which is referred to as Matrix metering. The alternative is a centre-weighted mode, which like the F3 has a strong central bias. The metering pattern has a 75:25 ratio distribution with the greater proportion concentrated in the 12mm circle marked on the focusing screen. The film speed range extends from ISO6 to 6400, and exposure compensation can be set across a wide range of +/- 5EV.

The shutter speed and aperture are displayed in whole steps with the aperture value prefixed by 'F'. In the program and shutter priority modes 'FEE' appears instead of the aperture value as a warning that the aperture ring has not been set to its minimum value and the shutter release button will be locked.

Film advance is offered in three speeds: 'CH' at 3.3fps, 'CL' at 2fps, and 'S' for single frame shooting. Multiple exposures of up to nine exposures per frame can be programmed by pressing the ME button; the necessary exposure com-

pensation must be set manually as it will vary from subject to subject.

The self-timer delay duration can be set between 2 and 30 seconds, but that is not all: in the 2F-position the camera will be released twice. The first time after 10 seconds and then again after another 5 seconds allowing you to take a second shot, a useful feature for self-portraits or shots of a group that includes the photographer.

The sliding auto-exposure lock switch and the button to switch on the viewfinder illumination, which turns on automatically whenever the ambient light falls below EV 6, are placed conveniently on the back beside the main command dial. The F-801 has a High-Eyepoint viewfinder, similar to the F3 HP model, and its comprehensive display shows almost all the information visible in the main LCD: shutter speed, aperture value, exposure mode, any compensation value, flash-ready signal, and the AF indicators are shown beneath the finder image. Even the film speed can be controlled in the finder by pressing the ISO button. The standard B-type focusing screen has the AF sensor area brackets marked in the centre. It can be changed for an E-type grid pattern screen. The viewing area of both screens is 92% of the total frame.

The ISO accessory shoe with its hot-shoe contacts is located on top

This cluster of buttons controls the basic operations of the F-801.

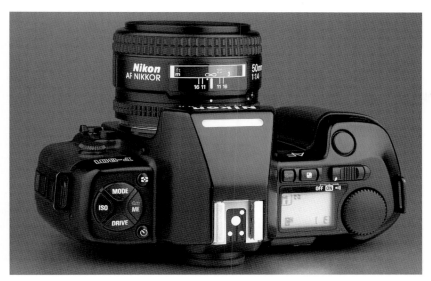

The Nikon F-801 viewed from above. Its much-improved flash exposure control made the camera a favourite with professional photographers.

of the prism housing. The F-801 has TTL flash metering with a modified and improved version of the fill-flash system from the F-401, which Nikon called 'cybernetic synchronization'. In plain language this means that the camera has the ability to change not only the aperture but also the sync-speed between 1/60sec and 1/250sec, depending on the level of ambient light in order to achieve the best balance between the two light sources. The system avoids the 'soot & whitewash' effect of an over lit subject against a dark background.

In high contrast shooting situations such as bright sunlight the latitude of film is often exceeded leading to either burnt out highlights or solid black shadow areas. The F-801 in combination with a Nikon Speedlight provides an easy solution to the problem. In the Matrix metering mode, flash output is controlled so that it contributes up to 1 EV less to the combined daylight/flash exposure, and with the centre-weighted mode it is reduced by exactly 2/3 EV. If one of the 'smart' Speedlights, the SB-24 onwards, is used its output can be

controlled within a range of +1 to –3 EV. The SB-24 also allows synchronization to be switched to the second shutter blind, which is referred to as Rear-sync flash, so that it is fired at the end of the exposure. The F-801's automatic fill-flash mode is available with any compatible Nikon Speedlight and

units equipped with the SCA-system from other manufacturers.

The F-801 has a reset function, which by pressing the both the Mode and Drive buttons simultaneously, returns the camera to a standard configuration of P-Dual and Matrix-metering modes, with single film frame advance, and cancels any exposure compensation factors. All the other controls are grouped on the top left next to the prism, with the exception of the exposure compensation button, where traditionally the rewind crank was situated. The F-801 has motorized film rewind that returns a 36-exposure film to its cassette in 15 seconds.

The camera is constructed around a core chassis made of die-cast aluminium. By making the shutter blades out of aluminum rather than titanium the engineers at Nikon were able to reduce their travel time and increase the size of the slit between them, which resulted in the new top shutter speed of 1/8000sec, but the sync speed of 1/250sec remained unchanged. In the case of

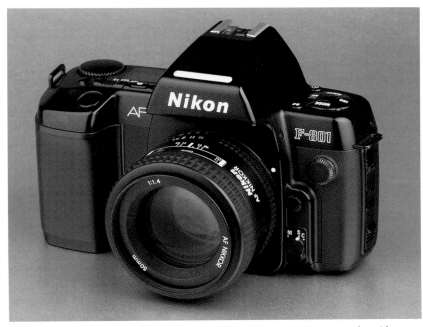

The F-801 with the second version of the AF Nikkor 50mm f1.4 lens: note the wider rubberized grip on the focusing ring.

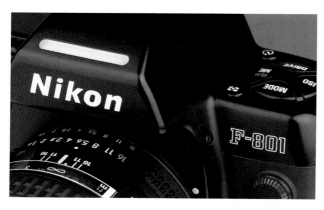

The prism head of the F-801 and beneath it the coupling ring around the lens mount that allows the use of many earlier non-AF Nikkor lenses.

The F-801 has a plethora of electrical contacts: those for the DX film code reading can be seen in the film chamber, whilst the row of 7 circular contacts below the lower film guide rail are for the multi-control and data backs.

the AF-system the same proven AM-200 module used in the F-401 was fitted to the F-801, and improving the data processing increased its sensitivity all the way down to -1EV. A new coreless motor with a higher torque and with quicker acceleration drives the AF system.

The familiar lens aperture-coupling ring is set around the bayonet making it possible to use non-AF lenses, although some of the camera's modes will be lost and in these circumstances the F-801 works in a similar manner to the FE2. In other words it offers aperture priority and manual modes, along with centre-weighted metering. The camera is powered by either four alkaline or rechargeable AA size batteries, which fit in a battery holder inside the grip section. The DB-5 external battery pack, with a 6V lithium battery, can be connected if the camera

The F-mount bayonet of the F-801: note the protruding AF drive shaft at the '7 o'clock' position, and the set of seven contacts above the mirror for connecting the camera to the lens.

is to be operated in very cold conditions.

As a true system camera the F-801 has two additional backs that can be fitted by the photographer: the MF-20 databack, the MF-21 Multi-Control Back. The former imprints

day/date/time information in the lower left-hand corner of the image area. The latter offers a number of versatile functions including a 'Freeze-focus' mode in which the lens is preset to the desired focus distance and as soon as the subject passes through this point the camera is released automatically. The only drawback to this system is that once set the camera continues to draw battery power, which limits its use for protracted remote operation.

The F-801 was an immediate best seller that found favour with experienced Nikon users as its versatility allowed the camera to assimilate it self into their camera systems, and could be used with all of their lenses. Many professionals used the F-801 as a backup to their F4 models as it offers almost as many features

Nikon F-801s/N8008s

Although the F-801 had gained widespread acceptance it became apparent to Nikon that a number of modifications were required. A problem with early models involving the build up of a static charge that disrupted the camera's displays was soon solved by a change to the electronics. However, technology does not stand still and by 1990 Nikon was faced with a growing tide of criticism concerning the F-801, in particular the fact that the lower priced F-601 offered features that were not available in the more professionally orientated F-801.

Nikon had anticipated this situation and was already working on an update and in 1991 they introduced the F-801s. The most useful new feature was the inclusion of a spot-metering mode. It also has an improved AF system that is slightly faster than its predecessor; focus tracking was extended to the continuous AF mode when used with the lower 'CL' continuous film advance mode. The design and features of

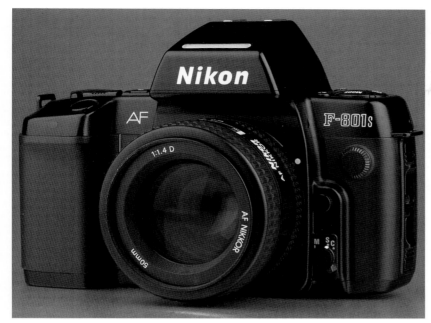

Introduced in 1991 to keep pace with camera technology the F801s incorporates a faster AF system and a spot meter function.

the F-801/s have ensured that it remains a popular camera that is used by many photographers on a regular basis even today.

F-601/N6006

The layout of the F-601, introduced in 1990, draws heavily on that of the F-801, to which it bears a close resemblance. Although the camera takes yet another step away from the traditional design of mechanical cameras it retains compatibility with all AF Nikkor lenses and can be used with other types if you accept some limitations.

Intended as a successor to the F-401 models it has a similar design of pop-up flash unit with a GN13 (ISO100, m) housed in the prism head that integrates with the camera to provide full TTL control in both the matrix and centre-weighted metering modes. The unit it is switched on by pressing the two lock-release buttons either side of the prism head, which allows it to swing up into its ready-position. Other flash modes include slow-sync within a shutter speed range from 30 seconds to 1/125sec, and rear curtain sync. The Flash Output Level Compensation mode allows ambient light and flash output to be finely balanced within the range of +1EV to -3 EV in increments of 1/3EV, even with units from independent brands provided they are equipped with the SCA-system.

The F-601 offers a choice between three different modes for exposure metering and control. It has the same Matrix metering system as the F-801 for swift, accurate, and automatic measurement. The centre-weighted mode is similar to the F-401 with its sensitivity distributed in a ratio of 75:25 between the centre and outer frame areas. Finally, the F-601 also offers spot metering for those who like to work in a more considered manner.

In addition to the standard three exposure modes, aperture priority, shutter priority, and full manual control the F-601 offers a choice

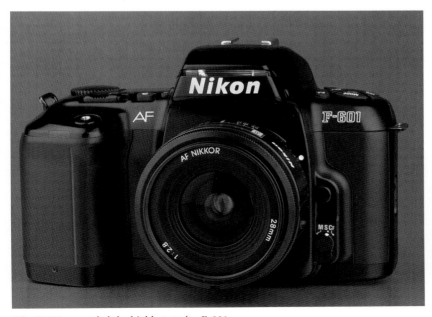

The F-601 succeeded the highly popular F-801.

The built-in flash unit of the F-601 has a Guide Number of 13 (ISO, m).

93

A direct development from the F-801 this cluster of buttons controls the principle operations of the F-601.

On the F-601 there is a sliding button to lock exposure and AF functions.

The LCD of the F-601 is clear and legible.

between a normal and the Auto multi-program modes for simple and rapid operation. In the multi-program mode the camera registers the focal length and maximum aperture of an attached AF Nikkor lens and alters the program curve accordingly in order to avoid slow shutter speeds, which might result in camera-shake. In addition, Program-shift allows the photographer to change the camera's own selection of shutter speed/aperture combination in steps of 1 EV any time.

There is an auto-exposure lock feature operated by a sliding switch located on the back of the camera between the main command dial and the viewfinder eyepiece, which falls quite naturally under the pho-

tographer's right thumb. Exposure compensation can be set across a range of ten stops from +5 to –5 in increments of 1/3EV. If this does not provide enough control the F-601 offers Automatic Exposure Bracketing with a choice of either three or five consecutive shots with a variation in steps of 1/3EV, 2/3EV or 1EV.

The camera has the two familiar AF modes, 'S' single servo and 'C' continuous servo, and a 'Focus Tracking' function operates in both if the camera detects a subject that is moving. Film advance and rewind

is automatic, and once a film has been placed in the film chamber and the leader pulled out until it reaches the red index mark beside the take-up spool the photographer just has to close the camera back an the film is instantly advanced to the first frame

The viewfinder has a High-Eyepoint design, similar to the F-801 that enables people who have to wear glasses to see the entire viewfinder image area. The Brite-view focusing screen, which had become a standard in all Nikon cameras since the F-301 provides

The F-601 models use a 6v Lithium battery for power.

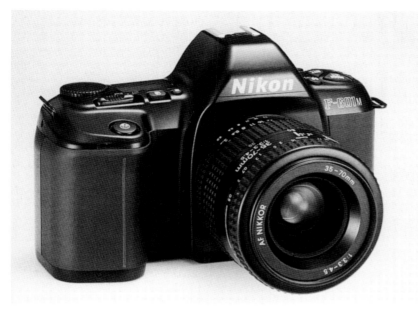

The 601M lacks a built-in flash, spot meter function, and auto focus, yet it requires the use of AF lenses to make full use of its automatic exposure control modes.

displays a crisp high contrast image. Viewfinder information is comprehensive and includes the aperture value, shutter speed, film speed (in case of manual setting), the number of frames in Auto Bracketing mode, the analogue exposure meter display, the exposure mode, any compensation factor, and the focus confirmation indicators.

The self-timer delay duration is between 2 and 30 seconds, with the option of a second exposure if the delay is set to 10 seconds or more. The DX coding system operates within the usual range from ISO25-5000, and from ISO6-6400 when set manually.

The F-601 is a well-designed camera with many advanced features that will satisfy the most demanding enthusiast photographer, however, I consider the omission of a depth-of-field preview function mars an otherwise excellent photographic tool.

Nikon F-601M/N6000

At a time when the market shares of both manual and AF systems were about equal, but with the AF sector growing rapidly due to the demands of beginners and enthusiasts alike Nikon took something of a gamble and introduced a manual focus camera model, the F-601M.

The F-601M is equipped with almost all the F-601's features, except for its automatic focusing function and built-in flash unit. The spot metering system is also absent, due to the design of the camera that includes a traditional split image rangefinder focusing screen to facilitate manual focusing. The viewfinder image is bright and clear so that focusing is quick and effective even with slower zoom lenses. In view of its design as a manual focus camera the F601M has a major drawback, because to access any of the camera's metering and exposure modes it is necessary to use autofocus type lenses. This is because their integral CPU's communicate the data necessary for these functions to work. If a non-AF lens, or one that does not have a CPU is attached to the F-601M the matrix metering as well as shutter priority and program modes are lost.

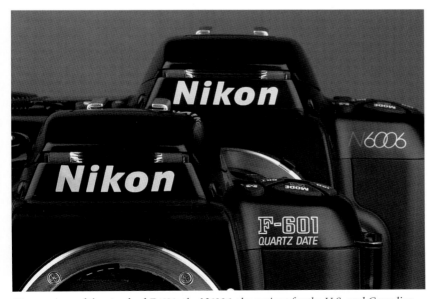

Two versions of the standard F-601: the N6006, the variant for the U.S. and Canadian markets, and a F-601 QD with its non-interchangeable data back for imprinting date/time information.

The Modern AF Generation

By 1991 Nikon had achieved a feat unparalleled by any competitor; without sacrificing their proven F-mount bayonet they had developed a series of multi-mode automatic AF cameras ranging from the entry level F-401x to the sophisticated F-801s and the 'flagship' professional model the F4. However, there was no point in either modifying existing technology or adding further features for the sake of doing so, as this would not advance AF camera design in a significant way.

Nikon Model Names

As mentioned in the previous chapter the introduction of the F-301 marked the start of a new practice for Nikon whereby camera models were assigned a name for the North American market that was different to the one used for the rest of the world. The specification for each model, however, is identical. For those models discussed in this chapter, with the exception of the F100 that retains the same name in all markets, the equivalent Nikon names are shown in the table.

Outside USA/Canada	Within USA/Canada
F90	N90
F90X	N90S
F50	N50
F70	N70
F60	N60
F80	N80
F65	N65
F55	N55
F75	N75

New Functions: New Features

By 1991 Nikon had accrued over six years of experience from their first two generations of AF cameras and were well aware of their shortcomings. The first concerned the AF system and its dependency on the subject's surface texture, size, and position in the frame to be effective. The second involved exposure metering, which ten years after the world's first multi-pattern system was introduced in the Nikon FA, still experienced difficulties with strongly backlit subjects, and more importantly was not able to determine where in the frame area the main subject was located. Lastly, even though the F-801 had opened up a hitherto unknown world of fully automatic flash exposure with its Matrix Balanced Fill-Flash mode, certain lighting situations could still fool even this sophisticated system.

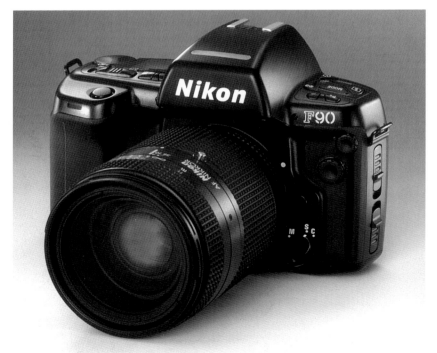

Innovative design features first seen in the Nikon F90 continue to be used in current cameras, including the Nikon digital SLR range.

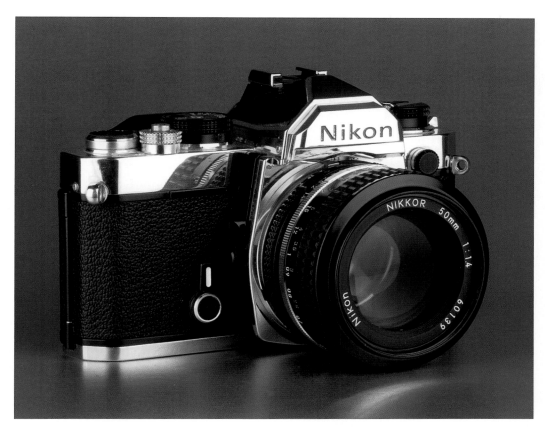

*Page vi
Nikon celebrated the accolades and awards collected by the innovative Nikon FA, which introduced the first multi-patterned metering system, by introducing a limited edition finished in gold.*

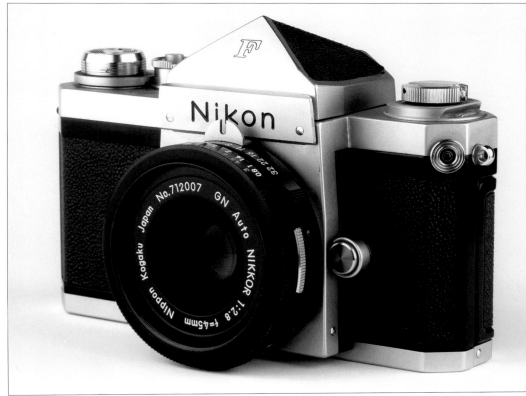

*Above:
To celebrate the 60th anniversary of the formation of Nippon Kogaku K.K. an edition of the Nikon FM with matched Nikkor 50mm f/1.4 finished in gold was introduced in 1977.*

*Left:
A Nikon F with Nikkor 45mm f/2.8 GN, which was designed for flash photography.*

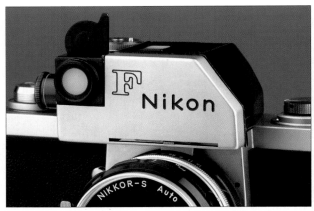

The first version of the Photomic metering head for the Nikon F. The meter cell has the diffuser disc in place for taking an incident light reading, but it is not a TTL system.

A view of the top plate of a Nikon F camera. Note the Nippon Kogaku logo.

Nikon introduced this limited special edition of the F5 the mark their 50th anniversary of camera manufacture.

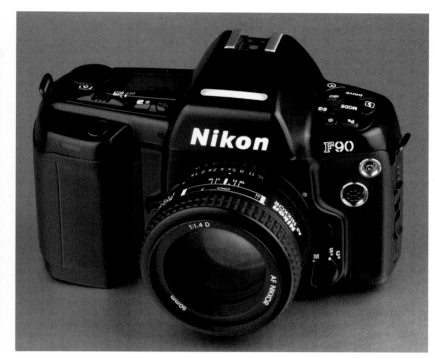

Successor to the F-801s: the Nikon F90 with an AF-Nikkor 50mm f1.4.

Nikon F90 / N90

In September 1992 Nikon introduced their solution to these problems, the F90. Positioned between the F-801s and the F4 it represented the most advanced 35mm SLR they had developed up to that time. The camera was packed with innovative features and offered a new level of performance. Its introduction marked the beginning of the completely new generation of film cameras that would in time include the F80, F100, and the F5. So successful was the basic design concept that it has been adopted in Nikon's current range of digital SLR cameras.

The AM 200 AF module fitted to a number of earlier cameras was replaced by a unit called the CAM 246: this Cross-type Autofocus Module covers a horizontal detection area of 7mm with 172 CCDs while 74 further elements are arranged across a vertical area of 3mm. The F90's hardware and software responsible for processing the data from the CAM 246 were

refined so that level line patterns like the horizon, slightly off-centre, and moving subjects are all detected more positively than before. Spot autofocus was a new feature, which limits the AF sensor module to an area covered by a 3 mm diameter circle in the centre of the image frame as an alternative for when the subject is too small to be metered precisely with the normal Wide-Area mode in which the closest and/or brightest of the detected objects usually determines focusing. A microcomputer on board the F90 is four times faster than in previous

models, and in conjunction with the Overlap-Servo function, which begins to drive the AF system while the final calculations are still being processed, results in an AF system that is 30% faster.

Focus tracking is automatically activated in both AF modes regardless of the film advance speed that has been selected. To compliment the F90's faster AF speed Nikon introduced a new, quicker focusing type of AF lens, which for the first time incorporated a coreless motor within the lens barrel. These AF-I types, forerunners of the current AF-S lens series, were only ever produced as long fast telephotos. The range comprised a 300mm and 400mm with a maximum aperture of f2.8, plus a 500mm and 600mm with a maximum aperture of f4. Normally, the system's single servo mode is linked to focus priority and continuous servo to release priority, but this can be changed with the multi-function databack MF-26.

Along with the F90 and AF-I lenses Nikon began to introduce modified versions of their existing AF Nikkors that contained a modified central processing unit (CPU) to communicate the focus distance to the camera for inclusion in the calculations of the new 3D Matrix exposure metering system. This further refinement of the original Matrix system links the AF sensor to the exposure metering sensors and was developed on the assumption

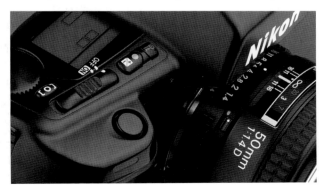

A light pressure on the shutter release button will activate the AF system of the Nikon F90.

that the subject would be at the point of focus and, therefore, the metering system would now know where the subject was in the frame and could bias exposure control accordingly. If the F90's AF sensor, which covers the central section of the frame, registers focus or only a small amount of defocus the camera concludes that the main subject is situated in the centre of the frame. Whereas a large degree of defocus will almost certainly indicate that the subject is off centre. The exception to this arrangement is if the focus-lock function is used and the matrix sensor simultaneously detects strong contrast, most likely caused by strong backlight. In this case the sophisticated electronics base the exposure on the scene it metered before the focus-lock was applied and the final composition was framed.

Instead of the five segments used before, the new system subdivides the central one into three separate areas to give a total of eight. In backlit situations this allows distant subjects to be analyzed with more precision, however, at close-up ranges the segmentation is switched back to five, as the subject is now likely to occupy a significant proportion of the frame area and the central exposure sensor can act as a single unit.

The LCD of the F90 displays all the relevant metering and exposure information.

To make the most of the 3D Matrix metering system the photographer needs to use the 'D' specification lenses. Non-D AF lenses can of course be used, the only drawback being the possibility of less accurate exposures in certain close-up and backlit situations.

Further refinements to the 3D Matrix metering system's software included a fuzzy-logic algorithm, which prevents sudden and radical changes to the exposure as a result of only minute differences in lighting or composition, and automatic sensing of vertical shots without the need for the expensive mercury switches used in the F4. As these features are internal to the camera they are available regardless of the type of CPU-equipped lens that is attached.

The F90 has a conventional centre-weighted metering pattern with a 75:25 ratio similar to the 401x/601/801/s, and the sensor of the spot-metering mode covers an area representing just 1% of the frame, as defined by the central 3mm circle in the viewfinder.

Nikon introduced yet more innovation in the flash exposure system of the F90. It was the first camera in

This cluster of buttons on the F90 is used to control flash, the motor drive, exposure mode, and film speed setting.

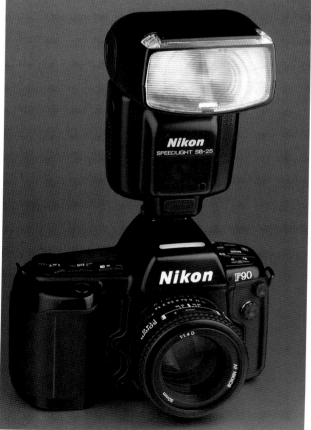

The Nikon F90 with SB-25 introduced a new level of flash exposure control.

the world to be equipped with a multi-segment TTL flash metering sensor. The five areas, arranged very much like the 3D Matrix sensor, together with the distance information supplied by the D-type AF Nikkor lenses achieve even more consistently accurate flash exposures than its predecessor the F-801/s. The F90 is able to determine between the various parts of the frame, their relative importance based on the focus information, and if an area with unusually high or low reflectivity would lead to incorrect exposure of the main subject.

In addition to the F90 and new Nikkor lenses Nikon also released an upgraded version of the SB-24 Speedlight, the SB-25. Combined with the F90 and D-type Nikkor lens this new unit provides 3D Multi-Sensor Balanced Fill-Flash. Although the name hardly rolls off the tongue it sums up the advanced nature of the flash system, which with a few refinements is the same system in use today with Nikon's latest film based SLRs and the latest SB-80DX.

The system operates in the following sequence: the instant after the reflex mirror has swung up, after the shutter release has been pressed, the SB-25 emits a rapid series of between 1 and 16 almost imperceptible, low-power flashes depending on the subject's distance and the selected lens aperture. This light is reflected back off the subject, through the lens, onto the 18% grey surface of the first shutter blind and then to the TTL flash multi-sensor. The five-segment TTL sensor then analyzes these so called Monitor Pre-flashes and the camera's microcomputer then compares their brightness with its theoretical exposure calculation based on the lens' distance information, the guide number, and aperture in use. This pre-checking identifies extremely

bright or dark areas within the frame and their position relative to the subject, which allows the camera to adjust the flash output accordingly. All of this happens in a minute fraction of a second before the shutter opens, and without causing any delay to its release. Once the shutter is open the camera's TTL flash sensor continues to monitor flash output directly off the film with reference to the value established by the system's pre-exposure assessment. The instant the TTL sensor determines that sufficient light has been emitted it tells the camera to quench the flash output.

At the time of its introduction 3D Multi-Sensor Balanced Fill-Flash was without a doubt the most advanced and reliable flash exposure control system available and it remains so today. Even with non-'D' AF lenses the F90 still produces more consistently accurate flash exposures compared to earlier Nikon cameras due to its improved ability to balance the flash output with the ambient light. The same applies to earlier Speedlights without the Monitor Pre-flash option because of the greater analysis of the flash output made by the F90's TTL flash multi-sensor during the actual exposure.

Among the many useful functions such as slow-sync and rear-sync flash control, the F90 also allows manual high-speed flash sync from 1/250sec to 1/4000sec, and automatic flash bracketing with the MF-26.

Over and above the standard exposure modes of Aperture priority (A), Shutter priority (S), Manual (M), and the Auto Multi-Program (P) all seen in previous Nikon cameras the F90 is equipped with a Vari-Program system of seven fixed customized program modes for different types of subjects. Designed to add an ease of operation and greater level of control in point and shoot

situations this Vari-Program system has options for the following subjects: Silhouette, Hyperfocal, Landscape, Sport, Close-up, Portrait, and Portrait with Red-Eye Reduction that uses a pre-flash to reduce the diameter of the subject's eye pupil. This last option is only available with the SB-25 Speedlight or later models.

The viewfinder and top plate LCD of the F90 provide a comprehensive amount of information to the photographer. The frame counter included in the viewfinder is an especially useful feature. The Brite-View B-type focusing screen has a central 3mm diameter circle to define the area of the Spot-AF measurement, a 7mm wide square bracket for the standard wide area AF sensor area, and a 12mm circle for assisting with the centre-weighted metering pattern. An optional E-type screen can be fitted that has the standard arrangement of etched grid lines. The viewfinder coverage represents 92% of the total image area.

As so many functions are controlled by its microcomputer Nikon realised that photographers could benefit from further customized control of their camera. The aptly named Data-Link system was introduced, and in place of the earlier two-pin remote terminal, a new ten-pin remote socket, located on the front of the camera, was fitted to allow the attachment of a Sharp electronic organizer via the MC-27 lead. Nikon released the AC-1E Data-link card that was compatible with the organizer and provided a whole host of remote control and customized operations beyond those offered by the MF-26 Multi-Control back. The functions include: downloading shooting data recorded by the F90, the ability to develop and store up to five individual program curves, and the organizer can serve

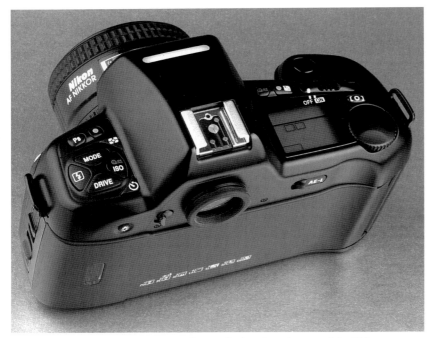

The icons for the various program modes are displayed on the rear of the F90.

as a remote LCD display.

Introduction of the ten-pin terminal required Nikon to produce a new set of remote accessories as well as two adaptors to ensure compatibility between the new and earlier devices. The MC-20 is an 80cm cord with handgrip, fitted with an illuminated LCD of its own and allowing remote setting of long exposures. MC21 is a 3m long extension lead, with a male and female socket, for the ten-pin accessories. The 1m long MC-22, the equivalent of the MC-

The F90's LCD and command dial seen from behind the camera.

4a, offers connection to purpose built triggering devices via its three separate single pin plugs. The 40cm long MC-23 connects two ten-pin cameras for simultaneous release. MC-25 permits the use of conventional two-pin remote control accessories with ten-pin terminal cameras, while MC-26 works the other way connecting the new equipment to the two-pin terminals of earlier cameras and accessories. Finally the MC-30 is similar to the MC-12A and provides a simple release switch that can be locked to maintain the power supply to a camera for remote control over protracted periods.

Since Nikon intended the F90 to meet the needs of professional photographers, the DB-6 external battery-pack introduced for the F4, which takes six D-size cells, can be connected to it via the MC-29 lead. Its terminal plugs directly into the F90's battery holder.

In the F90 Nikon achieved their aim to produce a camera that represented a significant advance in cam-

era design. For its time it offered state-of-the-art performance by combining innovative automatic functions with rapid, easy handling, whilst retaining the option to set almost everything manually should the photographer so desire.

Nikon F90X / N90S

Two years after the introduction of the original F90 its successor, the F90X appeared. Despite having undergone only a few modifications they are of such importance that the F90X represents a significant improvement compared with the earlier version of the camera. By incorporating new software in the camera's computer the AF system is capable of reading data at a rate 50% faster and setting focus 25% quicker than its predecessor.

At the time of the F90X's release I was using the F4 as my principle camera and I cursed the fact that when shooting sport or action, in my preferred manual exposure mode, changes to the shutter speed could only be made in increments of 1EV, which often meant I could not make the most of the maximum

Nikon's new ten-pin remote terminal; seen for the first time on the Nikon F90.

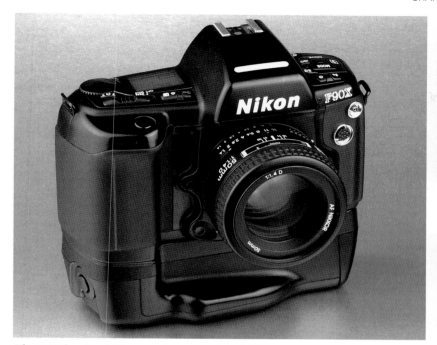

The layout of the controls is identical to the F90.

The F90X has the ability to set shutter speeds in 1/3EV steps.

aperture on my 300mm f2.8 and 500mm f4 Nikkor lenses. If you photograph fast moving subjects the difference between 1/250sec and 1/500sec can be critical in achieving a sharp picture. As light levels dropped I would be forced to sacrifice the shutter speed by selecting the next slowest speed and then close the aperture by 1/3-1/2-2/3EV.

The LCD of the F90X: the shutter speed is displayed in 1/3EV steps.

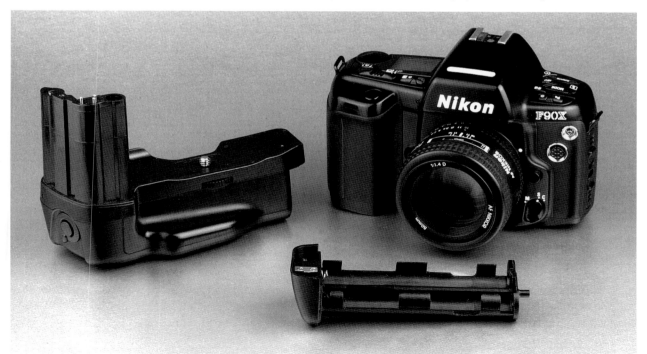

The F90X and MB-10 battery pack which provides an additional release for vertical shooting.

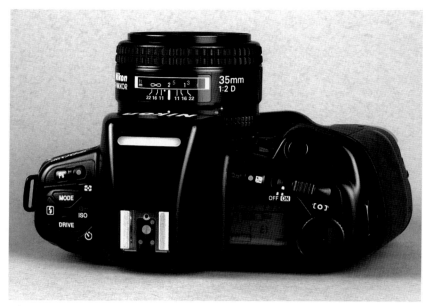

The F90X viewed from above.

Nikon F50 / N50

In 1994 Nikon introduced the F50 to compliment the more advanced F90, which became the F90X later that same year, and builds on the foundation of the earlier F-401 and F501 cameras. The advertising slogan for the camera read 'F50 - the simple way to perfect pictures'. This encapsulated the philosophy behind the camera, which was to produce an all-purpose, simple to operate model that retained an appeal to enthusiast photographers with ambitions beyond just a point-and-shoot compact camera.

The F50 has eight custom programme modes: the four simple programs are general purpose, landscape, portrait and close-up, whilst the advanced program modes are sport, silhouette, night and action. The camera also has the three standard exposure modes: shutter priority, aperture priority and manual. On the right side of the camera's top plate is a large LCD display with clear, easily understood icons for selecting the various functions and features. Like the F401 and F-601 models that preceded it the F50 has an in-built flash that provides cover-

The F90X changed all that with its ability to set shutter speeds in increments of 1/3EV. In similar circumstances I could now leave my lens wide open and reduce the shutter speed from 1/500sec to 1/400sec, or even a 1/320sec, and achieve a greater percentage of sharp pictures than if I had had to use 1/250sec. It represented a great innovation at the time and caused me to abandon the F4 and change to the F90X until the F5 became available.

The increase in AF speed also allows the maximum frame rate to be increased to 4.3fps. A new battery pack, the MB-10, was introduced that accepts four AA sized cells, or two Lithium cells in a dedicated battery holder. The MB-10 attaches to the base of the F90X body and provides an additional high profile handgrip that improves the camera's handling, especially with larger lenses. It also includes a second shutter release button with a locking collar for when the camera is used vertically. The MB-10 can be fitted to the earlier F90 however; the second shutter release will not work unless a workshop modifies the camera.

Other modifications included a revised set of seals on the top and bottom plates to improve resistance to the ingress of moisture and dust. The acoustic warning for incorrect camera settings incorporated in the F90 was thankfully omitted from the F90X as many photographers found it a distraction that could easy disturb subjects when shooting in quiet conditions.

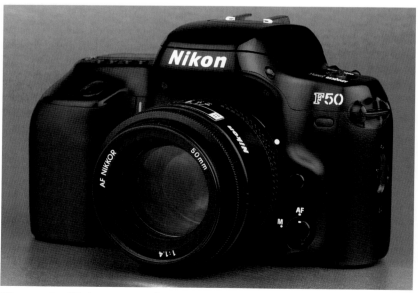

The entry level F50 camera was the successor to the earlier F-401.

The F50 features a built-in Speedlight unit.

The controls of the F50 are clear and concise.

age for a 35mm lens with a GN13 (ISO100, m). The auto focus system is managed by the AM200 module with a sensitivity range from EV1 to EV19 (ISO100) and offers a focus tracking function, which automatically switches on when the camera detects a moving subject. Film loading and advance is motorised, but limited to a speed of just 1fps, and once the end of the film is reached the camera does not wait to be told to rewind it but initiates rewind automatically. Should you wish to rewind in mid roll there is an auto-rewind button set into the base plate of the camera. The ISO range for DX coded film is ISO25 to 5000 and for non-DX coded film ISO6 to 6400.

The viewfinder displays essential information and is quite different to that shown in the top plate LCD. There is the familiar 'Hi' or 'Lo' symbol to indicate either over or under exposure, a flash ready signal, which blinks to indicate when the flash exposure has been insufficient. The shutter speed indicator will flash at speeds below 1/30sec to warn the photographer of the risk of camera shake. The autofocus confirmation symbol blinks to indicate the camera cannot attain critical focus.

Program exposure mode selection requires that either the simple or advanced option be selected first. This is done via a switch on the camera's top plate that once activated will cause the last program mode selected to appear in the LCD. To change modes you must first access the master Program exposure mode by pressing the menu button to the right of the viewfinder prism, which causes four symbols to appear: (P), (S), (A), and (M). Above each of these symbols is a button. You push the button above the (P) to access the Program modes. A number of icons will now appear with arrows pointing to the left and right. Depressing the button above the respective symbol will activate the required program. If the expected icon does not appear for a particular program you push the button above one of the arrows to scroll through the menu. At the end of the day there are only three screens, so selecting your chosen program icon is fast and straightforward. The four Simple-programs can be defined as follows: 'Landscape', this sets a bias towards smaller apertures for greater depth of field while retaining a fast enough shutter speed to prevent camera shake. The exposure metering assumes that a bright sky area is present and compensates accordingly. The 'Portrait' program on the other hand limits depth of field and is particularly suitable for lenses with a focal length between 85mm and 135mm. The 'Close-up' program is similar to the portrait programme in that the bias is towards limited depth of field, which is rather curious since in most close-up work it is the lack of depth of field that is often a hindrance. The 'Universal' program is flexible and the user can change the shutter speed and aperture combination as they wish. In this mode two arrows appear on the right hand side of the main LCD. Depressing the buttons above these

arrows shifts the shutter speed/aperture combination in steps of 1EV while maintaining the equivalent overall exposure value. Unfortunately, when the camera is turned off, automatically switches off, or the mode is changed, the selected combination is lost. A P* appears in the LCD to indicate that this flexible programme is in use.

The four advanced programmes include 'Night' program, which balances flash illumination for the foreground subject with the ambient background light. The 'Motion Effect' program sets a bias towards a slower shutter speed that can be used to create a blur with a moving subject, and is particularly applicable with the panning technique. The 'Silhouette' program detects, and meters for a bright background and bases the exposure on this in an attempt to record the subject as a silhouette. The 'Sport' program, as the name implies selects faster shutter speeds to freeze a moving subject. The F50 has three exposure modes. Shutter priority, aperture priority and manual. In shutter priority the speed is displayed in the LCD with two arrows next to it. The buttons above these arrows are pressed to alter this value. Again in aperture priority the preset aperture value, which is set electronically and not via the aperture ring, appears

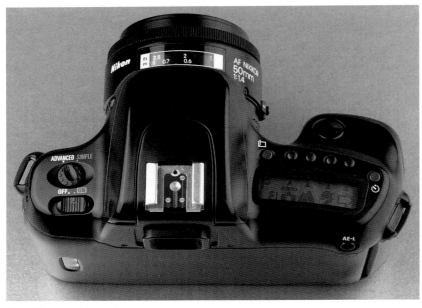

The F50 viewed from above.

with two arrows next to it. You can alter the aperture by pressing these buttons. In manual mode both the aperture and shutter speed are displayed in the LCD with the familiar arrows next to them. Once more the corresponding buttons are used to select the desired values. An analogue display of the exposure reading also appears in the manual mode to assist in assessing the metering. For all of these modes to operate the lens must be set to its minimum aperture.

The metering system of the F50 uses a six-segment 3D Matrix system, which requires 'D' specification Nikkor lenses with the additional CPU that communicates focus distance to the camera body. If a non-D lens is used the metering system defaults to standard matrix metering. There is also a conventional centre-weighted metering system with a 60/40 ratio. The metering system has a sensitivity range of EV1 to EV20 (ISO100). The F50 offers a time exposure function, which can be set in the advanced program or manual modes and allows an exposure time, which is

only limited by the battery life. The last notable function is the provision of a self-timer activated by pressing a button next to the self-timer symbol on the top of the camera.

Nikon F70 / N70

The F70 arrived in the autumn of 1994 as the replacement for the hugely popular F-801/F801s. It is the first Nikon camera that has the ability to combine with D-series Nikkor lenses that began to be introduced at the same time, which communicate the focus distance of the lens to the camera for inclusion in the exposure calculations. The additional data also meant that the F70 was the world's first camera with a 3D multi-sensor balanced fill-flash function. In spite of this innovation it got off to rather a slow start but eventually grew in popularity.

The F70, which weighs 585g without batteries, was available in either silver or black finish. The most obvious external difference to previous models is its multi-coloured LCD panel on the camera's top plate, which has a number of differ-

ent windows. The windows are arranged in a pattern like the extended panels of a fan and each one displays a different piece of information depending on which buttons have been pressed. The FUNCTION and/or SET buttons are used together with the main command dial to scroll through and select the various settings in an area Nikon calls the FUNCTION ZONE. There are eight functions displayed: from left to right they are Exposure Bracketing, Exposure Compensation, Flash Sync, Metering mode, Exposure mode, AF mode, Film Advance mode, and film speed. As the command dial is turned with the FUNCTION button depressed a pointer indicates the active window and the icon within it starts to flash. By releasing the FUNCTION button the window is selected, then you press the SET button and turn the main command dial again to go through the various options within the chosen window. Once you reach your required setting just release the SET button and the option is locked. It sounds complicated but in fact it is a simple and intuitive system once you become familiar with it.

Working back right to left, the film speed can be set automatically with the DX code system in a range from ISO25-5000. It can also be chosen manually from ISO6-5000. Film advance can operate at three different rates: single, continuous low (L) at 2fps, continuous high (H) at 3.5fps, and a new feature on the F70 was the silent rewind (SL) which whilst quieter than normal rewind is not silent! The focus modes are the familiar trio of manual, single servo (S), and continuous servo (C). In manual an electronic rangefinder is available and displayed in the viewfinder using the AF indicators. Focus tracking operates as soon as the F70 detects a

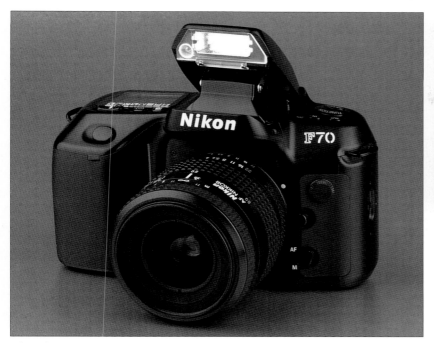

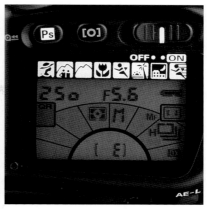

The Nikon F70 has a distinctive LCD display.

The Nikon F70, a worthy successor to the popular F801, includes a built-in flash unit amongst its many features.

moving subject in either of the two AF modes. In (S) the shutter is locked until focus is confirmed and in (C) the shutter can be released even if the subject is not in critical focus. The AF system has sensitivity range of EV–1 to EV19 (ISO100).

The F70 has a similar range of exposure modes to the F90. They are Aperture priority (A), Shutter priority (S), Manual (M), and Auto-Program (P), plus the Vari-Program (Ps) feature with its subject specific configurations of shutter and aperture values as described for the F50 above, that include Portrait, Hyperfocal, Landscape, Close-up, Sport, Silhouette, Night, and Motion-Effect.

The increasing sophistication of the integrated electronics of both the camera body and the AF Nikkor lenses really begins to show through in the F70. The lens aperture of appropriate AF-D Nikkors is displayed in 1/3EV steps and if a non-CPU Nikkor is attached the aperture reading is replaced by F- - as a

warning, and in the (S) (P) and (Ps) modes unless the lens is set to its minimum aperture the letters FEE appear. Shutter speeds are also shown in 1/3EV increments across a range from 30 seconds to 1/4000sec, and there is a Bulb (B) setting.

The F70 has three basic metering systems: 3D Matrix metering with the D-series Nikkors, or Advanced Matrix with non-D specification lenses, centre-weighted metering with a 75:25 distribution pattern that takes 75% of its reading from the area defined by the 12mm circle in the viewfinder, and a Spot-meter function that takes almost all its reading from the smaller 3mm diameter circle at the centre of the viewfinder. The meter sensitivity in the Matrix and Centre-weighted configuration is EV–1 to EV20 and for the Spot meter EV4 to EV20 (ISO100).

Mounted on the top of the prism is the pop-up flash unit that has a

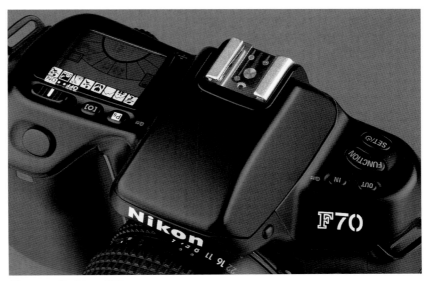

The versatile Nikon F70.

GN14 (ISO100, m), covers a focal length of 28mm and has a film sensitivity range of ISO25 to 800. Flash functions include normal front-curtain sync, Slow-sync from the maximum sync speed of 1/125sec to 30 seconds, Rear-curtain sync (on the SB-24, 25, and 26 this is set via the Speedlight's switch), and a Red-Eye Reduction function. The F70 was designed to offer its most comprehensive range of features including the 3D Matrix Balanced Fill-flash provided a D-series AF Nikkor is attached, together with a Speedlight such as the SB-25, SB-26. The output level of the integrated flash can have a compensation value applied to it from +1EV to –3EV by using the same method as setting an exposure compensation value, which is possible from –5EV to +5EV, for the ambient light exposure. Both can be set in increments of 1/3EV. A +/- symbol appears in the bottom of the window for exposure compensation and the top for flash compensation as a reminder to the photographer. The last function is exposure bracketing, which is available over three consecutive frames, in increments of 1/3, 1/2, 2/3, or 1EV steps. Flash bracketing can also be performed by the F70 across the same range in the same sized increments with either the integral flash or a separate Nikon Speedlight. Please note that flash exposure bracketing set on the camera over-rides any set independently on a separate Speedlight unit. To differentiate between the two the LCD displays AE BKT for ambient light bracketing and a thunderbolt icon next to BKT for flash bracketing. One point of interest is that with a Nikon Speedlight mounted on the camera the AF mode automatically defaults to Spot-AF.

Other functions and features that can be set from the main LCD and main command dial/buttons include the AF sensor area, which is either a wide-area configuration defined in the viewfinder by the square brackets, or the spot-AF area. In the LCD a small window above the right side of the 'fan' of windows shows either the square brackets for wide-area or a solid spot if spot-AF has been selected. On the opposite side of the main LCD panel is a box marked QR for Quick Recall. This function allows the camera to memorize a set of values for the film advance mode, focus area size, metering system, exposure mode, flash-sync mode and exposure compensation for instant recall. Four individual configurations can be memorized and are identified by numbers between 0-3. The zero holds the factory default settings whilst the photographer can program the other three. It some ways it is a forerunner to the Custom Setting functions of later cameras like the F100 and F5.

The F70's viewfinder displays the usual range of exposure and camera control information including; shutter speed, aperture, focus indicators, exposure mode, frame counter and a flash ready light. It has a fixed B-type Brite-view type II focusing screen and covers 92% of the total image area. Two 3v lithium CR-123A batteries that are housed inside the right hand finger grip power the camera. The F70, which has a fixed back, was also offered in a data-back version, the F70D. It has an integrated 24-hour clock and can imprint time (minute/hour) and day, month, and year in the frame area. The function can be disabled if required. This version of the camera also features a panoramic function, which works via a switch that moves a mask into the film gate to reduce the image area to 13mm x 36mm.

Nikon F60/N60

Following in the line of Nikon's entry-level cameras, such as the EM, and the F301, the company launched the F60 during late 1998. It was introduced to compete in the competitive sub-£300 ($400) bracket and was packed with a collection of useful features that made it a very attractive proposition.

The camera is quite striking because of its retro style chrome-silver coloured top and rounded body

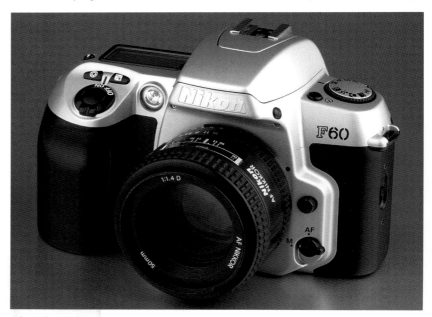

The Nikon F60.

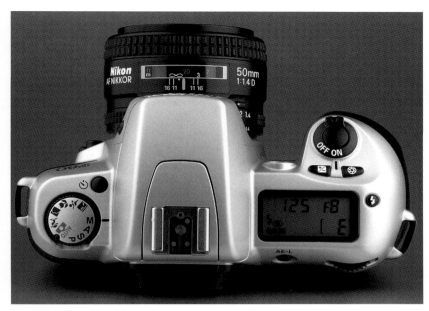

The Nikon F60 viewed from above.

The F60 has a powerful built-in pop-up flash with a GN15 (ISO100, m) and also has a standard ISO hot-shoe with TTL control in order that a separate Nikon Speedlight can be attached. An additional feature of the F60 is its built-in AF illuminator, located on the right hand side of the body at the front, which emits a beam of light to assist the camera in focusing in low light situations. This same lamp acts as the source of illumination for the red eye reduction function and the self-timer count down indicator. The shutter release is in the familiar position on the slanted top of the right-hand finger grip and behind this is the exposure compensation button that has a range of +/- 3 EV in increments of half a stop. It can only be applied in the standard exposure modes 'A', 'S', 'P' or 'M'. The main command dial on the camera's top plate is used to set the aperture in 'A' mode and shutter speed in the 'S' or 'M' mode. With an AF Nikkor lens fitted to the

styling. Its innate good looks were built around a tough, rigid metal chassis. Literature published by Nikon stated that the chassis is made from a die-cast aluminium alloy and the film guide rails from metal. This is actually incorrect as the chassis is constructed from die-cast zinc alloy and the film guide rails from aluminium. The F60 offers auto and manual focus and like many models before it uses the AM 200 AF module. This modified unit, which was first fitted to the F-401, is capable of determining between a static and moving subject, a system Nikon calls Auto-Servo AF, and for an entry level camera represents a sophisticated feature. The camera has the familiar aperture priority, shutter priority and manual exposure modes in addition to a variety of program modes, including 'General-Purpose' (AUTO), 'Portrait', 'Landscape', 'Close-up', 'Sport' and 'Night'. These are identical to those of previous models with the exception of the 'Universal' (AUTO) mode that is designed as a point and shoot system in which the camera determines

all the necessary functions. The F60 also features the Flexible Program (P*) that allows the photographer to change shutter speed and aperture combinations whilst retaining an equivalent exposure value.

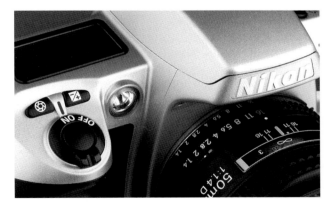

The aperture control and exposure compensation buttons can be seen behind the shutter release button of this Nikon F60. The AF illuminator lamp is next to the prism head.

Exposure mode dial of the F60 is located on the top plate of the F60.

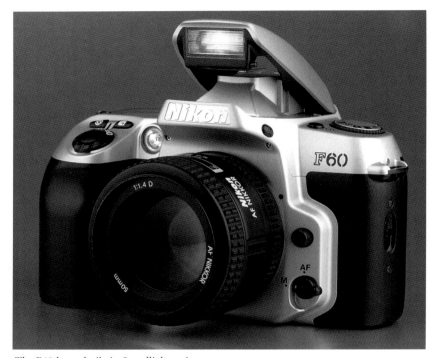

The F60 has a built-in Speedlight unit.

camera, the method of altering the aperture in manual mode differs slightly from previous arrangements. The aperture ring of the lens must be set to its minimum value then the aperture button, positioned next to the exposure compensation button, must be depressed. The command dial is then turned to select the aperture. There are limitations with certain classes of Nikkor lenses: if AI-type Nikkor lenses are used the exposure meter is automatically switched off, and autofocus will not function with AF-S or AF-I lenses. The F60 has the now familiar 'High-Eyepoint' viewfinder, which affords an unobscured view of the finder image with an eye-relief distance of 17mm. It has its own built-in dioptre adjustment from -1.5 to +1. The camera also features a self-timer function with a ten second delay. Two 3 volt CR-123A, or DL-123A type lithium batteries supply power for the F60. A data back version of the F60, the F60 QD, was also available permit-

ting the imprinting of time (hour/minute), day and date within the frame area for DX coded films between ISO25 - ISO3200.

Nikon F100

As with so many previous cameras speculation about the F100, introduced late in 1998, had started many months before. It is obvious from a number of the camera's features that Nikon had taken heed of feedback on their flagship model the F5, because in a number of ways the F100 is an improvement on its 'big brother' and has a greater ease of handling.

It is similar in size to the F90, weighs 780g without batteries and has an ergonomic shape. The top and bottom plates are made from a magnesium alloy fitted to a rigid alloy chassis. As a further improvement either 'O' rings or seals are fitted to all of the control buttons and dials to increase protection against the ingress of water and dust making it extremely rugged.

The shutter release button is surrounded by the power switch, which unlike the F5 has no lock, so it can be operated quickly with just one finger. Behind this are two buttons, one is used to select the exposure mode and other to set an exposure compensation factor. By pressing the MODE button and rotating the main command dial, the four exposure modes familiar from previous Nikon cameras, shutter priority (S), aperture priority (A), program (P) and manual (M) can be accessed. They operate in an identical fashion to those of the F5. The metering system has a sensitivity range in the 3D Matrix and Centre-weighted modes of EV0-21 (ISO100), and EV3-21 (ISO100) for the spot-metering mode. Exposure compensation can be set across a range of +/- 5 stops by depressing the exposure compensation button and rotating the main command dial, Alternatively, by using Custom Setting (CS) 13, compensation can be applied in (A) mode by turning the main command dial, and in either (S) or (P) mode by turning the sub-command dial, which for many photographers is the preferred way of operating this feature.

Whilst the F100 does not have the benefit of the F5's RGB metering system, Nikon upgraded their matrix metering system so the F100 now has a ten -segment 3-D matrix meter. Advanced algorithms are used for assessing exposure data, which take into consideration highlight and shadow values, the contrast range, and the subject distance information supplied by an appropriate 'D' specification Nikkor lens. The level of defocus of each AF sensor is also assessed to determine the likely position of the subject within the frame area. The F-100 then compares the exposure value it has calculated to 30,000 pre-programmed exposure examples before

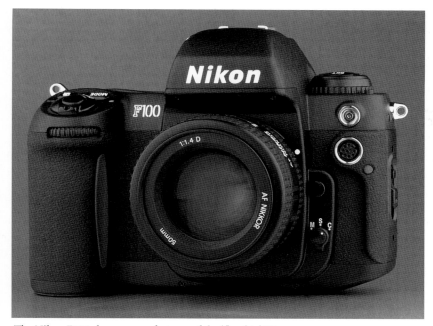

The Nikon F100 shares many features of the 'flagship' F5.

tom edge with all the usual information: shutter speed, aperture, metering mode, focus mode, flash ready light, focus indicators, exposure compensation warning, and frame counter, and offers 96% coverage of the image area. The focusing screen is a standard B-type plain screen with a 12mm circle in the centre and the five AF sensor area brackets arranged in a cross formation. The F100 does not have a mirror lock-up feature, but incorporates a new rapid return mirror assembly that reduces mirror bounce and vibration to an absolute minimum. As you would expect with a camera of this specification there is a depth-of-field button situated on the front below the main LCD. On the opposite side of the lens mount throat above the lens release button are the ten-pin terminal for remote control accessories, a standard pin cylinder (PC) socket for a flash sync lead and the indicator lamp for the self-timer function.

I have found autofocus system in the F100 is as good as, if not slightly better than the F5's. It has a detection range of EV1 to EV19 (ISO100). The AF mode selector

finalising its suggested camera settings. This level of sophistication bears no resemblance to cameras of twenty years ago, many of which used nothing more than a pair of Silicon Photo Diode cells to measure light levels!

The F100 has a centre weighted metering pattern with a 75:25 ratio and a spot meter system that, like the F5, uses the AF sensor area brackets. The three metering modes are selected with a dial, mounted on the right side of the prism head that is marked with the familiar icons that Nikon use to depict them. The F100 also offers auto exposure and flash exposure bracketing by pressing the BKT button and turning the sub-command dial. The photographer can select a bracket of either a two or three frames that varies in increments of 1/3EV to 1EV. The bracketing works in all of the four exposure modes. CS11 permits exposure bracketing for either the ambient or flash exposure: a feature unique to the F100. The camera has only one LCD located on its top plate which displays all the func-

tions including exposure mode, film advance mode, custom settings, exposure compensation and bracketing configuration.

The 'High-Eyepoint' viewfinder has an eye relief distance of 21mm, and a built-in dioptre adjustment of −3 to +1 m -1, but there is no eyepiece blind. The viewfinder has a comprehensive display along its bot-

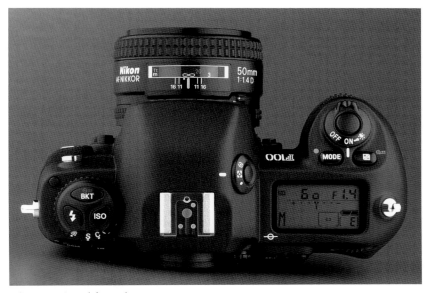

The F100 viewed form above.

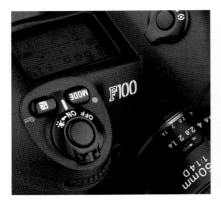

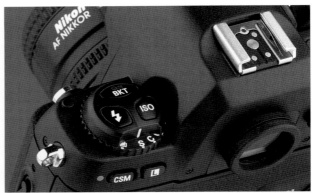

The viewfinder of the F100 is a High-Eyepoint type with built-in dioptre adjustment.

The main power switch surrounds the shutter release button of the F100.

switch is located in the usual position on the left side of the camera next to the lens mount, and has three positions for Single servo, Continuous servo, and manual focusing. The Single and Continuous servo modes have the normal configuration of focus priority being assigned to the former and release priority with the latter. In addition to single area and Dynamic autofocus modes, the F100 has an extra feature called Lock-On focus tracking, which activates automatically in both focusing modes and can keep pace with the camera's motor drive even at 5 fps. Dynamic autofocus is switched on via a small dial on the camera back next to the AF sensor selector switch. The function operates in exactly the same fashion as the system in the F5. In other words, if the subject moves the camera's computer detects this and shifts focus priority from the active sensor area to the appropriate neighbouring AF sensor. It is a little known fact that in Dynamic autofocus the area covered by the active AF sensor is actually greater than the area defined by the bracket in the viewfinder. In the F5 the active focusing sensor is highlighted in black however; in response to the feedback from many photographers, Nikon modified this in the F100 so that the sensor is now momentarily

highlighted in red when the shutter release is first pressed. This is particularly useful in bright conditions, but can be rather distracting when shooting in low light because the brightness of the bracket can obscure the subject, but on balance I prefer the system of the F100.

The F100 has three film advance

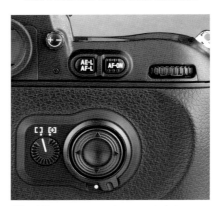

The AF sensor area selector switch is mounted on the rear of the F100.

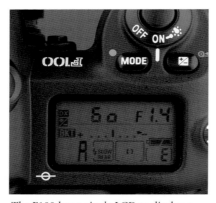

The F100 has a single LCD to display a variety of information.

modes: (S) single, (C) continuous, and (CS) continuous silent. Single frame advances the film one frame each time the shutter is released. In the continuous shooting mode the F100 advances film at 4.5fps and with the optional MB15 battery pack at up to 5fps. The (CS) mode provides continuous advance at 3fps, but although it is slightly quieter than the normal transport mechanism it can hardly be described as silent. Two other functions are accessed via the film advance mode selector dial located on the top left of the camera. These are the self-timer and multiple exposure functions. The F100 includes a menu of 22 customs settings offering a wide variety of control features in addition to those mentioned above.

The TTL flash control function of the F100 is comparable to that in the F5. Combined with an AF-D, AF-S, or AF-G lens and a Nikon Speedlight from the SB-26 or later the 3D Multi-sensor Balanced Fill-Flash is as accurate as the F5. Four AA size cells fit into the right hand grip to power the camera. Alternatively, the MB15 battery pack can be attached to the base plate of the F100. In my opinion this combination offers better handling compared to the F5 because it not only provides an alternative shutter release button with locking collar and AF start button, but also anoth-

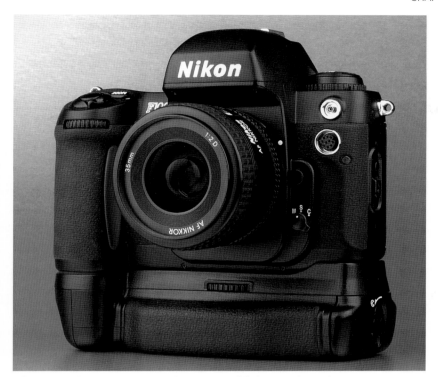

The F100 and MB-15 combine to form a powerful photographic tool.

er command dial with which you can adjust the shutter speed. When the camera is held vertically this dial falls conveniently below the photographer's right thumb and makes adjusting the shutter speed so much easier. The MB-15 accepts six AA sized batteries either alkaline, lithium, or NiHM and boosts the maximum frame rate to 5fps regardless of which type of battery is used. Alternatively the F100 can be powered by either the MN-15 NiMH battery pack, which is charged with the MH-15 charger, or two CR-123A lithium batteries held in the MS-13 holder.

The F100 has is own dedicated Databack, the MF-29, that provides imprinting day, date, and time (hour/minute).

As with any modern camera full of sophisticated electronics the weakest link in the chain is always the battery. In my experience the battery condition indicators of such cameras are generally rather opti-

mistic, which is frequently due to the build up of a static charge within the camera. I have found that you can often dissipate this charge by just depressing the depth-of-field button five or six times in rapid succession. Although a less common occurrence the same static charge can occasionally cause the various displays in the camera to go haywire. If this happens try the same remedy in the first instance it usually does the trick. The same procedure appears to work on the F5 and D1/D1X/D1H cameras as well.

All in all the F100 leaves very little to be desired, and is a camera that is capable of serving you faithfully for a lifetime. It has proved to be a huge success and is widely used by both keen enthusiasts and professional photographers everywhere, and although I do not doubt Nikon's ability to integrate small but significant improvements into a successor the real question is will they want to. In the light of the growing popu-

larity of the digital SLR, as with the F5, I wonder if in its class the F100 represents the pinnacle of Nikon's film based camera design. Only time will tell.

Nikon F80 / N80

Launched during mid-2000 to wide critical acclaim the Nikon F80 soon earned a reputation as a very capable camera. Aimed squarely at the keen enthusiast it boasts many of the features found on its bigger brother the F100, with a few extras thrown in for good measure.

At 515g without the batteries this is a camera you could carry around all day and hardly notice. However, it is certainly no lightweight when it comes to build quality and specification. The large contoured handgrip is comfortable and ensures a firm hold on the camera, aided by the rubberised finish to the front and back plates. The layout of the controls is clear and uncluttered. A large single action power switch surrounds the shutter release beneath which, on the front, is the sub-command dial used to set the lens aperture, in indents of a third of a stop, on AF lenses, or manual lenses that contain a CPU. Below this sub-command dial is a depth-of-field preview button. The camera is powered by two CR123A or DL123A lithium batteries, although, the optional MB-16 battery pack permits the use of four AA alkaline, Lithium, NiCd, or Ni-MH batteries. This pack does not have any other features such as an additional shutter release for vertical shooting, but it does improve handling when working in this format.

On the back of the camera, falling naturally under the photographer's right thumb, is the main-command dial used to set the shutter speed in increments of half a stop. The shutter speed range runs from 30 seconds to 1/4000sec, plus a 'B' setting

111

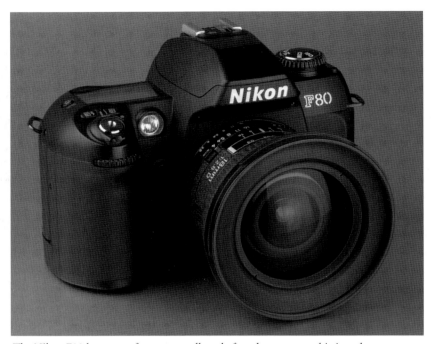

The Nikon F80 has many features usually only found on more sophisticated cameras.

with which you can lock the shutter open for up to six hours on a fresh set of batteries in an ambient temperature of 20∞C. The two command dials are also used in conjunction with each other to set custom functions, exposure compensation, and a variety of other options.

The F80 has three metering patterns: a ten-segment 3D Matrix, spot, and centre-weighted. They are selected via a switch set just to the right of the viewfinder. The Matrix pattern is identical to that used on the F100 and in all but the most extreme conditions, particularly strong backlighting, acquits itself very well. It also has a centre-weighted and spot metering mode. The spot meter uses any one of the five AF sensor area brackets, which represent approximately 1% of the total viewfinder area allowing very precise exposure measurement. Metering range in Matrix and centre weighted is EV0 to EV21, and for Spot mode EV3 to EV21 (ISO100, 50mm f1.4 lens). Film speed can be

set manually anywhere between ISO6-6400 in thirds of a stop, and with DX coded film in a range of ISO25-5000 the film speed is set automatically.

At some stage during the F80's development Nikon made a bold decision to leave out all the usual subject-biased program modes seen in earlier cameras such as the F50, F60, and F70. This was based on the assumption that enthusiast photographers, unlike beginners, understand how the shutter speed and lens aperture work and the effect they have on the photograph. Thus the F80, with its four exposure modes, Program, Shutter & Aperture Priority, and full Manual is very straightforward to operate.

The AF system is based around Nikon's Multi CAM 900 AF sensor with the same five-point array of brackets seen in the F100 and F5. It has a detection range of EV-1 to EV19 (ISO100). The central AF point is a cross type for detecting both vertical and horizontal edges, while the outer four, two either side and, one above and below the centre point, are single line type sensors that detect vertical edges.

Selection of the AF point is via the toggle switch on the camera back and is confirmed in the viewfinder by the brackets being momentarily highlighted in red. Next to this is the AF Area mode selector switch, which has two positions: single or dynamic. In 'single' mode the camera will only focus using the AF sensor you select. In the 'dynamic' mode the camera initially focuses with the AF point you select, but the other four remain active so that if the subject moves toward one of them the camera detects this and tracks the subject by switching between the appropriate focus areas. The F80 also has a 'closest-subject' priority mode, which automatically focuses on the closest subject.

The F80 has a large finger grip to ensure comfortable and secure handling.

The LCD of the F80 displays all the relevant exposure information.

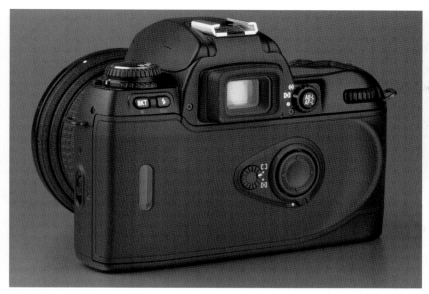

The F80 viewed from behind.

The F80 has a built-in Speedlight unit.

Against a low contrast subject, or in low light, the camera has an AF illuminator lamp that produces a bright beam of light to assist the AF system. This feature only works over short distances up to about 5m due to the relatively low output of the lamp.

The top plate of the F80 is well laid out with all the dials and switches clearly marked with unambiguous icons. A large dial to the left is used to select the four exposure modes as well as the film ISO and Custom Functions. This neat arrangement precludes the need for yet more buttons elsewhere. The film advance mode selector switch,

The exposure mode dial of the Nikon F80.

set around the base of the exposure mode dial, is a little awkward to operate due to the small size of its lock button. Options here include single frame advance, continuous advance at 2.5fps, and multiple-exposure. Worthy of note is Nikon's warning that infrared (IR) film cannot be used in the F80 as the film transport system employs an IR sensor to monitor film advance.

Included in the eighteen available Custom Settings are; Auto-load film advance on closing the camera back and, high speed, or quiet mode, film rewind. For a 36-exposure film the latter takes approximately 23sec with fresh batteries, as opposed to 15 seconds for the high-speed rewind. Mid-roll rewind is also possible.

The viewfinder display of the F80 is comprehensive. It has a built-in dioptre adjustment from −1.8 to + 0.8m -1 and shows 92% of the full frame. Full exposure information is displayed along the bottom edge, including shutter speed, lens aperture, exposure mode, an exposure and flash compensation warning, focus confirmation and selected focus point, flash ready light, frame

counter, and best of all, by selecting Custom Function 4, the camera displays illuminated grid lines across the focus screen. The grid is an invaluable aid to composition helping to ensure straight horizons, upright buildings and any other subjects that require careful alignment. The focus screen is the new Vari-Brite type, which provides a clear display of the focus area brackets. In bright light the brackets are displayed in black, but in low light conditions the brackets are momentarily displayed in red for easy identification. The screen provides a crisp image, full of contrast, in which the subject 'snaps' into focus.

Tucked away discretely within the prism head is a built-in flash, with a GN12 (ISO100, m) that provides coverage for lenses of 28mm or longer. The flash has a range of modes including slow-sync, rear curtain, and red-eye reduction. By using a 'D' specification Nikkor lens in conjunction with the built-in flash the F80 offers the benefit of 3D Multi-sensor Balanced Fill-Flash by virtue of its five-zone TTL flash meter. The film speed range for the built-in flash is ISO25 – 800 and, on a fresh set of batteries, the recycle time is impressively short. There are, however, a couple of idiosyncrasies. The flash sync speed is, by today's standards, a somewhat pedestrian 1/125 of a second, and the 3D Multi-sensor Balance Fill-Flash is

The Nikon F80 is a very capable camera.

not available in either the manual exposure mode, or spot meter exposure mode. Lastly the camera does not have a PC socket, although an AS-15 adapter can be attached to the hot shoe to provide one.

In another seemingly retro step Nikon have fitted a conventional threaded cable release socket to the shutter release button. This means you can use a less expensive mechanical cable release, however, the F80 does not have the ten-pin connector socket as found on the F90X, F100 and F5, so you cannot connect accessories such as the MC-30 electric cable release or, ML-3 infrared release, which is a great pity because given its attributes of lightweight, whisper quiet shutter operation, superb auto-exposure, AF and flash functions, this camera would otherwise be ideal for remote work.

As well as the basic F80, there is a Quartz Date databack version the F80D and an F80S, which offers exposure data imprinting between film frames. All versions are avail-

able in either black or silver finish except the F80S, which is supplied in black only.

Nikon F65 / N65

By mid-2001 Nikon's entry level camera the F60 was almost three years old and in need of an update. The limitations that it had with some AF lens types, particularly the AF-S lenses were becoming increasingly restrictive as the lens range expanded. Its successor the F65, which weighs just 335g, was released during the autumn of 2001 and is similar in appearance to the F60 but has a number of important improvements, including full compatibility with the latest AF-S and AF-G Nikkors and those lenses with Vibration Reduction (VR), whilst retaining the same design philosophy that it should be easy and intuitive to operate.

Another improvement is the adoption of the Multi-CAM 900 AF sensor as used in the Nikon F80, which provides the camera with a five-area Dynamic AF system with a

sensitivity range of EV-1 to EV19 (ISO100). The sensors are arranged in the usual cross configuration with a cross type sensor at the centre and the other four line types to the top, bottom, left and right. The system also offers two AF area modes: Dynamic AF and Closest-subject priority Dynamic AF. The F65 features a focus tracking system with automatic selection of either single servo or continuous servo AF depending on whether it detects a stationary or moving subject. Half depressing the shutter release activates the autofocus, which has Nikon's Lock-on feature, and will keep a subject that is being tracked in focus even if another object momentarily blocks the camera's view of the main subject. The F65's enhanced AF system is quick and positive and a significant improvement on the single sensor AM200 AF module system of the F60.

The camera has a six segment 3D Matrix metering system that is fully compatible with AF-D, AF-G and AF-S type Nikkor lenses and has a sensitivity range from 1EV to 20EV. It uses three sets of data to calculate exposure values: scene brightness, scene contrast, and subject distance. The metering sensor detects the first two and the lens provides the last set. This data is then compared to over 30,000 pre-programmed exposure values from shooting data before the camera settles on a final exposure setting. If the photographer chooses to use the manual exposure mode then a centre-weighted metering system is selected.

The F65 has a comprehensive exposure control system including a completely automatic AUTO mode for the convenience of point-and-shoot. There are four exposure modes that the photographer can use: Auto-Multi Program with Vari-Program (P), Aperture-Priority (A), Shutter-Priority (S), and Manual

The Nikon F65.

The camera has a small pop-up flash mounted on top of the prism head that has a GN12 (ISO100, m) and covers a focal length of 28mm, with a flash sync speed of 1/90sec. The flash and matrix meter sensors are linked providing Nikon's proven Matrix Balance Fill-Flash system for shooting in all lighting conditions. At low light levels the flash pops up automatically in the AUTO and Vari-Program modes. Other features comprise Red-Eye reduction, Slow-sync for shutter speeds from 1/90sec down to 30 seconds, and a Rear-Curtain sync.

The shutter release with the main power switch is on the top of the right hand finger grip and behind this, to the right of the prism, is a large LCD that displays all the relevant exposure settings and camera control functions including those for the flash. The main command dial is located on the rear edge of the camera behind the main LCD. To the right of the LCD is a small button to control the lens aperture. It has two more functions when pressed in combination with other controls: exposure compensation and film rewind. On the prism head there is a standard ISO accessory shoe with hot shoe contact for full compatibility with the Nikon Speedlight range. To the left of the prism are two buttons, the one at the rear is used to set exposure

(M) modes. The Vari-Program modes are: Portrait, Landscape, Close-up, Sports Continuous, and Night scenes. These operate in a similar way to those offered on the earlier F60. Exposure compensation can be applied in increments of 1/2EV to +/- 2EV, and there is an Auto-Bracketing function that again offers increments of 1/2EV to 2EV

in a sequence of three frames. The film speed range from ISO25-5000 is automatically set with DX coded film, but there is no manual override option, and with non-DX coded film the F65 sets ISO100. Shutter speeds run from 30 seconds to 1/2000sec and can be set in increments of 1/2EV in the (S) and (M) modes.

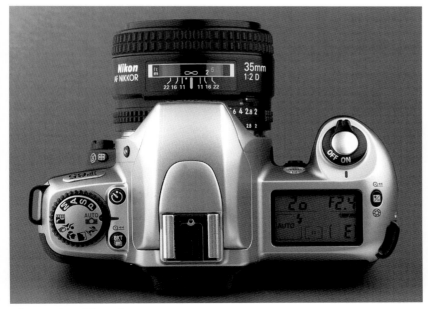

The F65 viewed from above.

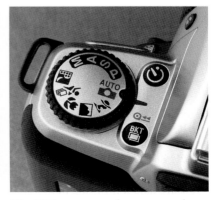

The F65 has a range of exposure modes.

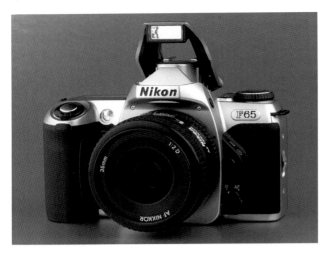

The Nikon F65 with its built-in Speedlight extended to the shooting position.

The LCD and shutter release of the F65 are similar in style to other Nikon AF cameras.

bracketing, multiple exposures, and film rewind. The other button activates the self-timer function. Beside these is the main exposure control dial for selecting the exposure mode.

On the front of the F65 below the LCD is the lamp for the AF-assist, self-timer indicator and red-eye reduction feature. Immediately under this lamp is the electronically operated depth-of-field preview button. On the other side of the lens mount is the two-position AF selector for manual (M) and autofocus (AF). It should be noted that there is no option to select either single or continuous servo AF as this is done automatically. Above this is the lens release button and on the shoulder around the lens mount is the button for AF sensor area selection, which also performs a cancellation option for the AF-assist illuminator. Finally the flash sync mode button is located on the side of the prism in front of the self-timer control.

The high eyepoint viewfinder has a built-in dioptre adjustment from −1.5 to +0.8m -1 with a 17mm eye relief distance and shows 89% of the total image area. The fixed focus screen is a plain matt B-type marked with the five AF sensor areas and a central 12mm circle as a reference for the centre–weighted metering pattern. Information dis-

played in the viewfinder includes: focus indicator, focus area, shutter speed, aperture, analogue exposure display, exposure compensation, frame counter/exposure compensation value, and a flash ready lamp that also signals flash recommended and full output warnings. The viewfinder display switches off automatically after five seconds if no camera function is performed to conserve battery power.

Film advance is automatic to the first frame when the camera back is

closed and thereafter you can select either single frame advance or in the Sports-Continuous Program a speed of 2.5fps. For a 36-exposure film the rewind time is approximately 16sec. Two CR2 3v Lithium batteries power the camera or alternatively the optional MB-17 battery pack can be fitted that accepts four AA sized alkaline, Lithium, Ni-Cd, or NiMH batteries. The MB-17 is just a battery pack and does not have a second shutter release or any other camera control function or remote

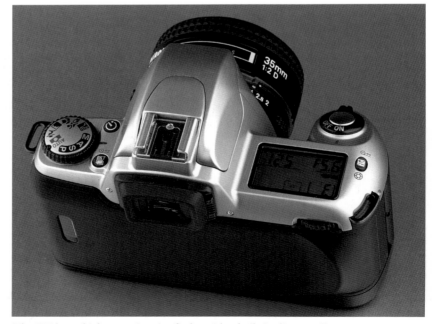

The F65 has a high-eye point viewfinder with a built-in dioptre adjustment.

accessory terminal, but does improve the handling with larger lenses.

The F65 is available in either silver or black finish and has the option of a Databack version, the F65D, which has a built-in clock, and can imprint minutes/hours, day, month, and year.

Nikon F55 / N55

The F55 joined Nikon's range of SLRs as the 'baby' of the family and is aimed at the beginner or enthusiast who wants the versatility of an SLR combined with the 'point and shoot' convenience of a compact style camera. Introduced in 2002 it only weighs 350g (without batteries) but is a fully featured camera with an amazing amount squeezed into its slight frame. In the Japanese home market the camera is known as the Nikon U, which means 'family' and this sums up the target market for this camera.

The F55 has a three-area AF system based on a new Multi CAM530 AF module that has a detection range of EV-1 to EV19 (ISO100). The three sensors are aligned horizontally across the frame area with one in the centre and the other two

to the left and right, and the system has an AF-assist illuminator. It has a Dynamic AF mode with Closest Subject Priority, standard Dynamic AF, and uses a single AF sensor area with manual focus. The Auto-servo mode automatically selects either Single-servo, or Continuous-servo AF operation according to whether it detects a static or moving subject. The same Lock-On function from other AF Nikon cameras is also employed to cope with circumstances when the primary subject is obscured momentarily during focus tracking. You can of course also choose manual focus mode.

Exposure control modes are similar to the F65 with a point-and-shoot AUTO mode that is fully automatic. There are four other modes: Vari-Program (P), that has the same specific Portrait, Close-up, Landscape, Sports-Continuous, and Night, shooting modes, Aperture priority (A), Shutter Priority (S), and Manual (M). Film speed is set automatically for DX coded film between ISO25-5000, and defaults to ISO100 with non-DX coded film. There is no option to set film speed manually.

The F55 has three metering con-

figurations. Selection of the Matrix metering system is automatic and determined by the type of Nikkor lens attached to the camera. A 3D five-segment Matrix meter operates with AF-D and AF-G type Nikkor lenses and with other AF Nikkor lenses and AI-P Nikkors a standard matrix meter is selected. In the manual exposure mode the camera sets a conventional centre-weighted metering pattern. The metering system has sensitivity a range of EV1-20 (ISO100) and exposure compensation can be set in +/- 2EV in increments of 1/2EV steps. Auto bracketing is available across a set of three frames in a range of +/- 2EV in increments of 1/2EV steps, except in the AUTO or Vari-Program modes.

The shutter release is located on the top of the finger grip to the right of the camera and has a power switch set around it. Shutter speeds run from 30 seconds to 1/2000sec in all exposure modes and can be set in 1/2EV steps in (S) and (M) modes. The layout of the controls and their functions are not dissimilar to the F65 with just a few minor differences. The LCD on the top plate displays the exposure, metering and

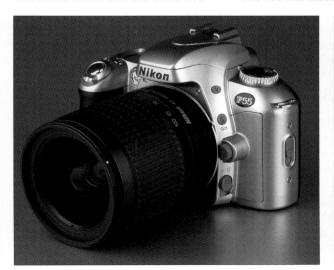

The F55 is a fully featured SLR designed to appeal to the beginner.

A view showing the top plate of the F55; the Speedlight unit is built-in to the prism head.

A close-up view of the F55.

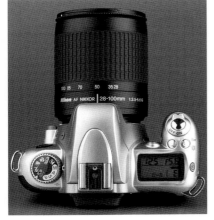

A Nikon F55 with a Nikkor 28-100mm f3.5-5.6G lens.

flash shooting information. Set around the LCD is three buttons: the first two control the focus area selection and self-timer, with 10 second delay, respectively, and the third has multiple functions in combination with other controls to set the aperture, exposure compensation, and film rewind. Below the LCD is the lamp for self-timer indication, AF-assist, and Red-Eye reduction functions. Behind the LCD panel on the top edge of the camera back is the main command dial positioned to fall under the photographer's right thumb in the now familiar arrangement on modern Nikon AF SLR cameras. On the left side of the prism is the exposure mode control dial that is identical to the F65's. The flash mode button is located on the shoulder of the lens mount in front of the exposure control dial and below it is the multi-function

button that sets exposure bracketing, multiple exposure, and film rewind.

The F55 has a pop-up flash that is activated automatically in the AUTO and Vari-Program mode (except Landscape and Sports Continuous). Otherwise the flash can be switched on by pressing the lock-release button on the side of the prism. The unit has a GN12 (ISO100, m), covers a focal length of 28mm, and has a film speed range of ISO25-800. There are two TTL flash modes: Matrix balanced Fill-Flash when used with a CPU equipped AF or AI-P Nikkor lens (except in Manual exposure mode) and Standard TTL in Manual exposure mode. However, if you use a separate Nikon Speedlight with the F55 and a Nikkor lens with a CPU control of the flash unit switches to non-TTL Auto mode. The integral flash has normal front-curtain sync, slow sync, which operates between the maximum sync speed of 1/90sec and a shutter speed of 30 seconds, plus a red-eye reduction function, but there is no rear-curtain sync facility.

Beneath the ISO accessory shoe is the viewfinder eyepiece with a dioptre adjustment of −1.5 to +0.8m −1 and an eye relief distance of 17mm. The Focusing screen is the familiar B-type plain screen with the 12mm circle marked for the centre-weighted metering pattern and the three sets of AF sensor area brackets. The viewfinder coverage is 89% of the total image area and shows the usual range of information including focus indicator, shutter speed, aperture, analogue exposure display, exposure compensation and a flash ready light that also signals flash recommended and full output warnings.

Film advance is automatic to the first frame on closing the back of the camera. Thereafter the F55 has a

single frame advance unless the Sports-Continuous Program mode is selected, which provides continuous advance at a rather pedestrian rate of 1.5 fps. Two CR2 3v batteries provide power and the exposure meter has an automatic switch off delay of five seconds to preserve them. The camera does not have the option of any additional battery pack.

Similar to the F65D the F55 is available in a databack version, the F55D, which records the same time (minute/hour) and day, month, year information in the frame area. It should be noted that F55 does not operate AF with AF-S Nikkors and the Vibration Reduction (VR) function of appropriate lenses is disabled. Do not forget that with any supplementary Nikon Speedlight the only flash mode available is non-TTL Auto in which the output is controlled by the Speedlight's sensor.

Nikon F75 / N75

Nikon announced the introduction of the F75 in early 2003, and explained that it is intended to fill what they perceive as a gap between the F65 and F80 in terms of a product with an appropriate price point and specification. It follows the concept of previous models with their combination of SLR versatility and compact camera ease of use. A lightweight camera, it weighs just 380g without batteries, its styling is similar to the F55 and F65, however, it offers a number of features and functions not found in these cameras, including a five-area AF system, and a 25-segment Matrix metering pattern. The F75 is fully compatible with AF-I, AF-S, and VR Nikkor lenses, although in the case of the latter battery drain can be significant so make sure you have plenty of spares.

The F75 has a five area AF system

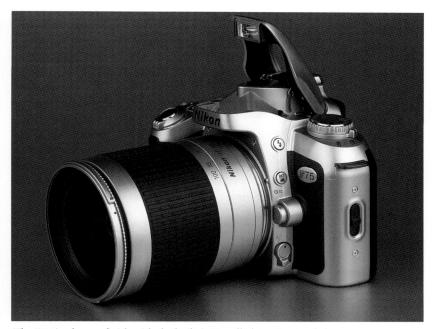

The F75 in chrome finish with the built-in Speedlight unit extended.

based on the Multi CAM900 AF module that has a detection range of EV-1 to EV19 (ISO100), and there is an AF-assist illuminator that has an approximate range between 0.5 –3m. The Auto-servo mode automatically selects either Single-servo, or Continuous-servo AF operation depending on whether the subject is stationary or moving, except in the Vari-program (P) – Sports mode when the camera sets continuous-servo automatically. The system features Nikon's proprietary Lock-on function, which maintains focus even if the camera's view of it is temporarily blocked. There are five options to select in respect of the response from the AF sensors: Dynamic AF Mode with Closest-Subject Priority, Dynamic AF Mode with Centre-subject Priority, Dynamic AF Mode, for AF operation, and either Centre Area Mode, or Single Area Mode in manual focus.

The range of exposure modes is the same as those listed for the F55 above, and the automatic DX coded film speed runs between ISO25-

5000, which defaults to ISO100 with non-DX coded film. You cannot manually select ISO sensitivity. The F75 has the familiar complement of three metering modes – Matrix, Centre-Weighted, and Spot. If you use a G or D type AF Nikkor lens the camera offers a 3D 25-segment Matrix meter, with other AF and AI-P Nikkor lenses the camera loses its 3D function, but retains the full 25-segment metering pattern. Matrix metering is selected automatically in all exposure modes except Manual, which defaults to the centre-weighted metering pattern. Spot metering is linked to the Auto-Exposure lock system and has to be selected via a custom setting (CS-7). It meters from the 4mm diameter AF sensor area, which represents approximately 1% of the entire frame area. The Matrix and Centre-weighted metering range has a sensitivity of EV 1-20, and EV 4-20 in Spot metering (all at ISO100). Exposure compensation can be set in +/- 3EV in steps of 1/2EV. Auto bracketing of three frames is available over a range of +/- 2EV in steps of 0.5, 1.0, 1.5, or

2EV, except for the Auto and Vari-Program modes.

Camera control layout is similar to other contemporary Nikon SLR cameras in this class. The F75 has shutter speeds between 30 seconds and 1/2000sec in all exposure modes and can be set in 1/2-stop steps in (S) and (M) modes. The top plate LCD displays all relevant shooting information for exposure, metering, and flash control. The button for the self-timer, which has a delay of 10 seconds, is located to the right of the LCD. The LCD illuminator switch and button for selecting either aperture/exposure compensation, or film rewind are just in front of the LCD. The lamp for self-timer indication, red-eye reduction, and AF-assist is situated on the front panel just below the LCD. Above and left of the main command dial on the rear panel is the Auto-exposure lock button. On the other side of the prism head is the exposure control dial, and set around this is the switch to select film advance and custom settings. There are a total twelve Custom Settings covering functions such as bracket order, focus area illumination, self-timer delay, and auto power off delay. Like the F55 and F65 the buttons for the flash mode, and auto exposure bracketing/multiple-exposure/second film rewind are arranged on the front panel above the lens release button. On the rear panel is the now familiar thumb pad for AF area selection, and around this is a switch to select the AF area mode.

The F75 has an integral Speedlight unit in the prism head. The unit has a GN12 (ISO100), will cover the angle of view of a 28mm lens, and a film speed range of ISO25-800. The maximum flash sync speed is 1/90sec. Used with G or D type Nikkors the flash provides 3D Multi-sensor Balanced Fill-Flash with either the built-in Speedlight

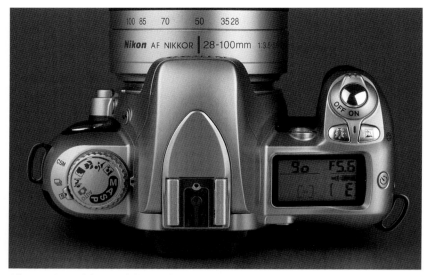

The top plate of the F75 follows a familiar layout.

89% of the full frame. The usual array of data, including focus indicator, shutter speed, aperture, analogue exposure scale, exposure compensation warning, flash ready light, full flash output warning, and battery status indicator.

Film advance is automatic to the first frame once the camera back is closed. The camera offers single-frame and continuous shooting in all exposure modes, with a maximum frame rate of 1.5 per second. There is an automatic motorised film rewind and a mid-roll rewind option. The camera is powered by two CR-2 3V batteries and has a user selectable variable delay auto power off function. In addition to the standard version of the F75 Nikon also offer the F75D, which has a databack to record minute/hour, or day, month, and year information within the frame area. For greater shooting duration Nikon produce the MB-18 Battery Pack, which accepts four AA size cells; it will work with alkaline, lithium, NiCd, or NiMH batteries, but the unit has no effect on the rate of film advance. I would consider this an essential accessory if you use AF-S VR type Nikkor lenses. The F75 shutter can also be released remotely via the ML-L3 Remote Control Unit.

or a separate unit. For other lenses with a CPU the flash control defaults to standard Multi-sensor Balanced Fill-Flash. In manual exposure mode the flash reverts to standard TTL control. The integral unit offers normal front-curtain sync, rear-curtain sync, slow sync, which operates between shutter speeds of 30 seconds and 1/90sec, red-eye reduction, and an override option to cancel the flash. There is a flash ready light in the viewfinder, and standard ISO hotshoe on the prism.

The viewfinder eyepiece offers a built-in dioptre adjustment of –1.5 to +0.8m-1 with an eye relief point of 17mm (at –1.0m-1). The fixed B-type clear matte screen is exceptionally bright and has the five AF brackets as well as a 12mm circle for assessment of the centre-weighted metering pattern marked on it, however, the viewfinder coverage is rather restricted at approximately

A close-up view of the buttons for flash mode, auto exposure bracketing/multiple-exposure/second film rewind button, and lens mount release.

The F75 seen from behind shows the AF area selector, and AF mode selector switches.

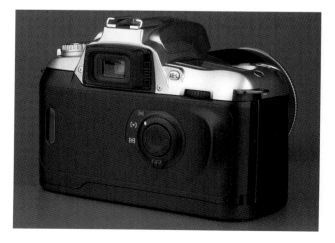

The Digital SLR Series

The 1990's saw the world of photojournalism slowly but surely dragged into the digital age. The company principally responsible for this transition was Kodak, who produced a long line of distinguished products, based on both Nikon and Canon 35mm film camera bodies. Beginning with the DCS100 back in 1991 and followed by the DCS200 the first two generations were exclusively Nikon-body based.

During this decade an increasing number of journalists were using Canon equipment and consequently Kodak began making Canon bodied variants of its third generation camera the DCS420. By 1998 Kodak's fourth generation digital cameras, the DCS520 and DCS560, were both based on Canon and not Nikon bodies. The world of press photography was now digital, predominantly, and yet the only Nikon based digital cameras aimed at this market were obsolescent products. It would take Kodak a further year to introduce the DCS620 based on the Nikon F5. Nikon realised their market share would be further eroded and could not allow their future to rest in the hands of Kodak. It was time to go it alone.

Nikon D1

On the 18th February 1999, at the PMA show in Las Vagas, coincidentally the same day that Kodak first showed its DCS620 digital camera based on the F5, Nikon announced it own digital camera project. Under the leadership of Naoki Tomino, General Manager – Product Development, and using the valuable experience gained from their successful Coolpix range, and the alliances first with Kodak and later Fuji, with whom Nikon co-produced the E2 / E3 series of digital cameras during the mid-1990's, Nikon had a product of their own under development.

Finally, on the 15th June 1999 the Nikon Corporation announced the release of a single lens reflex digital camera – the Nikon D1. From this moment on until the first deliveries during October that year the D1 held the world of photography spell bound. Its formidable specification and very aggressive pricing were destined to shake up the digital camera market in a way that no other product had done. Such is the company's reputation that Nikon's announcement virtually stalled the sales of digital cameras as everyone held off buying anything until they could see how good the D1 really was. Meanwhile, Kodak slashed its price of the D1's nearest rivals, the DCS620 and DCS520 halving their cost of £10,000 over night in an effort to compete with the £3,500 Nikon.

The D1 body is a hybrid of the F100 and F5 film cameras. Built on

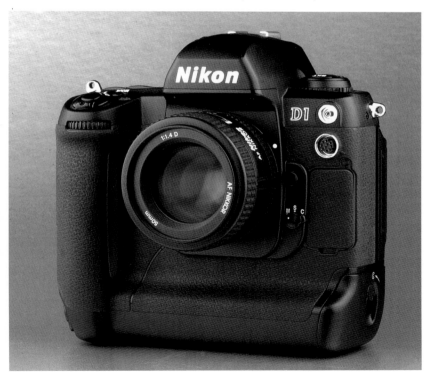

The Nikon D1, which was introduced at an affordable price, opened the door to high quality digital imaging for thousands of photographers.

The Nikon D1 from above.

a magnesium chassis for lightweight and rigidity, it shares the same basic layout of controls and functions, making it immediately familiar to users of these cameras. The body alone, without a battery weighs 1100g. There are the familiar dual command-dial controls, a second shutter release for vertical shooting, and an optical-type fixed eye-level pentaprism viewfinder, with a high eye-point at 22mm at –1 dioptre. There is also a user adjustable dioptre from –3 to +1m -1. The viewfinder provides 96% coverage of the image area, and has an eyepiece shutter to prevent unwanted light entering during self-timer or remote operation. The camera is supplied with the B-type Brite View clear matt screen III, marked with the five focus sensor area brackets and a central 12mm circle. Like the F100, the focus area bracket momentarily lights up in red to confirm which one of the five is active. Alternatively the user can fit the D1 with an optional E-type grid screen.

The main power switch is located around the main shutter release but-

ton and doubles as a switch it illuminate the camera's LCD screens when working in low light. The main command dial, at the default setting, is used to control the shutter speed which ranges from 16seconds to 1/16,000 second, and the sub-command dial the lens aperture. Both dials are used in conjunction with the various buttons arranged on the body to set other functions and features, in a similar fashion to the F5 / F100 film cameras. The maximum flash sync speed is a very useful 1/500sec., which expands the potential for fill-flash photography in bright ambient light. The camera offers four sensitivity settings that are set manually: these are the ISO equivalent of 200, 400, 800, and 1,600. For shooting at speeds in the critical range of 1/30 sec. to 1/2 sec the D1 has an anti-vibration mode that causes a delay between the mirror lifting and the shutter blades opening to reduce the effects of vibration caused by 'mirror slap'.

Behind the shutter release on the top plate is the main LCD. It displays the shutter speed, lens aperture, exposure mode, flash exposure

mode, focus mode and the active focus sensor, battery condition, a warning signal that exposure compensation or bracketing has been set, and a symbol to confirm that a card is inserted in the camera. The frame counter is also displayed in this top LCD but it is both inadequate for the task and rather misleading. There are two sets of numbers, the number in the brackets in the lower right hand corner of the LCD is the current frame number and refers to the number of images that have been captured. Whilst data is written from the camera's buffer memory to the storage card this number blinks and the true frame number will only be displayed once this process is complete. Above the frame number is another set of numbers that indicate the number of remaining frames, or captures, available. The letters REM appear immediately above this second figure as a reminder of what it represents.

The problem is that the LCD can only display a two digit number, therefore, if you are using a storage card with a capacity of more than 99 images of your selected file size the counter simply shows the letters FL. The rear LCD display, however, can display a three-digit number and is thus a more useful indicator

The main LCD showing the capture counter and shutter release button.

The rear LCD of the D1 displays a range of information including file type and number of remaining captures that can be made. The hinged flap is open showing the control buttons with the image playback options printed on the inside of the flap as a reminder.

of the number of remaining frames.

Using the rear LCD display and the array of five buttons under a hinged flap next to it the photographer can control the white balance settings, sensitivity level (ISO equivalent 200, 400, 800, 1600), file type and size, custom settings, and lock the shutter speed, lens aperture, and the AF sensor.

Power for the D1 comes from a dedicated re-chargeable Nickel Metal Hydride (Ni-MH) battery pack, the EN-4. It is recharged using the MH-16 (100v-240v AC) Quick Charger that will complete a full charge cycle in about 90 minutes. Alternatively, if you are away from a mains AC supply there is the MH-17 (12v DC) Charger that can be operated off a standard vehicle cigarette lighter socket. Using the MH-17, which has no refresh function, takes approximately 90 minutes provided the MH-17 receives an uninterrupted supply of power. There is also a mains AC adapter the EH-4. The F100's MH-15 Quick Charger can also be used with the advantage that it can charge two EN-4's simultaneously, although it takes about 120 minutes to complete a full charge. The earlier Nikon E3's EH-3 Charger is another option for charging the EN-4. The EN-4 is not supplied with a case but will fit in the case designed for the F5's MN-30 battery.

Initially Nikon claimed that the EN-4 battery was capable of powering the camera for more than a 1000 image captures. This figure was soon revised downwards, because in reality using a D1 set to AF with an AF-S lens, shooting in the FINE JPEG capture mode, and reviewing images on the LCD screen a fully charged EN-4 can support approximately 300 captures. This can of course be greatly affected by the ambient temperature.

At the heart of the new camera is a 23.7 x 15.6mm 2.74 mega-pixel CCD with an array of 2,012 x 1,324 effective pixels, providing a 2.66 million pixel, 12-bit, full colour image. The size of the imaging area, compared to a full 35mm film frame, results in an effective increase in focal length of 1.5x. Each D1 pixel is 11.8 μm square, compared to the pixels of the Coolpix 900 series, which are only 3.9 μm square. Mounted immediately infront of the CCD is a Low-Pass Filter made from an ultra thin layer of lithium niobate (LiNB), to prevent colour aliasing where areas of the image, which contain curved edges or abrupt changes in tone or colour record with a jagged edge, often referred to as the 'jaggies'. An infrared (IR) filter is also employed to reduce the effects of IR light. The anti-aliasing filter represents something of an Achilles heel for the D1 due to its proximity to the CCD. Any dust or dirt particles that settle on the filter are close enough to the plane of focus that they record as black spots in the processed image. Nikon offer only two suggestions in respect of cleaning the filter: the first requires that the camera is returned to a Nikon authorised workshop for the cleaning process to be carried out, which is hardly a practicable solution for a press photographer working in the field, the second involves using the dedicated EH-4 AC power adapter and Custom Setting 4 (Mirror lock-up) to raise the mirror out of the way so the user can clean the filter themselves. Although Nikon supports the latter option, it is fraught with the risk of damaging the very delicate surface of the filter and extreme care must be taken.

The D1 incorporates a range of image quality modes: Uncompressed Image mode provides users with three options; Raw (12-bit), TIFF YcbCr (8-bit) and TIFF RGB (8-bit). The familiar RGB TIFF is an 8-bit file that can be imported straight into Adobe Photoshop. It is the most memory hungry of the three options producing a file size of 7.8Mb. TIFF YcbCr is a Nikon proprietary format that is a little less memory intensive producing a 5.2Mb file per image, roughly two thirds the size of the RGB TIFF, but it can only be opened using Nikon View software, which is supplied with the camera. The Raw mode produces 4Mb 12-bit files that can only be opened in the optional extra Nikon Capture software.

The compressed image mode offers JEPG—baseline-compressed files at three quality settings: Fine mode compresses by a factor of four, Normal mode by a factor of 8,

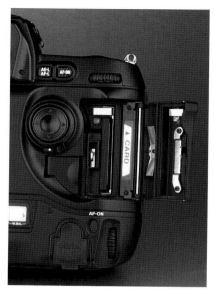

Seen from behind this D1 has the door to the storage card port open.

and Basic mode by a factor of 16 times. There is also a monochrome mode for all of the image quality settings.

One of the real strengths of the Nikon D1 is its capture speed. Remember the camera was aimed squarely at press and sports photographers with their need for expediency in image acquisition and dissemination. The camera has a very fast start up time, and an impressively short shutter release time lag of approximately 0.058 sec.

The D1 has a buffer memory of 64Mb allowing the camera to capture up to 21 images in continuous shooting mode at a rate of 4.5 fps when using any one of the JEPG file modes, which are the ones likely to be used the most by press and sports photographers. Once the buffer is full the camera locks up. It takes the camera about a minute to write all of these images to the memory card, but as soon as one or more images have been transferred to the card the camera is ready for use again, until of course the buffer is full again. Nikon abandoned the use of PCMCIA cards in favour of

the Type I and Type II Compact Flash cards. As an illustration of how fast card technology is progressing at the time of the D1's launch the highest capacity card available was 96Mb. Hence only 64Mb and 96Mb cards are mentioned in the camera's instruction booklet. By mid 2002 a 1Gb card, with a write speed of 16x is already on the market! A fairly modest 256Mb card will hold 32 images in the RGB TIFF file format and 176 images in the Fine JPEG mode. Nikon state quite clearly that the D1 will not support the IBM Microdrive because shooting a long burst of frames, or a series of bursts causes the Microdrive to heat up to unacceptable levels, which could damage the camera. The studio based photographer working with the D1 can also connect the camera directly to a computer using the IEEE 1394 (400mps) high-speed interface, allowing the direct downloading of images for processing in

either proprietary Nikon software or other image handling software. As an alternative medium for viewing the D1 images the camera offers both PAL and NTSC video output.

On the rear of the camera is a 2.0 in, 114,000-dot low temperature polysilicon TFT LCD monitor, which is used to display the captured images, various control function menus and histogram representations of images. The capture preview mode allows you to see the image so you can decide whether you wish to store or delete the image before it is processed. The image playback function has four settings: 1) 1 frame, 2) Thumbnails (9 images), 3) Slide show, 4) Histogram representation.

The D1 incorporates the same 1,005 pixels RGB 3D matrix metering system as the F5 with a sensitivity range of EV0-20 for Matrix and Centre-weighted metering and EV2-20 for Spot metering. On the right side of the pentaprism head, viewed

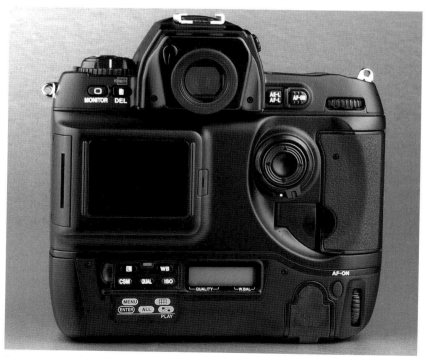

Images captured with the Nikon D1 can be displayed on the screen mounted on the back of the camera.

from behind the camera, is the three-position metering mode selector switch. The three options are: 3D Colour Matrix Metering, Centre Weighted metering, and Spot metering. The Centre Weighted metering mode places 75% of the meter sensitivity in a central 8mm circle. This can be further adjusted using Custom Setting (CS) 14 which allows the selection of a 6, 10, 13mm or average metering pattern. The Spot Metering mode takes a reading from a 4mm diameter circle, which represents approximately 2% of the image area. The five AF sensor areas double as the Spot Meter areas and can be selected manually by the photographer. It should be noted that in Dynamic AF mode with Closest Subject Priority, or when using a non-CPU type lens only the central AF sensor acts as the spot metering sensor regardless of which AF sensor is currently active.

The core of the 3D matrix metering system is its ability to compare the brightness, colour content, and with a suitable D-series Nikkor lens attached, the subject-to-camera distance, to a database of over 35,000 actual photographs. It then calculates the optimum exposure value. This value is then finely tuned by a TTL Auto-White Balance, which automatically adjusts the white balance by conducting an analysis of the white light passing through the lens. To compliment the Auto mode the D1 provides a Preset mode and Manual mode for white balance settings. The Preset mode stores a previously recorded white balance setting, whilst the manual mode provides six settings; 1) Incandescent light, 2) Fluorescent light, 3) Fine weather, 4) Cloudy, 5) Shade, 6) Electronic Flash. There is a further seven-step fine-tuning ability, which shifts from −3 (red bias) to +3 (blue bias). Finally the Tone

Compensation function operates to optimise the tonal curve of the image according to the scene's brightness and contrast. Once again though, the D1 allows full user control by offering a further four preset tone curves, available via CS-24, for lighter or heavier tones. Finally the level of image sharpness can be selected from the four preset values within the CS-23.

The D1 provides four exposure control modes Programmed Auto (P), Shutter-Priority Auto (S), Aperture-priority Auto (A), and full manual (M) mode. Exposure compensation covers a range from −5 to +5 EV in either 1/2 or, 1/3 EV steps. CS-13 allows the photographer to recall the preset exposure compensation instantly via the two command dials. Further exposure control is offered by way of the Auto Exposure Bracketing of two or three frames in 1/3 to 1 EV steps.

The D1 has a standard ISO flash hot shoe mounted on the top of the pentaprism, however, the sophisticated Off the Film (OTF) TTL flash control system used in cameras such as the F5 and F100, when combined with Nikon Speedlights like the SB-28 and SB-26, could not be

employed by Nikon in the D1. This is because the CCD does not reflect sufficient light, compared to film, from which an exposure calculation can be computed. Nikon's engineers solved the problem by enhancing the pre-exposure measurement of light using Nikon's proven Monitor Pre-Flash system and introducing a new, dedicated Speedlight, the SB 28DX. A five segment TTL Multi sensor, which is mounted in the base of the mirror box, performs precise control of the flash's output. Immediately prior to exposure the SB-28DX emits a series of imperceptible light pulses, known as Monitor Pre-Flashes, which are reflected off the subject through the lens and off the shutter curtains. Data from this TTL multi sensor is combined with lens aperture and focus distance information from an appropriate 'D' specification AF Nikkor lens, by the D1's central processor, which calculates the proper flash output level. This system, known as 3D Multi-sensor Balanced Fill-Flash, allows the D1 to produce well-balanced exposures, even in difficult situations such as a scene with a highly reflective background or a very dark background.

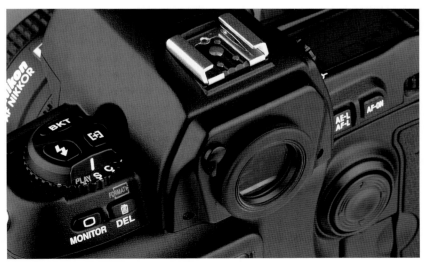

Any photographer who is familiar with the controls on the F100 or F5 will find the D1 quick and intuitive to operate.

The Monitor Pre-Flash system has a maximum effective range of about 6m. At greater distances the intensity of the Monitor Pre-Flash pulses fall off and exposure calculations have a tendency to become a rather erratic. Even at distances less than 6m the pre-flash system may give inconsistent results if you shoot rapidly as the flash does not re-cycle fast enough causing a variation in the output of the pre-flash pulses, which in turn can affect the camera's flash exposure calculations. The D1 is equipped with five flash sync modes: 1) Standard Front curtain sync, 2) Red-eye reduction, 3) Red-eye reduction with Slow sync, 4) Slow Sync, 5) Rear curtain sync. There is also a standard Pin Cylinder (PC) socket on the front plate, adjacent to the 10 pin remote socket, to trigger non-dedicated flash units.

The D1 has the CAM-1300 autofocus module as used in the flagship F5 film camera body and has the same toggle switch arrangement of the F5 / F100 to select the AF area sensor. The detection range is EV-1 to EV1919 (ISO100). The camera offers three focus modes, selected via a switch mounted on the front plate besides the lens throat: Single Servo (S) AF, Continuous Servo (C) AF mode and fully mechanical Manual (M). In addition to this the D1 provides two AF area modes: Single Area AF, when one of the five selected AF areas is locked. The selected area is displayed in the top plate LCD and superimposed in the viewfinder in red; and the Dynamic AF mode, which when selected in conjunction with the (C) AF mode allows you to choose the focus area that best suits the composition, if, however, the subject moves out of this area the Dynamic AF predicts the direction of movement and instantly shifts the focus to another of the five areas. In the (S) AF mode

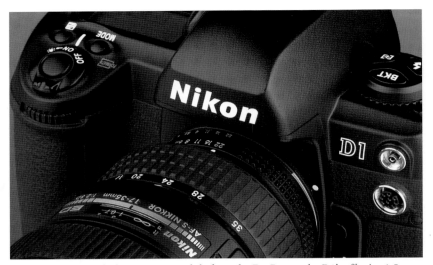

The D1 is fitted with the same AF module from the F5. Due to the D1's effective 1.5x increase in focal length Nikon launched the 17-35mm f2.8 AF-S Nikkor to provide greater wide-angle coverage.

the Closest Subject Priority function can be used to automatically select the focus area with the closet subject to allow the photographer to concentrate on composition and shutter timing. In common with other Nikon AF cameras the D1 has Focus Tracking, which operates automatically when the AF system is activated and the camera detects a moving subject, regardless of the AF mode or AF area mode selected. Focus tracking is further augmented by an overlap servo that ensures constant adjustment of the lens focusing, even during the driving of the lens elements. The final AF function is Nikon's proprietary Lock-On function, which allows continuous tracking of a moving subject, even in the event that it is momentarily obscured.

At the time of its launch the D1 was very convincing camera. Based on the proven pedigree of film cameras such as the F5, with its advanced metering and auto focus features, and its rugged build quality it took on its Kodak rivals and matched them on image quality. Despite a number of foibles the D1 proved a point: there were many

photographers who would convert to digital if the price was right. The D1 sold in its thousands not only to the target market of the press and sports photographers, but increasingly to a significant number of commercial, social, and wedding photographers as well.

Nikon D1X

Since the introduction of the original D1 other manufacturers have entered the market with their own digital cameras, some like the Fuji FinePix S1 Pro, and Canon EOS D30 offering higher resolution and faster image handling, at a considerable cost saving against the D1. The D1 survived on it build quality and widespread market penetration. However, little more than 18 months after the original D1 launch Nikon announced it was time for an update. Feedback on the D1 demonstrated that users fell into two distinct camps – those seeking the highest quality, such as the commercial, wedding, and portrait photographers, and those for whom speed is all important, such as news and sports photographers. Realising that to combine both qualities would

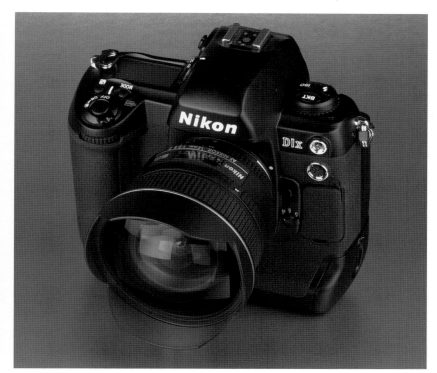

The successor to the ground breaking D1 the Nikon D1X. It has double the resolution of the earlier model and a number of significant improvements.

result in a 'jack of all trades, master of none' type camera, Nikon's solution was to produce two different models; the D1X with twice the resolution of the original D1, and the D1H, which can fire a burst of 40 frames at 5fps. Three areas of image quality hampered the original camera. Firstly the bias towards magenta casts which yielded unnatural skin tones. Secondly, erratic flash exposures with the dedicated SB28DX Speedlight, which would often occur, even between consecutive frames. Thirdly the noise and banding that appeared in images shot at the higher ISO settings.

Nikon chose an innovative way to increase the resolution in the D1X. The 2.7 mega-pixel chip used in the D1 has its pixels arranged 1,324 vertically and 2,012 horizontally. The D1X chip has the same physical dimensions and the same number of pixels vertically, but the horizontal pixels have been doubled to 4,024,

providing 5.4 million pixels. The raw image data is put through an interpolation program, which redistributes it into a 1,960 by 3,008 pixel image for a final output resolution of 5.9 mega-pixels.

By retaining the same chip size the D1X inherits the same 1.5x effective increase in focal length for any lens used with it. This is good news for sports photographers as a 300 f2.8 lens becomes, effectively, a 450mm f2.8 optic, but not such good news for extreme wide angle

The new badge of the D1X is one of the few external differences compared with the original D1.

work where even the Nikkor 14mm f2.8 AF-D only gives a coverage equivalent to a 21mm focal length.

Apart from the change to the badge on the front plate, cosmetically there is almost no difference between the D1X and the D1. All main controls, external ports, and sockets are in the same place as they were on the D1, and the body, without a battery weighs exactly the same 1,100g.

The viewfinder is the same as the D1 and provides an excellent and clear display of all the relevant exposure, focus, and frame information. That, however, is where any similarity stops as Nikon have undertaken an extensive overhaul of several key features. The various menus and the way in which functions are accessed and operated have been radically changed. Functions are now divided into four groups: Set-up, Shooting, Playback, and Custom Settings, and are displayed on the new large 130,000 pixel rear LCD panel, which shows 100% of the image, another small but significant improvement over the D1's display of only 92%. This has been achieved by simply making the image smaller to fit the screen. All the menus are highly intuitive; I have found them to be logical and well protected from accidental alteration. The toggle switch mounted on the rear panel is used to scroll through the chosen menu and it makes setting custom functions so much easier as each is described on the screen. No more fumbling through the camera bag looking for the little laminated card that was supplied with the D1 to remind you of which function is which!

Another small, but very useful change is the functionality of the histogram used to assess exposure. This can now be set to appear automatically when you call up an image, and then be switched on/off

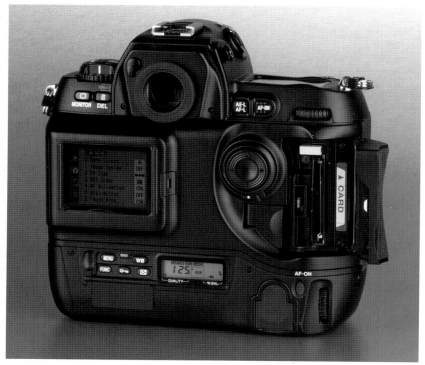

The rear screen on the D1X displays the various functions in a set of menus that are easy to navigate and intuitive in use.

charge / discharge cycles before using it.

Another area of the D1's performance that attracted a lot of adverse comment was its ability to render accurate skin tones, which the camera would habitually record with an excessive magenta cast. Some users have suggested that this could be reduced, if not eliminated, by shooting in the raw file mode and then manipulating the image post capture with Nikon's proprietary software. Hardly a quick fix for a press photographer in a hurry!

Nikon have done a great deal of work on this problem and the D1X now offers a much improved colour balance, which for outdoor shooting when colour balance becomes rather subjective due to the vagaries of natural light is fine. The problem has not been eliminated, however, and photographers who are required to work to within more critical tolerances will still need to experiment with their equipment set-up to achieve a totally accurate result.

Generally the White Balance (WB) function of the camera works very well, offering settings for various qualities of natural and artificial light, including direct sunlight,

with the toggle control. The histogram appears as a bright yellow display, which even in bright conditions remains clearly visible even if the image itself is more difficult to view. In common with the D1 the display can also be used to highlight areas of over exposure.

As with the D1, viewing the images on the LCD whilst outside in daylight is a difficult task. The new 'clear' plastic screen cover supplied by Nikon for the D1X / H does protect the screen from abrasion and finger marks, but is useless for viewing through as it is too opaque. Some photographers have suggested that the LCD displays a cooler and darker image than that captured by the camera, but this is a rather subjective issue.

Amongst the criticisms levelled at the original D1 was it high battery consumption. Nikon addressed this issue and the D1X appears to be considerably less power hungry

compared to the D1. Using a properly pre-conditioned Nikon EN-4 Nickel Metal Hydride (Ni-MH) battery, will certainly improve performance and many photographers are now in the habit of putting a brand new EN-4 through three complete

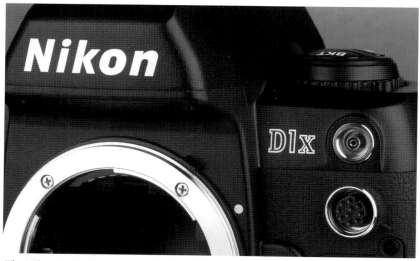

The Nikon D1X retains essentially the same Nikon F-mount as the original Nikon F SLR of 1959.

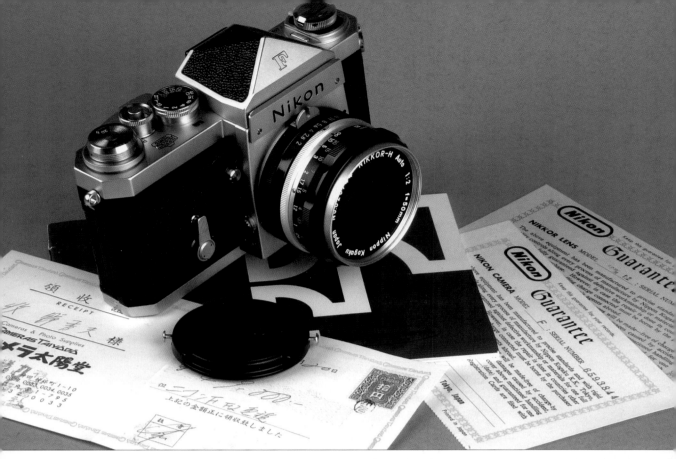

Above:
A Nikon F 'Red Dot' body with its quality control and guarantee papers. The dot indicates the body has been factory modified to accept the first version of the Photomic metering head.

Right:
An early Nikon F body from the 64-block serial number batch. The relatively low number, 6418272, suggests this camera was most probably manufactured within the first year of production.

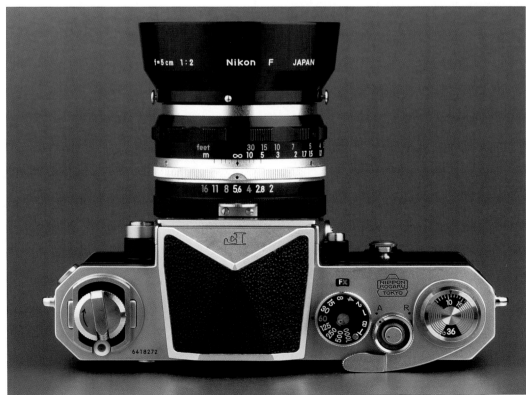

Left:
The world's first
and only autofocus
SLR camera
designed for
underwater
photography: the
Nikonos RS.

In a change from the D1 the ISO button is mounted on the top plate with the flash and exposure bracketing controls.

There is a further option that allows sensitivity to be raised by one or two stops over the 800 setting, however there is a considerable increase in noise (grain appearance). All in all this represents one of the biggest improvements over the original camera.

As with the D1 the D1X offers a variety of file formats for image output. Uncompressed, 8-bit TIFF files can be in either standard RGB format or Nikon's proprietary YCbCr format. The YcbCr format are two-thirds the size of the RGB TIFF's, but can only be opened using the Nikon View 4 software supplied with the camera. The RGB TIFF files are 16.9Mb in size and can of course be opened directly into Photoshop. These memory hungry files, whilst offering optimum quality, will I expect be reserved for shoots close to base, as the quality loss in the Fine JEPG mode, which captures images at a size of 2.8Mb, is minimal and therefore more appropriate for extended periods of shooting in the field. Compressed JPEG capture is available in three compression ratios of 1:4, 1:8, and 1:16. Finally, there is the option to capture 12 bit raw files in the Nikon Electronic File

shade, cloudy, flash, incandescent, and fluorescent as well as an auto-WB mode, and scope for three user defined preset values. Further fine-tuning of the WB can be achieved by shifting the bias toward blue or red by increments of +3 to –3. The positive figures increase the blue and the negative increase the red bias, just as with the D1.

The new camera offers a choice of two colour space options, one based on sRGB referred to as Mode I, and the other a version of Adobe RGB referred to as Mode II, with selection via the custom function menu. The sRGB space is based upon the display properties of many typical monitor screens when anything in a wider gamut would be unlikely to show further subtlety in image colour and tone. There appears to be noticeable difference between the two versions when viewing images on both the cameras' own LCD display and on a computer monitor with the Mode II providing the superior image. So Mode II (Adobe RGB version) will most probably be the default setting chosen by most users.

To further enhance the image quality of the D1X the nominal rat-ing (ISO equivalent) has been reduced from the 200 of the D1 to 125 for the new camera. The rating can be set in increments of 160, 200, 250, 320, 400, 500, 640, to a maximum of 800. At 125 the image is very clean and smooth with little appreciable difference up to 400. Thereafter the noise increases but images are still far superior to those obtained at equivalent settings on the D1. This is so even on long exposures of several seconds with no sign of hot spots or interference.

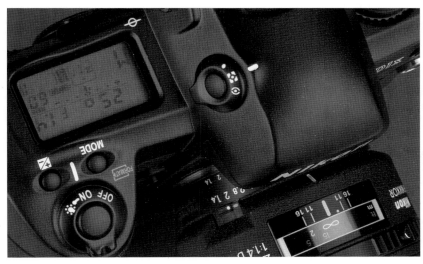

The main LCD of the D1X displays a wide range of information concerning camera settings and exposure control.

The storage media port of the D1X is identical to the earlier D1.

Format (NEF), which again requires the Nikon View 4 software to view images. The overall resolution can also be halved if required for each format.

Despite the large file size of the RGB TIFF format the camera can still move along at 3fps up to a maximum of 9 frames before it needs to write files from the buffer memory to the storage device. Storage can be on Type I or II Compact Flash cards, or on a 320Mb or 1Gb IBM Microdrive, which Nikon now support.

Alternatively the camera can be connected directly to a computer via an IEEE 1394 cable. The write speed of the D1X from buffer to storage media is significantly faster, approximately 2x, compared with the D1, which at times could be frustratingly slow. Another great improvement is the fact that you can opt to view the complete image even whilst the camera is still writing it to the storage media. On the D1 you had to wait until the data had been fully transferred to the Compact Flash card or Microdrive before you could view the full image. Of course this meant that the LCD was on for far longer with the subsequent increase

in power drain on the battery. The D1X allows for image play back as soon as you require it, and in various modes including single image, four or nine thumbnails, and a rolling slide show with user selected display intervals. There is even a

'zoom' function to enlarge a portion of the displayed image. Once again this is a tremendous improvement in handling over the D1.

In its highest quality mode the images produced by the D1X are without doubt very impressive. At a resolution of 300dpi, which is standard for high quality magazine reproduction, the 'straight' captured image will provide a 25cm x 16.5 cm print. In-camera sharpening is available at three levels via the custom menu, and can be disabled if required. Used with it turned off the camera yields a fairly soft looking picture that can be sharpened using Photoshop's 'unsharp mask', or a similar tool from other software. This is another area that will require a little experimentation on the part of the user to determine the optimum setting depending on their particular workflow.

One of the most frustrating problems that photographers experi-

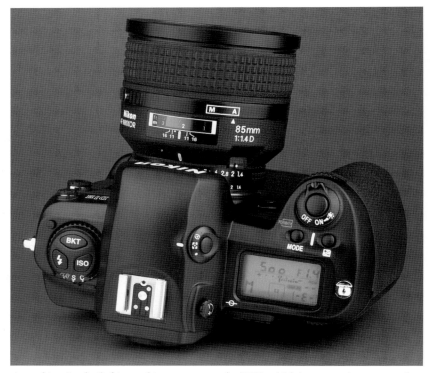

A combination built for speed in every sense; the D1H, which has a maximum rate of capture equivalent to 5fps, and the AF Nikkor 85mm f1.4D lens.

enced with the D1 was the collection of dust particles on the anti-aliasing filter, which is mounted just in front of the CCD chip. Unfortunately the D1X is no better in this department. Given the basic design layout of the D1X it is unlikely that Nikon could come up with a viable solution to this problem, so they continue to suggest returning the camera to them for cleaning, which is hardly a practical or financially viable proposition. As with the D1 you can clean the filter using a compressed air blower but great care must be taken, and there is always the risk of driving more unwanted material further into the camera. So until some form of better protection for the filter and chip is incorporated in future cameras photographers will have to accept this problem as a fact of life! One other area that has not received any attention is the top plate LCD frame counter that still only displays a two-digit figure to indicate the number of remaining frames, or captures.

The consistency of flash exposures is much improved with the D1X. No longer is it necessary to fiddle around dialling in exposure compensation to the Speedlight unit to prevent burnt out highlights. The tweaks to the firmware and software applied by Nikon have done the trick and the D1X / SB28X or SB-80DX can be used with a great deal more confidence. The 3D Multi-Sensor Balanced Fill-Flash mode now delivers a very finely controlled level of fill-in flash, although the effective range of the Monitor Pre-Flash system is still approximately 6m.

Nikon D1H

As mentioned earlier Nikon have chosen to produce two different cameras for to perform two very different roles. The D1H launched a

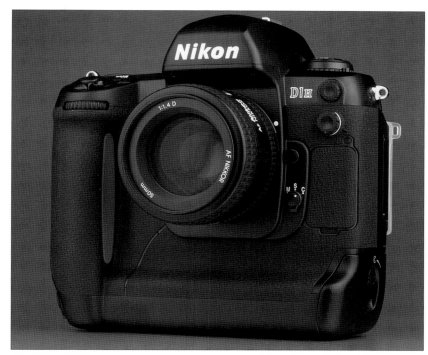

The Nikon D1H can capture a continuous sequence of forty images before it has to pause and write data from its buffer memory to the storage media.

short while after the D1X is designed with speed in mind. As with the D1X cosmetically there is little difference between the new camera and the original D1, with weights for both the same. Internally the D1H benefits from all the improvements to the D1, applied in the D1X, in the areas of colour management, flash exposure control and image quality at high ISO settings. The functionality of the menus, histogram and highlight displays all mirror those found in the D1X, including the new feature of being able to zoom in on an image whilst it is shown on the camera's rear LCD display.

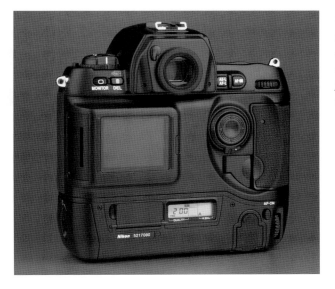

The rear screen of the D1H can display the same camera control function menus as the D1X.

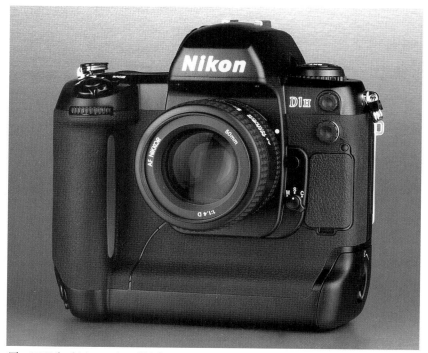

The D1H for high speed and high quality digital image capture is now the essential tool of many photojournalists.

For a camera designed with the press and sports photographer in mind perhaps the best improvements have come in the performance at ISO 800 and higher. As has been stated the D1 suffered from noise and banding towards the upper reaches of its ISO range, which even small amounts of under-exposure would invariably compound. The D1H has an ISO range of 200 – 1600, with maximum quality achieved at the 200 and 400 settings, however the 1600 rating produces very good quality images, and if needs must the boost settings to 3200, and 6400 will yield usable images.

The improvements to speed of handling also extend to the frame rate and capture rate of the D1H. The camera can now run at 5fps filling the buffer with up to forty images in the JPEG mode before it need to pause and write data to the storage media. Like the D1X, the D1H, is fully compatible with Type I

and II Compact Flash cards, as well as IBM Microdrives. The write speed to the storage media has also been significantly improved.

There is no doubt that the Nikon D1 series of cameras have revolutionised the way photographers feel about digital imaging. Nikon listened intently to the feed back on the D1, and set about making significant improvements with the D1x / D1H. The continued pressure to lower prices in the digital market means that all these improvements to the D1H come at a price less than that of a new D1 two years previously.

D1X/H Updates and Upgrades

Despite high expectations that Nikon would make a significant announcement during Photokina 2002 in response to the release of new digital cameras from Canon and Kodak the mythical Nikon D2 did not appear. Instead, Nikon

released updates to its Nikon Capture program, an upgrade to the firmware version for the D1X and D1H, and a buffer memory upgrade for the D1X.

The principle improvement offered by Nikon Capture 3.5 is the ability to output files from the D1X in excess of 10 megapixels. This is achieved by using the camera's full horizontal pixel count of 4024 and interpolating the vertical pixel count of 1324 to create an effective resolution of 4016 x 2616 pixels. Mac users will find version 3.5 runs much faster and supports tethered operation with both D1X and the D1H in Mac OS X, for 10.1.3 or higher including Mac OS 10.2 (Jaguar). Another new feature in Nikon capture 3.5 is the Auto-Vignetting mode, which corrects for the light fall off towards the edges of images.

The firmware upgrade to version 1.1 brings about a number of improvements to both cameras; however, no such upgrade has been made available for the original D1 camera. These include leaving the EXIF colour space tag set to 'uncalibrated' when shooting in colour modes other than sRGB, and embedding Nikon's proprietary Adobe RGB profile in images shot in Colour Mode II to improve colour managed workflows. The ability to operate tethered with Mac OS X as described above, the inclusion of Spanish to the camera menus, improved colour on the LCD menus, compatibility with Lexar Write Acceleration enabled compact flash cards, and images that comply with EXIF 2.2 (EXIFPrint) specification for direct printing from media cards. Although not promoted by Nikon some users have reported an apparent improvement to the consistency of TTL flash exposures following updating to the new version firmware.

The buffer memory upgrade simply increases the total number of images the buffer will hold before the camera stops firing to allow the buffer to be cleared to the storage media. For JPEG and TIFF files capacity is increased from 9 images to 21, and for Nikon Electronic Format (RAW) images from 6 images to 14. Fitting of the additional RAM module, which is chargeable, has no effect on the capture rate or image quality.

Nikon D100

Having firmly consolidated their position as market leaders in the field of the professional digital SLR Nikon turned their attention to producing a digital camera for the semi-professional / keen enthusiast photographer. The Nikon D1 had co-existed alongside the Fuji FinePix S1 Pro, which is based on a Nikon F65 body, almost since its launch. The S1's higher resolution and considerably lower price had made it many friends and early in 2002 Fuji announced its successor the S2. Statements followed this from both Canon and Contax about their intentions to introduce cameras with a similar specification.

On the 20th February 2002 Nikon released news of the D100 digital SLR. A 6.1 mega-pixel unit providing 3,008 x 2000 pixel images, built around an entirely new compact camera body, which weighs only 700g. It was conceived, designed, and built to bridge the gap between the flagship D1 series cameras and Nikon's Coolpix range, which is principally aimed at the enthusiast photographer market. A pre-production prototype was displayed at the PMA show in the U.S, and at the Focus show in the U.K., during February 2002, and the camera was finally released during July of that year.

Before I describe the camera let

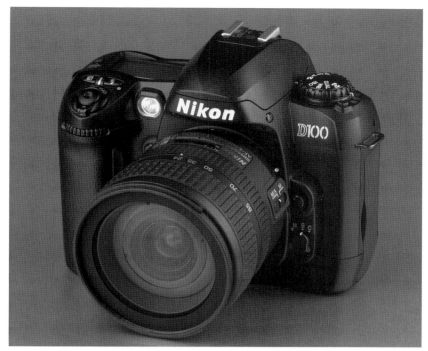

The D100, seen here with the Nikkor AF-S 24-85mm f/3.5-4.5 lens, is built on the experience of the D1 and D1X cameras. At less than half the price of a D1X it offers an affordable route to high quality digital imaging.

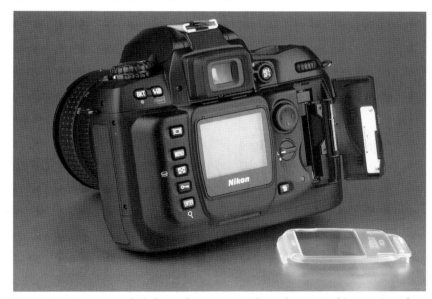

The TFT LCD screen and plethora of camera controls can be seen in this rear view of a D100. The media port door is open and the BM-2 LCD cover plate has been detached.

me dispel a couple of myths. First of all any photographer who harbours expectations that the D100 is be a scaled down version of the D1X / D1H cameras is going to be disappointed. If you require a digital camera with the high-speed operation and a robust build quality, capable of withstanding the rough and tumble of daily professional

use, then the latter two cameras are for you. The D100 is a wholly different tool designed to do a very different job in a less demanding environment. Second the D100 is not a digital version of the F80, despite using a number of F80 components. It is an entirely new compact camera body design that draws parts and features from a range of different Nikon cameras.

Basic Specification

The camera provides three file types; uncompressed TIFF files, compressed JEPG files, and Nikon Electronic Format (NEF) Raw (12 bit) files in either compressed or uncompressed form. The TIFF and JEPG can be sized to Large (3008 x 2000 pixels), Medium (2240 x 1488 pixels), or Small (1504 x 1000 pixels). The user has a choice of three colour spaces – two based on sRGB (one optimised for portraits, the other for nature subjects) and one conforming to Adobe 98 RGB. The division of the sRGB colour space has been done to provide higher fidelity in the yellow/red and blue/green hues respectively. Data processing has been speeded up by the use of a single Application Specific Integrated Circuit (ASIC) chip system, which replaces Nikon's previous three-chip arrangement. Storage is to either a Compact Flash cards (Type I/II), or an IBM Microdrive (512Mb and 1Gb). Captured images, and the camera's various function menus, are displayed on a 1.8in, 118,000-dot, low temperature polysilicon Thin Film Transistor (TFT) LCD screen with LED backlighting, which displays 100% of the captured image. For connection to a computer the D100 has a USB 1.1 interface, and is supplied with completely revised Nikon View 5 software to enable the transfer and viewing of images.

It has an ISO equivalent sensitivi-

The top plate LCD displays a comprehensive set of information about exposure control and general camera settings.

ty of 200-1600, and a shutter speed range from 30 seconds to 1/4000sec plus bulb (B). There is an automatic noise reduction feature, and for longer exposures a specific Custom Setting with an additional noise reduction function. The highest capture rate is 3fps with a maximum burst of six frames for

JPEG/TIFF files, and four frames for NEF files before the camera needs to write from its buffer memory to the storage media. The D100 has a built in Speedlight with a GN11 (ISO100, m), and a flash sync speed of 1/180 second.

It retains a CCD with the same physical dimensions as the D1 series cameras, providing an effective 1.5x magnification of the lens focal length. The optical type fixed eye-level pentaprism has a built-in dioptre adjustment of −2 to +1m -1, and the viewfinder offers approximately 95% coverage of the image area. The focus screen will display On-Demand Grid Lines similar to the F80 camera. The three metering options are: a ten segment 3D-Colour Matrix metering, Centre Weighted metering, and Spot metering. The camera supports all types of Nikkor lenses from the latest AF-D and AF-G types back to the non-CPU manual focus variants. However, the metering functions become more restricted with the non AF-D /G type lenses, and the camera exposure meter does not work with non-CPU manual lenses.

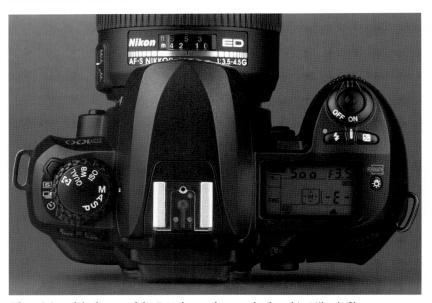

The origins of the layout of the D100's top plate can be found in Nikon's film cameras such as the F80 and F100.

There is no meter-coupling ring around the outside of the lens mount. Instead, similar to the F55 and F65, the D100 uses a small lever that protrudes from the body beside the lens mount to engage the minimum aperture signal post on Nikkor lenses other than the latest G type.

The new camera inherits many features of the D1X/H, including 3D Digital Matrix Image Control to optimise exposure, white balance, and colour accuracy, and a five sensor area auto focus system with Dynamic AF operation, which uses the Nikon CAM-900 auto focus module again from the F80. The detection range runs from EV-1 to EV19 at a temperature of 20° C. There are four exposure modes: Programmed Auto (P), Shutter-Priority Auto, Aperture-priority Auto (A), and full manual (M) mode, with both the shutter speed and aperture adjustable in 1/3 and 1/2 EV steps.

The 3D Multi-Sensor Balanced Fill-Flash mode, which is controlled by a five segment TTL Multi sensor, provides balanced fill-flash with Speedlights such as the SB 28DX, SB 80DX, and SB 50DX. The camera offers five flash sync modes: 1) Standard Front curtain sync, 2) Red-eye reduction, 3) Red-eye reduction with Slow sync, 4) Slow Sync, 5) Rear curtain sync.

The D100 has a dedicated Lithium–ion rechargeable battery, the EN-EL3, with the option of the MH-18 quick charger for a single battery, the MH-19 multi-charger for two batteries that can use either mains AC or a 12v DC supply, and an AC adapter the EH-5.

There is an optional Multi-Function Pack, the MB-D100, which will accept six standard AA size batteries, as well as one or two EN-EL3 batteries. For vertical shooting the pack has an additional shutter

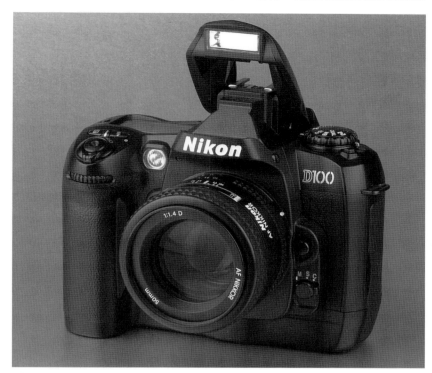

The integral flash unit of the D100 is housed in the prism head of the camera in a design similar to the F80.

The release button for the integral flash unit can be seen on the side of the prism head.

release, and two alternative command dials, which replicate the functions of the Main and Sub Command dials on the main body. It also provides a 10-pin remote terminal, and a voice recording/playback function.

Handling & Performance

On picking up the D100 you quickly realise how relatively small it is compared to the D1 /D1X cameras.

It fits comfortably in the hand and at 700g weighs almost 200g more than an F80, which is no bad thing as it helps to stabilise the camera for hand held shooting, and provides a more balanced feel especially when a longer lens is attached. The body is covered with a textured rubberised material that provides a good firm grip. The optional MB-D100 multi function battery pack, which is discussed in more detail below, improves handling even further,

especially for shooting with the camera held vertically.

The controls are arranged in a layout that is similar to most modern Nikon AF cameras. The shutter release button has a very light first pressure for activating the cameras exposure meter and AF system, and a much firmer second pressure to release the shutter. Although much smaller than the same control on the D1 series cameras the thumb pad for selecting the AF sensor area has a very positive feel to it with a well-defined click to signify its operation. Nikon have apparently taken heed of feedback concerning the infuriating two digit frame counters in the top plate LCD displays of the D1 series cameras. The D100 has a three digital counter that shows the number of remaining captures available on the storage card. In fact this easy to read LCD display shows all the relevant shooting data including file type, size, white balance setting,

flash mode, and AF mode, as well as full exposure information.

The function dial on the top plate to the left of the viewfinder is used to set exposure mode, ISO rating, white balance, image quality, and AF sensor mode. Unfortunately if you need to adjust the ISO setting or the white balance not only do you have to take your eye from the viewfinder, but also as soon as the dial is turned from the exposure mode position the shutter is disabled. So if you need to react to rapidly changing conditions this is an area were you may end up missing shots because of the time it takes to make the adjustment and then return the dial to the exposure mode position. Although the dial has distinct and reasonably positive click stop positions for each function in my opinion it should have been fitted with a locking mechanism to prevent it from being moved accidentally. Photographers with larger than

average sized hands will find the lock button for the shooting mode switch, which is used to select either single or continuous captures and the self-timer function, rather small and awkward to use.

The main LCD monitor on the rear of the D-100 provides a crisp clear image whether you are reviewing a picture or working through one of the three menus of camera controls. You navigate through these menus with the thumb pad and after a little practice the whole procedure becomes intuitive and quick to operate. The array of buttons set around the LCD monitor are marked with clear concise icons, although these are only printed on and not engraved, which raises the question of how durable they will be with prolonged use. One of the most useful features of the monitor is the ability to magnify the captured image. This can be done in nine individual steps using a single

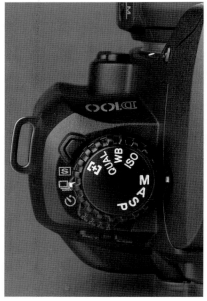

The function control dial of the D100 provides a quick route to adjusting settings for the white balance, ISO sensitivity, and file type, as well as the exposure mode, but it lacks a lock to prevent it being moved by accident.

In addition to previewing images and exposure information including histograms, the rear LCD monitor displays various menus used to select camera settings.

one-touch zoom button that provides a maximum magnification of 20x with an image captured at the 'Large' size file type. Once magnified you can scroll around the image using the thumb pad. This allows you to check for general sharpness and whilst the screen resolution is not sufficient to confirm critical focus in very fine detail it is a great improvement over the D1 series cameras, which have no such facility. Another really useful new innovation on the D100 is the ability to tag each image with a comment. The function is operated from the Set Up menu and you have the option of attaching a comment up to 36 characters in length to the image's EXIF file so it is recorded at the time of capture but not on the image itself. As well as letters and numerals there are a number of common symbols and punctuation marks, but curiously not the ',' international copyright symbol.

The generally the build quality of the D-100 is very high. The logically arranged controls operate with good positive actions and the all-metal lens mount has that solid Nikon feel when changing lenses. Overall the camera is reasonably well sealed to protect it from the elements. However, there are two potential weak spots. The first is the door to the Compact Flash (CF) card port is mounted on two rather flimsy plastic hinges, which will not withstand much force before breaking off. It could easily snag on clothing, or be caught by a thumb whilst working quickly so you need to take particular care whilst the door is open. The second is the lever that engages with the minimum aperture signal post on the lens aperture ring. It protrudes from an opening next to the lens mount on the front of the camera. The lever is susceptible to being bent and the opening invites the ingress of grit or moisture.

The door to the media port is a potential weak spot in another wise well-constructed camera. The port slot is set to an angle to help reduce to overall depth of the body profile.

The viewfinder of the D-100 offers a 95% view of the image area. The bright focusing screen has the usual array of five AF sensor area brackets and is marked with a central 12mm diameter circle to define the area of the centre-weighted metering pattern. Images are very crisp and snap in and out of focus. In low light the selected AF bracket momentarily lights up in red, as do the grid lines that can be selected with Custom Setting (CS) 19. The lines do not extend across the full frame only the area outside the 12mm circle, but are still very helpful for aligning the camera for precise compositions. In addition to showing the shutter speed and lens aperture the viewfinder has an analogue exposure display, focus confirmation light, capture counter and metering mode icon. These are all arranged along the bottom edge of the frame area, which makes reading them quick and simple. The viewfinder eyepiece has a rectangu-

lar shape so precludes the fitting of a proper circular eyecup, which is a pity as you can never be sure that all extraneous light has been excluded. The eyepiece has a built in dioptre adjustment, however the sliding switch used to make adjustments is rather small and difficult to move.

The exposure metering of the D100 leaves little to be desired provided you use it with the usual amount of thought that you should apply to any internal camera metering system that reads reflected light. The ten-segment 3D Matrix copes with averaged toned evenly lit scenes with aplomb. In difficult lighting situations it provides well-balanced exposures in most instances. The spot meter is very precise and not easily fooled by areas of light and shade in close proximity to each other. However, one circumstance that afflicts the D1 series cameras is large areas of very light tone, particularly those in shade, as these are habitually underexposed. Unfortunately the D100 does not appear to be any better in this respect. It is important to note that the camera's metering system does not operate with non-CPU type lenses.

The white balance (WB) options are the same as those in the D1 series with the additional option of a bracketing feature for making two or three captures with varying white balance levels. During July 2002 Nikon issued a public notice concerning the White Balance Bracketing (CS11) function of the D100. Essentially this feature was found not to perform correctly when the Image Review (CS1) was set to 'ON', or alternatively if the Monitor Button was pressed whilst images were being written to the storage media. This fault only affected very early production models of the camera with the version 1.0 of the firmware. To check which ver-

sion of firmware your camera has take a picture and preview it on the rear LCD. Then use the Multi Selector switch to display the shooting information. If the 'FIRM VER' is shown as 1.0 you should contact your Nikon service centre to arrange for a free upgrade.

One of the most impressive qualities of the D100 is its ability to handle electronic 'noise'. In digital cameras 'noise' can occur as a result of very brief exposure times, but it is particularly prevalent during long exposures in low light. This unwanted effect is characterized by random pixels of disproportionately bright intensity and colour that appear in the image. Nikon's Colour Noise Reduction is always active and helps to maintain quality in the shadow regions of an image. The D100 easily outperforms the D1X/H in this area at all settings between ISO 200 – 800. The additional Long Exposure Noise Reduction, selected with CS 4, is performs extremely well and exposures of 20 – 30 seconds often show no noise effect what so ever!

Whilst the results produced by the D100 are very good it is important that photographers understand how the camera performs whilst it achieves them. The first point to note is that the processing speed of this camera is somewhat less than the D1X/H series. The D100 has a maximum firing rate of 3fps with a maximum burst of six captures in the JPEG and TIFF file formats, or four in the NEF (RAW) format, before the camera buffer memory is full. At this point the camera locks up so it can write data from the buffer memory to the storage media. Once the buffer is full shooting in Fine JPEG (Large) it takes approximately1.25 – 1.5 seconds to write sufficient data before you can make the next exposure so the effective frame rate is reduced significantly.

The AF mode selector switch is located in the familiar position below the lens release button.

This is hardly going to trouble a photographer shooting landscapes or a still life, but action and sports subjects are not going to wait around whilst the D100 clears its buffer memory! In the same file format and size it took between 11 to 12 seconds to clear a full six frame burst from the buffer, longer than it takes a good sprinter to cover a 100m. Compared to a D1H that has a firing rate of 5fps and a maximum burst of forty frames the D100 seems positively pedestrian, but you must remember it was never designed with this role in mind.

The firing rate of any camera is only one component of its ability to deal with fast paced action the other is the speed of its auto focus (AF) system. In this respect the D100 is again somewhat slower than the D1 series cameras due to the use of the Multi-CAM900 AF sensor, another feature taken from the F80, rather than the Multi-CAM 1300 unit found in the F100, F5, and D1X/H.

Focus tracking of fast moving

subjects is not the forte of the D100, but its AF system is more than capable when it comes to slower or static subjects. Used with AF-S Nikkor lenses it is unlikely many photographers will perceive any noticeable variance in AF speed compared to either an original D1, or D1X/H. In low light levels with a low contrast subject using AF-D type lenses the D100 is not quite as quick or positive as the D1 series cameras.

Nikon's D-TTL system has come a long way since the difficult and unpredictable combination of the original D1 and SB28-DX. The enhanced monitor pre-flash system of the D100 when used with the SB-80DX will ensure far more consistent and accurate results. There, however, two major drawbacks to using flash with the D100. The first is its very modest 1/180sec sync speed, which combined with its minimum ISO200 sensitivity rating, which conspire to make using daylight fill-flash with wide lens apertures rather difficult to achieve. In bright sunny conditions, when fill-flash is very useful to help reduce contrast, maximum lens apertures are likely to be in the range of between f16 and f11, which makes it very difficult to isolate the subject from the background. The second is the inexplicable omission of a standard pin cylinder (PC) socket. To connect a standard sync cable you have to fit an AS-15 adapter in the camera's flash hot shoe.

The EN-EL3 rechargeable Li-ion battery supplied with the D100 offers a very impressive performance. It is possible to make many hundreds of captures and spend time reviewing them and adjusting camera settings on a single charge.

The final aspect of D100 performance concerns the options for operating the camera remotely. In the simplest form this involves using a conventional screw thread cable

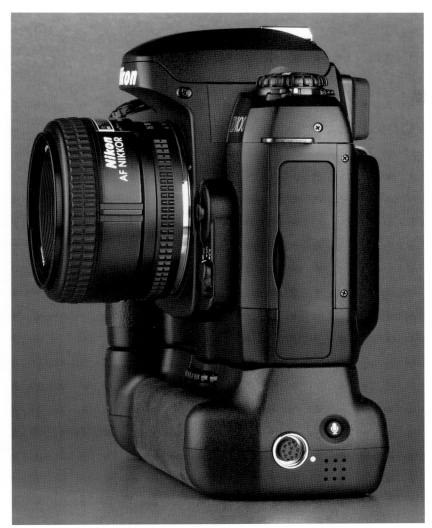

To attach any Nikon ten-pin terminal accessories to the D100 you must fit the MB-D100 multi function pack. The socket is located next to the internal microphone on the end face of the pack.

release that attaches to the shutter release button just like the F80. Some how such a basic feature seems almost out of place on a 21st century digital camera but it works well enough. Used in conjunction with the Anti-shock shutter release, CS 24, which causes a brief delay between the reflex mirror lifting and the shutter opening it certainly improved sharpness in the critical shutter speed range of 1/30sec – 1/2sec, especially when shooting high magnification close-ups, or with long focal length lenses.

To use Nikon's range of ten-pin terminal accessories like the MC-30 electric release, or ML-3 Modulite remote control set you must fit the MB-D100 multi-function battery pack, as the D100 body has no 10-pin terminal socket. The final method of remote control involves using Nikon Capture 3 software, which is available as an optional extra. This allows you to control the D100 from a computer tethered via a hard wire USB connection. Early versions of the Nikon Capture program only supported the Windows

operating system, but following the introduction of Nikon Capture 3 (version 3.5) and the camera's firmware upgrade to version 2.0, the D100 is fully compatible with the Mac platform, including Mac OS X, 10.1.3 or higher, plus 10.2 otherwise known as Jaguar.

The most important accessory for the D100 is without doubt the optional MB-D100 multi-function battery pack, which is far more than just an additional battery box. It can accept up to two EN-EL3 batteries, which given their very impressive performance should power the D100 for a considerable amount of shooting (Nikon claim up to 1600 exposures under optimum test conditions), or six of the ubiquitous AA size cells in a dedicated battery holder. The option of using AA cells is very useful, because you may not always be in a position to recharge the EN-EL3 when you need to. Addition of the pack makes no difference to the frame rate of the D100, but as mentioned above it certainly improves the general handling of the camera, because it not only provides extra surface area for a good solid grip, but also has two dials that replicate the functions of the main an sub command dials, and a shutter release button for vertical shooting. It has a button with which to lock the AF (auto focus) and AE (auto exposure) functions, plus select the AF sensor area. All of these controls are locked by the action of a single sliding switch to prevent accidental operation when the camera is held horizontally. The MB-D100 increases the camera's overall weight by 210g (excluding batteries) and raises its height profile by approximately 42mm.

Attachment of this accessory activates two extra Custom Settings. The first is CS-25, which works in conjunction with CS-14 two allow the user to select a range of opera-

tions that can be assigned to the AF-L/AE-L – Focus Area Selector Button on the pack. I suspect many photographers will find the most useful combination to be the default setting, which causes this button to lock the AF and AE when pressed alone, and the focus area to be changed by pressing the button and turning the sub-command dial at the same time.

The second is CS-26 that is used to adjust the playback volume of the voice memo function of the MB-D100 pack. This feature permits you to add a recording of between one to twenty seconds duration to each image by simply pressing the Voice Memo record/playback button and speaking into the built-in microphone mounted next to it. The recording is saved in the popular WAV file format for digital sound developed by Microsoft and used by many applications. These audio files are assigned the same reference number by the D100 as the image file to which they relate, but carry the extension .WAV. As the D100 automatically records all the shooting data within the image file this obviates the need to record this again in an audio form, and leaves you with ample scope to note all the relevant caption information about your subject by using the voice memo feature. Obviously using this feature will impact on the storage capacity of the camera's media card as audio files of 5 to 10 seconds duration typically averaged between 50 to 100 Kb in size.

As mentioned above the D100 received its first firmware upgrade soon after its release to patch the problem with the White Balance bracketing feature. During October 2002 a second firmware upgrade to version 2.0 introduced a number of small but very welcome improvements. Colour managed workflows are made easier as the EXIF colour

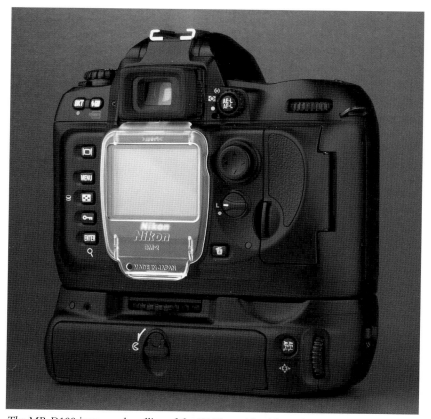

The MB-D100 improves handling of the D100 considerably and adds several extra features, but it does increase the bulk of the camera significantly.

space tag is now set to 'uncalibrated' in shooting modes other than sRGB, and the D100 embeds the Nikon proprietary Adobe RGB profile in images taken in Colour Mode II. To warn of impending battery exhaustion the battery indicator now flashes and if the battery charge is too low to ensure proper operation the camera will disable the shutter. Other enhancements include addition of Spanish to the menus, compatibility with Lexar Write Acceleration enabled compact flash cards, EXIF 2.2 (EXIFPrint) for direct printing from media cards, better naming of sound files using a four digit sequential number allied to the image number, and compatibility with a number of new features in Nikon Capture 3.5, including support for tethered shooting with the Mac OS platform.

The D100 is not, and was never intended to be, another D1x/D1H. It is there to fill the gap between the fully specified, robustly built, D1 series professional models and the top of the range fixed lens Nikon Coolpix cameras. Given its range of features and functions, SLR flexibility, compatibility with the AF Nikkor lens series, and a very competitive price point, the D100 represents a fantastic way for the dedicated enthusiast and professional photographer to enter high quality digital SLR photography. It is highly likely that as one of the first six megapixel, sub £2000 cameras, the D100 will be responsible for persuading many photographers it is time to turn to digital capture, and thus change the face of photography for ever.

The Nikkor Lens Series

Lenses are the key component of any camera system. The creative use of different focal lengths and lens types will determine the composition, perspective, and optical effect recorded in the resulting photograph. The quality of a photograph in respect of its colour rendition, contrast, and resolution are all directly affected by the quality of the lens. For these reasons Nikon controls every stage in the manufacture of a Nikkor lens from the production of the glass to the final assembly.

Lenses made by Nikon have carried the name Nikkor since 1932. The first camera lens for the 35mm format was produced in 1934 for the Hansa Kwanon Company, known these days as Canon. After Nikon began to sell their own cameras they continued to supply other camera manufacturers with lenses, including a series of 39mm thread screw fit lenses for Leica and Contax rangefinder cameras, and the first range of optics for the medium format 6cm x 6cm Zenza Bronica camera system that had eight focal

lengths from 40mm to 200mm. When Plaubel introduced their "Makina", a 6x7 rangefinder camera, it had a built-in Nikkor 80mm f2.8, and the wide-angle lens version, the W67, also had a Nikkor lens.

The Nikon F Mount Bayonet

In 1959 Nikon adopted a bayonet lens fitting for their first SLR camera, the Nikon F. Essentially this bayonet design has remained unchanged in its basic features to the present day. As a result of this

continuity a wide variety of recent AF lenses can be mounted on an earlier non-AF bodies. In many instances the reverse is also true as early Nikkor lenses can be mounted on most modern AF cameras. Although, depending on the combination involved, certain functions are not available because the necessary mechanical or electrical connections between the lens and camera are missing. This level of compatibility is a remarkable feat of engineering and is at the very heart of Nikon's philosophy.

Nikon have manufactured lenses using their own glass from the beginning; polished lens elements immediately after the coating process.

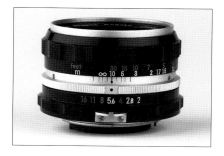
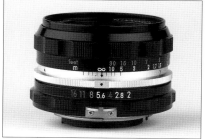
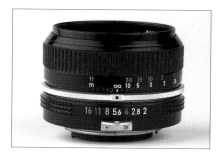
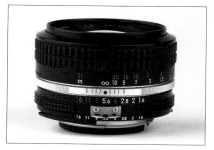
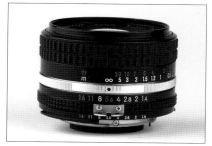
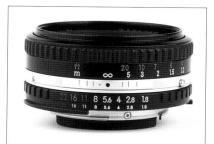

Nikon's principle lens versions shown from left to right, and top to bottom: A Type with its chrome filter ring, C Type with its black filter ring, K Type with a rubber finished focus ring, N Type with its AI aperture indexing cam on the aperture ring, AI-S Type, the economical E Series, first AF series lacks the meter coupling prong and has an impractically narrow focus ring, AF-D series with improved focus ring profile.

Nikkor lenses have gone through many modifications over the years as technology has advanced and designs have changed to keep pace. It is important to be aware of the differences between these lens versions from different generations to ensure you derive the most from your equipment. Manual focus Nikkor lenses can be classified into five different versions: these are the A, C, K, N, AI-S, and AI-E types. In spite of these classifications many variants appeared within each group, particularly in the early production models. Auto focus Nikkor lenses can also be classified into five different groups: AF, AF-D, AF-I, AF-S, and AF-G types. The different versions are described in this chapter, together with any relevant limitation of their compatibility.

Future Trends

The introduction of the Nikon G series lenses gave the first clue as to the direction I believe Nikon lens design will go in the future. It represents the first significant departure from the company's famed retro-compatibility, because they lack a conventional aperture ring. Their use is, therefore, restricted to those Nikon cameras that allow the lens aperture to be controlled from the body.

Professional digital photography is now through many of its early growing pains. Thanks to the efforts of Kodak during the 1990's many major news agencies adopted digital capture. Nikon's introduction of its D1 digital SLR turned a ripple into a wave of change as its specification allowed many independent photographers to embrace high quality digital imaging at an affordable price for the first time. The D100 camera has carried this even further as many more photographers, professional and enthusiast alike, are now converting to the digital medium.

At the Photokina exhibition in September 2002 both Kodak and Canon announced new digital SLR models with a CCD equivalent in size to a full 35mm film frame, however, there was no indication from Nikon that they would follow suit. As the newsgroups and forums of the Internet abounded with discussion and comment on Nikon's intentions in this respect, I strongly doubted if the company would ever

adopt a larger CCD than those used in their current digital SLR cameras. The alternative - adopt the size of CCD used in the D1 series and D100 as a wholly new format and to design lenses specifically for it makes a lot of sense, because the current Nikkor lenses, which were designed for the 35mm film format, project an image circle that is far larger than required for Nikon's current D-SLR cameras. By using the 23.7mm x 15.6mm sized format CCD of Nikon's current D-SLR cameras Nikon's engineers could produce lenses that project a smaller image circle. This has the potential of permitting designs which would not only be physically smaller and lighter, but also allow for ultra-wide angles of view, higher zoom ratios, and faster maximum apertures compared to their 35mm film format counterparts.

Nikon's product development announcement made in early December 2002 concerning the new range of DX-Nikkor lenses, to be produced specifically for their D-SLR cameras confirmed my earlier predictions. Yet again Nikon have embraced an innovative approach and it will be very interesting to see how this new lenses system evolves. Whatever transpires it is certainly a very exciting time for Nikon photographers!

Nikkor Lenses: Past and Present

The A-Type

The very first lenses for the Nikon F and the Nikkormat FT/FTN belong to the A-type and can be distinguished by the fact that no screw heads are visible on the lens bayonet ring, and the distance scale was only marked in metres. Later A-type lenses have screw heads protruding through the lens bayonet and a distance scale marked in both metres

Lenses: Functions and Features.

Sometimes it is easy to forget that cameras and lenses are mere tools; it is the proficiency with which photographers select and apply these tools that establishes them as a skilled practitioners. However, to attain technical excellence it is necessary to use tools of the highest quality. Many years ago I was given a piece of advice that has stood me in good stead ever since, "better to invest in glass for the camera rather than the camera itself", because however highly specified a camera may be is of little use if it is fitted with a poor quality lens.

In a utopian world all lenses would offer a resolution equal to the theoretical maximum, a large aperture, the ability to focus from infinity to life size, and yet remain compact, lightweight and affordable! Unfortunately, the laws of physics soon intervene and even in these days of hi-tech computer aided design each lens becomes the best compromise, depending upon its intended application, between all these features and qualities. This is especially true in the complex designs of high ratio, wide aperture zoom lenses.

The principle attribute of a lens that most photographers consider is how sharp it is, but what does this actually mean? The perceived sharpness in a two dimensional photographic image is a function of resolution - the ability to describe fine detail, and contrast - the delineation between a tone or colour, and another. Whilst sharpness can be influenced by many external factors such as vibration, atmospheric conditions, focusing errors, poor quality film and processing, and so on there are a number of optical effects that are also detrimental to it, which lens designers seek to minimise.

Chromatic aberration is caused by light of varying wavelengths being brought to different points of focus by a lens. Nikon's designers and engineers developed several types of special glass, known as Extra Low Dispersion (ED) glass, which are used in specific lenses to overcome this effect. Another optical aberration is coma, which has the effect of blurring an image at its edges. If the effect is particularly strong highlights in the peripheral areas of a picture appear to have tails that radiate away from the central axis of the picture. Nikon employ aspherical lens elements to help eliminate this effect, particularly in wide-angle and zoom lenses. Such elements are produced in three ways; precision-ground, which demands the most rigorous and costly production methods, hybrid, which are made by bonding a special optical resin onto glass, and lastly, moulded glass, which involves using a metal die to mould a particular type of optical glass.

Not all light entering a lens is transmitted through it. The surface of each element will reflect a very small amount of the light striking it, which can cause flare effects, ghost images, and an overall loss of contrast. To reduce these reflections and maintain the colour balance of light passing through the lens Nikon have developed their Super Integrated Coating (SIC). The amount and type of coating is tailored to each individual lens element and glass type to ensure consistency across the entire lens system.

Two other optical effects are vignetting and distortion. Vignetting is the result of light levels diminishing towards the extreme corners of an image, and results in the corners appearing darker than the centre of the fame. It is particularly obvious in large areas of continuous tone such as a clear sky. Distortion is caused by the inability of the lens to render straight lines as perfectly straight, which is a very unfavourable characteristic in critical applications like copying flat art work or architectural photography. If the straight line bows inwards towards the centre of the frame the lens is said to exhibit barrel distortion, and if it bows outwards it is referred to as pincushion distortion. In addition to the optical features already described Nikon makes use of a variety of different focusing systems, which not only reduce focusing speed in both manual and auto focus systems, but also help to further reduce the effects of vignetting and distortion: these include Close Range Correction (CRC), Internal Focusing (IF) and Rear Focusing (RF).

and feet. All A-type lenses have a chrome finished filter ring and the designation was engraved with the name 'Nikkor', the maximum aperture, and the focal length. Early A-types have the focal length shown in centimetres, whilst on later lenses it is given in millimetres. The term 'Auto' was also included, denoting the lens has an automatic diaphragm. The letter after the name 'Nikkor' indicated the number of elements. Nikon used the initial letter of the Greek word for the appropriate number as the code:

U	=	Uns	=	1 element
B	=	Bini	=	2 elements
T	=	Tres	=	3 elements
Q	=	Quatuor	=	4 elements
P	=	Pente	=	5 elements
H	=	Hex	=	6 elements
S	=	Septem	=	7 elements
O	=	Octo	=	8 elements
N	=	Novem	=	9 elements
D	=	Dece	=	10 elements

For example Nikon's first A-type 5cm f/2 standard lens was the Nikkor-S with seven elements, whilst a later A-type version the

Early Nikkor lenses carry a designation that described the number of elements in the optic – the letter 'Q' indicates there are four in this Nikkor-Q 13.5cm f3.5, and focal lengths are expressed in centimetres.

Nikkor-H has six elements. Similarly the 13.5cm f3.5 with its four elements carries the name Nikkor-Q, while the 15mm f5.6 that has 15 elements is a Nikkor-PD.

During the 1960's some twenty lenses were available in the A-type ranging in focal lengths from 21mm to 1000mm. Several of these lenses were modified by the addition of multi-coating to their glass elements to become C-types.

The C-Type

The C-type Nikkors resemble the A-versions, but some or all of their glass elements are multi-coated. Nikon introduced its Nikon Integrated Coating (NIC) process to improve the optical quality of its lenses. It involves applying several ultra-thin layers of special substances on to the surface of a lens element to increase two aspects of its performance. First, NIC reduces the reflection of the incident light from 4% in the case of an uncoated surface to less than 0.2%. Secondly, and even more important than the higher light transmission, NIC reduces flare caused by reflections. Even a small amount of flare will lower the contrast significantly and quickly degrade the image quality, making it look as though the photograph had been taken in hazy light conditions.

Not every element is coated in the same way; the designer decides which coating process and how many layers to apply. This is done to ensure that each lens is properly colour corrected, so that all Nikkor lenses in the system have the same colour rendition. Slight cosmetic changes also differentiate the C-type lenses, which have a black finish to their filter ring the additional 'C' after the code letter for the number of elements. The C-types were introduced from 1967 and remained in production into the early 1970's.

The K-Type

Most K-type lenses were fitted with a rubber covered focusing ring, which makes them instantly recognisable from their predecessors. Their depth-of-field rings were usually finished in black, but otherwise their internal construction was the same as the C-types. By the time the K-versions were introduced the total number of different lenses in the system had risen to 50. During 1977, after a relatively short time in production, the K-types were replaced by the new N-types designed for the automatic indexing of the maximum lens aperture with the camera body. Some Nikkor lenses were never available in a K-version.

The N-Type

The N-type lenses saw the introduction of the new AI-system, which stands for Automatic maximum aperture Indexing. Prior to this the value had to be conveyed to the camera's exposure meter by the pin-and-prong coupling on the lens and body. After the lens was attached the aperture ring had to be rotated once completely to the right and once to the left. On the cameras and lenses in the AI system a cam on the lens' aperture ring, known as the Meter Coupling Ridge, indicates the maximum as well as the preset aperture directly to the camera. This cam is located at slightly different positions on the ring depending on the speed of the lens. All manual focus lenses introduced in the N-type series and later AI-S series retained the meter-coupling prong in order that they could be attached to earlier 'pre-AI' cameras. These lenses can be distinguished by the two cut outs in the prong either side of the central notch. Another identifying feature of the N-type is the second smaller scale of aperture values on the rear edge of the aperture ring, which can

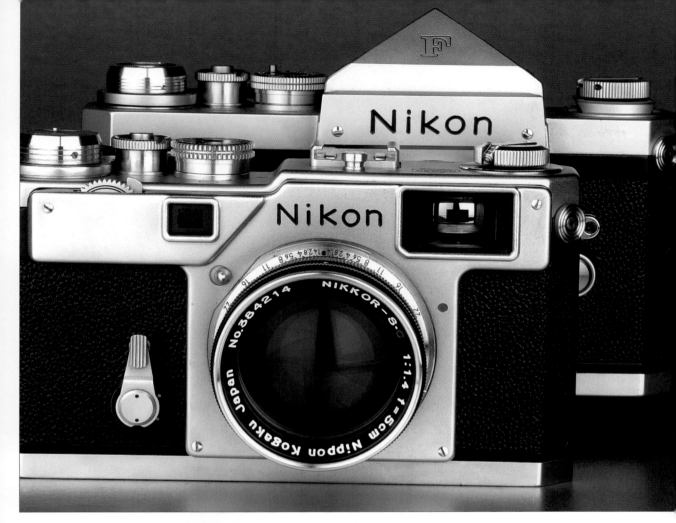

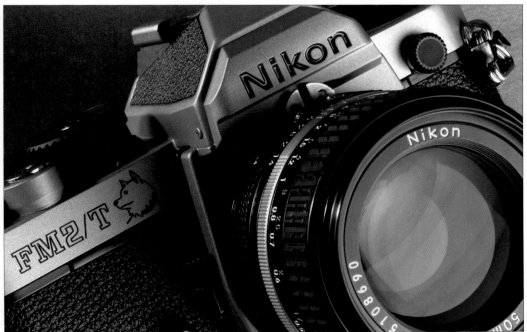

Above:
A Nikon S3
rangefinder with
Nikon F SLR.

Left:
Introduced in 1994
this limited edition
of the Nikon
FM2/T was made
to mark 'The Year
of the Dog'.

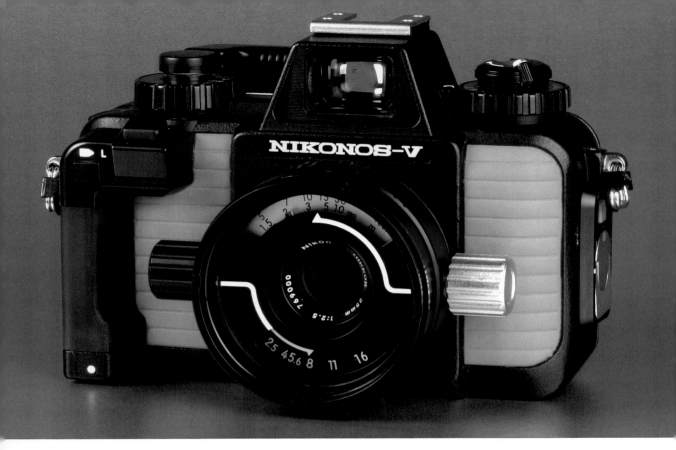

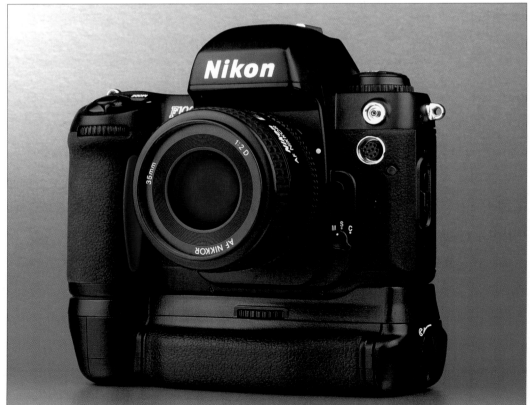

be read in the viewfinder of most AI-standard cameras. Nikon calls this system Aperture Direct Readout (ADR).

For a while Nikon offered a service to convert earlier pre-AI lenses to the new AI-system standard. Although the required conversion kits have been out of production for over ten years, it is still possible to have a lens converted by a workshop provided the necessary parts can be sourced. An original AI-lens and a modified lens can easily be identified as the latter has an additional lens speed indexing post located right next to the rear lens element and their new aperture rings carry the second aperture value scale.

The mechanics of the N-type lenses were improved. In earlier lenses the double helix that moves the optical system away from the film plane when focusing at close range causes the focusing ring to move forwards as well. To improve handling the two helixes in the N-type lenses have different thread pitches. So whilst the optical system is moved forward, the focusing ring is only displaced by a fraction of a millimetre. The depth-of-field scale is now located on the chrome ring between the focusing and aperture rings. Generally the N-types have a small advantage in terms of reduced size and weight compared to previous Nikkor optics.

The AI-S Type

This lens series was introduced in 1982 to compliment the forthcoming Nikon FA camera, which was introduced the following year. The orange-coloured minimum aperture value marking, and a milled semi-circular notch in the bayonet ring distinguish AI-S lenses. The notch is designed to inform Nikon cameras that employ a mechanical automatic aperture control for different exposure modes, such as the FA, that a

lens with a linear aperture mechanism is attached. This means that for every millimetre the aperture-coupling lever moves the stop-down of the lens aperture occurs in equal amounts. In a non-AI-S type lens movement of one millimetre by the coupling lever results in a non-linear amount of stop-down. Depending on its position this amount of movement may represent only a 1/2EV step, which increases to a 1EV step at the other end of the lever's movement range. This internal modification makes it far easier for the camera with an AI-S lens attached to control the lens diaphragm automatically in the various exposure modes.

The E-Series

The E-series lenses were introduced to compliment the Nikon EM camera for the budget conscious photographer. Their bayonet matches the AI standard except for the meter-coupling prong required for earlier pre-AI camera bodies was omitted. To help reduce production costs the focusing ring and the helix were made of plastic, and the 35mm, 50mm and 100mm lenses only had a single lens coating on their elements. In all the other lenses in this series the individual lens elements were all multi-coated.

The AF-Type

Nikon's first lenses designed for automatic focusing were the 80mm and 200mm optics introduced during 1983 with the F3 AF camera. These lenses have internal focusing motors and although they can be used with other AF Nikon cameras their focusing performance is positively agricultural compared to the present crop of AF Nikkor lenses.

The first versions of the current AF-Nikkor series were introduced during 1986 with the F-501. Their bayonet flange design is essentially

the same as an AI-S type, but without the meter-coupling prong. The most obvious difference is the slotted end of the focusing drive shaft that can be seen set into the lens' bayonet ring. Once the lens is attached to an AF camera body the drive shaft from the camera engages in this slot to couple the two together.

Internally the lenses are fitted with a central processing unit (CPU) to communicate specific lens data to the camera's autofocus drive and exposure metering systems, via a set of electrical contact pins located around the rear edge of the lens mount. To ensure correct functioning of the AF lenses in the various automatic exposure modes, which requires them to be set to their minimum aperture value, there is a small locking button that protrudes above their aperture ring. The focusing helixes were replaced by a cam construction similar to that employed in zoom lenses to change the focal length. This was done for two reasons. First to reduce the load on the focusing motor, which would otherwise have had to move the traditional greased helices, and second to increase the response time of moving the lens elements to provide a sufficiently quick AF system.

Many photographers found the general handling of these early AF lenses infuriating. The very low resistance to the rotation of the focus ring when operating them manually and their narrow focus rings did little to endear them to professionals and enthusiasts alike. So much so that some who missed the traditional Nikon 'feel' reverted to using manual focus Nikkors!

In 1987, to compound matters, Nikon almost sparked a revolution amongst their loyal followers when they announced their intention to replace all manual focus Nikkors with AF versions. Fortunately Nikon

145

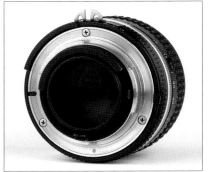
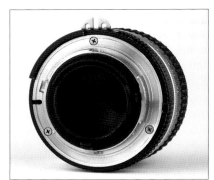

saw sense and a number of manual focus Nikkors have remained in production to the present day. Beginning in 1988 the company responded to the criticism from photographers concerning the design of the first generation AF Nikkors, and began to replace them with lenses that have more traditional, wider rubber coated focusing ring, and a greater focussing resistance to improve their manual focus action. The small minimum aperture-locking button was also re-designed as a sliding switch set in to the lens barrel, which is much easier to operate and provides a more streamlined profile. Despite these changes the advances in exposure and autofocus technology introduced with the Nikon F90, which was launched in 1992, combined with calls from sports and news photographers who demanded a faster AF system, meant Nikon had to re-think the concept of their AF lens design even further. This resulted in the modification of the CPU's

Nikon's principle lens versions shown from left to right, and top to bottom: The first A Type with no screw heads protruding through the lens mounting bayonet (this type cannot be converted to the AI standard), later A Type with screw heads showing (this type can be converted to the AI standard), C Type with its scalloped focusing ring, K Type with a rubber finished focus ring, N Type with its AI aperture indexing cam on the aperture ring, AI-S Type with a milled notch in the mounting bayonet ring, the AF-D series which lacks the meter coupling prong, has a series of electrical contacts and the slotted end of the AF drive shaft located on the lens mount.

incorporated in all AF Nikkor lenses, and changes to the AF drive system of some longer focal length lenses.

The AF- I Type

The first principle modification was the incorporation of the AF-drive motor and gear train into the lens itself. Sensibly Nikon chose to do

this in the case of long focal length lenses in which the focusing elements must travel a considerable distance between infinity and the minimum focus distance thus taking longer than in most other shorter lenses. The first AF-I lenses the 300mm f2.8 and 600mm f4, where the I is used to denote an integral coreless focus motor, appeared early in 1992. Two further lenses followed them: a 400mm f2.8 and finally a 500mm f4. Ultimately these four were the only lenses to be introduced in the AF-I series.

Potential users of these AF-I

Nikkors should be aware that their AF system will only operate with cameras such as the F5, F4, F90, F90X and later AF Nikon cameras equipped with the electronics to communicate with them. The AF-I lenses offer a number of very convenient additional features: the M/A mode that permits manual override of the autofocus operation at any time, a focus range limiter to eliminate unnecessary lens movement, and four AF-lock buttons situated around the front end of their barrels to improve their handling. An important feature of the AF-I type is that they do not require any electrical power to be operated manually and can therefore be used on non-AF camera bodies.

The AF-D Type

As has been described in earlier chapters that deal with Nikon camera bodies, starting from the introduction of the F90, Nikon sought to make use of the focus distance information to determine the whereabouts of the main subject and thus further refine exposure control for both ambient light and flash. A new version of AF lenses was introduced at the same time as the F90. These have a modified CPU that provides the approximate focus distance of the lens to the camera in order this information can be incorporated with the exposure calculations performed by the camera's metering CPU. These AF-D Nikkors are a key component of the '3D Matrix-Metering' system. During the course of the past decade the AF-D type has replaced virtually all the original AF Nikkors. The same technology is also included in the newer AF-S and AF-G variants.

The AF-S Type

The AF-S type lenses are the successors to the AF-I types, and as their name implies they incorporate a silent wave motor (SWM) that converts linear travelling wave energy into rotational energy to move lens elements for focusing. The AF-S motors are both smaller and quicker than the earlier AF-I coreless motors allowing for physically smaller lenses to be designed with an increase in AF speed of around 15%. The technology was first introduced during 1995 with three long fast lenses: the 300 f2.8, 500mm f4, and 600mm f4. A 400mm f2.8 lens followed and then in 1999 Nikon started to introduce a range of shorter zoom lenses with SWM technology beginning with the AF-S 80-200mm f2.8 and 28-70mm f2.8 lenses.

The AF-G Type

The AF-G type represents the latest innovation in lens design from Nikon and marks the end of the near universal compatibility of Nikkor lenses with all camera bodies from the Nikon F SLR of 1959 onwards. The reason for this is simple the AF-G types have no aperture ring. They are intended for more recent cameras that allow the aperture to be set via a control on the camera body, such as the F65, F80, F100, F5, D100, and D1 series. They can also be used on earlier AF cameras like the F4, F90, F70, and F801/s, but you are limited to only the Program and Shutter Priority exposure modes.

Special Features Of Nikkor Lenses

Nikon have employed a number of techniques and materials to offset the effects of the laws of optics for many years. One of the most important is their Close Range Correction (CRC) system. In the cases of extreme wide-angle lenses and lenses with large maximum apertures there is usually a marked reduction in image quality if they are used at short range. To reduce this problem the CRC design employs a number of 'floating elements' that move within the lens as the focus distance changes. This helps to keep the image quality as high as possible, even when shooting at very close distances. The system is used in many fisheye, wide-angle, Micro-Nikkors, and medium telephoto lenses of both manual focus and AF lens systems.

Nikon initially conceived their

This diagram shows how an internal focusing system avoids any change in the length of a lens as it is focused, as opposed to a conventional helicoid mechanism, which does alter.

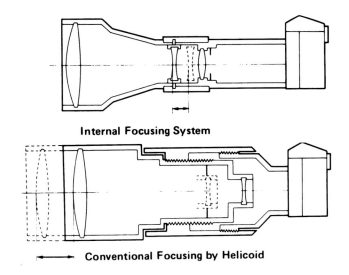

Internal Focusing System

Conventional Focusing by Helicoid

Internal Focusing (IF) system for long telephoto lenses. In early conventional lenses as the focus is adjusted from the infinity position the whole optical system is moved forward by the helical focusing mechanism. On a long fast lens this would require considerable physical effort, be slow to operate, and make the lens rather heavy. At short ranges, when its extension is at its greatest, the centre of gravity of the lens is shifted forwards unbalancing the camera lens combination. IF eliminates these drawbacks by moving only one small lens group inside the lens. This makes it easy to use long fast lenses even for hand-held shots. Even at close range, the lens will not change its length or its centre of gravity during focusing, and image quality is maintained as well. More recently Nikon have incorporated IF into many shorter lenses, particularly wide-angle AF zoom types where the system helps to prevent a reduction in image quality caused by curvature of field in a similar way to the CRC system.

The advent of the AF lenses has seen the introduction of another focusing system known as Rear Focusing (RF) in which the lens elements are divided into specific groups, but only the rear lens group moves. This improves both the speed and smoothness of the AF operation.

Nikon developed Extra Low Dispersion (ED) glass to counter the effects of chromatic aberration that occurs when light of various wavelengths passes through optical glass and is brought to focus at slightly different points. This problem is particularly prevalent in long fast lenses with large maximum apertures, because at the plane of the film or CCD the depth of focus at maximum aperture is exceeded by the distance between the points of focus for the various wavelengths.

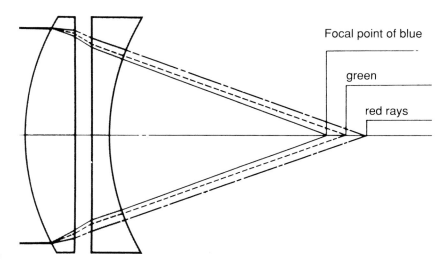

Focal point of blue

green

red rays

This diagram shows the effect of chromatic aberration; different wavelengths of light are brought to different focal points. Nikon developed Extra Low Dispersion (ED) glass so that the various wavelengths arrive to the same focal point.

The result is a visible colour fringing and general reduction in sharpness. ED glass causes the focal points for different wavelengths to converge far more closely providing a significant improvement in sharpness and even when the diaphragm is fully open. Nikon now regularly use ED glass in much shorter lenses, again particularly the complex wide-angle zoom lenses and ultra-wide angle optics such as the AF Nikkor 14mm f2.8D ED. A gold coloured band around the lens barrel distinguishes all lenses that incorporate ED glass. It not only signals their exceptional image quality, but often their significantly higher price due to the unusually high manufacturing costs involved in the production of ED lenses. One common feature of all telephoto lenses with ED glass is that their focusing rings turn beyond the infinity position. This is due to the fact that depending on the ambient temperature the length of the lens can change due to the expansion or contraction of the barrel, as it gets warmer or cooler. These changes are of the order of a fraction of a millimetre, but still significant as they lead to a shift of the focus point. To accommodate this shift the focus rings move beyond their infinity position.

The original Nikon Integrated Coating process introduced during the 1960's has be refined and modified over the years and the current Nikon Super Integrated Coating represents the state of the art in minimising reflection in a wider range of wavelengths and superior flare reduction qualities. The number of coatings applied to each lens element remains an integral part of the overall design of the lens to ensure a uniform colour balance across all Nikkor lenses.

Standard Lenses

A focal length of 50mm is considered to be 'normal' for the 35mm film format as its angle of view of 46° approximates to the field of view and perspective of the human eye. Most 50mm lens designs are optically quite simple, which allows for a fast maximum aperture without an unduly high price. The slowest of the standard Nikkors is the 50mm f2. The seven-element Nikkor-S

The very first version of the Nikkor 50mm f2 lens; the Nikkor-S with the IR index-mark denoted by the letter 'R'.

The Nikkor-H 50mm f2 lens has six elements.

50mm f2 was the first Nikkor for the Nikon F. The first version can be identified by the IR index mark, which is shown with a red 'R' and small coloured index marks against each aperture value. This type is often referred to as the 'Tick' mark type. The second version of this Nikkor-S has a red dot to indicate the IR focus point and the index marks on the aperture ring are omitted. Production ended during January 1964.

It was succeeded by the Nikkor-H 50mm f2, a six-element design, which remained essentially unchanged, except for improvements to the lens coating and addition of a rubberised focusing grip, until it was discontinued in 1979. This lens performs well in close-up work thanks to its seven elements and almost perfectly symmetrical layout. By restricting the lens to a rather modest maximum aperture the design ensures excellent image quality all the way into the corners of the frame even at full aperture.

In 1978 it was replaced by the 50mm f1.8 that has slightly modified optics and an increase in lens speed of 1/3-stop. This lens offers an outstanding optical performance, especially in the range of f4 to f8, with good contrast and colour saturation due to the application of

Later versions of the 50mm f2, like this K-Type, have rubberized finish to their focusing ring.

NIC. In 1985 a modified version, the 50mm f1.8N, appeared with slightly different optics and internal mechanics drawn from the E-series version, which makes it a very compact lens that is just 36mm long. This lens has NIC applied to all its elements to maintain the contrast and colour qualities of its predecessor. The 50mm f1.8E is an economical lens that was introduced for the EM and FG cameras. It has a plastic lens barrel, only a single coating on the lens, and no meter-coupling prong. Although sharp its performance is not quite up to that of the mainstream Nikkor version. The introduction of the AF F501 camera brought about the first AF version of the 50mm lens, the 50mm f1.8 AF. As mentioned earlier these first

generation AF Nikkor suffered from a number of drawbacks including very narrow focusing rings. In 1989 this lens was modified with a wider focus ring that had an increased resistance to ensure more positive manual operation. The lens is also extremely good for close-up work when it can be combined with either an extension ring or bellows. It remained unchanged as a standard AF-type until early 2002 when Nikon announced that it would finally be upgraded to AF-D specification.

The faster 58mm f1.4 was introduced for the Nikon F shortly after the 50mm f2 lens. It is a seven-element design that has the familiar chrome filter ring of A-type lenses, but curiously the red 'R' and aperture index marks of the first version of the 50mm f2 were never applied to this particular lens. It was only produced for three years and discontinued in January 1962. It successor, the 50mm f1.4 also has seven elements, but with considerably improved image quality. This lens has undergone numerous changes and modifications over the years to keep pace with Nikon's introduction of new lens types. Conversion to the AI standard brought about improvements to the optical quality and a smaller more compact design. The most recent AI-S version, introduced during 1984, has a very short focusing movement from infinity to the closest focus distance. The first AF version from 1986 has the unpopular narrow focus ring, which was later modified to allow better manual focus. The most recent variant has the same optical construction and qualities of its predecessors and is of the AF-D type. All lenses in the 50mm f1.4 class have excellent optical qualities with later versions demonstrating the best contrast and colour saturation due to their improved multi-coating.

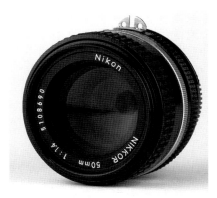

Probably the most popular 50mm lens is the fast 50mm f1.4; this is the AI-S version. Note the meter-coupling prong has drilled out centres.

The 45mm f2.8P lens contains a CPU to maintain full compatibility with a variety of exposure modes. It also has a dedicated and colour matched HN-35 lens hood, NC filter and lens cap.

On the AF version of the 50mm f1.4 the meter-coupling prong is omitted, but the meter-coupling ridge can be seen around the rear of the aperture ring.

However, like most fast lenses I cannot recommend using any of them reversed for close-up or copy work.

In 1967 Nikon introduced the 55mm f1.2. This very fast lens has a seven-element design and was intended to extend the boundaries of available light photography. It weighs a hefty 425g, and whilst its size and bulbous front element are impressive its optical quality leaves a little to be desired especially when used wide open. The corners are soft until stopped down to f5.6 and its optimum overall performance occurs around f8. This is not to denigrate this lens though because it was designed with speed rather than the highest optical quality as a pri-

ority. Like many Nikkors this lens received a number of updates and modifications during the 1970's culminating with conversion to the AI standard in 1977. It is a little known fact that this lens is particularly susceptible to knocks from the side due to the relatively thin mounts used for the lens elements, which are designed to produce as compact a lens as possible. A severe lateral

blow can lead to a misalignment of the elements. The 55mm f1.2 was succeeded by the 50mm f1.2 during 1978. The first version was introduced in the AI standard and subsequently updated to the AI-S type in 1981. The newer lens has a significantly better optical performance particularly at the critical widest aperture and is slightly lighter at 390g.

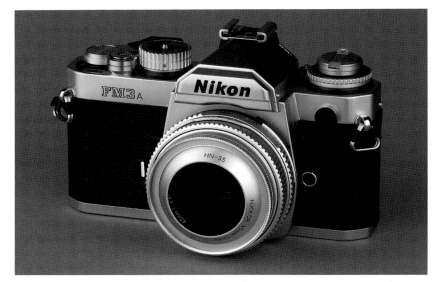

The Nikkor 45mm f2.8P was introduced to compliment the FM3A camera, and they make a very compact combination. The lens is available in either a chrome finish, as here, or black to match the body colour.

In an age when many photographers could be forgiven for thinking that most manufacturers have dispensed with the production of manual focus lenses for the 35mm film format, Nikon sprung a very pleasant surprise in 2001 when they announced the Nikkor 45mm f2.8P lens. Introduced to compliment the then new Nikon FM3A camera the lens is similar in size to the much earlier GN-Nikkor 45mm f2.8. It has a simple 4-element 3-group Tessar-type design that gives a 50° angle-of-view. Ultra-compact it extends just 17mm in front of the camera, only weighs120g, and takes 52mm filters. Although a manual focus optic it has a built-in CPU so that it is compatible with all exposure modes on modern Nikon cameras, including the F5, F100, F80, F65, and of course the FM3A. It has the advantage of Nikon's latest multi-coating technology and a nine-blade diaphragm to improve the appearance of out-of-focus highlights. The lens is incredibly sharp and produces images with full contrast and colour saturation. Initially released with an elegant chrome finish on the outer surface of its barrel an all black version is now available as well. The lens is supplied with a Nikon NC filter and the dedicated HN-35 hood, which match the finish of the lens.

Wide-angle Lenses

Nikon has a long pedigree in manufacturing high quality, practically distortion-free wide-angle lenses for their 35mm SLR cameras.

13mm Wide-angle

First introduced during 1975 the 13mm f5.6 covers an angle of 118°. This extraordinary lens has only ever been available to special order with its equally extraordinary price supplied on application! The front element has a diameter of almost

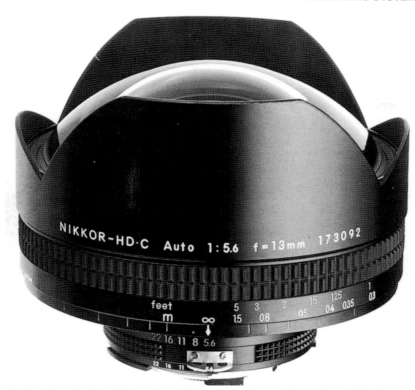

The focal length of the Nikkor 13mm f5.6 is still the shortest in the 35mm (135) format, with an angle of view of 118°.

11cm and is surrounded by a fixed 'petal' style lens hood. It weighs in at 1200 grams and represents the widest rectilinear lens design available for the 35mm format. The slightest tilt of this enormous wide-angle will cause any vertical line in the image to converge dramatically. Understandably, filters cannot be mounted in front of the spherical front element instead they are attached at the rear. The first version of the lens was supplied with four filters: yellow, orange, red, and a natural density. In 1977 the lens was updated to the AI standard, and in 1981 the third version was introduced with the AI-S type lens mount and a different set of filters that include a skylight, orange, pale amber and pale blue.

14mm Wide-angle

A brand new focal length for Nikon this lens was first introduced during

2000 to compliment the D1 series digital cameras, which due to the dimensions of their CCD offer an effective 1.5x magnification of lens focal length. So this optic equates to a 21mm focal length of a 35mm film camera when attached to one of the Nikon digital SLR cameras, including the new D100.

As with other ultra-wide lenses the 14mm has a fixed 'petal' style lens hood and a large spherical front element that cannot be filtered. The lens has a metal spring clip set around the rear element for the attachment of gel filters that need to be cut to size. The optical design incorporates 14 elements two of which are aspherical types and one that is made of ED glass. For a relatively compact lens it weighs a hefty 670g. To facilitate fast AF operation it employs Nikon's Rear Focus (RF) system, which gives an incredible short focus throw and an impres-

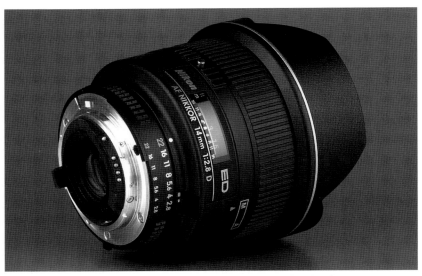

The Nikkor AF 14mm f2.8D ED; note the fixed petal shaped lens hood.

sively close focus distance of just 0.2m.

I have to confess to a great affection for this lens, which I acquired as soon as it was available. It produces wonderfully sharp, crisp images wide open and these qualities improve even further as the lens is stopped down to f8 – f11. The ED glass ensures vivid saturated colour across the range of apertures. There is a mere hint of vignetting at its maximum aperture, which is all but

gone by f4. Although susceptible to flare due to its extreme 114° angle of view the lens controls this significantly better than the earlier manual focus 15mm Nikkors.

15mm Wide-angle

As a more modest alternative to the 13mm optic Nikon have produced a range of 15mm focal length lenses beginning with the 15mm f5.6 introduced in 1973. The first version has 15 elements in 12 groups and a

rotating filter turret that introduces a UV, yellow, orange, or a red filter into the light path. It has a fixed scalloped 'petal' style hood and weighs 560g. In 1974 a second version with a modified optical construction of 14 elements was introduced, and the final update took place during 1976 when the lens was upgraded to the AI standard.

It was succeeded during 1979 by the Nikkor 15mm f3.5, which has the same impressive 110° angle of view and incorporates the CRC system for improved close focusing performance. The new lens dispensed with the integral filter turret and uses bayonet fitting 39mm filters attached at the rear. The scalloped hood is an integral part of this lens and as with other extreme wide-angle Nikkors serves more as a protection for the vulnerable large front element than as an effective hood. The lens was adapted to the AI-S type during 1982 and in this form remains in production to the present day.

18mm Wide-angle

The Nikkor 18mm f4, which became available during 1975, was intended as a less costly alternative to the 13mm and 15mm ultra-wide lenses. It has formidable coverage of 100° and rapidly became a favourite lens of many landscape and architectural photographers partly due to its far more modest size and weight of just 315g. This lens with its 86mm filter thread is one of the last to be designed for the use with Series 9 filters that mounted between the barrel and the hood. In 1977 it received an update to the then new AI standard. Discontinued in 1982 it was replaced by the currently available 18mm f3.5, which offers a number of advantages. The use of the CRC system improves close range performance down to the minimum focus distance of 25cm, it

The huge front element of the Nikkor AI-S 15mm f3.5 lens dwarfs this FE2 camera.

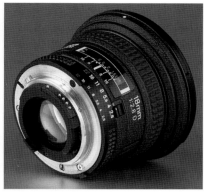

The Nikkor 18mm f2.8D lens has a 77mm filter thread and is the widest fixed focal length that can accept filters over its front element.

accepts standard 72mm thread filters, and although slightly heavier at 350g it is more compact. The optical performance was also improved with maximum resolution being achieved around f8-f11.

In 1993 Nikon introduced a new version of the 18mm lens as an AF optic. The 18mm f2.8 AF-D lens has the familiar crinkle style finish of metal barrel AF lenses and due to its large convex front element, it has a 77mm filter thread and a dedicated lens hood that attaches via a bayonet fitting. At 385g it is both heavier and more bulky than its manual counter part. It employs the RF sys-

tem to ensure fast AF operation and corner-to-corner sharpness, however, I believe this lens suffers from not having any ED glass in its construction as colour rendition lags behind other contemporary AF Nikkors.

20mm Wide-angle

Nikon's very first 20mm was the Nikkor-UD 20mm f3.5 that consists of 11 elements in 9 groups, has a 72mm filter thread and weighs 390g. It was introduced in 1967 and at the time represented Nikon's most extreme wide-angle lens and also the first retro-focus design of this focal length. Prior to this only the 21mm f4 originally conceived for the rangefinder models had been available. Handling of this optic is awkward to a say the least as the reflex mirror has to be locked up before the lens can be mounted, and an external viewfinder attached for it to be used. On the other hand it only has eight lens elements in six groups, accepts 52mm filters, and at just 135g it is very light. These days it is regarded more as a collector's item.

The successor to the UD 20mm f3.5 is the 20mm f4, which also has a 52mm filter thread, and was pro-

The Retro-focus Design

Wide-angle lenses present a particular problem for designers due to the laws of optics. On any SLR camera there needs to be sufficient clearance between the rear of the lens and the film plane to allow the reflex mirror sufficient space to swing up out of the light path at the moment of exposure. Below a certain focal length it is not possible to achieve the required distance with a conventionally designed wide-angle lens. An example of this is the early Nikkor 21mm f4 for the Nikon F, which can only be used with an additional viewfinder, and the camera's mirror locked in the up position. So designers must incorporate some additional lens elements that allow the rear element of the lens to be positioned further away from the film plane whilst still providing the same angle of view. These designs are known as Retro-focus lenses and their optical configurations have the beneficial side effect of reducing vignetting. Nikon also employ their Close Range Correction (CRC) system of floating elements in many of their lens designs to further improve their performance when shooting at short distances.

duced between 1974 and 1978. Its 10 element 8-group design achieves nearly the same image quality in a far more compact and lighter (210g) construction. This version received the update to the AI standard during 1977.

In 1979 it was followed by the even more compact 20mm f3.5. The newer lens lacks the CRC system but this does not appear to compromise the image sharpness at close ranges even down to the minimum focus distance of 30cm. It does, however, demonstrate considerable curvature-of-field, which can be a major disadvantage in certain shooting situations. The principle attribute of

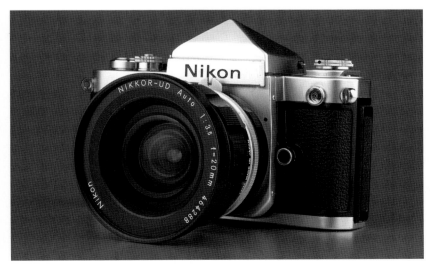

A Nikkor-UD 20mm f3.5 lens mounted on a standard F2.

153

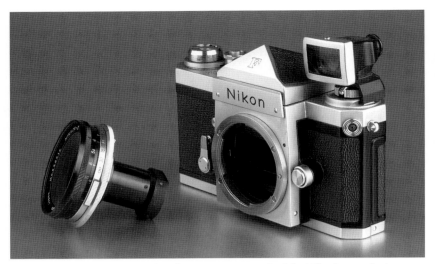

The Nikkor AI-S 24mm f2.8 has remained a favourite with many photographers since its introduction.

The original 2.1cm lens, introduced in 1959, was conceived for Nikon's rangefinder cameras. It requires the reflex mirror to be locked up before it can be mounted on an SLR like this Nikon F.

this lens though is its formidable ability to control flare and ghost imaging, which makes it ideal for shooting in to bright light sources. This lens received the conversion to the AI-S standard during 1981.

The most recent version is the 20mm f/2.8 introduced from early 1985. It is without doubt the best 20mm Nikkor yet and provides excellent image quality with even coverage from corner-to-corner. Use

The Nikkor AF 20mm f2.8D lens has a 62mm filter ring and uses the CRC system for superior image quality even at close range.

of the CRC system ensures the best possible image quality down to the shortest focusing distance of 25cm, although the 12-element design is not as good at controlling flare as its predecessor. It is a compact lens that weighs just 260g and accepts 62mm thread filters.

Nikon introduced an AF version with an identical optical construction to the manual focus version during 1989. Externally the lens matches other AF Nikkors with the window above the distance scale and a wide rubberized focus ring. Then following the introduction of the F90 camera the lens was updated to the newer AF-D specification to make use of the 3D-metering pattern. Otherwise the lens is identical to the earlier AF version and produces the same outstanding performance. It remains in production in this form to the present day.

24mm Wide-angle

The Nikkor 24mm f2.8 is a venerable favourite among countless thousands of photographers. It first appeared in 1967, and it quickly gained a reputation as an outstanding optic. This was due no doubt to

the fact it was the first Nikkor to employ the CRC system that helps to maintain image quality at close focus range. The original 9-element, 7-group design was up-dated in 1977, with the introduction of a new optical arrangement that uses 9 elements in 9 groups and a lens mount that conforms to the AI standard. This newer version exhibits even less vignetting than its predecessor, which was already very low, although it seems slightly less able to control flare compared to the earlier lens design. There is a perceptible curvature of field at short distances so avoid using his lens to copy flat subjects. Its peak performance occurs in the range of f5.6 to f11. The same optical design was adopted for the AF version that was first introduced in 1988. As with all other first generation AF Nikkors this lens suffered from the narrow focus ring and loose feel to the focus action. The second AF version addressed these deficiencies, and in 1993 the lens was updated to the AF-D specification whilst remaining unchanged in all other respects.

Nikon's other twenty-four is the 24mm f2, which was introduced in 1977. Although it is a stop faster and uses the CRC system in my opinion it does not offer the same all round performance of its slower sibling. If you require the fast maximum aper-

The AF-Nikkor 24mm f2.8D represents the latest in this line of popular lenses.

ture, and can accept the rather soft corner performance and its great susceptibility to flare, then the f2 variant is an ideal lens for low available light photography. The first version is of the AI standard and in 1981 it was updated to the AI-S lens mount type, but otherwise its specification was unchanged and it remains in production.

28mm Wide-angle

For many enthusiast photographers the 28mm focal length is the 'standard' wide-angle. The first version appeared in 1960 in the form of the Nikkor-H 28mm f3.5. It has six elements in six groups and covers a 74° angle of view. Despite its modest

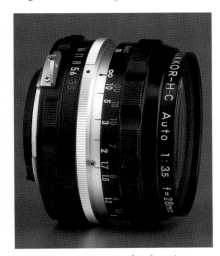

The Nikkor-H.C 28mm f3.5 lens; its modest specification belies a more than capable performance.

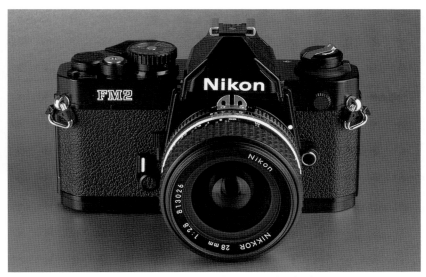

The AI-S version of the 28mm f2.8 has eight elements and Nikon's CRC system.

specification this lens in its various forms provides an excellent performance when used at middle apertures of f5.6 to f8. It received several updates to its cosmetic appearance and lens coating during the late 1960's and through the early 1970's. The first significant change to the optical design appeared in 1977 when the AI standard version was introduced with a larger rear element to counter the effects of vignetting. The last version was made to the AI-S standard but finally discontinued in 1983. This lens is ideally suited for reproduction ratios beyond 1:1 when reverse mounted on a bellows unit.

The popular 28mm f2.8, which Nikon introduced in 1974, has seven elements in seven groups and weighs just 240g. The first two versions of this lens acquired a rather poor reputation due to their mediocre image quality. Their successor the 28mm f2.8 AI-S, which was introduced in 1981, changed all that. It has a completely new 8-element optical construction, the CRC system, and a reduced minimum focus distance of just 20cm. At close range this is one of the sharpest Nikkor lens ever made, and

although its performance tails off slightly at greater shooting ranges it is still considerably better than the two earlier variants.

To compliment the economically priced Nikon EM camera Nikon introduced a simple five-element design 28mm lens for the E-series in 1979. Image quality can best be described as average, but then it was a lens that was built to a specific price point, and aimed at less demanding enthusiast photographers who were unlikely to require significant enlargements from their negative and transparencies. A second variant of the E-series lens was offered that has a narrow chrome

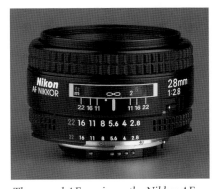

The second AF version – the Nikkor AF 28mm f2.8 N, has a wider focusing ring with a rubberized grip.

finish mounting ring around the lens barrel and a modified rubberized focusing grip. Unfortunately the AF version of the 28mm f2.8 lens adopted the same five-element design from the E-series lens and again it offers a rather mediocre performance. This AF lens has been produced in three different versions. The first, like other early AF lenses was updated to provide a wider focus ring and better feel to the focus action. This second version was subsequently modified to the AF-D specification.

Unlike the slower twenty-eights the Nikkor 28mm f/2 is an outstanding lens, which due to its relatively higher price and moderate angle of view has never enjoyed the status achieved by other Nikkor

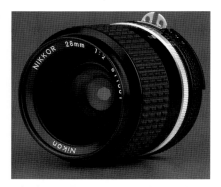

The fast Nikkor AI-S 28mm f2 is the best performing manual focus twenty-eight, its performance is only surpassed by the even faster AF 28mm f1.4.

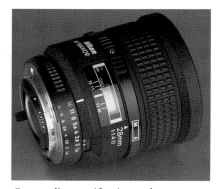

Outstanding specification and performance, but at a price: the AF-Nikkor 28mm f1.4D.

lenses. First introduced in 1971 its 9-element design remained unchanged up to and including the AI version from 1977. Its optical quality is apparent even at full aperture and the CRC system, which unusually operates on the front group of elements, ensures this performance it maintained at close range. Peak performance occurs between f4 and f5.6 and resistance to flare and ghost imaging is very impressive. The change to the newer AI-S standard saw the introduction of an 8-element design, which reduced the minimum focus distance to just 25cm. This lens has a comparable performance to the earlier version.

For a time, following the introduction of their AF system, Nikon concentrated on the design and production of wide-angle AF zooms with modest maximum apertures. They announced a sensational lens in 1993; the AF-Nikkor 28mm f1.4D. This extremely fast lens, which weighs 520g, takes 72mm filters, and has 11 elements in 8 groups, incorporates a completely new design, an aspherical element, CRC, and the RF system to ensure an impressive performance at any aperture and distance setting. Optimum quality is achieved between f4 and f11, but even wide open this lens excels in terms of contrast and colour correction, although the extreme corners are a little soft until f4. Its one drawback is its relatively high price, which currently exceeds that of a new F5 body!

35mm Wide-angle

The 35mm focal length covers an angle of view of 62° and has frequently been adopted by many photographers as an alternative to the 50mm focal length. Over the years Nikon has offered three different speeds within this popular focal

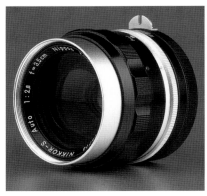

This is second version of the original Nikkor-S 35mm f2.8 design.

length. The first 35mm introduced in 1959 was the Nikkor-S 35mm f2.8 with seven elements, that weighed just 220g. As with other early Nikkor lenses released for the Nikon F camera this version has a red 'R' to denote the IR focus point. The second version from 1962 dispensed with this marking and has a simple red dot in its place. A new lens with a recomputed optical arrangement that uses six elements was introduced in 1975. This version also has a smaller minimum aperture of f22, and a smaller front element to help reduce the detrimental effects of vignetting, and extraneous light that could cause flare. Not long after the lens received the update to the AI standard in 1977, a new five-element design was introduced, which was subsequently converted to the AI-S standard in 1981. Although now discontinued the 35mm f2.8, like the 28mm f3.5, is ideally suited for use in the reversed position on a bellows unit.

Nikon did produce a 35mm f2.5 in the economical E-series, which delivered an acceptable performance, however, the target customer group for the E-series preferred zoom lenses and this fixed lens never achieved popularity. Consequently it was withdrawn from production after just three years.

Unquestionably the best seller as far as the 35mm focal length is concerned is the 35mm f2. Introduced in 1962 the first version carried the red 'R' to indicate the IR focus point and had the small index marks against the aperture values similar to the 50mm f2. Later versions have multi-coating and show cosmetic differences in their external appearance. In 1974 the third version had the aperture range extended to f22, but it remained an eight-element design. The next version received the upgrade to the AI standard during 1977. The most recent variant of the manual focus lens is the AI-S type introduced in 1981. The 35 f2 is a classic design that offers a well-balanced compromise between speed, sharpness, freedom of vignetting, and compact size. The six-element AF Nikkor 35mm f2 is a completely new design that equals the performance of the manual focus lens at the centre but is somewhat inferior in the extreme corners. The AF version has a smaller front element and is significantly lighter at just 205g due to the use of lightweight materials in its construction. The lens was subsequently modified to the AF-D type following the introduction of the F90

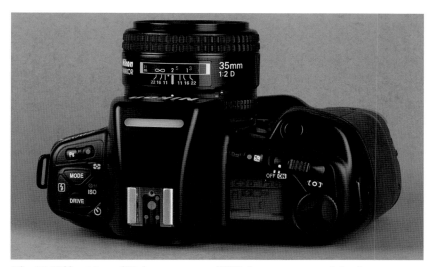

The AF-Nikkor 35mm f2D, here seen on an F90X, has a re-computed six-element design.

camera to make the lens fully compatible with the camera's 3D metering system.

In 1971 Nikon launched the very fast Nikkor 35mm f1.4. It has a nine-element design and includes CRC. Although capable of producing excellent sharpness at close range there is a noticeable amount of barrel distortion when focused this close. Whilst acceptable wide open the lens suffers from internal flare, which reduces overall image contrast, but this has all but disappeared by f2.8. Between f4 and f5.6 it produces outstandingly sharp images, however beyond f8 the quality declines. A feature of the AI version is the reduced aperture range, down from f22 to f16, which is also seen in the more recent AI-S type, but otherwise the lens design, which copes well with flare and ghosting, has remained unchanged and Nikon continue to produce it.

Telephoto Lenses

Nikon's 8.5cm f2 lens for their rangefinder cameras can rightly be credited as the lens that formed the corner stone of Nikon's early reputation. It was this optic that the well-known American photojour-

nalist David Douglas Duncan happened across during a visit to Japan. After testing the lens against his existing German lenses he enthusiastically reported its outstanding optical qualities to his colleagues. Very soon the name Nikkor became a bye word for optical quality as more and more photographers came to experience the performance of these lenses.

80mm AF-Telephoto

The AF-Nikkor 80mm f2.8, designed for the F3 AF was introduced along with the camera in 1983. It has an internal focusing motor, which by today's standards is pitifully slow. AF operation is possible on the F3 AF, F-501 and F4 cameras. Whilst the lens can be mounted on an F5 or D1 series camera for manual operation I cannot recommend this as the lens still draws a heavy current from these cameras draining their batteries in no time at all. Optically it is some what soft wide open, but in the middle range apertures it offers stunning optical quality, however, handling suffers from the narrow focus ring and resistance of the focus motor which slows the focus action.

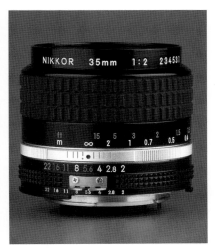

Probably Nikon's most ubiquitous 'thirty-five' is the Nikkor AI-S 35mm f2.

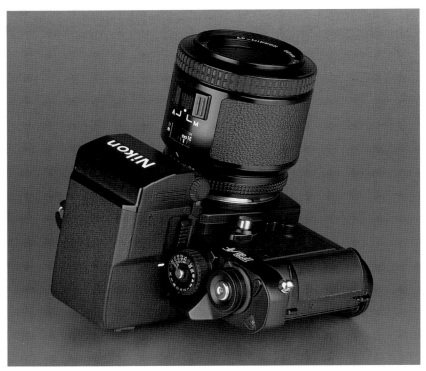

The F3 AF with its dedicated AF 80mm f2.8 auto-focus lens.

design with a maximum aperture of f/2 appeared as a successor to the earlier lens. Unfortunately this optic has never enjoyed a great reputation and is considered by many to be very much the poor relation to the f1.8 version. It lacks the familiar crisp bite of other Nikkors and although its reduced contrast is applicable to some areas such as portrait photography it performance has limited its appeal. Now discontinued it was first offered in the AI standard and later made available as an AI-S type.

Nikon introduced a real gem of a lens in 1981 with their Nikkor 85mm f1.4. It uses the CRC system, which obviates the need for aspherical elements, and delivers brilliant, crisp images full of contrast at all apertures. Whilst there is a slight loss in terms of sharpness and vignetting wide open by f2.8 this has disappeared and thereafter performance is stunning. The huge front element requires a 72mm filter to cover it and can on occasions be the source of flare. The lens is supplied with the very deep HN-20 hood,

85mm Telephoto

The first 85mm for the Nikon F SLR was the 85mm f1.8 introduced in 1964. A six-element design it delivers an excellent degree of sharpness and contrast, and it lead many professional photographers to adopt the Nikon system. It remained in production for almost 15 years during which time it remained basically unchanged. Later versions with multi-coating, which also received cosmetic changes to

the aperture and focus rings, offer the best performance that peaks around f8, however, all versions are susceptible to flare.

In 1977 a new five-element lens

A Nikkor 85mm f2 AI-S lens.

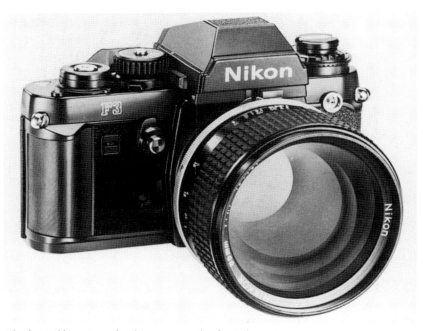

The fast Nikkor 85mm f1.4 has a spectacular front element.

which does a good job of protecting the lens. Despite its wide maximum aperture the CRC system provides excellent image quality when shooting at close ranges, although I would not recommend it for critical close-up work when copying flat subjects.

In 1988 the AF-Nikkor 85mm f1.8, a six-element lens with a filter thread of 62mm, was introduced for Nikon autofocus cameras. Its image quality is comparable to that of the first 85mm f1.8. It uses the RF system to enable fast, positive AF operation and provides an excellent image quality even at close range. The lens, which accepts 62mm filters and weighs 415g, represents a really well balanced compromise between lens speed, optical performance and cost.

The reputation of the 85mm f1.4 manual lens made many photographers ask Nikon if an AF version would be produced. They need not have worried because in 1996 the AF-Nikkor 85mm f1.4D lens arrived and surpassed their highest expectations. This lens is quiet simply stunning. Its performance wide open is significantly better than the manual lens version and as you would expect in a lens designed for low light photography peak optical quality is achieved around f2.8 to f4. The Internal Focusing (IF) system pro-

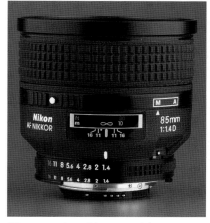

The reputation of its manual focus predecessor is not only maintained, but many photographers consider it to be surpassed by the AF Nikkor 85mm f1.4D.

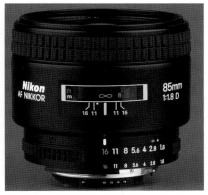

A reincarnation of Nikon's original 85mm lens specification – the AF Nikkor 85mm f1.8D.

vides very rapid AF response and the nine-blade diaphragm creates an appealing appearance in out of focus highlights.

100mm Telephoto

Nikon have only ever produced one lens with this focal length; the 100mm f/2.8E series lens. Built to a budget it has four elements, which only have a single lens coating. Consequently it delivers a very average performance and benefits from having a Nikon filter treated with the NIC process fitted at all times as well as the dedicated lens hood to help improve image contrast.

105mm Telephoto

The 105mm focal length is almost synonymous with the name Nikon. Nikkor lenses of this particular focal length have held the highest reputation for optical quality from the earliest days of the Nikon system. The first one-o-five was the rather curious pre-set 105mm f4 lens that has the same optical construction as the 105mm lens for the rangefinder cameras. Introduced in 1959 it is

Telephoto Lenses

In the 35mm (135) film format it is common for all lenses with a focal length in excess of 50mm to be called telephoto lenses. Strictly speaking a lens can only be regarded as a telephoto if its back focal length (the distance between the film plane and the rear element) is shorter than its actual focal length. In many early lens designs this is not the case and they are known as long focal length lenses. Similar to the way in which Nikon use the retro-focus design for wide-angle lenses by increasing the back focal length, additional lens elements can be used to shorten it, and create a telephoto lens such as the AF-S 300mm f4D IF-ED, which is only 222mm long.

In addition to the complex design required for a wide aperture telephoto lens manufacturers must also balance other factors including weight, size, and cost, far more so than wide-angle lenses. Fast lenses are less compact than slower types, even with an equivalent focal length. In a wide angle lens the difference between a maximum aperture of f2 compared to f2.8 results in an increase of only a few millimetres in the diameter of the front element, but with a focal length of 300mm the difference in the size of the front element between an f2.8 and an f4 optic is significant.

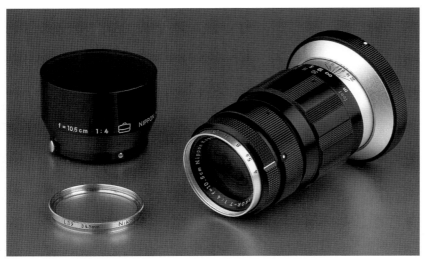

A legacy from the Nikon rangefinder lenses the 105mm f4T has a pre-set aperture and a distinctive wide flange at the rear to accommodate the lens bayonet for the Nikon F mount.

135mm Telephoto

Before the rise in popularity of the telephoto-zoom lens the 135mm focal length was frequently found in many photographs equipment bags. Nikon's first offering in this range was the Nikkor-Q 13.5cm f3.5, which produces respectable image quality, especially stopped down to around f5.6. Introduced in 1959 it has just four elements, and over the following years underwent a series of essentially cosmetic changes. In 1977 the first major modifications including a reduction in overall size, redesigned optical construction, and integral lens hood were introduced along with conversion to the AI standard. The final version, now discontinued, appeared in 1981 as the updated AI-S type.

It was not until 1965 that Nikon released a slightly faster f2.8 version of the 135mm lens. The first three versions of this lens can only be described as providing a moderate performance. In 1976 it received a significant overhaul including an extra lens element, an extended aperture range to f32, reduced minimum focus distance, and a much

quite a small, narrow lens, but has a wide flange at the rear to allow attachment the larger diameter lens throat of an SLR camera.

The first Nikkor 105mm f2.5 was also introduced during 1959 with the Nikon F camera, and has the same red 'R' IR index mark and aperture markings as other very early Nikkor lenses. This design uses five elements in three-groups as do several versions that followed it, and is a direct descendent of the legendary lens for the rangefinder cameras from 1953. In 1972 the lens was modified to five elements in four groups to improve its close range performance since this lens had become the 'standard' portrait lens. It also received a smaller minimum aperture of f32. Subsequent versions saw the conversion to the AI standard in 1977, and to the AI-S type in 1981. The lenses that use the newer optical construction offer a superior performance wide-open and outstandingly sharp resolution from f4 onwards. The latest version of the lens has an integral lens hood that retracts over the lens barrel.

The Nikkor 105mm f1.8 launched during 1981 is a stop faster, and like

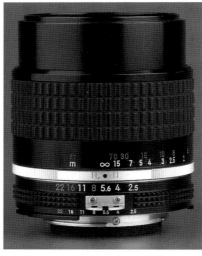

The latest version of the manual focus Nikkor 105mm f2.5 is the AI-S type lens with its retractable lens hood.

the 85mm f1.4 it is ideal for available light photography. It produces very sharp images full of contrast thanks to the extensive use of NIC. Used wide-open image quality is slightly lower but it remains impressive, with flare and ghosting reasonably well controlled. Like the latest 105 f2.5 it has a retractable lens hood. Combined with the TC-14A Teleconverter it works effectively as a 150mm f2.5 lens.

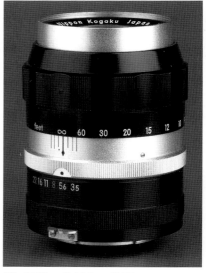

The Nikkor-Q 13.5cm f3.5 lens was introduced with the original Nikon F SLR camera.

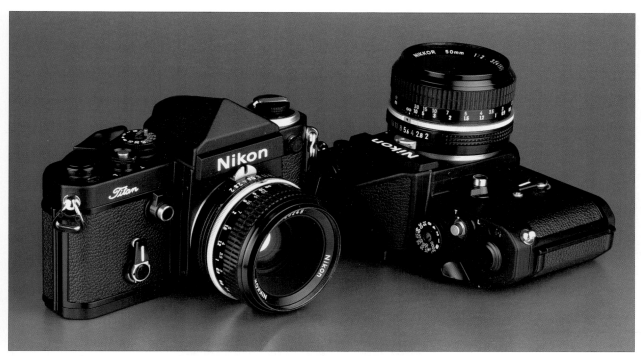

Two versions of the F2 Titan: the earlier version has the name 'Titan' on the front plate, which was omitted on the later variant.

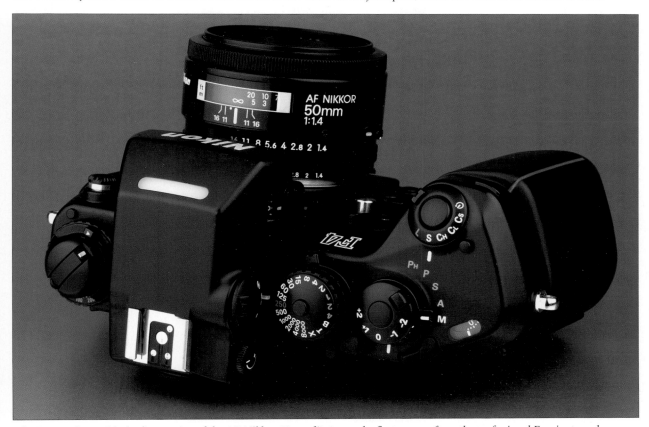

The F4, seen here with the first version of the AF-Nikkor 50mm f/1.4, was the first camera from the professional F series to embrace autofocus.

Rihgt:
The Nikon S2 with BC-5 flash bulb reflector. Note the angled flash adapter that allows co-location of the accessory viewfinder.

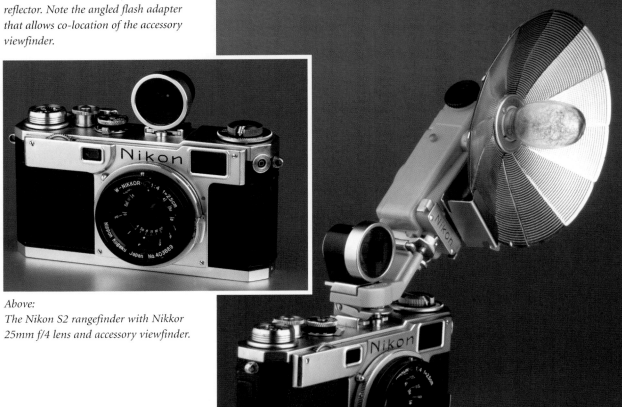

Above:
The Nikon S2 rangefinder with Nikkor 25mm f/4 lens and accessory viewfinder.

Left:
A Nikon S2 Black Dial rangefinder with accessory viewfinder for the 25mm Nikkor lens.

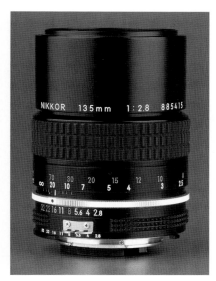

The penultimate version of the Nikkor 135mm f2.8 is the AI type.

more compact design. In 1977 the lens was upgraded to the AI standard, and the last version benefited from being reduced in size and conversion to the AI-S type.

Nikon offered an even faster 135mm lens in 1975 with the introduction of the Nikkor 135mm f2. Obviously designed for working in low light this lens is something of a compromise in terms of its optical characteristics. Wide open it provides a bright image on the focusing screen and good optical quality at middle to long ranges, however, performance at close ranges is not particularly impressive. Under certain conditions internal flare can also be a problem when used at, or near, its maximum aperture. It can only be recommended to those photographers who really need that extra stop.

For a time a 135mm f2.8 E series lens was made available for the Nikon EM and FG cameras. However, in the way that the 100mm E series lens never gained popularity due to the preference for zoom lenses on the part of enthusiast photographers the same applies to this longer optic. Its four-element design achieves a respectable image quality, but with only a single lens coating its performance cannot be expected to match that of other prime Nikkor lenses.

180mm Telephoto

The Nikkor 180mm f2.8 created a sensation when it was introduced in 1970, and it is another one of the legendary lenses in the Nikon system. This five-element lens only weighs 800g in spite of its high specification. It can focus down to just 1.8m and accepts 72mm filters. A second version had a number of cosmetic changes and the third version saw it upgraded to the AI standard. The first major changes occurred with the introduction of the AI-S type in 1982. The newer lens has ED glass and a re-computed optical arrangement of 5-elements in five groups. The optical performance of this version is far superior to the previous lenses, especially used wide open, and around f5.6

The second AF version of the 180mm f2.8 has a much-improved manual focus ring.

would be difficult to beat. At the time it became the first choice for many sports and press photographers, but subsequently many photographers have come to value this lens when used in combination with extension tubes for close-up work.

In 1986 an AF-version of the 180mm was introduced. To reduce the load on the focusing motor the lens has an IF design in which only the central group of elements are moved. This arrangement also allows image quality to be maintained down to the closest focusing distance of 1.5m. In common with other first version AF-Nikkors this lens has a narrow focusing ring and a plastic lens barrel, which unfortunately gives an impression of inferior quality. So two years later it was modified and fitted with a wider focusing ring, and a sliding switch toward the front of the lens to select either AF, or manual operation. In the AF-mode the focusing ring is locked, but in the manual focus mode the focus action suffers from the drag of AF mechanics. The lens barrel is constructed from metal and has the hammered finish of other top quality Nikkors. The optical construction of 8-elements in six groups remained unchanged. In 1995 the lens was converted to the AF-D type. Wide open this version performs very well, but stop it down to f4 and below and its true qualities come to the fore. It is a very impressive optic, with high contrast and colour saturation as well as excellent sharpness, which surpasses the manual version. It is one of the best ever Nikkor lenses. The only aspect to draw criticism is the inadequacy of the short integral lens hood.

200mm Telephoto

The first 200mm lens available from Nikon arrived 1961 in the form of the Nikkor-Q 200mm f4. It is a four-element design that delivers a

rather mediocre performance. Like so many other early Nikkors it went through a variety of modifications, mostly cosmetic, until 1976, when a new five-element design was introduced. This version has a better all round optical performance thanks

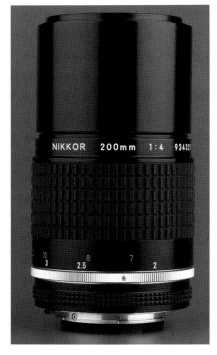

to NIC being applied to the elements, and is slightly lighter at 540g. The final version, which weighs even less at 510g, is the AI-S type that appeared in late 1981. This has a slimmer profile compared to the AI version and a smother focusing action. Optically the last two versions are very sharp even wide open, and can be used with confidence when combined with supplementary 3T and 4T Nikon close-up lenses.

The AF-Nikkor 200mm f3.5 IF-ED with its integrated AF-motor was one of the two lenses available for the F3 AF. In terms of quality it can be compared to the manual focus 180mm f/2.8 IF-ED. Otherwise its use is limited in the same way as the shorter 80mm lens for the F3 AF as described above.

Nikon's reputation and expertise in producing long fast lenses is legendary. Their range of fast telephoto lens that incorporate IF, and ED glass is the epitome of the highest optical quality. The shortest focal length in this series is the Nikkor 200mm f2 IF-ED first introduced in

1977. It has ten elements, accepts 122mm filters and weighs a hefty 2300g. The rapid focusing of the IF system works down to the minimum focus distance of 2.5m, and a rotating tripod collar improves handling when mounted on a support. Peak performance, which is outstanding, is attained between f2 and f5.6, but beyond this it declines appreciably. Although it can be used with teleconverters there is a drop in overall optical quality. In 1982 the lens was modified to the AI-S standard, and then in 1985 it was modified again with the fitting of an integrated glass plate to protect the front element, a slip-in gel filter holder, and a two-piece lens hood. A favourite for indoor-sport and concert photography this fast telephoto lens is ideal whenever the camera-to-subject distances are not too great.

300mm Telephoto

The first 300mm Nikkor lens, the Nikkor 300mm f4.5 appeared in 1964. A five-element design it provides an acceptable performance

The Nikkor AI-S 200mm f4 lens turns in a very capable performance, even when used with supplementary close-up lenses.

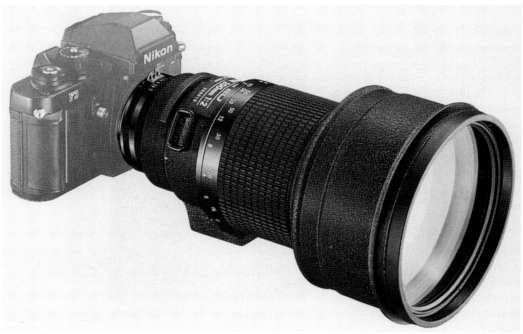

The shortest focal length offered as a wide aperture telephoto the Nikkor 200 f2 IF-ED.

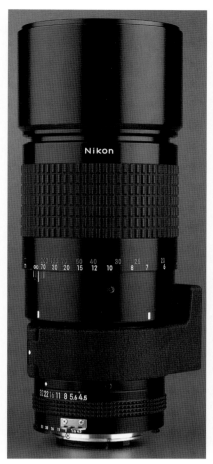

The last variant of the Nikkor 300mm f4.5 lens is the discontinued AI-S version.

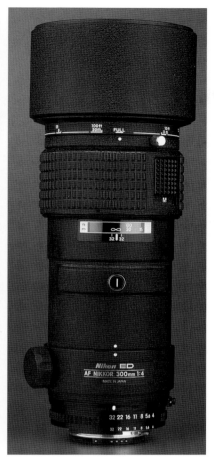

The first compact AF 300: the 300mm f4 has outstanding optics but its AF performance is pedestrian.

when stopped down a couple of aperture values from its maximum. A second version with a completely new six-element design was introduced in 1969. Subsequent versions have a number of cosmetic changes, and in 1977 it was modified to the AI standard. In 1981 a new optical configuration was used again with six elements in a wider profile design. This lens has a number of improvements including a removable tripod collar, an extended aperture range to f32, and a closer minimum focus distance of 3.5m.

The effects of chromatic aberration begin to become significant at this focal length so in 1975 Nikon launched an alternative lens with ED glass that has a much-improved

optical quality. Two years later this lens, the 300 f4.5 ED was upgraded to the AI standard, however, it was still built with large helices that make focusing slow to operate. In 1978 it was replaced by the 300mm f4.5 IF-ED which offers far quicker and more convenient focusing thanks to its IF system. Its optical performance around f8-f11 is beyond criticism, but not quite as good wide open or closed down beyond f16. The minimum focus distance of this version is significantly lower at 2.5m, and the lens benefits from a much slimmer profile, and removable tripod collar.

Nikon's first compact AF 300mm lens was the AF-Nikkor 300mm f/4

IF-ED, which appeared in 1987. A third of a stop faster than its manual focus counterpart it has IF and ED glass, and produces superbly sharp images comparable to those obtained by the faster f2.8 version but at a fraction of the cost! To allow for the AF mechanism and increased speed of the lens its barrel has a wider profile, and the front element has an unusual size 82mm filter thread. However, there is a slip in filter draw towards the rear of the lens that accepts 39mm thread or gel filters. The focusing action can be limited to various ranges between infinity and the minimum focus distance of 2.5m by turning a ring set around the barrel just in front of the focus ring. This helps AF speed as well as conserve battery power. The lens has a retracting, integrated hood, which is too short to be of any real benefit, and a rotating tripod collar. Even by contemporary standards at the time of its introduction this lens suffered from a ponderously slow AF action, and its handling when attached to a lightweight camera is hindered by it being somewhat front heavy.

The first AF 300mm f4 was one of the few Nikkor lenses not to receive an update to the AF-D specification and it remained in production until 2000 when it was finally replaced by the long awaited AF-S 300mm f4. On paper this lens looks impressive as in addition to IF and ED glass the minimum focus distance is reduced to an incredibly short 1.5m, and it has the latest Silent Wave motor technology to drive the AF from within the lens. Optically it is superb and produces images of the highest quality from corner-to-corner, and the AF action is fast and positive. Sadly this lens has a major flaw: its tripod collar. Used in the critical range of shutter speeds between 1/30sec and 1/2sec, when the effect of camera vibration is

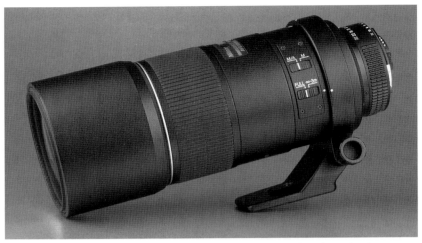

The Nikkor AF-S 300mm f4 IF-ED lens has outstanding optical qualities, but its performance is marred by poor handling characteristics.

most likely to manifest itself, many photographers found the collar and foot to be insufficiently rigid to guarantee sharpness. Although unconfirmed by Nikon it appears the collar underwent a re-design around mid-2001, and whilst this seems to have addressed the issue of rigidity all is still not well. I believe the root cause of the problem has

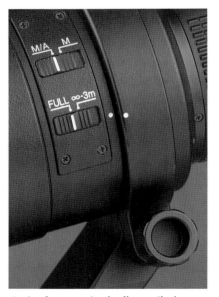

An inadequate tripod collar spoils the early versions of the AF-S 300mm f4 IF-ED, and although later versions have a more rigid foot, the clamping action can still be ineffective.

more to do with the collar's locking mechanism. In my opinion the locking knob of the collar is too small, therefore, if it is turned to no more than a normal 'finger-tight' fit the collar is still not gripping the lens properly. Whilst making sure you do not over tighten the collar it is important to ensure that it is done up firmly. I also consider the omission of focus lock buttons around the lens barrel detracts from its handling capabilities. After all Nikon fitted them to the AF-S Zoom-Nikkor 80-200mm f2.8D, so why not this lens?

The first long fast telephoto introduced by Nikon was the Nikkor 300mm f2.8 ED. It weighs 3000g, has a pre-set aperture, and a conventional helicoid focusing mechanism, but only a handful were ever made. The next version was a pre-production prototype that was introduced for the Montreal Olympic Games in 1976, but again this lens is extremely rare due to the very low number that were actually made.

In 1977 the 300mm f2.8 received an overhaul. Weight was reduced to 2500g and it was redesigned with an automatic diaphragm, a lens mount of the AI standard, IF, retractable

integrated lens hood, an adjustable click-stop ring that allows a preset distance to be set, and a slip-in filter draw for 39mm filters. The lens balances well thanks to the IF system and its optical quality is outstanding due in no small part to the ED glass. It caused a sensation in the ranks of sports, wildlife, and fashion photographers, because used wide open they could apply selective focus to isolate their subjects from the background without any fear of the image quality suffering. The next version of the lens was introduced in 1982 following an upgrade to the AI-S standard otherwise specification remained the same. The final version was launched in 1985. This lens has a plain glass plate fitted to protect the front element, a new two-piece detachable lens hood, and a reduced minimum focus distance of 3m.

In 1987 an AF version was introduced. At 2700g it weighs slightly more and it is fitted with a focus range limiter and AF/manual focus selector switches, but otherwise specifications are the same as for the manual version. Many photographers found the play in the focusing ring of the first AF-version during manual operation, caused by the autofocus drive train rather distracting. Optically though its eight-element design produces outstandingly sharp images with a high degree of contrast and colour saturation.

Nikon's first AF-lens with its own built-in autofocus drive motor was the AF-I Nikkor 300mm f2.8D IF-ED. It has a coreless DC motor that provides a significantly faster and quieter AF action compared to the previous version. New features seen for the first time in this lens are the four focus lock buttons set around the front end of the lens barrel, and the M/A mode, which allows the photographer to take manual control of the focusing at any time as

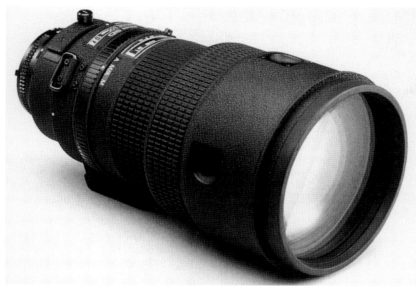

Nikon's M/A focus mode, that allows near instantaneous interchange between manual and auto focus was first seen in the Nikkor AF-I 300mm f2.8 IF-ED.

soon as the focus ring is touched. AF resumes the moment the ring is released. This lens requires no electrical power for manual focus and is therefore compatible in this mode with earlier non-AF Nikon cameras. Optically it is absolutely first class rendering the sharpest of images with crisp contrast and fully saturated colour.

As AF technology moved on even the speed of the AF-I lens began to look a little sluggish so in 1996 Nikon introduced the AF-S Nikkor 300mmf2.8D IF-ED. This lens has a Silent Wave motor (SWM) that uses ultrasonic waves to produce a rotary motion to drive the lens elements, thereby eliminating any mechanical action that would otherwise generate noise. Equipped with the SWM and new software this lens has noticeably quicker AF compared to the AF-I version. The optical construction was also revised and comprises of 11 elements in 8 groups. The iris diaphragm has nine blades to produce softer out of focus highlights, and the slip-in filter draw now accepts 52mm filters. It has a minimum focus distance of 2.5m and weighs 3100g. During 2001 Nikon introduced their second generation of long fast AF-S lenses. All have reduced weight and closer minimum focus distances. The AF-S Nikkor 300mm f2.8D IF-ED II weighs just 2560g and focuses down to 2.3m in AF mode and 2.2m with manual focus. Optically this latest version of the 300mm f2.8 leaves absolutely nothing to be desired, and is without doubt the best Nikkor of its type so far. Cosmetically the lens has a new smoother finish to the outer surface of the lens barrel and a different pattern on the rubberized grips of the focus ring.

In 1983 Nikon presented the Nikkor 300mm f2 IF-ED. A giant of a lens with a front element 15cm in diameter and weighing 7000g it balances surprisingly well on a tripod. Optically it is outstanding and is ideally suited for fast action indoor sports. Although unconfirmed it is likely that no more than 300 units were ever produced so the lens was instantly of interest to well-heeled collectors as well as practitioners who required its unique specification. It was supplied with the dedicated TC-14C Teleconverter which turns it into a 420mm f2.8, and it also performs extremely well with the TC-301 providing a 600mm f4 optic.

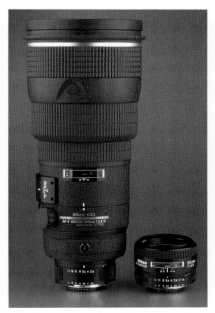

The first AF-S version of the 300mm f2.8 IF-ED is shown here with a Nikkor 50mm f1.4D for comparison.

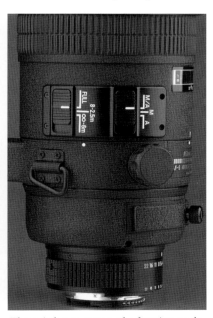

The switches to operate the focusing mode and range limiter are set on the lens barrel of the AF-S 300mm f2.8 Type I lens.

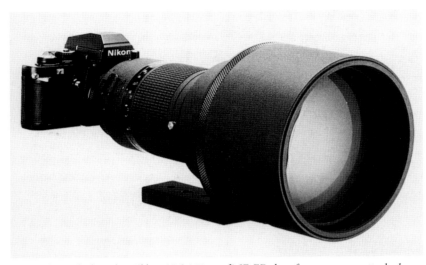

A leviathan of a lens the Nikkor AI-S 300mm f2 IF-ED dwarfs any camera attached to it.

400mm Telephoto

Nikon's first long lens design, that is with a focal length of 400mm or more, comprised of two separate sections, a focusing unit and a lens head of a particular focal length. The first two versions of the focusing mount were designated FU for Focusing Unit. The FU Model 1 and FU Model 2 can be distinguished by the colour of their focus ring. On the former it is light grey and on the latter it is black. They both offer an aperture range of f4.5 to f22, but they do not have an automatic diaphragm and must be preset for metering and shooting. These units were succeeded by the AU-1 (Aperture Unit) focusing mount, which was introduced with the later versions of the lens heads that have ED glass. This offers an improved focusing action, a colour coded distance scale to denote the focus distance for the four different focal length heads that could be fitted to it, an automatic diaphragm with a range of f4.5 to f22, and a filter holder that accepts 52mm filters. It can be fitted with a detachable focusing lever to assist the focus action. The shortest focal length head for these focusing units is the

400mm f4.5, a four-element design 275mm long that was introduced in 1964.

The Nikkor 400mm f5.6, the first single piece 400mm lens, was introduced in 1973, it has five elements and a filter thread of 72mm. Two years later it was updated by the incorporation of ED glass and a slightly modified focusing unit and tripod collar. The third version of this lens appeared in 1977 and has the AI standard lens mount and remained in production until the early 1980's. Nikon introduced a far

superior 400mm f5.6 lens during 1978 that has internal focusing (IF), and ED glass. The use of these allowed the designers to produce a lens with a much slimmer profile, lower weight, and a minimum focus distance 1m shorter than the non-IF variant. This 400mm f5.6 IF-ED lens was subsequently converted to the AI-S lens mount standard in 1982, and represents the best of the slow 400's made by Nikon. Image quality is excellent used wide open and improves slightly by being stopped down to f8, but it does not compare with the performance of the faster 400mm lenses or the other super-telephoto Nikkors described below, which are all optimized to provide optical quality second to none at their widest apertures with size, weight, and cost considered as secondary priorities.

In 1976 the Nikkor 400mm f3.5 IF-ED appeared and at the time was the world's fastest 400mm lens. The first version made to the pre-AI standard was in production for a very short time. It was succeeded by a new lens with the AI lens mount in 1977, and was followed by the AI-S type in 1982. All versions have the same optical construction of 8 elements and weigh 2.8Kg. A very well

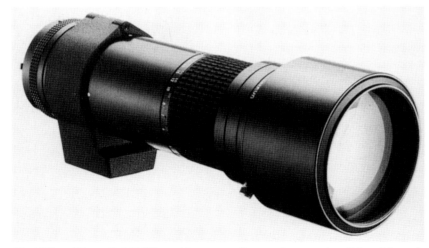

The Nikkor 400mm f5.6 IF-ED combines an excellent performance in a lightweight and compact package.

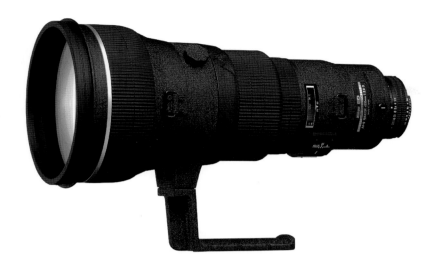

The Nikkor AF-S 400mm f2.8D IF-ED Type I lens – a favourite with sports photographers.

f2.8D IF-ED. At 6300g this lens is even heavier than the non-AF variant. It has an integral DC coreless motor to drive the AF, a D-type specification CPU to relay distance information to the cameras' metering and exposure control systems, the A-M focusing mode that allows manual override of autofocus operation at any time, and four AF lock buttons set around the front of the lens barrel. The new optical construction uses 10 elements in 7 groups and the minimum focus dis-

balanced design it is quite possible to use it hand held. The only drawback is the totally inadequate retractable lens hood that hardly protrudes beyond the front element. The same cannot be said of the next 400mm lens to be introduced by Nikon in 1985, again another world first in terms of speed, it is the Nikkor 400m f2.8 IF-ED. A giant lens that weighs 5250g it can only be used with some form of support. It has a fixed plain glass plate to protect its huge front element and a slip-in filter holder that accepts 52mm filters. Despite its size it handles extremely well and produces stunning images at its maximum aperture; quality is maintained until around f8 after which there is a perceptible decline. This is a common characteristic of all the fast super-telephoto Nikkors because their optical design is biased towards wide apertures.

Late in 1993 an AF-version was introduced, the AF-I Nikkor 400mm

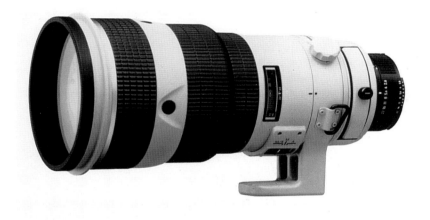

Nikon produce a number of popular telephoto focal lengths and zoom lenses in a light grey finish. The AF-S 300mm and 400mm f2.8 IF-ED Type I lenses are shown here.

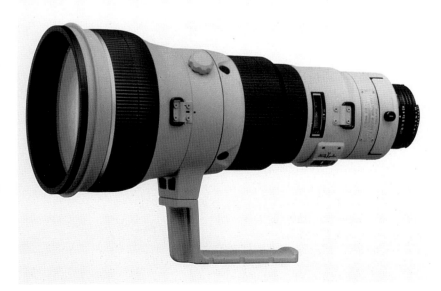

tance (MFD) is reduced to 3.3m compared to 4m for the manual focus version.

During 1998 a totally redesigned version of this lens appeared that has the benefit of a Silent Wave Motor (SWM) and a new optical arrangement. To say the Nikkor AF-S 400mm f2.8D IF-ED lens is a significant improvement over the AF-I version is an understatement. By using resin and carbon fibre in its construction and modified elements the weight has been reduced to 4800g. The AF is incredibly fast and very positive, especially when combined with the F5 or D1 series cameras. The lens features four focus lock buttons on the barrel, the M/A mode, a nine-blade diaphragm, a slip-in draw for 52mm filters, and can focus down to 3.8m. In 2001 the latest version of this lens was introduced featuring identical optics. Nikon use a magnesium alloy in its construction to reduce weight to 4440g. The MFD is reduced to 3.5m in AF mode and 3.4m for manual focus. Externally the lens has a new smooth hammered finish and modified profile on the rubberized grip on the focus ring.

500mm Telephoto

The Nikkor 500mm f4 P IF-ED, introduced in 1988, filled a gap in the Nikon lens stable. Although it is a manual focus lens it has a CPU so it can be used with appropriate modern camera bodies to maintain compatibility with their metering and exposure control systems. It rapidly became the favourite lens of many sports and wildlife photographers who appreciated its compact design and, at 2950g, its relatively low weight. The lens has a filter draw for 39mm screw thread filters and a locking collar for selecting a pre-set focus distance.

In 1993 Nikon introduced its first AF 500mm the Nikkor AF-I 500mm

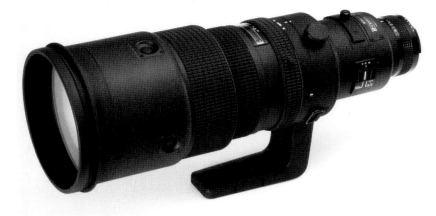

The AF-I 500mm f4 IF-ED lens was the first Nikkor in this class of focal length offered with auto focusing.

f4D IF-ED. The lens retains the same 5m MFD and 39mm filter draw of the manual lens but has a new 9 element optical design, the familiar four focus lock buttons of the AF-I series lenses, but it weight increased significantly to 4200g. The lens was updated in 1996 with the introduction of the AF-S version, which has a new optical arrangement of 11 elements, weighs 3800g, MFD of 5m, accepts 52mm filters in the slip-in filter draw, and a nine bladed diaphragm. The SWM and new software in the lens' CPU provides a quicker, more positive AF response.

In common with the fast 300mm and 400mm AF-S telephoto lenses this lens was also upgraded during 2001 with the MFD being reduced to 4.6m in AF mode and 4.4m for manual focus. Its weight was also reduced to just 3430g by using a magnesium alloy in its construction.

600mm Telephoto

Nikon's first 600mm lens, introduced in 1964, was the f5.6 lens head for the FU and AU-1 focusing units. In 1975 a second version with ED glass was introduced that provides a much superior optical performance. However, one year later it

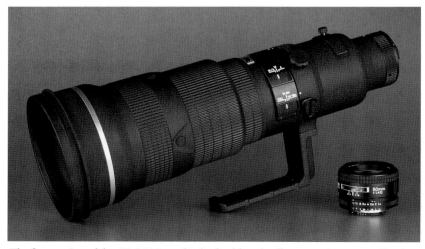

The first version of the AF-S 500mm f4; the focal length offers a ten times magnification over the AF 50mm f1.4D lens seen next to it.

was replaced by the Nikkor 600mm f5.6 IF-ED. It went through a number of principally cosmetic changes over the years, whilst its 7-element design and weight of 2700g remained unchanged. It is considered by many photographers to be optically superior to the faster f4 version. In 1977 it was fitted with the AI standard lens mount and in 1982, with conversion to the AI-S type mount, it received a smaller minimum aperture of f32. The final version introduced in 1985 has a plain glass protective plate over the front element and the MFD is reduced to 5m.

Nikon's fastest super-telephoto lens, the Nikkor 600mm f4 IF-ED, was released in 1977. The first version weighs 5200g, has an MFD of 6.5m, and was supplied with the TC-14 (1.4x) teleconverter. In 1982 the lens was updated to the AI-S specification lens mount and was fitted with a sturdier tripod collar and foot, which lead to an increase in overall weight to 6300g. The third version, which weighs 5650g, appeared in 1985 with a modified barrel profile and a fixed plain glass plate to protect the front element. Both the AI-S variants, which have a 7.5m MFD, work particularly well

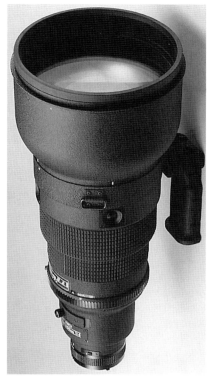

The first AF version of the fast 600mm Nikkors was the AF-I variant.

with the TC-14B teleconverter to provide an effective 840mm f5.6 lens, however, optical quality suffers when the TC-301 is attached to these lenses and can only be recommended when no other solution is available. All three versions have a

slip-in filter draw for 39mm thread filters.

The first AF lens in this focal length was the AF-I Nikkor 600mm f4D IFED, which appeared in 1992. Using a DC coreless motor similor to other AF-I lenses, it has a totally redesigned optical arrangement of 9 elements in 7 groups that produces outstandingly sharp images with superb contrast and colour saturation. It weighs 6050g, focuses to 6m, has four AF lock buttons, a slip-in 52mm filter draw, and a switch for the A/M focusing mode. The substantial foot of the tripod collar acts as a very effective carrying handle. Nikon completely revised this lens in 1996 and introduced the first AF-S version. AF operation is improved by virtue of the SWM and the optical performance enhanced even further with a new 10-element configuration. It retains the 6m MFD, four AF lock buttons, and A/M focus mode of its predecessor, however, at 5900g it is slightly lighter. In 2001 along with the rest of the fast AF-S telephotos Nikon introduced the second version of this lens, which has a reduced weight of 4750g, and MFD of 5.6m in AF mode and 5.4m for manual focus. Otherwise its specification remained unchanged.

800mm Telephoto

A focal length of 800mm was made available in 1964 in the form of a 70cm long lens head with a maximum aperture of f/8 for the FU and AU-1 focusing units. The second version introduced in 1974 has a revised lens coating, and the third version from 1975 incorporates ED glass with the consequent improvement this gives to image quality. It was not until 1978 that Nikon released a single piece 800mm lens with IF, ED glass, and an AI standard lens mount. Weighing 3300g the lens has a 10m MFD, and accepts 39mm filters in its slip-in

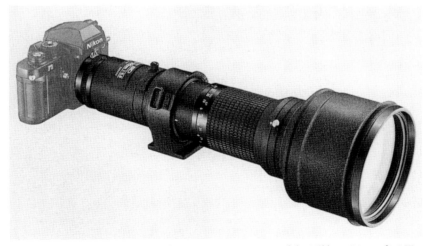

Although optically superb the modest maximum aperture of the Nikkor 600mm f5.6 IF-ED lens prevented it from gaining wide spread popularity.

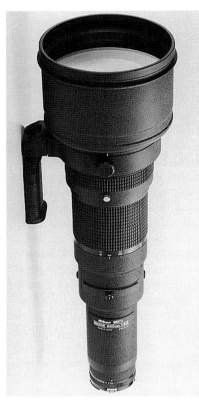

A favourite choice for wildlife photographers is the Nikkor 800mm f5.6 IF-ED.

holder. The lens was upgraded to the AI-S type mount in 1982. The f8 lens was replaced in 1985 by the faster f5.6 version, which made it the fastest 800mm lens available at the time. This 8-element design that weighs 5400g and accepts 52mm filters remains in production to the present day. It has become a favourite with wild life photographers, particularly for photographing birds, many of whom use it in combination with either a TC-14B to provide an effective 1120mm f8 lens, or a PK-11a extension tube to reduce the lens' normal 8m MFD.

1200mm Telephoto

Nikon first introduced a 1200mm f11 head for their FU and later AU-1 Focusing units in 1964. A modified version of this head with ED glass appeared in 1975. The main draw-

back of both head types is the minimum focus distance of 43m when used with the FU model focus units, and 50m with the AU-1. These were replaced in 1979 by the Nikkor 1200mm f/11 IF-ED, which has a far more practical MFD of just 14m and weighs a manageable 3800g. The only modification this lens received was the upgrade to the AI-S lens mount in 1982. The demand for such a long focal length has always been very small since most photographers would rather carry a shorter lens and add a teleconverter when necessary. Consequently very few of these lenses have ever been made, a fact that is reflected in their prohibitively high price.

Mirror Lenses

An extremely rare find today is Nikon's first mirror lens the Reflex-

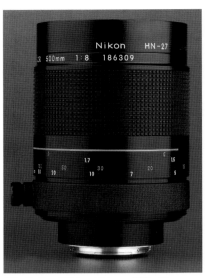

The Reflex-Nikkor 500mm f8N offers an affordable long focal length lens.

Nikkor 500mm f5, which was introduced in 1961. It is a large unwieldy lens with an MFD of 15m that is

Mirror (Reflex) Lenses

One general problem facing lens designers with all long focal length lenses is overall physical length, which tends to make a conventional lens rather unwieldy. Even using the latest lens designs and manufacturing techniques there is a limit beyond which any lens made with normal glass elements can be reduced in size. However, by folding the light path with mirrors it is possible to achieve a considerable reduction in the length and weight of a long focal length lens. This type of optic is called a mirror-lens, or catadioptric lens. Nikon refer to lenses in this class as Reflex-Nikkors.

They use a system whereby the light passing through the front element is reflected back by a concave mirror mounted toward the rear of the lens onto a second, smaller mirror mounted immediately behind the front element. This second mirror in turn finally reflects the light back onto the film. So the light is effectively folded back on itself twice before reaching the film. The major drawback of this design is the fixed aperture of the lens. This means that the exposure can only be controlled by adjusting the shutter speed or by using neutral density (ND) filters. All mirror lenses share a particular characteristic since they record out-of-focus highlights in the shape of a ring. As there is no way to avoid this effect many photographers seek to use it as a creative aspect of their overall composition.

In general, mirror lenses deliver an image quality that is slightly inferior to that of a conventional lens design with glass elements. However, the latter usually require the use of Nikon's Extra-Low Dispersion (ED) glass, which is very expensive, to limit the effects of chromatic aberrations. Mirror lenses on the other hand are far less susceptible to the effects of chromatic aberrations and are compact, lightweight, and cost considerably less. For many photographers these factors often outweigh the minor differences in performance between the two lens types.

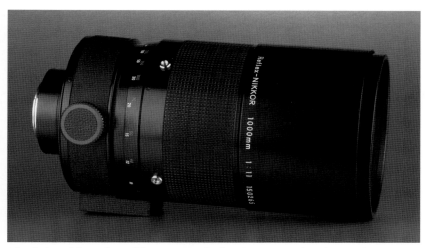

The design of the Reflex-Nikkor 1000mm f11 lens has remained unchanged for over a quarter of a century.

difficult to focus due to it narrow scalloped focus ring set toward the rear of the lens. A second version has a smoother finish to its barrel, but is otherwise unchanged and was finally discontinued in 1970. It was replaced by the slower, but much more compact f8 version that has a far more useful MFD of 4m. It has 5 elements, weighs 1000g, a rotating tripod collar, and a detachable screw-in lens hood. This lens went through a number of modifications including a new lens coating applied to models produced from 1974, and upgrading to the AI lens mount in 1977. The next model was released in 1984 and has a significantly shorter MFD of just 1.5m that provides a maximum reproduction ratio of 1:2.5. The weight was also reduced to 840g and the new 6-element design provides a far more even light distribution across the frame. It is by far the best version of the lens, although its compact dimensions mean that the proximity of stubby foot of the rotating tripod collar to the rear of the lens often causes it to obstruct larger camera bodies such as the F4 and F5 when you try to change the orientation of the camera whilst attached to the lens. I have also found that the

marked aperture value is rather optimistic and in practice the lens transmits about one stop less light. It is supplied with a set of 39mm screw fit filter that attach to the rear of the lens and are part of the optical configuration so a filter must be kept in place at all times.

In 1959 Nikon released a 1000mm f6.3 mirror lens alongside the Nikon F camera. It was available with either an F-mount bayonet, or a mirror-box for the rangefinder cameras. Although fast for a mirror lens design the f6.3 version weighs a massive 9.9kg, and suffers from having a MFD of 30m. In 1965 a modified Reflex-Nikkor 1000mm f11 was introduced, which offers a reduced MFD of just 8m and a far more

manageable weight of 1900g, but retains the same revolving filter turret of the earlier lens. A second version introduced in 1974 dispensed with this arrangement and uses 39mm screw fit filters that attach behind the rear element. The third version released in 1976, which is still listed by Nikon, has a rotating tripod collar, an improved shorter focusing action that can be assisted by the use of a screw-in lever, and a set of five 39mm filters. Like the 500mm mirror lens a filter must be in place at all times.

The Reflex-Nikkor 2000mm f11 has only ever been available to special order, and has the longest focal length and highest price tag of any Nikkor lens. First introduced in 1968 the lens alone weighs 17500g, which increases to 42500g when combined with its dedicated yoke shape mount. The first version accepts 62mm filters; the second version was modified to take 39mm screw fit filters. The most recent version launched in 1975 has an MFD of 8m that compares favourably with the 20m MFD of the earlier variants.

Zoom Lenses

The difficulty in designing a zoom lens manifested itself in the rather inferior optical quality of early examples when compared to contemporary fixed prime lenses.

The lens with the longest focal length ever offered by Nikon is the Reflex-Nikkor 2000mm f11.

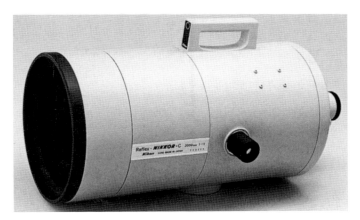

Nikon began their Zoom-Nikkor program with a telephoto lens, the 85-250mm f4.5, which appeared in 1959. The advance in optical engineering since those days has been immense to a point where today most professional and enthusiast photographers consider zoom lenses as essential tools, which they use in preference to fixed focal length lenses.

Standard Zooms

In 1960 Nikon developed their first prototype zoom to span the 50mm focal length: the Zoom-Nikkor 35-85mm f2.8 lens. However, this fast lens never went into production. The next lens, the Zoom-Nikkor 43-86mm f3.5, which was introduced in1963, had originally been developed for the Nikkorex Zoom 35 camera. This first version has a one-ring design with 9 elements, and was quiet popular despite its rather mediocre optical performance. It was revised in 1976 and received two extra elements in its optical configuration giving it 11 elements

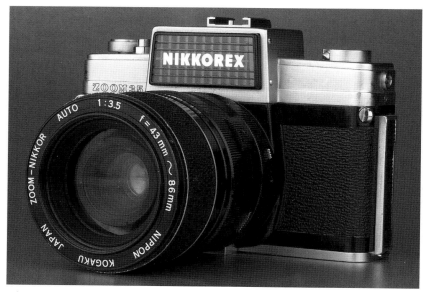

The 43-86mm lens on the Nikkorex Zoom represents Nikon's first production zoom lens to span the 50mm 'standard' focal length.

in 8 groups that provides a significantly better image quality compared with its predecessor. Zooming this lens to its longest focal length changes its overall length, which is a feature seen in many modern AF zoom lenses. The third version has the AI standard lens mount, but by

this time photographers were demanding a lens with a greater focal length range beginning at 35mm or even 28mm so production was discontinued in 1982.

The first Zoom-Nikkor to achieve a truly wide-angle focal length and still encompass the 50mm setting

Zoom Lenses

Any lens that is designed so that a group of its elements can be moved to change its effective focal length is known as a zoom lens. The complicated optical arrangement and greater number of elements required to construct such lenses meant the quality of most early types lagged far behind that of the far simpler designs of fixed focal length, prime lenses. Consequently they were considered as something of a novelty and did not enjoy a very good reputation. Now, however, optical technology has developed to the point where zoom lenses dominate the product list of most lens manufacturers, and Nikon is no exception. There is hardly a single focal length not covered by a current Zoom-Nikkor; the only exceptions being specialist optics that require extreme angles of view, very fast maximum apertures, or the ability to focus at extremely short distances for close-up and macro work. The use of computers in the design and manufacture of zooms has allowed the development of extremely complex optical configurations that for all practical purposes equal and in some cases surpass the performance and quality of prime lenses. Good examples are the latest AF-S series of Zoom-Nikkors such as the 17-35mm, 28-70mm, and 80-200mm, which all have constant maximum apertures of f2.8, and deliver outstanding performance in terms of sharpness, contrast, and colour saturation.

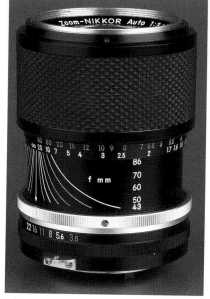

This is an example of the first type, one-ring, Zoom-Nikkor 43-86mm f3.5 variant.

The Zoom-Nikkor 35-70mm f2.8D offers outstanding optical quality, but has a rotating filter thread that impairs handling with polarising and graduated filters.

was the Zoom-Nikkor 35-70mm f3.5 introduced in 1977. This 10-element, two-ring zoom produces excellent results in terms of sharpness and evenness of illumination, however, shoot into the light with this lens and you will experience terrible flare and ghost effects. It can focus down to 1m, accepts 72mm filters, and weighs 550g. In 1982 it was modified to the AI-S lens mount, but otherwise remained the same. Shortly after this a third version of this lens appeared in the same year, except this lens has a close focus capability down to 35cm at the 70mm focal length. Physically much smaller than its predecessor it weighs 510g, accepts 62mm filters, and has a much-improved ability to control flare and ghosting, however the image quality is not as sharp as the earlier version.

In 1987 Nikon released the AF Zoom-Nikkor 35-70mm f2.8, which is an outstanding lens with crisp sharpness, contrast, and colour saturation through the focal length

range. For all intents and purposes distortion and vignetting are non-existent. It has 15 elements in 12 groups, accepts 62mm filters, and can focus to 60cm normally and to 28cm at 35mm using the close focus feature, which gives a reproduction ratio of 1:4, although there is a perceptible softness in the extreme corners at this magnification. It has a new feature seen for the first time on a Nikkor lens; a bayonet mount for its dedicated HB-1 lens hood. For a lens of this quality it is a shame the front filter ring rotates, but that is the only criticism that can be made. The second version of this lens, the AF Zoom-Nikkor 35-70mm f2.8D, which appeared in 1992, has the D specification CPU for compatibility with the metering and exposure control systems of modern cameras beginning with the F90. Otherwise, the lens remained unchanged.

In 1984 Nikon introduced the Zoom-Nikkor 35-70mm f3.3-4.5 to compete with similar lenses from the independent manufacturers. A small compact lens that weighs just 255g it is only 70mm long and accepts 52mm filters. The lens is a two-ring, eight-element design that can focus to 50cm at all focal lengths, and has a close focus capa-

The later 'N' versions of the AF Zoom-Nikkor 35-70mm f3.3-4.5 have a textured rubberised grip on a wider focusing ring.

bility at the 70mm setting that reduces this to 35cm. In 1986 Nikon offered this lens in an AF version, but like all their first generation AF lenses it suffers from having a very narrow focusing ring. So a second modified version, which carries an 'N' suffix to its designation, was introduced in 1989 with a much wider ring that has a rubberized grip. At the same time Nikon took the opportunity to revise the minimum aperture switch and replaced the earlier button style with a sliding switch. A little known lens in this class that was originally introduced to compliment the FM-10 camera released to the Asian markets is the Zoom-Nikkor 35-70mm f3.5-4.8. It weighs just 190g, has no close focus feature and a slightly slower aperture at the 70mm setting.

The predecessor of this popular standard zoom was the Nikon Zoom 36-72mm f3.5 E, an eight-element design introduced in 1981 for the entry level EM camera. Whilst cen-

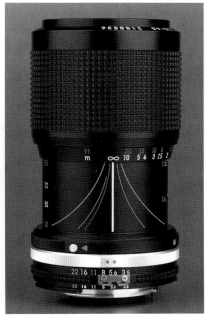

The manual focus version of the popular 35-105 was only ever available as an AI-S type.

tral image sharpness is good it can only be described as acceptable in the corners, and it suffers from strong vignetting. Hence the lens was discontinued after just two years.

Its successor the Zoom-Nikkor 35-105mm f3.5-4.5 is a different story altogether. An excellent lens it has a one-ring, 16-element design, weighs 510g and accepts 52mm filters. It has very good sharpness at all focal lengths, and whilst there is perceptible vignetting this only occurs at close focus distances, and even then is much lower than the E series lens. The lens focuses to 1.4m at all focal lengths, which can be reduced at the 35mm setting to just 27cm with the close focus feature where the maximum reproduction ratio is 1:4. The first AF version of this lens, which was introduced in 1986, is a two-ring design that is 50g lighter than the manual focus lens. Performance is similar except the push/pull zooming action is replaced by a rotating ring, and the minimum focus distance is 38cm instead of 27cm. The narrow focus ring hampers the handling of this early AF lens, so in 1990 Nikon introduced a revised version that reverts to the earlier push/pull zoom ring, has a wider rubberized grip on the focus ring, a reduced minimum focus distance of 28cm, and a lower profile sliding switch to lock the minimum aperture. As a result of these changes the weight increased to 510g. Four years later the lens underwent another extensive modification and apart from receiving the D specification CPU it has a new optical configuration of 13 elements in 10 groups and weight is reduced to 410g. A new internal focusing system allowed Nikon to dispense with the close focus feature and the lens now has a minimum focus distance of 85cm at all focal lengths. The optical performance of the

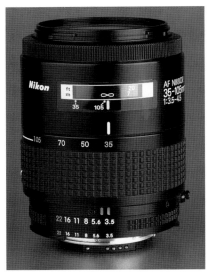

The first AF Zoom-Nikkor 35-105mm f3.5-4.5 has a two-ring design, but like many early AF Nikkors handling suffers due to the very narrow manual focus ring.

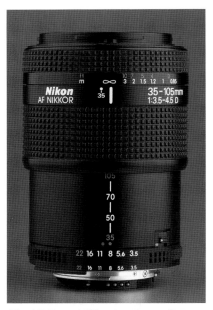

The AF Zoom-Nikkor 35-105mm f3.5-4.5D represents the final version of this lens that underwent several significant design changes during its production lifespan.

Zoom-Nikkor 35-105mm f3.5-4.5D is the best of all the versions of this lens.

In 1984 Nikon introduced a lens with a slightly longer telephoto

range. The Zoom-Nikkor 35-135mm f3.5-4.5 has 15 elements in 14 groups, weighs 600g, accepts 62mm filter, and can focus to 1.5m at all focal lengths. At the 135mm setting it has a close focus capability that reduces this to just 40cm, providing a maximum reproduction ratio of 1:4.

In a similar way to the shorter 35-105mm lens the first AF version of the longer lens has a narrow focusing ring and a rotating ring to select the focal length rather than the push/pull arrangement of the non-AF version. Otherwise the specifications remained the same. Nikon introduced a revised lens in 1989 that again reverted to the use of a push/pull action for altering the focal length, and a wider focus ring with a rubberized grip. This lens, which can be identified by the 'N' suffix to its designation never received an update to the D specification CPU and was subsequently discontinued in 1998. The performance of all versions of the 35-135mm lenses can be summed up as satisfactory rather than outstanding.

In 1993 Nikon introduced the Zoom-Nikkor 35-80mm f4-5.6, which for a lens designed for the mass-market has an outstanding performance, due partly to the inclusion of an aspherical lens element. A compact lightweight lens that weighs just 255g it has a 6 element 6 group configuration that can focus to 50cm at all focal lengths. It is a conventional rotating two-ring design that has the D specification CPU. In an effort to compete with the flood of lenses from independent manufacturers Nikon introduced a new version of this optic in 1995. Designed with economy as a priority to the Nikon purist it is something of a 'bete noire' since it was the first Nikkor to have a lens mount made from polycarbonate. It weighs just 180g, accepts 52mm fil-

ters, and the width of the focus ring was reduced so much that it is barely useable. In spite of its 'budget lens' appearance and feel the optical quality is very good.

Nikon's reputation for optical innovation was enhanced further in 1985 with the introduction of the Zoom-Nikkor 35-200mm f3.5-4.5. Any lens that covers a 6x zoom range is special and this is no exception. It weighs 740g, is nearly 13cm long, accepts 62mm filters, and has a 17-element one-ring design. It can focus down to 1.3m at all focal lengths and a close focus feature reduces this to just 30cm when the maximum reproduction ratio is 1:4 and works very well with Nikon's 5T and 6T supplementary close-up lenses. Using the latter achieves a reproduction ratio close to 1:1. Wide open the optical quality is excellent with sharp results at all focal lengths with a peak performance around f8. It has very even illumination for such a lens and distortion it well controlled with some mild barrel distortion at the short end shifting to slight pincushion at the long end. I know a number of photographers have experienced less than satisfactory results from this lens, which I can only attribute to variances in Nikon's production and quality control.

Nikon introduced a new focal length range in 1992 with the compact AF Zoom-Nikkor 28-70mm f3.5-4.5 lens. Its lightweight (350g) and low cost were the result of a new manufacturing process, which involves producing an aspherical element with a compound of glass and plastic. This key lens element accounts for the excellent performance of this little lens across its entire focal length range. Instead of using the traditional and very expensive grinding and polishing method to produce an all glass aspheric element Nikon developed a

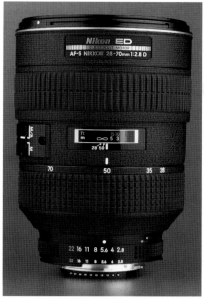

The AF-S Zoom-Nikkor 28-70mm f2.8D IF-ED

much simpler solution. After finishing the glass blank with much lower tolerances an ultra thin layer of optical plastic, with a varying degree of thickness, is applied to it to achieve the require aspherical profile. The optical performance of this 8-element lens is very good and the NIC process controls flare and ghosting to extremely low levels. The lens can focus to 50cm, which can be reduced to 39cm with the close focus feature. The lens was upgraded to the D-type specification in 1992 with the inclusion of the required CPU, but otherwise it remained unchanged.

Nikon excelled themselves in 1998 when they introduced the AF-S Zoom-Nikkor 28-70 f2.8 IF-ED. Its designation gives a clue to the totally outstanding all round performance of this Nikkor lens. It has 15 elements in 11 groups, with two made from ED glass and the front one being aspherical. It is quite a large lens that weighs 935g and can focus down to 70cm, with a close focusing capability at all focal lengths of 50cm. The SWM ensures

the AF is very quick and positive. It also has the M/A mode that allows near instantaneous switch between AF and manual control. In common with most comtemporary professional quality Zoom-Nikkors it accepts 77mm filters and it has a non-rotating filter mount. Images are extremely sharp at all focal lengths and apertures, even wide open, with a highly commendable flat field. There is only a mere hint of vignetting at 28mm and the nine-blade diaphragm provides a gentle softness to out of focus image areas. Flare and ghosting are well controlled at apertures below f5.6, but above this care needs to be taken shooting against the light.

Another lens designed to compliment the entry-level cameras in Nikon's range is the AF Zoom-Nikkor 28-80 f3.5-5.6D. Like the earlier 35-80 lens it has a polycarbonate lens mount and shares the same ridiculously narrow focus ring. You must remember though it is built to a very strict price point. A two-ring design it has 7 elements in 7 groups and for reasons best known to Nikon has a 58mm filter ring. This is a curious feature since Nikon did not make any filters in this size, although a 58mm Neutral Colour (NC) filter was released for this optic. Like its shorter sibling the optical performance is very good for a lens of this type and benefits from having an aspherical element. The complaints Nikon received in respect of the focus ring lead them to introduce a revised version of the lens in 1999 that has a wider ring, and a seven blade diaphragm to improve the appearance of out-of-focus image areas.

In 2001 Nikon performed something of a 'U' turn on the focus ring issue when they released the second of their G specification lenses, the AF Zoom-Nikkor 28-80 f3.5-5.6G. It has a very similar design to the first

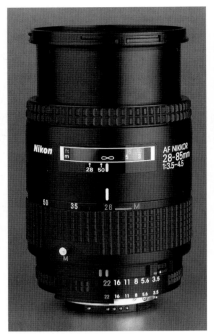

This version of the Zoom-Nikkor 28-85mm f3.5-4.5 was introduced during 1989, but it never received an upgrade to the 'D' type specification.

version of the AF-D 28-80mm, including the virtually unusable focus ring! As a G-type lens it has no aperture ring, but the diaphragm has nine blades and there is a hybrid aspherical element using the plastic-glass compound construction developed by Nikon. It weighs just 195g, can focus to 35cm, and accepts 58mm filters. Performance is comparable to the AF-D versions.

The Zoom-Nikkor 28-85mm f3.5-4.5 was a popular lens in this class. Introduced in 1985 it is a two-ring design with 15 elements in 11 groups. The minimum focus distance is 80cm, which can be reduced to just 23cm with the close focus feature. It weighs 510g and accepts 62mm filters. Optical performance is adequate with the best sharpness being reserved for the longer focal lengths. At the short end there is a noticeable softness in the corners, and flare can also be a problem. Vignetting is very apparent at 28mm

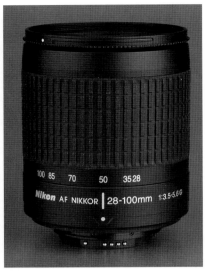

Probably the poorest quality lens to ever bear the Nikkor name: the 28-100mm f3.5-5.6G is aimed squarely at the undemanding enthusiast.

especially when the lens is used wide open. The AF version of this optic was released in 1986 and is afflicted by the usual problem of having a very narrow focus ring. Otherwise specification and performance mirror that of the non-AF type. In 1989 Nikon revised the lens design to include a wider focus ring and a sliding switch for locking the minimum aperture. All other specifications are identical to the first AF version.

The next AF Zoom-Nikkor in the G-type lens series is the 28-100mm f3.5-5.6G, which weighs 245g, has 8 elements in 6 groups including an aspherical one, focuses to 56cm, accepts 62mm filters, and has seven blades in the diaphragm. Performance of this lens can at best be described as being barely adequate; it is highly susceptible to flare, suffers from noticeable distortion, and image quality at the edges of the frame trail some way behind the central resolution, which is never that good.

Nikon released the AF Zoom-Nikkor 28-105 f3.5-4.5D IF lens in 1998 and due to its excellent performance in all departments it has become a very popular lens. It uses 16 elements in 12 groups the fourth element is an aspherical type, it focuses to 50cm at all focal lengths and between 50mm and 105mm can focus down to just 22cm, which approaches a reproduction ratio of 1:2. The lens weighs 455g, and its compact size and rapid AF performance is due in some part to the use of an internal focusing (IF) system. Images are sharp, bright, and full of contrast and colour saturation with its peak performance occurring around f8. Distortion and vignetting are both negligible and it

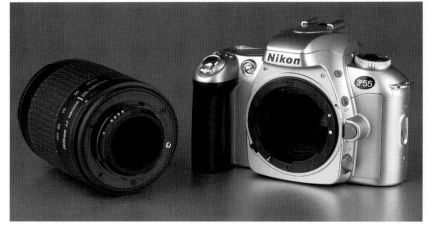

Built to a very low price point the first G-type lenses are synonymous with all the attributes of an entry-level product including an all-plastic lens bayonet.

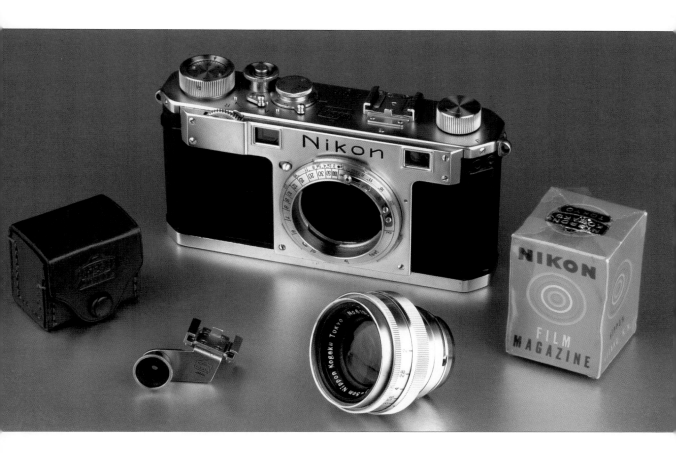

A Nikon S rangefinder and 50mm f2 lens: with an extremely rare adjustable dioptre viewfinder eyepiece, its original leather case, and film cassette in its original packaging.

Nikon Rangefinder S with an adjustable dioptre viewfinder eyepiece. Apparently never listed in any Nikon literature, including the original instruction books to the Nikon 1, M, and S models for which it was designed, the eyepiece is believed to be only the fourth known example.

Above:
The F90X was the first Nikon camera to offer shutter speeds to be selected in increments of 1/3EV steps.

Left:
The Nikon F301 marked the start of a new generation of Nikon cameras with integral motor drives.

The AF Zoom-Nikkor 28-105mm f3.5-4.5D enjoys reputation as a lens capable of turning in a very good optical performance.

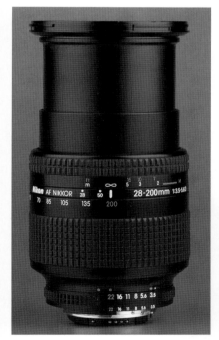

The AF 28-200mm f3.5-5.6D IF is shown here fully extended at its longest focal length.

demonstrates very good flat field qualities even at the wider aperture settings.

Many photographers like the convenience of having a wide range of focal lengths covered in a single lens. The AF Zoom-Nikkor 28-200mm f3.5-5.6D IF is a prime example of Nikon's attempts to provide them with just such an optic. A relatively short lens thanks to its IF system it has a wide profile to accommodate 16 elements in 13 groups used in the optical arrangement. Two elements are hybrid aspherical types made from the plastic-glass compound process described previously. The lens is a true two-ring design that weighs 555g, accepts 72mm filters and can focus down to 2m. This can be reduced by using the close focusing feature that lowers the distances to 1.5m at the long end and 0.85m at the short end of the focal length range. The optical performance is generally very good with a high degree of sharpness in the centre of the image. The corners do lag behind in this respect at the widest apertures, but performance is improved by stopping down to f8-11. There is noticeable vignetting at the short end together with mild barrel distortion. Pincushion can also be detected at the 200mm focal length, but again it is well controlled. As ever a lens of this type

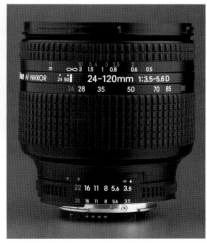

The popularity of a high zoom ratio lead Nikon to introduce the AF Zoom-Nikkor 24-120mm f3.5-5.6D IF lens.

must be considered as a compromise between convenience and optical performance, and the decision to use it must be based on the particular circumstances that the photographer will encounter and the results that are required.

The 28-200mm arrived following the success of the AF Zoom-Nikkor 24-120 f3.5-5.6D IF lens introduced in 1996. The latter is a short stubby lens that weighs 555g. It has 15 elements in 11 groups and uses an IF system to reduce its size and speed up AF response. The lens extends a considerable amount when it is zoomed to the maximum focal length, but this does not upset the balance unduly. The large front element, which requires 72mm filters, is prone to flare but otherwise optical performance is very good, particularly at the shorter end. The lens achieves a commendable level of even light distribution and achieves peak performance between f8-11 however, there is marked barrel distortion at the 24mm setting. The lens was discontinued during early 2003.

The most recent incarnation of the 28-200mm zoom range is the AF Zoom-Nikkor 28-200mm f3.5-5.6G IF-ED, announced during February 2003, which will replace the now discontinued D-type version. The lens is aimed squarely at enthusiast photographers who want an affordable, high power, portable lens. It boasts a 7.1x zoom capability, with three ED glass and two aspherical elements in its 12-element and 11-group construction. It weighs a very modest 360g, accepts 62mm filters, and at 200mm can focus down to just 44cm, where it offers a maximum reproduction ratio of 1:3.1. Supplied with the HB-30 petal shaped hood the lens is available in either silver, or black finish.

The modest aperture ranges of the two lenses just described lead to

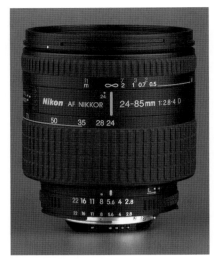

The penalty of a high zoom ratio is usually a modest maximum aperture, so Nikon introduced the fast AF Zoom-Nikkor 24-85mm f2.8-4D IF.

calls for a faster lens. Nikon responded by introducing the AF Zoom-Nikkor 24-85mm f2.8-4D IF. A compact lens that weighs 545g, it has 15 elements arranged in 11 groups, accepts 72mm filters, and can focus down to 0.5m at all focal lengths and between 35mm and 85mm to 0.21m. Although the two-ring design does not have ED glass the images are sharp, with high contrast, and fully saturated colours. Mild vignetting is apparent at the short end when used wide open, but has largely disappeared by f5.6. Unfortunately it does not demonstrate the same remarkable flat field performance of the 28-105mm lens as there is perceptible softness in the extreme corners, but again stopped down to f5.6 this is negligible. There is noticeable pincushion distortion at the long end when used at f4, and more moderate barrel distortion at the short end, though once again this is well controlled two stops below maximum aperture. Its best performance occurs between 50mm and 85mm around f8.

The first G-type Nikkor lens to be released with a specification above

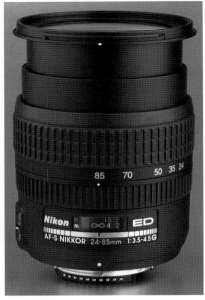

The AF-S 24-85mm f3.5-4.5D IF-ED was the first 'G' type lens that did not conform to the specification of an entry-level product.

that normally associated with an entry-level product is the AF-S Zoom-Nikkor 24-85mm f3.5-4.5G IF-ED, which became available during June of 2002. My initial impressions of this lens are rather mixed; optically I cannot fault it as images are bright, crisp, and full of contrast. Its performance makes it a good alternative to the AF-S 28-70mm f2.8 lens especially on a digital SLR, however, although its two-ring design has a very smooth action for both focus and zoom, handling suffers due to the rather narrow focus ring located closest to the camera. This arrangement is the reverse of all other AF Zoom-Nikkors, and whilst it makes sense for this relatively short lens as the zoom ring then falls more naturally to hand, I found focusing manually rather awkward. The fact that its rubberized grip also has a very low profile does not help matters. The other curious feature is the 67mm filter ring, a size that occurs nowhere else in the Nikon system. The lens has 15

elements in 12 groups, focuses to 0.38m, and weighs just 415g.

A little more than a week after Nikon released their long awaited AF-S VR 70-200 f/2.8G IF-ED lens, during February 2003, they announced the introduction of a second lens in which the AF-S and VR technology is combined; the AF-S VR 24-120mm f3.5-5.6G IF-ED lens, which replaces the already discontinued 'D' version of this 5x zoom lens.

The lens has 15 elements arranged in 13 groups. There are two aspherical elements and two ED glass elements to control the effects of chromatic aberration. A two-ring zoom, it offers a five times zoom ratio covering a useful range of focal lengths from wide-angle to medium telephoto. At 50cm the minimum focus distance is the same as the earlier 'D' version. As it is a G-type lens there is no aperture ring, so aperture values are set from the camera body via one of the command dials. The diaphragm has seven blades.

In a similar design to the AF-S 24-

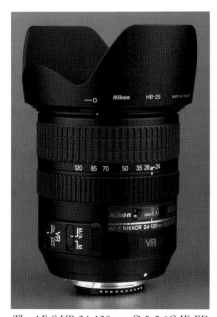

The AF-S VR 24-120mm f3.5-5.6G IF-ED is shown here with its dedicated HB-25 lens hood.

Bearing serial number 200001, this is probably the first production prototype of the VR 24-120mm G luns.

85mm f3.5-4.5G IF-ED the zoom ring of this lens is at the front, with the focus ring closest to the camera. The use of an internal focusing mechanism means that the lens does not change length due to the focusing action, and the lens hood bayonet and filter ring do not rotate. The broad zoom ring is turned counter clockwise to reduce the focal length, however, the zoom action causes the lens to extend as the focal length is increased, with maximum extension occurring at 120mm, then as the zoom is returned to the 24mm setting two sections of the extended barrel collapse inside each other.

In common with many recent Nikkor lenses there are no depth-of-field scale markings or infrared focusing index point, and the VR function is either on or off, as this lens does not offer the Normal and Active modes of the VR 70-200mm lens. Unfortunately, like its predecessor Nikon have opted for a 72mm filter thread and not the more common 77mm thread of

The full lens designation is set out on a plate next to the focus distance scale window.

many current professional grade Nikkors. It comes supplied with a dedicated lens hood, the HB-25.

At the time of writing I had only tried one example, serial number 200001, which I believe to be the first production prototype. Its chunky feel complimented the weight of my F5 body and made a well-balanced pair. The Silent Wave Motor provided a very swift and positive AF response. The manual focus ring is thankfully wider than the one on the AF-S 24-85mm lens, which definitely improves the handling of this lens.

Wide-angle Zooms

Nikon's designers and engineers have enough problems to deal with in the development of fixed focal length wide-angle lenses, let alone wide-angle zoom lenses. The greatest challenge with this class of lens is to create an optical formula and configuration of elements that all but eliminates distortion.

It was Nikon's innovation in optical engineering that lead to the world's first wide-angle zoom, the Zoom-Nikkor 28-45mm f4.5, which appeared in 1975. The 1.6x zoom range and maximum aperture appear rather modest by today's standards, but this retro focus lens with 11 elements in 7 groups can focus down to 1.2m. It is a two-ring design that weighs 440g and accepts 72mm filters. The filter ring does not rotate during focusing, which is a very convenient feature when using polarizing filters. In 1978 it was upgraded to the AI lens mount standard.

Its successor the Zoom-Nikkor 25-50mm f4 appeared in 1979. It is also an 11-element design, but with a completely revised optical configuration that reduces the minimum focus distance to 60cm and allows for the slight increase in lens speed. At 600g it is heaver than its prede-

cessor, but that did not prevent this optic from gaining a very high reputation for its outstanding optical performance. It controls flare and ghosting with aplomb, vignetting is minimal even wide open, and sharpness extends across the frame from corner to corner. Unfortunately such quality came at a price and due to relatively low volume sales it was discontinued in 1982, shortly after it received the AI-S lens mount.

Photographers had to wait until 1987 until Nikon introduced a new lens covering this range, the AF Zoom-Nikkor 24-50mm f3.3-4.5. It is very compact, weighs only 375 grams, has 9 elements in 8 groups and accepts 62mm filters. I can only think that the popularity of this lens has more to do with its useful focal length range than optical performance and build quality. The handful of examples I have tried suffered from a rather loose focusing action, prominent barrel distortion at the short end and had a tendency to flare. The 'macro' setting is nothing more than a marketing tool as it only reduces the close focus limit by 10cm. Handling is handicapped by the filter ring, that rotates when the lens is focused. In 1996 a slightly modified version with a revised minimum aperture lock button and the D specification CPU was introduced, otherwise it remained unchanged.

Another wide-angle zoom, the Zoom-Nikkor 28-50mm f3.5, was introduced in 1984. I used this lens for a while and found it to be a very capable performer that produced high quality images. Its relatively high speed, just half stop slower than comparable fixed focal lengths should have made it more popular, but it remained almost unnoticed during its short production life. A compact 9-element lens, with a single zoom-focus ring, it has a close

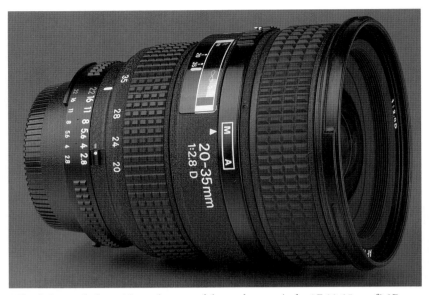

along with the Nikon D1 digital SLR, is the AF-S 17-35mm f2.8D IF-ED. In my opinion this lens represents one of the best Nikkors ever made. Its designation alone singles it out as something special, but it is not until you see the results that this lens is capable of that you fully appreciate its awesome qualities. The 13-element design includes four aspherical and two made from ED

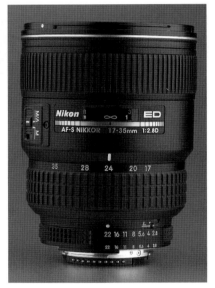

Nikon's first truly fast wide-angle zoom of the modern era is the AF 20-35mm f2.8D.

focus setting at the 50mm focal length, which reduces the minimum focus distance to just 32cm.

For a number of years Nikon photographers could only look on with envy as their contemporaries equipped with the Canon EOS system used their AF 20-35mm lenses. However, Nikon's first lens of this type was the Zoom-Nikkor R-UW 20-35mm f2.8D for the Nikonos RS underwater SLR camera. It was not until 1993 that the AF Zoom-Nikkor 20-35mm f2.8D appeared. It rapidly established itself as an immensely popular lens, which complimented Nikon's existing fast 35-70mm f2.8 and 80-200mm f2.8 AF zooms.

A spectacular, solidly built lens with a metal barrel it has an aspherical front element which helps to reduce aberrations to a minimum, even at its full aperture, the central image area is sharp at all focal lengths, as are the edges below f4. To be harshly critical, used wide open the lens does suffer from a perceptible softness in the extreme corners at 20mm, but otherwise vignetting and barrel distort are remarkably low for such a complex lens. It has a

14-element, two-ring design that weighs 640g, and can focus down to 50cm. It has a constant maximum aperture and by using an IF system the lens does not change length or rotate its front filter ring with either focusing or zooming actions. It was one of the first Nikkors to accept the larger 77mm filter size that is now common to many professionally specified AF Nikkor lenses.

It successor, introduced in 1999

The Zoom-Nikkor AF-S 17-35mm f2.8D IF-ED

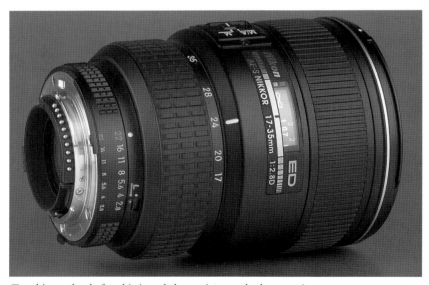

To achieve a level of sophisticated electronic control a lens requires numerous contacts for communication with a camera as can be seen on this AF-S 17-35mm f2.8.

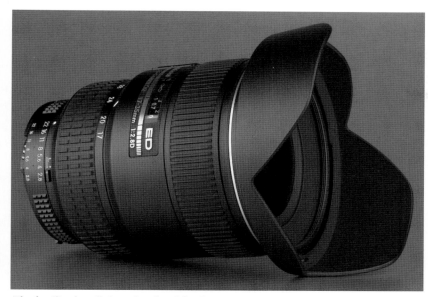

The familiar 'petal' shape lens hood for the AF-S 17-35mm f2.8 is the HB-23.

glass. It maintains a constant maximum aperture throughout the focal length range and has nine blades in the iris diaphragm. Weighing 745g it is heavier than its predecessor, but this is a small price to pay for the outstanding handling and optical quality it provides. Sharpness, contrast and colour saturation are extremely impressive at all focal lengths, as is vignetting, which although mild is present at the maximum aperture, but stopped down to f4 it disappears. Below 24mm there is slight barrel distortion especially at close focus ranges, however, this is offset by an amazingly good flat field performance. One of the best features of this lens is its ability to focus continually down to just 28cm!

The control of flare and ghosting are also remarkable and better than in some fixed focal length lenses. However, I am aware that some photographers have commented adversely about this, but in my experience this is unfair criticism. I expect that in most cases it is a filter rather than the lens itself that caused the flare they detected. I would always recommend removing

any filter, even one habitually kept in place to protect the lens, when you want to shoot a scene that includes a bright point source of light such the sun, or streetlights.

The latest wide-angle Zoom-Nikkor for both film and digital cameras is the 18-35mm f3.5-4.5D IF-ED lens introduced in 2000. Made to appeal to photographers who do not require the speed and robust build quality of the AF-S 17-

35mm, this lens still uses ED glass and an aspherical element and provides a compact lightweight alternative.

The lens weighs just 370g, and uses 11 elements in 8 groups, has IF that allows focusing down to 0.33m, and nine blades in its diaphragm. At the shorter focal lengths the over all image quality lags slightly behind the 17-35mm lens, but there is a steady improvement as you head towards the 35mm setting. Vignetting is noticeable at wide apertures and the extreme corners display some softness until stopped down to f8-11. Sharpness and colour saturation are excellent at the centre and quickly catch up at the edges by f5.6. Despite its variable and more modest maximum aperture this lens is already proving to be a favourite with many photographers as it makes an ideal companion to the D100.

In response to feedback from photographers wanting to exploit the full potential of their wide-angle lenses, many camera manufacturers have been consumed in a race to produce a digital SLR camera with a sensor the same size as a full-frame

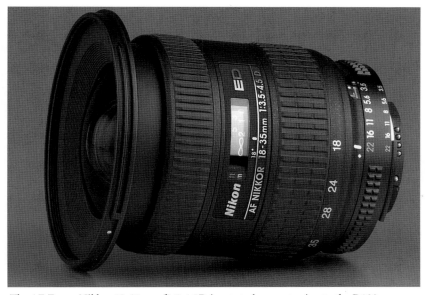

The AF Zoom-Nikkor 18-35mm f3.5-4.5D is a popular companion to the D100.

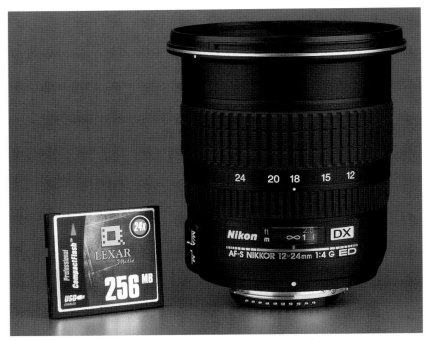

The first lens in the DX-Nikkor series is the AF-S DX 12-24mm f4G IF-ED.

ED lens with a wide flange at the front, which has a 77mm filter thread and the bayonet ring for the lens hood. Following the design of the AF-S 24-85mm f3.5-4.5 IF-ED the manual zoom ring is at the front and turns counter-clockwise to shorten the focal length. The focusing ring, which is the same width at the 24-85mm lens, is closest to the camera body, and in common with many recent Nikkor lenses there are no depth-of-field scale markings or infrared focusing index point.

The use of an internal focusing mechanism means that the overall length of the lens does not change with the focus action. The outer barrel section with the lens hood bayonet and filter ring does not move, however, the front element rotates and moves forward within the barrel as the focal length is shifted to 12mm. At 30cm the minimum focus distance is impressive, and the lens can achieve a maximum reproduction ratio of 1:8.3. Finally, as it is a G-type lens there is no aperture ring, and aperture values are set from the camera body via one of the command dials. I am also pleased

of 35mm film. However, Nikon have bucked this trend and as mentioned earlier in this chapter they have recently announced the first in an entirely new series of lenses dedicated to their digital SLR camera range. To be known as DX-Nikkors these optics will project an image circle to cover the 23.7mm x 15.6mm format of the CCD used in these cameras, and as such are not fully compatible with Nikon's film cameras. Nikon claim these lenses will be optimised for the size and light gathering characteristics of the CCD sensor.

The first DX lens is the AF-S DX 12-24mm f/4G IF-ED, which is expected to be available by mid-2003. The lens has no less than three aspherical elements and two others made of ED glass to control the effects of chromatic aberration. A two-ring zoom, it has a constant maximum aperture of f/4, seven blades in the diaphragm, and offers focal lengths equivalent to 18-36mm on a 35mm film camera. Nikon state that due to the smaller image circle this lens projects it can only be used

on Nikon's digital SLR bodies, but it can be mounted on a film camera (if you really want to!), however, the further below 18mm you go the more the image suffers from an increasing amount of vignetting.

The lens has a similar profile to the current 18-35mm f3.5-4.5D IF-

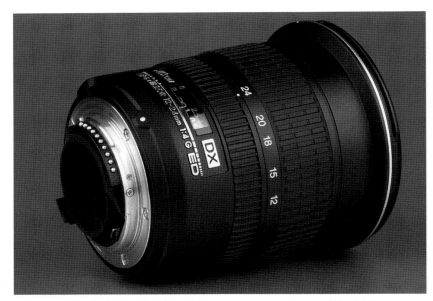

The DX-Nikkor is dedicated to the smaller 23.7 x 15.6mm format of the CCD sensor used in current Nikon D-SLR cameras.

that Nikon have opted for a 77mm filter thread for compatibility with many other current Nikkor lenses, and it has a dedicated petal shaped hood, the HB-23.

At the time of writing I had only handled one example of the lens, serial no. 200010, but my first impressions are of a short, squat lens that fits comfortably in the hand, although I found the manual focus ring rather narrow. The Silent Wave Motor provided a very swift and positive AF response, and optically it appears to be a very capable performer.

Telephoto Zooms

As discussed above, zoom lenses in the wide-angle range are particularly difficult to design. It should come as no surprise that the early zoom lenses were telephoto designs, which have seen a steady improvement in their performance to the point where these days, with the exception of circumstances that require a long fast lens, most photographers use them in place of a fixed prime focal length.

The Popular 80-200mm Class

Nikon's first zoom lens, which appeared at the same time as the Nikon F, was introduced during 1959. The Zoom-Nikkor 85-250mm f4-4.5 was only in production for a very short time and was replaced in 1960 by a modified version with improved handling and cleaner profile. The first lens has a curious two-ring design in which the focal length is changed by a push/pull movement of the rear ring, whilst focusing was achieved by rotating the front one. Unlike its predecessor the second version is a one-ring design with the same 15 elements in 8 groups, it weighs 1800g and accepts 82mm Series 9 filters. The focus/zoom ring, which has a wide

Dating from 1959 Nikon's first telephoto-zoom lens, the Zoom-Nikkor 85-250mm f4-4.5, is shown here on a Nikon F.

rubberized grip, is fitted with a screw lock fitted to secure the focal length and the barrel is marked with a coloured scale displaying the depth-of-field and a second scale, engraved in white, showing the focal length. The tripod mount is the same as the first lens and has two threads one for horizontal and the other for vertical shooting. A supplementary close-up lens can be used to reduce the minimum focus distance from 4m to 2.2m. A third version appeared in 1969 with a slightly modified optical configuration that has 16 elements. This provides a constant maximum aperture of f4 at all focal lengths. The NIC process applied to the lens elements improved their contrast.

Probably one of the most versatile and popular focal length ranges of zoom lens regardless of the manufacturer is the 80-200mm. Nikon's lenses in this length are no exception and have a long tradition of outstanding quality. The first version was introduced in 1969 and

replaced the 85-250mm lens. Half the length and weight of its predecessor it has 15 elements, focuses continuously down to 1.8m, accepts 52mm filters, and weighs 830g. A one-ring design that inherited the coloured depth-of-field scale from the earlier lens it underwent a number of small cosmetic changes during the 1970's, but its outstanding optics remained the same. It was this lens that almost single handedly convinced a generation of photographers that zoom lenses could be the equal of fixed prime lenses. Shortly after the lens received the AI standard lens mount Nikon introduced a new version with a revised optical arrangement of 12 elements and Nikon Integrated Coating (NIC). Optical performance and image quality is even better. The lens barrel was re-designed with a narrower profile, which lead to a reduction in weight by 80g, and a rectangular frame behind the rear element to prevent light spreading into the mirror box.

The legendary Nikkor 80-200 f4.5 is a favourite of many photographers.

The successor to this classic Nikkor was introduced in 1981. The Zoom-Nikkor 80-200mm f4 has 13 elements in 9 groups, weighs 810g, accepts 62mm filters, and can focus continuously down to 1.2m providing a reproduction ratio (RR) of 1:4.4. Attaching a supplementary Nikon 6T close-up lens lowers this RR so that it approaches 1:1. It displays outstanding sharpness, contrast, and colour saturation with improved light coverage that effectively eliminates the slight vignetting that its predecessor showed at 200mm. Optically this lens is so good that it can even be used to very effectively with the TC-14A and TC-201 teleconverters.

As zoom lenses became ever more popular with professional photographers they demanded a lens with a wider maximum aperture. Nikon developed a two-ring prototype 80-200mm f2.8 lens that was displayed at the Photokina exhibition in 1978, however, it did not go into production. It was not until four years later that the Zoom-Nikkor 80-200mm f2.8 ED appeared. A large lens that provides superb image quality it had an equally impressive price tag! Weighing 1900g and comprising 15 elements in 11 groups it accepts 95mm filters and can focus down to 2.5m. Its size and cost limited its appeal even in professional circles and production volume was rather low.

Incorporating AF technology its successor the AF Zoom-Nikkor 80-200mm f2.8 ED arrived in 1988. Physically much smaller than the non-AF version, this 16 element design won wide appeal amongst even those photographers who had not adopted AF but were lured by its speed and image quality. Initially Nikon could not keep pace with demand and dealer's customer waiting lists for this optic grew longer and longer. A one-ring type zoom

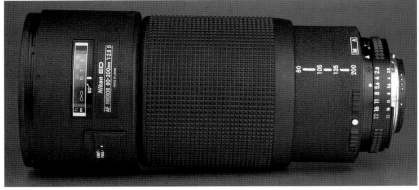

Optically excellent, the second version of the AF 80-200mm f2.8 ED lacks a tripod collar. This makes handling difficult when shooting a vertical composition from a tripod so many photographers resorted to third party braces to help support it.

that weighs 1200g, it can focus down to 1.8m, and has a built in close focus system that extends this range down to 1.5m. To help improve the AF response time there is a focus range limiter operated by moving a ring around the barrel located toward the front of the lens. The three ED glass elements ensure an outstanding image quality, but this lens was not without its faults. Principally these involved its handling and AF system. Surprisingly for such a large and relatively heavy lens Nikon did not see fit to incorporate a tripod collar. This makes operating it on a tripod, especially for vertical compositions rather awkward. The AF performance is

disappointingly slow and drew much criticism from many photographers.

In 1992 when the lens was modified to the D specification to make it compatible with the F90 camera Nikon took the opportunity to completely redesign its mechanical construction. The new version, the AF Zoom-Nikkor 80-200mm f2.8D ED has a much-improved AF performance that is quieter, smoother, and faster, and a new two-position single sliding switch for the focus range limiter. The front filter ring no longer rotates with the focus/zoom action to facilitate the use of polarizing filters, and the minimum aperture ring switch has a lower profile,

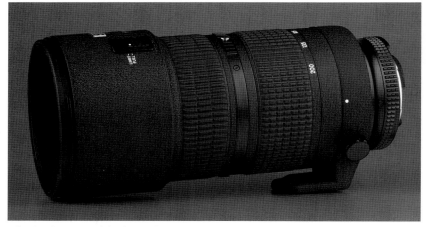

The third version of the fast 80-200mm is the first to feature a rotating tripod collar, which improved its handling significantly.

but unfortunately the lens still lacks a tripod collar. Optically it is the same as the earlier version. In 1996 Nikon responded to the outstanding handling deficiencies of this lens and introduced a new lens with a rearranged optical configuration. A two–ring design that has 16 elements and a rotating tripod collar, replaced the previous one-ring lens. As a further improvement to its handling the focus mode selector switch was moved forward and is now located between the focus and zoom rings. Focus speed and optical quality are superior to the earlier versions.

By 1995 the Nikon lens range contained a number of optics aimed squarely at the beginner and hobby photographer. These were built to reflect their target market by being economical and compact. The AF Zoom-Nikkor 80-200mm f4.5-5.6D is no exception as it weighs just 330g. The expectation is that this and lens like it will be used predominantly in their AF mode so the manual focus ring is very narrow. The lenses has 10 elements can focus to 1.5m, and accepts affordable 52mm filters.

Following the introduction of their long, fast telephoto lenses with Silent Wave Motor (SWM) technology it was not long before Nikon applied it to smaller lenses beginning with the AF-S Zoom-Nikkor 80-200mm f2.8D IF-ED, which arrived in 1998. This two-ring design, 18-element lens, that uses no fewer than five made from ED glass, weighs 1580g, and can focus down to 1.5m is without doubt the best lens of this class that Nikon have ever made. Its performance is truly outstanding in all departments so much so that it does not bear comparison with the earlier versions. The AF is exceptionally quick, and near silent. Handling is excellent and the four focus lock buttons set

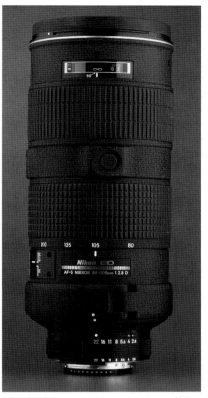

The AF-S Zoom-Nikkor 80-200mm f2.8 lens has excellent AF and optical qualities, but its tripod collar does not operate with the smooth action of its predecessor.

around the lens barrel allow for rapid and secure operation when the composition requires adjustment because the subject falls outside the area covered by the cameras AF sensors. Sharpness, contrast, and colour saturation are superb. There is a trace of vignetting at the two extremes of the focal length range. For all but the most critical applications distortion can be considered as non-existent. I used the earlier two-ring AF-D version of this lens for a number of years and became accustomed to its good handling so the disappointing tripod collar on the AF-S lens surprised me. Whilst it is more than sufficiently rigid it has a very rough action when you try to rotate the lens to change the orientation of the camera, due to the collar being too narrow.

In 1980 Nikon released a small gem of a lens the 75-150mm f3.5 E, for the Nikon EM and FG cameras. A 12-element design that is just 12cm long and weighs 520g, its image quality is belied by the E series specification. Unlike the prime E series optics this one has NIC on most lens elements with the consequence that it can match many mainstream Nikkor lenses, however its restricted focal length range meant that it never sold in sufficient quality. So it was discontinued in 1983 and replaced by the 70-210mm f4 E. A 13-element design that accepts 62mm filters, and weighs 730g, it can focus continuously down to 1.5m. Using its close focus ability that can be reduced to a minimum of 56cm at the 70mm focal length. Its performance must be

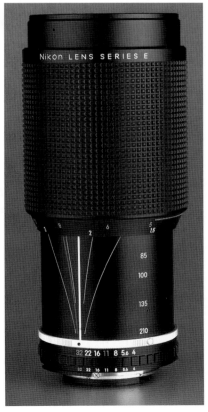

The 70-210mm f4 E series lens was introduced to provide a longer reach in the entry-level telephoto zoom class.

regarded as inferior to that of the AI-S 80-200mm f4, but only due to the lower level of contrast that it exhibits. It was, however, made to a price and in this respect the build quality will not withstand day-to-day professional use. A revised AF version of this lens appeared in 1986 as a two-ring design, which like many early AF Nikkors has a rather narrow focus ring set right at the front. This not only causes the lens to feel unbalanced in the hand, but also makes manual focusing rather difficult. It has a close focus capability of 1.1m, at the shortest focal length, otherwise it is 1.5m for longer focal lengths.

In 1987 a completely revised lens with a variable aperture was introduced. The AF Zoom-Nikkor 70-210mm f4-5.6 has 12 elements in 9 groups, weighs just 590g, accepts 62mm filters, and is 50mm shorter than its predecessor. The lower speed at the longer end allows for a more compact design that can be

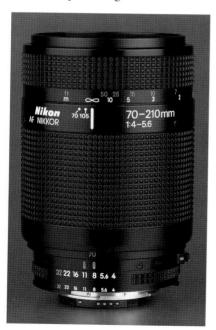

One Nikkor to receive a complete makeover following the introduction of the second generation of AF lenses was the AF Zoom-Nikkor 70-210 f4.5-5.6 N.

made for less; two very important criteria when designing lenses for the mass market. In 1993 the lens was modified with the addition of the D specification CPU, but otherwise it remained identical to the earlier version. These two lenses demonstrate a remarkably good performance considering their price and can be commended to any photographer who has no need of a wide aperture lens in this class. To compliment the entry level FE-10 and FM-10 cameras Nikon introduced an economical and lightweight a manual focus version of the 70-210mmf4-5.6 in 1997. It is a one-ring design that accepts affordable 52mm filters.

A new focal length range appeared in 1999 with the launch of the AF Zoom Nikkor 75-240mm f4.5-5.6D lens. Another optic intended for the mass-market it only weighs 410g, has 12 elements in 9 groups, and focuses to 1.5m. The seven-blade diaphragm helps to create a more natural appearance to out-of-focus highlights, and it benefits from accepting 52mm filters.

The Vibration Reduction (VR) System

In the autumn of 2001 another completely new type of Nikkor lens arrived with a system designed to reduce the effects of camera shake when it is used hand-held. Nikon's new Vibration Reduction (VR) technology was first fitted to the AF VR Zoom-Nikkor 80-400 f4.5-5.6D ED. The lens looks like a slightly oversized 80-200mm optic with a wider barrel profile to accommodate the additional VR mechanism. In simple terms the lens has a number of motion detectors that sense the direction in which the lens is moving and then initiate a number of micro motors to move a group of lens elements to compensate for the detected movement of the lens.

Nikon claim that the VR system will permit shooting at shutter speeds three stops slower than you would normally use to prevent camera shake. The lens, which weighs 1340g, has 17 elements in eleven groups, including three with ED glass, and an aperture range from f4.5 at 80mm to f32, accepts 77mm filters, and has nine blades in the diaphragm. Optically it is outstanding up to 200, with a marginal fall off in the corners up to 300mm, and whilst it does show a greater softness beyond this to 400mm it is still a very capable performer. It provides sharp, high contrast images with full colour saturation over the full range of focal lengths. Distortion is extremely well controlled with a hint of barrel distortion at the short end and mild pincushion at the long end. The lens projects a very evenly illuminated image with little to no evidence of flare or ghosting.

The VR is certainly very effective; hand held I have shot successfully with the lens set to 400mm at speeds in the range of 1/30sc to 1/8sec and obtained sharp results, which would have been impossible with a conventional lens. Its ability to detect any deliberate panning motion and only apply the VR in the plane perpendicular to the direction of the pan is very effective. The VR can be set to operate all the time or only at the moment of exposure. The reason for the second option is to prevent the slight, but continuous motion of the viewfinder image from inducing any sensation of motion sickness in the photographer. I would always recommend using the continuous VR mode to ensure precise framing at the moment of exposure. In the instruction booklet that comes with the lens Nikon state that you should switch the VR function off when the lens is attached to a tripod. The explanation for this is that it pre-

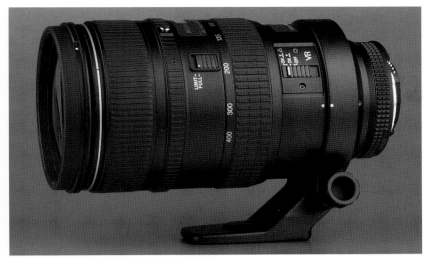

The first Nikkor lens for an SLR to feature Vibration Reduction (VR) is the AF VR Zoom-Nikkor 80-400 f4.5-5.6D ED

f2.8G IF-ED has a barrel and tripod mount constructed from a light, die-cast magnesium alloy, which is covered in a smooth 'hammered-metal' finish similar to other current professional grade Nikkors such as the AF-S Zoom-Nikkor 17-35mm f/2.8D IF-ED. A professional grade lens it has been designed to operate in harsh conditions and inclement weather; there are seals and 'O' rings to protect any point where the ingress of moisture or dust might occur, including a rubber gasket around the lens mount to protect the electrical contacts between the

vents unnecessary drain of the batteries, however, I would suggest that there is a more important reason. If the VR is switched on in these circumstances there is a risk that the lens will detect slight amounts of camera movement due to the movement of the reflex mirror. The VR system attempts to compensate for this, but because the lens is attached

to a tripod it has a tendency to over-compensate with the result that the VR system defeats itself and actually causes unsharp images. The tripod collar of this lens, which is identical to the one used on the AF-S 300mm f4 lens, has received similar levels of criticism for being insufficiently rigid, and another cause of unsharp images. My thoughts and comments concerning this issue are the same as those given earlier. There are two factors that would improve this lens immeasurably: the inclusion of a SWM to speed up the rather ponderous AF, which in my experience struggles to keep pace with fast moving action, and focus lock buttons set around the barrel to improve handling when shooting a composition where the subject is outside the AF sensor area.

As if in answer to photographers prayers in February of 2002 Nikon announced that they were developing a new class of lens that combines SWM and Vibration Reduction technology in a Nikkor lens for the first time. Although initially expected to be available in the autumn of that year its was finally released during February 2003. The AF-S VR Zoom-Nikkor 70-200mm

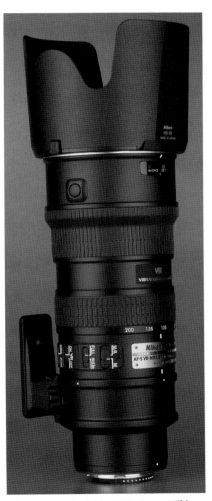

The long awaited AF-S VR Zoom-Nikkor 70-200mm f2.8G IF-ED combines AF-S and VR technology for the first time in a Nikkor lens.

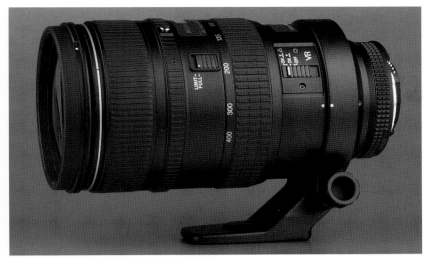

Details of the lens barrel controls on the AF VR Zoom-Nikkor 80-400 f4.5-5.6D ED

lens and camera body. Nikon claim it has a level of protection equivalent to that of an F5.

It has a focal length range from 70mm to 200mm (effectively 105-300mm on a Nikon digital SLR cameras) with a constant maximum aperture of f/2.8, and minimum aperture of f/22. The diaphragm has nine blades to produce a near circular aperture, and there are twenty-one elements, of which no less than five are made from Extra-Low Dispersion (ED) glass, arranged in fifteen groups. The minimum focus distance is 1.4m in manual focus (MF) and 1.5m in Auto Focus (AF). At the longest focal length setting this provides a maximum reproduction ratio (RR) of 1:5.6 at 1.4m (MF), and 1:6.1 at 1.5m (AF). It weighs 1430g (with the tripod mounting foot) making it 10% lighter than the current AF-S 80-200mm f/2.8.

Since this is a G-type lens there is no aperture ring. The rotating tripod collar cannot be detached, despite the instruction book stating that it can! In reality Nikon have fitted it with an innovative removable

foot that is attached by a dovetail shaped clamp. The lens rotates freely through 360° within the collar with none of the judder that afflicts the collars on lenses like the AF-S 80-200 f/2.8 and AF-S300 f/4.

I have to commend Nikon on the action of both the manual focusing and zoom rings, which is extremely smooth and has a perfect weight. The AF is swift, near silent, and the three AF lock buttons fall naturally to hand, to further enhance handling. Optically this lens leaves nothing to be desired, and is destined to become one of those select few – a truly legendary Nikkor!

The zoom ring is marked for focal lengths of 70, 80, 105, 135, and 200mm, and the manual focus ring turns through approximately 100° to shift focus from infinity to the MFD of 1.4m. The profile of the front third of this ring changes to a greater diameter creating a shallow ridge against which your thumb and fingers come to rest naturally. The lens is bereft of any depth-of-field scale or infrared focusing mark - Nikon do not even supply any depth of field or IR focusing compensa-

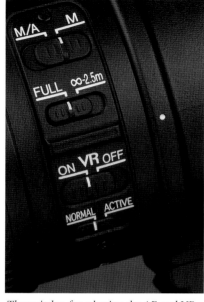

The switches for selecting the AF and VR modes are located on the lens barrel. Note the new VR modes - Normal and Active.

tion data in the instruction booklet. The lens comes supplied with a petal shaped HB-29 lens hood, and Nikon have further improved the bayonet fitting of the hood, which now has a locking button that must be depressed before you can remove it.

Some photographers have questioned the worth of incorporating VR technology within this lens with its fairly modest maximum focal length. In my opinion they have missed the point! At 200mm, four times the magnification of a 50mm lens, the effect of camera shake, even at reasonably high shutter speeds can be very detrimental, and on a Nikon D-SLR the magnification is six times greater as the effective focal length is equivalent to 300mm.

Nikon have obviously listened to feedback because the VR function, which is only available with the F5, F100, F80, F65, D100, and D1 series cameras, has been overhauled. Thankfully Nikon have dispensed with the Mode II option of the AF VR 80-400mm f3.5-5.6D, which

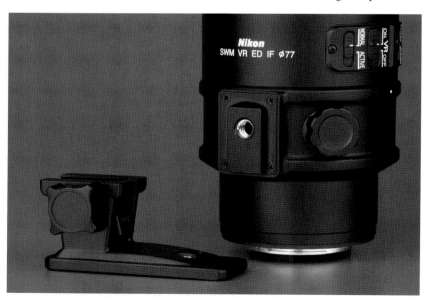

The innovative removable foot of the lens collar lowers the profile of the lens for hand held shooting and stowage, plus it acts as a quick release mechanism from a tripod.

activated the VR system at the moment of exposure. I was never convinced by this feature, and found that it would frequently cause slight changes to precise compositions, which you could not observe in the viewfinder. On this lens the VR is either off, or on all the time. If you chose to use the VR there are two options available; Normal, that is intended to reduce the effects of camera shake, whilst still allowing for smooth panning shots when only vibration in the plane perpendicular to the panning movement is suppressed, and Active, that helps to reduce the more vigorous vibrations you may encounter when working from a moving camera platform such as a motor car, boat, or helicopter. It is important to note that in this mode the lens does not distinguish panning movement from camera shake. So always set the VR to Normal for panned shots. The good news is that the VR will operate when the lens is used on an unsecured tripod head, or monopod for supported panning, and is fully compatible with the AF-I and AF-S teleconverters, TC-14E/TC-14E II/TC-20E/TC-20E II. One idiosyncrasy of the VR systems is that when used with the F65, F80, and D100 it will not work whilst a flash unit is recycling.

The AF-S VR Zoom-Nikkor 70-200mm f2.8G IF-ED will replace the current AF-S 80-200mm f/2.8 in due course, which will also see the legendary retro-compatibility of all professional type Nikkor lenses come to an end, because G specification types have no aperture ring. In a recent meeting with Mr. Tetsuro Goto, Head of Research and Development for Nikon SLR cameras, I asked if all future professional specification Nikkors would follow suit and be of the G-type. He explained that the decision to adopt the G specification for the VR 70-

200mm lens was based purely on engineering reasons, because Nikon's priority was to produce a lightweight, compact lens, and that there was no policy to dispense with a conventional aperture ring in future lenses provided it fitted the design criteria.

Long Telephoto Zooms

Sometimes a focal length of 200mm is not long enough and for those photographers who required a little extra reach Nikon introduced the Zoom-Nikkor 100-300mm f5.6 in 1984. Due to its modest speed and relative low weight of 930g this 14-element one-ring design provides quite a compact lens that is just over 20cm long. It is capable of an excellent performance even wide open and demonstrates very good sharpness, colour saturation, and contrast. It does not have a tripod collar, but thanks to its low weight it balances well when attached to a support.

In 1989 it was replaced by the AF Zoom-Nikkor 75-300mm f4.5-5.6. This 13-element two-ring design is only 170mm long and at 850g weighs even less than its predecessor. It has a minimum focus distance of 3m and accepts 62mm filters. A close focus feature is available at all focal lengths and reduces the focus distance to 1.5m. There is a focus range limit switch that offers

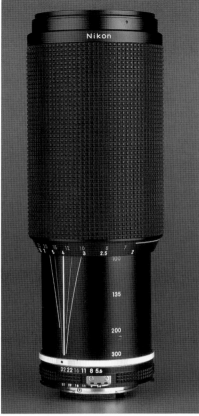

Despite its modest maximum aperture the Zoom-Nikkor 100-300mm f5.6 produces very sharp images with excellent contrast and colour saturation.

two settings: Full (∞ to 1.5m) and Limit (∞ - 3m). Handling is rather tiresome as the narrow focus ring is situated at the front of the lens and the filter ring rotates with the focusing action. Given its longest focal

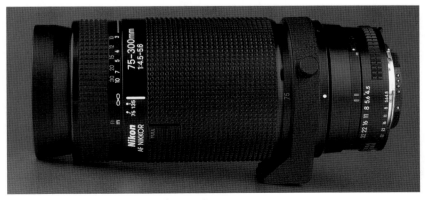

An AF Zoom-Nikkor 75-300mm f4.5-5.6 lens.

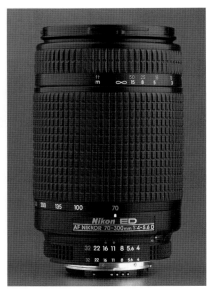

The AF Nikkor 70-300 f4.5-5.6D features ED glass to help control the effects of chromatic aberration.

length this lens is one that would have benefited from having ED glass because image quality can only be described as adequate at the long end. It also has a reputation for flare and ghosting. The rotating tripod collar is barely able to support a heavy camera such as an F4 or F5 without the risk of camera shake spoiling image quality. These deficiencies are possibly the reason that this lens never received an update to the D specification although it remained in production until 1998.

It was finally replaced by the AF Nikkor 70-300 f4.5-5.6D, which was the first economical compact AF Nikkor to have ED glass. A featherweight at just 515g this two-ring design lens is remarkably small. It has 13 elements in 9 groups, focuses to 1.5m, and accepts 62mm filters. Compared to the earlier lens it handles far better despite having the focus ring right at the front, because it is much shorter. Optically it is very good with far better sharpness at all focal lengths. Mild vignetting is present at the extreme ends of the focal length range, but disappears

when stopped down to f8, with barrel distortion controlled to acceptable limits. For the travel photographer looking for a good compromise between weight, size, and range of focal lengths this represents a very good option.

The latest lens in this class is the AF Nikkor 70-300 f4.5-5.6G, which appeared in 2000. Aimed very much at the beginner with an entry-level camera this was the first Nikkor lens designed for use with modern AF cameras that allow the aperture to be set from the camera as the lens has no aperture ring itself. It has 13 elements in 9 groups, accepts 62mm filters and will focus to 1.5m. The diaphragm has nine blades and a D specification CPU is housed within the barrel. Nikon have made extensive use of polycarbonate in the construction of this lens including the lens mount itself, to reduce its weight to just 425g. The original concept behind the AF-G type was to simplify the lens making them easier to use, and eliminating the risk of mistakes because the aperture does not need to be set to its minimum value. In early 2001 Nikon announced the lens would

also be available in a silver finish as well as black to compliment the silver-coloured F65 and F80 cameras.

The Zoom-Nikkor 50-135mm f3.5, which was released in 1982 was intended to offer photojournalists a fast, compact, high-performance zoom covering a focal length range from the standard 50mm to a short telephoto. The image quality of this 16-element design, that takes 62mm filters, is so good as to be comparable to fixed prime lenses. For some reason it never gained wide acceptance amongst press photographers; maybe this was because of its modest maximum aperture or limited close focus. As a result it came and went in a very short time and like a number of other Nikkor lenses only become popular after it was discontinued. A firm favourite with wildlife and landscape photographers because its front filter ring does not rotate, which is a really useful feature when using a polarizing or graduated filters, and it works very well with the supplementary 6T close-up lens, second hand examples can still command very good prices because of its reputation. I owned and used one extensively until a few

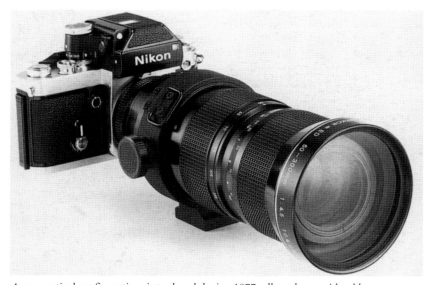

A new optical configuration, introduced during 1977, allowed a considerably more compact design for the AI version of the 6x zoom ratio Nikkor 50-300mm f4.5 ED lens.

years ago, but for reasons that I now cannot recall I decided to sell it; a decision I regret to this day!

Nikon's innovation in optical design won the company another world first with the Zoom-Nikkor 50-300mm f4.5 because of its 6x zoom range. The original version has 20 elements in 13 groups, weighs 2300g, and accepts 95mm filters. The barrel is 300mm long at the shortest focal length and set to infinity, but extends a further 100mm at the long end. A slightly modified version with an altered optical arrangement was released in 1968. In 1977 the lens mount was converted to the AI standard and fitted with news style focus and zoom rings.

In 1977 the optics were completely redesigned with 15 elements in 11 groups including some made from ED glass. This not only improved performance but also allowed a

The second telephoto-zoom to be introduced by Nikon was the Zoom-Nikkor 200-600mm f9.5.

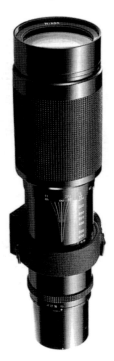

reduction in overall size. A 100g reduction in weight and a shorter barrel length than its predecessor offers a better balance around the rotating tripod collar. In 1982 the lens was upgraded to the AI-S lens mount and further modifications reduced the weight still further to 1950g.

Super-Telephoto Zooms

Nikon had a super-telephoto zoom lens in their range as early as 1961. The Nikkor 200-600mm f9.5-10.5 is a one-ring design comprising of 13 elements. It weighs 2300g, accepts 82mm Series 9 filters, and has a minimum focus distance of 4m, which can be reduced by a supplementary close-up lens to 2.3m. It lacks an automatic diaphragm so

must be used with a pre-set aperture. A modified version received improved lens coatings in 1971 that boosted the image contrast along with a new optical configuration comprising 19 elements and a constant maximum aperture of f9.5. The lens mount was changed to the AI standard in 1977, and followed by the last version with the AI-S type mount in 1982. Due to the appearance of the faster f8 lens with ED glass the slower lens was discontinued in 1983.

The Zoom-Nikkor 180-600mm f8 ED was introduced in 1975. It has a constant maximum aperture of f8 but the first version again lacks an automatic diaphragm. It has 18 elements in 11 groups, weighs 3600g, accepts 95mm filters and can focus

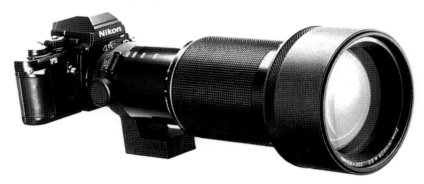

A longtime favourite with wildlife photographers the Zoom-Nikkor 200-400mm f4 ED combines a reasonably wide maximum aperture with high quality optics.

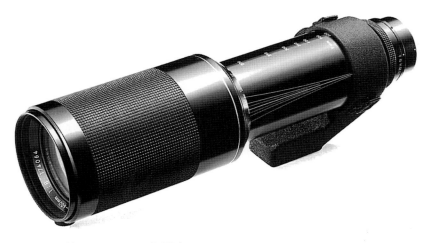

A Zoom-Nikkor 180-600mm f8 ED lens.

to 2.5m. In 1982 the lens was upgraded to the AI-S standard and fitted with an automatic diaphragm.

The Zoom-Nikkor 200-400mm f4 ED was introduced in 1984 ahead of the Olympic Games held in Los Angles later that year. Intended as a fast optic for sport and wildlife photographers this is one of those Nikkors that has achieved an almost legendary status because of its outstanding optics and image quality. A 15-element, one-ring design that accepts 122mm filters and can focus to 4m, it was only in production for a short while. Whilst large rotating tripod collar offers solid support it is very close to the focus/zoom ring when the lens is used at longer lengths, which can sometimes obstruct the photographers' hand when focusing.

The Zoom-Nikkor 360-1200mm f11 ED, which was first shown at the Photokina exhibition in 1974, did not go into production until almost two years later. This huge one-ring lens weighs 7900g and has no less than 20 elements arranged in 12 groups. It takes 122mm filters and will focus to a minimum distance of 6m. Like similar lenses of this class the first version has no automatic diaphragm. In 1982 the second version received internal focusing, the AI-S lens mount and an automatic diaphragm all of which improved its handling considerably.

The most recent addition to the super-telephoto zoom went into production in 1993. The mammoth Zoom-Nikkor 1200-1700mm f5.6-8 P IF-ED weighs 16000g and is over 88cm long. Intended for very long range photography, of particularly sport and action, the lens is one of only three Nikkor to conform to the P specification; the others are the 500mm f4P and 45mm f2.8P. All are manual focus lenses but they have a CPU that provided compatibility with the multi-pattern metering and shutter priority and program exposure control systems of modern AF cameras. The lens, which has only ever been available to special order, has 18 elements in 13 groups, focuses to 10m and accepts 52mm filters in a slip-in filter draw.

Special Purpose Lenses

There are a number of optical effects and photographic applications that can only be achieved with a lens designed specifically for that role. Nikon's philosophy of providing photographers with the necessary tools of the highest quality to meet the most demanding photographic challenges has lead the company to introduce many innovative lens types over the years.

Fisheye Nikkors

Fisheye lenses, which have extreme picture angles, were originally conceived for use in scientific applications such as meteorology and astronomy, or technical analysis of industrial and technological processes in confined spaces. Photographers use these lenses in conventional pictorial work to achieve dramatic effects by virtue of their exaggerated perspective and unnatural distortion, particularly of straight lines and edges.

The Fisheye-Nikkor 8mm f8, introduced in 1962, was the world's first 35mm fisheye lens to go into full production. A nine-element design with a diagonal angle-of-view of 180° it projects an image 24mm in diameter. Its principle drawback is that fact that it is not a retro–focus design. The rear element protrudes so far into the mirror box that there is less than one centimetre clearance between it and the shutter. Unless modified by a workshop it can only be attached to either a Nikon F or F2 body, and due to its shape the lens prevents any Photomic head being fitted to these cameras. The mirror must be locked in the up position before mounting the lens and viewing is done through the DF-1 supplementary viewfinder that attaches to the accessory shoe over the rewind crank. It has a rotating filter turret that introduces six different filters in to the light path. If you add the less than convincing optical performance of this lens to the handling difficulties it ceases to be a practical tool and is really only of interest to collectors. It successor, the Fisheye-Nikkor 7.5mm f5.6, appeared in 1965, and except for the fact it is one stop faster the specification and performance are similar to the earlier lens.

In 1968 Nikon introduced a specialist amongst specialists, the Fisheye-Nikkor 10mm f5.6 OP (orthographic projection) lens. It has nine elements, an angle-of-view

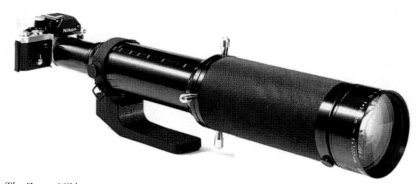

The Zoom-Nikkor 360-1200mm f11 ED has a single ring zoom. There are four handles that protrude from it to facilitate the focus and zoom action.

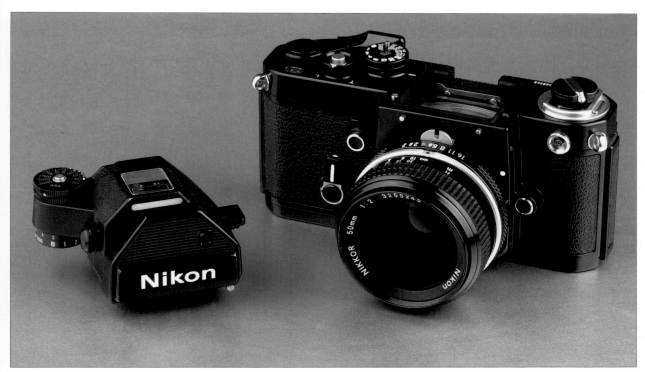

The Nikon F2 with DP-2 viewfinder head combine to make the F2S.

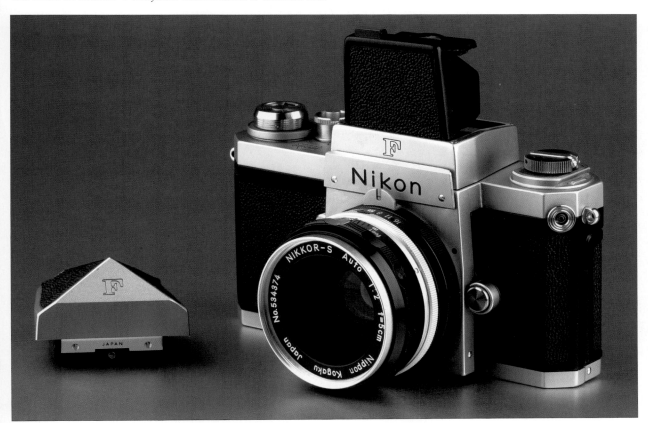

A true system camera this Nikon F has a waist level finder attached and an eye-level finder beside it.

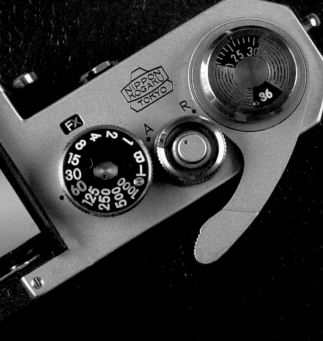

SERVICE PARTS CATALOG

Nikon F

NIPPON KOGAKU K.K.

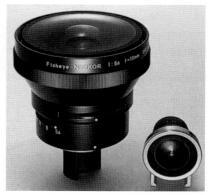

The Fisheye-Nikkor 10mm f5.6 OP is shown with its dedicated accessory viewfinder.

of 180°, and the same set of six filters mounted in a rotating turret as the previous Fisheye-Nikkors. Orthographic projection means that the lens, which has an aspheric front element and projects a 21mm diameter image circle, distributes light evenly across the entire frame so there is no vignetting effect. It is still not a retro focus lens though and requires the camera mirror to be locked up. Although it allows Photomic heads to be fitted to the F or F2 body it does not couple with the metering mechanism.

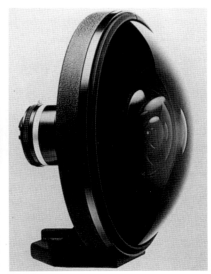

The Fisheye-Nikkor 6mm f2.8, which has an angle of view across the diagonal of 220°, can effectively look behind itself.

Nikon's next fisheye followed in 1969. The Fisheye-Nikkor 6mm f5.6 has an angle-of-view of 220° and again requires the camera mirror to be locked up before it can be mounted. It projects an image circle of 21.6mm and has a similar filter turret to the lenses described above.

The first fisheye with a retro focus design appeared in 1970. The Fisheye-Nikkor 8mm f2.8 allows normal viewing on the camera's focusing screen. It has 10 elements, an angle-of-view of 180°, and a slip-in filter holder. It projects an image circle 23mm in diameter. In 1977 it was updated to the AI standard lens mount, and converted to the AI-S type in 1982. It has only recently been deleted from Nikon's range.

The Fisheye-Nikkor 6mm f2.8 represents one of the most extraordinary camera lenses ever made. Its awesome front element, which has a diameter of 20cm, is just 7mm thick at its centre increasing to 60mm at the edge. This gigantic lens, that dwarfs any camera body to which it is attached, weighs 5Kg, has a retro focus design with 9 elements, focuses down to 25cm, projects an image circle that is 21.6mm in diameter, and when stopped down to f22 the depth-of-field extends from 17cm to infinity.

Distinct from the fisheye lenses described so far, which produce a circular image, the full frame Fisheye-Nikkors project an image that covers the entire 35mm film frame. Unlike the rectilinear designs of Nikon's ultra wide-angle lenses these optics render straight lines that do not pass through their central axis as curved and the further off axis the line occurs the more pronounced the effect. Nikon introduced their first lens of this type, the Fisheye-Nikkor 16mm f3.5, in 1973. A retro focus design it has 8 elements, a picture angle of 170° across the diagonal of the frame. It

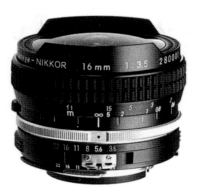

The Fisheye-Nikkor 16mm f3.5 represents Nikon's first full-frame fisheye lens.

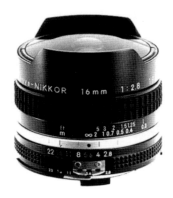

Nikon revised the optical configuration of the Fisheye-Nikkor 16mm f2.8 to improve the distribution of light.

has a revolving filter turret and can focus down to 30cm, and is similar in size to a 50mm standard lens. Its successor, the Fisheye-Nikkor 16mm f2.8, was introduced in 1979. A completely revised optical configuration improved the evenness of light distribution and corner sharpness as well as the overall lens speed. In addition to the improved speed the angle-of-view was increased to 180°, and it accepts 39mm filters on a bayonet mount at the rear of the lens. This filter is actually part of the lens design computation and if removed the close focus ability of the lens can be reduced below its normal 30cm, however, it will no longer focus to infinity.

The AF Fisheye-Nikkor 16mm f2.8D, which was introduced in

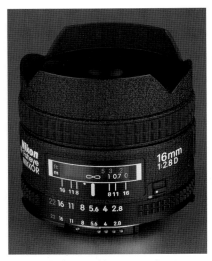

The AF Fisheye-Nikkor 16mm f2.8D

1993, has an identical optical design and operates in the same way as the manual focus version. It has the D specification CPU giving it full compatibility with the exposure control systems of modern AF Nikon cameras. The three full frame fisheye variants all have a narrow flange that extends from above and below the front edge of the lens barrel to act as a lens hood, however, due to the enormous coverage of these lenses they are best considered as offering limited protection, rather than effective shading, to the front elements. Nikon's NIC process ensures that in both the f2.8 versions flare is controlled very tightly and ghosting is virtually eliminated.

Perspective Control Nikkors

The first ever Perspective Control (shift) lens, the PC Nikkor 35mm f3.5, was introduced by Nikon in 1962. The front section of the lens can be shifted up to 11mm off the central axis by sliding along on dovetail shaped rails. The lens can be rotated a full 360° with click stops every 30° so that shifting is possible vertically, horizontally, and diagonally. In the latter direction shift is limited to just 7mm in order

Control of Perspective

Control of perspective is a common problem with all cameras in which the lens axis is fixed in a perpendicular plane to the film. It often manifests itself when shooting a tall object such as a building because the camera has to be tilted upwards to include the entire subject. The result is that the normally parallel lines of the building appear to converge towards the top making the building appear as though it is leaning backwards. This effect is due to the rules of projection and has nothing to do with optical distortion. The phenomenon of converging verticals can be avoided by keeping the film plane exactly parallel to the subject plane. Most large format and some medium format cameras allow the lens to be moved in relation to the film plane so that the correct perspective can be maintained. Such lens movements are not widely available for 35mm film format cameras, however, Nikon have produced two shift lenses, in focal lengths of 35mm and 28mm. These allow their lens elements to be moved off the central axis of the lens, whilst still being kept perpendicular to the film plane. They allow the back of a camera to remain parallel to the subject, as the image circle projected by the lens is much larger than normal, and can be moved in relation to the position of the film or CCD. A third lens, the Micro-Nikkor 85mm f2.8D PC allows its lens elements to be tilted off axis as well as shifted in relation to the film plane. This additional movement allows the depth-of-field to be controlled very precisely.

to prevent vignetting. Perspective Control (PC) lenses are very versatile and ideally suited to shooting architecture and landscapes. All PC-Nikkors project an enlarged image circle that allows the lens elements to be moved off the lens axis. Due to

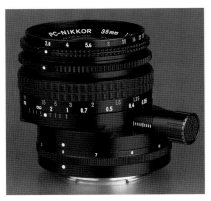

The PC-Nikkor 35mm f2.8 allows the lens elements to be shifted off-axis as shown here.

their construction these lenses cannot be fitted with an automatic diaphragm or couplings for the metering system. Instead they use a simple pre-set aperture system that has two rings set around the front of the lens. The desired aperture is selected with the first ring whilst the second ring, which actually stops the aperture down, is left at the maximum aperture value to facilitate focusing and composition. Then before the expose is made this ring is rotated to close down the iris diaphragm. It is important to perform any TTL-metering before the lens is shifted, otherwise the meter reading may be incorrect due to light fall off inside the camera. This is often seen in the viewfinder image at or near the maximum shift position due to the fact that the rear element of the lens is displaced past the edge of the reflex mirror.

The first version of the 35mm PC-Nikkor lacks NIC and suffers from mediocre sharpness and contrast as a result. In 1968 a new faster f2.8 version was introduced with a few cosmetic changes. Optically it is far better than its predecessor and has 8 elements in 7 groups, weighs 335g, and focuses down to 30cm. A third version introduced in 1975 has a couple of minor modifications to its external appearance. The fourth ver-

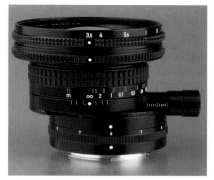

The current version of the PC-Nikkor 28mm f3.5

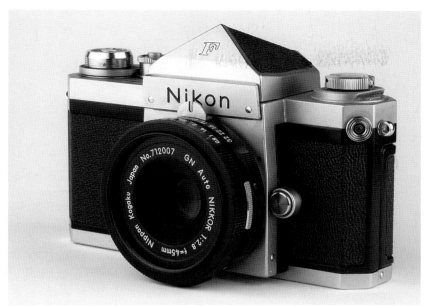

A GN-Nikkor 45mm f2.8 is shown here mounted on a Nikon F camera.

sion appeared in 1980 and is distinguished by its black adjusting knob. It has a new 7 element optical configuration that reduces its weight to 320g produces the best results of all the 35mm PC-Nikkor lenses. This lens was converted to the AI-S type mount in 1982, but was otherwise unchanged and remained in production in this form until it was discontinued during 2001.

For many applications the 62° angle-of-view of the 35mm PC lens was not sufficient. So in 1975 Nikon introduced the PC-Nikkor 28mm f4, a 10-element design with a 74° angle-of-view. It accepts 72mm filters, weighs 410g, and can be shifted up to 11mm off the central axis and produces a stronger perspective effect due to its shorter focal length. Its operation is identical to the longer PC Nikkor including the 30° click stop positions when the lens is rotated around the lens mount. In 1980 it was replaced by the faster 9-element PC-Nikkor 28mm f/3.5. At 380g this lens is lighter than its predecessor, and has the CRC system to improve the optical quality at all focus distances. In my experience the best performance with this version is attained at f11, although even here at maximum shift there is a perceptible softness in the extreme corners. At the time of writing this version continues to be in production. The debate as to which version

of the 28mm PC-Nikkor is the best has never been properly resolved; personally I would opt for the later f3.5 version, but this is a purely subjective decision.

The 45mm GN-Nikkor

Designed specifically for flash photography the GN-Nikkor 45mm f2.8, which was introduced in 1968, protrudes just 2cm in front of the camera body. In the days before electronically controlled automatic flash units photographers had to calculate the shooting aperture by dividing the guide number of the flash unit by the distance between the camera and subject. Each time the distance changed the calculation has to be repeated so Nikon designed this lens to link the two parameters mechanically. On the GN-Nikkor the guide number of the flash unit is set on a scale on the focusing ring. At ISO100 the scale is marked in metres (10 to 80) and feet (32 to 250). Once this value is selected and set the focus ring becomes linked to the aperture ring. In this way as the focus distance is altered the aperture is opened or

closed accordingly, thus saving the photographer the time and effort of performing the necessary calculations. The lens has 4 elements in 3 groups, an aperture range of f2.8 to f32, seven blades in the diaphragm, and focuses down to 80cm. It has the unusual feature of being the only Nikkor lens in which the focus ring turns clockwise (viewed from behind the camera) to focus closer. The image quality is high, but unremarkable by Nikon standards, however, its rather low contrast is ideal for the high contrast light quality of flash. The lens received one update in 1973 with the introduction of an improved lens coating before being discontinued in 1977.

This is a close-up view of the film speed scale on the GN-Nikkor 45mm f2.8 lens.

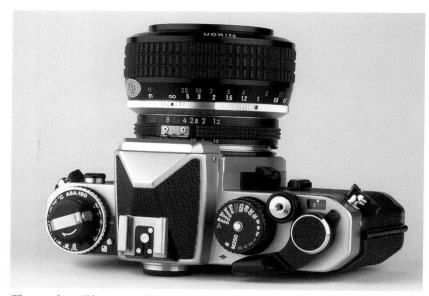

The very fast Nikkor 58mm f1.2 Noct lens is seen here on a Nikon FE2 camera.

The 58mm Noct Nikkor

The name of this lens is an abbreviation for nocturnal and gives a clue as to the intended application of this very fast lens. The principle difficulty in shooting any low light scene that includes bright point sources of light with a fast lens wide open is the effect of coma. This phenomenon is caused by light from such sources that passes through the lens off its central axis and results in an asymmetrical blurring of these highlights.

Nikon's first lens with a maximum aperture of f1.2 was the Nikkor 55mm f1.2 introduced in 1967, however, the Nikkor 58mm f1.2 Noct lens did not appear until 1977. By using an aspherical front element coma is virtually eliminated in the Noct lens, but due to its optical construction this specialist optic was very expensive. It uses seven elements in six groups, accepts 52mm filters and weighs 485g. The second version was introduced in 1982 with the AI-S type lens mount but is otherwise unchanged. It has since been discontinued although doubtless a few new examples can still be found.

Defocus Control (DC) Nikkors

In 1990 Nikon added a completely new type of lens to their line-up: the DC-Nikkor 135mm f2. It has a special Defocus Control operated by turning a ring set around the barrel, which shifts certain elements within the lens independently of the focus action that either under, or over corrects the spherical aberration in the out-of-focus highlights. Combined with the nine blades of the diaphragm this additional control allows the photographer to apply a graduated amount of softness to the out-of-focus areas, either in front of, or behind the subject, by matching the aperture value on the DC ring to the shooting aperture whilst maintaining a crisp sharpness in the plane of focus. Setting the DC ring to an aperture value that is smaller than the shooting aperture induces softness over the entire image. The degree of softness increases the more the DC aperture value deviates from the shooting aperture. Since the system operates by using spherical aberration, which is largely eliminated at small apertures the most pronounced effect is achieved between f2 and f5.6. The 135mm f2 DC lens has 7 elements, weighs 815g, a 72mm filter thread, and focuses down to 1.1m. The first version was upgraded in 1992 to the D-CPU specification following the introduction of the F90. This lens was an instant hit with fashion photographers who wished to isolate their model from the background as it mimics the effect of a 300 f2.8 optic used wide open, but at less then half the working distance.

In 1993 Nikon introduced a second DC-Nikkor in the 105mm focal length. It operates in exactly the same way as the longer lens. Its 6-element design has the D specification CPU, focuses down to just 0.9m, takes 72mm filters, and

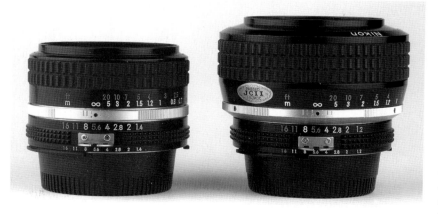

The Nikkor 58mm f1.2 Noct lens dwarfs the 50mm f1.4 lens next to it.

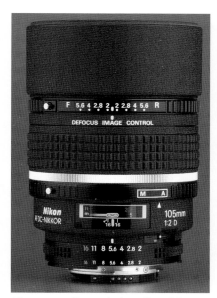

The outstanding optical quality of the AF DC 105mm f2D elevates it to a position as one of the very best Nikkor lenses ever made.

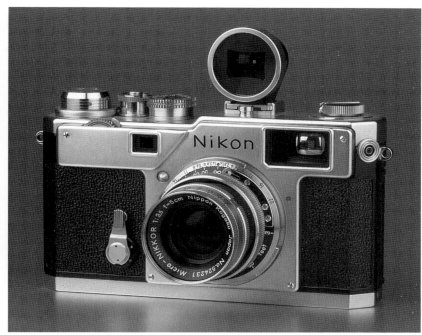

A Nikon S3 rangefinder camera with the ancestor of all Micro-Nikkors the 5cm f3.5 lens.

weighs only 640g. It provides a good compromise of medium focal length and wide aperture to give the natural perspective and shallow depth-of-field favoured by many portrait photographers. I have shot with both versions of this unique lens design; optically the 135mm is very good but no match for the outstanding performance of the 105mm. The RF system provides quick positive AF response and although it takes a little experimentation once mastered the DC control feature is a very creative tool. I do have a couple of criticism though as the retractable lens hood on both lenses is so short it is next to useless, and rather than being engraved the numerous lens markings are printed on, and with extensive use will eventually rub off!

Micro Nikkors

Most normal Nikkors offer reproduction ratios of between 1:10 and 1:7 at their closest focus distance, and are corrected to deliver their best performance between middle to long distances, generally from a range equivalent to 25 times their focal length. Many can be used with either extension tubes or supplementary close-up lenses to provide higher magnifications, however, lenses specifically corrected for working at short distances will always produce higher image quality for close-up and macro work.

The three fixed focal length AF Micro-Nikkor lenses currently available: the 105mm f2.8, 200mm f4, and 60mm f2.8 (l to r).

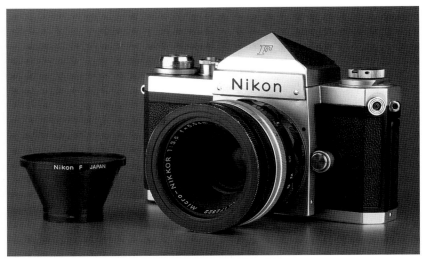

Nikon F with the Pre-set 5.5cm f3.5. The conical accessory is the detachable filter ring that is required because the front element is recessed so far, and the front lens ring rotates to stop down the aperture.

Nikkor lenses are no exception and Nikon have produced some legendary optics in this class of lens over the years.

All close focusing Nikon lenses are

The Micro-Nikkor 5.5cm f3.5 lens uses a pre-set aperture.

known as Micro-Nikkors, which is something of a misnomer since true microphotography starts at reproduction rations of around 1:25 and generally involves the use of a microscope. The name is a hangover from an early lens, Nikon's first true macro lens for their rangefinder cameras. Introduced in 1956 it carried the name - Micro-Nikkor, has a focal length of 5cm, a maximum aperture of f3.5, a five-element design, and a closest focusing distance of 45cm.

The first close focus Nikkor for the Nikon F camera was the 5.5cm f3.5 Pre-set. Introduced in 1961 it

can achieve a reproduction ratio of 1:1, but has to be used with a preset aperture rather than the far more convenient automatic diaphragm system, and the significant lens extension as it is focused closer and closer means that it is very slow to operate, which reduces its handling performance even further. This was followed by the Nikkor 5.5cm f3.5 Micro-Compensating, which as the name implies automatically compensates for the fall of light at the film plane due to the extension of the lens as it is focused progressively closer. Introduced in 1963 it was discontinued within a year. On its own it can achieve a maximum reproduction ratio of 1:2, and when fitted with the M extension tube this is increased to 1:1.

It was succeeded by the Micro-Nikkor 55mm f3.5, which has an automatic diaphragm. It was supplied with the M extension ring to provide a 1:1 reproduction ration and can focus continually from infinity down to 24cm. Although optimized for a reproduction ratio of 1:10 or less it performed so well throughout the whole distance range that many photographers used it as their standard lens. The sharpness and contrast of this Micro-Nikkor are so high that it exceeded that of most films available at the time. In 1970 a modified ver-

A Micro-Nikkor 55mm f3.5 with an M extension tube

The manual focus Micro-Nikkor 55mm f2.8 is shown here at full extension for a reproduction ratio of 1:2.

sion with improved coating was introduced along with the new M2 extension ring, and in 1975 it was further modified mechanically and delivered with the automatic extension ring PK-3. The final version appeared in 1977 with the AI type lens mount.

A slightly faster successor, the Micro-Nikkor 55mm f2.8 was introduced in 1979. The increase in speed was achieved by use of the CRC system, which moves the central lens group in this six-element design. It has a deeply recessed front element that obviates the need for a lens hood, and provides a maximum reproduction ratio of 1:2. In 1987 an AF version appeared which can be focused down continuously down to 23cm, which gives a reproduction ratio of 1:1 without the need for an extension ring. The filter size was increased from the 52mm of the previous lenses to 62mm, and a ring around the barrel is used to select AF or manual focus. Like all early AF Nikkors it suffers from a very narrow focus ring which impairs its handling, and there is so

much play in the AF cam system that often many photographers thought the lens had developed a fault due to the noises they heard when it operated. In 1989 a totally new lens with a focal length of 60mm was introduced.

It offers excellent manual as well as AF performance focusing from infinity to 22cm, where it gives a reproduction ratio of 1:1 at the minimum focus distance (MFD), with a working distance of just 7.3cm. The lens weighs a modest 440g and has a 62mm filter thread. On the lens barrel there is a sliding switch used to set two AF focus ranges to speed up AF operation.

Image quality is comparable to its shorter 55mm f/2.8 predecessors, both manual and AF, in other words excellent in the range of f5.6 to f/11, but below this image quality does deteriorate. Close focusing aside it is a good general-purpose optic, and it is particularly suited to copying flat artwork. However, this lens suffers from two drawbacks, the first concerns the effective focal length, which gets progressively shorter as you approach its MFD. The second

is the very short working distance between the front of the lens and the subject at, or close to, 1:1 magnifications. This often means that the lens can obstruct light from a flash unit or reflector from reaching the subject. Worse still is the risk that such close proximity might disturb a timid creature. The only remedy is to use a lens with a longer focal length.

Nikon's first close focusing long lens for the Nikon F was a 135mm f4 lens head, which lacks a focusing mount. It came from the rangefinder lens programme and can only be fitted to an F-mount camera via a BR-1 ring. Together with either the PB-2 or PB-3 bellows unit it allowed reproduction ratios from infinity to 1:1. In 1970 this lens head was succeeded by the Bellows-Nikkor 105mm f4, which still depends on a bellows but has an F-mount bayonet. This lens does not have an automatic diaphragm, but its aperture values can be set in 1/3stops.

In 1974 Nikon introduced their first true close focus telephoto, the five-element Micro-Nikkor 105mm f4, which has a standard F-mount

Currently the AF Micro-Nikkor 60mm f2.8D is the shortest in the Micro-Nikkor class.

The AI-S Micro-Nikkor 105mm f2.8, a manual focus lens that offers a practical working distance for most subjects.

and permits focusing to 47cm resulting in a reproduction ratio of 1:2. The PN-1 extension ring, which later became the PN-11 in the AI-version, extends this to 1:1. It has a retractable lens hood and accepts 52mm filters. One small flaw in this design was that after a period of use the focusing action would naturally become looser with use. In certain circumstances, particularly when used vertically on a copy stand, the weight of the focus ring could cause it to move inadvertently and cause a focus shift. In 1977 a modified version with the AI mount and a locking screw to secure the focus ring was introduced. The final version of this lens appeared in 1981 following conversion to the AI-S type mount, otherwise its specification is the same as the AI version.

In 1983 the Micro-Nikkor 105mm f2.8 with CRC appeared. A full stop faster than its predecessor it has ten elements, weighs 515g, and accepts 52mm filters. Many consider this lens delivers images with slightly lower contrast than its predecessor, but I believe this is splitting hairs.

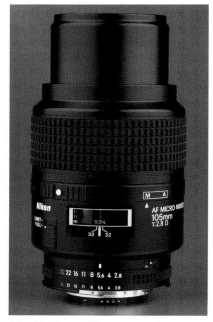

The AF Micro-Nikkor 105mm f2.8

Used with the PN-11 ring it goes beyond 1:1 upto 1:0.88.

An AF version, the AF Micro-Nikkor 105mm f2.8, was introduced during 1990. It has a nine-element design with floating elements as part of Nikon's Close Range Correction (CRC) system, which is employed to improve image quality at close ranges. The lens can be focused down to 3.14cm to provide a ratio of 1:1, where the working distance is reduced to 13.6cm. Unfortunately, like the AF 60mm f2.8 optic the penalty for having a lens that focuses continuously from infinity to life-size is that the effective focal length becomes shorter the closer you focus, until at 1:1 it is barely more than $^2/_3$ its original length. It is also worth noting that at this point the effective maximum aperture is only f/5. Image quality is excellent at the wider apertures and peaks around f/5.6 however, below f/11 there is a noticeable reduction in sharpness at the corners despite the use of the CRC system. There is a focus range limit switch to facilitate faster AF operation and unlike the other AF Micro-Nikkors it has a 52mm filter thread. In 1993 the lens was upgraded to the D-type specification.

The longest Micro-Nikkor is the 200mm f4. The first version appeared in 1978 and achieves its largest reproduction ratio of 1:2 at a working distance of 71cm. This nine-element design with internal focusing is also an excellent all round telephoto lens that can be used for normal photography. It is fitted with a wide and very sturdy rotating tripod collar that provides secure support as well as balanced, easy handling. The extra working distance offered by this focal length makes these lenses very popular for photographing any subject that is difficult to approach. The lens was modified to the AI-S standard in 1982 and provided with a detach-

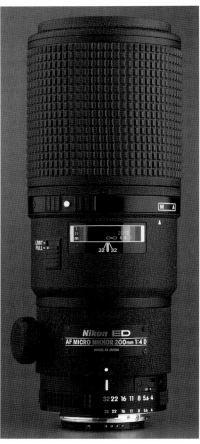

A classic Nikkor lens – the AF Micro-Nikkor 200mm f4 D IF-ED

able tripod collar. A reproduction ratio of 1:1 can be achieved in two ways: either in combination with two PN-11 extension rings, or with a 2x teleconverter. The TC-300/301 is recommended because optically it provides a superior combination. The TC 200/201 can also be used, but vignetting is apparent towards the corners at full aperture due to the greater distance between the rear lens element and the converter's front element.

The AF version of the 200mm Micro, the AF Micro-Nikkor 200mm f4D IF-ED, is a sensational lens that ranks alongside my other favourite fixed focal length Nikkors; the AF 105mm f2 DC, and AF 14mm f2.8. It has 13 elements in 8 groups, weighs 1200g, and accepts

62m filters. The lens focuses down to 50cm where it provides a reproduction ratio of 1:1, with a working distance of 26cm. The combination of its narrow angle of view and long working distance (almost four times that of the 60mm Micro) helps to isolate the subject and simplify backgrounds at the same time, setting this lens apart from its shorter siblings.

The AF is quick if not lightening fast, but then I believe AF for macro work is irrelevant anyway, because the extremely shallow depth-of-field, even at small apertures, requires critical focusing. In practical field conditions there will usually be minute movements of the subject, which will result in the AF system constantly 'hunting' as the exact plane of focus shifts. So stick to manual focus and remain in control!

Optical quality between f/4 and f/16 is second to none and its performance is equally good at long or short distances. The two ED glass elements ensure images have a rich contrast with no hint of chromatic aberration, and resistance to flare and ghosting is impressive. It handles extremely well thanks to a broad, sturdy, detachable tripod collar, so changing from horizontal to vertical format very easy. I am not sure if I am just unlucky, but on my lens, which I have owned for nearly ten years the A/M collar, used to switch between AF and manual focus, has developed a number of shallow stress cracks around the screw heads set in to it – this is of no particular concern to me since I only ever use manual focus with this lens. The wonders of gaffer tape!

As if the fixed focal length Nikkors were not enough Nikon's reputation for innovation in optical design was further enhanced in 1997 with the release of the AF Micro-Nikkor Zoom 70-180mm f4.5-5.6D.

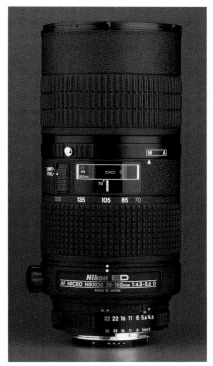

Another world first in optical design for Nikon: the AF Micro Zoom-Nikkor 70-180mm f4.5-5.6D.

The world's only true AF macro-zoom this extraordinary lens is unique. It has no less than eighteen elements in fourteen groups and can focus down to 0.37m at all focal lengths. Set to 180mm the lens offers a maximum reproduction ratio of 1:1.3 with a free working distance of over 112mm. This can be increased to 1:1 by attaching Nikon's 6T close-up lens. The nine-blade diaphragm produces an even appearance in out of focus high-lights, whilst the incorporation of ED glass ensures a spectacular optical performance by which the subject is rendered with a crisp clarity regardless of the shooting range. It has a two ring design one for the focus action and the other to select the focal length. Both rings are wide enough for safe operation by gloved hands. It weighs 1010g and accepts 62mm filters, and has the advantage that the effective aperture does not vary as the focus distance is altered. The great advantage of this versatile lens is its ability to fine tune a composition without having to reposition the camera each time. Often in close-up work, especially in the field, it is difficult to position the camera and tripod without disturbing your subject. This lens allows you to settle into position then by using the zoom feature and rotating the lens around its tripod collar

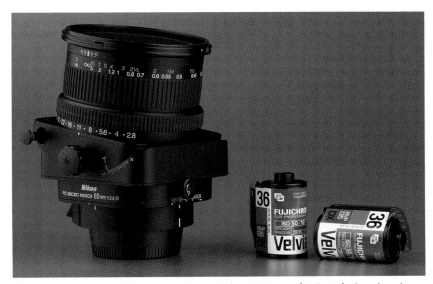

The tilt and shift capabilities of the Micro-Nikkor PC 85mm f2.8D make it unique in the Nikkor lens family.

attain precise framing and a variety of compositions without having to move constantly. For these reasons it is a lens I rarely leave out of my bag.

The most recent addition to the Micro-Nikkor series is the 85mm f2.8D PC Micro that was released in 1999. Capable of tilt and shift movements it represents a first for Nikon, unlike Canon who have had a series of such lenses in their range for a number of years. Designed to provide greater control over depth-of-field and perspective its abilities can be employed to produce some very creative photographs as well. It was launched alongside the Nikon D1 digital SLR and was clearly intended to compliment this camera in the domain of studio based product photography, though it would be wrong to restrict this versatile optic to just that role. I have used it very effectively for landscape, architecture, and close-up photography in the field. It is a manual focus lens that weighs 775g, has a 77mm filter ring and focuses down to 0.4m. It has a D specification CPU to communicate the aperture setting and

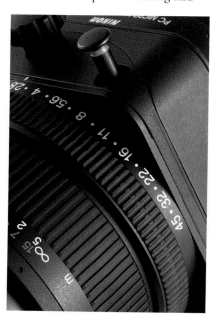

This close-up shows the lens diaphragm stop down button.

focus distance to the camera body. The aperture must be set manually using the pre-set aperture ring, which has indents at half-stop values between f2.8 and f45. Metering must be carried out before any lens movements are applied. The diaphragm can be held open by releasing the aperture stop down button, then once the lens settings have been made and the composition finalized the button is depressed to close the aperture to its shooting value. Both the shift and tilt movements, which operate in planes set at 90° to each other, are controlled by their respective knobs and can be locked in place by small-

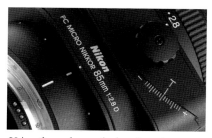

Using the scales on the lens barrel you can measure both tilt and shift movements.

er secondary knobs set on the opposite side of the lens.

The instruction book states that the lens can be workshop modified in order that the two movements operate in the same plane if the photographer should require this feature. To use the movements in a diagonal direction the lens can be rotated around the lens mount by releasing the locking button located on the rear edge by the lens mount flange; there are click stops at each 30° positions. This is a specialist lens that uses the tilt mechanism to control depth-of field, and the shift movements to alter perspective. It produces incredibly sharp images with a degree of control offered by no other Nikkor. I only wish Nikon would produce a similar lens with a 24mm focal length!

UV Nikkors

In 1964 Nikon introduced the Ultra Violet (UV) Micro-Nikkor 55mm f4 with an especially high transmission value for wavelengths between 300nm and 400nm. A three-element design it was based on the standard 55mm f3.5 Micro-Nikkor and allows close focusing down to 36cm. In 1985 Nikon introduced the UV-Nikkor 105mm f4.5, which is optimized for wavelengths from 220nm to 1100nm with the help of lens elements made with quartz glass and

The Wavelengths of Light

The glass used to make lens elements, and the complex chemical coatings that are applied to them in Nikon's Super Integrated Coating (SIC) process, are designed to restrict the range of wavelengths of light they transmit. The visible part of the spectrum occurs in the range of 400 to 700 nanometres (nm). Infrared (IR) light has a range of wavelengths that begin around 750nm and increases up to about 1400nm beyond which it becomes heat radiation. Ultraviolet (UV) light has a wavelength range between about 100 to 380 nm, and is often the cause of the strong blue cast recorded on film at high altitude or, in the vicinity of a coastline, where levels of UV light are generally at their highest. For normal photography the SIC applied to Nikkor lenses usually eliminates the effect of UV light, but to be absolutely sure many photographers use an UV filter, which to be more accurate should be called a UV blocking filter, on their lenses. However, there are some specific applications in the fields of medicine, science, and technology where the use of a controlled UV light source can reveal features that cannot be detected within the normal visible spectrum. For these situations Nikon made a range of UV-Nikkor lenses.

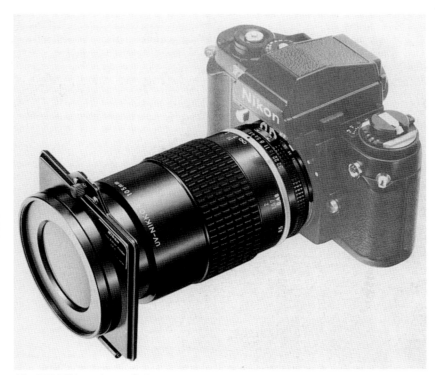

The UV-Nikkor 105mm f4.5

SB-140, was introduced to compliment this lens. It is capable of emitting just ultraviolet or infrared light with the help of appropriate filters. At the 1988 Photokina a prototype of a second UV-lens, the UV-Nikkor 50mm f4.5, was displayed; this lens has never been put into production.

Medical-Nikkors

The two Medical-Nikkor lens models produced by Nikon combine a macro-lens and a ring-light flash unit, and were developed to record medical and dental procedures. The first type was introduced in 1962; the Medical-Nikkor 200mm f5.6 consists of four elements and is fixed at a focusing distance of 3.35m, which provides a reproduction ratio of 1:15. The six supplementary lenses supplied with the lens, some of which can be combined with each other, enable this to be increased to 3:1. Due to its design the lens can only be used with the built-in flash unit; hence there are no couplings to link with a camera metering system. A ring around the lens barrel is used to set the film speed, which is marked in ASA units. The aperture is set automatically between f/5.6 and f/45 according to the film speed and reproduction ratio that are selected. If required sequential numbers from 1

fluorite. Its outstanding image quality comes close to the theoretically possible maximum throughout the focusing range. It was designed for special applications in forensic work, industrial product examination, and medical science.

This six-element design uses the same focusing system as the Micro-Nikkor 105mm f4 lens, which allows reproduction ratios to 1:2. A special

UV filter and the matching UR-2 filter holder were supplied with the lens. The transmission of this filter is limited to a range of wavelengths between 250nm and 380nm. Obviously any lens accessory such as a filter or teleconverter that is coated to eliminate UV transmission cannot be used with this lens for UV-photography. One year later a special Nikon Speedlight flash unit, the

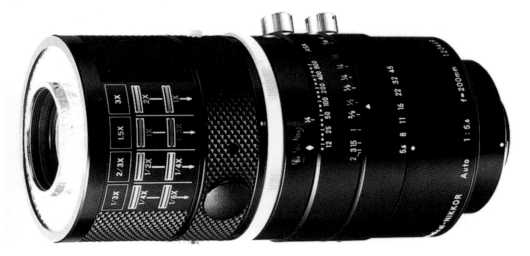

The Medical –Nikkor 200mm f5.6 with its built-in ring light flash tube.

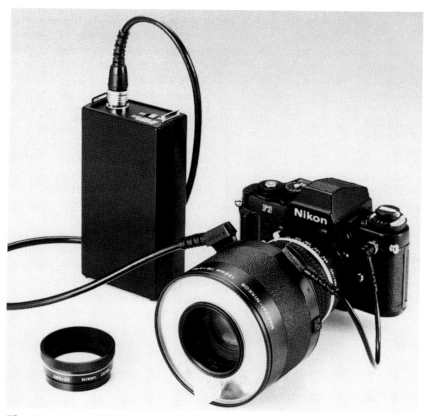

There is an internal focusing system in the Medical-Nikkor 120mm f4 to assist handling.

weighs 890g and accepts 49mm filters. The most significant difference is the much easier continuous focusing, which operates between 1.6m to 0.35m, providing reproduction ratios between 1:11 and 1:1. The dedicated close-up lens extends this range from 1:1 to 2:1. The larger ring light gives a softer illumination while the film speed setting, which has a range of ISO25-800, controls the flash exposure. The correct aperture is automatically selected as the focus is adjusted. Either the LA-2 AC unit or the LD-2 battery pack can be used as power supplies for both this lens and the SB-21 Speedlight flash unit. If required the reproduction ratio can be imprinted onto the picture. To facilitate focusing a small lamp located in the flash reflector can be illuminated for up to 16 seconds. The effective focal length can be extended to 170mm by using a TC14A or TC14B Teleconverter, although this causes a loss of one stop of light.

to 39, and the reproduction ratio can be imprinted within the image area of the film frame. The lens has an automatic diaphragm and a focusing lamp in the flash tube to improve handling. Either the LA-1 AC unit or, the LD-1 battery pack, which can also be used for the SR2/SM-2 ring lights, supplies the power. A second version of the lens was introduced in 1972 with a simplified colour coded table to assist in selecting the supplementary lens and calculating the reproduction ratio. Flash output can be switch between full and 1/4 power and the lens has an improved coating. In 1974 a mechanically modified version appeared which looked almost identical to the original. It can easily be distinguished though by its three-pin terminal as opposed to the older four-pin version. The built-in ring light has a guide number of just

7.5, but this is quite sufficient for the short distances involved.

The Medical-Nikkor 120mm f4 was introduced in 1981 and offers much more convenient handling. The lens is a 9-element design that

Teleconverters

Nikon's stable of teleconverters has evolved steadily over the years reflecting the development in Nikon camera and Nikkor lens design. The first converters, introduced during

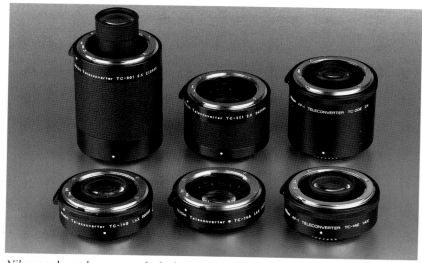

Nikon produce teleconverters for both manual and AF Nikkor lenses.

How Teleconverters Work

Teleconverters sometimes referred to as 'extenders' have an optical system designed to effectively increase the focal length of lenses. Placed between the lens and the camera they work by magnifying the image formed by the lens so that an enlarged section of this image appears at the film plane.

There is, however, a price to pay because the converter reduces the amount of light that reaches the film due to the fact that the magnification process spreads the light from the lens image over a greater area. A 1.4x converter spreads the light over an area approximately twice the size of the lens image, thus the intensity of the light at the film plane is halved; the light 'loss' is equivalent to 1 stop. A 2x converter spreads the light over an area four times the size of the lens image, thus the intensity of the light at the film plane is reduced to a quarter; equivalent to a 'loss' of 2 stops. For example a 300mm f2.8 lens with a 1.4x converter attached, and set to its maximum aperture, has an effective focal length of 420mm and an effective maximum aperture of f4. The same lens fitted with a 2x converter will have an effective focal length of 600mm and maximum aperture of f5.6.

This though is only half the story since use of a converter brings about other changes. Teleconverters do not alter the minimum focus distance (MFD) of the lens with which they are combined. This greatly enhances the close-up abilities of the combination. For example on its own the 200mm f4 AI-S Micro-Nikkor lens focuses down to a maximum reproduction ratio of 1:2, or half-life size, at a working distance, the distance between the front of the lens and the subject, of 50cm. Add the TC 301 (2x) teleconverter, and at the same working distance, the lens, which now has an effective focal length of 400mm and aperture of f8, provides a reproduction ratio of 1:1, or life size.

Although the MFD does not change, using a converter does reduce the depth of field of the lens in use. The amount of reduction is in direct inverse proportion to the magnification factor of the converter. As described above fitting a 2x converter to a 300mm f2.8 lens doubles its effective focal length to 600mm, decreases the effective maximum aperture to f5.6, but also reduces the DoF by half. For instance the 600mm f5.6 IF-ED Nikkor focused at its MFD of 5m and set to f5.6 has a DoF of 16.8cm. A 300mm f2.8 IF-ED lens, with a TC301 (2x) converter, set to f2.8 (effective f5.6) and focused to the same distance has a DoF of 8.4cm.

Whilst this reduction in DoF could potentially cause difficulties when shooting close-up pictures, it can be an advantage when using long telephoto lenses. The shallower DoF will enhance the isolating effect of the lens on the subject, thus helping to separate it from its background. This is one of the principle reasons that high quality Nikon teleconverters are now so widely used by professional photographers across all disciplines of photography.

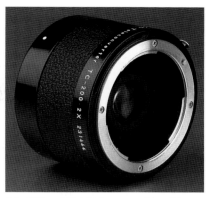

The Nikon TC-200 is compatible with lenses up to a 200mm focal length.

The TC-2 was also a 2x converter usable with lenses having an aperture of f2.8 or less, but designed specifically for lenses with a focal length of 300mm or more. The optimisation of its five element optical system meant that the converter's first element protruded about 25mm beyond the front bayonet flange. Like the TC-1, the TC-2 was replaced by the TC-300 during 1977 and later, in 1983, it was modified to provide compatibility with AI-S Nikkor lenses, and was renamed the TC-301.

Also released during 1977 was another teleconverter, the TC-14. It gives a magnification factor of 1.4x the focal length of the lens, and was constructed with five optical elements. Intended for lenses with focal lengths of 300mm or longer, and apertures of f2 and smaller, it has a first element that protrudes

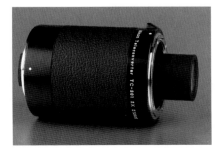

The Nikon TC-301 teleconverter magnifies the lens image by a factor of two for lenses of 300mm or longer.

1976, were the TC-1 and TC-2. The TC-1, a 2x converter, was designed for focal lengths up to 200mm, including any zooms with this focal length in their range, as well as the 500mm f8 Reflex-Nikkor. It comprised seven optical elements with Nikon Integrated Coating (NIC), and was suitable for lenses with a maximum aperture of f2 or less. Just one year later the TC-1 was replaced by the TC-200 that incorporated the AI-aperture lens coupling system. Optically it was unchanged, as was its successor the TC-201, which was released in 1983, to maintain compatibility with the Nikon AI-S lens coupling system introduced the year before, preceding the launch of the Nikon FA camera.

Nikon Teleconverters

Model	Lens Mount	Period in production	Extension factor	Usable focal length	Light loss (stops)	Usable lens speed	Weight (g)	Dimensions Dia/L (mm)	Special features
TC-1	K	06/76-06/77	2x	≤ 200	2	2.0-32	230	64.5 x 51.5	
TC-200	N	08/77-09/83	2x	≤ 200	2	2.0-32	230	64.5 x 52	
TC-201	Ai-S	Since 10/83	2x	≤ 200	2	2.0-32	230	64.5 x 52	
TC-2	K	06/76-06/77	2x	≥ 300	2	2.8-32	280	64.5 x 115	
TC-300	N	08/77-09/83	2x	≥ 300	2	2.8-32	325	64.5 x 115	
TC-301	Ai-S	Since 10/83	2x	≥ 300	2	2.8-32	325	64.5 x 115	
TC-14	N	08/77-10/83	1.4x	≥ 300	1	2.0-32	170	64.5 x 33.5	
TC-14B	Ai-S	Since 10/83	1.4x	≥ 300	1	2.0-32	165	65 x 34	
TC-14C	Ai-S	06/84-06/90	1.4x	300	1	2.0-16	200	64.5 x 35.5	300 f2 IF-ED
TC-14A	Ai-S	Since 10/83	1.4x	≤ 200	1	1.8-32	145	65 x 25.5	
TC-16	AF	05/84-01/86	1.6x	Various	1.3	1.8-32	285	88 x 44	F3 AF only
TC-16A	AF	03/86-01/91	1.6x	Various	1.3	1.8-32	150	69 x 30	See below ***
TC-14E	AF	03/93-06/01	1.4x	≥ 300	1	2.0-32	200	66 x 24.5	AF-I & AF-S *
TC-20E	AF	03/93-06/01	2x	≥ 300	2	2.0-32	355	66 x 55	AF-I & AF-S **
TC-14E II	AF	Since 06/01	1.4x	≥ 300	1	2.0-32	200	66 x 24.5	AF-I & AF-S *
TC-20E II	AF	Since 06/01	2x	≥ 300	2	2.0-32	355	66 x 55	AF-I & AF-S **

Notes to table:

* Can only be used with 300 f2.8, 400 f2.8, 500 f4, 600 f4 AF-I lenses & 80-200 f2.8, 300 f2.8, 300 f4, 400 f2.8, 500 f4, and 600 f4 AF-S lenses.
Not compatible with the AF-S 17-35mm f2.8, AF-S 28-70mm f2.8, AF-S 24-120 f3.5-5.6 G, or AF-S 24-85mm f3.5-4.5 lenses.
** AF only operates with 300 f2.8, 400 f2.8 AF-I lenses, and the 80-200 f2.8, 300 f2.8, 300 f4, 400 f2.8 AF-S lenses.
Not compatible with the AF-S 17-35mm f2.8, AF-S 28-70mm f2.8, AF-S 24-120 f3.5-5.6 G, or AF-S 24-85mm f3.5-4.5 lenses.
*** Designed to work with F-501 / F801 / F-801S / F90 / F90X / F4.

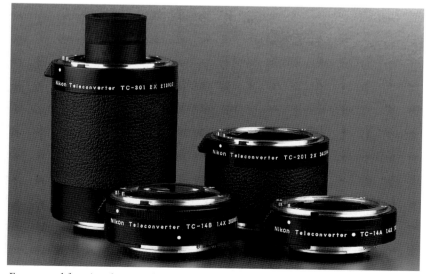

For manual focusing there are four teleconverters the TC-301 and TC-201 (back l to r) and the TC-14B and TC-14A (front l to r)

slightly beyond the front bayonet flange. The TC-14 can also be used successfully with some shorter lenses provided their rear element is located far enough inside the lens barrel. For example, 200mm f4 AI-S Micro-Nikkor, as well as the 135mm f3.5, and 200mm f2 IF-ED, which becomes a 280mm f2.8. As with the other Nikon teleconverters the TC-14 was modified during 1983 to make it compatible with the AI-S lens coupling, and was re-designated as the TC-14B.

During 1984 Nikon released the amazing 300mm f2 IF-ED Nikkor, a monster of a lens, it was supplied with its own dedicated teleconverter the TC-14C. The converter's perfor-

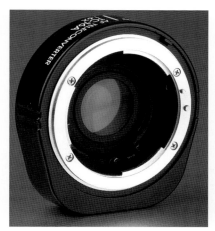

The TC-16A was intended to act as a bridge between the early Nikon AF cameras and manual focus Nikkor lenses.

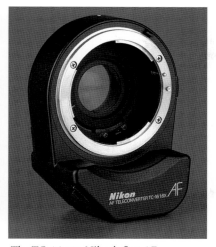

The TC-16 was Nikon's first AF compatible teleconverter.

mance is comparable to that of the TC14-B, and turns the 300mm f2 into a 420mm f2.8 lens.

Coinciding with the update of the TC-14 to the TC-14B during 1983, Nikon announced a new class of 1.4x converter for lenses with a focal length of 200mm or less, the TC-14A. It is a five element design for use with lenses having an aperture of f1.8 or smaller. So for example the 105 f1.8 Nikkor is converted to a 150mm f2.5, and the 180mm f2.8 becomes a 250mm f4.

The TC-14A, TC-14B, TC201, and TC301 remain in production and, like their predecessors, are designed for manual focus Nikkor lenses. None of them have the necessary mechanical drive connections or electrical contacts required by any of the various generations of Nikon auto focus (AF) cameras and Nikkor AF lenses to perform AF. Nor are they able to perform the exchange of electronic data between lens and camera for the 3D-multi-segment metering and flash control functions.

1984 saw the introduction of Nikon's first auto focus (AF) camera, the F3 AF, and at the same time the corporation's first AF compatible teleconverter, the TC-16. It

extends the focal length by a factor of 1.6x, causing a loss of light equivalent to 1 1/3 stops, and can be used with lenses having a maximum aperture of f1.8 or less. However, it can only be used with the F3 AF camera.

Two years later Nikon's engineers had managed to refine their AF system and Nikon released the F501 camera. In conjunction with the F501 came a modified version of the TC-16 the TC-16A. The idea behind the TC-16A was to provide a

head start in the new AF era for Nikon photographers by providing an AF function with more than 30, of the then available, conventional manual focus Nikkor lenses. To achieve this the movable optical system of the TC-16A converter is driven by the AF motor in the camera body via a mechanical linkage. Since the optical elements of the converter can only be shifted through a range of 5mm the AF range available decreases as focal length increases. A 35mm lens can be focused automatically between infinity and 60cm, but with a 180mm lens the focusing range is restricted from infinity to 13m, when the lens is manually set to infinity. To work at a shorter focus point the lens must first be manually preset to approximately the required distance, and then the AF converter can be used to carry out the final precise focusing action. There is a further restriction in that the lens must have a maximum aperture of f2.8 or more, but otherwise magnification and light loss are the same as for the TC-16. The TC-16A was discontinued during 1991.

The advent of the AF-I lens series, and the later AF-S series, with their

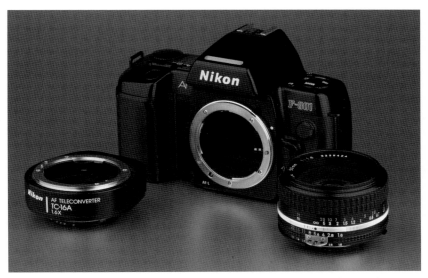

The TC-16A brings a limited AF capability to manual focus Nikkors when used on an AF camera such as this Nikon F801.

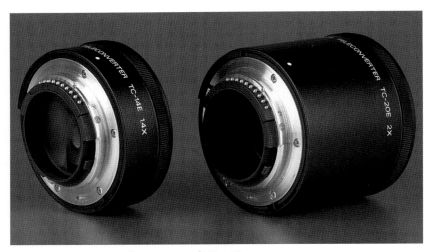

The AF-I teleconverters: the TC-14E and TC-20E.

built-in AF motors required a new design of teleconverter capable of carrying the focus information between the AF camera and lens. Soon after the launch of the first AF-I lenses, during 1993, came the announcement of the AF-I Teleconverters; the TC-14E and TC-20E, which provide magnification factors of 1.4x and 2x respectively. Their electrical contacts retain full exposure, lens aperture control, and focus distance information, as well as AF communication with the appropriate AF camera body. Since they lack any mechanical linkage system, or movable elements like the TC-16A, they can only maintain an AF function with either AF-I or AF-S series lenses. Some photographers have had their TC-14E and TC-20E converters modified so they can fit other AF-Nikkor lenses, such as the AF 80-200mm f2.8D and AF 300mm f4. This requires a small metal lug on the inside of the lens bayonet to be milled away. Although lenses can only be used with manual focus the metering connections are maintained. Please note you will invalidate any Nikon warranty if you chose to have this work done.

Conversely, although non-AF converters such as the TC-14B or TC-301 can be used with the AF-I, and

An AF-I TC-14E teleconverter: the arrow indicates the lug that must be removed to allow use with non-AF-I and AF-S lenses.

AF-S lenses, the AF function will of course be lost, as will the ability to set lens aperture from the camera body controls of more recent camera body designs.

Following the release of the new lightweight AF-S Series II telephoto lenses during 2001 Nikon announced the introduction of two new AF-S Teleconverters: the TC-14E II and TC-20E II. Compatible with both AF-I and AF-S lenses they have identical optical designs and dimensions to the earlier AF-I converters. The new converters are cosmetically matched to the 'hammered metal' paint finish found on the newer AF-S lenses, use a new front cap the BF-3A, which can also be

used as a camera body cap, and benefit from a lower price compared with the AF-I variants.

As the Nikon AF-S lens series has expanded so has the appeal of these AF converters. Lenses such as the 80-200 f2.8 AF-S and 300 f4 AF-S are prime candidates to be used in conjunction with AF-I, or AF-S converters.

Filters

Filters are used to restrict either the amount, or spectral range, of the light that reaches the film, or in the case of a digital camera the CCD. Nikon filters are made of the same high-quality optical glass as Nikkor lenses and are ground with great precision to ensure they are absolutely flat. The glass is then treated with the NIC process to help eliminate the effects of flare and ghost images. Finally it is mounted in slim metal rings to provided stability without the risk of causing vignetting in even ultra wide-angle lenses such as the Nikkor 18mm f2.8 AF-D, with its 100∞ angle-of–view.

Nikon currently manufactures a range of screw-in filters in diameters from 39mm to 122mm, and bayonet filters in 39mm for lenses with an extreme angle-of-view, which require the filter to be mounted at the rear of the lens, and slip-in polarizing filters for the long fast telephoto lenses.

As a general rule in black-and-white photography filters are used to control contrast and tonal range: subject colours similar to that of the filter record with a lighter tone whilst complimentary colours, which are absorbed by the filter, appear darker. For colour photography filters are used to correct colour casts.

Neutral Colour Filters

Nikon produce a completely neutral filter, designated NC, which allows

Right:
A black Nikon S3 rangefinder with S-36 motor drive. Despite the well-worn condition of this pair their rarity will ensure a handsome price in the collectors market.

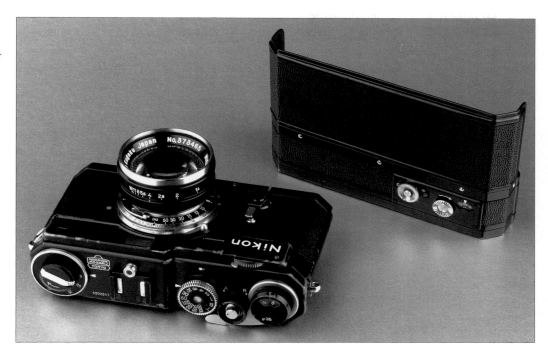

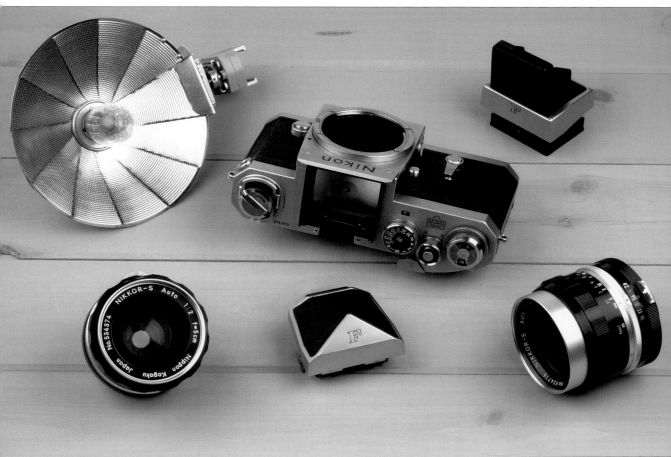

Above: The Nikon F, seen here with a range of lenses and accessories, was designed as a system camera from the very beginning.

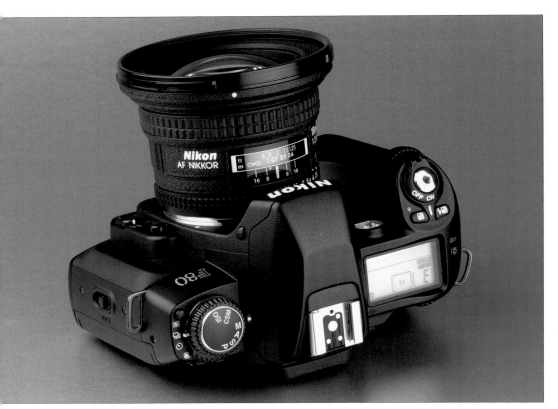

Left:
The Nikon F80 offers a range of advanced features in a camera aimed at the keen enthusiast.

Below:
Made for the consumer market the Nikon F65, with its built-in flash, has many features seen in more sophisticated Nikon cameras.

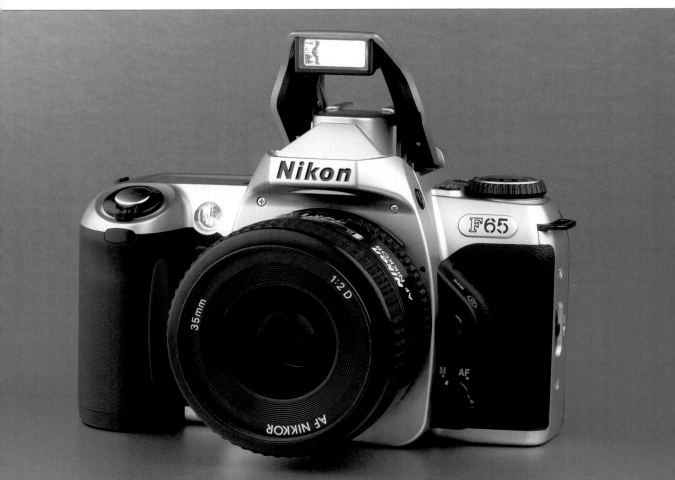

Type		Skylight	UV	UV	UV	Yellow	Yellow	Yellow	Orange	Red	Green	Green	Soft	Soft
Designation	NC	L1BC	L37C	L37	L39	Y44	Y48	Y52	O56	R60	X0	X1	No.1	No.2
Kodak Designation		1A			2B	3	8	15	21	25	11	13		
Filter Factor														
Daylight	1	1	1		1	1.5	1.7	2	3.5	8	2	5	1	1
Tungsten	1	1	1		1	1	1.2	1.4	2	5	1.7	3.5	1	1
Screw-in Type														
39mm		•	•	•			•	•	•	•				
46mm		•												
52mm		•	•	•	NA	•	•	•	•	•	•	•	•	•
58mm		•												
62mm		•	•	•			•		•	•			•	•
72mm		•	•	•	NA	NA	•		•	•			•	•
77mm		•	•				•		•	•				
82mm			NA											
95mm			•		NA				•	•				
122mm			•		NA		•		•	•				
160mm			NA											
Series 9					NA	NA	NA	NA	NA					
Slip-in Type														
39mm														
52mm														
Bayonet Type														
39mm		•					•		•	•				

Note: • = currently available NA = No longer available

An AF Fisheye-Nikkor 16mm f2.8 with its set of bayonet mount 39mm filters.

Type	Linear Polariser	Circular Polariser	C-PL	C-PL	ND	ND	ND	ND	ND					
Designation	L-PL	C-PL	1S & 2S	1L & 2L	ND2S	ND4	ND4S	ND8S	ND400	A2	A12	B2	B8	B12
Kodak Designation					ND.3	ND.6	ND.6	ND.9		81A	85	82A	80C	80B
Filter Factor														
Daylight	2-4	2-4	2-4	2-4	2	4	4	8	400	1.2	2	1.2	1.6	2.2
Tungsten	2-4	2-4	2-4	2-4	2	4	4	8	400	1.2	2	1.2	1.6	2.2
Screw-in Type														
39mm					•		•	•		•	•	•	•	•
46mm		•												
52mm	NA	•					•	•	•	•	•	•	•	•
58mm														
62mm	NA	•								•	•	•		•
72mm	NA	•				•				•		•		
77mm		•								•		•		
82mm														
95mm														
122mm														
160mm														
Slip-in Type														
39mm			•											
52mm				•										
Bayonet Type														
39mm										•		•		

Note: • = currently available NA = No longer available

transmission of the full spectrum of light. Intended to either protect the front element of a lens, or complete part of the optical configuration in lens that has a drop-in or rear mounted filter, they have NIC to eliminate the effects of flare and ghosting.

UV Filters

Ultra violet light is invisible to the human eye, but can reduce contrast and sharpness in a photograph. Nikon's colourless UV filters are designed to eliminate these effects. The L39 UV filter cuts out ultra-violet light up to a wavelength of 390nm and is ideal for black and white photography.

The multi-coated L37c UV filter cuts out ultraviolet light up to a wavelength of 390nm, and is ideal for colour photography as it helps to eliminate the blue colour casts that

often occur when shooting at high altitude of near the sea. These two filters allow the transmission of all other wavelengths, and can be kept in place to protect the font element of a lens if required. The L1Bc, which also restricts UV wavelengths, is a Skylight filter that has an extremely pale amber tint to further reduce the effects of blue colour casts when shooting under a clear blue or overcast sky. It equates to a Kodak Wratten 1A filter.

Filters for black-and white photography

Nikon produce seven filters for contrast control in black-and-white photography, and I have given the Kodak Wratten equivalent in brackets. There are three different strengths of yellow filter: the pale yellow Y44 (No.3), the medium Y48 (No.8), and the strong Y52 (No.15).

Many long fast Nikkor lenses, like this AF-S 500mm f4 IF-ED, use a filter draw to hold a screw-in filter.

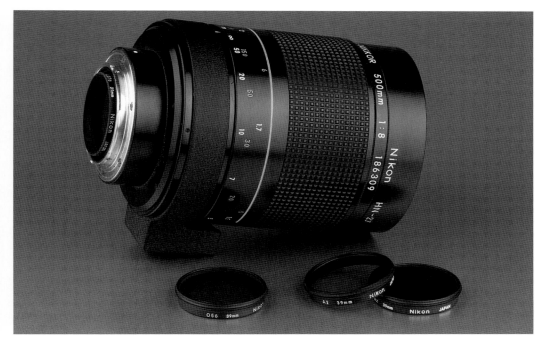

The Reflex-Nikkor 500mm f8 is supplied with a set of 39mm screw-in filters, including L37c, Y48, O56, R60, and ND-4.

They absorb blue light to an increasing degree and are used in landscape photography for eliminating atmospheric haze and darkening a blue sky. The O56 (No.21) orange filter absorbs some green as well as most blue light. This renders blue sky with an even darker tone and also darkens green foliage. The R60 (No.25) red filter has an even more dramatic effect since it renders a blue sky almost black. It is also useful for infrared photography.

The light green XO (No.11) filter absorbs red and blue light and is an ideal choice for general daylight photography. It renders pale skin tones with a more natural tone. The stronger X1 green filter (No.13) give a more pronounced effect and is particularly good at lightening the tone of foliage.

Filters for colour photography

Nikon makes five colour correction filters. The A2 is a pale amber filter that equates to a Kodak 81A and produces a more pronounced effect compared to the L1Bc Skylight filter.

It is especially useful for shooting in overcast conditions or in shade under a clear blue sky when the light temperature can be particularly high. The stronger A12 is equivalent to a Kodak 85 and is used to balance tungsten film to daylight.

Nikon's blue filters, the B2, B8, and B12, work in the opposite way to reduce the amount of red light. The B2 (82A) is a pale blue that removes the warm tint of natural light at sunrise or sunset. The B8 (80C) is a mild blue that has a slightly stronger effect, and the B12 (80A), and is used to correct the pronounced red-orange cast caused on daylight balanced film when shooting with tungsten balanced light.

Generally the TTL metering systems of Nikon cameras will automatically compensate for the light loss caused by a filter's restricted transmission. However, in the case of the B12, O56, and R60, their strong colour can lead TTL systems to underexposure so photographers should conduct some tests to determine the exact amount of compen-

sation required. These filters can also affect auto focus systems so it is advisable to focus manually.

Polarizing Filters

Polarizing filters reduce or even eliminate reflections from nonmetallic surfaces such as foliage, water, or glass. Commonly associated with deepening the colour of a blue sky they are equally useful for intensifying the colour saturation of most daylight scenes even under an overcast sky.

There are two types of polarizing filters: linear and circular. Nikon now only offers the circular version because this type must be used to ensure the proper function of AF

The 62mm Nikon Circular Polarizing filter.

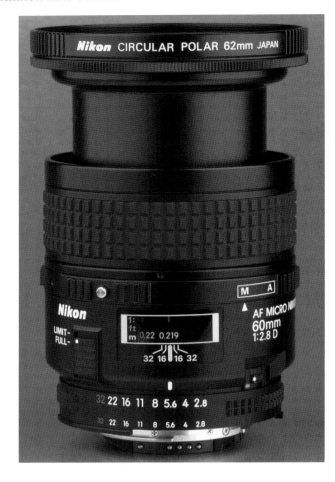

An AF Micro-Nikkor 60mm f2.8 with polarizing filter: Nikon polarizing filters have a greater diameter than their thread size to reduce the risk of vignetting.

which the effects of diffraction reduce optical performance.

Soft Focus Filters

For some subjects the exceptional sharpness of a Nikkor lens is sometimes inappropriate so Nikon produce a Soft Focus filter in two strengths. The weaker No1 filter is designed for shooting portraits while the stronger No.2 creates a mist like effect useful for shooting creative landscape pictures. Both the soft focus filters apply an even effect at all apertures.

Nikon also produce a number of filter accessories: the AF-1 (52mm thread), AF-2 (72mm thread), AF-3 (52mm-77mm), and AF-4 (52mm-95mm) gelatin filter holders, which accept standard 75mm square gelatin or polyester filters, and the UR-1 step down ring for attaching 72mm thread filters to a 62mm lens filter ring.

Lens Hoods and Caps

To help realise the maximum potential of any lens it should be fitted with a lens hood at all times. They protect the front element and filter, if fitted, from stray light, which can cause flare or ghost images. Nikon produce an extensive range of hoods that are dedicated to specific focal lengths.

Some Nikkors have built in hoods that are either fixed, as in the case of the AF Nikkor 14mm f2.8D ED, or retractable, as in the case of the AF-S Nikkor 300mm f4 IF-ED, for example. Removable lens hoods have a number of designations depending on the method of attachment: the HS type snap-on, the HN type screw-in, the HK type slip-on, and the HB type attach via a bayonet fitting. The HR types have a collapsible rubber hood that screw-in and the HE type are extension sections for some of the fast telephoto Nikkors.

and multi-pattern metering systems. Most non-AF Nikon cameras that use simple centre weighted meter systems can be fitted with the earlier Nikon linear type. The principle exception is the F3 camera because of its semi-silvered mirror, which must be used with the circular type. A special feature of Nikon polarizing filters is their larger diameter compared to the front thread of the lens on which they are mounted. They are designed in this way to make sure that the thicker filter mount necessary in a polarizing filter does not cause vignetting of the image, particularly with wide-angle lenses. As a result each size of filter has its own dedicated lens hood. They are the HN-12 for 52mm filters, the HN-26 for 62mm filters, the HN-13 for 72mm filters, and the

HN-34 for 77mm filters.

To compliment the long fast telephoto Nikkor lenses there is a series of slip-in circular polarizing filters that are rotated via a small wheel protruding from the filter holder.

Neutral Density filters

Neutral density filters reduce the transmission of all wavelengths and can be used in both black-and-white and colour photography. The designation of the filter indicates the necessary compensation factor. The ND-2S reduces the light by 1EV, the ND-4S by 2EV, the ND-8S by 3EV, and the ND-400 by 8.5 EV. These filters are used, for example, when a photographer wants to use a slow shutter speed in bright conditions without having to resort to using the lenses minimum aperture at

Most Nikkor lenses with front fil-
ter rings in the range of 52mm to
77mm have a rigid snap-on front
lens cap. Other lenses have soft lens
caps that are secured by a draw-
string, or a push fit soft plastic cap.
The LF-1 rear lens cap is common
to all Nikkors. Nikon camera body
lens mounts accept a bayonet fit
cap. The first version, the BF-1 fits
all non-AF cameras, but must not
be attached to an AF body as it may
damage the electrical contacts in the
bayonet mount. The newer BF-1A is
universal and can be used on both
camera types.

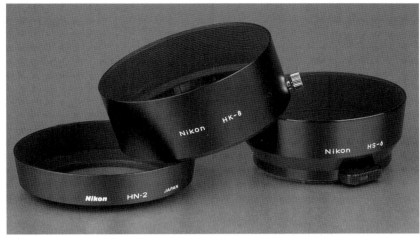

A selection of screw-in and snap-on type lens hoods for fixed focal length Nikkor lenses.

*Many modern
Nikkor lenses,
particularly zoom
types, have a
scalloped, or 'petal'
shaped profile to
maximize shading.*

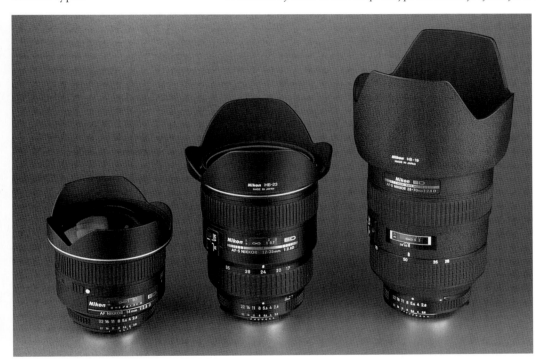

The Early Speedlight System

The desire of photographers to have a portable artificial source of illumination as an alternative to daylight is as old as photography itself. Nikon's first electronic flash unit, the SB-1, was introduced 1971, and the Speedlight system has remained at the forefront of electronic flash photography ever since constantly evolving as technology has advanced.

The Early Days

Photographer's very earliest attempts to provide their own light source started with devices in which a mixture of potassium nitrate and sulphur was ignited to produce a very bright flash of light. From about 1860 magnesium powder or strips were used: a somewhat hazardous procedure, which occasionally scorched more than just the hair on the photographers head! The first commercially successful flash bulb, a magnesium strip sealed in a glass bulb filled with oxygen and ignited electrically, did not appear until 1929.

The American, Harold Edgerton, produced the first practical electronic flash apparatus in 1940. Early electronic flash units, which often weighed several kilograms, had very modest outputs by today's standards. A guide number of 20 (ISO50, m), the normal film sensitivity of the day, were about the limit.

At some point in the mid-1960s the American company Honeywell developed a flash unit with a metering sensor that measured the light reflected by the subject and switched off the flash as soon as the sensor

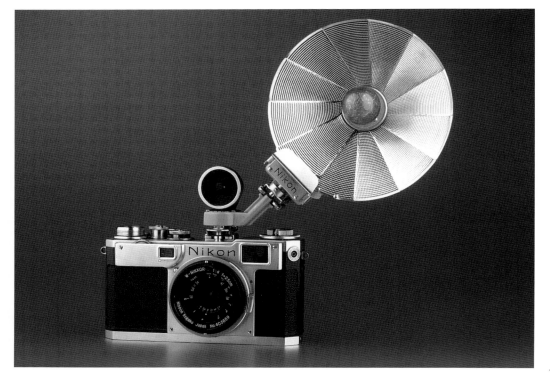

Nikon S2 rangefinder with BC-5 flash bulb reflector: note the angled flash adapter that permits the simultaneous attachment of the separate viewfinder and flash unit.

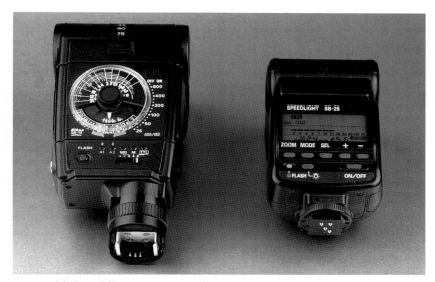

Two models from different generations of Nikon TTL Speedlights: the Nikon SB-16A and SB-28.

registered sufficient for a correct exposure. This made it possible to preset an aperture on the lens and leave the exposure control to the flash unit. This was a significant advance because the metering sensor had to be capable of reacting extremely quickly, since a modern electronic flash can emit a burst of light that has a very short duration of between 1/1000 sec. and 1/50,000sec. In those days such metering technology was euphorically termed 'computer-controlled'.

By the end of the 1970s flash control had evolved again with systems in which the metering sensor was built into the camera instead of the flash unit; TTL-flash control had arrived. Most Nikon cameras from that time to the present use a similar system in which the TTL flash metering sensor is located in the mirror box of the camera. It registers the light reflected from the film surface and quenches the flash tube's output the instant that the camera's flash exposure control system senses that sufficient light has reached the subject. Should the flash's output be insufficient, perhaps because the lens aperture was

too small or the distance to the subject too great, the TTL-flash unit will signal a warning, often in the form of a flash ready-light in the viewfinder or icon on the flash unit's LCD display blinking. Most of the Nikon systems have a wide margin of error and the warning will actually appear about one EV step before the absolute limit to inform the photographer that the system is close to its maximum output. In many of the various Nikon

camera/flash combinations this warning will also indicate whenever the range of usable ISO film speeds for TTL-operation is exceeded.

It has long been recognized that flash lighting could be used to do a lot more than just illuminate dark interiors. Until the late 1980s successful use of flash to supplement ambient light depended on the experience and skill of the photographer, who would have to perform some relatively complex calculations involving the lens aperture, shutter speed, subject distance, flash guide number, and other factors. The process was time consuming and as soon as one of the variable factors changed the calculations would have to be carried out again. It will come as no surprise that many shied away from using flash in all but the most obvious applications. Today, modern micro-processor controlled flash units such as the latest SB-80DX, SB-50DX, combined with the sophisticated metering and flash exposure control systems of cameras like the F5 and D1, that take care of all the complicated calculations in a fraction of a second, and provide almost fool-proof flash photography. The creative potential of these

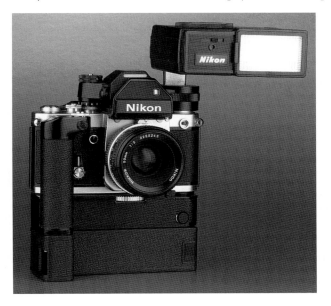

The SB-2 was the first compact electronic flash unit produced by Nikon. It is seen here on an F2S with MD-3.

215

new systems is only limited by a photographer's imagination.

The Nikon Flash Bulb Reflector System

Nikon's involvement in flash technology began with the S-series rangefinder models; they were the first Nikon cameras to be equipped with an M-type sync terminal for flashbulbs. At the same time the first Nikon flash unit, the BC-1 was introduced. Six further versions followed, of which the last, the BC-7 for the F and F2 SLR models, mounts in the accessory shoe and is triggered by a hot shoe contact rather than a lead. Three types of bulbs can be used, the FP, M, and ME. Even with the most powerful bulbs the sync speed was often limited to around 1/60sec because of their relatively long burn time that lasted about 1/20sec, which meant that only a portion of the emitted light contributed to the exposure at fast shutter speeds. The aperture scale on the back of the BC-7 takes this factor into account. The reflector is designed like a folding fan that can be collapsed to reduce its bulk for storage. Extended it has a diameter of 120mm and was designed to cover the angle of view of a 35mm lens. It can be tilted upwards up to an angle of 120° for bounced flash operation. The unit uses a 15v battery.

The Speedlight System: From SB-1 to SB-10

From the S2 rangefinder onwards all Nikon cameras were equipped with an X type sync-terminal for electronic flash. Nikon's first electronic flash, the SB-1, appeared in 1971. It was a hammer head style unit with a guide number of 28 at (ISO100, m), and powered by a rechargeable battery that fitted in the grip section that could deliver just less than 80 flashes. It took about 15 hours to recharge the SB-1's battery so if a greater capacity was required the SD-2 external battery pack was available. Its six D size cells could deliver more than 1000 flashes. The SD-3, a 510v high-power battery unit, was available to special order. It could store sufficient energy for about 700 flashes and recycle the SB-1 in only 1.5sec compared with the standard 4sec recycle time of the other power supplies. The SB-1 covered the angle of view of a 35mm lens, had a fixed reflector and no facility to vary its output. Together with the battery and the connecting bracket, the SB-1 weighed almost a kilo.

For the time the terminal on the SB-1 for connecting to the SM-1 and SR-1 ring light units, which drew their power from the SB-1, was an advanced feature, which automatically switched off the SB-1's flash tube once the ring light was connected. The flash-ready light was located on the flash unit itself, but

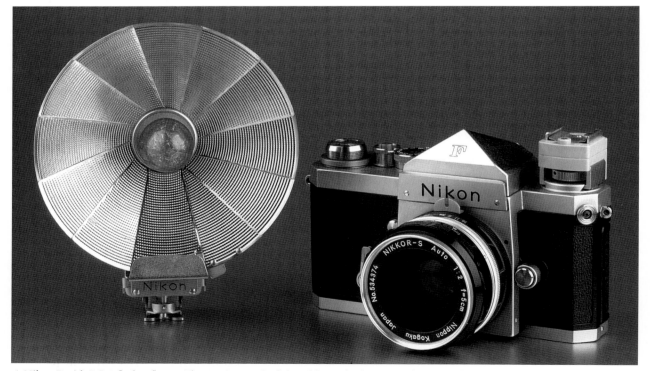

A Nikon F with BC-5 flash reflector. The camera required the additional adapter seen here over the rewind crank to allow attachment of such units.

The SB-6 could keep pace with an F2 Photomic and MD-1 motor drive.

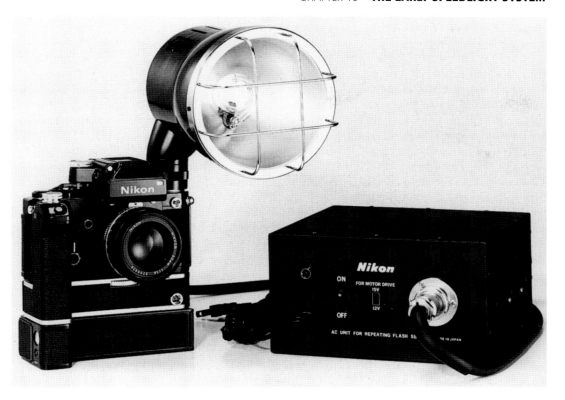

with the help of the SC-4 adaptor for the F2 and the SF-1 adaptor for other Nikon cameras, it could be transferred to the viewfinder. The later SM-2 and SR-2 ring light units, identical in other respects to the SM-1 and SR-1, had their own integral power supply.

Nikon's first compact electronic flash units, which could be mounted on the camera, were the SB-2 and SB-3. The only difference is that the SB-2 is equipped with a mounting foot for the F and F2, which in the case of the latter included the connection for the ready light in the viewfinder. The SB-3 on the other hand has the usual ISO-type foot for the Nikkormat cameras with the hot shoe contact. The guide number for both units was 25 (ISO100, m) and the reflector provided coverage for a 35mm lens. At this film speed three automatic settings were available for f/4, f/5.6 and f/8. Four AA size batteries provided the power supply, which was sufficient for

approximately five 36-exposure films, but there was no facility to connect an external power supply. At full output the recycling time was about eight seconds. The electronic circuitry contained a thyristor, which in the automatic flash mode enabled excess energy in the capacitor to be stored and saved for the following flash output. This had the effect of not only reducing the recycle time, but also significantly increased the number of flashes that could be obtained from a single set of batteries. The reflectors of the SB-2 and SB-3 were fixed, however, an additional wide-angle flash adaptor increased the coverage to match the angle of view of a 28mm lens.

Nikon introduced the SB-4, a small simple unit designed for snap-shot photography, with a guide number of 18 (ISO100, m) that weighs only 180g at the same time as the Nikkormat EL. It is equipped with one automatic setting at f4 and can recycling in 10 to 12 seconds.

Powered by two AA size batteries the SB-4 has neither a sync terminal, nor a wide-angle adaptor.

The next Speedlight to be introduced was the professionally specified SB-5. This powerful unit weighs 1200g, and has a guide number (GN) of 32 (ISO100, m) with a coverage matching a 28mm lens. There is a choice of three automatic shooting ranges at f/4, f/5.6 and f/8, as well as three manually selected output levels; 'Full' with a GN32, '1/4' with a GN16, and 'MD' (Motor drive) with a GN11. At the last two settings the SB-5 produces light pulses at up to 2.5 and 3.8 per second respectively. Power is supplied either by the special rechargeable NiCd unit housed in the grip section, or by the external SD-4 power pack, which uses two customized 240v batteries. The accessory sensor unit SU-1, normally plugged into the side of the flash, can also be attached directly to the hot-shoe of the F and F2 with the extension

cord SC-9. The whole unit can be tilted in 30° steps for bounce-flash operation and its recycling time is less than 3 seconds at full output. The SE-2 extension cord permits the simultaneous release of several flash units, and with the special SU-3 sensor the SB-5 could be triggered by the ML-1 remote control set up to a maximum range of 60m.

Following the SB-5 came the SB-6 with its powerful guide number of 45 (ISO, m) that has the ability to fire up to 40 flashes per second for stroboscopic photography. Equipped with a large 13cm diameter reflector it offers a range of six output levels: 'Full', 1/2, 1/4, 1/8, 1/16, and 1/32. The last two levels permit a firing rate of up to 3.8 fps, similar to the SB-5, for shooting with motor-driven cameras. Three automatic settings are available when the SU-1 sensor unit is attached. The SB-6 is powered by either the SN-3 NiCd for the SD-5 battery pack, or the SA-3 mains AC unit. Even with the lightest of these power supplies the outfit still weighs 6kg. It is amazing to think that the recently released SB-80DX that has a GN38 and offers a repeating flash mode with a frequency of up to 100Hz, only weighs 335g. How times have changed!

The SB-7E flash unit is a modified version of the earlier SB-2, which uses thyristor circuitry in place of the latter's rectifiers. It is 100g lighter than the SB-2 and the choice of automatic settings is limited to f4 and f8. The SW-2 wide adaptor was available as an accessory. The SB-3 was succeeded by the SB-8E offering the same features as the SB-7E. The SB-7E has a foot to fit the F and F2 series cameras and the SB-8E has a standard ISO accessory shoe. Both have a GN25 (ISO100, m) and are powered by four AA size batteries that provide approximately 160 full output flashes, with a recycle time of

about 8 seconds. The flash head pivots around the flash foot in an arc of 180(with click stops at each 90(position. The reflector covers the field of view for a 35mm lens, which can be extended to 28mm with the SW-2 wide-angle adapter.

The small, slim SB-9 replaced the SB-4. It is only 24mm thick and weighs just 90g. Two automatic settings can be chosen: f/2.8 and f/4, and it has a GN14 (ISO100, m). After a short production period the SB-8E was replaced by the SB-10, the only difference being a second contact pin in the mounting foot, which completes the circuit with the flash ready light in the viewfinder of the Nikon FE and the camera models that followed it.

The SB-E introduced in 1979 has a GN17 (ISO100, m), weighs just 130g, and was made for the entry-level EM and FG-20 models. Attached to these two cameras it offers just one exposure control: automatic, which is controlled by a flash sensor on the front of the unit. The photographer must read off a scale on the rear panel and set the

appropriate lens aperture according to the film speed in use. For example at ISO100 apertures of f2.8, f4, and f5.6 can be set for the auto-flash shooting range of 0.6 to 3.0m. It is powered by two AA size batteries that provide approximately 80 full output flashes with a recycle time of about 9 seconds. On any other camera the SB-E is restricted to only one automatic setting at f5.6.

The SB-E was succeeded in 1984 by the SB-19 with a GN20 (ISO100, m) it weighs 170g without batteries and has a fixed reflector that covers the field of view of a 35mm lens. In combination with the EM and FG-20 it offers just two automatic flash exposure control modes. In the A mode the shooting distance is limited from 0.6m to 3.0m and at ISO100 the aperture range is between f2.8 and f11. In the B mode the aperture is set on the lens but the distance scale on the rear panel of the SB-19 determines the shooting range. It is powered by four AA size batteries that provide approximately 250 full output flashes with a recycle time of about seven seconds.

The compact SB-E designed specifically for the Nikon EM and FG cameras.

Successor to the SB-E: the SB-19 seen here attached to an FG-20,

NIKON TTL SPEEDLIGHTS

Nikon SB-11

Nikon's first TTL controlled flash unit was the hammerhead style SB-11 that has a GN36 (ISO100, m), and was introduced along with the F3 camera. In spite of the eight AA size cells, housed in the grip section, that provide the necessary power it has a limited capacity of 150 flashes with a minimum recycle time 8 seconds. The optional SD-7 external battery pack, introduced later, adds an additional six C size cells allowing up to 270 flashes. The reflector can be tilted for bounce flash operation, and together with the SW-2 wide adaptor there is adequate coverage for a 28mm lens. Located beneath the reflector is its SU-2 sensor, which offers an 'M' position for manual full output as well as the three automatic settings for f/4, f/5.6 and f/8, plus the 'S' position which assumes the receiver's function when working with the ML-1 remote control set. The SU-2 sensor is removable and can be mounted on the camera accessory shoe via the SC-13 connecting lead. For TTL control of the SB-11 with an F3 the SC-12 sensor lead is required. On those cameras fitted with a standard ISO accessory shoe with a hot shoe contact the SC-23 sensor lead must be used. Due to its limited power and recycle time the SB-11 was never widely accepted by professional photographers.

Nikon SB-12

Introduced in 1980 the SB-12 has a TTL mode designed for exclusive use with the Nikon F3 camera. The flash foot allows the unit to be attached to the earlier F and F2 series cameras but the SB-12 is then restricted to manual flash control. It has a GN25 (ISO100, m) and weighs 350g without batteries. The head pivots around the flash foot through an arc of 180° with click stop positions at 90°. The flash reflector, which cannot be tilted, covers a 35mm lens and with the SW-4 wide-angle adapter this is increased

Nikon's first TTL flash unit the SB-11.

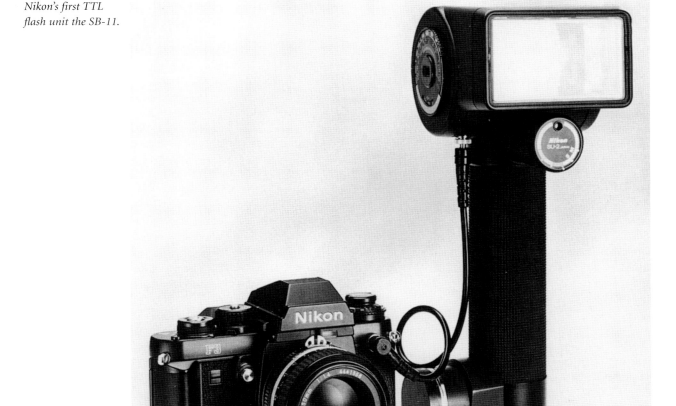

to 28mm. The unit offers two flash exposure control modes, TTL and full manual. At the normal 35mm setting in the TTL mode at ISO100 it has a shooting range of 0.6m to12m with apertures between f2 and f22. The SB-12 can be used off the camera in TTL mode via the SC-14 (1.0m) lead, which connects between the flash foot and the F3's flash shoe. There is also a standard PC sync terminal on the rear panel of the unit next to the flash mode selector switch. Also on this panel are the flash ready LED, a flash test button and the On/Off switch. On the top of the SB-12 is an exposure calculation dial that displays the various shooting ranges for different lens aperture and film speed combinations.

Nikon SB-14

The SB14 is another hammerhead style flash unit that bears a close resemblance to the SB-11, although it is slightly less powerful and smaller. It weighs 515g and is attached by the SK-5 bracket that adds a further 290g to the overall weight. The SB-14 has a guide number of 32 (ISO100, m) and requires the SD-7 external power pack, as it has no internal battery of its own. The SD-7 fitted with alkaline batteries can provide approximately 270 full output flashes, 1/800sec duration, with a recycle time of 9.5 seconds.

It only offers TTL control with the F3 series cameras via the SC-12 sensor lead otherwise flash exposure control is limited to an automatic mode. At ISO100 with the normal coverage of the reflector it offers three different aperture settings with a shooting range between 0.6m and 8m. The flash head can be tilted from the horizontal to +120(, with click stops at 30, 60, 90, and 120(, and rotated to either the left or right by 120(. The standard reflector covers a 35mm focal length, which can be increased to 24mm with the SW-5 wide-angle diffuser.

A special version of the SB-14, the SB-140 was introduced for scientific and crime investigation applications. It is supplied with a set of three adapters that fit in front of the reflector to filter the light out put to a specific range of wavelengths. The flash reflector provides coverage of a 28mm lens slightly wider than the SB-14, and the manual flash control offers both full and 1/4 output levels, but otherwise the specification is the same. The SB-140 uses the SU-3 sensor unit as opposed to the SU-2 of the SB-14.

The three adapters provide a range of different output wavelengths: the SW-5V (visible) covers 400nm to 1100nm, the SW-5UV (ultraviolet) extends output below 400nm with a peak around 300nm, and the SW-5IR (infrared) restricts output wavelengths to between 750nm and 1100nm, with a peak between 800 and 1000nm. If you use dedicated IR or UV film the guide numbers will vary according to the sensitivity of the specific emulsion.

Nikon SB-15

In 1982 Nikon introduced an updated version of the SB-12, the SB-15. It has a GN of 25 (ISO100, m) and weighs 270g without batteries. It has the same rotating head design as the earlier model but with the additional versatility of being able to angle the flash tube module from the horizontal to +90°, with click stop positions at 15, 30, 60,and 90°. The flash reflector covers a 35mm lens and

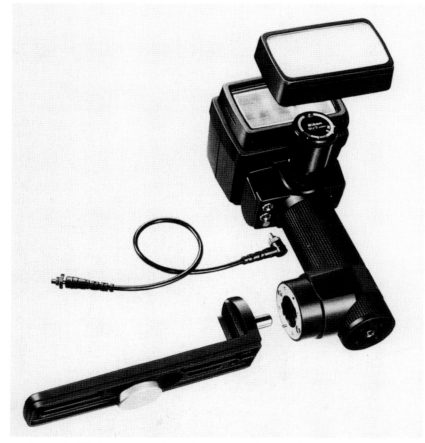

Similar to the SB-11 the SB-14 shown here requires the SD-7 battery pack as it has no battery compartment of its own.

this can be extended to 28mm with the SW-6 wide-angle adapter.

Powered by four AA batteries that can provide approximately 160 full output flashes it has a recycle time of about 8 seconds. The SB-15 was designed to offer TTL control with contemporary cameras such as the FA, FE-2, and FG, but will of course operate with later models as well. In addition to TTL the SB-15 has a two-aperture automatic flash mode. At ISO100 in the A1 auto mode the working aperture is f8 with a shooting range between 0.7 and 3m, whilst in the A2 mode that has a working aperture of f4 the range is between 1.0 and 6.0m. There is also the option of full manual output and a motor drive mode with an effective GN of 7 (ISO100, m). The

number of consecutive frames is limited to four at a maximum frame rate of 3.8fps to prevent the flash tube from overheating. The TTL and automatic modes do not operate with this function.

Nikon SB-16A/B

Until the first model in the new generation of so-called 'smart' flash units, the SB-24, arrived in 1988 the 'flagship' Speedlight was the SB16, which was introduced in 1983. This versatile unit has a common main module and flash head that can be fitted to either the AS-8 flash coupler for attachment to the F3 series cameras when it becomes the SB-16A, or the AS-9 flash coupler for attachment to a standard ISO accessory shoe when is becomes the SB-16B.

Apart from the slight increase in weight of the SB-16A (485g) compared with the SB-16B (445g), which is due to the different flash couplers, they have a similar specification. There is a second fixed flash tube located in the main body of the unit that provides a small output to fill shadows and add a catch-light to the eyes of subjects when the main head is tilted up for bounce flash. The SB-16 has a GN of 32 (ISO100, m) and is powered by four AA size batteries that provide approximately 100 full output flashes, 1/1250sec duration, with a recycle time of about 11 seconds using alkaline types.

The main flash head can be tilted from the horizontal by +90°, with click stops at 30, 45, 60, or 90°, and

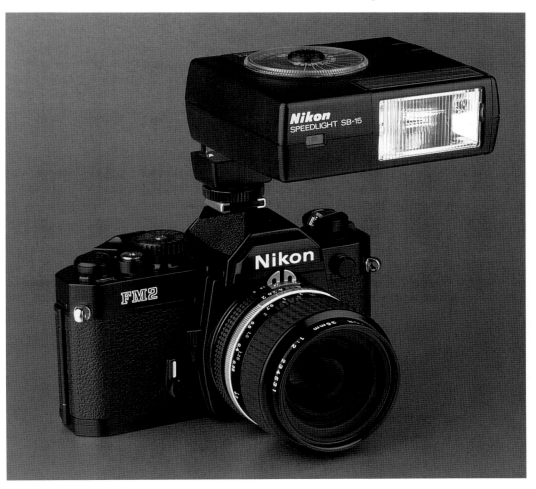

The SB-15 Speedlight has a standard ISO-type hotshoe foot and is shown here with an FM2N camera.

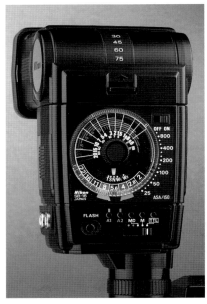

The principle components of an SB-16A: the main flash unit, AS-8 flash coupler, and SW-7 wide-angle diffuser.

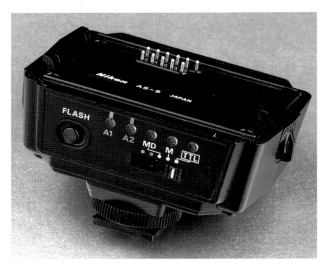

The AS-9 flash coupler is used to convert the unit to the SB-16B for attachment to a standard ISO accessory shoe.

The rear control panel of an SB-16A offers a variety of flash control options.

The SB-17, a modified version of the SB-15, was introduced for the Nikon F3 series cameras.

mode the aperture is f8 with a shooting range between 0.7 and 5m, whilst in the A2 mode that has an aperture of f4 the range is between 1.5 and 7.5m. There is also the option of full manual output and a motor drive mode with an effective GN of 8 (ISO100, m). The number of consecutive frames is limited to eight at a maximum frame rate of 4fps and only the main flash tube fires. The TTL and automatic modes

can be rotated 90° to the right and 180° to the left. It has a manual zoom head with positions that correspond to focal lengths of 28mm, 35mm, 50mm and 85mm. This can be extended to cover a 24mm lens with the SW-7 wide-angle flash adapter.

The SB-16 offers three flash exposure control modes: TTL, a two-aperture automatic flash, and full manual. In the TTL mode the flash shooting distance is between 0.8 and 21m across an aperture range of f2 to f22. In addition to TTL the SB-16 has a two-aperture automatic flash mode. At ISO100 in the A1 auto

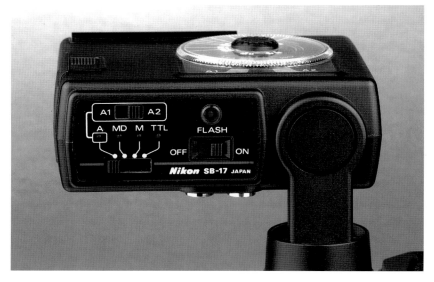

do not operate with this function.

The AS-8 and AS-9 couplers have both a PC sync terminal and a TTL lead terminal to allow the SB-16 to be used in multiple flash set-ups, but there is no terminal to connect an external power source.

Nikon SB-17

The SB17 introduced in 1983 is a modified version of the earlier SB-15 and is designed exclusively for the unique flash foot connection of the F3 series cameras. Apart from the flash foot, which increases the weight of the unit by 30g, all other specifications are identical.

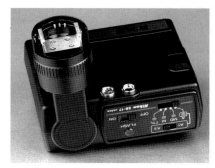

The dedicated flash foot of the SB-17 for attaching the unit to an F3.

Nikon SB-18

One of the most compact TTL controlled electronic flash units made by Nikon was the SB-18. Introduced to compliment the Nikon FG camera it weighs only 150g and has a GN20 (ISO100, m). It is powered by four AA size batteries that provide approximately 250 full output flashes, which can recycle the unit in about 6 seconds. It has a fixed head and reflector that covers the field-of-view of a 35mm focal length lens. The only other mode available is manual full output, and it has no external terminal for connection in multi-flash set ups.

The advent of AF cameras in the Nikon range gave rise to a new attribute in their Speedlights – the integrated AF illuminator, which, in very low ambient light conditions, projects a patterned beam of light onto the subject to assist the camera's AF system.

Nikon SB-20

The SB-20 was the first Nikon TTL-controlled flash unit to incorporate this feature, and it has an operating range from about 0.5m to 10m depending on the sensitivity of the camera's AF-system.

The unit has a GN30 (ISO100, m) at the normal (N) 35mm focal length. As a precursor to the automatic zoom heads of units that would come later the SB-20 has an ingenious rotating flash reflector that offers three positions providing coverage for different focal lengths. Apart from (N) that covers 35mm there is a (T) setting for 85mm with a GN36 and a (W) setting for 28mm focal length with a GN22 (ISO100, m). The rotating flash reflector module can be tilted +90° and down -7° from the horizontal providing a more even illumination for close-up shots.

It is powered by four AA size batteries that provide approximately

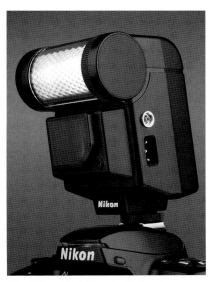

The Nikon SB-20 has its flash tube mounted in a rotating module that provides coverage for different lenses.

150 full output flashes, 1/1200sec duration, with a recycling time of about 7 seconds. There are three flash exposure control modes, TTL, automatic, and manual. In the manual mode it has a range of output levels from Full to 1/16.

Nikon state the SB-20 can be used with a motorized camera and provide a burst of eight consecutive frames at the 1/16 power level to a maximum frame rate of 4.2fps. On the left side of the unit are terminals for an external power source and a PC sync lead. An external power source will not only increase the total number of full output flashes and reduce the recycle time by about half, but also improve the performance when a rapid series of outputs are required to keep pace with a motorized camera. Care should be taken with shooting a number of frequent bursts or a single protracted burst as the flash tube may overheat and be damaged. The other new feature seen for the first time on a Nikon Speedlight is the third position on the main power switch. This standby function allows the unit to shift in to a 'sleep' mode after a period of about a minute of inactivity to conserve the batteries. To reactivate the unit you just lightly press the shutter release button.

Nikon SB-21A/B

In 1986 Nikon replaced their two ring-light units the SR-2 and SM-2, which had been in production since 1975, with a single macro-flash unit the SB-21. This is not a true ring-light with a circular flash tube but has two separate tubes on either side of a housing that can be orientated at any angle around the front of the lens by turning it around its adapter ring that attaches to the lens filter ring. It was supplied with two rings of 52mm and 62mm diameter. The SB-21 can be configured to fire either the two tubes or just one.

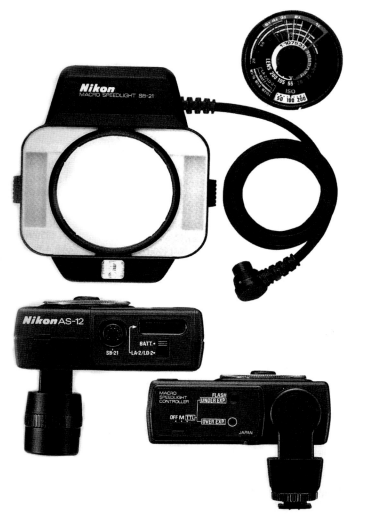

The SB-21 Macro-Speedlight: it has two different control units depending on the type of camera it is connected to, the AS-12 for the F3 series and the AS-14 for a standard ISO hotshoe contact.

ISO accessory shoe, it becomes the SB-21B.

On the rear panel of the control unit is a switch for OFF, M, and TTL. In M mode there is a calculator dial on top of the control unit to assist with exposure calculations. Other features include a flash ready/under exposure warning LED, and a second yellow LED that operates to warn of overexposure. In the TTL mode they both blink to signal their warning. The SB-21A/B can be powered by three sources: four AA-size batteries, the LD-2 external battery pack for the Medical-Nikkor 120mm f/4, or the LA-2 AC Unit. If any other external power source is used only one flash tube will fire.

To attach the SB-21A/B to a lens that is reverse mounted on the camera the BR-6 adapter is required. To use it with the Micro-Nikkor 60mm f2.8 AF lens the flash unit must be attached via the UR-3 Adapter Ring, which fits on the lens barrel rather than the filter ring in order that the AF motor does not have to move the additional mass of the flash unit. Coincidentally the 62mm adapter ring supplied with the SB-21 can be used for the same purpose as the UR-3 on the 105mm f2.8 Micro-Nikkor lens. Care should be taken with lenses whose filter ring rotates with either the focusing or zooming action, as it will shift the orientation of flash tubes. The best method is to attach the adapter ring first then focus/zoom, and finally mount the SB-21 flash head making sure that the focus or zoom position are not shifted. The unit cannot be used with a focal length of 35mm or less because the flash head will cause vignetting.

The SB-21 can be used in a TTL multi-flash set-up as the master unit with the slave unit(s) connected by a SC-18 or SC-19 lead to the control unit's TTL terminal. During the late 1990s, following a change in the

As well as the TTL-control, the SB-21 offers manual control with full, 1/4, and 1/16 power output. It has a GN12 (ISO100, m) which may sound rather low but remember this unit is designed specifically for close-up and macro work were the working distances are extremely short, therefore the unit has more than enough power. To produce a more even illumination at distances less than 40mm the SW-8 diffuser can be fitted. To assist with critical focusing in less than perfect light there is a small lamp between the flash tubes that is operated by a button on the rear of the flash tube unit. Its output, whilst welcome, is fairly low and of limited help.

The SB-21's flash tube unit is connected to its power supply and control unit, which looks like a SB-15 or SB-17 without a reflector, by a lead. The control unit comes in two different versions depending on which type of camera the unit is to be attached to: with the AS-12 adapter it becomes the SB-21A for the F3 series cameras, with the AS-14, which connects to a standard

Right:
The current state of the art Nikon D1X digital SLR uses its rear LCD panel to display a comprehensive set of menus for camera control.

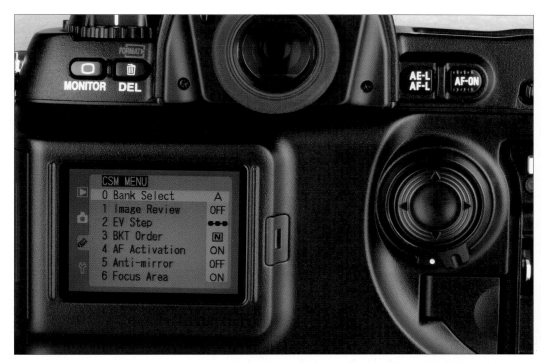

Below:
The Nikon D1, introduced in 1999, convinced many photographers it was time to embrace digital photography.

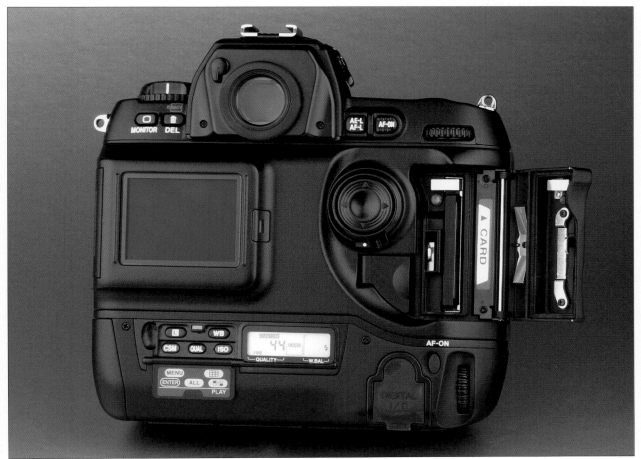

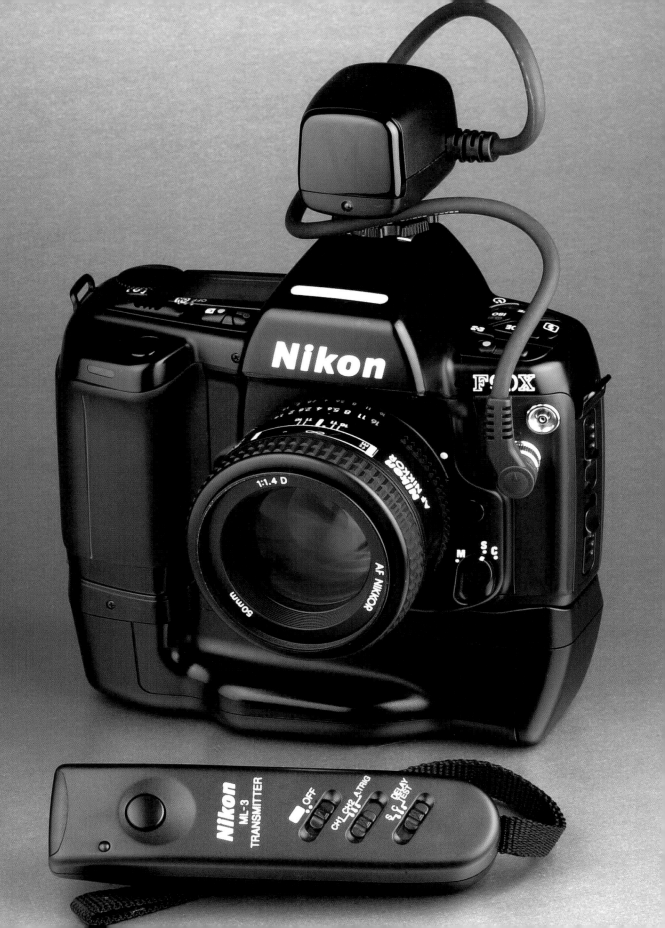

European Union regulations governing the design of electrical devices the SB-21A/B were withdrawn from sale in European countries. It was subsequently replaced by the SB-29.

Nikon SB-22

The SB-20's smaller sibling is the SB-22, which Nikon introduced in 1987. It has a GN25 (ISO100, m) that is reduced to GN18 when the built-in wide-angle adapter for focal lengths down to 28mm is in use. It has a similar specification to the SB-15 with TTL, manual (M), and Auto flash exposure control. At ISO100, for example, apertures of either f4 or f8 are available for the two different shooting ranges. There is also a Motor Drive (MD) mode with a GN8 (ISO100, m) that allows a series of rapid outputs to keep pace with automatic film advance. In this mode Nikon recommend that no more than forty flashes should be made in quick succession to prevent the flash tube from being damaged by overheating. The SB-22 also has the advantage of having an AF assist function making it fully compatible with Nikon AF cameras

The reflector can be tilted +90° down to -7° from the horizontal,

The SB-22 has a module that contains the flash tube, which can be tilted for bounced flash.

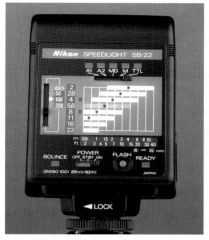

The flash shooting range can be determined with the chart on the rear control panel of the SB-22.

which is useful to achieve a more even illumination for close-up shots. An LED marked 'Bounce' lights up when this facility is used. It is powered by four AA size batteries that provide approximately 200 full output flashes, 1/1700sec duration, with a recycle time of about 4 seconds. The unit has a terminal for external power sources such as the SD-8A, which can double the total number of full out put flashes and halve the recycle time.

Nikon SB-23

The SB-23, released in 1988 was the last autofocus TTL flash unit to be introduced before the ground breaking SB-24 arrived. It was designed for the F-301, F401, and F-501 cameras, but operates with any TTL camera body. It is a simple unit with a limited range of features.

It is powered by four AA batteries that provide approximately 400 full output flashes with a very rapid recycle time of just two seconds. The head is fixed, as is the reflector, which covers the field-of–view of a 35mm lens, but there is no optional wide-angle diffuser. There are only two flash control modes, TTL and manual. The TTL mode has a film

The compact SB-23 has a slim low profile.

The SB-23 has limited features but offers a very rapid recycle time.

speed range of ISO25 to 800. The rear control panel has only the three-position switch for OFF, TTL, and M, with an LED flash ready light. The AF assist lamp is located beneath the flash reflector.

Nikon Multiple TTL Flash System

The Nikon system for multiple TTL flash unit control appears daunting at first but provided you abide by some simple rules it is very straightforward. There are three methods of triggering a multiple flash system: by using connecting leads, built-in slave units, or the SU-4 TTL slave flash controller. All of the TTL Nikon Speedlights mentioned in this chapter are capable of operating in a multiple TTL flash unit system. A detailed description of the three different methods of connection is given at the end of the next chapter.

The Modern Speedlight Series

By the late 1980's TTL flash control was nothing new but the arrival of new technology, in cameras such as the F-801 and 'flagship' F4, heralded a fundamental change in concept and design of Nikon Speedlights that would change flash photography forever.

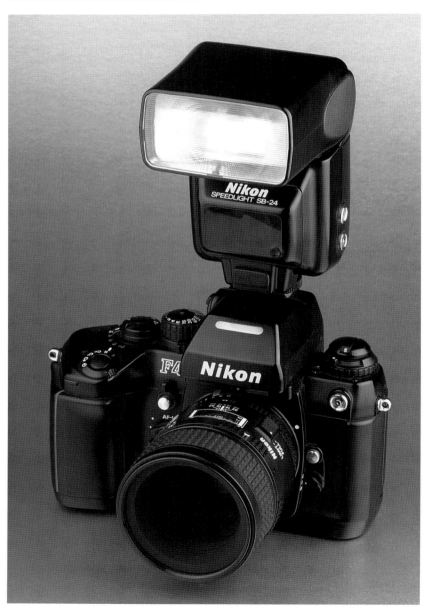

Nikon SB-24

Most photographers agree that the Nikon SB-24 Speedlight, introduced in 1988, revolutionized TTL flash photography over night. Possessing many more features than the SB-16 it replaced; its level of automation when combined with an appropriate camera such as the F-801s or F4 provided unparalleled accuracy in flash exposure control. Now even novice photographers could achieve results that previously were only obtained by careful calculation on the part of an experienced photographer.

The design of the SB-24, which weighs 390g, was also revolutionary and incorporates a large LCD panel in which all the exposure and flash control information is displayed. The flash head tilts down by 7(, up by 90(, and can be rotated through 180(. The SB-24 has a GN36 (ISO100, m) at 50mm setting but this varies as the unit has an automatic zoom-head that covers focal lengths between 24mm (GN30) and 85mm (GN50). Powered by four AA size batteries, on a fresh set the unit can produce approximately 100 full output flashes, duration 1/1,000sec, and recycle in about seven seconds. It has a terminal for an external power source such as the SD-8A.

The SB-24 introduced in the same year as the F4 revolutionised flash photography.

shooting range, aperture, film speed and zoom head setting. Using AF Nikkor lenses or AI-P lenses the SB-24 will automatically adjust its zoom-head position to the nearest focal length corresponding to the lens and this applies to Zoom-Nikkors as their focal length is changed. The unit has an AF assist lamp to facilitate shooting in low-light conditions that has a maximum range of 8m and can be used with lenses up to 105mm.

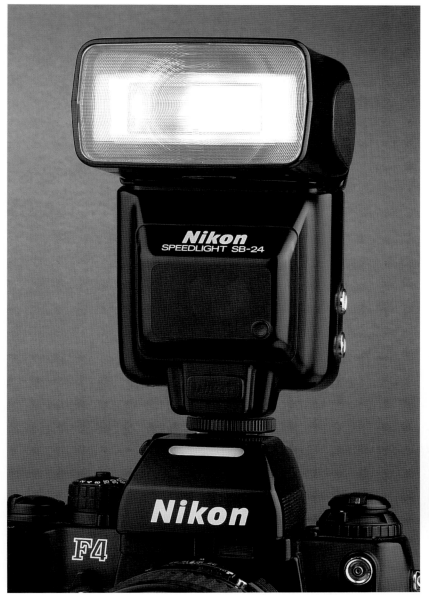

Combined with the Nikon f4 the SB-24 offers a highly versatile and sophisticated package for flash photography.

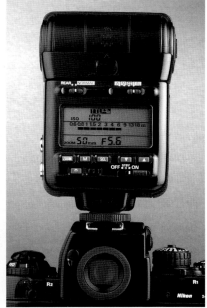

The rear LCD panel and controls of an SB-24, seen here attached to an F4, are very different to the control dials used on earlier Speedlights.

The SB-24 offers a range of flash exposure control modes including Matrix Balanced Fill-Flash, Standard TTL flash, Auto flash, Manual flash, Rear-curtain sync, and a Repeating (Strobe) flash, which can operate at 10Hz and produce a maximum of ten flashes at either the 1/8 or 1/16 maximum power output settings. Flash compensation can be set in increments of 1/3EV between +1 and –3EV to further fine tune the mix of flash and ambient light when the two sources are mixed. The SB24 offers 6 automatic settings from f2 to f11 at ISO100 and 5 manual output levels from full power to 1/16. The LCD panel, which has an illuminator lamp, displays a comprehensive amount of information including the flash mode, compensation factor, analogue display of the

Such was the diversity of functions and features offered by the SB-24 that Nikon had to prepare an 80-page instruction manual to describe them all, but it was no substitute for practical experience and for most photographers this was the only way to learn and understand its full capabilities. The sophistication and versatility of this Speedlight, and the units that were to succeed it, have continued to keep Nikon at the forefront of TTL flash photography.

Nikon SB-25

The huge success of the SB-24 encouraged Nikon to develop their 'smart' flash system ever further and in 1992 they introduced its successor the SB-25, which shares the same guide number and basic features of the SB-24 and is very similar in appearance. The new Speedlight was intended to compliment the F90 camera with its sophisticated multi-sensor TTL metering system.

The SB-25 weighs 380g, slightly less than the SB-24, but shares nearly identical dimensions. It has GN36 (ISO100, m) at 35mm and is powered by four AA size batteries that can provide approximately 100 full output flashes, 1/1000sec duration, and recycle the unit in 7 seconds. There is a terminal for an external power source such as the SD-8A battery pack.

The overall profile of the new unit is more rounded than the SB-24.

The extra features include a pullout diffuser screen, which is concealed neatly below the top surface of the zoom-head that drops down across the reflector lens to increase its coverage for a 20mm focal length lens. Alongside it is a small white 'bounce' card for directing the light when 'bouncing' the flash illumination and the TTL and PC terminals now have a rubber cover. The function buttons on the rear panel are recessed to protect them from both wear and tear as well as accidental changes, and the 'arrow' buttons used to increase/decrease values are arranged more logically so the 'up' arrow increases settings whilst the 'down' arrow reduces them. The SB-25 has a locking pin that seats into a small hole in the F90's ISO accessory shoe to prevent the flash from falling off. It is activated by turning the locking-wheel set around the flash foot and to release the flash from the camera you must make sure the wheel is rotated fully in the opposite direction to ensure the pin is fully retracted. For earlier cameras such as the F4 and F-801, which do not have a corresponding hole in their accessory shoe the spring loaded pin remains inside the flash foot.

Connecting the SB-25 to an F90 that is set to Matrix metering automatically sets the camera/flash combination to Automatic Balanced Fill-Flash mode with the following metering options: 3D-Multi-sensor Balanced Fill-Flash, Multi-sensor Balanced Fill-Flash, Centre-weighted Fill-Flash, and Spot Fill-Flash. In the Balanced Fill-Flash modes the camera's ambient and flash meter sensors automatically balance the available light to the flash output between a ratio of 1:1 and about 1:3. By pressing the MODE button the SB-25 defaults to Standard TTL flash and the linked metering system involving the F90's Matrix meter

Introduced with the F90 the SB-25 offered even more than its predecessor the SB-24. This combination was the first to use the Monitor Pre-flash system for improved flash control.

and TTL flash sensor is switched off to give the photographer control over the flash output level. To confirm which mode the flash is in the LCD screen on its rear panel displays a variety of icons. In the 3D Multi-sensor mode the Matrix metering symbol appears next to the TTL icon. If a non-D specification lens is used or the flash is attached to an F4 or F-801 the familiar 'sun & person' icon appears next to the TTL icon. If the flash is set to standard TTL mode then only the TTL icon will be displayed.

The assessment of flash output was made more accurate with the SB-25, because of the introduction of the Monitor Pre-flash system, which works in conjunction with the F90 and later cameras.

In a nutshell this is a method of making a pre-exposure assessment for the flash output of the overall scene and subject by adjusting it accordingly to cope with difficult conditions such a very dark background or highly reflective surface that would otherwise fool a conventional flash system.

The system operates in the following sequence: the instant after the reflex mirror has swung up, after the shutter release has been pressed, the SB-25 emits a rapid series of between 1 and 16 almost imperceptible, low-power flashes depending on the subject's distance and the lens aperture set. This light is reflected back off the subject, through the lens, onto the 18% grey surface of the first set of shutter blades and then on to the TTL flash multi-sensor. The five-segment TTL sensor then analyzes these so called Monitor Pre-flashes and the camera's microcomputer then compares their brightness with its theoretical exposure calculation based on the lens' distance information, the guide number, and aperture in use. This pre-checking identifies extremely

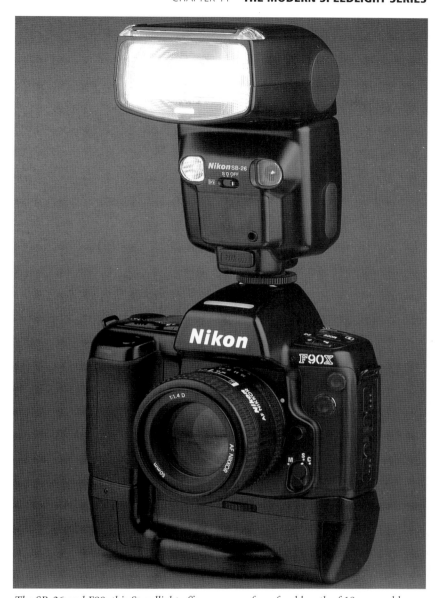

The SB-26 and F90: this Speedlight offers coverage for a focal length of 18mm and has an integral slave cell.

bright or dark areas within the frame and their position relative to the subject, which allows the camera to adjust the flash output accordingly. All of this happens in a fraction of a second before the shutter opens, and without causing any delay to its release. Once the shutter is open the camera's TTL flash sensor continues to monitor flash output directly off the film with reference to the value established by the

system's pre-exposure assessment. The instant the TTL sensor determines that sufficient light has been emitted it tells the camera to quench the flash output.

At the time of its introduction 3D Multi-Sensor Balanced Fill-Flash was without a doubt the most advanced and reliable flash exposure control system available and it remains so today.

The SB-25 has a number of other

flash modes including the Repeating (Strobe) Flash, which at its maximum frequency of 50Hz can fire a series of up to 40 flashes at the 1/64 power setting, a significant increase on that achieved by the SB-24. The FP High-Speed Sync option that is available on the F90 and some other later models including the F80, F100, and F5, allows the SB-25 can be synchronized at shutter speeds up to 1/4000sec. It works by emitting the flash output as a series of very rapid pulses of light rather than a continuous burst, however, due to the very reduced level of output and the fact that the system can only operate in the Manual flash mode it is not a particularly convenient feature and one that generally will be reserved for specific, controllable shooting conditions.

Nikon SB-26

The SB-25 was upgraded a couple of years later when, in 1994, Nikon introduced the SB-26. It has the same guide number, GN36 (ISO100, m) at 35mm, and regime of symbols for the multitude of flash modes and various controls that the photographer can set within them as used on the SB-25, including the Monitor Pre-flash system. The external appearance is very similar and its dimensions are identical, but the weight has increased by 10g to 390g without batteries. The locking arrangement of the flash unit's foot is identical to the SB-25. Four AA size batteries power the SB-26 and improved circuitry allows approximately 150 full power flashes, with 1/1000sec duration, from a fresh set, which can recycle the unit in approximately 7 seconds.

The two principle improvements are the pullout diffuser, which offers an increase in coverage to a focal length of 18mm and the inclusion of an integral slave cell. On the front of the main body of the SB-26

above the AF illuminator lamp is a switch for determining when the unit fires if it is used in the slave mode. If the switched is positioned at 'S' the slave unit will fire at the same time as the master unit. At the 'D' position triggering of the slave unit is delayed until after the main unit has fired. This prevents the output from the slave flash from influencing the master flash output when that unit is under TTL control. This last point is very important, and it is explained in the Nikon instruction book to the SB-26, but many photographers do not appreciate the significance of using the 'D' delay function.

The slave cell of the SB-26 is a 'simple' unit, which will trigger the slave flash after it registers that another flash has fired. The key word here is 'after' since the slave SB-26 is not controlled by the TTL system operating the master flash. This point is often not understood by many photographers who mistakenly believe that by firing the two flash units with the slave set to 'S' (simultaneous) they operate as though they are both in TTL mode. As the slave unit is not under TTL control it will not shut off at the same time as the master flash. It is the built-in AUTO flash sensor

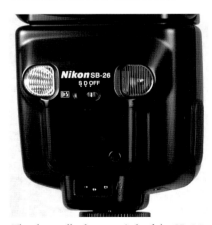

The slave cell selector switch of the SB-26 located between the slave cell sensor (right) and the Red-eye reduction lamp.

located on the front of the slave unit that controls its output, which will continue until that sensor determines sufficient light has been emitted. For this reason you must consider very carefully the positioning and settings applied to the slave unit and treat it as a completely separate part of your flash set-up.

My preferred method of working with the SB-26 as a slave unit is as follows: First set the unit to 'A' auto-flash mode and adjust the ISO value to match that set on the camera. You how have to make a decision on the lighting ratio between the master and slave unit. I generally opt for 1:4 so the slave unit provides an output 2EV less than the master flash. To do this adjust the aperture value on the slave SB-26 so that it is two stops greater than set on the lens. Remember the slave is going to operate as a completely separate entity that has no communication with the camera and master flash. So with a lens set to f5.6 I would adjust the slave unit to f2.8. By doing this the slave unit assumes that the shooting aperture is f2.8 and produces an appropriate output for that aperture, which will be 2 stops less than is required for the shooting aperture of f5.6. Hence the master flash output for f5.6 is twice as much as the slave unit's giving a 1:4 ratio between them. Finally set the slave SB-26 unit to delay firing, the 'D' position, to ensure that the TTL controlled output from the master flash has been completed before the slave unit is triggered.

If you use the two units with the slave flash at the 'S' (simultaneous) setting some or all of its output will be combined with the master flash output affecting the TTL control of the latter, which could cause it to under or over expose the subject.

A number of slave SB-26 units can be fired by the master unit and can be set to either automatic con-

The F90X and SB-26 maintain full TTL control for off camera flash with the SC-17 TTL lead.

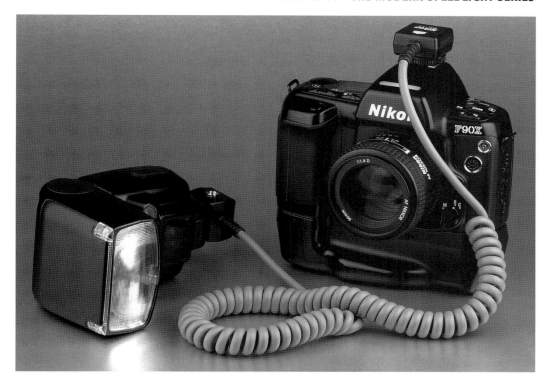

trol as described above or to manual output, in which case the photographer must either calculate the combined output or use a flash meter to measure it.

There is, however, one major drawback to using the SB-26 as a slave unit since the slave flash sensor and the AUTO flash sensor are next to each other on the front panel of the unit's main body and, therefore, point in the same direction. This places limitations on the positioning of the slave flash, which must be able to 'see' both the master-flash and the subject at the same time. This limitation and the difficulties experienced by photographers was the reason the slave cell feature was omitted from the later SB-28 and the SU-4 TTL flash slave sensor was subsequently introduced.

The only other new feature on the SB-26 is the small 'eye' symbol that appears in the rear LCD display to confirm that the Red-Eye Reduction function has been set on the camera. The Repeating Flash mode of

the SB-26 has the same maximum frequency of 50Hz but the maximum number of flashes is restricted to 24. Photographers should be aware that the table printed on page 92 (English version) of Nikon's instruction manual for the SB-26 setting out the maximum number of flashes for various power settings and frequencies is completely incorrect.

Nikon SB-27

Nikon did not stop at the regular updating of their flagship Speedlight model. In 1995 the SB-27 was introduced to provide a smaller cheaper flash unit for those photographers who did not require the specification of the SB-26. Its looks resemble the earlier SB-15 model, which is not surprising as in its day this unit occupied the same position in Nikon's Speedlight range as that of the SB-27. The flash foot is mounted on a bracket that has a pivot point at the rear that allows the main flash head of the SB-27 to be

rotated from a horizontal to vertical configuration.

Orientation of the head determines the focal length coverage. The automatic zoom flash head, which can also be adjusted manually, covers focal lengths between 24mm and 50mm when the head is in the horizontal position and 35mm to 70mm when it is set vertically.

Four AA sized batteries power the unit and can produce approximately 140 full power flashes, with 1/1000sec duration, and a relatively short recycle time of five seconds. The same locking-pin arrangement used on the SB-25 and 26 to guarantee a positive and secure attachment to all cameras beginning with the F90 is fitted to the SB-27. Located inside the battery chamber is a small switch, which for modern cameras that have a stand-by mode should be set to TTL S. In other cameras, generally manual types, the switch should be set to S. This is to ensure that the SB-27 operates in the TTL mode with the appropriate

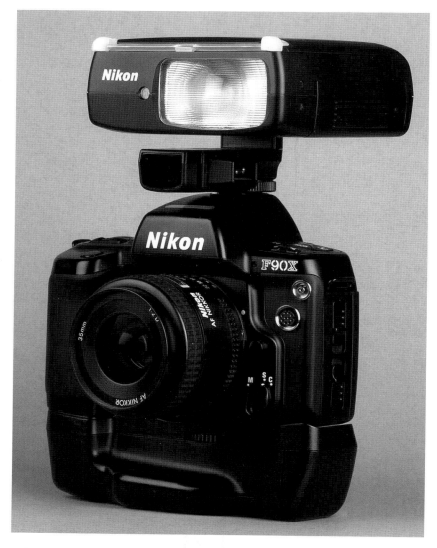

The SB-27 with F90X offers a comprehensive range of flash options. Resembling the SB-15 it was introduced as a lower priced alternative to the SB-26.

cameras. The unit has the Monitor Pre-flash system introduced with the SB-25 for sophisticated flash exposure control, especially in circumstances with highly reflective or very dark backgrounds.

The SB-27 offers both full TTL and manual control with a variable guide number depending on the zoom head setting. At the widest 24mm position it has a GN25 (ISO100, m) and a GN34 (ISO100, m). The control buttons are arranged on the rear of the main flash head around an LCD panel in which the various settings are displayed. Like the SB25 and SB-26 before it the SB-27 has a pull out diffuser and bounce card incorporated in the main head. The diffuser card is hinged at the leading edge of the bounce card and can be used to reflect light down in front of the lens when the camera/lens are used for close-up shooting, as well as controlling light when shooting at normal ranges. Other features include an AF illuminator attached above the flash unit's foot, a Red-Eye reduction lamp located next to the main reflector lens, a PC terminal and a socket for an external power supply such as the SD-8A battery pack.

Nikon SB-28

In 1997, three years after the introduction of the SB-26 it metamorphosed into the SB-28 and this time there are some obvious differences and adaptations compared to the previous model. Physically the SB-28 is much smaller (127mm H x 68mm W x 91mm D) and weighs only 335g (without batteries) but it retains the same GN36 (ISO100, m) at 35mm and maximum GN50

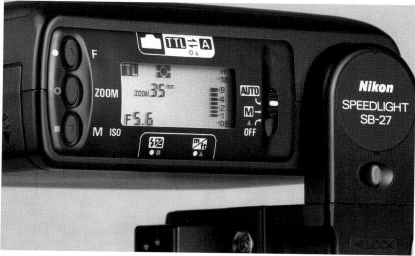

The LCD display and controls of the SB-27.

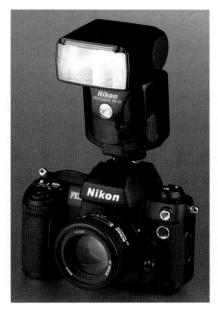

The SB-28 is more compact than its predecessors. Combined with cameras such as the F100 it offers a wide variety of options for flash photography.

(ISO100, m) with the zoom head set to 85mm as the earlier SB-25 and 26 models. The zoom head range (18mm – 85mm), pull out diffuser, and bounce card all operate in the same way as well. The auto-zoom range runs from 24mm to 85mm.

The design of the rear control panel under went a radical makeover with all the switches and buttons of the SB-26 either being replaced by recessed rubber coated buttons or omitted altogether. The adjust buttons are no longer marked with arrowheads but have a + and – symbol to avoid any confusion as to their function. The flash test button is red and located immediately above the flash ready indicator lamp. Flash mode is set by a single button that has to be pushed repeatedly to scroll through the various options, as opposed to the sliding switch arrangement of the SB-25. As a further refinement to the handling of the SB-28 its flash head has only one lock button, rather than the two-lock button arrangement, one

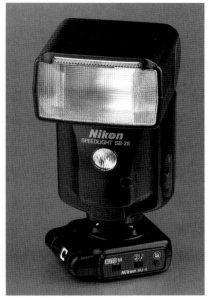

The slave cell of the SB-26 did not prove to be a popular feature so Nikon introduced the SU-4 to accompany units such as the SB-28 to provide a slave flash with TTL control.

for vertically adjustment the other lateral adjustment of the head position, on the SB-26. The re-designed single button is much larger and covered with a rubber diaphragm to prevent the entry of moisture and dust. All in all it is far quicker and simpler to operate.

The power button has to be held down for two or three seconds

before it operates to prevent the unit from being switched on or off accidentally. Unlike the SB-26 the SB-28 ON/OFF button does not have a position for the stand-by mode. The unit goes to this automatically after approximately 90 seconds to conserve battery power. The Normal/Rear sync button of the SB-26 has been omitted and this function can now only be set via an appropriately equipped camera body such as the F90, F90X, F80, F100, and F5, and this also applies to the red-eye reduction function.

The SB-28 is powered by four AA size batteries that can provide approximately 150 outputs at full power, duration of 1/1000sec, with a slightly reduced recycle time of 6.5 seconds. There is also a terminal for an external power source such as the SD-8A battery pack. Due to its reduction in size the AF illuminator of the SB-28 is proportionally smaller and emits a lower intensity light compared with the SB-25 and SB-26, which can restrict shooing ranges in very dark conditions. On the left side of the main body under a rubber cover is the PC terminal and the TTL lead terminal.

The SB-28 offers five basic modes: TTL, Automatic, Manual, Repeating Flash with the same capacity of the

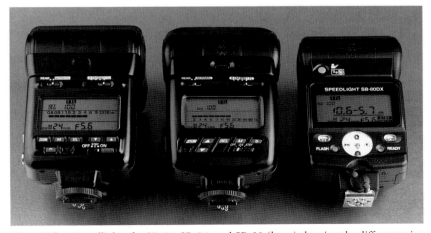

Three Nikon Speedlights the SB-24, SB-26, and SB-28 (l to r) showing the differences in their rear control panel design.

SB-26, and FP (high-speed sync) Flash. The nature of the Multi-sensor flash control will be determined by the combination of camera and lens type in use. The most advanced system, 3D Multi-sensor Balanced Fill Flash, will require a camera such as the F90 or later and AF-D, AF-S, or AF-G specification lenses and uses the same Monitor Pre-flash system as described before. Other combinations of different cameras and lenses will provide either standard Multi-sensor Balanced Fill Flash, this generally applies to lenses with a CPU, or Centre-weighted Balanced Fill Flash, which applies to non-CPU equipped lenses. The LCD display shows all the relevant information but its layout is rather different to the previous models. Flash output can be adjusted manually from –3 to +1EV in 1/3EV steps and the compensation value is displayed in the top right corner of the LCD panel.

Nikon SB-22s

In 1998 Nikon released a modified version of the SB-22 that had been in production since 1987. Called the SB-22s it has a number of new features. Essentially the same design it has identical dimensions and the same rotating flash tube module. The weigh has been decreased slight by 40g to 210g, and the flash duration is longer at 1/1100sec, The MD motor drive mode of the earlier model has been omitted and replace with two extra automatic flash modes. It accepts AA size batteries which can provide approximately 230 full output flashes with a recycle time of about 5 seconds. Otherwise all other specifications are the same.

Nikon SB-28DX

The introduction of the Nikon D1 in 1999 coincided with the release of a modified version of the SB28, the SB-28DX. Nikon could not employ the sophisticated off-the-film (OTF) TTL flash control system used in cameras such as the F5 and F100 with the D1 because its CCD, which replaces film, reflects an insufficient amount of light to the camera's TTL flash sensor for a flash exposure calculation can be computed. Nikon's engineers solved the problem by enhancing the pre-exposure assessment of the light emitted by the

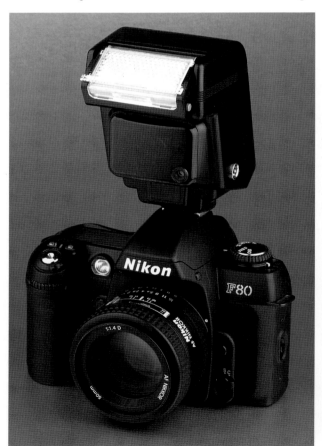

The SB-22s is an updated version of the 'workhorse' SB-22 that offers full compatibility with current cameras such as the F80.

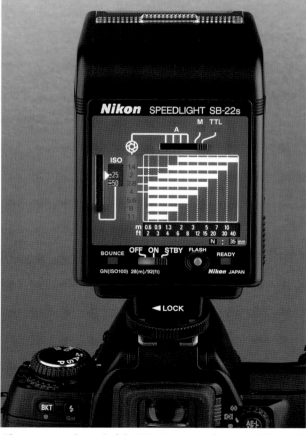

The rear control panel of the SB-22s may not have an LCD panel but is still clear and concise.

The SB-28DX was introduced with the D1 digital SLR.

flash during the operation of Nikon's proven Monitor Pre-Flash system. So with the D1, D1X, D1H, and D100 digital SLRs all the flash exposure calculations are performed before the shutter opens.

Initially same sequence of events occurs as with film based-cameras. Immediately prior to exposure the SB-28DX emits a series of imperceptible light pulses, the Monitor Pre-Flashes, which are reflected off the subject through the lens and off the back of the shutter blades, which are an 18% grey in colour. Data from the TTL flash multi sensor is combined with lens aperture and focus distance information from an appropriate 'D' specification AF Nikkor lens, by the D1's central processor, which calculates the proper flash output level.

The Monitor Pre-Flash system has a maximum effective range of about 6m. At greater distances the intensity of the light pulses fall off and exposure calculations can become less accurate. Even at distances less than 6m the pre-flash system may give inconsistent results if you shoot rapidly as the flash does not re-cycle

fast enough. This can cause a variation in the output of the pre-flash pulses, which in turn can affect the camera's flash exposure calculations. It cannot be corrected once the shutter has opened because there is no measurement of flash output during the actual exposure.

Apart from the enhanced Monitor Pre-flash control the specification of the SB-28DX is identical to the SB-28, as are the features and functions that it offers.

Nikon SB-29

The SB-29 Macro-Speedlight was introduced in 1999 as a direct replacement for the SB21A/B that had been in production since 1986. In essence it is a simplified and updated version that has the same basic configuration of the earlier unit. It has two modules linked by a cable: one houses the two flash tubes that are arranged one on each side and the other holds the control unit that has a accessory shoe foot

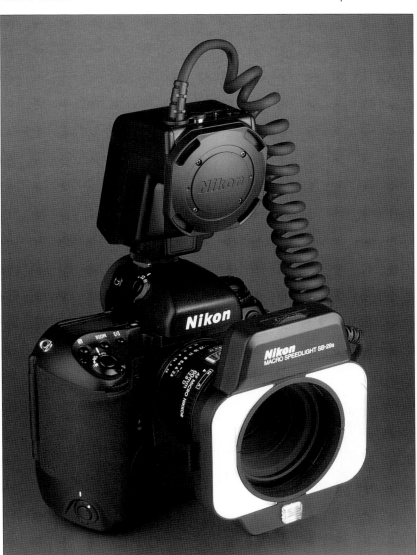

The Macro-Speedlight SB-29s: the focus lamp can be seen on the lower edge of the flash unit between the two tubes. The control unit is housed in an SB-22s body and allows the flash unit to be attached to it if required.

for mounting on the camera body.

It is designed for full TTL exposure control and to be used, principally, with the range of Micro-Nikkor lenses for soft even illumination in close-up and macro photography. It comes supplied with a set of three adapter rings in 52mm, 62mm, and 72mm diameter. Normally the flash module attaches to the one of the adapter rings that has been screwed into the lens filter ring, however, it can be fixed to the control unit when it is mounted in the camera's accessory shoe.

The SB-29, which weighs 410g without batteries, has a GN11 (ISO100, m) for both flash modules, and GN12 if only one is used at full output. The unit can also be set manually to provide a 1/4-power output, in which case it has a GN5.5 (ISO100, m) for both flash tubes and GN6 if only one is used. The film speed range is from ISO25 to ISO1000. For further flexibility the new unit allows the two flash tubes to be set so that they operate at in 1:4 ratio with each other with either tube providing the dominant output. The SB-29 has a modelling lamp function that fires a rapid series of light pulses at approximately 40Hz for a maximum duration of 3 seconds so the photographer can assess the effect the flash will have before the exposure is made, and to assist in focusing in low light conditions or at high magnifications there is a focus illuminator lamp between the two flash tubes that can be switched on by either pressing the shutter release or a button on the flash tube unit. Nikon advise that at very close ranges, less than 150mm, this lamp is switched off to prevent it affecting the exposure calculations. The SB-29 is powered by four AA size batteries that can provide approximately 300 full power discharges, of 1/1400sec duration, and can recycle in approximately 3 sec-

onds. At a range of one metre the unit has the coverage of a 20mm lens with the tubes arranged vertically and a 24mm lens when they are positioned horizontally. You can use the SB-29 in a multi flash set-up but it must operate as the master unit. It has a standard PC sync lead terminal on the control unit, but no TTL terminal.

In February 2001 Nikon announced that a modified version of the SB-29, the SB-29s, was to be introduced following feedback from photographers using the D1 series of digital SLRs. The increased sensitivity of these cameras, which have a minimum ISO equivalent in the range of ISO125 – 200, meant that even at the 1/4-power setting it was sometimes not possible to achieve a proper exposure with the SB-29. The new unit has an identical specification to the SB-29 with the addition of a 1/32-power output at which the guide number is reduced to GN1.9 (ISO100, m) for both flash tubes and GN2.1 for a single tube.

Nikon SB-50DX

The SB-50DX, introduced in late 2000, is an ingenious device

The SB-50DX is available for those photographers who do not require the power and specification of the SB-80DX. The white diffusing panel on the front of the unit can be swung down to cover the reflector of integral pop-up flash units on cameras such as the F80 and D100.

designed for use with most Nikon cameras, but particularly those that feature a pop-up flash such as the F65, F80, and D100. Its flash foot has a high profile to ensure there is sufficient clearance above these camera's built-in flash and a diffuser screen, which is attached to the front of the main body of the SB-50DX below its head, that can be swung in front of the camera's pop-up flash to soften its light whilst the SB50-DX, that is more powerful and has a tilting head for bounce flash, is used as the primary light source.

The SB-50DX is a compact unit weighing just 235g without batteries. It is powered by two CR-123A type lithium batteries that can provide approximately 260 full output flashes, 1/800sec duration, and recycle in 3.5 seconds. The unit has a guide number of GN22 (ISO100, m) with the zoom-head set to 35mm. This varies of course as the zoom head, which has a range of 24mm to 50mm, is adjusted. At 24mm it is GN18 and at 50mm GN26 (ISO100, m). The built in wide-angle diffuser that pulls out from beneath the head extends coverage to a 14mm focal length but reduces the GN to

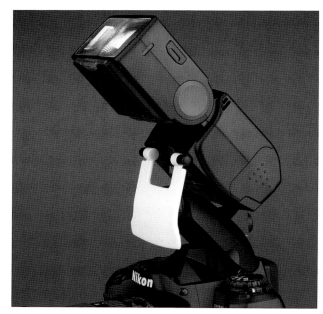

12. The head can be depressed by 18(to facilitate shooting at close range down to 30cm, and tilted up by 90(, but it cannot be rotated.

The SB-50DX is intended for use with both film and digital cameras and its features and functions reflect this. Flash modes include 3D-Multi-sensor Balance Fill-Flash, D-TTL, Standard TTL Flash, and Manual flash. The unit offers a comprehensive variety of options within each mode determined by the type of camera (film or digital) to which it is attached, and the Monitor Pre-flash system operates with both. The manual flash option is only available at full power output. It covers a range of film sensitivity between ISO25-1000 and flash exposure compensation can be set +/-3EV in increments of 1/6EV for digital cameras and 1/3EV for film.

On the rear is a small LCD panel, which displays the relevant shooting and flash control information. The control buttons located below and to the right of it are recessed and have a rubber cover but are rather small. Consequently only the nimblest of fingers will be able to operate them with ease and I expect anyone wearing gloves will find them rather difficult to use. The flash foot has the familiar locking-pin to locate the unit securely in an accessory shoe, however, it has as a small but very useful innovation to improve handling the locking wheel of earlier units has been replaced by a lever that swings to the right to lock and to the left to unlock the SB-50DX. The unit is capable of acting as a remote slave flash and comes complete with the SW-9IR infrared filter for triggering remote units.

Nikon SB-30

Nikon introduced the SB-30 Speedlight for those photographers with Nikon SLRs that lack a built-in

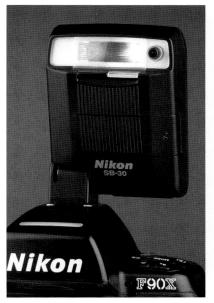

Despite its diminutive size the SB-30 boasts plenty of features. It has an integral slave unit making it a versatile companion as a supplementary unit in multi-flash set-ups.

flash unit and who require a very portable flashgun. It weighs just 92g, less than a third of the SB-80DX 'flagship' Speedlight, and has a head that pivots around a hinged flash foot so the reflector can be angled down to illuminate subjects between 0.3–1.0m. When not in use the design allows the unit to be folded flat across the camera's prism head whilst still attached to the accessory shoe.

The SB30 has a GN16 (ISO100, m) and provides coverage of a 28mm lens, which can be increased with the built-in wide-angle flash adapter to cover a 17mm lens with a GN10. The film speed range in the TTL Auto flash modes is ISO25-800. It is powered a single CR-123A lithium battery, which Nikon claims can produce approximately 250 full power flashes with a rapid recycle time of just 4 seconds. The flash modes include Automatic Balanced Fill-Flash, Standard TTL, non-TTL Auto, and Manual. Apart from full

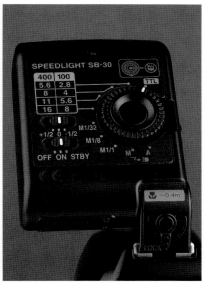

Although its flash reflector is fixed the SB-30 can be tilted forward of close-range shooting.

output the SB-30 can be set to give 1/8 or 1/32 output levels in manual and can be set for apertures between f2.8 to f8 in the Auto flash mode. In the non-TTL and manual mode the flash output can be compensated buy +/-1/2EV. It also has a wireless remote slave flash function and a built-in infrared (IR) filter, which is housed with the wide-angle adapter in a vertical pocket below the flash head, enabling it to be used as an IR command trigger for compatible flash units used in remote multiple flash set-ups. The SB-30's wireless slave function is fully compatible with Nikon's Coolpix cameras' own built-in flash units to enhance their versatility when used with flash.

The SB-30 does not have an LCD display but a control dial with which the photographer can select the TTL mode, Auto flash aperture, or manual output. There is a three-position power switch for ON/OFF and Stand-by, and another switch for the flash output compensation. The wireless slave function can be set to either auto or manual, and there is a flash ready lamp.

Nikon SB-80 DX

During February 2002 Nikon announced a completely new Speedlight the SB-80 DX, which consolidates the features of the SB-28 and SB-28 DX into one unit that is fully compatible with both film and digital cameras, whilst at the same time benefiting from a number of changes in design and performance.

The SB-80 DX specification includes a tilting/rotating flash head for bounced flash, a built-in flash bounce card, and wide-angle adapter that provides coverage for a 14mm wide-angle lens. For shooting in very low light situations, when the camera's AF system may not operate correctly, there is an AF-Assist illumination function. It has a maximum operating range of 10m, and emits a beam of light from a lamp mounted below the flash head. On cameras with Focus Area selection the central area must be select-

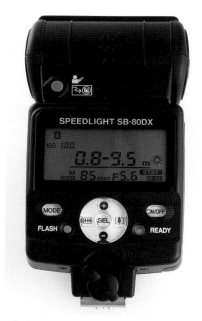

The latest 'flagship' Speedlight the SB-80DX is fully compatible with film and digital cameras. Compared with earlier models the rear control panel has been completely re-designed.

ed for the AF-Assist to work. The film speed range in the TTL Auto flash modes is ISO25-1000. New features include a wireless slave flash function and a modelling flash function, but more on this later.

The large LCD screen on the rear of the unit provides a very clear display of all the relevant information including, flash mode, film speed, lens aperture and focal length, shooting range (shown numerically as the minimum and maximum distance in either metres or feet), the exposure compensation value, and

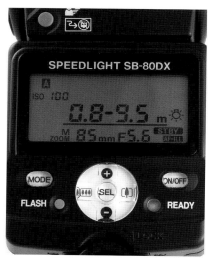

The simplified control panel of the SB-80DX: a single main switch controls its numerous functions.

finally an under exposure indicator which flashes if the TTL meter registers insufficient output. There is a menu of custom settings, accessed via the SEL button and the toggle switch that surrounds it. They comprise an off camera wireless slave flash function, which has two modes; Auto Mode, when the slave SB-80 DX starts and stops firing in sync with the master flash unit, and a Manual Mode when the slave unit just fires in sync with the master unit. There is a sound monitor function to confirm firing when the unit is used as a wireless slave-flash.

Other custom settings include an on/off option for the AF-assist illuminator, a variable delay, between 40s, 80s, 160s, and 300s before the unit switches to Standby mode, or you can cancel the Standby mode altogether, the option of displaying the flash shooting range in metres or feet, an Emergency Mode that allows you to manually select zoom head positions for focal lengths between 24mm and 105mm should the wide-flash adapter be broken off whilst in use as this would otherwise restrict the zoom head to 14mm and 17mm positions, and an on/off option for the auto zoom head and LCD illuminator.

The rear panel of this new unit has a completely new appearance. The array of switches or buttons of the earlier models, SB-24 to SB-28, have been replaced by a single toggle switch flanked by an on/off power button and a button to select the flash mode. Another obvious difference is the method used to attach the SB-80 DX to a camera. The plastic foot and locking wheel arrangement of the SB-28 / SB-28 DX has been replaced by a substantial looking, metal, hot-shoe foot with a locking lever that depresses a pin, which passes through the foot, and locates in the camera's hot shoe plate. It is a very secure arrangement and much quicker and easier to operate, especially in gloved hands, than the former locking wheel design.

The unit takes the usual complement of four AA size batteries and accepts Alkaline (1.5v), Lithium (1.5v), Ni-Cd rechargeable (1.2v), and Ni-MH rechargeable (1.2v). Using alkaline batteries Nikon state that the unit will provide 150 full-power discharges, 1/1050sec duration, with a recycle time of 6.5sec, and with Ni-MH batteries the total number of flashes is reduced to 100 but so is the recycle time to 4sec.

The flash foot of the SB-80DX: the various contact pins and the locking pin (far right) protrude through its metal plate.

The SB-80DX has a GN38 (ISO, m) at 35mm. At the 14mm setting it has a GN17 and at 105mm this is increased to GN56 (ISO, m). The flash output level can be adjusted manually in eight steps from full to 1/128. At the lowest power setting the quoted flash duration is just 1/41,600sec. The battery chamber cover is not hinged like the SB-28 but is tethered to the body of the main flash unit by a short strap. To close the cover you push it down, against the batteries, and slide it along until it seats in the closed position. Trying to locate the cover against the sprung resistance of the batteries can be awkward, and the strap does not appear to be very durable.

Once the unit is powered up the mode button is used to select from one of the following options for film-based cameras: TTL 3D Multi Sensor Balanced Fill Flash, TTL Matrix Balance Fill Flash, Standard TTL, Non-TTL Auto Flash, Manual Flash, and Repeating Flash.

For digital cameras the following modes are available: D-TTL 3D Multi Sensor Balanced Fill Flash, D-TTL Matrix Balance Fill Flash, Standard D-TTL, Auto Aperture Flash, Non-TTL Auto Flash, Manual Flash, and Repeating flash.

It is beyond the scope of this book to describe every possible camera/lens type combination with the SB-80 DX. Suffice to say that full

functionality is achieved when using the F5, F100, F90 / 90X, F80, and F70 film cameras, or the D1 series and soon to be released D-100 digital cameras, in combination with AF-S, AF-G, AF-D, and AF-I series lenses. The range of features and modes available on cameras and lenses outside of this group are more restricted, but as an example even the long discontinued Nikon FA, FE2, and FG cameras, used with manual focus Nikkor lenses, remain compatible by offering standard TTL control.

The SB-80 DX can also be used with the Coolpix 900 and 5000 series cameras should you wish to supplement their built-in flash units, or use a multiple flash set-up. Auto flash operation is possible with these cameras by setting the SB-80 DX to the TTL auto flash mode. The firing and output level from the SB-80 DX is controlled in synchronisation with the built-in flash units of the Coolpix camera using its Non-

TTL auto flash operation. The built-in flash units of the Coolpix cannot be used as the master flash unit, with the SB-80 DX as a wireless slave unit, because the monitor pre-flashes from the Coolpix flash cannot be switched off. The pre-flashes would cause premature firing of the slave units.

The default setting for the flash mode is either TTL 3D Multi Sensor Balanced Fill Flash for film cameras, or D-TTL 3D Multi Sensor Balanced Fill Flash for digital cameras. In either case the SB-80 DX's zoom head will automatically adjust to match lens focal lengths in a range of 24mm to 105mm (from 35mm to 105mm this is done in steps of 5mm). You can take control of the zoom head at any time by just pressing the toggle switch to select a wider or longer focal length from the range of 24mm, 28mm, 35mm, 50mm, 70mm, 85mm, and 105mm.

The built-in wide-flash adapter, which is housed under the top plate of the zoom head has to be manually pulled out, but once in place offers coverage for focal lengths of 17mm and 14mm. The default setting is 17mm and you have to push the toggle switch to select the 14mm position. Nikon make a comment in the instruction booklet that at these extremely wide-angle focal lengths the distance between the camera and subject becomes increasingly pronounced from the centre of the frame to the periphery. In some cir-

The main toggle switch is used to adjust the zoom head of the SB-80DX.

cumstances this may mean that the peripheral areas may be insufficiently lit. On a Nikon D1 I have found the coverage with the wide-flash adapter more than adequate even with a 14mm F2.8 AF-D lens, which equates to a focal length of 21mm due to the camera's CCD being smaller than the full 35mm frame area. Using an F5 and the same 14mm lens there is a noticeable, but not significant, fall off of illumination in the extreme corners of the film frame.

From a handling point of view using the wide-flash adapter is rather frustrating. If you have a wide angle zoom lens, which includes a focal length of less than 20mm in its range attached and use the adapter to provide sufficient coverage, should you change the lens to a longer focal length the flash's zoom head remains locked at 17mm. Conversely, replacing the wide-flash adapter resumes the auto-zoom function of the flash head. However, if you now zoom the lens to a focal length shorter than 24mm it leaves the flash head zoom stuck at its widest auto-setting of 24mm. It terms of coverage there is a lot of difference between a focal length of 17mm and 24mm, and the need to extend or put away the wide-flash adapter could easily be over looked.

To assist in the diffusion of light Nikon have included with the SB-80 DX the SW-10H Diffusion Dome.

Similar to the Sto-Fen Flash diffusers that many press photographers use, the Diffusion Dome, which is made of a semi opaque white plastic material, fits over the front of the SB-80 DX's flash reflector. When in place it depresses a small button on the bottom plate of the zoom head causing the 14mm position to be set automatically. The Diffusion Dome can still be used with longer focal length lenses, shooting with the zoom head tilted upward for bounced flash. In this instance Nikon recommend setting the head to an angle of 60º to achieve the widest coverage and softest light quality.

One of the most innovative features of the SB-80 DX is its Modelling Flash function. Available on all camera and lens combinations it is operated by pressing a small button on the rear of the flash's zoom head. This causes the unit to emit a series of very rapid pluses of light, for a maximum of three seconds, during which time you can quickly asses the quality of illumination and position of any shadows cast by the light from the flash. Its an ingenious, simple, and very useful feature that I used frequently, especially when trying to assess the position of any unnatural looking secondary shadows caused by the flash unit when using fill-flash in bright day light.

The ability to balance both daylight and flash into one exposure,

when used with a suitably specified camera body, has been the main strength of the SB range of Speedlights from the SB-24 onwards. The SB-80DX is no exception and is capable providing very competent fill-flash pictures, but like its predecessors I found the standard TTL 3D Multi Sensor Balanced Fill Flash and D-TTL 3D Multi Sensor Balanced Fill Flash settings gave a slightly over lit result. Fill-flash should be subtle; just lifting the shadows with a small 'puff' of flash illumination. Like many photographers I prefer to set a degree of compensation on the flash, generally around −1.7 stops for an average toned subject, reducing its output to achieve a more natural effect. The SB-80 DX allows exposure compensation of +/−3 stops, in steps of 1/3 EV, for film cameras, and steps of 1/6 EV for digital cameras.

Multiple flash set-ups are easy to achieve with the SB-80 DX. It is fully compatible with the SC-17 Remote Lead for fully dedicated off camera operation, and has terminals for the SC-18 and SC-19 flash sync leads, plus a standard Pin Cylinder (PC) socket. It can also be used with SU-4 Wireless Slave Flash Controller. External power sources such as the SD-8A Battery Pack and SK-6A Power Bracket are available to reduce recycle times and extend the flash shooting capacity. As a final touch Nikon supply the SB-80 DX in a new design of padded case, the SS-80, made from a nylon material with a double-ended draw string, which effects a very quick and positive closure sealing the unit securely away.

External Power Sources

Nikon produce a number of dedicated external power sources for their Speedlight range.

The SK-6 Power Bracket provides

This button on the rear control panel operates the modelling light function of the SB-80DX.

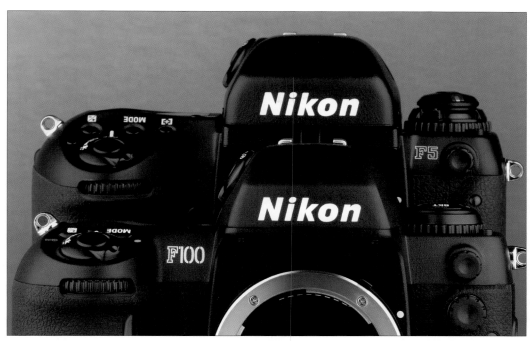

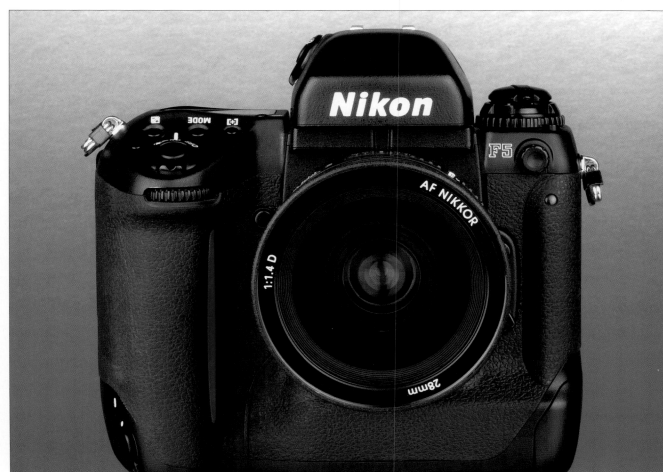

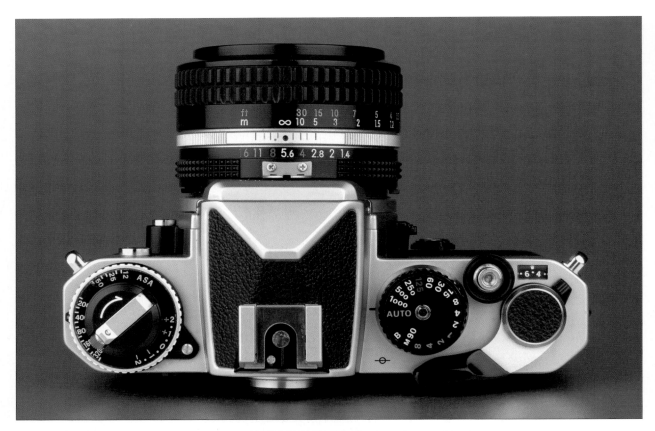

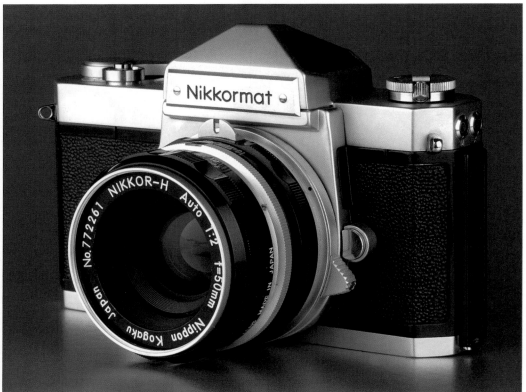

Above:
The Nikon FE was the successor to the electronic cameras from the Nikkormat series.

Left:
Back to basics, the Nikkormat FS, which lacks a built-in meter and mirror lock-up facility, was introduced in 1965.

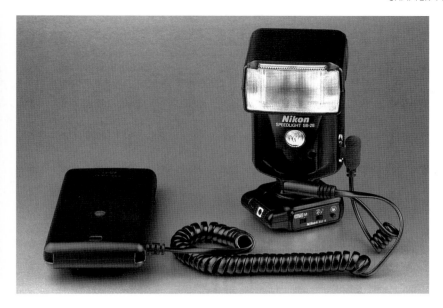

The SD-8A battery pack combined with an SB-28 and the SU-4 TTL slave flash controller.

The SD-8A can be attached to a camera making it a portable unit that increases a Speedlight's performance for extended periods of flash photography.

small coupler unit fits into the ISO accessory shoe and connects the SK6 to the camera's TTL flash system. The flash unit then attaches to a standard TTL ISO accessory shoe on the SK-6, which is located to the left of the camera. Personally I find the placement of the flash unit rather curious because for horizontal shooting the SK-6 lowers the unit closer the lens axis than if it were mounted in the camera's accessory shoe. This gives flat frontal lighting with the increased risk of red-eye effect. If you want to use the set-up for vertical shooting the flash is on the wrong end of the camera because using either the camera's normal shutter release or those with vertical releases on motor drives or battery packs (e.g. F100+MB-15, or F5), held in the conventional way with the release to the top, places the flash below the camera. The SK-6 can accept 1.5v alkaline and lithium batteries, or 1.2v Ni-Cd types.

The SD-7 is battery box that accepts six C size batteries and comes complete with a leather case and shoulder strap. It is not sold in the European market and cannot be used with Nikon Speedlights that have an external power terminal that conforms to the European specification.

In 1990 Nikon introduced the compact SD-8. It is a simple battery box that accepts six AA size batteries, which can be 1.5v alkaline, and lithium batteries, or 1.2v Ni-Cd and NiMH types. It has two leads, a power lead that attaches to the external power socket of compatible flash units including the SB-24, 25, 26, 27, 28, 28DX, and SB-80DX, and a PC lead that must be attached to the flash unit's PC socket and not the camera's. Nikon stress that it is important to plug or unplug the PC lead before the power lead. The SD-8 can either be carried in its case that has a belt loop, or attached to

additional power and a handgrip in one. It supplements the flash unit's batteries with a further four AA size batteries to reduce recycle time by approximately a half and double the total number of flashes available. Its bracket attaches to the base plate tripod bush of the camera and a

the base of the camera via a dedicated screw, which disappointingly has to be purchased as an extra accessory!

During the 1990's European countries introduced strict regulations that govern the design of electrical devices. To comply with these Nikon had to modify the three-pin external power supply socket on their Speedlights. Consequently the SK6 and SD-8 were also modified and designated SK-6A and SD-8A respectively, however all other specifications are identical. Photographers should note that the SD-7, SD-8 and SK-6 are not compatible with Speedlights that conform the European specification.

Nikon SU-4 Slave Flash Controller

After the complaints that Nikon received concerning the slave flash function of the SB-26 they set about designing a better solution that offered full TTL compatibility. The answer arrived in 1999 in the form of the SU-4 Wireless Slave Flash Controller. This small unit, which weighs just 52g, can make setting up and using a multiple flash system with full TTL control very easy provided you observe a few key points. The most important is that all flash units, including the master, must be set to Standard TTL exposure control. There are three ways to cancel the Monitor Pre-flash system: select

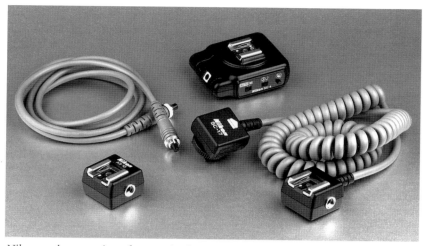

Nikon produce a variety of accessories for connecting multiple Speedlights: some of the most useful are the SU-4, SC-17 TTL lead, SC-18 TTL lead, and AS-10 flash connector seen here.

Standard TTL, swing the flash head up/down from its normal position, or switch the flash units to Rear Sync mode. This is because the light pluses from the pre-flashes would otherwise cause the slave units connected to an SU-4 to fire prematurely, before the master TTL unit fires.

You can use as many slave flash units, each attached to an SU-4, as you like. The unit offers either Auto TTL or manual control. The maximum range from the master flash in the Auto TTL mode is 7m, and 40m in manual. The flash attaches to the ISO TTL hotshoe on the top of the SU-4, which rotates horizontally +/- 120(, and has a standard tripod bush in its base for connecting it to a tripod or stand. The light sensor is mounted on the side of the unit and rotates vertically +/- 120(. This allows a great deal of flexibility when it comes to positioning the slave units. There is a small control panel on one side of the SU-4 with the selector switch for Auto/Manual and another On/Off switch for an audible warning that signals that the flash unit has completed its recycle or that flash output was at its maximum. The third button is used to cancel flash firing of the slave unit

so the photographer can assess the effect of other units.

The Nikon Multiple TTL Flash System

The Nikon system for multiple TTL flash unit control appears daunting at first but provided you abide by some simple rules it is very straightforward. There are three methods of triggering a multiple flash system: by using connecting leads, built-in slave units, or the SU-4 TTL slave flash controller. I will confine the following description to the use of the connecting lead method as the other two options have already been discussed earlier in this chapter.

The key accessory is the 1.5m long SC17 TTL lead, which has a five-

The SU-4 TTL slave flash controller: extremely useful for setting up wireless TTL multiple flash unit lighting.

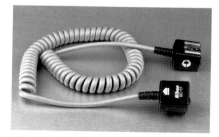

The SC-17 lead has a five-wire core and maintains full TTL control of Speedlights as though they were attached to the camera hotshoe contacts.

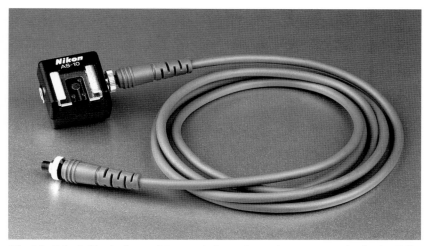

The SC-18 lead, like the longer SC-19, only has a three-wire core. It carries the On/Off signal for TTL control.

wire core and communicates all the relevant information from the camera to the flash as though it was attached to the TTL accessory shoe of a camera. One end of the SC-17 attaches to the hotshoe of the camera and the other end has another hotshoe with two TTL terminals and a tripod socket. The SC-18 (1.5m) and SC-19 (3.0m) are three-wire leads that can only carry the TTL On/Off signal. The SC-24 lead

is designed specifically for the DW-30 and DW-31 finders of the Nikon F5 and the DW-20 and DW-21 finders for the F4 camera. The last accessory is the AS-10 Multi-flash adapter, which has a TTL hotshoe, three TTL terminals, and a tripod socket.

There are three factors that you must consider when connecting the various Speedlight units together: the load that each flash unit places

on the lead, the total cable length, and the number of units. The load varies from Speedlight to Speedlight and the total load must not exceed 1400(A at 20(C and 910(A at 40(C (the values for each Speedlight are given in the accompanying table). The total length of the connecting cables must not be greater than 10m and you must not connect more than five Speedlight units together.

The lighting ratio between the various flash units should be considered, and it is far easier if you use Speedlights with the same Guide Number. For example in a two light set-up, with a master and a slave flash, where both have the same flash-to-subject distance, then the subject will receive an equal amount of light from each flash and the ratio will be 1:1. If the slave unit is moved to a position where is twice as far away as the master unit the light from the slave unit will be four times less. The ratio between the slave and master is now 1:4.

It is important that any unit that offers the Monitor Pre-flash system has this function cancelled other-

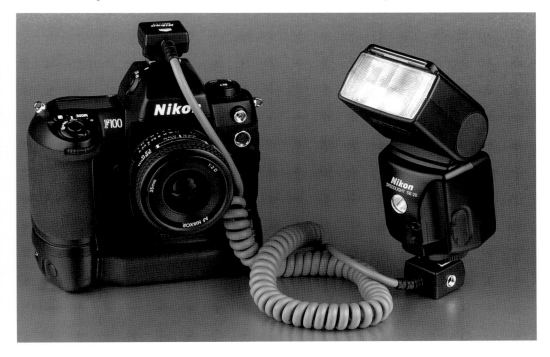

The SC-17 lead maintains full TTL control between a Nikon camera and Speedlight.

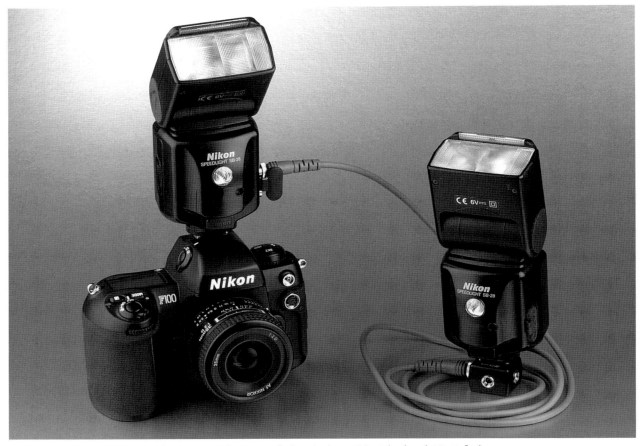

Two SB-28 Speedlights connected to an F100: the remote flash unit via an SC-18 lead and AS-10 flash connector.

wise the TTL exposure control may be inaccurate. Do this by setting all the units to the Standard TTL mode or to Rear Sync mode.

Setting up and using a multiple TTL flash system is simple if you observe these conditions. The sequence is as follows:

Make sure all the Speedlight units are switched off.

Attach the master Speedlight unit either directly to the camera's TTL hotshoe or via an SC-17 lead.

Connect the first slave unit to the TTL terminal of the master flash, if it has one, or the terminal of the SC-17 lead via an SC18/19 lead. The next additional slave unit can be connected to the first slave's TTL

terminal, or via the terminal in an AS-10 adapter by another SC18/19 lead. Further salve units can be added in a similar way. (See table) Turn on the master unit followed by the next closest unit and work your way along until all the units are ON. It is most important that you do not set any of the slave units to the STBY setting. Any slave unit connected by an SC-18 or SC-19 that is set to STBY will not be reactivated from its 'sleep' mode when the camera's shutter is released because they do not recieve the appropriate signal. In this case you must manually reactivate each unit.

Set each unit to standard TTL control. Then adjust the film speed, zoom head position, and aperture value on each slave unit to match

the settings on the master flash. Nikon state that if more than three Speedlights are connected together then the AS-10 adapter should be used in place of the TTL terminal on the Speedlight.

Position the Speedlights as required to light the subject and its surroundings. Remember to consider the lighting ratio, for example if the flash-to-subject distance is doubled the light level drops by a factor of four.

Focus, compose, and shoot.

The Accessory System

Nikon has always striven to make its camera bodies, especially those of the professional F-series, the centre of a comprehensive array of lenses and accessories to enable photographers to tackle a wide variety of tasks, however obscure or demanding.

Nikon made this adjustable dioptre viewfinder eyepiece for their first rangefinder cameras, the Nikon 1, M, and S; however, it was never officially listed and is extremely rare.

Nikon produced a variety of accessories for their rangefinder camera system, including a motor drive, supplementary viewfinders, eyepiece lenses, filters, and a range of lens hoods. The advent of the Nikon F system called for an even more

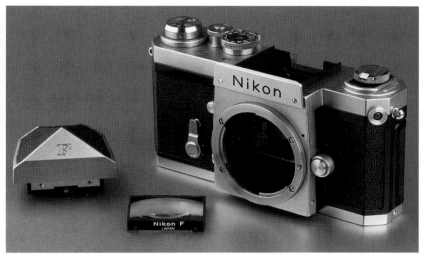

The standard non-metering prism head for the Nikon F shown here with the focus screen removed.

diverse series of accessories to complement the greater flexibility of the

SLR camera design and the wider applications it can tackle.

SLR Viewfinder Systems

The viewfinder of an SLR camera with its 'what you see is what you get' view allows the photographer to compose, confirm focus, and depending on the particular camera model, observe a range of information concerning exposure values, and the camera's functions.

In its simplest form the viewfinder of an SLR comprises a reflex mirror that deflects the light passing through the lens upwards by 45° onto a focusing screen. The image on the screen can be viewed via a basic waist-level finder that forms a hood around the screen to shield it from the light, and a flip-up magni-

This clip-on accessory light meter, with its adapters, was made for the Nikon SP rangefinder camera.

fier to aid focusing. This simple viewfinder design has two drawbacks: the image appears upright but laterally reversed, and it forces the user to place their eye perpendicular to the screen, which for many applications is rather awkward.

By placing a pentaprism above the focusing screen to divert the light into an eyepiece the image is laterally corrected and at eye-level, making it far more convenient to view the subject whilst operating the camera. In the majority of SLR cameras this prism is fixed, although some allow the focusing screen to be changed. There are, however, a number of special applications in which a photographer may want to use an alternative viewing system and this is why the finders of the Nikon's professional F-series cameras are interchangeable.

In addition to the interchangeable reflex viewing finders Nikon also produced a range of direct view finders for those lens, which due to their design, required the reflex mirror to be locked in the 'up' position before the lens can be mounted on the camera body.

The Nikon F - Exposure Meters

The first exposure meter for the Nikon F was a detachable selenium cell type. It was coupled to both the shutter speed dial and the lens aperture ring and could thus react to changes of the shutter speed/aperture combination, which was a distinct advantage over a separate hand-held meter. Called the 'Model 1', it had a film speed range from ISO6 to 4000, and was followed by two later modified versions the Models 2 and 3. The inclusion of an amplifier cell in the latter increased its sensitivity in low light, but these early finders were quite large and unwieldy and impaired the handling of the camera.

The Nikon F - Photomic Heads

In 1962 the first Photomic finder with an integrated exposure meter appeared. Replacing the standard eye-level prism finder of a Nikon F with the Photomic head converted the camera into the Nikon F Photomic. This first metering head has a CdS cell built into the top right corner of the finder body and

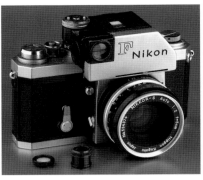

The first metering head for the Nikon F: the Photomic head.

a shutter speed dial that links to the camera's dial. A second coupling on the front conveys the aperture setting to the exposure meter. The Photomic head over hangs the front of the camera obscuring the aperture ring so the preset aperture value is displayed on the back of the head in a small window above the eyepiece. A film speed scale with values from ISO6 to 6400 is situated within the shutter speed dial and must be set on the inner dial so that the value in use is opposite the black triangular index.

This is not a TTL system because the first Photomic did not measure the light passing through the lens onto the camera's focusing screen. The unit was supplied with two converters, which allowed the characteristics of the metering cell to be modified. The first is a black cylindrical tube, which narrows the metering-angle, and is screwed over the metering cell whenever telephoto lenses over 105mm are used. The second converter is an opal disc that disperses the light falling on the cell allowing an incident light reading to be taken. Both converters can be screwed to the battery compartment lid on the side of the head when they are not required. The exposure meter is switched on by flipping up a hinged shield that covers the metering-cell. In later versions On/Off switches were added to the right

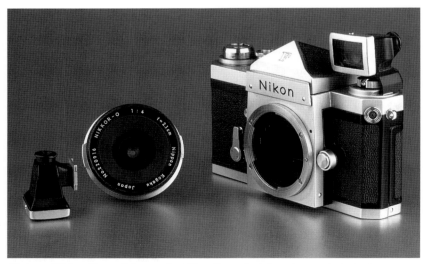

Fitting a Nikkor 21mm f4 lens to the Nikon F required the mirror to be locked up; therefore, it was supplied with a separate direct viewfinder that attaches to the accessory shoe.

The first Nikon SLR with TTL metering: the Nikon F Photomic T.

and above the metering window respectively.

Nikon's first TTL metering system appeared in 1965. Two CdS cells located inside the viewfinder next to the eyepiece measure the light from the subject off the focusing screen. The advantage of this is obvious: only the light that actually exposes the film is evaluated, and the angle of view of the lens is taken into account automatically, as are any exposure compensation factors necessary when employing filters or close-up accessories. Complicated calculations are no longer required and metering is easier and more reliable. Powered by two 1.35v button-size cells this metering head has a sensitivity range from EV2 to EV17 and is known as the Photomic T. It was introduced at the same time as the Nikkormat FT.

Two years later the Photomic T was succeeded by a modified version, the 'Photomic TN' that has aspheric lenses in front of the metering cells to modify their measuring characteristics. The Photomic T evaluates the light evenly across the whole of the focusing screen,

however the Photomic TN employs the metering configuration that was to become a standard for many Nikon cameras over the years: the 60:40 ratio biased toward the central area of the screen. The 12mm circle on the focusing screen defines the area from which 60% of the light reading is taken, whilst the remaining 40% is evaluated from the outer area. An 'N' engraved beneath the power-off switch, and a small white battery check button identify the Photomic 'TN' head. Provided the

meter needle in the finder moves to the left there is sufficient power and when this needle is centred on the notch the exposure setting is 'correct'. The shutter speed setting is displayed next to the needle. A second needle display is located on top of the Photomic heads in a small window, which is quite useful for monitoring exposure when shooting with the camera on a tripod as it saves having to look through the viewfinder each time.

In 1969 the last metering head for the Nikon F was introduced, the Photomic FTN. It has the advantage of automatically indexing the maximum aperture of the lens in use. Prior to then it had been necessary to change the ISO value opposite the maximum aperture mark on the shutter speed dial of the Photomic heads every time a different lens was attached: a very clumsy procedure that was often forgotten with dire consequences. To index the maximum aperture on a camera with the FTN head requires the aperture ring to be rotated all the way to the left and then back again to the right after the lens has been attached. The correct setting can be checked easily by observing the small pin in the slit on the front of the head underneath the Nikon logo, which indicates the

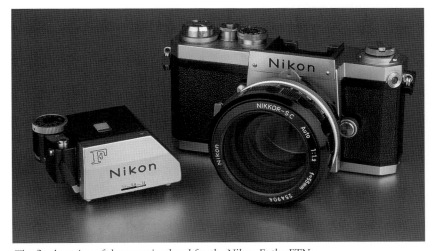

The final version of the metering head for the Nikon F: the FTN.

A close-up view of the two power buttons and the finder lock lever on the FTN head.

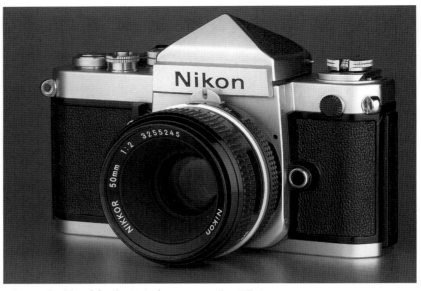

The standard head for the F2 is the non-metering DE-1.

maximum aperture of the lens between f1.2 and f5.6. As another improvement the film speed range was extended from ISO6 to ISO6400.

The FTN's battery chamber located on the underside requires the head to be removed from the camera before changing the batteries. The silver button on the side of the finder is the power ON switch. Pressing the power OFF switch on the top causes the former to pop out again. It also serves as a battery check: when it is held down the meter needle should move to the small central circle in the display on the top of the head.

The Nikon F2 - Photomic Heads

The internal metering system of the FTN head for the Nikon F was adopted for the first metering head for the F2: the DP-1, which converts a standard F2 into an F2 Photomic. As an improvement over the Nikon F system the preset aperture is visible in the viewfinder of the F2 Photomic, and a ± symbol indicates whether the preset shutter speed/aperture combination will result in an over, or under exposure.

Whereas the F-Photomic heads were available with front plates in either chrome or black finish, those for the F2 were only supplied in black. A small silver button on the front of the head operates the battery check, and a rubber seal between the finder and the camera body helps to prevent dust and moisture from entering. Inside the eyepiece a red LED acts as a flash-ready signal. This is activated when the terminal on the outside of the head is linked to the Nikon SB-2/7E Speedlights via the SC-4 lead.

In the F2 series cameras the batteries are located in the base of the camera so power to the head is supplied through the two contacts to the left and right of the camera's focusing screen frame. Pulling out the film advance lever to its 30∞ stand off position switches on the exposure meter. As the F2 Photomic heads do not need to house batteries they are more compact than the F-Photomic heads. It should be noted that the two types are not inter-changeable.

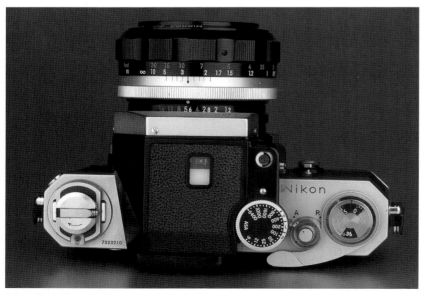

The Nikon Photomic FTN seen from above.

The DP-11 head: the F2 becomes the F2 A Photomic.

When the AI (aperture indexing) system was introduced the Photomic DP-1 was modified to become the DP-11, turning the F2 Photomic into the F2 A Photomic. The maximum aperture indexing was changed and the preset aperture, which can now be read off a second smaller scale on the aperture ring, is visible in the finder. A viewfinder illuminator, the DL-1, that uses a small LED powered by a button battery to illuminate the meter-needle, was available as an accessory for low-light conditions. It can also be used on the F-Photomic heads by attaching it to the finder eyepiece.

The DL-1 was no longer necessary for the DP-2 viewfinder introduced in 1973, which turns the F2 into an F2 S Photomic. An LED display that uses red ± symbols to indicate the

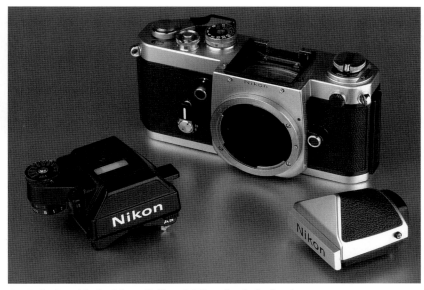

An F2 body: with the DP-12 (left) and DE-1 viewfinder heads.

'correct' exposure setting, replaced the needle in this metering finder. The sensitivity in low-light conditions was also enhanced by extending the metering range down to EV -2, equivalent to an exposure of 8 seconds at f1.4 (ISO100). Shutter speeds slower than one second, which are not available on the shutter speed dial, can be set in conjunction with the self-timer lever. Set the shutter speed to B and the shutter release collar to T, then select one of the speeds, 2, 4, 6, 8, and 10 seconds,

on the small scale around the self-timer lever axis on a smaller scale below. Finally press the shutter release. The indexed maximum aperture is displayed in a small window on the front of the finder head. The DP-2 also has contacts for the DS-1 aperture control unit, which provides the F2 with a mechanically operated shutter priority mode.

The F2 S Photomic head was replaced by a modified version, the F2 SB Photomic, in 1976. Its DP-3 finder was the first Nikon model to employ the more sensitive silicon cells and due to a re-designed internal construction it has a lower profile similar to the DP-11. Three LEDs indicate the exposure level in this version: if the central circle lights up alone the 'correct' exposure has been set with a margin of +/- 1/5EV, at the most. The plus or minus symbols appear together with the circle when the deviation ranges from 1/5 to 1EV. If the deviation is greater than 1 EV either the appropriate plus, or minus, symbol lights up alone. The exposure indication on the top of the finder was reduced to a single red LED that has a second function, which is to indicate

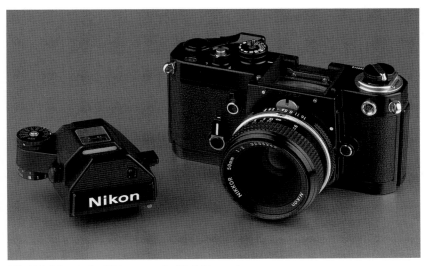

The DP-2 head: the F2 becomes the F2 S Photomic.

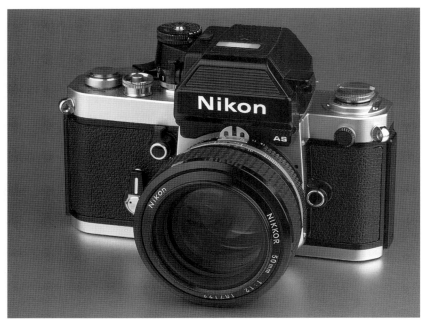

The F2 AS represents the final version of the Nikon F2.

The DP-12 viewfinder head as viewed from above.

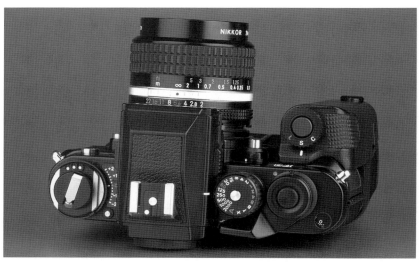

This Nikon F3 camera is fitted with a DE-4 High Eye-Point viewfinder.

Eyepoint (HP) type, for photographers who wear glasses. Prior to then they had only two choices, either keep wearing their glasses when looking through the finder, or fit a matching dioptre correction lenses to the eyepiece. The main disadvantage of correction lenses is that they can only correct simple short or long sightedness but offer no remedy for complex eye defects, and are generally only available in rather large steps of 1 dioptre from +3 to –5m^{-1}. It is inconvenient removing glasses each time you look through the view finder, but the alternative of keeping them on often means it impossible to see the complete finder image, because the eye is too far from the eyepiece. The normal finders of other cameras are designed so that the eye can be kept about 18mm from the eyepiece. In the case of the HP finder the eyepiece has a larger diameter so that the whole finder image is visible from a distance of 25mm.

Only one metering finder was made for the F3-system, the DX-1 Auto-focus finder for the F3 AF camera. As such it was designed to provide an evaluation of focusing and control the two dedicated AF

battery condition when the sliding lever on the top is used to illuminate the shutter speed display in the viewfinder.

In the AI version the DP-3 was modified to become the DP-12 finder, which changes the standard F2 into its most advanced and last version, the Nikon F2 AS.

Nikon F3 - Viewfinders

Unlike the F and F2 models, the F3 has its metering system built into the camera body, so its range of viewfinder heads are only concerned with providing a view of the subject. In 1982 Nikon introduced a new style of head for the F3, the High-

The only viewfinder head for the F3 camera to be fitted with an ISO-standard accessory shoe was designed for the F3 P.

The DX-1 was the only viewfinder head with an integral metering system that was produced for the F3 series.

lenses produced for the camera. Its optical range-finder system can also be used with any standard F3 to confirm focus when focusing manually with these cameras.

Nikon F4 - Viewfinders

The introduction of the F4 series cameras saw a return to the incorporation of the metering system in the viewfinder head. This was necessary for several reasons. First, the F4 offers three different metering methods and second, due to its many functions and features, the

designers and engineers were faced with the problem of finding sufficient space in the body.

Without a viewfinder attached the F4 can only provide spot metering as the metering cells responsible for the Matrix and centre-weighted modes are located inside the finder next to the eyepiece. The standard DP-20 head has an HP type eyepiece with an integrated shutter curtain. The three metering modes are selected by rotating the dial on the right side of the head (when viewed from behind the camera). A innovation in the DP-20 is the inclusion of two tiny mercury switches, which not only inform the Matrix metering system if the camera is being held horizontally or vertically, but also in which direction. This was done in order that the appropriate metering segments in either the portrait, or landscape, format can evaluate different parts of the subject and influence the exposure control system accordingly. As the camera is moved the liquid mercury in the switches makes and breaks the necessary electrical contacts: ingeniously simple, but effective.

Since the metering cells are situated in the DP-20 viewfinder head,

compensation factors have to be set when certain special focusing screens are employed. Values within a range of - 2 to +0.5 EV can be set with the help of the screw-like dial on the bottom of the finder body and controlled in a window on its lower right side. The finder itself offers a multitude of information in windows above and below the image on the focusing screen, including a frame counter. Eleven contact pins located at the bottom rear edge of the finder make all the necessary connections with the main camera body. Although eyepiece correction lenses (+2 to –3m –1) are available as a separate item the DP-20 as it has its own built-in dioptre correction adjustment with a range of +1 to –3m –1 dioptre, which is set with the small knob on the right side of the head.

The DP-20 has an ISO-standard accessory shoe with hot-shoe contacts for the Nikon Speedlight range, including the SB-24 and later Speedlights with which it offers the most sophisticated flash exposure control system. Early DP-20 heads gained a reputation for having a rather weak top so in later versions Nikon increased the thickness of the double wall to improve their resistance to knocks. Likewise the small semi-opaque window on the slanted front face of the head would often fall off and drop inside the head, again Nikon modified the attachment of these in later models.

The DA-20 Action Finder is like a super-HP head and is intended for those situations when the photographer is wearing eye protection equipment such as goggles or a helmet. It does not offer Matrix metering, because apparently with so much glass inside it there was no room left for the metering electronics! The lower window display below the finder image of the DP-20, which includes shutter speeds in the

The standard viewfinder head for the F4 is the DP-20.

251

P and A modes, or the aperture values in the S mode and the exposure mode indicator, are visible in the upper window of the DA-20.

The DW-21 6x Magnifying Finder and the DW-20 Waist-Level Finder only provide spot-metering, but they do have a terminal for the SC-24 TTL flash lead to maintain off camera TTL flash control.

Nikon F5 – Viewfinders

The range of finders for the F5 essentially mirrors those available for the F4 camera.

The standard DP-30 head has an HP type eyepiece with an integrated shutter curtain. The three metering modes are selected by rotating the dial on the right side of the head (when viewed from behind the camera). As in the F4 the meter cells for

the F5's 3D Colour Matrix and centre-weighted modes are located inside the DP-30. So if the finder is detached the camera can only perform spot metering.

The DP-30 has its own built-in dioptre correction adjustment with a range of +1 to –3m $^{-1}$ dioptre, which is set with the small knob on the right side of the head, an ISO-standard accessory shoe, and eye-piece curtain to prevent extraneous light entering the viewfinder when the camera is used remotely.

The DA-30 Action Finder provides an increased eye relief position of approximately 60mm for situations when the photographer must wear protective head or eyewear such as goggles. Again, like the DA-20, it lacks the matrix meter sensors so it only offers centre-weighted and

spot metering. The DW-30 Waist Level Finder is ideal of viewing the focus screen when the camera is at a low angle, and it has a flip-up 5x magnifier for the centre area of the screen's field. The DW-31 High Magnification Finder is designed, principally for critical focusing in close-up and macro photography. Its viewing turret is fitted with a +3 to –5m $^{-1}$ dioptre adjustment, and has a built-in rubber eyecup and eyepiece cover.

Nikon F Models - Special Viewfinders

The interchangeable viewfinder system is without doubt the most obvious difference between the professional Nikon F cameras and other Nikon models.

Waist-level finders

Originally only two finders were offered for the Nikon F camera, a simple eye-level pentaprism without a metering system and a waist-level finder with a collapsible hood for viewing the image directly on the focusing screen. The folding hood shields the focusing screen from extraneous light, which would otherwise impair the image quality. A small magnifier can be flipped up to enlarge the centre of the image five times to aid focusing.

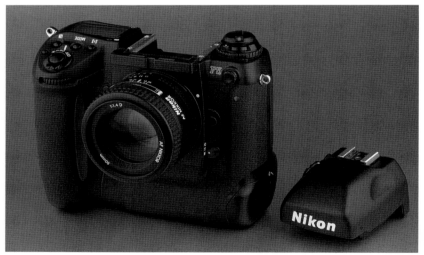

The DP-30 contains the 3D Colour Matrix metering sensors for the Nikon F5.

The various viewfinder heads to the F5 body are connected via these locating rails and electrical contacts.

This Nikon F has the second type of waist-level viewfinder head fitted.

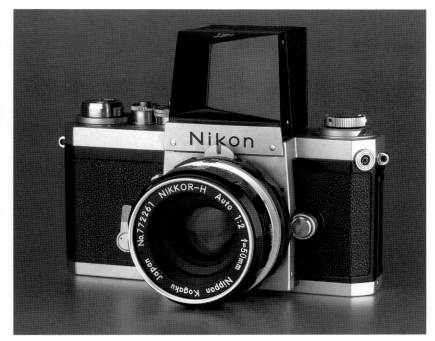

This is first Action Finder for the F series fitted to a Nikon F camera.

Action Finders

The Action Finders are designed to provide a viewing distance of about six to eight centimetres between eye and eyepiece. The ability to see the entire viewfinder image from this range is useful for shooting fast paced action, using the camera in an underwater housing, or in situations when the photographer must wear protective head or eyewear such as goggles. The Action Finders offer an eye relief distance of approximately 60mm. The DA-20 and DA-30 have an ISO-standard accessory shoe, but the Action Finders for the Nikon F, F2, and F3 cameras lack this feature.

Magnifying Finders

The 6x High-magnification Finders are designed to assist critical focusing in high magnification macro work. They enlarge the complete viewfinder image by a factor of 6

and have a built-in eyesight correction adjustment from +3 to −5 m $^{-1}$ dioptre.

A finder of this type was not available for the Nikon F, but the DW-2 version for the F2 can be attached after unscrewing the two screws on the reverse side of the Nikon nameplate on the front of the F body. This procedure also makes it possible to use all of the finders for the F2, except for the Photomic heads, on the Nikon F. You can fit Nikon F finders to the F2, but the finders for the F3, F4, and F5 are not interchangeable with other Nikon F models.

The DW-21 is the 6x High Magnification finder for the F4 camera.

VIEWFINDER ACCESSORIES

Eyecups

One of the most useful accessories for any camera is a rubber eye-cup, as it not only prevents extraneous light entering through the eye-piece, which can potentially affect the exposure meter reading, but also helps when handholding the camera as you can assist in bracing it by pressing your eye to the viewfinder. This bracing principle also applies when working with long telephoto lenses mounted on a tripod or

Camera	Eye-level	High Eyepoint	Waist-level	Action Finder	Magnifying x6
Nikon F	Y	X	Y	Y	Use DW-2***
Nikon F2	DE-1	X	DW-1	DA-1	DW-2
Nikon F3	DE-2	DE-3	DW-3	DA-2	DW-4
Nikon F4	X	DP-20	DW-20*	DA-20**	DW-21*
Nikon F5	X	DP-30	DW-30*	DA-30**	DW-31*

Notes:

Y – available but has no specific designation.

X – Not available

* Spot metering only

** Matrix metering is not available.

*** It can be used with modification of the camera body.

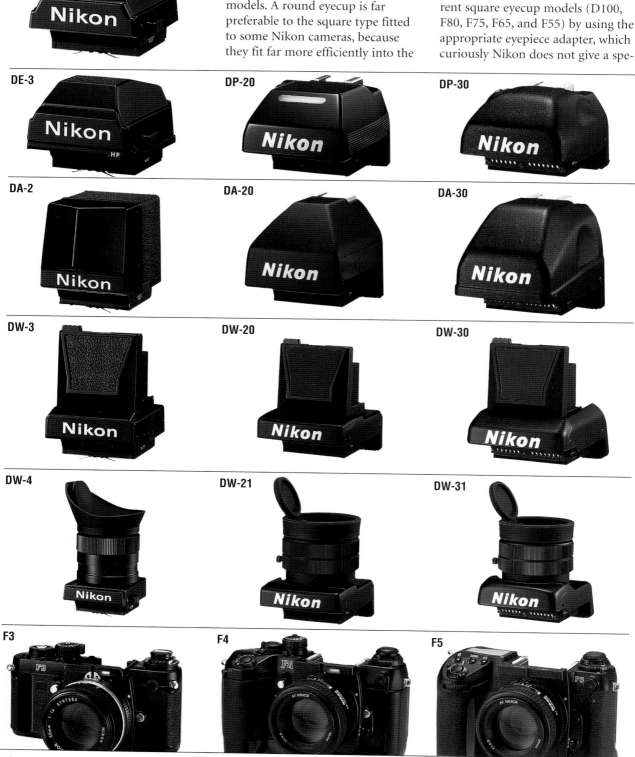

DE-2

DE-3

DP-20

DP-30

DA-2

DA-20

DA-30

DW-3

DW-20

DW-30

DW-4

DW-21

DW-31

F3

F4

F5

monopod. Nikon produce a range of eyecups for all their SLR camera models. A round eyecup is far preferable to the square type fitted to some Nikon cameras, because they fit far more efficiently into the circular shape of the eye orbit.

It is possible to convert the current square eyecup models (D100, F80, F75, F65, and F55) by using the appropriate eyepiece adapter, which curiously Nikon does not give a spe-

The system of viewfinder heads for the Nikon F3, F4, and F5 cameras.

The component parts required to adapt a square viewfinder eyepiece to take a circular eyecup: the eyepiece adapter, DK-3 eyecup, and eyepiece lens for the FM3A camera.

not notice. This was chosen to give a comfortable view of the viewfinder image by simulating a distance of one metre from the focusing screen, even though the eye is actually only a few centimetres away. The dioptre designation on the eyepiece lens ring, however, describes the effect of the complete viewing system. So a lens with the designation '0' is actually a +1 dioptre lens. Those who wear glasses must bear in mind the need to subtract 1 dioptre from the prescription value of their eyeglasses when ordering correction lenses. These lenses are available for all Nikon models, slip-on versions for cameras that have rectangular eye-

The D100 adapted to accept a circular DK-3 rubber eyecup.

Eyepiece correction lenses were available for the Nikon rangefinder cameras. This is an adjustable model with its leather case.

cific designation. Use the following procedure: remove the square rubber eyecup, and then slot the adapter into place over the eyepiece frame. Place a DK-3 eyecup (for the FM2 and FM3A) against the eyepiece adapter, and then screw in an FM2/ FM3A eyepiece cover lens to hold the eyecup in place.

Viewfinder Eyepiece Lenses

For those photographers with less than perfect eyesight Nikon manufacture a series of eyepiece correction lenses. The standard eyepiece lens on Nikon cameras have a correction of $-1\ m^{-1}$ dioptre, which most users with normal vision will

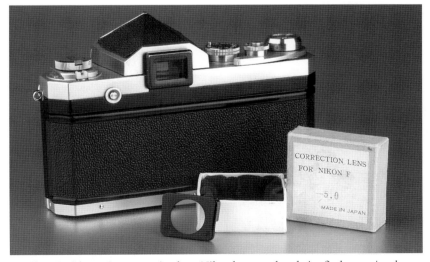

A Nikon F with eyepiece correction lens: Nikon have produced viewfinder eyepiece lenses in a variety of dioptre strengths from the very beginning of their SLR camera system.

pieces, and screw-in types for all the other models. Although many modern Nikon cameras have a viewfinder eyepiece with a built-in dioptre adjustment eyepiece correction lenses are also available for these models.

A recent innovation from Nikon is the Anti-fog Viewfinder Eyepiece. Photographers working in cold or humid conditions, when the finder eyepiece is susceptible to fogging due to condensation, can replace the standard eyepiece with either DK-14 for the D1 series, F5, and F3 HP, or the DK-15 for the F100 and F90/90X. These lenses have a transparent plastic plate with a special hydrophobic coating to help prevent moisture condensing on its surface. I have found them to be very useful for this purpose but under certain conditions they can cause a double image in the eyepiece, which can impede manual focusing. They have no detrimental effect on the final image though.

The DG-2 Eyepiece Magnifier, which enlarges the centre of the

The DR-4 Right-angle Viewer: attached to this F5 allow the camera to be placed in a very low shooting position.

image by a factor of 2x, is useful for critical focusing. It screws directly into the eyepiece of cameras such as the F3 (DE-2 Finder only), FM2N, and FM3A, or via the DK-7 (Note: The DK-7 is identical to the DK-1, an earlier accessory listed by Nikon), for other models and a hinge allows it to be swung out of the way when it is necessary to see the complete finder image. It has a dioptre correction of +1 to −5m −1 and an integral rubber eyecup.

The DR-3 Right-Angle Viewing Attachment provides a full, upright, laterally correct viewfinder image for occasions when it is desirable to view the image from above, or in situations when it is difficult to place your eye to the conventional eyelevel finder such as shooting from a very low elevation. It is attached by screwing it into the finder eyepiece thread, has an integral rubber eyecup, and offers a built-in dioptre adjustment of +3 to −5m $^{-1}$. It fits directly to the eyepieces of the F3 (DE-2 Finder only) and the FM/FE range of cameras. The DK-7 adaptor is necessary with the High Eye-Point type finders (F5, F4, F3 HP, and D1 series) that have a larger diameter eyepiece thread. An updated and modified version, the DR-4, has replaced the earlier DR-3. It threads directly onto the HP type finder eyepieces of modern AF cameras, but can be used on the smaller diameter eyepiece of cameras such as the F3, FM2N, and FM3A, via the DK-13 adapter ring, which is supplied with it.

To set the continuous dioptre correction of the DG-2 and DR-3 / DR-4 look at the focusing screen image with the accessory attached but without a lens mounted. Loosen the locking screw and adjust the eyepiece focus until you can see the focusing screen markings clearly, and then carefully tighten the locking screw.

Interchangeable Focusing Screens

In an SLR camera the focusing screen and the plane in which the film is held are equidistant from the reflex mirror, but perpendicular to each other. The image is formed on the screen by light from the subject being focused by the lens. The early focusing screens, including Nikon's, were called 'matte screens' due to their appearance, which was the result of the sandblasting process used in their production. They provided a rather dim and grainy image compared to modern screens that are produced by laser etching and offer a fine, barely perceptible grain, and a degree of light transmission that approaches the theoretical maximum. Advances in this technology are quite recent; for example you only have to compare the screen of an F5 (1996) to that of the D100 (2002) to see the significantly brighter view that the latter achieves.

Nikon offer a multitude of focusing screens for their cameras to provide optimum viewing of the subject in almost every situation for any photographic task. The ability to change screens allows the photographer to adjust the viewfinder image to suit their preferences. For example the K type screen with its split-image and microprism ring focusing aids is fitted, as standard to non-AF cameras such as the Nikon FM3A, but it is not suitable for slow zoom or long telephoto lenses, due to the 'black-out' effect that occurs with the split-image prism. All the AF cameras have a version of the plain B type screen, which provides the best all round performance regardless of which type of lens is attached to the camera.

Type A: F, F2, F3, F4, F5, FTN, and EL.

This was the first standard screen, with a split-image rangefinder and

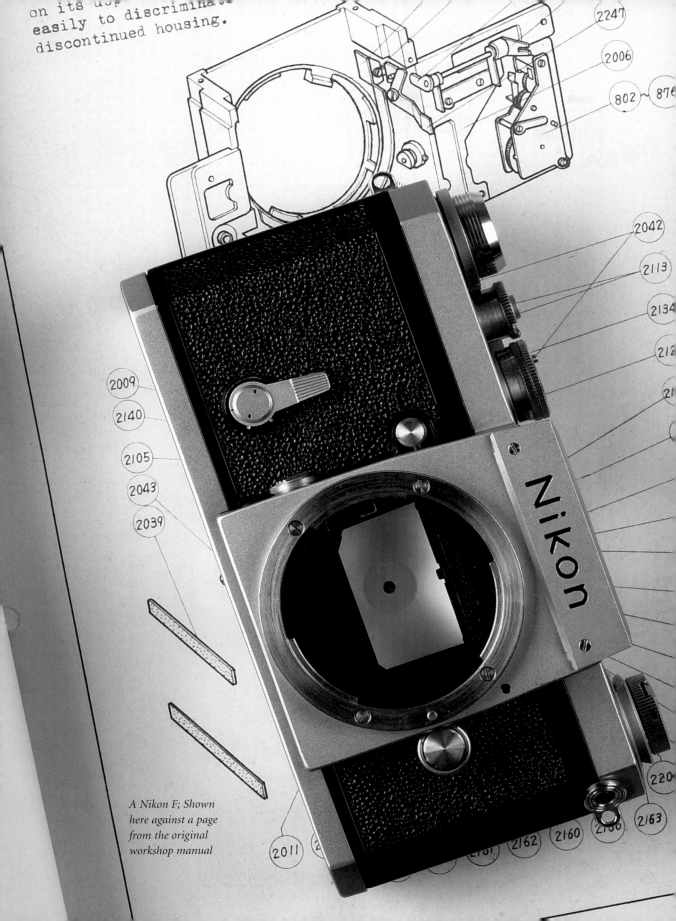

A Nikon F; Shown here against a page from the original workshop manual

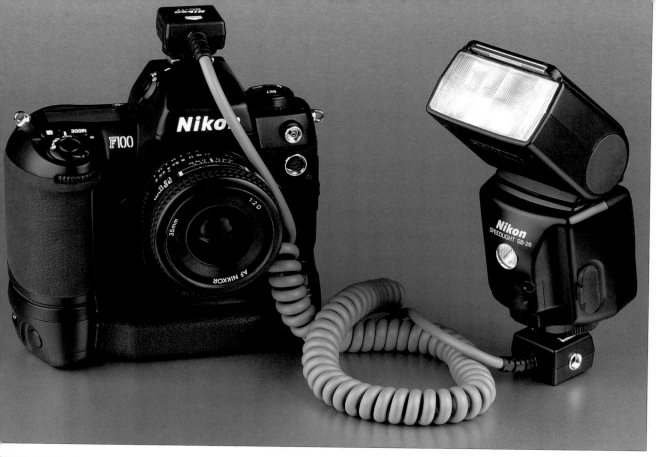

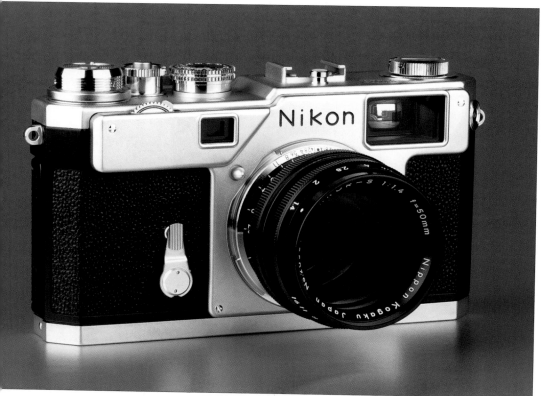

Above:
An F100 with SB-28 Speedlight connected via the SC-17 TTL lead.

Left:
To mark the Millennium year 2000 Nikon introduced a limited edition of its S3 rangefinder. Built with modern materials and techniques it is otherwise identical to the 1958 version.

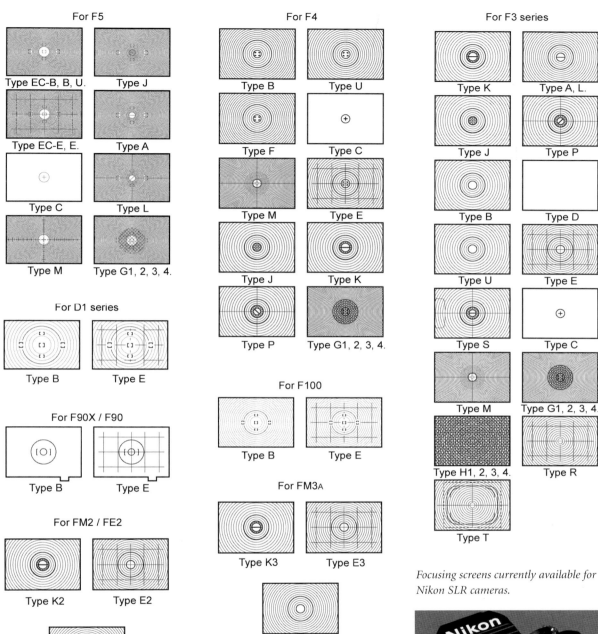

For F5

Type EC-B, B, U. Type J

Type EC-E, E. Type A

Type C Type L

Type M Type G1, 2, 3, 4.

For D1 series

Type B Type E

For F90X / F90

Type B Type E

For FM2 / FE2

Type K2 Type E2

Type B2

For F4

Type B Type U

Type F Type C

Type M Type E

Type J Type K

Type P Type G1, 2, 3, 4.

For F100

Type B Type E

For FM3A

Type K3 Type E3

Type B3

For F3 series

Type K Type A, L.

Type J Type P

Type B Type D

Type U Type E

Type S Type C

Type M Type G1, 2, 3, 4.

Type H1, 2, 3, 4. Type R

Type T

Focusing screens currently available for Nikon SLR cameras.

In cameras with a fixed viewfinder head, such as this FM2N, the focusing screen is changed through the lens throat.

Fresnel lens. The latter enhances overall brightness and prevents darkening of the image at the edges of the screen. The split-image range-finder consists of two prisms arranged at an angle of 20° to the

screen plane, one surface slanted to the left, the other to the right. In the centre they meet exactly at the screen surface. If focusing is not correct, edges within the subject will not coincide in the split-image area. In many cases this screen ensures very precise focusing, but it does

have the drawback that a distinct edge or line within the subject is necessary. A further disadvantage with this type of screen is that used with lenses having a maximum aperture smaller than f/4 often causes one half of the prism to blacken.

Type B: Universal screen available for all Nikon SLR cameras.

This plain matte screen has no other focusing aids and offers a clear unobstructed view of the image. In AF cameras it has a variety of configurations of the AF sensor brackets depending on the model. It is ideal for almost all lenses including long lenses and Micro-Nikkors. There is a special version of the screen, the EC-B type, for the Nikon F5 that has an electro-chromic device that highlights the selected focus area.

Type C: F, F2, F3, F4, and F5.

A special screen with a small cross-hair reticle at its centre; it is designed for extreme magnification applications such as macro-photography or astro-photohraphy when shooting through a telescope.

Type D: F, F2, and F3.

This screen is a relic from the days of the F and F2 cameras and was designed for use with simple long focal length lenses having small maximum aperture. It is no longer necessary following the introduction of long fast lenses, although it can be useful with fisheye types.

Type E: F, F2, F3, F4, F5, FM/FM2, FE/FE2, FM3A, FA, F-501, F801, F90/90X, F100, D1 series.

Similar to the B type screen this one has a grid of lines dividing the screen every 7.5mm. It is ideal for any work when precise alignment of the camera is necessary. It is partic-ularly useful for architectural photography. There is a special version of the screen, the EC-E type, for the Nikon F5 that has an electro-chromic device that highlights the selected focus area.

Type F: F4

Introduced for the F4 series cameras this screen is designed for use with Reflex-Nikkor lenses.

Type G: F, F2, F3, F4, and F5.

A very bright screen; it lacks a matte surface making it impossible to assess the depth-of-field. This is because the only area in which focus can be assessed is the central 12mm micro-prism circle. It is produced in four different versions corresponding to the focal length in use: G1 – for fisheye lenses only, G2 – fixed focal lengths between 24mm and 200mm, G3 – for 300mm to 400mm, and G4 – for long lenses of 600mm or more.

Type H: F, F2, and F3.

Similar to the G type in that you cannot determine the depth-of-field due to the lack of a matte surface this screen has a microprism pattern over the entire screen area. It was intended for sports photography and like the G type was supplied in four versions for different focal lengths.

Type J: F, F2, F3, F4, F5, and FTN/EL.

A screen with a 5mm microprism spot at its centre that provides a clear image only when precise focus is set. It is useful with slower zoom lenses. Nikon cameras were equipped with either the J-screen or the A-type as a standard until the middle of the 1970's.

Type K: A universal screen for non-AF cameras, also available for the F4.

Since the mid-1970s the focusing aids of the A and J type screens have been combined in the K type. A microprism collar is situated around a central split-image rangefinder and surrounded by a very fine Fresnel pattern providing the photographer with three different focusing tools. Over time the brightness of this, and the B and E type screens has been improved. The latest 'Brite-view' versions provide a remarkably clear image. The original "Brite-view' Type-1 screens for the FE and FM2 can be identified by a single solid tongue on one long edge of the screen, later these were improved to become the Type-2 for the FM2N and FE2 cameras and can be identi-fied by a small notch in the tongue, the latest Type-3 screens for the FM3A have their designation etched on the tongue. The Type-2 and Type-3 screens are interchangeable between the FM3A, FM2N and FE2, without any requirement to set any exposure compensation. They can be fitted to a Nikon FE, however, as they provide a brighter image you must set a compensation factor of +1/3EV.

Type L: F, F2, F3, and F5.

Suitable as a standard screen it is similar to the A type except for the fact that the split-image prisms are arranged diagonally instead of hori-zontally. The advantage is that the subject need not necessarily have a vertical edge or line as a focusing point.

Type M: F, F2, F3, F4, and F5.

This exceptionally bright screen has a Fresnel lens with a clear central area and is especially useful for macro-photography beyond repro-duction ratios of 1:1. It is marked with a pair of cross hairs with scales calibrated in millimetres.

Type P: F, F2, F3, and F4.

Resembles the L type screen with a diagonally arranged split-image rangefinder and a single etched vertical and horizontal line to aid alignment of the camera.

Type R: F3.

This screen combines the features of the A type and E type screens and has a split-image rangefinder designed specifically for lenses with maximum apertures of f/3.5 of smaller.

Type S: F, F2, and F3.

Resembles the A type, but has an etched line on the left side outlining the area where data is recorded when the MF-1, MF-11, and MF-17 databacks are used.

Type T: F3

Another screen based on the A type, but with additional lines that define the area corresponding to the aspect ratio of a conventional television screen.

Type U: F3, and F4

Similar to the B type, this screen is designed especially for fixed focal lengths of 135mm and above.

Motor Drives

From the earliest days of 35mm photography photographers wanted a system that transported the film and cocked the shutter in order that they could expose a series of pictures quickly without having to take their eye away from the viewfinder.

In the first half of the 20th century this was done with a strong spring powered clockwork motor that was either built-in or attached to the camera. The various designs were wound like a clock, worked completely mechanically and, depending on the picture format, could transport a dozen of so frames at rates of four frames per second.

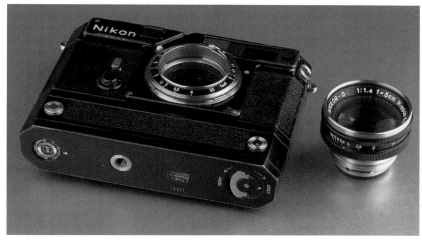

The S-36 motor drive unit can advance film at 3fps. It is seen here attached to an S3 camera.

Obviously a clockwork system has a number of disadvantages including the stress that a strong spring places on the mechanism, its variable performance, and the fact that periodically you must re-tension the spring. In view of this Nikon decided to design and construct a battery powered electric motor driven system. In 1957 a prototype motor drive was introduced for the Nikon S2 rangefinder camera, but it did not go into general production. Later that year a modified version, the S-36, was introduced with the Nikon SP. It was connected to an external battery pack containing six 1.5v AA size cells by a cable and was capable of advancing film through the SP at the then remarkable rate of 3fps.

The S-36 motor drive caused a sensation at the time as the very first battery powered motor drive, and it represents another cornerstone to the reputation of Nikon. Later a slightly modified model, the S-250 with a bulk-film magazine attached for 250 exposures, was made available. Another variant, the S-72, was

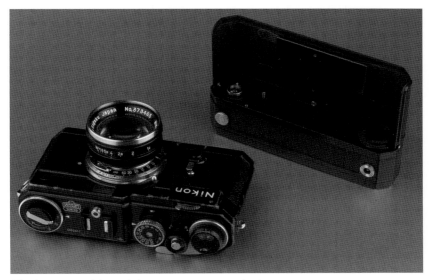

The S-36 motor drive unit incorporates a camera back.

introduced for the S3-M half-frame format camera with which it could achieve a frame rate of 4.5fps.

Nikon F - Motor drives

Based on the S-36, the F-36 was developed for the Nikon F, and even though the two versions may look exactly alike they cannot be interchanged. The F-36 is capable of 4fps when the mirror is locked up, and 3fps when it is operating normally. The firing rate can be set to four frequencies: 2, 2.5, 3, and 4fps, via a dial on the rear panel of the F-36. The release button is located on the back of the motor drive and around it is the dial for the single and continuous advance modes.

An integrated film counter allows a preset number of exposures to be made after which film transport is stopped automatically. At first the power was supplied by an external battery pack, but later a cordless version became available, which could be attached to the motor drive unit. It also provided an additional grip with an integrated shutter release button. The F-36 even has a remote release terminal. This com-

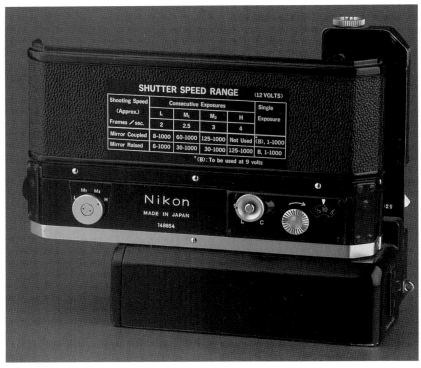

An F-36 motor drive unit attached to the later type battery pack/grip.

bination was the most popular since camera, motor drive, and battery pack make up a compact and easy-to-handle unit. As such the F-36 can be rightly considered as the ancestor of all the Nikon motor drives.

This relay box for the F-36 motor drive unit allows multiple units to be fired simultaneously.

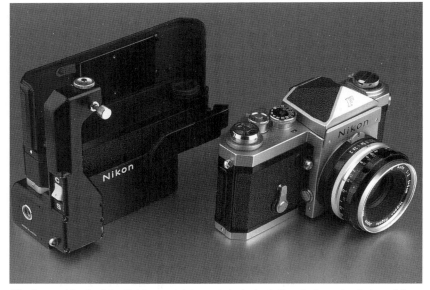

The integral back of the F-36 motor drive unit is derived directly from the design of the S-36 unit for the rangefinder cameras.

One of the unique features of the F-36 motor drive was that each camera/motor drive combination had to be matched by a Nikon service engineer, because the camera base plate had to be drilled to accept the release pin of the F-36. The camera back is an integral part of the motor drive, which is a feature that was utilized when a bulk film magazine, F-250, for 250 exposures was constructed. It could be loaded with 10m of film and was driven by its own motor that provided a performance identical to that of the F-36.

Nikon F2 - Motor drives

The new 'flagship' model that succeeded the classic Nikon F in 1971 was supplied with a completely new motor drive, the MD-1, which was different from the F-36 in several ways. It can be mounted on any F2 without special modification, has an integral grip, and is capable of a maximum firing rate of 5fps with the mirror locked up and 4.3fps with it operating normally. The MD-1 is attached to the camera by removing the camera back Open/Close (O/C) locking catch. This is necessary to allow the spindle for the film rewind to enter the film chamber. The motorized film rewind is a great advantage over the earlier F-36 and can return a 36-exposure film in just seven seconds. There is a small chamber in the grip of the MD-1 to accommodate the O/C key once it has been removed to prevent it being lost.

The MD-1 attaches via the tripod bush in the camera base plate. All the motor's controls are on the back including the film counter, firing rate selector that offers five steps of, 1.3, 2.5, 3.8, 4.3, and 5fps, the power rewind lever, and the lever for opening the camera back.

The firing rate must be selected according to the preset shutter speed, as the completely mechanical system cannot communicate between the camera and motor drive. The release button on the grip has three positions for single, continuous advance, and locked. It can also be removed and used as a remote release via the MC-1 Extension lead. This design was later dropped in favour of an external remote lead terminal. In the MD-1 this terminal has two functions: either for connecting a remote release, or the MC-2 lead for the external MA-4 AC/DC Converter power supply.

The MD-1 is powered by ten AA

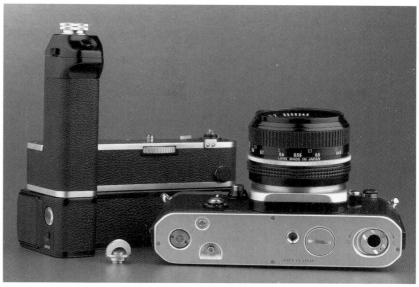

An MD-1 with F2 camera: the O/C key must be removed from the base plate of the F2 to allow access for the drive spindle.

sized batteries housed in the MB-1 battery pack that attaches to the base of the motor drive. For extended shooting periods the MN-1 NiCd batteries can be used, which are recharged with the MH-1 Quick Charger.

The MD-1 was later replaced by a modified version, the MD-2, that has a redesigned release button and a double contact located on the motor's right rear corner that are

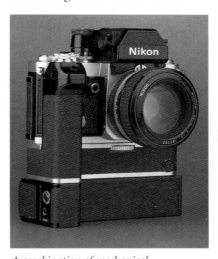

A combination of mechanical masterpieces: the Nikon F2 AS and MD-2 motor drive unit.

used to relay the signal from the MF-3 Auto-Stop back. The MF-3 causes the film rewind to stop at the point when just the film leader remains outside its cassette.

The MD-3 Motor Drive was a less expensive variant that lacked a number of the features included in the MD-2. It has no motorized film rewind, and is only capable of a maximum frame rate of 2.5fps with the MB-2 battery pack, which carries eight AA size batteries. The larger capacity MB-1 pack can be fitted to increase the frame rate to 3.5fps, however, there is no option to vary the speed of advance on the MD-3. It also has a terminal for remote

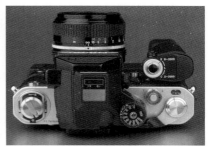

An F2S with MD-3 motor drive unit, which offers a lower specification than the MD-2.

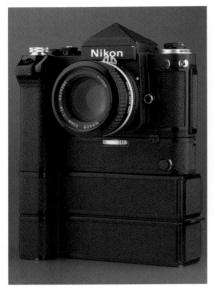

The Nikon F2 High Speed: its 10fps performance is still remarkable even by today's standards.

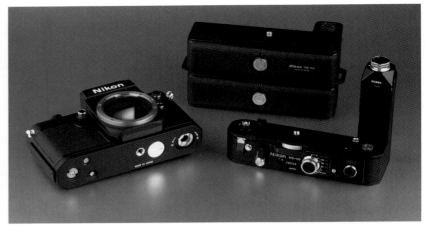

The component parts of the F2 High Speed: F2 H body, MD-100 motor unit, and a double MB-1 battery pack, the MB-100

control and an external power supply. The MF-3 Auto-Stop back cannot be used because the necessary contacts are not present. When the motor is attached the O/C key does not have to be removed from the camera base plate, it is just folded out vertically so that it fits into the corresponding slot in the motor. Care must be taken to ensure the motor drive shaft coupling mates precisely with the camera otherwise the motor may jam after only half of a film transport cycle.

Besides the standard motor drives for the F2 series cameras Nikon produced the MD-100 designed specifically for the F2 H. This special motor drive was matched to the camera body during production to ensure that they both operate with the minimum tolerances to achieve the full frame rate of 10fps. The MD-100 is a modified MD-2 equipped with two MB-1 Battery Packs that deliver 30v to the motor system. Since alkaline batteries would have a very short life in a device that demands so much power it uses four MN-1 NiCd batteries.

Nikon F3 - Motor Drive

In respect of the shutter release mechanism the motor drives for the mechanically controlled Nikon F and F2 models are not linked to the camera's own shutter control system. As a result the camera and motor mechanisms can conflict with each other when an inappropriate shutter speed/firing-rate combination is set.

The MD-4 motor drive introduced for the Nikon F3 is controlled electronically by the camera via six contact pins located around the rewind spindle and it will only transport film at a rate appropriate to the preset shutter speed. It has a maximum frame rate of 6fps when the mirror is locked up and 5.5fps when it operates normally.

The motor drive and battery compartment form a single unit, which takes either 8 AA size cells, or the rechargeable MN-2 NiCd battery. Once attached the MD-4 also pro-

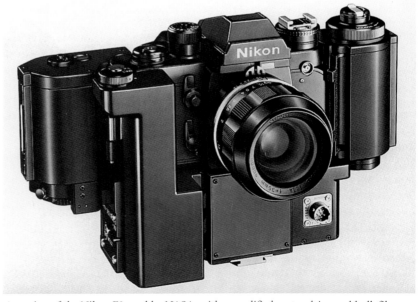

A version of the Nikon F3 used by NASA, with a modified motor drive and bulk film back.

Nikon Separate Motor Drives

Motor Drive	Modes	Firing Rate	Battery Compartment	Battery Holder	Rechargeable Battery	AC/DC converter	Rewind time	Capacity (NO. films) **	Remote lead	Film counter	Weight (g)
F-36	S/C	4/3/2.5/2	External	X	X	MA-2/4	X	15	Y	Y	410
F-36	S/C	4/3/2.5/2	Integral	X	X	MA-2/4	X	20	Y	Y	675
MD-1	S/C	5/4.3/3.8 2.5/1.3	MB-1	MS-1	MN-1	MA-2/4	7	50	MC-10	Y	710
MD-1	S/C	4/3.5/3 2/1	MB-2	MS-2	X	MA-2/4	7	30	MC-10	Y	710
MD-2	S/C	5/4.3/3.8 2.5/1.3	MB-1	MS-1	MN-1	MA-2/4	7	50	MC-10	Y	710
MD-2	S/C	4/3.5/3 2/1	MB-2	MS-2	X	MA-2/4	7	30	MC-10	Y	710
MD-3	S/C	4	MB-1	MS-1	MN-1	MA-2/4	X	100	MC-10	Y	595
MD-3	S/C	2.5	MB-2	MS-2	X	MA-2/4	X	80	MC-10	Y	595
MD-100	S/C	10/7.5/6 3.5/3	MB-100	MS-1	MN-1	X	6	80	MC-10	Y	960
MD-4	S/C	3/2/1*	X	MS-3	MN-2	MA-2/4	4.5/8	140	MC-10/RA/B	Y	480
MD-4H	S/C	13	X	MS-3	MN-2	MA-2/4	X	140	MC-10/RA/B	Y	480
AW-1	S	2	X	X	X	X	X	150	X	X	280
MD-11	S/C	3.5	X	Y	X	X	X	100	MC-10	X	410
MD-12	S/C	3.5	X	Y	X	X	X	100	MC-10/12A	X	410
MD-15	S/C	3.5	X	MS-4	X	X	X	70	MC-12A/B	X	390
MD-E	C	2	X	X	X	X	X	50	X	X	185
MD-14	C	3.2/2	X	MS-4	X	X	X	50	X	X	350

Notes:
*Requires the MK-1 firing rate converter
** Assumes alkaline batteries at 20°C
S - Single
C - Continuous
Y - Yes
X - Not Applicable

vides power to the camera offering a considerably larger capacity and better performance in cold conditions over the two 1.5v button batteries in the camera base plate, which can be removed if required. The electronic communication between the camera and MD-4 allows the motor drive's shutter release button to activate the exposure meter when it is depressed. The MA-4 AC/DC Converter can be connected via a terminal located above the remote release terminal on the front of the unit. A third terminal at the bottom of the finger grip allows connection for the MF-4 Bulk-Film Magazine or simultaneous release a second motorized camera via the MC-17S (0.4m) lead.

The MF-6B Auto-stop back is available for the MD-4 just as with the MD2/MF-3, but the MD-4 has no variable frame rate switch. To control this the optional accessory MK-1 Firing Rate Converter must be attached, which offers reduced film advance rates of 1, 2, or 3fps instead of the full 5.5fps. This unit also has a second release button to improve handling for vertical shots.

Another advantage of the MK-1 is its centrally located tripod bush that is directly below the axis of the lens. The one on the MD-4 is offset due to the design of the battery holder. The AH-3 adapter can be fitted to overcome this.

As a matter of interest the drive spindle of the MD-4 rotates at three times the speed of the MD-2's in order to reduce its noise and the stress on the camera's film transport mechanism. The condition of the batteries is indicated by two LEDs, and when it is attached to the camera the motor drive coupling cover, which must be removed, can be stored in a chamber in the MS-3 battery holder. The F3 and MD-4

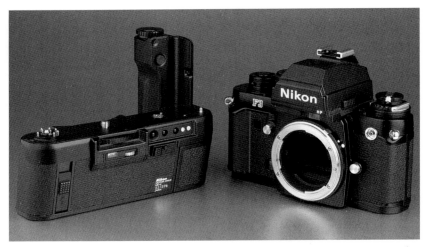

An F3 P camera with MD-4 motor drive unit: the MD-4 communicates via integrated electronics with all the F3 series cameras.

combination was designed to have a very low centre of gravity to improve handling with long fast focal length lenses. The MD-4 was the last standard separate motor drive unit made for a professional Nikon F-series camera, as the F4 and F5 cameras both have internal motors for film transport.

The Nikon F3 High Speed has a modified version of the MD-4, the MD-4H that was only ever produced for this variant of the camera. It shares the same features as the standard MD-4, but can be distinguished by the additional On/Off switch located on the front below the lens axis. This combination can advance film at the incredible rate of 13fps. This is possible because the F3 H has a fixed pellicle mirror so its exposure cycle does not involve the lifting and lowering of a conventional reflex mirror, but just the re-cocking of the shutter.

Nikon F2 - Aperture Control Units

In addition to the film transport units for the F2 camera system Nikon manufactured another motor driven device that was designed to adjust the lens aperture ring. It provided certain models of the F2 with a mechanically operated forerunner to the electronic shutter priority exposure control familiar in modern Nikon cameras. It is only available with the DP2, DP-3, and DP-12 Photomic heads and increases the overall weight of the camera by 500g. Due to their reputation for being rather unreliable these units were generally best used in a controlled environment for predominantly static applications.

The DS Aperture Control units are attached via the PC sync-terminal of the F2 and automatically connect to the two outside contacts of the metering head. It is important to mount the parts in the right order: first the Photomic head, then the DS unit, and finally the lens. The ring via which the DS unit sets the aperture locates around the lens bayonet mount. The unit operates mechanically and its motor has an independent power supply that uses a 3.6V DN-1 rechargeable battery, which must be inserted in either the battery chamber in the lower part of its body, or the external battery compartment DB-1. Alternatively the MA-4 AC/DC Converter can be connected. The DS unit takes about 3 seconds to drive the aperture ring through a full range from f1.2 to f32, which is very slow compared to the electronically operated systems of current Nikon cameras.

Great care must be taken when mounting a lens to ensure a proper coupling to the meter pins of both

The Nikon F3 High Speed can achieve 13fps, which means a 36-exposure film would last approximately three seconds!

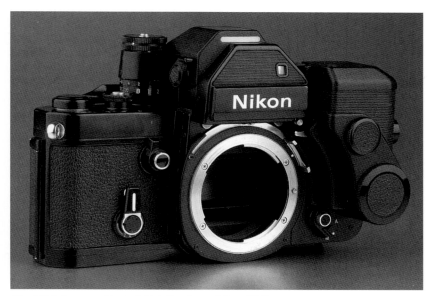

The DS-1 Aperture Control Unit fitted to a Nikon F2 S camera.

Ideal for remote camera applications: the DS-1 Aperture Control Unit.

the camera and the aperture control attachment. Three different versions were made: the DS-1 and DS-2 versions can only be told apart by the latter's additional sync terminal, which is necessary because the PC terminal on the camera is used to secure the DS unit. The DS-12 version was designed for AI type lenses, so it can only be combined with the F2 AS. The first two versions of the DS unit control the lens' aperture ring with the help of a coupling fork. In the case of the AI type lenses the DS-12 uses the AI indexing prong on the aperture ring. In order to mount the lens, or when manual aperture operation is preferred, the attachment motor can be switched

off. Two control modes are available: either set the desired shutter speed and press the On/Off button and the DS unit will set the aperture to match the metered exposure value; or set the On/Off switch to On and the unit will set the appropriate aperture continuously as the exposure value changes. The load placed on the motor is considerable and battery consumption is correspondingly high. In fact, used under normal conditions, the DS units with the NiCd battery fitted will operate for approximately one hour before the battery is exhausted.

However, Nikon never conceived the DS units as an alternative to the manual control of the aperture ring. They were intended, principally to assist in remote-controlled applications, such as time-lapse sequences in scientific and technical photography.

Motor Winder AW 1

Whilst a rapid cycling motor drive may have applications in fast paced news and sports photography a frame rate of 5, or 6fps is not really required by a vast majority of photographers. Automatic film advance

is still important though as the photographer does not have to take their eye from the viewfinder whilst shooting a sequence of pictures, for example in portrait photography when expressions can be fleeting and often missed in a manually wound camera. In these applications motor winders offering single or reduced frame rates of 2, or 3fps are usually more than adequate.

In 1976 Nikon developed the AW-1 winder, which can be combined with two Nikkormat models the ELW and EL-2. It lacks an integrated grip and its only controls are its On/Off switch and a battery check LED. Six AA size batteries supply the power and it is operated via the camera's shutter release button. It does not offer a continuous shooting mode or remote control terminal. Completion of the shutter's operation is communicated electronically to the AW-1 by the camera, which then allows the unit to advance the film and re-cock the shutter. One complete cycle takes approximately 0.5 seconds, which equates to a frame rate of 2fps. Although it is not a true motor drive the AW-1 was the first unit to offer automatic film advance for Nikon cameras outside the professional F-series range.

Motor Drives MD-11, MD-12, and MD-15.

The Nikon FM/FE series cameras, successors to the Nikkormat models, and the later Nikon FA were designed for motorized operation from the outset. The first motor drive model for this series of cameras is the MD-11.

Capable of a maximum frame rate of 3.5fps, with the option of either single or continuous advance, it has a finger-grip with a locking shutter release button on top of it. The unit requires eight AA size batteries that are held in a battery holder, which

fits inside the base section. Following its release many professionals considered equipping themselves with a pair of Nikon FM cameras and MD-11's in place of a singe F2 and MD-2 combination.

Four contacts convey the electronic signals between the motor and the body: two carry the signal which starts the film transport after the shutter operation, while the other two activate the metering system when the motor is switched on. A terminal for remote control accessories is located on the front at the bottom of the ergonomically rounded grip, but there is no facility to attach an external power supply.

The MD-11 was later succeeded by the MD-12 and although both models appear to be identical on the outside there are two important differences. Unlike the MD-11, which continues to supply power to the camera's metering system until it is switched off the MD-12 shuts off the power supply automatically about 60 seconds after the last shutter release. This is an important feature since many photographers would forget to switch off their MD-11 units causing its batteries and those of the camera to drain unnecessarily. The second difference is in the control circuitry. The MD-11 only transports the film in the single advance mode after the photographer's finger is removed from

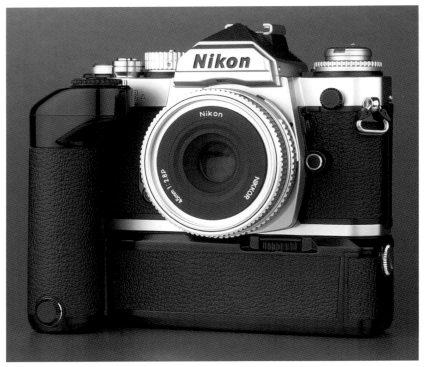

A classic combination: the Nikon FM3A with MD-12 motor drive.

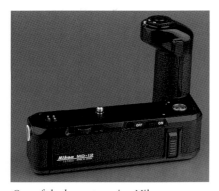

One of the longest serving Nikon accessories: the Nikon MD-12 motor drive.

the release button. The MD-12 advances the film immediately after the shutter operation has finished.

The third unit in this class of motor drives was introduced for the Nikon FA camera and is easily distinguished by its angular shaped grip. Unlike the mechanical release of the MD-11 and MD-12 in which a pin is driven upwards into the camera's base the release in the FA / MD-15 combination is electronic. The MD-15 also supplies the camera with power making the camera's batteries redundant. Although the MD-11/MD-12 motors can be fitted to the FA, when the maximum frame rate is reduced to 2.7fps, the MD-15 will not work with the FM or FE series cameras.

The MD-15 is long discontinued but the MD-12 remains in production to complement the latest FM3A camera with which it is fully compatible: it offers an identical performance to that of an FM2/FE2 and MD-12 combination.

Motor Drives for the EM, FG, and FG-20

The MD-E motor winder was produced for the Nikon EM. It weighs a mere 185g and has a continuous advance mode at 2fps. The MD-E has a narrow finger grip that fits against the front of the camera body but it lacks a separate shutter release button. It can be used with the FG and FG-20 cameras, even though another motor drive, the MD-14, was introduced for the FG. The MD-14 is capable of cycling all three types in this series of cameras at a rate of 3.2fps, which equals the performance of the MD-11, 12, and 15 models. The higher performance has to be paid for in terms of weight, which is twice that of the MD-E. Like the MD-E the finger grip lacks a release button, and the unit has no terminal for remote control accessories.

Motor Drive Accessories

The various motor drive units for

Camera / Motor Drive combination and frame rates (fps)

Camera	F-36	F-250	MD-1	MD-2	MD-3	MD-4	MD-11	MD-12	MD-15	MD-100	MD-4H	AW-1	MD-14	MD-E
F	4	4	x	x	x	x	x	x	x	x	x	x	x	x
F2	x	x	4-5	4-5	2.5-4	x	x	x	x	x	x	x	x	x
F3	x	x	x	x	x	3.8-6	x	x	x	x	x	x	x	x
ELW/EL-2	x	x	x	x	x	x	x	x	x	x	x	0.5	x	x
FM/FE	x	x	x	x	x	x	3.5	3.5	x	x	x	x	x	x
FM2/FE2	x	x	x	x	x	x	3.5	3.5	x	x	x	x	x	x
FA	x	x	x	x	x	x	2.7	2.7	3.2	x	x	x	x	x
EM	x	x	x	x	x	x	x	x	x	x	x	x	3.2	2
FG-20	x	x	x	x	x	x	x	x	x	x	x	x	3.2	2
FG	x	x	x	x	x	x	x	x	x	x	x	x	3.2	1.5
F2 H	x	x	x	x	x	x	x	x	x	10	x	x	x	x
F3 H	x	x	x	x	x	x	x	x	x	x	13	x	x	x

the F and F2 cameras and their corresponding power supplies are separate units. In later motor drive models such as the MD-12 and MD-4 they were combined in one unit. In the F4, and the AF cameras that followed it, the motors for film advance were incorporated in the camera body. Some models have additional battery packs that can be attached to enhance the performance and handling of the camera.

Battery and Power Packs

The F-36 for the Nikon F can be powered by either an external or a cordless attachable battery pack with an integrated grip section. The 15V MB-1 battery pack and the 12V MB-2 units can be fitted to the motor drives for the F2 series cameras. The more powerful MB-1 can be loaded with two rechargeable MN-1 NiCd batteries of 7.5V each, which require the MH-1 Quick Charger. For working in extremely low temperatures these battery packs can be kept in the MA-3 Battery Pack Jacket and connected to the motor drive unit by a lead. The MD-4 motor drive can be powered with the MN-2A NiCd batter-

ies, and these can be recharged with the MH-2. Nikon also produced the MA-4 AC/DC Converter for static operation of the F2, F3 and F4E models. It supplies the camera with a steady 15 volts and possesses an additional terminal for the DS-type aperture control attachments.

In the case of the F4 the photographer has the choice of four different power supply sources. The battery grip MB-20 with its four AA-size cells is supplied as standard. The F4S is equipped with the two-piece MB-21 battery compartment that takes six AA size batteries or rechargeable cells of the same size.

Unlike the MB-20, it has an additional remote control terminal and a second release button for vertical shots. The third unit, MB-22, serves as a terminal for external power sources such as the MA-4 AC/DC Converter and possesses an additional socket for the magazine back MF-24. The MB-23 battery pack has a one-piece body and was designed for professional applications. It converts a standard F4 into the F4E and can accept the high-power rechargeable MN-20 NiCd battery, two of which can be charged simultaneously with the MH-20 charger unit.

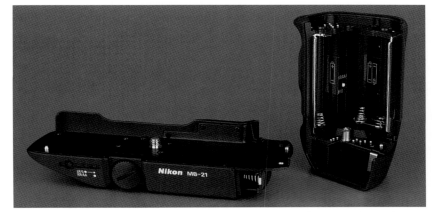

The MB-21 battery pack converts the standard Nikon F4 into the F4S, and provides a 10-pin remote socket and second shutter release.

Nikon Integral Motor Drives

Motor Drive	Modes	Firing Rate	Battery Compartment	Battery Holder	Rechargeable Battery	AC/DC converter	Rewind time (seconds)***	Remote lead
F-301	S/C	2.5	MB-3/4	X	X	X	X	MC-12A
F-401	S	X	X	X	X	X	25	X
F-501	S/C	2.5	MB-3/4	X	X	X	X	MC-12A
F-601/M	S/CL/CH	2/1.2	X	X	X	X	26	AR-3
F801/s	S/CL/CH	3.3/2	X	MS-7	X	X	15	MC-12A
F50	S/C	1	X	X	X	X	18	X
F55	S/C	1.5	X	X	X	X	16	X
F60	S/C	1	X	X	X	X	17	X
F65	S/C	2.5	MB-17	X	X	X	16	X
F70	S/CL/CH	3.7/2	X	X	X	X	15	MC12A
F80	S/C	2.5	MB-16	X	X	X	15	AR-3
F90	S/CL/CH	3.6/2	X	MS-8	X	X	12	MC-30
F90X	S/CL/CH	4.3/2	MB-10	MS-10/11	X	X	8	MC-30
F100*	S/C/CS	5/4.5	MB-15	MS-12/15	MN-15	X	9	MC-30
F4	S/CL//CH/CS	4/3.3/0.8	MB-20	X	X	X	8	AR-3
F4s	S/CL//CH/CS	5.7/3.4/1	MB-21	X	X	X	8	MC-12A
F4E	S/CL//CH/CS	5.7/3.4/1	MB-23	MS-23	MN-20	MA-4	8	MC-12A
F5**	S/CL//CH/CS	8/7.4/3/1	X	MS-30	MN-30	X	6/4	MC-30

Notes:
- * Fastest rate requires the MB-15 battery pack
- ** Fastest rate requires the MN-30 battery
- *** Assumes alkaline batteries at 20°C
- S - Single
- C - Continuous
- CL - Continuous low
- CH - Continuous high
- CS - Continuous silent

The F4 becomes the F4E when fitted with the MB-23 battery pack.

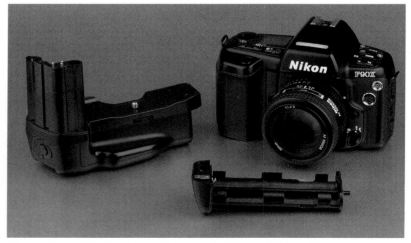

The handling of the F90X, is much improved with the addition of the MB-10 battery pack.

The F5 with its fixed battery compartment can be powered by the rechargeable MN-30 NiMH battery pack; it requires the MH-30 charger that can charge two MN-30 simultaneously. Alternatively it can be connected to any 12v DC supply, via the MC-32 lead.

Other Nikon cameras beginning with the F90 can also benefit from the attachment of a dedicated battery pack. The F90/90X can be fitted with the MB-10 Multi-power vertical grip. It accepts four AA size batteries or two CR-123A lithium cells in the MS-11 battery holder. The unit provides an additional shutter release for vertical shooting. It should be noted that whilst it can be attached to the original F90 camera model the vertical shutter release does not work.

The Nikon F80 can have the MB-16 battery pack attached via the camera's tripod bush. It accepts four AA sized batteries, improves the overall handling of the camera, but does not provide an additional shutter release button. Likewise the F65 can be fitted with the MB-17 battery pack that also accepts four of the popular AA size battery. The F75 camera has a similar accessory, the MB-18 battery pack, which offers an

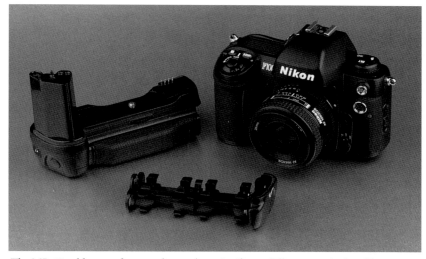

The MB-15 adds extra features that make a significant difference to the handling performance of the F100.

improvement in handling of the camera, not only because it provides a more stable grip, but also because it has a second shutter release for vertical shooting. It should be noted that the MB-10, MB-16, MB-17, and MB-18 do not increase the frame rate of their respective cameras. They can all accept Lithium, NiCd, or NiMH type batteries as an alternative source of power to increase the duration of camera operation, which makes them very worthwhile accessories.

The MB-15 for the F100 camera is different as it lifts the frame rate to 5fps when attached to the camera. It accepts six AA size batteries, or the MN-15 NiMH battery pack that requires the MH-15 battery charger, which can charge two batteries simultaneously. The MB-15 is a very useful accessory as it also provides a second shutter release and a second command dial to adjust shutter speeds when shooting in the vertical format. This latter feature is not available on any other Nikon film camera, including the F5, but has since been adopted on the D1 series and MB-D100 for the D100 digital SLR cameras.

The introduction of the Nikon D1 series cameras has brought about a restriction in the variety of battery types available to power them. The only battery option is the EN-4 NiMH battery pack, which is recharged with either the MH-16 Quick Charger, or new MH-19 Multi-Charger (see table below). The MH-16 can only charge one battery at a time, but as an alternative you can use the MH-15 charger for the F100 to charge two EN-4s simultaneously, or use the MH-17 12v DC charger that fits a standard vehicle 12v auxiliary power socket.

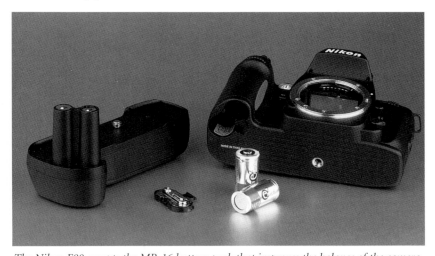

The Nikon F80 accepts the MB-16 battery pack that improves the balance of the camera, but does not increase its frame rate, or provide a second shutter release.

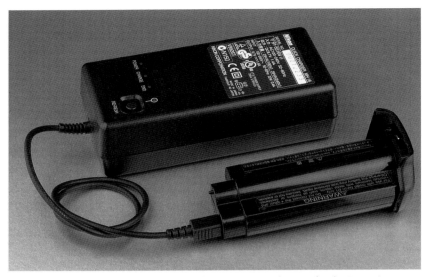

The MH-16 charger unit is dedicated to the EN-4 NiHM battery for the D1 series cameras.

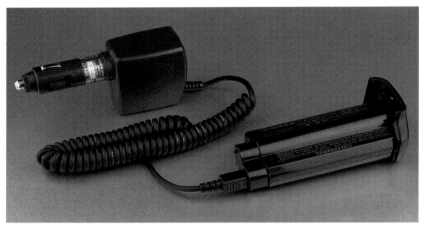

The MH-17 allows an EN-4 battery to be recharged from a 12V DC supply, such as a vehicle, but it has no refresh function.

The D1 cameras can also be powered from a mains AC supply via the EH-4 adapter.

The D100 camera is a little more flexible as in addition to its standard Lithium-Ion (Li-ion) EN-EL3 battery pack it can be fitted with the optional MB-D100 that accepts six AA size batteries as well as one or two EN-EL3 cells for extended shooting. The MB-D100 provides a second shutter release, command, and sub-command dials for vertical shooting, an AF start button, 10 pin remote accessory terminal, and a voice memo recording/playback function.

Using two EN-EL3 batteries, which give a very impressive performance, the D100 is powered for a considerable amount of shooting (Nikon claim up to 1600 exposures under optimum test conditions). The option of using six AA cells is very useful, because you may not always be in a position to recharge the EN-EL3 when you need to, although they should only be considered as a back-stop solution as they will exhaust quite quickly, espe-

cially if you use the colour LCD screen frequently for picture review. Addition of the pack makes no difference to the cyclic rate of the D100, but it certainly improves the general handling of the camera, because it not only provides extra surface area for a good solid grip, but also has two dials that replicate the functions of the main an sub command dials, and a shutter release button for vertical shooting. It also has a button with which to lock the AF (auto focus) and AE (auto exposure) functions, plus select the AF sensor area. All of these controls are locked by the action of a single sliding switch to prevent accidental operation when the camera is held horizontally. The MB-D100 increases the camera's overall weight by 210g (excluding batteries) and raises its height profile by approximately 42mm.

Attachment of this accessory activates two extra Custom Settings (CS). The first is CS-25, which works in conjunction with CS-14 two allow the user to select a range of operations that can be assigned to the AF-L/AE-L – Focus Area Selector Button on the pack. I believe the most useful combination is the default setting, which causes this button to lock the AF and AE when pressed alone, and the focus area to be changed by pressing the button and turning the sub-command dial at the same time.

The second is CS-26 that is used to adjust the playback volume of the voice memo function of the MB-D100 pack. This feature permits you to add a recording of between one to twenty seconds duration to each image by simply pressing the Voice Memo record/playback button and speaking into the built-in microphone mounted next to it. The recording is saved in the popular WAV file format for digital sound developed by Microsoft and used by

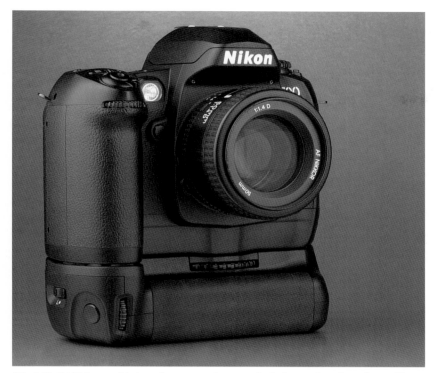

The MB-D100 is a sophisticated accessory that even includes a microphone for making voice recordings.

enough time to record what I needed, and for this sort of duration the audio files averaged between 50 to 100 Kilobytes in size. Obviously the more recordings you make the more space they take up on the camera's storage media. How times have changed from the days of the S-36 and F-36 motor drives!

To fit the MB-D100 you must remove the battery compartment door and a rubber grommet from the base of the D100. These can be stowed within the MB-D100 for safekeeping. Once fitted to the camera I have found there is an amount of play between the multi-function pack and camera, around the base of the right hand finger grip, because the electrical contacts on the MB-D100, which enter into the battery compartment, do not seat particularly well. This is just an unfortunate element of the design and does not signify a fault with the equipment.

Nikon have received criticism for the diverse range of battery types used in their film and digital cameras, which require photographers to carry a range of different charger units. So they have introduced, at a price, the MH-19 Multi-Charger. It can charge two EN-EL3 batteries, one after the other, from either a mains AC output, or a 12V DC supply. By adding the MC-E1 the MH-19 can charge an MN-30 battery for the F5, and the MC-E2 allows you to charge either the MN-15 for the F100, or the EN-4 for the D1 series.

many applications. These audio files are assigned the same reference number by the D100 as the image file to which they relate, but carry the extension .wav. As the D100 automatically records all the shooting data within the image file this

obviates the need to record this again in an audio form, and leaves you with ample scope to note all the relevant caption information about you subject by using the voice memo feature. Generally, I have found 5 to 10 seconds is more than

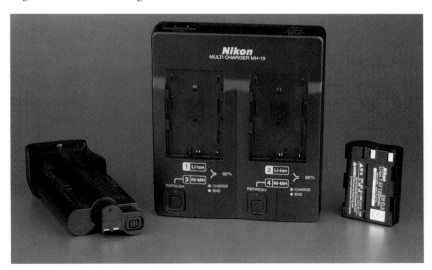

Nikon's range of dedicated chargers for film and digital cameras has expanded considerably. The MH-19 is an attempt to consolidate their function into a single unit.

The NiMH technology of the D1's EN-4 (left) has given way to Lithium-Ion type batteries such as the EN-EL3 for the D100.

Batteries for Nikon Digital Cameras

The Nikon EN-4 NiMH Battery
The Nikon EN-4 7.2V 2000mAh NiMH battery is used exclusively for the Nikon D1 series cameras.

In my experience it is essential that the EN-4 be pre-conditioned before first use, as this will enhance their performance significantly. Rather than giving a brand new battery straight out of the box a single full charge cycle, as recommended by Nikon, before first use, I put a new EN-4 battery through three consecutive full refresh cycles using Nikon's dedicated MH-16, or MH-19 multi-battery type, charging unit. These combined refresh cycles ensure the battery is fully discharged to complete exhaustion. The battery should then receive a full charge. In my experience an EN-4 pre-conditioned in this way exhibits an increase in its shooting capacity by approximately 30% compared with non pre-conditioned batteries that I have used.

Tips on using the EN-4
• Always pre-condition a new battery.
• Always connect power to the charger before connecting the battery.
• Never take a warm battery from the camera and place it in the charger.
• Always allow a battery to cool before each refresh or charge cycle.
• Always allow the battery to cool before removing from the charger.
• Never press the refresh button on the charger during a charge cycle.
• Refresh the battery once for every ten complete charge cycles.
• Recharge a battery that has been idle for over four weeks.

The Nikon EN-EL1 and EN-EL3 Lithium-ion Batteries
The Nikon EN-EL1 (7.4V - 680mAh) battery is used for most of the current Coolpix cameras, including the Coolpix 5000 and Coolpix 5700. The EN-EL3 (7.4V - 1400mAh) battery is used exclusively for the D100 camera.

A new, out of the box, an EN-EL1 or EN-EL3 battery will hold approximately an 80% capacity charge. It is important that before first use they are fully charged. After the charger indicates that the charging process has finished leave it switched on, and allow the battery to cool whilst still attached to it. This will ensure the battery is fully charged. Although the EN-EL1 and EN-EL3 do not suffer the charge memory problem of the EN-4 it is advisable to allow them to completely discharge/charge three times before you attempt to give a partially discharged battery a 'top-up' charge.

Tips on using the EN-EL1 and EN-EL3
• Always completely charge a new battery.
• Always connect power to the charger before connecting the battery.
• Never take a warm battery from the camera and place it in the charger.
• Always allow a battery to cool before each refresh or charge cycle.
• Always allow the battery to cool before removing from the charger.
• Fully charged, idle batteries should show little power loss over 4-6 weeks.

Remote Control Devices
Over the years Nikon have produced a wide variety of remote control accessories for motorized cameras. The principle models are described below.

The MC-10 remote lead has a straight plug and no lock on the release button.

The MC-12A remote lead has a 90° plug and a lockable release button.

Remote Leads

MC-10: A 3m-long lead with a two-pin connection designed for the MD-2/3/4/11 and 12 motor drives. It has a simple single stage switch to activate the shutter release.

MC-12A: A 3m-long lead with a two-pin connection designed for the MD-12, MD-15 and MD-4 motor drives and the Nikon F4s, F70, 801/s, 501, and 301 cameras. Its contoured handgrip has a two-stage switch, which activates the exposure meter when pressed halfway, and a locking button to keep the camera switched on for time exposures, or the focus-lock function in appropriate models.

MC-12B: A 0.8m-long lead with a two-pin connection designed for the

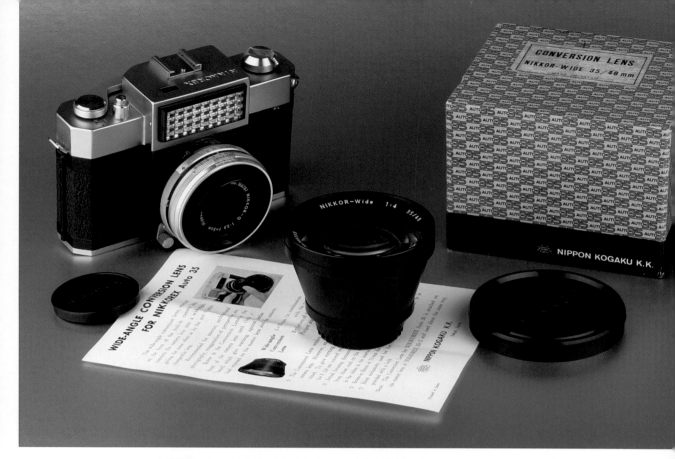

Above:
Introduced during
1960 the Nikkorex
Auto35 has a fixed
Nikkor 50mm
f/2.5 lens, which
accepts a wide-
angle adapter, seen
here, to provide an
effective focal
length of 35mm.

Right:
The Nikkorex F
offers
interchangeable
lenses and was the
first Nikon camera
to use metal blades
in a focal plane
shutter.

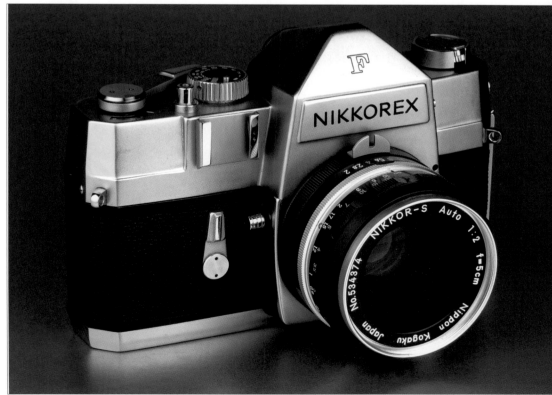

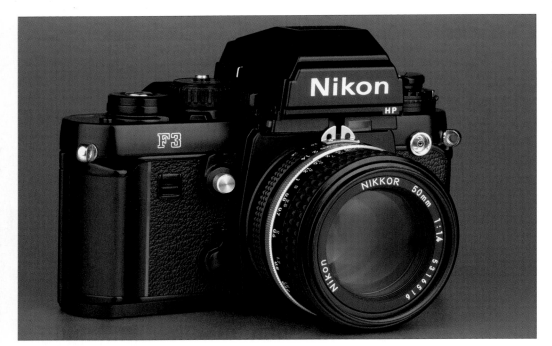

The first camera to offer a high eye-point viewfinder the Nikon F3 HP.

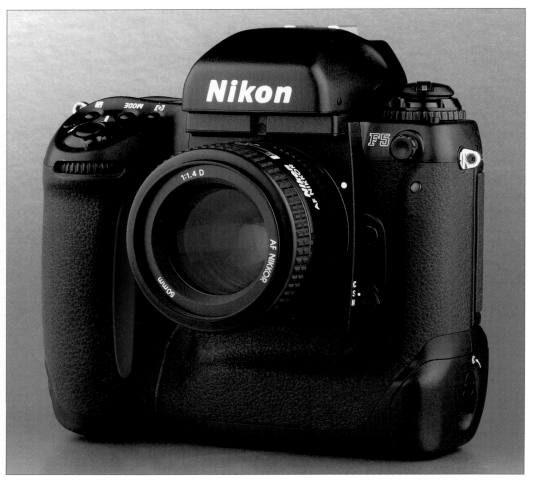

As an increasing number of professional photographers switch to digital capture it is likely that the Nikon F5 will be the last model in the series of professional F film cameras.

Optimising Battery Performance in Nikon Digital Cameras

Given the total dependence of Nikon's digital cameras on electrical power I have listed a few points you may wish to consider in helping to maintain the performance, and extend the life of these batteries.

- Use of the colour LCD will increase power consumption by about 50%.
- Driving AF lenses does not contribute significantly to battery power drain.
- Use of Vibration Reduction (VR) will increase power consumption.
- Consider reducing the auto meter-off delay to reduce consumption.
- Power consumption (idle): Microdrive about 65mA, CF about 0.2mA.
- Power consumption (active): Microdrive about 300mA, CF about 60mA.
- Never remove a battery whilst a camera buffer still holds images.
- Do not use rechargeable NiMH batteries in battery packs (e.g. MB-D100).
- In low temperatures alternate between two batteries, periodically allowing one to warm up inside your clothing, before swapping it over.

Note: CF – Compact Flash Microdrive – IBM Microdrive

Charger / Battery compatibility

	MN-2 (for F3)	MN-20 (for F4)	MN-30 (for F5)	MN-15 (for F100)	EN-4 (for D1)	EN-EL3 (for D100)
MH-2A	Y (60)	X	X	X	X	X
MH-20	X	Y (90)	X	X	X	X
MH-30	X	X	Y (100)	X	X	X
MH-15	X	X	X	Y (70)	Y (110)	X
MH-16	X	X	X	X	Y (90)	X
MH-17	X	X	X	Y (110)	Y (160)	X
MH-18	X	X	X	X	X	Y (120)
MH-19	X	X	Y* (95)	Y* (65)	Y* (110)	Y (120)

Y – Compatible (approx. charging time – min.)

X – Not compatible

* - Use the MC-E1 lead to charge or refresh the MN-30, and the MC-E2 for the MN-15 and EN-4.

MD-15 and MD-4 motor drives and the Nikon F4s, F70, 801/s, 501, and 301 cameras. Its contoured handgrip has a two-stage switch, which activates the exposure meter when pressed halfway, and a locking button to keep the camera switched on for time exposures, or the focus-lock function. If used with the MD-12 the unit's auto power-off does not work.

MC-4A: A 1m-long lead with a two-pin connection designed for the MD-1/2/3/4/11/12, and 15 motor drives and the Nikon F4s, F70, 801/s, 501, and 301 cameras. It has banana-type plugs for connection to custom-made release mechanisms, for example with several cameras or with automatic triggering devices. The camera is released by completing the circuit between the two pins.

MR-3: A release button that screws into the two-pin remote terminal of the MD-11/12/ and 15 to provide a vertical release button. Alternatively it allows the use of the AR-3 standard ISO cable release with all Nikon cameras and motor drives that have the two-pin remote terminal.

AH-3: An adaptor plate that attaches to the base of cameras and motor drive units, which places the tripod thread directly beneath the lens axis. In many cases cameras such as the F-501/301, and motor drives such as the MD-4 and MD-12, have an asymmetrical tripod bush, which can be a problem in alignment and balance of the camera.

Following the introduction of the Nikon F90 camera, and for all subsequent AF cameras, Nikon have produced a set of ten-pin remote accessories, as well two adaptors, to ensure compatibility between these and earlier two-pin devices.

MC-20: A 0.8m lead with handgrip, fitted with an illuminated LCD of its own that allows remote setting of long exposures.

MC21: A 3m long extension lead, with a male and female socket, for the ten-pin accessories.

The earlier Nikon cameras, like this F70, have a 2-pin terminal for remote release accessories.

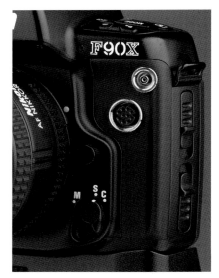

On later models, beginning with the F90 / F90X cameras, a 10-pin remote terminal was introduced.

MC-22: A 1m long equivalent of the MC-4a, it offers connection to purpose built triggering devices via its three separate single pin banana plugs.

MC-23: A 0.4m long leads connects two ten-pin cameras for near simultaneous shutter release.

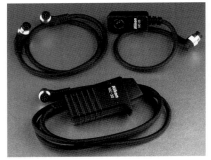

The new 10-pin remote accessory releases and connectors include: the MC-30 (front), MC-23 (back left), and the MC25.

MC-25: A 0.2m long lead that permits the use of an earlier two-pin remote control accessory with ten-pin terminal cameras.

MC-26: A 0.2m long lead that works the other way round from the MC-25 connecting the newer 10-pin equipment with older two-pin equipped cameras and accessories.

MC-30: A 0.8m long lead similar to the MC-12A that provides a simple two-stage release switch that activates the camera meter when half pressed, and can be locked to keep the power supply to a camera switched on over protracted periods.

Besides the hard wire options Nikon has offered a range of wireless remote release methods. The two-channel ML-1 Remote Control Set works with a modulated light output signal that has a maximum range of 60m. By using a light rather than a radio signal there is no requirement to observe the regulations of any relevant radio licensing authority.

The ML-1 system consists of a receiver that can be mounted in the accessory shoe and is connected to the camera's remote control terminal, and a transmitter. Single as well as continuous modes are possible. It was replaced in 1990 by the ML-2

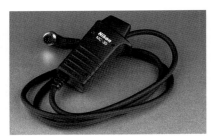

The MC-30 remote lead replicates the function of the MC-12A, but uses a 10-pin plug.

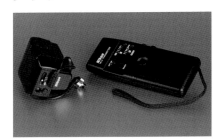

The ML-2 IR remote release: the transmitter (left) and the receiver unit have a range of up to 100m.

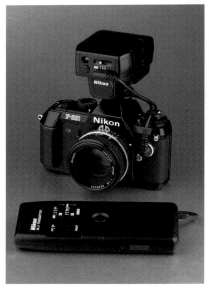

A Nikon F-301 camera fitted with the ML-2 receiver unit with the transmitter in the foreground.

set, which operates with an infrared signal and has a range up to 100m. It offers three instead of the ML-1's two channels. The ML-3 set was introduced with the F90 in 1992. It includes a feature many photogra-

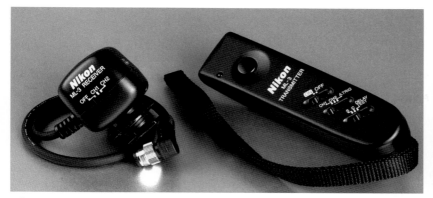

The ML-3 IR remote release: the transmitter (right) and the receiver unit have a range of up to 8m.

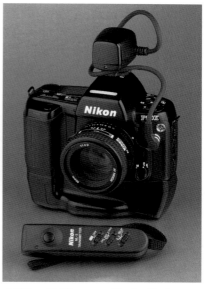

A Nikon F90X camera fitted with the ML-3 receiver unit with the transmitter in the foreground.

phers had asked for: an auto triggering system. This functions when a subject breaks a continuous beam of infrared light, which is transmitted between the two components of the system. Both the transmitter and receiver units are considerably smaller than the ML-2 units because two AAA size batteries power the receiver and the transmitter draws power directly from the camera via the ten-pin terminal. The ML-3 has a maximum operating range of just 8m, however the transmitter from the ML-2 set can be used with the ML-3 receiver to increase the operating range to 100m.

The MW-1/2 Radio Control Set,

which is no longer made by Nikon, is not permitted in some countries. Depending on the weather conditions and the line of sight this unit can cover a distance between 150 and 700m and control up to three cameras individually or simultaneously.

Before the advent of electronic multi-function backs, interval or time-lapse photography was only possible with the MT-1 and MT-2 control units. Intervals between 0.5 seconds and 27 hours can be set with them, and depending on the length of each exposure the duration of the release signal can be set between 6 seconds and 30 minutes.

Camera Backs

Until the introduction of digital technology that allows captured images to be transmitted directly to a computer for storage there were certain situations in which the normal 36 exposures allowed by a 35mm film were insufficient, for example in scientific or law enforcement applications. One of the first cameras to be equipped with a bulk

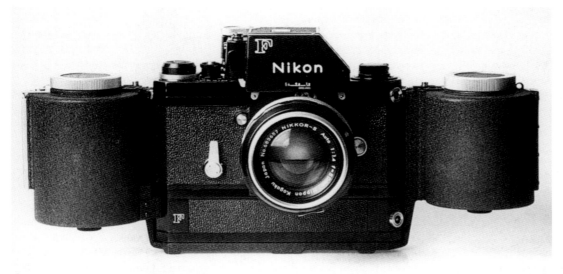

The first multi-exposure film back to be combined with a motor drive unit: the F-250 for the Nikon F camera.

The MF-2, developed for the F2 series, can hold a 30m length of film to provide approximately 750 exposures.

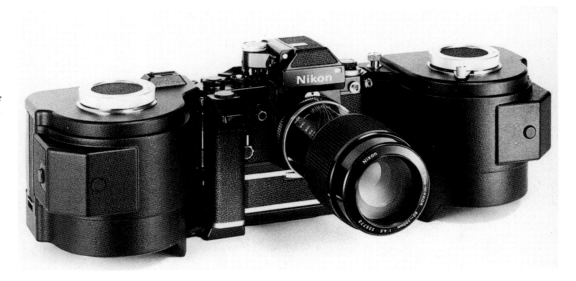

film magazine was the Leica Reporter, which appeared in 1934, and was capable of 250 exposures. It had special cassettes, holding up to 10 metres of film, which had to be loaded by the user. The bulk film backs for the variants of the F, F2, F3, and F4 cameras produced by Nikon, work on the same principle.

Bulk Film Camera Backs

Nikon responded to requests for such equipment in the very early days of the Nikon F camera by producing dedicated F-36 motor drive and F-250 bulk film back capable of 250 exposures. For the later F2 series cameras this led to the development of the MF-1 Bulk Film Back. Either the MD-1 or MD-2 motor drive must be attached to advance the film, which is held in the special MZ-1 cassettes. Nikon offered a special bulk film loader for the MZ-1. The MF-2 was also available for the F2: it has a capacity of 750 exposures from a 30m long film roll. In order to remove exposed sections of film it has a built-in film cutter.

The MF-4 bulk film back was available for the F3 camera and provided a capacity of 250 exposures. The MF-24 unit for the F4 camera, which combines a 250 exposure

Nikon Bulk Film Backs

Model	Camera	Capacity (frames)	Firing Rate (fps)	Dimensions (mm)	Weight (g)	Remarks
F-250	F	250	4	303x108x67	1260	Built-in motor drive
MF-1	F2	250	5	302x127x73	1250	
MF-2	F2	750	3.7	425x144x129	4200	
MF-4	F3	250	6	303x98x84	1100	
MF-24	F4	250	5.7	303x89x91	1400	Integrated databack

back with a multi-function back, followed this. The film is still held in the MZ-1 cassettes. The multi-function back provides a variety of camera control modes and data imprinting on the film.

Data Backs

The F2 Data, a special model within the F2-series, was the first Nikon that enabled the photographer to imprint the date, the time, and additional information onto the film. A tiny flash unit lights up the date display as well as the analogue clock, and a small mirror reflects this data into the picture frame. Small memo plates allow written information to

be imprinted. This MF-10 databack unit was also available as an integral part of a bulk film back, which converted the unit into the MF-11. The corresponding model for the F3 is called MF-17, and for the F4 it is the MF-24 as described above.

These are quite large and heavy units, but the standard databacks the first of which was the MF-12 introduced in 1981 for the FM/FE cameras are only a few millimetres thicker than the normal camera back. The imprinting is effected by an array of small LEDs situated in the pressure plate, which expose the film from behind over an area 7mm wide and 0.5mm high. In order to

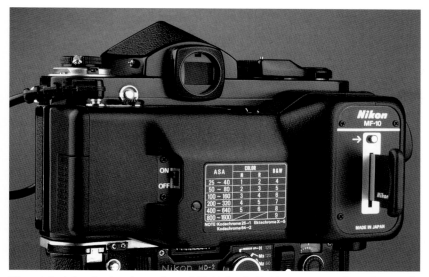

The original data back – the analogue MF-10 for the F2 Data camera. Shown here with the memo plate partially inserted. The flash sync cord can be seen on the extreme left.

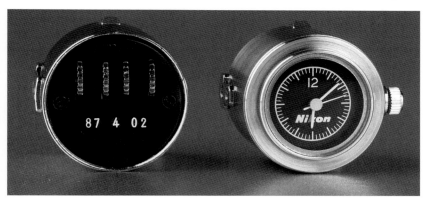

The counter/date unit and analogue clock units from the MF-10, from an age before the digital revolution!

allows a sequential four-digit number to be imprinted in addition to the time/day/date information. Its integrated clock can serve as an alarm clock if required. Similar databacks were also available in the form of the MF-15 for the Nikon FG and the MF-16 for the FM-2, FE2, and FA models. In fact the MF-16 is still in production for the FM3A camera. The MF-18 for the F3 offers an additional function: although it is equipped with the same basic features and options as the MF14, it imprints the data between the frames. Since this requires very precise transport of the film this back can only be used with the MD-4 motor drive. The MF-18 also replicates the function of the MF-3 Auto-Stop back for motorized film rewind. The MF-18 was followed by the MF-20 for the F-801/801s cameras, which imprints the familiar range of time/day/date information.

The MF-22 back for the F4 can be used with a wider range of film speeds from ISO32 to 3200, and uses a single CR2025 3V Lithium battery for power. It imprints the usual time/day/date information, but does not have an integrated alarm clock function. The MF-25 back for the F90X camera has a similar specification to the MF-22 with the addition of a list of different cities in various time zones around

ensure the synchronization of the shutter with the data imprinting the cord from the MF-12 back has to be connected to the camera's PC sync-terminal. Either year/month/day, or day/hour/minute, or a two-digit number can be imprinted in the picture. Two 1.5V button batteries of the same type used in the camera provide the power. The sensitivity of the film in use must be preset within the range of ISO25 to 400 with the small dial to ensure the correct level of illumination for the imprinting.

Nikon's next databack, the MF-14 for the F3, does not need a sync-

cord because two gold contact pins beneath the film guide rails connect the back to the body. This unit

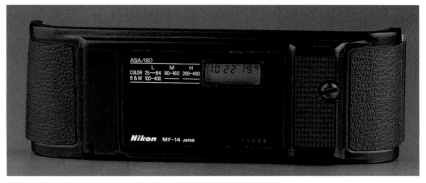

The MF-14 Data Back for the F3 series allows either time or a sequential number to imprinted within the film frame area.

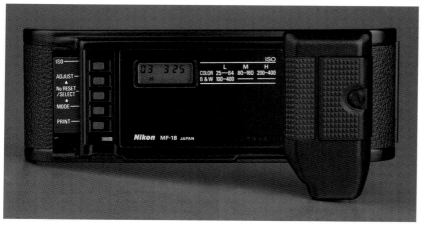

The MF-18 Data Back can imprint data between frames of film, but requires the MD-4 to ensure accurate alignment of film advance to do so.

the world printed on the back next to the LCD panel. By pressing the appropriate adjust buttons the time in any of the listed cities is shown immediately. Two CR2025 Lithium batteries power the unit. The next databack introduced by Nikon was the MF-27 for the F5. It has a similar specification to the MF-22 for the F4 and has the AF sensor area selector switch located in the usual position. A single CR2025 Lithium battery also powers the unit. The most recent databack to be released is the MF-29 for the F100 camera. It has a similar specification to the MF-27 and incorporates the AF sen-

sor area selector switch and is powered by a single CR2025 battery.

Multi-Control Backs

Nikon developed the basic databacks described above with the introduction of the MF-19 for the F-301/501. It not only imprints data but can also control a number of camera operations. For example intervals between two exposures of up to almost 100 hours can be set, or alternatively it can be programmed to release the shutter once or a number of times each day or month. Prior to this unit the considerably more expensive and bulky

MT-1/2 Intervalometer was the only device in the Nikon range capable of this level of control.

The MF-19 was upgraded by Nikon for the F-801 camera and became the MF-21. It is capable of anything the MF-19 can do, but also offers automatic exposure bracketing over up to 19 frames with compensation in increments of 1/3 or 1/2EV. The MF-21 also allows long exposures between one second and 100 hours to be programmed. One of its most innovative features is the freeze-focus function, which releases the shutter as soon as the camera's AF system detects a subject has reached the preset focus distance defined within the AF sensor area brackets in the centre of the viewfinder frame.

The MF-23 databack for the F4 is almost identical to the MF-21 except it can also imprint the data between the frames. It also allows the 'correct' frame of a bracketed sequence of exposures to be positioned in different location with in the sequence. Other features include an interval-timer, shutter release delay, long time exposure, freeze focus, alarm clock, film alarm and film stop at frame 35 or 36.

Nikon took the multi-control back to new heights with the MF-26 for the F90/90X cameras. This unit includes features such as flash exposure bracketing in addition to the normal ambient light exposure bracketing mode, flash output compensation, a multiple exposure function, and custom reset function to return the unit to its default settings. The pinnacle of Nikon's design of multi-control backs is represented by the MF-28 for the F5. It incorporates all that the MF-26 has to offer plus features such as the imprinting of a caption up to 22 characters long including the universal copyright symbol between the frames, shutter speed/aperture, and

The MF-25 Data back was designed for the F90/F90X camera series.

Nikon Data and Multifunction Camera Backs

Model	Camera	Display	ISO Range	Data Displayed	Alarm clock	Internal Timer	Battery life (approx)	Dimensions (mm)	Weight (g)
MF-10	F2	Analogue	32-1600	Y/M/D H/M/S HS	X	X	3000	176x60x69	400
MF-11	F2+MF-1	Analogue	32-1600	Y/M/D H/M/S HS	X	X	3000	302x127x73	650
MF-12	FM, FE	LED	25-400	Y/M/D D/H/M No.	X	X	2 Yrs	118x46x7	75
MF-14	F3	LED	25-400	Y/M/D D/H/M No.	Y	X	1 Yr	148x53x26	85
MF-15	FG	LED	25-400	Y/M/D D/H/M No.	Y	X	1 Yr	136x53x26	85
MF-16	FM2, FE2, FA FM3A	LED	25-400	Y/M/D D/H/M No.	Y	X	1 Yr	142x53x26	90
MF-17	F3+MD-4	Analogue	32-1600	Y/M/D H/M/S HS	X	X	3000	299x69x78	650
MF-18	F3+MD-4	LED	25-400	Y/M/D D/H/M No.	X	X	1 Yr	148x69x30	100
MF-19	F301/501	LED	25-1600	Y/M/D D/H/M No.	Y	Y	1 Yr	147x53x24	90
MF-20	F801	LED	32-1000	Y/M/D D/H/M	X	X	1 Yr	140x61x26	70
MF-21	F801	LED	25-3200	Y/M/D D/H/M No.	X	Y	1 Yr	140x61x29	90
MF-22	F4/F4s	LED	32-3200	Y/M/D D/H/M	X	X	1 Yr	160x56x22	100
MF-23	F4/F4s	LED	25-3200	Y/M/D D/H/M No. S/A, CF	Y	Y	1 Yr	160x56x30	120
MF-24	F4/F4s	LED	25-3200	Y/M/D D/H/M No. S/A, CF	Y	Y	1 Yr	330x98x91	1400
MF-25	F90/90X	LCD	32-3200	Y/M/D D/H/M	Y	X	1 Yr	140x61x29	80

Model	Camera	Display	ISO Range	Data Displayed	Alarm clock	Internal Timer	Battery capacity	Dimensions (mm)	Weight (g)
MF-26	F90/90X	LCD	25-3200	Y/M/D D/H/M No. S/A, CF F Exp/Bkt	X	Y	1 Yr	140x61x29	90
MF-27	F5	LCD	32-3200	Y/M/D D/H/M	X	X	1 Yr	156x58x26	95
MF-28	F5	LCD	25-3200	Y/M/D D/H/M No. S/A, CF F Exp/Bkt	X	Y	1 Yr	156x58x32	150
MF-29	F100	LCD	32-3200	Y/M/D D/H/M	X	X	1 Yr	150x60x29	80

Notes:
- Y/M/D – Year/Month/Day
- D/H/M – Day/Hour/Minute
- No. – Sequential number printing
- S/A – Shutter/Aperture printing
- CF – Exposure compensation factor printing
- F Exp/Bkt – Flash exposure compensation and bracketing

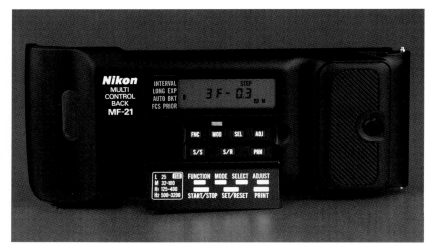

The MF-21 Multi-Function back for the F-801 camera offers far more than just the imprinting of data.

exposure compensation factors in the auto–bracketing mode. This degree of control provides the photographer with enormous scope to influence the final image.

Close-up Accessories.

Close-up photography, which covers reproduction ratios down to 1:1 that corresponds to life size, and macro-photography, which extends down

to reproduction ratios of 25:1 is one of the most interesting areas of photography. This is partly due to the unfamiliar view of even common subjects, and partly because the accessories required for modest reproduction ratios is accessible to most photographers. The reproduction ratio defines the size at which a subject will be recorded on the film in relation to the original. Therefore the reproduction ratio is always related to the relevant film format, which for 35mm cameras measures 24mx36mm. For example, a reproduction ratio of 1:1 means the subject is actually 24mmx36mm and at this life-size fills the full frame area of the film. If the reproduction ratio is 1:2 and the subject still fills the full frame area it is actually 48mmx72mm in life-size. Conversely if the reproduction ratio is 2:1 and the subject fills the frame then at life-size the subject is just 12mmx18mm. If you cannot remember whether 2:1 represents half or twice the natural life-size a helpful tip is to replace the colon by a slash to make the value look like a fraction (e.g. 1/2 instead of 1:2

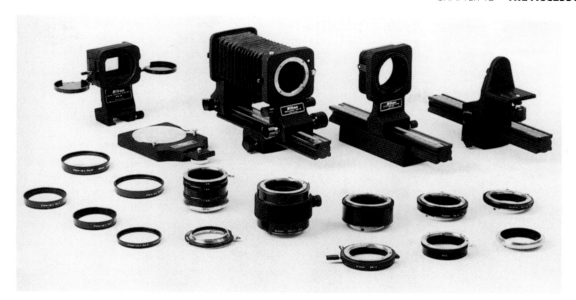

Nikon produce a diverse range of accessories, of varying complexity, to help photographers engage in close-up and macro photography.

makes it clear that this means half life-size).

Almost all fixed focal length Nikkor lenses can be set to reproduction ratios between 1:8 and 1:10 without the need for further accessories. Modern zoom lenses can often achieve ratios up to 1:4 or 1:5 and sometimes even 1:3 with their 'macro' focusing facility. To exceed these magnifications with a lens

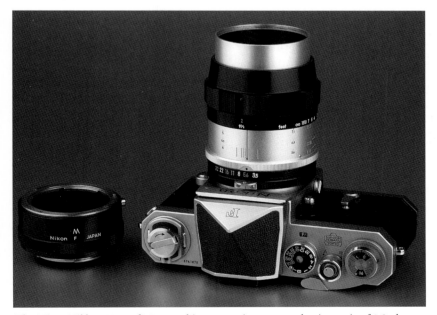

The Micro-Nikkor 55mm f3.5 can achieve a maximum reproduction ratio of 1:2 alone, which is increased to 1:1 with the extension tube M.

alone the Micro-Nikkors, which have optically corrected designs optimized for close-up work must be used. The manual focus Micro-Nikkors can all achieve a maximum reproduction ratio (RR) of 1:2 (half life-size). Attaching combinations of the PN-11 and PK-11a, 12, and 13 Auto-extension rings increases the RR to 1:1. The early 55mm f2.8 AF Micro-Nikkor, and current 60mm,

105mm, and 200mm AF-D Micro-Nikkors are capable of achieving 1:1 without any other accessory.

Close-Up Lenses

Close-up lenses, also known as supplementary lenses, are generally the simplest, least expensive, lightweight, and convenient means to reduce the closest focusing distance of the lens in use. They screw into the filter thread of the lens and have an effect similar to that of a far-sighted person's reading glasses.

However, photographers pay a price for the moderately low cost and convenience of these lenses due to the reduced optical quality that they deliver. This is because the designer of the main lens will not have taken the close-up lens into consideration, so the corners of the frame often show distortion and curvature of field. These effects are not noticeable in many subjects if the corners of the frame are out of focus, but become very apparent in critical copying work.

Nikon's range of close-up lenses can be used singly or in combinations and are all treated with the Nikon Integrated Coating to improve contrast and reduce the

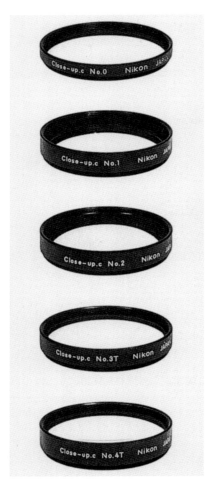

The simplest, and most affordable way into the realms of close-up photography: supplementary close-up lenses, which Nikon make in a variety of strengths and sizes.

effects of glare. The No. 0 is the least powerful with a dioptre power of 0.7. The No. 1 has a dioptre power of 1.5 and the No.2 lens has a dioptre power of 3.0. These first three lenses are recommended for lenses with a focal length up to 55mm. The next two lenses in this range are two-element achromatic designs that provide a superior performance and are best suited to lenses between 85mm and 200mm. They are the No. 3T of 1.5 dioptre and the No. 4T of 2.9 dioptre strengths. All of the above lenses have a 52mm filter thread, which will fit most of the

appropriate fixed prime lenses in the manual and AF lens ranges. The newer 60mm and 200mm AF Micro-Nikkors and a number of Zoom-Nikkors have a 62mm filter thread. For these lenses the No. 5T of 1.5 dioptre and No. 6T of 2.9 dioptre are available. Nikon recommend that only the achromatic T types are stacked in combination with each other.

Extension Tubes

To obtain a larger RR than those possible with close-up lenses extension tubes can be mounted between the camera body and the lens. The earliest set of tubes produced by Nikon was the K-set. It consisted of a camera bayonet ring, plus three extension tubes with no mechanical linkage between the body and lens. Extensions between 5.8 and 46.6mm can be created with these rings.

Nikon's 55mm f3.5 Micro-Nikkor released in 1963 was supplied with a 27.5mm tube known as the M ring,

which was later update to become the M2 ring but neither is capable of meter coupling. The first set of meter coupling rings was designed for the pre-AI lenses, which were available before 1977, and are known as the PK1/2/3 and PN-1. The next set of rings offered by Nikon carry a slightly different designation following their modification to the AI aperture-indexing standard. They are called the PK-11 (8mm), PK-12 (14mm), PK-13 (27.5mm), and PN-11 (52.5mm). The original PK-11 can damage the electrical contacts of AF Nikkor lenses, so Nikon carried out a further modification it is now known as the PK-11a. The PN-11 provides a RR of 1:1 with the manual focus 105mm f2.8 Micro-Nikkor. All of the rings preserve the automatic diaphragm and full aperture metering functions with the manual and AF Nikkor lenses, however because they lack the necessary electrical contacts the tubes restrict the

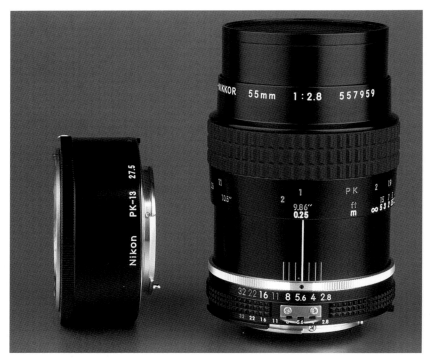

The popular Micro-Nikkor 55mm f2.8 can achieve half-life size alone, but with the PK-13 extension tube reach life-size magnification.

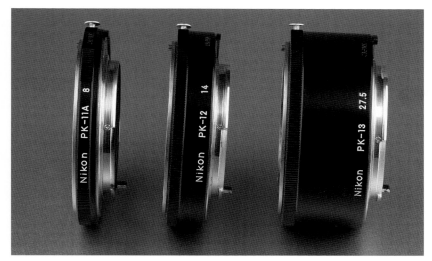

Three extension tubes (l to r) PK-11A, PK-12, and the PK-13.

rings is that the image quality remains virtually unchanged because they introduce no other glass elements into the optical arrangement, however, they do cause a loss of light at the film plane due to the lens being moved further away.

Bellows Focusing Units

Bellows units offer degrees of magnification far beyond those that can be achieved with rigid extension rings. In addition to the greater extensions that are possible they offer a continuously variable reproduction ratio. Nikon introduced their first bellows unit in 1958 for the rangefinder camera series, but to use it the camera required a reflex-mirror box.

Versions for the Nikon F were introduced at the same time as the camera. The first was the Model II with a variable extension from 52mm to 132mm, which was followed by its successor, the PB-3 that

metering mode options available with AF cameras such as the F90X. F100, F4, and F5, which is a great pity. Given their usefulness with almost all focal lengths of lens it is something of an enigma as to why Nikon have never produced a set of rings that is fully compatible with AF cameras and lenses.

As an example here are some reproduction ratios possible with the PK set of rings used in combination with a standard 50mm lens, which is capable of a RR up to 1:7 on its own: 1:3.3 with PK-11A, 1:2.4 with the PK-12, 1:1.5 with PK-13, and 1.1:1 with PN11. One of the principle advantages of extension

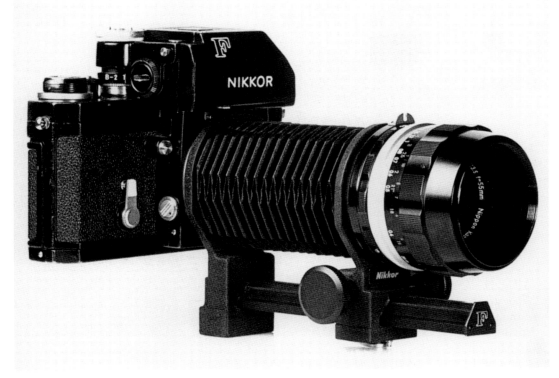

A Nikon F Photomic T with Micro–Nikkor 55mm f3.5 lens mounted on a PB-3 Bellows Unit.

283

offered a range of 33mm to 142mm and an improved tripod mount. By the time the PB-4 had arrived Nikon had developed a number of bellows accessories to compliment the main unit, which included the PS-4 slide-copying adaptor that allows duplicates to be made from mounted transparencies and uncut strips of film. The bellows unit itself has a variable extension between 43mm and 185mm, Both the lens panel and camera panel are geared, and can be adjusted independently with a great deal of precision. The twin rail design is fitted with an adjustable geared tripod plate on its lower rail, which allows the entire unit to be moved back and forth without the need to move the tri-pod. This is a very important feature that greatly improves its handling for altering the focus and composition, because otherwise the whole assembly, including the tripod, would have to be moved.

The PB-4 is unique amongst Nikon's bellows unit in that the lens panel can be shifted laterally or vertically by 10mm and swung through an arc of 25°. Although useful these movements have a limited effect on the 35mm film format. The sophistication of the PB-4 came at a high price, which why Nikon introduced a less well-specified, but more affordable version, the PB-5. It is technically similar to the PB-3 but retains the PB4's 43mm to 185mm extension range. It also accepted the PS-5 slide-copying adaptor for mounted 35mm transparencies.

The currently available bellows unit is the PB-6. With the exception of the tilt and shift of the lens panel, it offers the same features as the PB-4. Its panels are mounted on a double dovetail rail that offers an extension range of 48mm to 208mm. If that is not sufficient the PB-6E Extension Unit can be fitted to extend this range to 83mm to 438mm. This amount of extension used with a reversed 20mm lens provides a maximum reproduction ratio of 23:1, which takes the photographer into the realms of microphotography. Due to their higher profile some cameras such as the F5, F4E, F4s, F3+MD-4, and D1

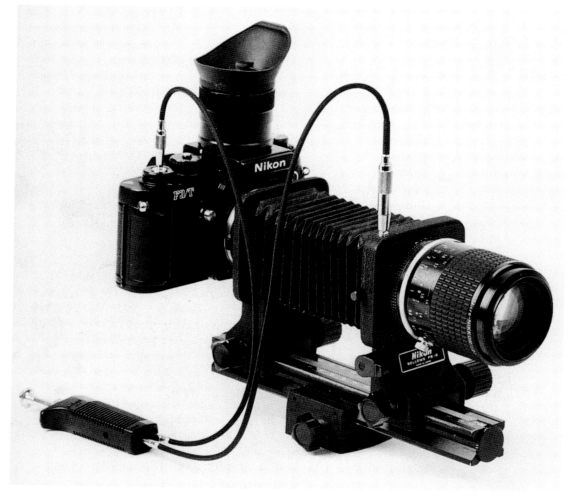

A Nikon F3/T with DW-4 6x High-Magnification finder mounted on a PB-6 Bellows Unit. The AR-7 double cable release synchronizes the shutter release with the lens aperture diaphragm of the Micro-Nikkor 104mm f2.8 lens.

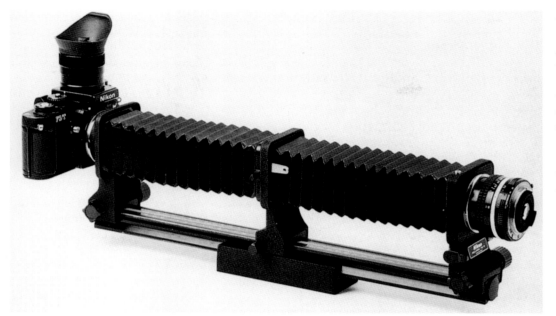

Not for the feint hearted! It is possible to achieve very high magnifications by combining the PB-6 and PB-6E. In this case the lens has been reversed and attached via a BR-2A ring.

series, require the PB-6D Bellows Spacer. This accessory raises the camera to prevent is from interfering with the focusing rails: two are required for the PB-6 and three when the PB-6E is attached.

The Copy Stand PB-6M can be attached to the double dovetail rail providing the PB-6 with specimen stage for small subjects. It has two clips to hold the subject securely in place and is supplied with a white semi-opaque acrylic plate and grey-painted aluminium plate that has an 18% reflectivity. The PS-6 slide-copying adaptor can be shifted up to 6mm in any direction to make slight adjustments to the composition.

For fine adjustment of focusing, when working with a camera mounted on a tripod, Nikon produce the PG-2 Focusing Stage. This has a camera plate that sits in a geared dovetail rail that can be continuously adjusted to aid critical focusing when working at high magnifications.

None of the Nikon bellows units possess the couplings necessary for automatic diaphragm and full aperture metering operation. To main-

The PG-2 Focusing Stage is very useful for fine adjustment of focusing at high magnifications or short working distances.

tain this highly convenient feature a double cable release must be used to ensure simultaneous operation of the shutter and lens diaphragm. The AR-4 version, now discontinued, was available for Nikon cameras whose shutter release button is fitted with the Leica-type male thread, the AR-7 for those with the standard ISO type thread, while the AR-10 fits those cameras with the two-pin electrical remote accessory terminal. The MC-25 lead can adapt the AR-10 to fit cameras with the 10-pin remote terminal. The appropriate cable is attached to the camera while the second, marked by a red ring, is

connected to the lens panel of the PB-6 bellows unit. All earlier bellows units also require the now discontinued BR-4 Auto Ring. As the button of the double cable release is pushed, the lens diaphragm is stopped down to the preset value and then the shutter is released.

For optimum image quality at reproduction ratios greater than 1:1 it is often advisable to reverse-mount the lens so its rear element points towards the subject. This applies particularly to wide-angle lenses due to their very short working distances. The BR-2A Macro Adaptor Ring is requires to mount the lens with a 52mm filter thread to the lens panel. For those lenses with a 62mm filter thread such as the 20mm f2.8 AF-D optic the BR-5 Auto Adaptor Ring must be fitted between the lens and the BR-2A.

In addition to the adapters for attaching Nikkor lenses to a bellows unit Nikon produced other rings to attach Nikkor enlarging lenses, which due to their optical design are well suited to bellows applications. The BR-15 was made to attach enlarging lenses with a 39mm filter

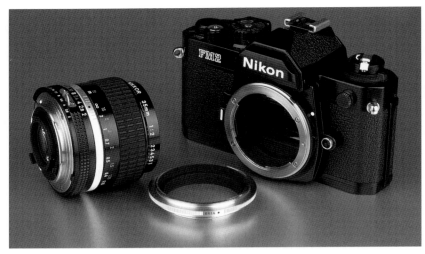

To reverse mount a lens the BR-2A ring is required.

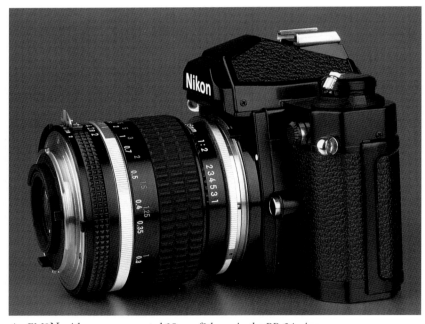

An FM2N with reverse mounted 35mm f2 lens via the BR-2A ring.

The ES-1 slide-copying attachment and BR-5 52mm to 62mm adapter ring.

thread, and another adapter the BR-16 was made to allow the attachment of RMA-treaded microscope lenses. It had to be used in conjunction with the BR-15. Both these rings are no longer manufactured.

For those photographers who require a simple method of duplicating transparencies on to fim, at a 1:1 ratio Nikon produce the ES-1 Slide Copying Adapter. It has a 52mm attachment thread and can be connected directly onto the 55mm f2.8 Micro-Nikkor with PK-13 extension ring, or using the BR-5 Stepping Ring, it can be attached to lenses with a 62mm filter thread such as the 60mm f2.8 AF-D Micro-Nikkor, which offers continuous focusing to a RR of 1:1.

General Accessories

Nikon has always striven to provide photographers with every conceivable accessory to ensure that their camera system is as adaptable and comprehensive as is possible.

Pistol Grip

This rather curious accessory was intended to assist photographers in hand holding cameras with long heavy telephoto lenses attached. It connects via a standard tripod screw to the tripod bush of either a camera body or lens tripod collar. A trigger in the grip section operates the shutter release via either a normal mechanical cable release or a two-pin remote terminal via the MC-3A lead. Production was discontinued a number of years ago, so these days it is only available through the second-hand market.

Panoramic Head

The AP-2 Panorama Head AP-2 mounts between the camera and the tripod and rotates an precisely calibrated click-stop positions for picture angles of 28, 35, 50, 85, and 105mm focal lengths. Each position for its relevant lens allows a slight overlap to ensure full 360° coverage. Like the pistol grip this is no longer listed by Nikon but can be sourced from the secondhand market.

Battery Holders

From the introduction of the Nikkormat EL all succeeding Nikon cameras, except the FM, FM-2, and FM3A have depended on battery power to operate their shutter release. Until the introduction of the

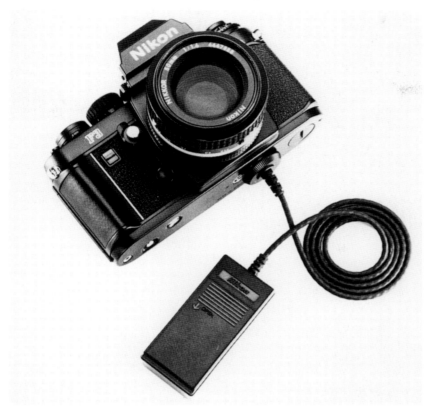

The DB-2 Anti-cold Battery Holder is useful if a camera is likely to be exposed to low temperature for a protracted period.

F-301 with its built-in motor, cameras used either two 1.5V button batteries, or a single 3V type. These small batteries can soon become exhausted in cold conditions, and although modern Lithium cells are less susceptible to the effects of low temperature it is always wise to carry spares.

To overcome this problem Nikon offers external battery holders for certain camera models. The DB-1 for the DS-type aperture control attachments was the first battery holder. Its four D-size cells increased the duration of its operation by a factor of four. The DB-2 Anti-Cold battery holder battery fits the EM, FG, FG-20, F3, FE, FE2, FA, FM, FM2, and FM3A. It holds two AA size batteries that can be kept warm by placing the DB-2 underneath a coat or in a pocket. The terminal

on its 0.5m long lead is screwed into the camera's battery compartment. The much larger DB-6, which accepts six D size batteries, was introduced for the F4E, but can also be used with the F90/F90X cameras, and provides sufficient power for

protracted shooting regardless of the temperature. To connect the DB-6 to the F4E use the MC-28 power lead, and the MC-29 if you want to connect it to an F90/90X. Both the DB-2 and DB-6 remain in production.

Nikon also produced a number of other external camera battery packs, which are no longer available new. The DB-3 was designed for the MF-12 databack and provides power from two AAA-size cells. The DX-1 finder of the F3 AF can be powered by the DB-4 that takes two AA size batteries to assist the autofocus motor. The DB5 substitutes the four AA size batteries in the F-801/801s with one 6v lithium battery, which offers a superior performance in cold conditions.

Neck Straps

Many new camera models and larger lenses are supplied with their own dedicated neck straps, however, Nikon also produce a variety of other straps in different widths and materials. Their designations are all prefixed with 'AN' while the following numbers and letters signify the width, colour and material used. They are available in nylon, leather, and leatherette. The leather and leatherette straps have a non-slip rubber pad and the nylon straps

Although no longer available new the DB-5 External Battery Pack for the F-801 series can be found amongst the secondhand stocks of many dealers.

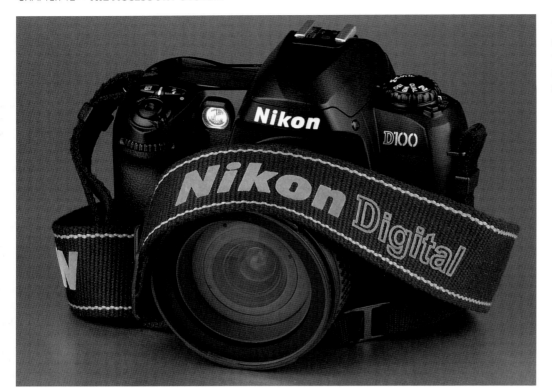

The Nikon D100 comes supplied with its own dedicated neck strap.

have a pad of non-slip material on the underside.

Cases

The 'ever ready' case was an accessory that used to be supplied with many cameras. Some cynics have coined the expression 'never-ready' case, because they say that by the time you have unfastened the case to ready the camera for use you will have missed the shot! Their use is a matter of personal preference, speaking personally I have never used one in over twenty years of photography. They are also rather limited as they can only accommodate a single camera and lens.

Nikon offers a variety of camera cases for their various camera models with different front flaps to fit several focal lengths. These cases have their designation prefixed with 'CF' and are made from a semi-soft leatherette material. The CF-23D and CF-27D have a small aperture to allow viewing of the MF-14 and

MF-16 databacks respectively. All of the cases are black with the exception of those for the F3 and F4, which only come in a light tan colour. In the days of the Nikon F and F2 camers a set of hard cases were available that carried the designation 'CH'.

The 'CS' versions are simple soft cases for dust-protection and are still available for the F3, F4, and FM/FE series cameras. There is also a series of generic soft cases for 35mm SLRs that have a range of front panels with different lengths. all the cameras from the Nikkormat to the F3. They differ according to the focal lengths they can house. One case that deserves a special mention is the CS-13, which has an extra thick padding and is intended to reduce the noise of a motor driven camera. It is useful on those occasions when such noise would be intrusive or disturb a sensitive subject.

Nikon even make a compartment

case the FB-14 to carry a number of cameras and lenses together. Its side panel can be swung open to provide easy access to the equipment.

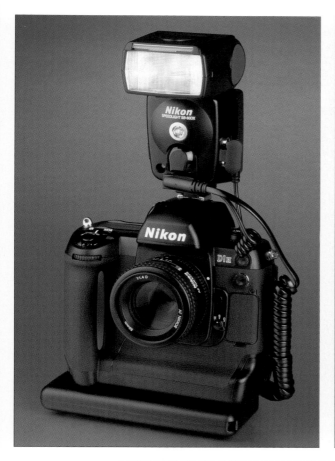

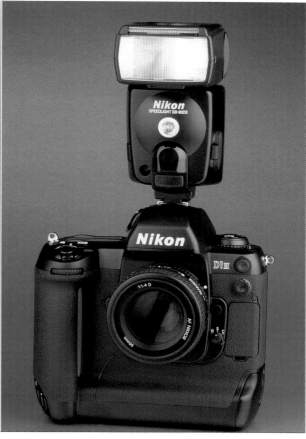

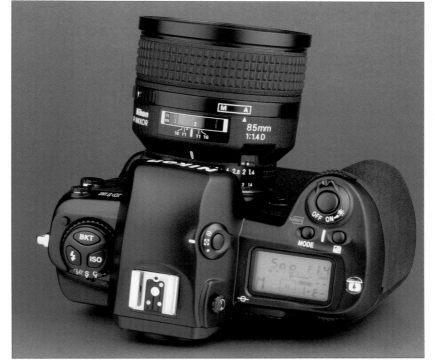

Above:
One solution for high-speed digital photography: the D1H with an SB-80DX and SD-8A battery pack.

Above:
Digital SLR cameras like the D1H require a Speedlight unit from the DX series for TTL flash exposure control.

Left:
A D1H with the AF Nikkor 85mm f1.4D, an ideal combination for high-speed photography in low light.

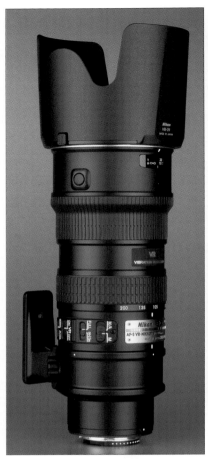

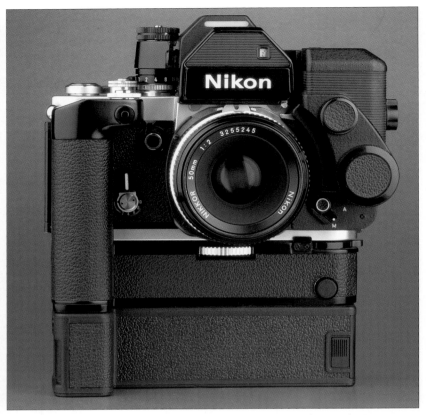

Full automation from a different era: an F2S with MD-3 motor drive and DS-1 aperture control unit.

The Nikkor AF-S VR 70-200mm f2.8G is the first Nikon lens to combine VR and AF-S technology.

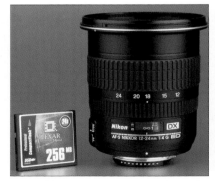

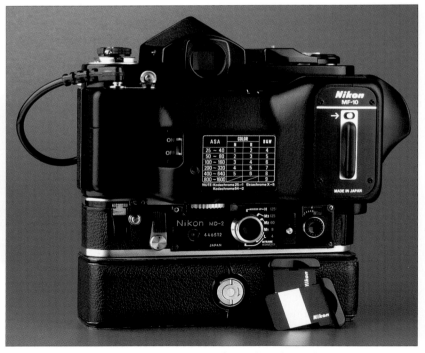

The Nikkor AF-S DX 12-24mm f4G is the first lens in a new series dedicated to the DX format CCD sensor size of Nikon digital SLR cameras. It provides an angle of view equivalent to an 18-36mm lens for 35mm film cameras.

The Nikon F2 Data represents a masterpiece of optical-mechanical engineering.

The Nikonos System

Any work under water, including photography, is a potentially hazardous at the best of times requiring great skill and experience on the part of the diver. From the very beginning of its Nikonos programme Nikon has appreciated the demands that this hostile environment places on equipment can be extreme. As the only professional camera system in the world designed to be used under water without any additional housing, or special equipment, the Nikonos system remains unique.

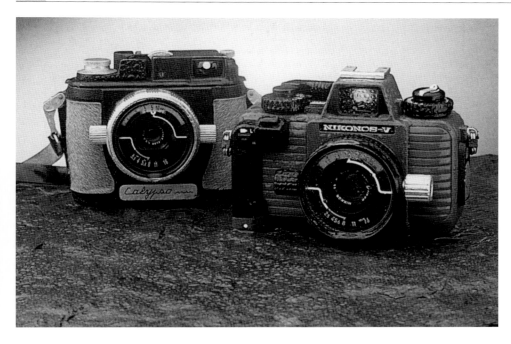

Two generations of underwater camera: the original "Calypso" and the Nikonos V both designed to operate at depths of up to 50m.

Water is much denser than air, and has a different refractive index, which makes everything under water appear to be about 30% larger than at the same distance on dry land. This important fact must be borne in mind when estimating distances, since none of the Nikonos viewfinder models have a rangefinder to aid focusing. Only an SLR can perform accurate focusing, but with any camera other than the Nikonos RS this makes an additional, and usually extremely expensive, watertight housing a necessity. Under water the angle of view of a lens is also reduced. For example a 35mm lens will show the equivalent view of a 50mm lens used on land.

Photographers face another problem caused by water's absorption of parts of the visible spectrum. At a depth of three metres most of the red portion of the spectrum has been filtered out. By five metres most of the yellow light has gone as well, and beyond this depth visible light comprises principally of light from the blue part of the spectrum. This applies to the distances between the surface and subject or subject and camera. Since filters cannot be used to correct for this colour imbalance it is usually necessary to employ a special flash unit to capture the full gamut of colours in the under water world. As if the diver did not have enough to consider there are two further factors, which can influence results: the angle at which the light enters the water and the texture of its surface. These unique and very special conditions illustrate why underwater photography is so demanding, even as a hobby.

Nikon's earliest efforts concerning underwater photography began dur-

The enormous pressure at depths of up to 50m demands waterproofing with O-rings. These are designed to deform under pressure (see lower diagram) to increase their effectiveness as seals.

ing the reign of the rangefinder cameras, when they introduced an underwater housing for the S2, S3, and SP models. It was designed to be used at depths down to 50m and could accommodate the camera with one of the following Nikkor lenses attached: 28mm f3.5, 35mm f1.8, and 35mm f2.5. Film transport as well as focus and aperture set-

tings were accessible from the outside, and a flash unit and an action finder could be attached to the housing.

From Calypso to the Nikonos RS SLR

At the beginning of the 1960's the Belgian camera designer Jean de Wouters, in collaboration with the French maritime scientist Jacques Yves Cousteau, developed a 35mm model capable of withstanding water pressure down to 50m. Known as the 'Calypso', it was named after Cousteau's exploration ship. This three-part camera design consists of the watertight outer housing, an interior body incorporating the film transport mechanism, shutter and controls, and finally the lens. The double walled construction provides comfortable handling on land as well as under water, and each of the fourteen joints is sealed with a greased O-ring.

The original lens was the French Som-Berthiot 35mm f3.5. Distance and aperture are set with two rotating knobs to the left and right of the lens barrel. The film is transported and the shutter cocked with one

lever, which also incorporates the shutter release. This lever springs back to its ready-position after every shot and cocks the shutter when pressed inwards towards the camera body. This innovative method ensures positive handling even with thick gloves. Shutter speeds run from 1/20sec to 1/1000sec, as well as a 'B' position. The bright frame in the viewfinder is matched to the 35mm lens. In stark contrast to the concerns that many people have to day in respect of the environment and conservation the camera body was trimmed with sealskin! Nikon immediately realized how ingenious the concept was and acquired the necessary licences to produce it in Japan.

The Nikonos I, the first underwater camera to be manufactured by Nikon was released in 1963. The most significant modification compared to the original 'Calypso' model was its Nikkor-W 35mm f2.5, a design resurrected from earlier rangefinder days. The ostentatious sealskin was replaced by a more practical plastic coating that provided a far more positive grip. The first lens designed specifically for underwater use, the UW-Nikkor 28mm f3.5 was introduced the following year. It was a six-element optic corrected for the refractive index of water and as a result performs significantly better than the first 35mm f2.5 lens. Since the 28mm lens can only be used under water, its distance scale is marked with the apparent values when submerged.

In 1968 the Nikonos II appeared. Its most distinguishing feature is the rewind crank, which replaced the cumbersome knob design of the Nikonos I. As well as having an extended range of shutter speeds from 1/30sec to 1/1000sec and 'B', the scale includes the position 'R' which must be set when rewinding the film. The film transport mecha-

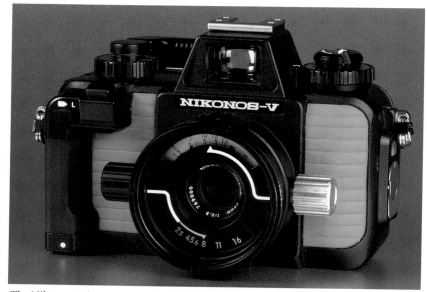

The Nikonos V, designed with TTL flash control and improved seals

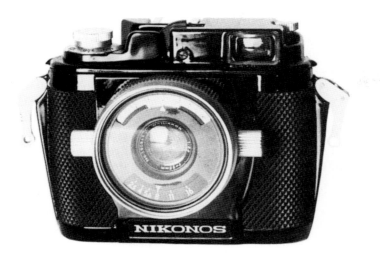

The first Nikonos built by Nikon fitted with the UW-Nikkor 35mm f2.5.

nism was also modified. The Nikonos II permits underwater flash units to be triggered at speeds of 1/60 and 1/30sec. The depth-of-field indicator and the markings on the lens scales were enlarged to improve their legibility.

The lens range was supplemented by a third lens, the Nikkor-W 80mm f4, it has four-element design that can be employed on land as well as under water. Nikon also introduced a close-up kit for use with this lens and the 28mm and 35mm optics.

This consists of a two-element achromatic supplementary lens for the prime lens, and a 24cm-long supporting rod which supports one of three different field frames depending on the lens in use. The following reproduction ratios are possible under water: 1:6 with the 28mm f3.5, 1:4.5 with the 35mm f2.5, and 1:2.2 with the 80mm f4.0. Unlike extension rings this kit has the advantage of being usable both above and below water. By now the Nikonos was developing into a true system camera especially with its additional accessories such as the dedicated lens hoods and a water-tight case for the Sekonic exposure meter, the Auto-Lumi L-86, being available.

The next lens to be released was the sensational UW-Nikkor 15mm f2.8 made exclusively for use under-water where it has an angle of view of 94°. Many underwater photo-graphers consider this eight-element design to be the best UW-lens ever manufactured. It has its own dedi-cated optical viewfinder, which can be attached to the camera's accessory shoe, to assist composition. Later, an optical viewfinder for the 28mm lens was introduced, which can be masked for framing compositions with the 35mm lens. Wearing a div-ing mask invariably restricted the photographer's view of the camera's viewfinder, but this very practical accessory over came the problem.

The Last 'Calypso' Design

The Nikonos III was released in 1975. Although it had a new outer casing it still resembled its predecessor. The controls were enlarged to improve handling and bright frames for both 35mm and 80mm focal lengths were visible in the viewfinder, as well as parallax marks for dis-tances below 80cm. The frame counter could now be viewed from

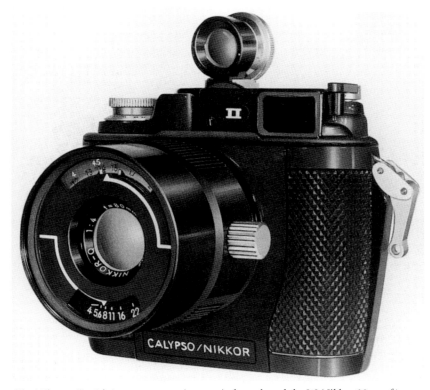

The Nikonos II with its more convenient rewind crank and the W-Nikkor 80mm f4.

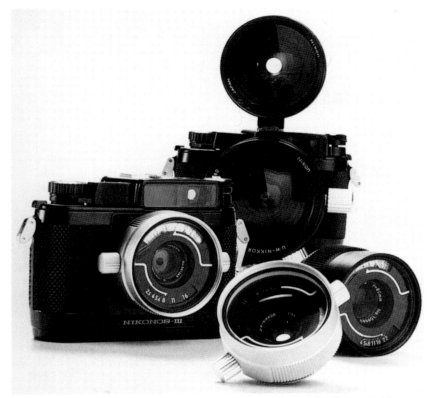

The classic Nikonos for many years: the Nikonos III with four of the then available lenses.

Nikonos IV A

The Nikonos IV-A, released in 1980, introduced a completely new concept in underwater camera design. It bears no more in common with its predecessors than the Nikonos name and the lens mount bayonet. The Nikonos IV-A is designed like a normal SLR with a one-piece body with a hinged back. It is the first Nikonos with an integrated TTL-metering and exposure control system. Based on the Nikon EM it has an aperture priority exposure mode with speeds from 1/30sec to 1/1000sec. A red LED indicates when the speed selected by the camera is within this range, a blinking LED indicates under or over exposure. Contrary to Nikon's official specification ignoring the under exposure warning is rarely a problem since the camera's electronics seem capable of operating with sufficient precision below 1/30 second up to several seconds. The TTL system uses an SPD cell located beneath the viewfinder to measure

above, and the watertight flash terminal was modified to a three-pin version. The lens control knobs were enlarged and to avoid any confusion were marked: black for the aperture and silver for the focus distance. Even so, many photographers preferred to mount the lens upside down on the body so they could read the scales more easily from above.

Further modifications were made to the film transport mechanism; the advance lever can be operated in a series of several short strokes and the precision of the film positioning was improved. The body's lens bayonet is made of stainless steel and no longer a part of the housing itself. On land the Nikonos III weighs 620g together with the 35mm lens, but in water this is reduced effectively to just 300g.

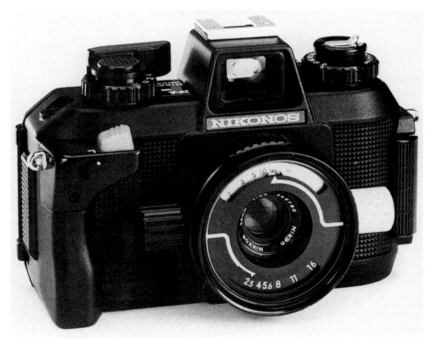

The TTL exposure metering and aperture priority exposure mode of the Nikonos IV-A were adapted from the Nikon EM.

light bounced off a grey reflector on the shutter blades. Two mechanically controlled shutter settings, 1/90 sec and 'B' are available besides the aperture-priority mode. The 'R' position unlocks the film transport system for rewinding. Film speeds from ISO25 to ISO1600 can be set. Since the Nikonos IV-A has neither a manual exposure compensation facility, nor an auto-exposure lock function, the ISO value has to be changed to cope with difficult lighting conditions. Fortunately this can be done whilst submerged. A new bright-frame finder was developed with an eye relief distance of 40mm allowing the complete frame to be seen with a diving mask on. The viewfinder display includes the frame for the 35mm lens, the red exposure LED and the flash-ready signal. The SB-101 dedicated flash unit switches the camera to its sync-speed of 1/90 sec automatically when they are connected. The one-piece outer body is waterproofed by twelve '0' rings and a flat seal that seats in a channel around the camera's back. The film pressure-plate is hinged on the internal body and not the back in order to secure optimum flatness on land and under water, where at its maximum operating depth of 50m a pressure of up to 5 kgs/cm² is exerted on the body.

Thanks to its versatility the Nikonos IV-A is equally at home being used for many applications in extreme conditions on land where other cameras would not survive the rigours of being exposed to rain, snow, or dust.

However, Nikon soon began to receive negative feedback on the Nikonos IV-A from divers who where not completely satisfied by this model. Many considered its 1/90 sec flash sync-speed be too slow, and of limited use when balancing flash and available light in the same exposure, but the camera does not permit an alternative speed to be set. The flat seal set in the camera back was the second feature to attract their criticism because even the tiniest grain of sand on this gasket was enough to cause a leak that would invariably flood the camera. They also expressed their disapproval that the UW-Nikkor 15mm f2.8 lens could not be used because its rear protrudes so far into the camera body that the metering cell is partly obscured. Although this problem was solved in 1982 with the introduction of a new lens employing 12 elements in a retro-focus design, together with a new optical finder, the DF-11, its performance is considered to be slightly inferior to its predecessor's.

Another optical viewfinder, the DF-10, was made available for the 80mm lens. Designed for use on land only, it is fitted with a ring parallax-compensation between infinity and 1m. In 1983 a new lens, the LW-Nikkor 28mm f2.8 was added to the range. It was not designed for underwater applications, but it is water-resistant. It resembles the

The most extreme wide angle for the Nikonos: the highly acclaimed UW-Nikkor 15mm f2.8.

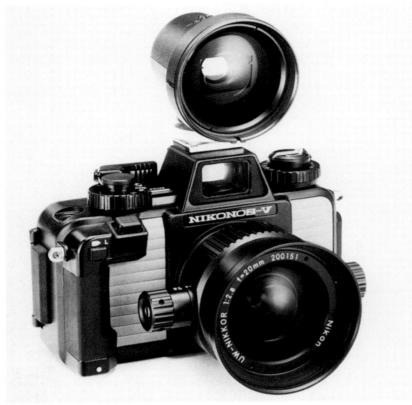

28mm f2.8 E-series lens and has the normal aperture and distance rings, however it has no matched viewfinder, although the complete finder area approximates to its field of view. The LW-Nikkor 28mm lens has a 52mm filter thread while the 28mm, 35mm, and 80mm UW-Nikkors have a 58mm thread.

Nikonos V

Taking into account the criticisms expressed about the Nikonos IV-A Nikon set about rectifying them and introduced its successor, the Nikonos V, in 1984. The most conspicuous change were the olive green, or bright orange coloured plastic panels on the body surface. Aside from the cosmetic changes the technical advances were far more significant and practical. In addition to the aperture priority mode, shutter speeds can be set manually between 1/30sec and 1/1000sec and are displayed in the viewfinder. It retains the same 1/90sec flash sync speed of the Nikonos IV-A.

The UW-Nikkor 20mm f2.8 provides an attractive alternative to the 15mm f2.8, partly due to its lower cost.

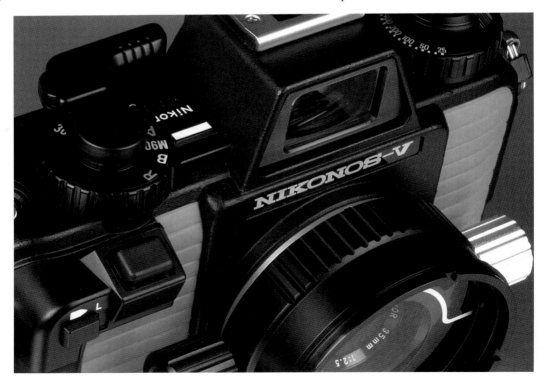

The Nikonos V provides TTL flash control and a manual exposure mode.

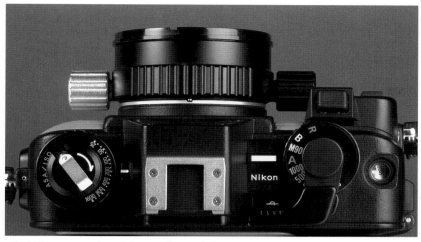

The Nikonos V: a view of the top plate and the accessory shoe.

The other important improvements are the TTL-controlled flash exposure system with the dedicated SB-102 and SB-103 flash units and the modified camera back locking system. The entire sealing system was upgraded to quell the criticisms from divers. The back is sealed with an 'O' ring, which under pressure forces away any particles clinging to it and the surfaces of its channel. The earlier three-pin sync-terminal, which had remained unchanged since the Nikonos III, was fitted with two additional contacts for the TTL control circuitry. The Nikonos V was to be the last Nikonos model in the series. In late 2001 Nikon finally issued news of its intention to discontinue production.

In 1986 a wide-angle lens, the UW-Nikkor 20mm f2.8, which only costs about half the price of the 15mm f2.8, was added to the lens range. The nine-element design has an angle of view of 78° and can focus down to 0.4m. A dedicated optical finder, the DF-12 is available for this lens, and by fitting a mask, the same finder can also be used for the UW-Nikkor 28mm f3.5.

Nikonos RS

As the Nikonos system evolved under water photographers continued to ask Nikon when they could expect an underwater SLR. Considering the expense of developing such a camera, for example it would require a completely new set of lenses, and the limited size of its user group, nobody really expected Nikon to take up the challenge. However they did and in early 1992 Nikon whetted the appetite of photographers by announcing the world's first fully-fledged under water SLR system. Expectations concerning the new camera began to rise but these paled against the specification of the camera that was finally unveiled. An extraordinary photographic tool, the Nikonos RS combines the best features of the proven Nikonos viewfinder models with technology drawn from the F-601.

The RS is an outstanding piece of design and engineering; watertight down to an almost unbelievable 100m it offers, auto-focus operation including focus tracking and freeze-focus functions (at the time only available in other Nikon cameras with an additional multifunction-back), Matrix metering including Matrix balanced fill-flash control, aperture priority automatic or manual exposure modes, a centre-weighted metering pattern with 75:25 ratio, shutter speeds from 1sec to 1/1000sec plus 'B', a maximum flash sync-speed of 1/125sec, the choice of either front or rear curtain flash sync modes, automatic film advance, automatic DX-coding from ISO25 to ISO5000, and a large action-type viewfinder that has LCD's to display all the relevant camera settings.

The body is so large that on seeing one for the first time some people believe it is a medium format camera. On land it weighs a mighty 2060g while submerged its effective weight drops to 920g. Except for two details the lens bayonet is exactly like that of other Nikon SLRs. The

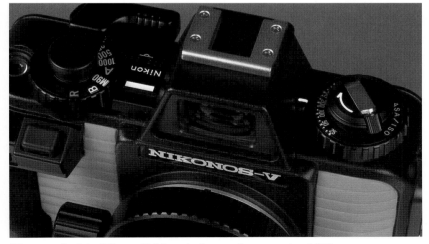

The controls of the Nikonos V follow the layout of a conventional SLR.

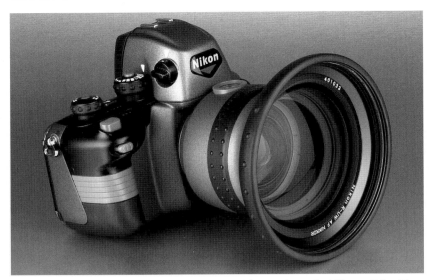

The world's first purpose built underwater SLR with auto-focus, the Nikonos-RS, with the R-UW AF Nikkor 20-35mm f2.8.

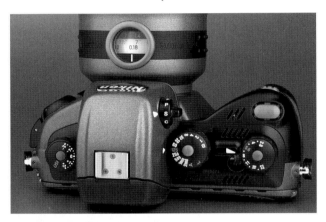

The large clear controls of the Nikonos RS facilitate operation down to depths of 100m.

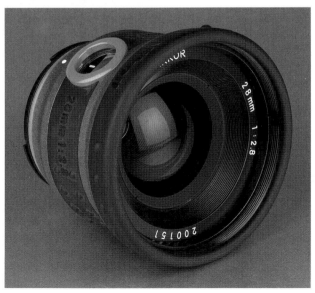

The R-UW 28mm f2.8 lens was one of three initially released along with the Nikonos RS.

claws are not situated at the same angles and there are actually two bayonets. The second, larger one fastened to the outer body of the camera helps to secure the equally weighty lenses by their metal barrels.

Initially the Nikonos RS was released with three completely new lenses that are designed exclusively for use under water. The R-UW AF Nikkor 28mm f2.8 that has a universally usable picture angle of 60° and is the lightest of the trio at 550g can be considered the camera's standard lens. It is constructed from six independent elements and has an illuminated distance scale. The next lens in the line up is a specialist, the R-UW AF Micro-Nikkor 50mm f2.8. It can be focused continuously down to a maximum reproduction ratio of 1:1, manually or automatically without additional accessories. Unlike the other two this lens can be used to produce pictures of acceptable quality out of water, however, there is evidence of slight colour fringing in these circumstances. The third lens is the most spectacular. Designed with just ten elements and offering angles of view continuously from 51° to 80° underwater, the RU-W AF Zoom-Nikkor 20-35mm f2.8 almost dwarfs the RS body.

Introduced during May 1994 the R-UW AF Fisheye Nikkor 13mm f2.8 was the last lens introduced specifically for the Nikonos RS. Weighing a hefty 970g it consists of ten elements arranged in 9 groups, with the bulbous front element acting as a protective cover, and provides a huge 170° angle of view. Underwater it has a minimum focus distance of just 14cm making it ideal for close-up work.

A world first and, so far, only underwater autofocus reflex camera the Nikonos RS is unique, and in spite of the fact that Nikon decided to discontinue its production in

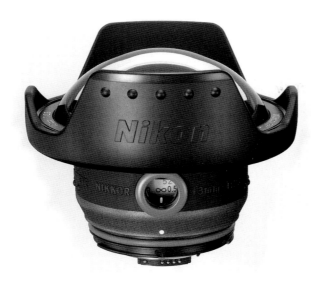

The spectacular R-UW Nikkor 13mm f2.8: it has a minimum focus distance under water of just 14cm and a 170∞ angle of view.

den in the grip section triggered the flash bulbs. This model was available later with the appropriate connection for the Nikonos III sync terminal. The first electronic flash unit was introduced as a prototype in 1978 but never manufactured. It was computer controlled, had one automatic setting of f5.6, and its angle of illumination covered that of a 28mm lens. The first production electronic flash unit was called the SB-101 and designed for the Nikonos IV-A.

Depending on the condition of the water a flash unit's guide number is reduced by 50 to 70% compared to its land based rating, but due to the short shooting distances that are invariably involved under water this reduction is not too critical. It is vital to place the flash reflector as far away from the lens axis as possible so that the ever-present particles suspended in the water do not reflect the light from

1996 it remains the ultimate dream camera for many underwater photographers.

Nikonos Speedlights

As mentioned at the beginning of this chapter, underwater photography is closely linked to the subject of flash exposure. Only artificial light sources allow us to reproduce the submerged world in all its colourful splendour.

The first flash unit appeared during the early 1970s for the Nikonos II. It was a reflector mounted on an extension rod. A 22.5v battery hid-

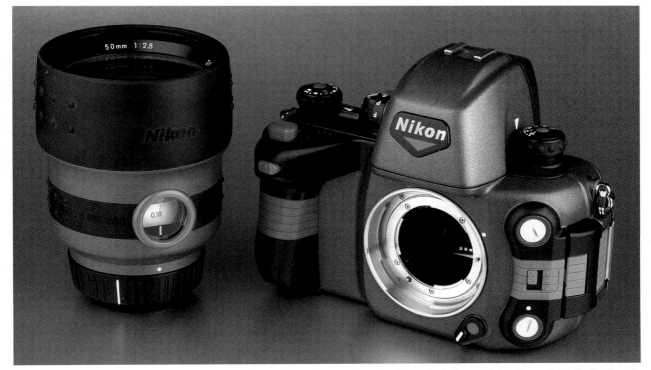

The R-UW AF Micro-Nikkor 50mm f2.8 can close focus to provide a 1:1 reproduction ratio. It is one of three lenses initially developed specifically for the Nikonos-RS, which has a modified Nikon F-mount bayonet.

A Nikonos II with the prototype SB-11 Flash unit, the forerunner to the later production models.

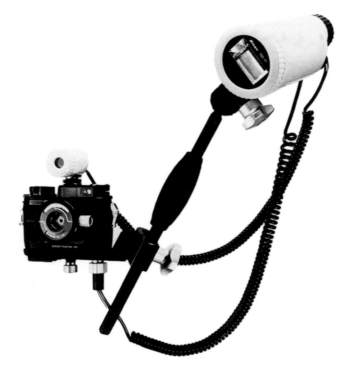

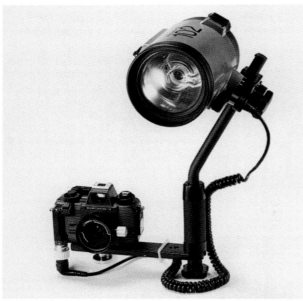

The SB-102 unit with its large reflector dwarfs the Nikonos V, with which it combines to provide TTL control.

shoe. It provides two automatic settings of f4 and f8 at ISO100. The reflector head can be tilted and rotated freely on its ball-socket head. Eight AA size batteries, fitted in the grip section, can recycle the unit in 8 seconds at full output. The elegant SS-101 carrying case was supplied with the unit.

The SB-102, introduced for the Nikonos V, is a TTL-controlled flash with a guide number of 32 (ISO100, m) and an illumination angle sufficient for a 28mm focal length. Fitted with the SW-102 diffuser the picture angle of the 15mm lens can be covered. The six C-size batteries fit in the reflector head, which has a pilot lamp to assist in aiming the unit precisely. In spite of the larger batteries the recycling time is a lengthy 15 seconds at full output. Besides the TTL-controlled operation available with the Nikonos V, the unit also offers manual control for full, 1/4, and 1/16 power output, and with the external SU-101 sensor two automatic positions can be chosen for use with the Nikonos III or IV-A. The SB-102 has an integral slave sensor allowing it to be triggered remotely by any other flash unit without the need for a connecting lead. The standard sync cord is detachable, so should it become damaged it can be replaced by the photographer. For the more adventurous under water photographer Nikon produced a double bracket as well as a multi-flash sync cord allowing two SB-102/103 flash units to be operated simultaneously in TTL-mode. To increase the versatility of the lighting set-up an extension arm is available to place the reflector further away from the optical axis.

In 1984 the SB-103 with a guide number of 20 (ISO 100, m) was introduced as the "little brother". Its reflector covers the picture angle of a 28mm lens, and fitted with the

the flash back to the lens causing a loss of contrast and sharpness. Hence the reason for all Nikonos Speedlight under water flash units being mounted on a grip with an extension arm.

The SB-101 has a guide number of 32 (ISO 100, m) on land and illuminated the picture angle of a 35mm lens. The diffuser SW101 was available for a focal length of 28mm. In addition to full and 1/4 power manual output, the automatic mode can be selected, but requires the external sensor SU-101 to be attached to the camera's accessory

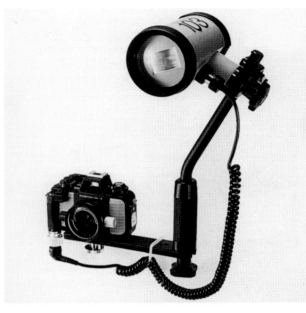

The SB-103 is a much smaller unit that lacks automatic settings of its own, a pilot light, or an integrated slave cell.

The Nikonos-RS, capable of operating at a maximum depth of 100m, required a new flash unit, the SB-104.

dangerous fault involving the SB-103. In a few rare cases when charged and uncharged NiCd batteries were used together hydrogen gas was discharged from the batteries. The gas mixed with oxygen inside the flash head and could be ignited by an electrical spark when the flash was fired causing the flash tube and reflector lens with its rubber seal to detach from the unit's housing. Nikon issued a global recall of all SB-103s with an offer to exchange them for the current SB-105 model.

The SB-101, SB-102, and SB-103 all have an orange coloured housing and can operate to a maximum depth of 50m. To use flash with the Nikonos RS at its maximum operating depth of 100m required a new unit, so Nikon introduced the SB-104, which is similar to SB-102 in size, weight, and guide number. It is powered, exclusively, by the SN-104 NiCd battery pack that provides about 120 flashes at full power with a recycle time of just 3 seconds, and can be recharged by the SH-104 charger in approximately two hours. It is compatible with all the RS's comprehensive flash modes including rear curtain sync, and has a slave sensor, which can release the camera's shutter in addition to the flash. The bracket and extension arm system was modified to improve handling and includes the SK-104 angle

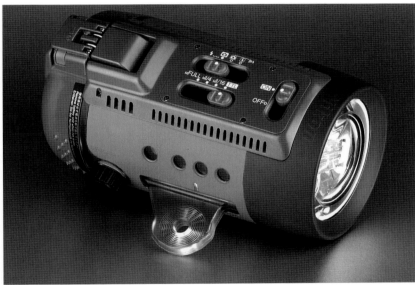

SW-103 diffuser covers the angle of a 20mm lens. In an effort to achieve a more moderate price the automatic settings, pilot light, and the slave sensor were omitted. Four AA-size batteries fitted in the reflector head provided the power source. Consequently the weight of this unit was reduced to just 780g. Production of the SB-103 ceased in 1994 after the manufacture of just over 66,000 units. During 1998 Nikon became aware of a potentially

The SN-104 NiCd batteries power the SB-104.

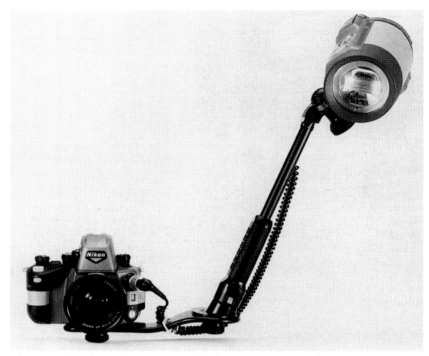

The camera bracket and extension arm for the SB-104 were modified to improve handling.

bracket and the SW-104W double arm bracket.

The last flash unit introduced for the Nikonos system was the SB-105, a successor to the earlier SB-103 this small compact unit, that weighs 780g above water, has a guide number of 11 (ISO100, m) under water and an angle of coverage for a 28mm lens. Fitting the SW-103 dif-

fuser increases the angle of coverage to accommodate a 15mm lens. It can be powered with either NiCd or alkaline batteries, and with the former can provide 45 full power flashes with a fast recycle time of just 4 seconds. It has an integral slave sensor, offers TTL and manual flash control, and is compatible with the Matrix metering fill-flash system of the RS.

Standard Nikon Speedlight units can be used with all Nikonos viewfinder models on land via either a TTL lead, or a terminal adaptor. The SC-17 TTL lead is equipped with an ISO type hot-shoe foot that can be attached to the camera's accessory shoe, and has TTL terminals of its own for use with the SC-18 and SC-19 leads to trigger multiple flash units, while the AS-15 terminal adaptor is fitted with the universal pin-cylinder (PC) sync-lead socket.

Following the news that Nikon have decided to discontinued production of the last Nikonos camera, the Nikonos V, due to relatively low sales volumes, the company stated that it would continue to supply accessories, including interchangeable lenses, Nikonos Speedlights, the close-up kit and other accessories until at least the end of 2002. At a later date, the company will decide whether or not to continue production of these accessories.

The SB-104 with its synchronization lead: the unit has a holder on the rear for the set of three flash exposure compensation charts for depths of 25m, 50m, and 100m.

Technical Data – Nikonos Cameras

Camera	Shutter Speeds	Shutter Control	Exposure Control	Film speed Range (ISO)	Viewfinder display	Sync Speed	Sync Terminal	TTL Flash	Weight (1) With 35mm f2.5	Dimensions (mm)
Calypso/ Nikonos I	1/20 –1/1000 B	m	M	-	-	M=1/20-1/1000 X=1/20-1/60	Nik. II	-	720 (255)	100x130x45
Nikonos II	1/20 – 1/1000 B	m	M	-	-	M=1/30-1/500 X=1/30-1/60	Nik. II	-	700 (250)	100x130x45
Nikonos III	1/30 – 1/1000 B	m	M	-	-	M=1/30-1/500 X=1/30-1/60	Nik. III	-	780 (270)	99x144x47
Nikonos IV A	1/30 – 1/1000 B	e	A; M90	25-1600	Exp. R	X= 1/90	Nik. III	-	800 (280)	99x149x58
Nikonos V	1/30 – 1/1000 B	e	A; M	25-1600	Exp. R, S	X=1/30- 1/90	Nik. III(2)	+	860 (300)	99x146x58
Nikonos RS (5)	1– 1/000	e	A; M	25-5000 DX 6-6400 Manual	Exp. R, S, AV, AF,Exp. Comp, Exp mode, ISO film speed	1s– 1/250	Nik. III (3)	+(4)	2060 (920)	196x151x85

(1) On land (under water)
 *m = mechanical; e = electrical
(2) Plus TTL contacts
 *M= Manual; A= Aperture Priority Automatic

(3) Slightly different dimensions with TTL contacts
 *Exp.= exposure
(4) Including Matrix-Balanced Fill Flash
 *R= Flash ready light

(5) Auto-focus, Matrix & Centre weighted metering
 *S= shutter speeds

Technical Data – Nikonos Speedlight Units

Flash Unit	SB-101	SB-102	SB-103	SB-104	SB-105
GN ISO 100/21º (land)	32	32	20	32	22
GN ISO 100/21º (water)	10/16	10/16	7/10	16	11
Focal length covered (mm) (1)	35	28	28	15	15
Focal length covered (mm) (2)	28	15	15	-	-
GN with diffuser on land	22	22	11	-	-
GN with diffuser in water	8/11	8/11	5/7	-	-
TTL flash control	-	Y	Y	Y	Y
Automatic aperture (3)	4+8	4+8	-	-	-
Flash duration full output	1/800	1/500	1/1500	1/1000	1/1500
Flash duration 1/4 output	1/3000	1/1400	1/5000	1/7000	1/5000
Flash duration 1/16 output	-	1/5500	1/16000	1/7000	1/16000
Recycle time (sec)	8	14	9	3	4
No. of full output flashes	150	120	130	120	130
Dimensions (mm) (D x W x H)	403x93x157	152x139x212	130x175x99	124 dia. x222	181x130x99
Weight (g)	2000	1670	780	1990	780

(1) By angle of illumination
(2) With diffuser
(3) With Sensor SU-101 at ISO 100

Technical Data – Nikonos Lenses

Lens	Angle of view (1)	Angle of view (2)	Elements/Groups	Minimum Focus (m)	Minimum Aperture	Filter Size (mm)	Case	Max R:R (3)	Max R:R (4)	Weight (g) (on land)	Opticalviewfinder	Dimensions (dia./ length) (mm)
UW 15mm f2.8	94°	-	9/5	0.3	22	-	-	-	-	310	-	90x80
UW 15mm f2.8N	94°	-	12/9	0.3	22	-	-	-	-	665	DF-11	93x90
UW 20mm f2.8	78°	-	9/7	0.4	22	67	-	-	-	350	DF-12	70x74
LW 28mm f2.8	-	74°	5/5	0.5	22	52	CL-51	-	-	240	-	68x57
UW 28mm f3.5	59°	-	6/5	0.6	22	58(5)	CL-50	1:6	-	175	DF-12	62x44
W 35mm f2.5	59°	62°	7/5	0.8	22	58(5)	CL-50	1:4.5	1:6.5	160	-	62x40
80mm f4	22°	30°	5/5	1.0	22	58(5)	CL-51	1:2.2	1:3	275	DF-10	62x66
R-UW AF 13mm f2.8	170°	-	10/9	0.14	22	-	-	1:5.22	-	970	-	126x94
R-UW AF 28mm f2.8	59°	-	6/6	0.26	22	88	-	1:6	-	550	-	99x85
R-UW AF 20-35mm f2.8	79-51°	-	10/9	0.38	22	148	-	1:10	-	1750	-	162x129
R-UW AF Micro-50mm f2.8	35°	-	10/9	0.167	22	88	-	1:1	-	1100	-	103x126

(1) Underwater

(2) On land

(3) With close-up attachment – underwater

(4) With close-up attachment – on land

(5) Underwater use a 52mm filter with rigid lens hood

The Coolpix Series

The Nikon introduced the Coolpix range of cameras to allow enthusiast and professional photographers alike access to the exciting possibilities of digital imaging.

Early Coolpix

Nikon had introduced the EM 35mm SLR camera model almost twenty years ago to broaden accessibility to the brand. In many ways history has repeated itself because the first Coolpix cameras, introduced during 1997, broke through the prohibitive cost barrier of early digital SLR cameras, which had prevented many photographers from embracing the emerging (digital imaging) technology.

Driven by the twin engines of consumer demand and marketing strategy the production of these cameras has been prolific. The Coolpix series has seen no less than twenty-three different models released in less than six years, of which only eight remain in current production. Mass produced digital cameras are ephemeral devices; a specification that is considered advanced by today's standards is often regarded as being rather modest within a matter of few months. As imaging technology marches inexorably forward manufacturers incorporate new features and functions with each model, and supporting software is constantly upgraded compounding the obsolescence of earlier cameras.

Coolpix 100

First announced at the PMA show in Las Vegas during 1997 this innovative camera was in many ways

ahead of its time. It was the first camera in the world designed to fit directly into a computer. The Coolpix 100 weighs just a160g and comprises two sections; the first houses the lens, an optical viewfinder, integral fixed flash unit, and two LCD panels. The top LCD displays camera setting information whilst the second located on the rear of the camera displays the image. The lens is a fixed focal length Nikkor 6.2mm f4 with an angle-of-view that corresponds to a 35mm lens. Behind the lens is a 1/3-inch Charged Coupled Device (CCD) sensor that has 330,000 pixels (photo-sites). The camera has a maximum resolution of 512 x 480 pixels and it stores images to a flash RAM card that is built-in to this section of the body.

The Coolpix 100 comprises of two component parts.

The Coolpix 100: a camera ahead of its time.

The second section forms the handgrip with the shutter release button located in the centre of the front panel. The batteries are also contained in this section. To download the images from the camera the two sections of the body are pulled apart and the upper section is then inserted into the PCMCIA slot of a computer. During the time of its production this ingenious design did not find any particular favour

and following its discontinuation Nikon had to heavily discount remaining stocks to dispose of them. It is only with hindsight that you fully appreciate its design and functionality set in the context of the period.

Coolpix 300

Introduced at the same time as the Coolpix 100 the Coolpix 300 represents the first fully multi-media device designed for photography. It is capable of making audio recordings and hand-written notes via a stylus that can be stored in the body of the camera. This function is similar to the many Personal Digital

The Coolpix 300 is a true multi-media device. You can take pictures with it, make audio recordings, and write notes on the LCD panel.

Organisers (PDAs) now available but like the Coolpix 100 it was highly innovative in its day.

The camera uses a fixed focal length Nikkor 6.2mm f4 lens to record images via a 1/3-inch CCD sensor that provides a maximum resolution of 640 x 480 pixels, onto

The telescopic stylus for writing on the Coolpix 300 LCD screen can be stowed on the camera body.

a flash RAM card. The Coolpix can record images at a maximum frequency of 1 'frame' per second. The large colour LCD monitor located on the rear of the camera is used for displaying the various camera function menus and viewing the lens image. It has a sliding cover to protect it when the camera is not in use. The optical viewfinder has a bright line frame with markings for parallax correction. Beside the

viewfinder are a built-in microphone for audio recording and a loudspeaker for listening to the recording. Alternatively you can connect a set of headphones to the built-in socket on the side. Handwritten notes made with the telescopic stylus are recorded digitally by 'writing' on the LCD screen surface. Images can be transferred to a computer via a serial connector.

Coolpix 600

The Coolpix 600 introduced even more refinements whilst adopting a rather less radical design compared to the Coolpix 100 and 300 models. In fact the Coolpix 600 could easily be mistaken for a point and shoot type film based compact camera.

The camera weighs 210g and has a fixed focal length Nikkor 5mm f2.8 lens. The lens can focus down to 50cm without using either of the two the Macro modes, which reduce the minimum focus distance to 27cm and 214cm respectively. The CCD sensor has a fixed sensitivity rating equivalent to an ISO100 film and a maximum resolution of 1024 x 768 pixels. Images can be viewed on a 2-inch Thin Film Transistor (TFT) LCD panel on the rear of the camera. The 600 is the first of the

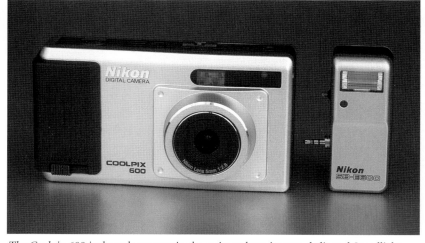

The Coolpix 600 is the only camera in the series to have its own dedicated Speedlight unit the SB-600.

Right:
The MF-10 back uses an analogue clock, date/counter unit, and hand written memo card, seen here partially inserted, to record data on to the film frame.

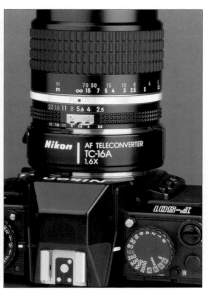

Left:
Bridging the transition from manual to automatic focusing: the F-501 was Nikon's first mass production AF SLR, and combined with the TC-16A allows a limited automatic focusing capability with manual focus Nikkor lenses.

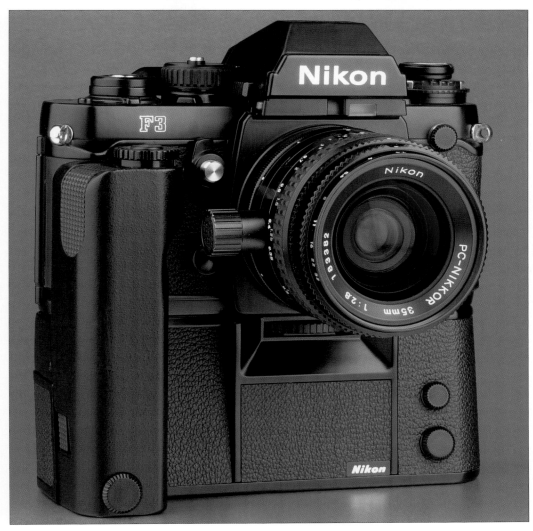

Left:
An F3 with MD-4 motor drive and PC-Nikkor 35mm f2.8 lens.

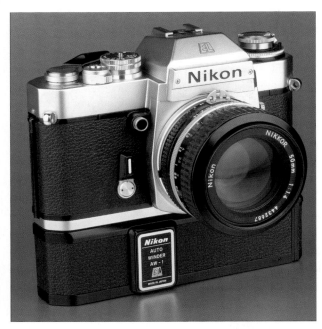

Left:
Automation Nikkormat style: an EL-2 camera with AW-1 auto-winder.

Right
The view beneath the prism head of an FE-2.

Below:
In its day the Nikon FG with MD-E auto winder provided a good level of automation at an affordable price.

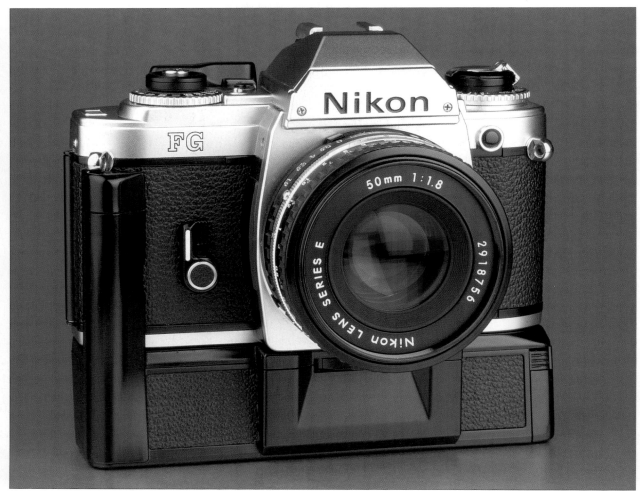

The Coolpix 600 sitting in its docking station from where images can be transferred to a computer and the camera can be charged.

can save image files as either Tagged Image File Format (TIFF) or JEPG files to Compact Flash card media. At the best resolution pictures can be captured at a maximum rate of 1.5 'frames' per second.

The auto focusing system has 127-step control, which can be switched between Normal AF and Macro mode, and there is a 10-step manual focus function. The camera also benefits from a far more sophisticated metering system with options for matrix, centre-weighted, and spot. Exposure is fully automatic and the shutter speed range runs from a full 8 seconds to 1/750sec. The shutter lag is also commendable short at 0.1 second. Unlike the Coolpix 600 the 700 has a built-in flash unit with a

fixed body type Coolpix cameras to store images to a Compact Flash card, and it uses the JPEG format.

The camera has an optical viewfinder, a shutter speed range of 1/4 – 1/2000, and offers a programmed auto-exposure system and auto-white balance control.

There are terminal sockets for a serial connection data cable, mains AC-power, and a dedicated docking station. The supplied flash unit, the Speedlight 600, is removable. It attaches to the left side of the camera body via a screw turned by a thumb wheel and electrical connection is made via a jack-pin and socket. The unit has a GN 7 (ISO100, m).

Coolpix 700

Each new Coolpix model brought incremental increases in specification and the Coolpix 700 was no exception. Continuing with the 35mm compact camera type of design it has a fixed focal length Nikkor 6.5mm f/2.8 lens that can focus down to just 9cm in the Macro mode. It has a maximum resolution of 1600 x 1200 pixels and

The Coolpix 700 with styling similar to a film compact camera.

The Compact Flash card port is located in the base of the Coolpix 700.

GN 7 (ISO100, m) with slow sync and red-eye reduction features.

Pictures can be reviewed on the 1.8-inch TFT LCD located on the rear of the camera, which shows approximate 97% of the full image. The Coolpix 700 offers either fully automatic white balance control, or five presets for Sunny, Cloudy, Incandescent, Fluorescent, and Flash. Connection to a computer is via a serial interface. Four AA size batteries power the Coolpix 700 and it has a very short start up time of just 2 seconds. Another new feature seen for the first time is the Best-Shot Selector (BBS) function that automatically selects the sharpest image from a consecutive sequence of images. Personally I doubt the worth of BBS as the sharpest shot may not always be the 'best' shot, and since post image manipulation can always help improve perceived sharpness I would rather make the decisions about which pictures to keep and which ones to discard!

At the same time as Nikon released the 700 they introduced the first optical lens adapters for the Coolpix series. They comprise the FC-E8 Fish-eye converter, the WC-E24 wide-angle adapter, and TC-E2 teleconverter (see the table at the end of this chapter for their specification and adapter ring requirements).

COOLPIX 800-SERIES

Coolpix 880

The 800-series Coolpix cameras carry on the evolutionary line from the Coolpix 600 and 700 models with their compact camera looks, diminutive size, which is quite distinct from the swivel-type Coolpix cameras.

The 880 has a 1/1.8-in CCD sensor that has a maximum resolution of 2048 x 1536 pixels. Files can be saved in the TIFF or JPEG format to

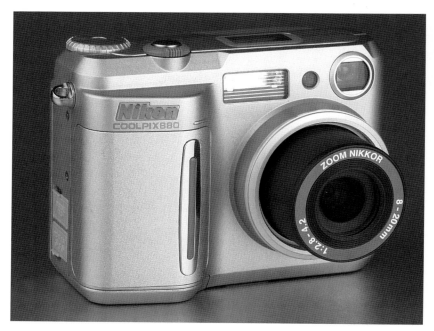

The diminutive Coolpix 880

The Li-ion EN-EL1 battery enhances performance of the Coolpix 880.

a Compact Flash card and the camera can be connected to a computer via a USB or serial interface. Its Zoom-Nikkor lens has a focal length range of 8 – 20mm f2.8 – 4.2, giving an angle of coverage equivalent to 38 – 95mm lens on the 35mm film format. Lens coverage can be extended further by use of the dedicated optical adapters and the appropriate UR-E2 adapter ring, although most of these will render the optical viewfinder useless as they obstruct it once mounted on the lens so you must resort to the LCD monitor to compose your picture.

The AF system in the Coolpix 880 has the five AF-area array similar to some AF-Nikon SLR cameras. If you opt to use the LCD monitor for focusing the Continuous AF Mode operates, whilst the camera sets Single AF Mode when the optical viewfinder is used. Alternatively this can be selected via the camera control menu. There is also a 48-step manual focus function with a focus confirmation feature.

The shutter speed range runs from 1/1000sec down to 8 seconds and there is a Bulb mode that can extend the exposure time to 60 seconds, although I cannot recommend this due to the excessive 'noise' level that is generated. Metering has the usual compliment of matrix, centre-

weighted, and spot as well as Spot AF. Exposure control can be programmed, shutter or aperture priority, and manual, with exposure compensation applied in increments of 1/3EV over +/-2EV. Exposure bracketing is available over 5EV steps in increments of +/-2/3EV. Sensitivity can be set to an ISO equivalent of 100, 200, and 400, or to an Auto function.

The optical viewfinder offers a rather restricted 80% view of the full image, however, the 1.8-inch TFT LCD colour monitor screen shows a rather more revealing 97%. The Coolpix 880 offers either fully automatic white balance control, or five presets for Sunny, Cloudy, Incandescent, Fluorescent, and Flash. The built-in flash, which is too close to the lens axis to avoid red-eye in virtually all shooting conditions, has unsurprisingly a red-eye reduction feature plus a slow-sync function. Either an EN-EL1 Li-ion rechargeable battery or a 6V 2CR5 Lithium cell provides power and for extended shooting the Coolpix 880 accepts the EH-21 main AC adapter.

Coolpix 885

The Coolpix 885, successor to the 880, arrived barely a year later. It has the same size CCD sensor and maximum resolution but a slightly wider range of focal lengths extended at the long end by 4mm. This gives it an equivalent coverage of 38 –114mm in the 35mm film format. The TFT LCD monitor is slightly smaller at 1.5-inch, which is a backward step in my opinion since the 1.8-inch monitors are hard enough to view effectively. All other principle specifications are the same as the Coolpix 880. The only new features found in the 885 are an automatic noise reduction system, which runs in the background all the time. The camera effectively takes two pictures when you release the shutter. One of

The size of the Coolpix 885 means that the controls are rather small.

The Coolpix 885

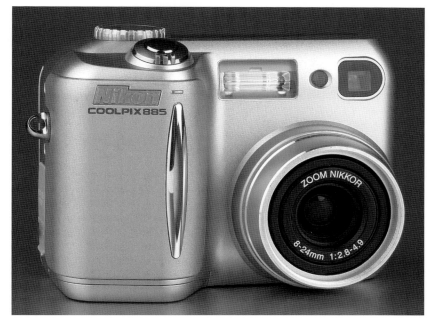

the full subject and the other with the shutter closed to record the residual 'dark noise'. The camera then compares the main image with a 'dark noise' exposure and subtracts the 'dark noise' values from the final image thereby reducing the level of overall 'noise'. The other useful feature added to the 885 is white balance bracketing. I say useful because the 885 is aimed squarely at the enthusiast photographer and this is an invaluable feature if you are willing to experiment to learn about, and ultimately understand, how this important control can affect your pictures.

COOLPIX 900-SERIES

Coolpix 900

The Coolpix 900 not only introduced some revolutionary technical specifications but also a ground breaking, innovative design. This is the first of the 'swivel and shoot' Coolpix cameras in which the lens is mounted in one half of the body that pivots around the other half that houses the TFT LCD so it can be orientated independently of the lens. This allows a photographer to place the camera in positions that would other wise make it difficult, if not impossible, to see the view seen by the lens.

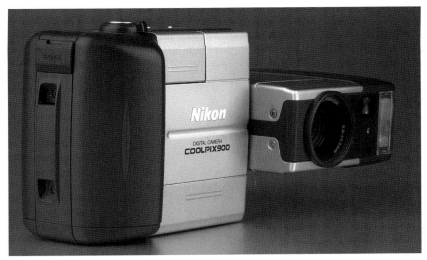

The first of the 'swivel and shoot' design in the Coolpix series; the 900 was a groundbreaking camera.

exposure modes, matrix, centre-weighted, and spot. Exposure compensation can be set +/-2EV in increments of 1/2EV. The Coolpix 900 offers either fully automatic white balance control, or five presets for Sunny, Cloudy, Incandescent, Fluorescent, and Flash. The built-in flash has a GN 9 (ISO100, m) and apart from Auto flash offers red-eye reduction and slow-sync functions. It is mounted in the same body section as the lens.

Coolpix 950

The second camera in the swivel and shoot type of Coolpix the 950 introduced some further refinements whilst maintaining the same maximum resolution of the earlier 900 model. The sensitivity of the CCD sensor was raised to an equivalent of ISO 80 with the option to manually override this to 100, 200, or 400 although noise levels do become increasingly visible at these higher ISO ratings. The focal length of the 3x zoom was increased slightly to 7 – 21mm f2.6 – 4. Whilst the AF system has no less than 4,746 steps for Normal AF and the Macro mode, which is over kill in my opinion given the tremendous depth-of-field afforded by the short focal lengths even at its widest aperture. There is also a 10-step manual focus option. Exposure compensation can be set over a range of +/-2EV but in increments of 1/3EV rather than 1/2EV. Metering and exposure control options are the same as for the Coolpix 900. As is the white balance control and specification of the built-in flash. The 950 makes use of the same BBS system seen in the Coolpix 700. One of the most notable features of the 950 is its use of a command wheel, similar to those used on Nikon film cameras, set just below the shutter release button that facilitates the setting of camera controls.

The technical innovation came as a result of this being the first compact digital camera in the world to combine a 3x Zoom-Nikkor lens with a CCD sensor that has a resolution of 1280 x 960 pixels (1.3Mp). The lens has a focal length range of 5.8 – 17.4mm, which corresponds to a 38-115mm lens on the 35mm film format, and an aperture range of f2.4-3.7. It can focus down to a minimum distance of between 8 – 50cm depending on the focal length. At the highest resolution the camera can record two images per second in

the JPEG file format and save them to a Compact Flash card. It can be connected to a computer via a serial interface. Pictures can be viewed on a 2-inch TFT LCD on the body section that carries the shutter release button and function buttons for setting camera controls.

The camera has a shutter speed range of 1/4 – 1/750sec, full auto focus with 945-step control and options for Normal AF, Fixed Infinity Focus, and Macro. The camera has a fixed ISO sensitivity equivalent to an ISO64 film, and three

The reliance of the Coolpix 900 on alkaline type batteries is a problem because of the power requirements of the camera. Their life is generally very short!

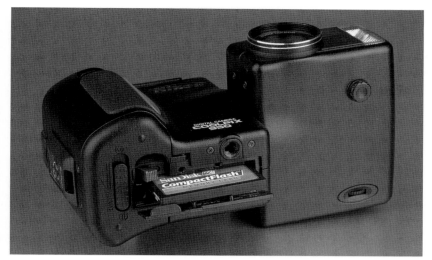

The card port on the Coolpix 950 is located in the base next to the tripod socket, which is not the best place for it to be if you need to change the card.

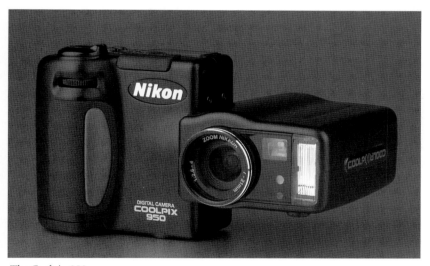

The Coolpix 950

Coolpix 990

There are many similarities between the 990 and the previous 950. The ISO sensitivity range is the same whether it is set automatically at ISO80, or overridden to 100, 200, or 400. The TFT LCD monitor is the same size but subjectively the Coolpix 990 screen is easier to see in bright light conditions. The 3x zoom range is retained but with slightly different focal lengths from 8 - 24mm, however, since the CCD sensor in the 990 is also slightly bigger the angle of view covered by the lens remains essentially the same. The built-in flash has the same specification and its close location to the lens, as with all the swivel and shoot Coolpix cameras, is a guaranteed recipe for severe cases of red-eye! The 990 has even more focusing steps than the 950 but as I commented above they really are no more than a marketing ploy since the effects of the tremendous depth of field means you will not perceive any focusing errors.

So why opt for the 990 over the 950. Well the 1600 x 1200 pixel reso-lution of the 950 is fine for producing prints up to 12.5 x 17.5cm and will be adequate at 20 x 25cm, how-ever, the 2048 x 1536 pixel resolu-tion of the 995 allows you to pro-duce good prints at this size and go to 27.5 x 35cm with out too much loss of quality. From a camera han-dling perspective the 990 has a few modifications that make life a little easier. The card port on the 950 is accessed via the base of the camera, which make changing cards when it is mounted on a tripod impossible! Nikon moved this port to the side on the 990. They also raised the top shutter speed to 1/1000sec, allowed more manual control of the flash unit, including the ability to set flash output compensation manual-ly. The last major improvement con-cerns battery life, which is distress-ingly short in the 950 but signifi-cantly longer with the 990.

Coolpix 995

The imminent release of the Coolpix 995 initially caused some excitement but this soon subsided when the apparently less than inspiring changes to the specifica-tion became known. It is only after closer examination of the camera and its results that the worth of this exercise can be appreciated. The top shutter speed has been lifted to 1/2300sec, and the long end of the zoom extended out to 32mm, which means it has the same coverage as a

The design of the Coolpix 995 draws much from Nikon's SLR cameras, including the use of a command wheel.

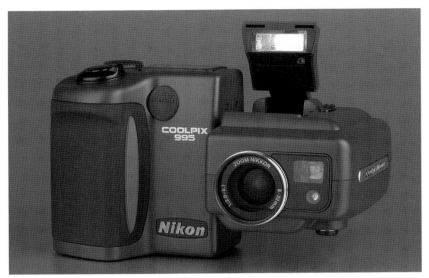

The Coolpix 995 with its pop-up flash extended.

38 – 152mm lens on the 35mm film format. The fixed flash no longer resides next to the lens but pops up from the top of the lens half of the body and the flash TTL sensor has made the same migration. Battery life issues with the 950 and 990 are largely laid to rest as the 995 uses the very efficient rechargeable EN-EL1 Lithium-ion battery. The card port has been modified to accept Type-II cards which means you can load IBM Microdrives, although Nikon do not official support their use in the Coolpix due to issues of overheating and the potential this has for causing damage. A post prevents the pivoting lens section going past 90°, the white balance has a bracketing feature, and there is a new 'noise' reduction function that subtracts a dark noise exposure from long exposures to remove the effects of background 'noise'.

Where I believe the 995 scores over the previous 900-series cameras, particularly the 990, is in the improvement to overall image quality. The noise reduction feature works extremely well and I suspect that tweaks to the firmware are responsible for better colour saturation and fidelity.

COOLPIX 4000-SERIES

Coolpix 4300

Nikon have continued with an ultra-compact, non-swivelling lens design by introducing the Coolpix 4300, which picks up from where the Coolpix 885 finished.

The 4300 has a 1/1.8-in CCD sensor that has a maximum resolution of 2272 x 1704 pixels. Files can be saved in the TIFF or JEPG format to a Compact Flash card and the cam-

era can be connected to a computer via a USB interface. Its Zoom-Nikkor lens has a focal length range of 8 – 20mm f2.8 – 4.9, giving an angle of coverage equivalent to 38 – 95mm lens on the 35mm film format. Lens coverage can be extended further by use of the dedicated optical adapters and the appropriate UR-E4 adapter ring, although most of these will render the optical viewfinder useless as they obstruct it once mounted on the lens so you must resort to the LCD monitor to compose your picture.

The AF system in the Coolpix 4300 offers the same specification as the 885 with a five AF-sensor array and user selectable Spot AF. If you opt to use the LCD monitor for focusing the Continuous AF Mode operates, whilst the camera sets Single AF Mode when the optical viewfinder is used. Alternatively this can be selected via the camera control menu. There is also a 49-step manual focus function with a focus confirmation feature. At the shortest focal length the lens will focus to 30cm, and 60cm at the longest end. In the Macro mode it gets down to just 4cm so take care not to bump

The Coolpix 4300 and TC-E2 teleconverter

A rear view of the Coolpix 4300

Coolpix 4500

The Coolpix 4500 represent the latest incarnation of the swivel and shoot type camera, which began with the Coolpix 900. As the immediate successor to the Coolpix 995 this camera has a 4.13 Megapixel CCD sensor with a maximum resolution of 2272 x 1704 pixels and can save images in either the TIFF or JEPG format. The Zoom-Nikkor lens has a focal length range of 7.85 – 32mm giving an angle of coverage equivalent to a 38 – 155mm lens on the 35mm format. The AF system can focus down to 50cm in Normal mode and just 2cm in Macro mode.

Metering modes comprise the familiar matrix, centre-weighted, and spot, whilst exposure control includes Programmed Auto, Aperture and Shutter speed Priority, plus Manual. Exposure compensation can be applied in 1/3EV steps over +/-2EV and there is an auto-bracketing exposure function. The top shutter speed is the same as its predecessor at 1/2300sec going all the way down to 8 seconds, which can be extended to a maximum of 5 minutes using the Bulb setting – just be aware of the detrimental effect of 'noise' at these long exposure times,

the front of the lens into your subject!

The shutter speed range runs from 1/1000sec down to 8 seconds and there is a Bulb mode that can extend the exposure time to 60 seconds. Metering has the usual compliment of matrix, centre-weighted, and spot as well as Spot AF. Exposure control can be programmed, shutter or aperture priority, and manual, with exposure compensation applied in increments of 1/3EV over +/-2EV. Exposure bracketing is available over 5EV steps in increments of +/-2/3EV. Sensitivity can be set to an ISO equivalent of 100, 200, and 400, or to an Auto function. If you tire of shooting still images the 4300 allows you to shoot video clips up to 40 seconds in duration.

The optical viewfinder offers a similarly restricted 80% view of the full image, however, the 1.5-inch TFT LCD colour monitor screen shows the same 97% coverage. The Coolpix 4300 offers either fully automatic white balance control, or five presets for Sunny, Cloudy, Incandescent, Fluorescent, and Flash. Again the built-in flash is only

just above the lens axis to red-eye is virtually assured! A red-eye reduction feature is incorporated accordingly. There is also a slow-sync function for those occasions when you want the ambient light to combine with the flash output to contribute to the overall exposure. Despite its somewhat dubious value the Best Shot Selector feature is also included. Power is supplied from an EN-EL1 Li-ion rechargeable battery or alternatively the EH-53 AC adapter.

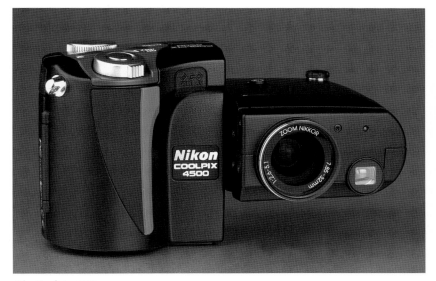

The Coolpix 4500

A rather unconventional profile for a camera but this Coolpix 4500 has a hood over its LCD monitor to facilitate viewing, and a wide-angle adaptor fitted to the lens.

The SL-1 Macro Cool-light on the Coolpix 4500

even allowing for the very effective 'noise reduction feature'.

The camera has an optical viewfinder and pop-up flash mounted in the same portion of the body as the lens. Be aware that the viewfinder offers a very modest 80% coverage of the full frame area so do not be surprised if you see a lot more in your picture when you review it using the rather petite 1.5-inch TFT LCD that shows 97% of the full image. All menu-based functions are accessed via this screen, as are digital controls like in-camera sharpening, colour, and tone control.

The EN-EL1 Li-ion battery, which Nikon claim will provide enough

A view of the LCD monitor on the Coolpix 4500

energy for over one-and-half hours of continuous use, powers the camera.

A true system camera the Coolpix 4500 can accept no less than five optical lens adapters, the Macro Cool-light, and additional Nikon Speedlights via the 3-pin multiple flash terminal.

COOLPIX 5000-SERIES

Coolpix 5000

The Coolpix 5000 is the first camera in the new, 'top set' of the Coolpix series. Its introduction was seen as the culmination of the experiences and lessons learned over several generations of compact digital cameras, during which there was a steady increase in resolution allied to the development of useful features and functions.

The specification to the Coolpix 5000 is impressive. It boasts 5 million effective (image forming) pixels on a 2/3-inch CCD sensor with a maximum resolution of 2560 x 1920 pixels. Images can be saved as TIFF or JPEG files and the camera will support both Type I & II Compact Flash cards as well as 512Mb/1Gb IBM Microdrives. The Coolpix 5000 has the ability to capture frames at 3fps for a maximum of 3 frames, or shoot at the lower rate of 1.5fps. A 3x Zoom-Nikkor lens that has a focal length of 7.1 – 21.4mm f2.8-4.8 that covers the same field as a 28-85mm lens on the 35mm film format. For further versatility the camera accepts virtually all the Coolpix optical lens adapters with the appropriate UR-E type of adapter ring.

If you opt to use the LCD monitor for focusing the Continuous AF Mode operates, whilst the camera sets Single AF Mode when the optical viewfinder is used. Alternatively this can be selected via the camera control menu. There is also a 50-

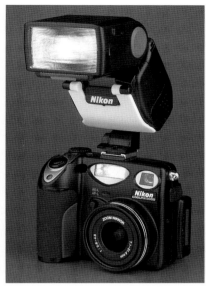

*The Coolpix 5000 with supplementary
SB-50DX Speedlight unit*

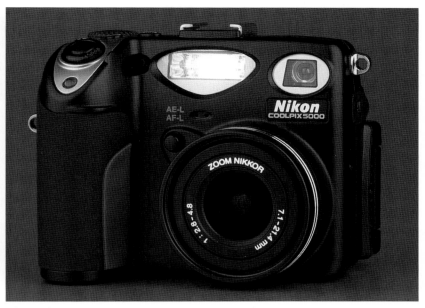

The Coolpix 5000

step manual focus function with a focus confirmation feature. The lens will focus to 50cm at all focal lengths and down to an incredibly close 2cm in the macro mode. The 1.8-inch TFT LCD colour monitor shows 97% of the total image area whilst there is also an optical viewfinder with built-in dioptre adjustment.

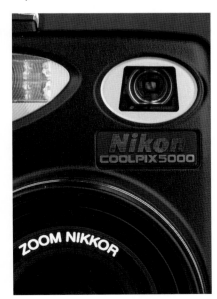

*A close up view of the optical viewfinder
on the Coolpix 5000*

The shutter speed range depends on the exposure mode you select; in Program and Aperture Priority it runs from 1/4000 to 1 second, however, in Shutter priority and Manual it is slightly more restricted at 1/2000 to 1 second. There is also a Bulb setting with a limit of five minutes. Short video clips with audio of up to 60 seconds duration can also be recorded. The camera has matrix, centre-weighted, and spot metering as well as Spot AF feature. Exposure compensation can be made over +/-2EX steps in increments of 1/3EV and auto exposure bracketing can be applied over either three or five frames within a range of +/-2EV. The Coolpix 5000 offers fully automatic white balance control, five manually selected values for Sunny, Cloudy, Incandescent, Fluorescent, and Flash, and a preset option. There is also white balance bracketing.

The built-in flash unit has a GN 10 (ISO100, m) but being so close to the axis of the lens axis hamstrings its performance producing flat frontal lighting. This unit is best used for modest amounts of fill-

flash. Due to the high risk of red-eye a reduction feature is incorporated accordingly. There is also a slow-sync function for those occasions when you want the ambient light to combine with the flash output to contribute to the overall exposure. As the Coolpix has a standard ISO flash hotshoe, and is fully compatible with the Nikon Speedlight range of flash units, there are other ways of achieving a greater versatility with flash lighting. The Best Shot Selector feature is also included. Power is supplied from an EN-EL1 Li-ion rechargeable battery or alternatively the MB-E5000 battery pack that attaches to the base plate of the camera in a similar way to the MB-D100 for the D100 digital SLR. A third power option is the EH-21 mains AC/EN-EL1 battery charger unit.

Despite its glowing specification the Coolpix 5000 did not enjoy a particularly happy time during its relatively short two-year life. Discontinued following the announcement of the Coolpix 5400 it suffered from a reputation of poor optical quality. Photographers com-

plained of unsharp images blighted by chromatic aberrations, which manifests as colour fringes. It is particularly prominent around areas of high frequency change between tones, or different colour.

Coolpix 5400

Introduced as the replacement for the Coolpix 5000 the Coolpix 5400 has a number of small but potentially important advantages/disadvantages. The focal length range is extended to 5.8 – 24mm f2.8-4.6 that covers the same field as a 28-116mm lens on the 35mm film format. The Coolpix 5400 sees the introduction of two new optical adapters the FC-E9 Fisheye converter and the TC-15E ED teleconverter, and there are also new UR-E type adapter rings.

The CCD sensor has a higher pixel count at 5.26Mp with a maximum resolution of 2592 x 1944 pixels. However, the TFT LCD monitor screen has been reduced to 1.5-inch but offers a 100% view on play back mode. For shooting fast paced action the camera's buffer has been expanded so that it can now sustain a sequence of seven frames at 3fps in the Continuous High mode, or eighteen frames at 1.5fps in the continuous Low mode. The ISO equivalent sensitivity has been reduced to 50, with options to manually select 100, 200, 400, and Auto. Otherwise functions and features are broadly similar to the Coolpix 5000. Including power options such as the EN-EL1 Li-ion battery and EH-53 main AC adapter/battery charger. One new feature in the options for capture image is the time lapse movie mode, which records images at fixed intervals of 30sec, or 1, 5, 10, 30, or 60 min., and then converts them into a Motion JPEG stream played back at a rate of 30 fps. Great fun if you have the time!

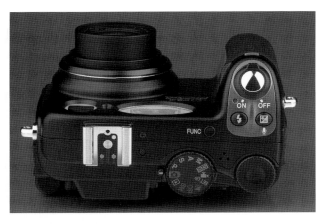

A view of the top plate of the latest Coolpix 5400

The Coolpix 5400

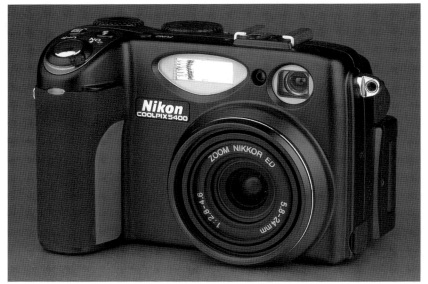

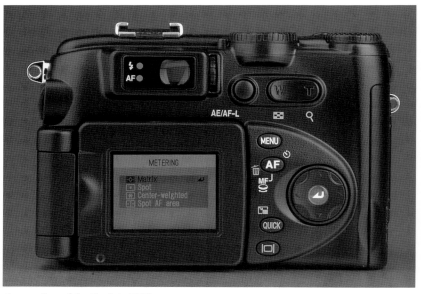

A rear view of the Coolpix 5400

Coolpix 5700

Introduced during 2002 the Coolpix 5700 is currently the 'flagship' model in the series and its specification is impressive. It has five million effective (image forming) pixels on a 2/3-inch CCD sensor that produce a maximum resolution of 2560 x 1920 pixels. Images can be saved as TIFF or JPEG files and the camera will support both Type I & II Compact Flash cards as well as 512Mb/1Gb IBM Microdrives. The Coolpix 5700 has the ability to capture frames at 3fps for a maximum of 3 frames, or shoot at the lower rate of 1.5fps. A 8x Zoom-Nikkor lens that has a focal length of 8.9 – 71.2mm f2.8-4.2 that covers the same field as a 35-280mm lens on the 35mm film format. For further versatility the camera accepts the Coolpix WC-E80 wide-angle and TC-E15ED teleconverter adapters with the appropriate UR-E8 adapter ring.

If you opt to use the LCD monitor for focusing the Continuous AF Mode operates, whilst the camera sets Single AF Mode when the optical viewfinder is used. Alternatively this can be selected via the camera control menu. There is also a 64-step manual focus function with a focus confirmation feature. The lens will focus to 50cm at all focal lengths and down to an incredibly close 3cm in the macro mode. The 1.5-inch TFT LCD colour monitor shows 100% of the total image area when reviewing images but only 97% when viewing to compose prior to capture. The most significant difference with the Coolpix 5700 is the use of an electronic viewfinder. This shows the same level of coverage as the LCD monitor.

The shutter speed range runs from 1/4000 to 8 seconds and there is also a Bulb setting with a limit of five minutes. Short video clips with audio of up to 60 seconds duration

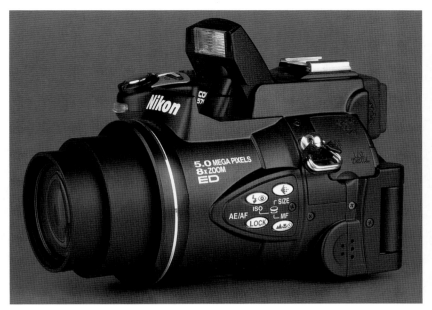

The Coolpix 5700

can also be recorded. The camera has matrix, centre-weighted, and spot metering as well as Spot AF feature. Exposure compensation can be made over +/-2EV steps in increments of 1/3EV and auto exposure bracketing can be applied over either three or five frames within a range of +/-2EV. The Coolpix 5700 offers fully automatic white balance control, five manually selected values for Sunny, Cloudy, Incandescent, Fluorescent, and Flash, and a preset option. There is also white balance bracketing.

The built-in flash unit has a GN 10 (ISO100, m) and is located above the lens. It pops up automatically if the camera determines that it is needed but can be overridden manually if required. It has a red-eye reduction feature and a slow-sync function for those occasions when you want the ambient light to combine with the flash output to contribute to the overall exposure. As the Coolpix has a standard ISO flash hotshoe, and is fully compatible with the Nikon Speedlight range of flash units. The Best Shot Selector feature is also included. Power is

supplied from an EN-EL1 Li-ion rechargeable battery or alternatively the MB-E5700 battery pack that takes 6 AA size batteries can be attached to the base plate of the camera in a similar way to the MB-D100 for the D100 digital SLR. A third power option is the EH-21 mains AC/EN-EL1 battery charger unit.

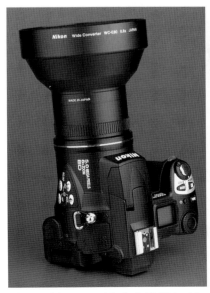

The Coolpix 5700 with the WC-E80 wide-angle adapter

Coolpix Series – (Compact models)

Model	600	700	880	885	4300
Focal length (mm)	5.0	6.5	8.0 – 20.0	8.0 – 24.0	8.0 – 24.0
Zoom ratio	N/A	N/A	X2.5	X3	X3
Digital-zoom (maximum)	N	N	X4	X4	X4
Maximum Aperture (f/)	2.8	2.6	2.8 – 4.2	2.8 – 4.9	2.8 – 4.9
Elements/Groups	N/K	5/4	9/7	9/8	9/8
Shutter Speeds (sec)	1/2000- 1/4	1/750 - 8	1/1000 – 8	1/1000 - 8,+ B	1/1000 - 8,+ B
Shutter Type	Elec	Elec	Elec	Elec	Elec
Exposure mode	Auto program	Auto program	Ma Ap P	Ma P	Ma P
Metering Range (EV) ISO100	N/K	-2 – 15.5	0 – 16.0(W) 1.2 –17.2(T)	-3.0 – 15.0(W) 1.4 – 16.6(T)	-3.0 – 15.0(W) 1.4 – 16.6(T)
Metering pattern	CW	Matrix CW Spot	Matrix CW Spot	Matrix CW Spot	Matrix CW Spot
Sensitivity (ISO)	N/K	80	100 – 400	100 – 400	100 – 400
File formats	JPEG	TIFF JPEG	TIFF JPEG	TIFF JPEG	TIFF JPEG
Storage Media	CF	CF	CF	CF	CF
Viewfinder type	Optical	Optical	Optical	Optical	Optical
LCD monitor	2-in	1.8-in	1.8-in	1.5-in	1.5-in
Flash GN (ISO100, m)	7	7	9	9	9
Flash terminal	SB-600	N	N	N	N
Flash ready light	Y	Y	Y	Y	Y

Model	600	700	880	885	4300
CCD size	1/2.7-in	1/2-in	1/1.8-in	1/1.8-in	1/1.5-in
Resolution - pixels (Effective)	1024 x 768	1600 x 1200	2048 x 1536	2048 x 1536	2272 x 1704
Battery	LR6 (2x)	LR6 (2x)	EN-EL1	EN-EL1	EN-EL1
Self timer	Y Elec	Y Elec	Y Elec	Y Elec	Y Elec
Interface	Serial	Serial	USB Serial	USB	USB
Accessory Shoe	N	N	N	N	N
Weight (g)	210	270	275	225	225
Dimensions (HxWxD) in (mm)	60.0x109.5x 44.5	67.0x114.0x38.5	75.0x99.5x53.2	69.0x95.0x52.0	69.0x95.0x52.0

Coolpix Series – (Swivel and Shoot models)

Model	900	950	990	995	4500
Focal length (mm)	5.8 – 17.4	7.0 – 21.0	8.0 – 24.0	8.0 – 32.0	7.85 – 32
Zoom ratio	X3	X3	X3	X4	X4
Digital-zoom (maximum)	N	X2.5	X4	X4	X4
Maximum Aperture (f/)	2.4 – 3.6	2.6 – 4	2.5 – 4	2.6 – 5.1	2.6 – 5.1
Elements/Groups	9/7	9/7	9/8	10/8	10/8
Shutter Speeds (sec)	1/750 - 1/4	1/750 - 8	1/1000 – 8	1/2300 - 8,+ B	1/2300 - 8,+ B
Shutter Type	Elec	Elec	Elec	Elec	Elec
Exposure mode	Auto Custom	Auto Custom	Ma Ap Sh P	Ma Ap Sh P	Ma Ap Sh P
Metering Range (EV) ISO100	4.5 – 16(W)	-2 – 15.5(W)	-2 – 15.5(W)	-2.2 – 17.0(W)	-2.2 – 17.0(W)
	5.8 – 17(T)	-0.8 – 16.7(T)	-0.8 – 16.7(T)	-0.3 – 18.1(T)	-0.3 – 18.1(T)
Metering pattern	Matrix CW Spot	Matrix CW Spot	Matrix CW Spot	Matrix CW Spot	Matrix CW Spot
Sensitivity (ISO)	64	80	100 – 400	100 – 800	100 – 800
File formats	JPEG	TIFF JPEG	TIFF JPEG	TIFF JPEG	TIFF JPEG
Storage Media	CF	CF	CF	CF	CF
Viewfinder type	Optical	Optical	Optical	Optical	Optical
LCD monitor	2-in	2-in	1.8-in	1.8-in	1.5-in
Flash GN (ISO100, m)	9	9	9	10	10
Flash terminal	Y	Y	Y	Y	
Flash ready light	Y	Y	Y	Y	Y

Model	900	950	990	995	4500
CCD size	1/2.7-in	1/2-in 15.6	1/1.8-in	1/1.8-in	1/1.8-in
Resolution - pixels (Effective)	1280 x 960	1600 x 1200	2048 x 1536	2048 x 1536	2272 x 1704
Battery	LR6 (4x)	LR6 (4x)	LR6 (4x)	EN-EL1	EN-EL1
Self timer	Y Elec	Y Elec	Y Elec	Y Elec	Y Elec
Interface	Serial	Serial	USB Serial	USB	USB
Accessory Shoe	N	N	N	N	N
Weight(g)	360	350	370	390	360
Dimensions (HxWxD) in (mm)	75.0x157.0x 35.0	76.5x143.0x36.5	79.0x149.0x38.0	82.0x138.0x40.0	73.0x130.0x50.0

Coolpix Series – (compact models – 5000 series)

Model	5000	5400	5700
Focal length (mm)	7.1 – 21.4	5.8 – 24.0	8.9 – 71.2
Zoom ratio	X3	X4	X8
Digital-zoom (maximum)	X4	X4	X4
Maximum Aperture (f/)	2.8 – 4.8	2.8 – 4.6	2.8 – 4.2
Elements/Groups	9/7	9/8	14/10
Shutter Speeds (sec)	1/4000 – 8	1/4000 - 8,+ B	1/4000 - 8,+ B
Shutter Type	Elec	Elec	Elec
Exposure mode	Ma Ap Sh P	Ma Ap Sh P -	Ma Ap Sh P
Metering Range (EV) ISO100	2.0 – 18.0(W)-0.5 – 17.(T)	1.0 – 18.0(W) 0.5 – 18.0(T)	-2.0 – 18.0(W)-0.5 – 18.0(T)
Metering pattern	Matrix CW Spot	Matrix CW Spot	Matrix CW Spot
Sensitivity (ISO)	100 – 800	50 – 400	100 – 800
File formats	TIFF JPEG	TIFF JPEG	TIFF JPEG
Storage Media	CF	CF	CF
Viewfinder type	Optical	Optical	Electronic
LCD monitor	1.8-in	1.5-in	1.5-in
Flash GN (ISO100, m)	10	10	10
Flash terminal	N	N	N
Flash ready light	Y	Y	Y

Model	5000	5400	5700
CCD size	2/3-in	1/1.8-in	2/3-in
Resolution - pixels (Effective)	2560 x 1920	2592 x 1944	2560 x 1920
Battery	EN-EL1	EN-EL1	EN-EL1
Self timer	Y Elec	Y Elec	Y Elec
Interface	USB	USB	USB
Accessory Shoe	Y	Y	Y
Weight (g)	360	320	480
Dimensions (HxWxD) in (mm)	81.5x101.5x67.5	73.0x108.0x69.0	76.0x108.0x102.0

Coolpix Accessories – Lens Adapter/Adapter ring

Lens Adapter	FC-E8	FC-E9	WC-E24	WC-E63	WC-E68	WC-E80	TC-E15ED	TC-E2	TC-E3ED
Power	X0.21	X0.20	X0.66	X0.63	X0.68	X0.8	X1.5	X2	X3
700	UR-E1	N	UR-E1	UR-E1	UR-E1 + UR-E7	N	N	UR-E1	UR-E1
775	N	N	UR-E3	UR-E3	UR-E3 + UR-E7	N	N	UR-E3	N
800	Y	N	Y	Y	UR-E7	N	N	Y	Y
880	UR-E2	N	UR-E2	UR-E2	UR-E2 + UR-E7	N	N	UR-E2	UR-E2
885	UR-E4	N	UR-E4	UR-E4	UR-E4 + UR-E7	N	N	UR-E4	UR-E4
900	Y	N	Y	Y	UR-E7	N	N	Y	Y
950	Y	N	Y	Y	UR-E7	N	N	Y	Y
990	Y	N	Y	Y	UR-E7	N	N	Y	Y
995	Y	N	Y	Y	UR-E7	N	N	Y	Y
4300	UR-E4	N	UR-E4	UR-E4	UR-E4 + UR-E7	N	N	UR-E4	UR-E4
4500	Y	N	Y	Y	UR-E7	N	N	Y	Y
5000	Y	N	N	N	UR-E5	N	N	UR-E6	UR-E6
5400	UR-E6	UR-E10	N	N	N	UR-E9	UR-E9	N	N
5700	N	N	N	N	N	UR-E8	UR-E8	N	N

Coolpix Accessories – Compatibility

Accessory	HN-E5000	HR-E5700	HL-E5000	HL-E885	HL-CP10	ES-E28	SL-1	SK-E900	MC-EU1	UC-E1
Description	Lens hood	Lens hood	Monitor hood	Monitor hood	Monitor hood	Slide copying adapter	Macro light	Speedlight bracket	Remote lead	USB lead
700	N	N	N	N	N	UR-E1	N	N	N	N
775	N	N	N	N	N	N	N	N	N	N
800	N	N	N	N	N	Y	N	N	N	N
880	N	N	N	N	N	UR-E2	UR-E2	N	Y	Y
885	N	N	N	Y	N	UR-E4	UR-E4	N	Y	Y
900	N	N	N	N	N	Y	Y	N	N	N
950	N	N	N	N	N	Y	Y	N	N	N
990	N	N	N	N	N	Y	Y	Y	N	N
995	N	N	N	N	N	Y	Y	Y	Y	N
4300	N	N	N	N	N	UR-E4	UR-E4	N	Y	Y
4500	N	N	N	N	Y	Y	Y	Y	Y	Y
5000	Y	N	Y	N	N	UR-E6	UR-E6	N	Y	Y
5400	N	N	N	N	N	UR-E11	N	N	Y	Y
5700	N	Y	N	N	N	N	N	N	Y	Y

Coolpix Battery Requirements & Battery Chargers

Power source	Battery	AC Adapter/ Charger	EH-21	EH-30	EH-31	EH-53	Battery Charger	MH-50	MH-53	MH-53C	Battery pack	MB-E5000	MB-E5700
Rating		Rating	100-240V AC			100-240V AC	Rating	100-240V AC	100-240V AC	12V DC	Rating	9V DC	9V DC
700	LR6 (x4)	700	N	N	N	N	700	N	N	N	700	N	N
775	EN-EL1	775	Y	N	N	Y	775	Y	Y	Y	775	N	N
800	LR6 (x4)	800	N	N	N	N	800	N	N	N	800	N	N
880	EN-EL1	880	Y	N	N	Y	880	Y	Y	Y	880	N	N
885	EN-EL1	885	Y	N	N	Y	885	Y	Y	Y	885	N	N
900	LR6 (x4)	900	N	N	N	N	900	N	N	N	900	N	N
950	LR6 (x4)	950	N	N	N	N	950	N	N	N	950	N	N
990	LR6 (x4)	990	Y	N	N	N	990	N	N	N	990	N	N
995	EN-EL1	995	Y	N	N	Y	995	Y	Y	Y	995	N	N
4300	EN-EL1	4300	Y	N	N	Y	4300	Y	Y	Y	4300	N	N
4500	EN-EL1	4500	Y	N	N	Y	4500	Y	Y	Y	4500	N	N
5000	EN-EL1	5000	Y	N	Y	Y	5000	Y	Y	Y	5000	LR6 (x6)	N
5400	EN-EL1	5400	Y	N	N	Y	5400	Y	Y	Y	5400	N	N
5700	EN-EL1	5700	Y	Y	N	Y	5700	Y	Y	Y	5700	N	LR6 (x6)

Coolpix Tables:

Y = Available / Fitted

N = Not Available / Not Fitted

Exposure Made:

Ma = Manual

Ap = Aperture Priority

Sh = Shutter Priority

P = Program

Appendix

The following sections contain comprehensive data and technical specifications on Nikon cameras, lenses, flash units, and accessories for close-up/macro photography, including information concerning battery requirements, a guide to Nikon product codes, together with an index.

Nikon Camera Data
Nikon Lens Data
Nikon Speedlight Data
Nikon Close-up/Macro Accessory data
Nikon Software
Battery – Types/Designations/Requirements
Nikon Product Codes
Index

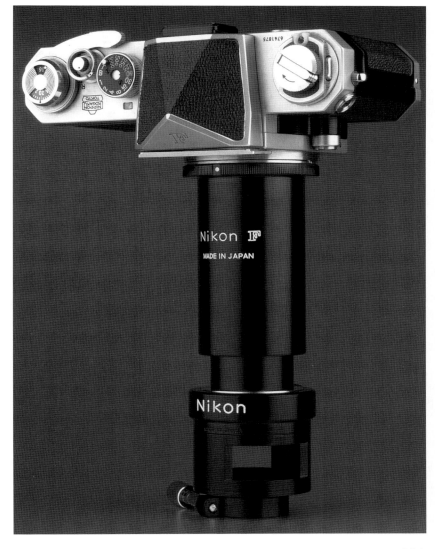

A Nikon F camera mounted on a Model II Microscope Adapter

Nikon Cameras - Professional F (Manual Focus) Series

Model	Bayonet	Shutter travel	Shutter Speeds	Shutter Type	Exposure mode	Metering Range (EV) ISO100 f/1.4	Metering pattern	Metering display	ISO range	Changeable viewfinder	Viewfinder display	Viewfinder coverage	Eye piece shutter	Flash sync. speed	PC socket	Flash ready light	Flash sync. contacts	ISO range TTL flash control
F	Pre - Ai	H	1/1000-1s, B, T	Mech	Ma	N/A	N/A	N	N/A	Y	N/A	100%	N	1/60	Y	N/A	X, M	N/A
F Photomic	Pre - Ai	H	1/1000-1s, B, T	Mech	Ma	3-17	External	Needle	25-6400	Y	A, S, M	100%	N	1/60	Y	N/A	X, M	N/A
F Photomic T	Pre - Ai	H	1/1000-1s, B, T	Mech	Ma	2-17	Universal	Needle	25-6400	Y	A, S, M	100%	N	1/60	Y	N/A	X, M	N/A
F Photomic TN	Pre - Ai	H	1/1000-1s, B, T	Mech	Ma	2-17	60:40	Needle	25-6400	Y	A, S, M	100%	N	1/60	Y	N/A	X, M	N/A
F Photomic FTN	Pre - Ai	H	1/1000-1s, B, T	Mech	Ma	2-17	60:40	Needle	6-6400	Y	A, S, M	100%	N	1/60	Y	N/A	X, M	N/A
F2	Pre - Ai	H	1/2000-10s, B, T, x1/80	Mech	Ma	N/A	N/A	N	N/A	Y	R	100%	N	1/80	Y	Y	X	N/A
F2 Photomic	Pre - Ai	H	1/2000-10s, B, T, x1/80	Mech	Ma	1-17	60:40	Needle	6-6400	Y	A, S, M, R	100%	N	1/80	Y	Y	X	N/A
F2 S Photomic	Pre - Ai	H	1/2000-10s, B, T, x1/80	Mech	Ma	-2-17	60:40	LED	12-6400	Y	A, S, M, R	100%	N	1/80	Y	Y	X	N/A
F2 SB Photomic	Pre - Ai	H	1/2000-10s, B, T, x1/80	Mech	Ma	-2-17	60:40	LED	12-6400	Y	A, S, M, R	100%	N	1/80	Y	Y	X	N/A
F2 A Photomic	Pre - Ai	H	1/2000-10s, B, T, x1/80	Mech	Ma	1-17	60:40	Needle	6-6400	Y	A, S, M, R	100%	N	1/80	Y	Y	X	N/A
F2 AS Photomic	Pre - Ai	H	1/2000-10s, B, T, x1/80	Mech	Ma	-2-17	60:40	LED	12-6400	Y	A, S, M, R	100%	N	1/80	Y	Y	X	N/A
F2 H	Ai	H	1/1000-1s	Mech	Ma	N/A	N/A	N/A	N/A	Y	R	100%	N	1/80	Y	Y	X	N/A
F3, F3 HP, F3 T	Ai	H	1/2000-8s, B, T, x1/80	Elec	Ma, Ap	1-18	80:20	LCD	12-6400	Y	A, S, M, R	100%	Y	1/80	Y	Y	X	25-400
F3 P	Ai	H	1/2000-8s, B, T, x1/80	Elec	Ma, Ap	1-18	80:20	LCD	12-6400	Y	A, S, M, R	100%	Y	1/80	Y	Y	X	25-400
F3 H	Ai	H	1/2000-8s, B, T, x1/80	Elec	Ma, Ap	1-18	80:20	LCD	12-6400	Y	A, S, M, R	100%	Y	1/80	Y	Y	X	25-400
F3 AF	AF[1]	H	1/2000-8s, B, T, x1/80	Elec	Ma, Ap	1-18	80:20	LCD	12-6400	Y	A, S, M, R, F	100%	Y	1/80	Y	Y	X	25-400

Nikon Cameras - Professional F (Manual Focus) Series

Model	Dimensions (HxWxD) in (mm)	Weight (g)	Focus tracking	AF sensor	Minimum lens aperture for AF	AF sensitivity Range (EV) ISO100	Changeable focusing screen	Accessory Shoe	Motor drive	Changeable camera back	Film Rewind	Film Advance	Cable release	Self timer	DoF Preview	Mirror lock-up
F	98.0x147.0x56.0	685	N/A	N/A	N/A	N/A	Y(Type –A – R)	F type	F-36	Y	Crank	Lever	Leica-thread	Mech	Y	Y
F Photomic	102.0x147.0x67.0	830	N/A	N/A	N/A	N/A	Y(Type –A – R)	F type	F-36	Y	Crank	Lever	Leica-Thread	Mech	Y	Y
F Photomic T	102.0x147.0x67.0	830	N/A	N/A	N/A	N/A	Y(Type –A – R)	F type	F-36	Y	Crank	Lever	Leica-Thread	Mech	Y	Y
F Photomic TN	102.0x147.0x67.0	830	N/A	N/A	N/A	N/A	Y(Type –A – R)	F type	F-36	Y	Crank	Lever	Leica-Thread	Mech	Y	Y
F Photomic FTN	102.0x147.0x67.0	860	N/A	N/A	N/A	N/A	Y(Type –A – R)	F type	F-36	Y	Crank	Lever	Leica-Thread	Mech	Y	Y
F2	98.0x152.0x65.0	730	N/A	N/A	N/A	N/A	Y(Type –A – R)	F type	MD-1/2/3	Y	Crank	Lever	Leica-Thread	Mech	Y	Y
F2 Photomic	98.0x152.0x65.0	840	N/A	N/A	N/A	N/A	Y(Type –A – R)	F type	MD-1/2/3	Y	Crank	Lever	Leica-Thread	Mech	Y	Y
F2 S Photomic	110.0x152.0x65.0	880	N/A	N/A	N/A	N/A	Y(Type –A – R)	F type	MD-1/2/3	Y	Crank	Lever	Leica-Thread	Mech	Y	Y
F2 SB Photomic	102.0x152.0x65.0	850	N/A	N/A	N/A	N/A	Y(Type –A – R)	F type	MD-1/2/3	Y	Crank	Lever	Leica-Thread	Mech	Y	Y
F2 A Photomic	102.0x152.0x65.0	820	N/A	N/A	N/A	N/A	Y(Type –A – R)	F type	MD-1/2/3	Y	Crank	Lever	Leica-Thread	Mech	Y	Y
F2 AS Photomic	102.0x152.0x65.0	840	N/A	N/A	N/A	N/A	Y(Type –A – R)	F type	MD-1/2/3	Y	Crank	Lever	Leica-Thread	Mech	Y	Y
F2 H	98.0x152.0x65.0	700	N/A	N/A	N/A	N/A	Y(Type –A – R)	F type	MD-100	Y	Crank	Lever	Leica-thread	N	Y	Y
F3 F3 HP F3 T	96.5x(F3)101.5x148.0x69.0	700 (F3) 745	N/A	N/A	N/A	N/A	Y(Type –A – U)	F3 type	MD-4	Y(MF-14)	Crank	Lever	ISO (Use AR-3)	Elec	Y	Y
F3 P	105.0x148.0x69.0	745	N/A	N/A	N/A	N/A	Y(Type –A – U)	ISO	MD-4	Y(MF-14)	Crank	Lever	ISO	Elec	Y	Y
F3 H	105.0x148.0x69.0	745	N/A	N/A	N/A	N/A	Y(Type –A – U)	ISO	MD-4H	Y(MF-14)	Crank	Lever	ISO	N	Y	Y
F3 AF	115.0x148.0x90.0	950	Y	2 SPD	1:3.5	4-20	Y(Type –A – U)	F3 type	MD-4	Y(MF-14)	Crank	Lever	ISO	Elec	Y	Y

Nikon Cameras - Professional F (Auto-focus) Series

Feature	F4	F4s	F4E	F5
ISO range TTL flash control	25-1000	25-1000	25-1000	25-1000
Flash sync. contacts	X	X	X	X
Flash ready light	Y	Y	Y	Y
PC socket	Y	Y	Y	Y
Flash sync. speed	1/250	1/250	1/250	1/250
Eyepiece shutter	Y	Y	Y	Y
Viewfinder coverage	100%	100%	100%	100%
Viewfinder display	A S M R C AF	A S M R C AF	A S M R C AF	A S M R C AF
Changeable viewfinder	Y	Y	Y	Y
ISO range	25-5000 6-6400DX	25-5000 6-6400DX	25-5000 6-6400DX	25-5000 6-6400DX
Metering display	LCD	LCD	LCD	LCD
Metering pattern	60:40 Matrix Spot	60:40 Matrix Spot	60:40 Matrix Spot	60:40 Matrix Spot
Metering Range (EV) ISO100 f/1.4	2 – 21	2 – 21	2 – 21	0 – 20
Exposure mode	Ma Ap Sh P Ph	Ma Ap Sh P Ph	Ma Ap Sh P Ph	Ma Ap Sh P Ph
Shutter Type	Elec	Elec	Elec	Elec
Shutter Speeds	1/8000-30s, B.T, X	1/8000-30s, B.T, X	1/8000-30s, B.T, X	1/8000-30s, B.T, X
Shutter travel	V	V	V	V
Bayonet	AF	AF	AF	AF
Model	F4	F4s	F4E	F5

Feature	F4	F4s	F4E	F5
Dimensions (HxWxD) in (mm)	117.5x168.5x76.5	138.5x168.5x76.5	156.0x168.5x76.5	149.0x158.0x79.0
Weight (g)	1090	1280	1370	1210
Focus tracking	Y	Y	Y	Y
AF sensor	CAM 200	CAM 200	CAM 200	CAM 1300
Minimum lens aperture for AF	f/5.6	f/5.6	f/5.6	f/5.6
AF sensitivity Range (EV) at ISO100	-1 - 18	-1 - 18	-1 - 18	-1 - 19
Changeable focusing screen	Y (Type – A – U)	Y (Type – A – U)	Y (Type – A – U)	Y (Type – A – U)
Accessory Shoe	ISO	ISO	ISO	ISO
Motor drive	Built-in	Built-in	Built-in	Built-in
Changeable camera back	Y (MF-22/23/24)	Y (MF-22/23/24)	Y (MF-22/23/24)	Y (MF-27/28)
Film Rewind	Crank, or motor	Crank, or motor	Crank, or motor	Crank, or motor
Film Advance (Max. fps)	Motor (4.0fps)	Motor (5.7fps)	Motor (5.7fps)	Motor (8.0fps)
Cable release	ISO	ISO, or Elec	ISO, or Elec	Elec
Self timer	Elec	Elec	Elec	Elec
DoF Preview	Y	Y	Y	Y
Mirror lock-up	Y	Y	Y	Y
Model	F4	F4s	F4E	F5

Nikon Cameras – Nikkormat Series

Model	Bayonet	Shutter travel	Shutter Speeds	Shutter Type	Exposure mode	Metering Range (EV)	Metering pattern	Metering display	ISO range	Changeable viewfinder	Viewfinder display	Viewfinder coverage	Eyepiece shutter	Flash sync. speed	PC socket	Flash ready light	Flash sync. contacts	ISO range TTL flash control
FS	Pre-Ai	V	1/1000 - 1s, + B	Mech	Ma	N/A	N/A	N	N/A	N	N/A	92%	N	1/125	Y	N	X, M	N/A
FT	Pre-Ai	V	1/1000 - 1s, + B	Mech	Ma	3 - 17	60:40	Needle	12 - 1600	N	M	92%	N	1/125	Y	N	X, M	N/A
FTN	Pre-Ai	V	1/1000 - 1s, + B	Mech	Ma	3 - 17	60:40	Needle	12 – 1600	N	S M	92%	N	1/125	Y	N	X, M	N/A
FT-2	Pre-Ai	V	1/1000 - 1s, + B	Mech	Ma	3 - 17	60:40	Needle	12 – 1600	N	S M	92%	N	1/125	Y	N	X, M	N/A
FT-3	Ai	V	1/1000 - 1s, + B	Mech	Ma	3 - 17	60:40	Needle	12 – 1600	N	S M	92%	N	1/125	Y	N	X, M	N/A
EL	Pre-Ai	V	1/1000 - 4s, + B	Elec	Ma Ap	1 - 18	60:40	Needle	12 – 1600	N	S M	92%	N	1/125	Y	N	X	N/A
ELW	Pre-Ai	V	1/1000 - 4s, + B	Elec	Ma Ap	1 - 18	60:40	Needle	12 – 1600	N	S M	92%	N	1/125	Y	N	X	N/A
EL-2	Ai	V	1/1000 - 8s, + B	Elec	Ma Ap	1 - 18	60:40	Needle	12 - 3200	N	S M	92%	N	1/125	Y	N	X	N/A

Model	Mirror lock-up	DoF Preview	Self timer	Cable release	Film Advance	Film Rewind	Changeable camera back	Motor drive	Accessory Shoe	Changeable focusing screen	AF sensitivity Range (EV)	Minimum lens aperture for AF	AF sensor	Focus tracking	Weight (g)	Dimensions (HxWxD) in (mm)
FS	N	Y	Mech	ISO (Use AR-3)	Lever	Crank	N	N	N	N	N/A	N/A	N/A	N/A	705	95.0x146.0x54.0
FT	Y	Y	Mech	ISO (Use AR-3)	Lever	Crank	N	N	N	N	N/A	N/A	N/A	N/A	740	95.0x146.0x54.0
FTN	Y	Y	Mech	ISO (Use AR-3)	Lever	Crank	N	N	N	A or J type (Optional at factory)	N/A	N/A	N/A	N/A	750	95.0x146.0x54.0
FT-2	Y	Y	Mech	ISO (Use AR-3)	Lever	Crank	N	N	ISO	N	N/A	N/A	N/A	N/A	780	96.0x146.0x54.0
FT-3	Y	Y	Mech	ISO (Use AR-3)	Lever	Crank	N	N	ISO	N	N/A	N/A	N/A	N/A	740	96.0x146.0x54.0
EL	Y	Y	Mech	ISO (Use AR-3)	Lever	Crank	N	N	ISO	A, J, K type (Optional at factory)	N/A	N/A	N/A	N/A	760	93.0x145.0x54.0
ELW	Y	Y	Mech	ISO (Use AR-3)	Lever	Crank	N	AW-1	ISO	N	N/A	N/A	N/A	N/A	790	93.0x145.0x54.0
EL-2	Y	Y	Mech	ISO (Use AR-3)	Lever	Crank	N	AW-1	ISO	N	N/A	N/A	N/A	N/A	780	93.0x145.0x54.0

Nikon Cameras - Compact F Series

Model	Bayonet	Shutter travel	Shutter Speeds	Shutter Type	Exposure mode	Metering Range (EV) ISO100 f/1.4	Metering pattern	Metering display	ISO range	Changeable viewfinder	Viewfinder display	Viewfinder coverage	Eyepiece shutter	Flash sync. speed	PC socket	Flash ready light	Flash sync. contacts	ISO range TTL flash control
Nikon FM	Ai	V	1/1000- 1s + B, x1/125	Mech	Ma	1-18	60:40	LED	12 - 3200	N	A S M	93%	N	1/125	Y	N	X	N
Nikon FM-2	Ai	V	1/4000- 1s +B, x1/200	Mech	Ma	1-18	60:40	LED	12 - 6400	N	A S M	93%	N	1/200	Y	Y	X	N
Nikon FM2N	Ai	V	1/4000- 1s +B, x1/250	Mech	xMa	1-18	60:40	LED	12 - 6400	N	A S M R	93%	N	1/250	Y	Y	X	N
Nikon FM-3A	Ai	V	1/4000- 8s +B, x1/250	Mech/Elec	Ma, Ap		60:40	Needle	12 - 6400	N	A S M R C	93%	N	1/250	Y	Y	X	12 - 1000
Nikon FE	Ai	V	1/1000-1s +B, x1/125	Elec	Ma, Ap	1-18	60:40	Needle	12 - 4000	N	A S MR	93%	N	1/125	Y	Y	X	N
Nikon FE-2	Ai	V	1/4000- 8s +B, x1/250	Elec	Ma, Ap	1-18	60:40	Needle	12 - 4000	N	A S M R C	93%	N	1/250	Y	Y	X	25 - 400
Nikon FA	Ai	V	1/4000-1s +B, x1/250	Elec	Ma, Ap, P, Sh	1-18	60:40 AMP	LED	12 - 4000	N	A S M R C	93%	Y	1/250	Y	Y	X	25 - 400

Model	Mirror lock-up	DoF Preview	Self timer	Cable release	Film Advance	Film Rewind	Changeable camera back	Motor drive	Accessory Shoe	Changeable focusing screen	AF sensitivity Range (EV) ISO100	Minimum lens aperture for AF	AF sensor	Focus tracking	Weight (g)	Dimensions (HxWxD) in (mm)
Nikon FM	N	Y	Mech	ISO (Use AR-3)	Lever	Crank	Y(MF-12)	MD-11/12	ISO	N	N/A	N/A	N/A	N/A	590	90.0x142.0x60.0
Nikon FM-2	Y	Y	Mech	ISO (Use AR-3)	Lever	Crank	Y(MF-16)	MD-11/12	ISO	Y (Type-B, K, E)	N/A	N/A	N/A	N/A	540	90.0x142.0x60.0
Nikon FM2N	Y	Y	Mech	ISO (Use AR-3)	Lever	Crank	Y(MF-16)	MD-11/12	ISO	Y (Type-B, K, E)	N/A	N/A	N/A	N/A	550	90.0x142.0x60.0
Nikon FM-3A	Y	Y	Mech	ISO (Use AR-3)	Lever	Crank	Y(MF-16)	MD-11/12	ISO	Y (Type-B, K, E)	N/A	N/A	N/A	N/A	570	90.0x142.5x58.0
Nikon FE	Y	Y	Mech	ISO (Use AR-3)	Lever	Crank	Y(MF-12)	MD-11/12	ISO	Y (Type-B, K, E)	N/A	N/A	N/A	N/A	590	90.0x142.0x57.0
Nikon FE-2	Y	Y	Mech	ISO (Use AR-3)	Lever	Crank	Y(MF-16)	MD-11/12	ISO	Y (Type-B, K, E)	N/A	N/A	N/A	N/A	550	90.0x142.0x57.0
Nikon FA	Y	Y	Mech	ISO (Use AR-3)	Lever	Crank	Y(MF-16)	MD-11/12/15	ISO	Y (Type-B, K, E)	N/A	N/A	N/A	N/A	625	92.0x142.0x64.0

Nikon Cameras - Popular Camera Series

Model	Bayonet	Shutter travel	Shutter Speeds	Shutter Type	Exposure mode	Metering Range (EV) ISO100 f/1.4	Metering pattern	Metering display	ISO range	Changeable viewfinder	Viewfinder display	Viewfinder coverage	Eyepiece shutter	Flash sync. speed	PC socket	Flash ready light	Flash sync. contacts	ISO range TTL flash control
Nikon EM	Ai	V	1/1000- 1s + B, M1/90	Elec	Ap	2 - 18	60:40	Needle	25 - 3200	N	S M R	92%	N (Use DK-5)	1/90	N (Use AS-15)	Y	X	N/A
Nikon FG	Ai	V	1/1000- 1s + B, M1/90	Elec	Ma Ap P	1 - 18	60:40	LED	12 – 3200 25 – 5000DX	N	S M R	92%	N (Use DK-5)	1/90	N) (Use AS-15	Y	X	25 - 400
Nikon FG-20	Ai	V	1/1000- 1s + B, M1/90	Elec	Ma Ap	1 - 18	60:40	Needle	25 - 3200	N	S M R	92%	N (Use DK-5)	1/90	N (Use AS-15)	Y	X	25 - 400
Nikon FM-10	Ai	V	1/2000- 1s + B	Mech	Ma	2 - 19	60:40	LED	25 -3200	N	M	92%	N	1/125	N (Use AS-15)	N	X	N/A
Nikon FE-10	Ai	V	1/2000- 8s + B	Elec	Ma Ap	1 - 18	60:40	LED	25 - 3200	N	S M R	93%	N	1/60 (Auto- 1/90)	N(Use AS-15)	Y	X	N/A

Model	Mirror lock-up	DoF Preview	Self timer	Cable release	Film Advance	Film Rewind	Changeable camera back	Motor drive	Accessory Shoe	Changeable focusing screen	AF sensitivity Range (EV) ISO100	Minimum lens aperture for AF	AF sensor	Focus tracking	Weight (g)	Dimensions (HxWxD) in (mm)
Nikon EM	N	N	Y Mech	ISO (Use AR-3)	Lever	Crank	N	MD-E MD-14	ISO	N (K-type fitted)	N/A	N/A	N	N	460	86.0x135.0x54.0
Nikon FG	N	N	Y Mech	ISO (Use AR-3)	Lever	Crank	Y MF-15	MD-E MD-14	ISO	N (K-type fitted)	N/A	N/A	N	N	490	87.0x136.0x54.0
Nikon FG-20	N	N	Y Mech	ISO (Use AR-3)	Lever	Crank	N	MD-E MD-14	ISO	N (K-type fitted)	N/A	N/A	N	N	440	88.0x136.0x54.0
Nikon FM-10	N	Y	Y Mech	ISO (Use AR-3)	Lever	Crank	N	N	ISO	N (K-type fitted)	N/A	N/A	N	N	420	86.0x139.0x53.0
Nikon FE-10	N	Y	Y Elec	ISO (Use AR-3)	Lever	Crank	N	N	ISO	N (K-type fitted)	N/A	N/A	N	N	400	86.0x139.0x53.0

Nikon Cameras – Early Auto Focus Series

Model	Bayonet	Shutter travel	Shutter Speeds	Shutter Type	Exposure mode	Metering Range (EV) ISO100 f/1.4	Metering pattern	Metering display	ISO range	Changeable viewfinder	Viewfinder display	Viewfinder coverage	Eyepiece shutter	Flash sync. speed	PC socket	Flash ready light	Flash sync. contacts	ISO range TTL flash control
Nikon F-301	Ai-S	V	1/2000- 1s, B	Elec	Ma Ap P Ph	1 -18	60:40	LED	25 - 3200	N	M R F	92%	Use DK-5	1/125	N (AS-15)	Y	X	25 - 1000
Nikon F-401	AF	V	1/2000- 1s, + B	Elec	Ma Ap Sh P	1 -19	60:40 Multi	LED	25 – 5000 DX	N	M R F	92%	Use DK-5	1/100	N (AS-15)	Y	X	25 - 400
Nikon F-401s	AF	V	1/2000- 1s, + B	Elec	Ma Ap Sh	1 - 19	60:40 Multi	LED	25 – 5000 DX	N	M R F	92%	Use DK-5	1/100	N (AS-15)	Y	X	25 – 400
Nikon F-401x	AF	V	1/2000- 30s, + B, T	Elec	Ma Ap Sh	0 - 19	60:40 Multi	LED	25 – 5000 DX	N	S M R F	92%	Use DK-5	1/125	N (AS-15)	Y	X	25 - 800
Nikon F-501	AF	V	1/2000- 1s, + B	Elec	Ma Ap P Ph	1 -19	60:40	LED	12-320025 – 5000DX	N	S MC R F	92%	Use DK-5	1/125	N (AS-15)	Y	X	25 - 1000
Nikon F601	AF	V	1/2000- 30s, + B	Elec	Ma Ap Sh P Ph	0-19 (Spot 4 –19)	75:25 Matrix Spot	LCD	6-6400 25 – 5000DX	N	S MC R F	92%	Use DK-5	1/125	N (AS-15)	Y	X	25 - 1000
Nikon F601M	AF	V	1/2000- 30s, + B	Elec	Ma Ap Sh P Ph	0-19	75:25 Matrix	LCD	6-6400 25 – 5000DX	N	S MC R	92%	Use DK-5	1/125	N (AS-15)	Y	X	25 - 1000
Nikon F-801	AF	V	1/8000- 30s, + B	Elec	Ma Ap Sh P Pd Ph	0 -21	75:25 Matrix	LCD	6-6400 25 – 5000DX	N	S A MC R F	92%	Use DK-8	1/250	N (AS-15)	Y	X	25 - 1000
Nikon F-801s	AF	V	1/8000- 30s, + B	Elec	Ma Ap Sh P Pd Ph	0 –21 (Spot 4 –21)	75:25 Matrix Spot	LCD	6-6400 25 – 5000DX	N	S A MC R F	92%	Use DK-8	1/250	N (AS-15)	Y	X	25 - 1000

Model	Mirror lock-up	DoF Preview	Self timer	Cable release	Film Advance (Max. fps)	Film Rewind	Changeable camera back	Motor drive	Accessory Shoe	Changeable focusing screen	AF sensitivity Range (EV) ISO100	Minimum lens aperture for AF	AF sensor	Focus tracking	Weight (g)	Dimensions (HxWxD) in (mm)
Nikon F-301	N	N	Elec	Elec 2-pin	Motor (2.5fps)	Crank	Y(MF-19)	Built-in	ISO	N	N/A	N/A	N/A	N/A	570	97.0x148.0x51.0
Nikon F-401	N	N	Elec	N	Motor (0.4fps)	Motor	N	Built-in	ISO	N	2 -18	f/5.6	AM200	Y	650	102.0x154.0x65.0
Nikon F-401s	N	N	Elec	N	Motor (0.4fps)	Motor	N	Built-in	ISO	N	-1 - 17	f/5.6	AM200	Y	655	102.0x154.0x65.5
Nikon F-401x	N	N	Elec	N	Motor (0.4fps)	Motor	N	Built-in	ISO	N	-1 - 19	f/5.6	AM200	Y	647	102.0x154.0x65.0
Nikon F-501	N	N	Elec	Elec 2-pin	Motor (2.5fps)	Crank	Y(MF-19)	Built-in	ISO	Y (Type –B, E, J)	4 - 17	f/5.6	96 xCCD	Y	610	97.0x148.0x54.0
Nikon F601	N	N	Elec	ISO (Use AR-3)	Motor (2.0fps)	Motor	N	Built-in	ISO	N	-1 - 19	f/5.6	AM200	Y	650	100.0x155.0x66.0
Nikon F601M	N	N	Elec	ISO (Use AR-3)	Motor (2.0fps)	Motor	N	Built-in	ISO	N	N/A	N/A	N/A	N/A	565	96.0x155.0x66.0
Nikon F-801	N	Y	Elec	Elec 2-pin	Motor (3.3fps)	Motor	Y(MF-20/21)	Built-in	ISO	Y (Type –B, E)	-1 - 19	f/5.6	AM200	Y	695	102.0x153.0x67.0
Nikon F-801s	N	Y	Elec	Elec2-pin	Motor (3.3fps)	Motor	Y(MF-20/21)	Built-in	ISO	Y (Type – B, E)	-1 - 19	f/5.6	AM200	Y	695	102.0x153.0x67.0

Nikon Cameras - Modern Auto Focus Series

Model	Bayonet	Shutter travel	Shutter Speeds	Shutter Type	Exposure mode	Metering Range (EV) ISO100 f/1.4	Metering pattern	Metering display	ISO range	Changeable viewfinder	Viewfinder display	Viewfinder coverage	Eyepiece shutter	Flash sync. speed	PC socket	Flash ready light	Flash sync. contacts	ISO range TTL flash control
F100	AF	V	1/8000 - 30s,B	Elec	Ma Ap Sh P	0 - 21 (Spot -3 - 21)	75:25 Matrix Spot	LCD	6-6400 25 – 5000DX	N	S A M C R F	96%	Use DK-8	1/250	Y	Y	X	25 -1000
F90X	AF	V	1/8000 - 30s,B	Elec	Ma Ap Sh P	-1 - 21 (Spot -3 - 21)	75:25 Matrix Spot	LCD	6-6400 25 – 5000DX	N	S A M C R F	92%	Use DK-8	1/250	Y	Y	X	25 -1000
F90	AF	V	1/8000 - 30s,B	Elec	Ma Ap Sh P	-1 - 21 (Spot -3 - 21)	75:25 Matrix Spot	LCD	6-6400 25 – 5000DX	N	S A M C R F	92%	Use DK-8	1/25	Y	Y	X	25 -1000
F80	AF	V	1/4000 - 30s + B	Elec	Ma Ap Sh P	0 - 21 (Spot -3 - 21)	75:25 Matrix Spot	LCD	6-6400 25 – 5000DX	N	S A M C R F	92%	Use DK-5	1/125	N (Use AS-15)	Y	X	25 - 800
F75	AF	V	1/2000 - 30s + T	Elec	Ma Ap Sh P	1 – 20 (Spot -4 - 20)	75:25 Matrix Spot	LCD	25 – 5000 + DX	N	S A M C R F	89%	Use DK-5	1/90	N (Use AS-15)	Y	X	25 - 800
F70	AF	V	1/4000 - 30s + B	Elec	Ma Ap Sh P	1 – 20 (Spot – 4 - 20)	75:25 Matrix Spot	LCD	6-6400 25 – 5000DX	N	S A M C R F	92%	Use DK-5	1/125	N (Use AS-15)	Y	X	25 - 800
F65	AF	V	1/2000 - 30s + T	Elec	Ma Ap Sh P	1 - 20	75:25 Matrix	LCD C R F	25 – 5000 + DX	N	S A M	89%	Use DK-5	1/90	N (Use AS-15)	Y	X	25 -800
F60	AF	V	1/2000 - 30s + T	Elec	Ma Ap Sh P	1 - 20	75:25 Matrix	LCD C R F	25 – 5000 + DX	N	S A M	90%	Use DK-5	1/125	N (Use AS-15)	Y	X	25 -800
F55	AF	V	1/2000 - 30s + T	Elec	Ma Ap Sh P	1 - 20	75:25 Matrix	LCD C R F	25 – 5000 + DX	N	S A M	89%	Use DK-5	1/90	N (Use AS-15)	Y	X	25 -800
F50	AF	V	1/2000 - 30s + T	Elec	Ma Ap Sh P	1 - 20	75:25 Matrix	LCD	6-6400 25 – 5000DX	N	S A M C R F	90%	Use DK-5	1/125	N (Use AS-15)	Y	X	25 - 800

Model	Mirror lock-up	DoF Preview	Self timer	Cable release	Film Advance (Max. fps)	Film Rewind	Changeable camera back	Motor drive	Accessory Shoe	Changeable focusing screen	AF sensitivity Range (EV) ISO100	Minimum lens aperture for AF	AF sensor	Focus tracking	Weight (g)	Dimensions (HxWxD) in (mm)
F100	N	Y	Y Elec	Elec 10-pin	Motor (4.5fps)	Motor	Y MF-29	Built-in	ISO	Y (Type -B, E)	-1 - 19	f/5.6	Cam 1300	Y	785	113.0x155.0x66.0
F90X	N	Y	Y Elec	Elec 10-pin	Motor (4.3fps)	Motor	Y MF-25/26	Built-in (MB-10)	ISO	Y (Type -B, E)	-1 - 19	f/5.6	Cam 246	Y	755	106.0x154.0x69.0
F90	N	Y	Y Elec	Elec 10-pin	Motor (3.6fps)	Motor	Y MF-25/26	Built-in	ISO	Y (Type -B, E)	-1 - 19	f/5.6	Cam 246	Y	755	106.0x154.0x 69.0
F80	N	Y	Y Elec	ISO(Use AR-3)	Motor (2.5fps)	Motor	N	Built-in (MB-16)	ISO	N (B-type fitted)	-1 - 19	f/5.6	CAM 900	Y	515	98.5x141.5x71.0
F75	N	Y	Y Elec	N (Use ML-L3)	Motor (1.5fps)	Motor	N	Built-in (MB-18)	ISO	N (B-type fitted)	-1 - 19	f/5.6	CAM 900	Y	380	92.5x131.0x65.0
F70	N	N	Y Elec	Elec 2-pin	Motor (3.7fps)	Motor	N	Built-in	ISO	N (B-type fitted)	-1 - 19	f/5.6	CAM 274	Y	585	103.0x151.0x70.0
F65	N	Y	Y Elec	N (Use ML-L3)	Motor (2.5fps)	Motor	N	Built-in (MB-17)	ISO	N (B-type fitted)	-1 - 19	f/5.6	CAM 900	Y	395	92.5x139.5x65.5
F60	N	N	Y Elec	N	Motor (1.0fps)	Motor	N	Built-in	ISO	N (B-type fitted)	-1 - 19	f/5.6	CAM 200	Y	575	96.0x148.5x69.0
F55	N	N	Y Elec	N	Motor (1.5fps)	Motor	N	Built-in	ISO	N (B-type fitted)	-1 - 19	f/5.6	CAM 530	Y	350	92.0x129.0x65.0
F50	N	N	Y Elec	N	Motor (1.0fps)	Motor	N (Use F50D)	Built-in	ISO	N (B-type fitted)	-1 - 19	f/5.6	CAM 200	Y	580	96.0x149.0x70.0

Nikon Cameras – Digital SLR Camera Series

Model	Bayonet	Shutter travel	Shutter Speeds	Shutter Type	Exposure mode	Metering Range (EV) ISO100 f/1.4	Metering pattern	Metering display	Sensitivity Range (ISO)	File formats	Storage Media	Changeable viewfinder	Viewfinder display	Viewfinder coverage	Eyepiece shutter	Flash sync. speed	PC socket	Flash ready light	Flash sync. contacts	ISO range TTL flash control
D1	AF	V	1/16000 - 30s, +B	Elec	Ma Ap Sh P	0 - 20 (Spot 2 - 20)	75:25 Matrix Spot	LCD	200 –1600	RAW TIFF JPEG	CF Mdr	N	S A M C R F	96%	Y (Built-in)	1/500	Y	Y	X	200 –1600
D1X	AF	V	1/16000 - 30s, +B	Elec	Ma Ap Sh P	0 - 20 (Spot 2 – 20)	75:25 Matrix Spot	LCD	125 - 800	RAW TIFF JPEG	CF Mdr	N	S A M C R F	96%	Y (Built-in)	1/500	Y	Y	X	125 - 800
D1H	AF	V	1/16000 - 30s, +B	Elec	Ma Ap Sh P	0 - 20 (Spot 2 - 20)	75:25 Matrix Spot	LCD	200 - 1600	RAW TIFF JPEG	CF Mdr	N	S A M C R F	96%	Y (Built-in)	1/500	Y	Y	X	200 - 1600
D100	AF	V	1/4000 - 30s,+ B	Elec	Ma Ap Sh P	0- 21 (Spot 3 - 21)	60:40 Matrix Spot	LCD	200 –1600	RAW TIFF JPEG	CF Mdr	N	S A M C R F	95%	N (Use AS-15)	1/180	N	Y	X	200 –1600

Model	CCD size (mm)	Resolution Mega-pixels (Effective)	Max capture rate (fps)	Buffer size	Battery	Mirror lock-up	DoF Preview	Self timer	Cable release	Interface	Accessory Shoe	Changeable focusing screen	AF sensitivity Range (EV)	Min. lens aperture for AF	AF sensor	Focus tracking	Weight (g)	Dimensions (HxWxD) in (mm)
D1	23.7x15.6	2.66	4.5	21	EN-4	N (Use EH-4)	Y Elec	Y Elec	Y 10-pin	Firewire (IEEE 1394)	ISO	Y (B-type fitted, E-type)	-1 - 19	f/5.6	CAM 1300	Y	1100	153.0x157.0x85
D1X	23.7x15.6	5.33	3	9 (21 with buffer upgrade)	EN-4	N (Use EH-4)	Y Elec	Y Elec	Y 10-pin	Firewire (IEEE1394)	ISO	Y (B-type fitted, E-type)	-1 - 19	f/5.6	CAM 1300	Y	1100	153.0x157.0x85
D1H	23.7x15.6	2.66	5	40	EN-4	N (Use EH-4)	Y Elec	Y Elec	Y 10-pin	Firewire (IEEE1394)	ISO	Y (B-type fitted, E-type)	-1 - 19	f/5.6	CAM 1300	Y	1100	153.0x157.0x85
D100	23.7x15.6	6.1	3	6	EN-EL3 (AA in MB-D100)	N (Use EH-5)	Y Elec	Y Elec	Y - ISO (use AR-3)	USB 1.1	ISO	N (B-type fitted)	-1 - 19	f/5.6	CAM 900	Y	700	116.0x144.0x80.5

Notes:

1. Y = Usable / available

2. N = Not usable / not available

3. N/A = Not Applicable

4. Mech = Mechanical operation

5. Elec = Electronic operation

6. Exposure Mode:

Ma = Manual

Ap = Aperture Priority

Sh = Shutter Priority

P = Program

Ph = Program High

Pd = Program Dual

7. Viewfinder Display:

S = Shutter Speed

A = Aperture

M = Exposure Meter

C = Exposure Compensation

R = Flash Ready Signal

F = Auto Focus / Electronic Rangefinder

8. AF-S (Silent Wave) Nikkor Lenses:

Auto focus function only works with F5, F4, F100, F90X, F90, F80, F75, F70, F65, D1 Series, and D100 cameras.

9. VR (Vibration Reduction0 Nikkor Lenses:

Vibration reduction function only works with F5, F100, F80, F75, F65, D1 Series, and D100 cameras.

10. Digital SLR Series:

RAW = Files are stored in the Nikon Electronic File (NEF) format

TIFF = Files stored in the Tagged Image File Format

JPEG = Files stored in the Joint Photographic Experts Group format

CF = Compact Flash card

Mdr = IBM Microdrive

11. Early Auto Focus Series:

F601M = Camera requires auto focus Nikkor lenses for Matrix metering to function

Manual Focus Fixed Focal Length Nikkor Lenses

Lens	Type of Bayonet	Elements/Groups	Angle of view	Minimum aperture	Min. focus distance	Filter size (mm)	Lens hood	Weight (g)	Dia. /Length (mm)	TC-201	TC-301	TC-14A	TC-14B	TC-16A	Remarks
6mm/5.6	A	9/6	220	22	Fixed focus	Built-in	N/A	430	92 x 81	N	N	N	N	N	Image dia. 21.6mm
6mm/2.8	C	12/9	220	22	0.75	Built-in	N/A	5200	236 x 171	Y	N	Y	N	Y	Image dia. 23mm
6mm/2.8	Ai-S	12/9	220	22	0.75	Built-in	N/A	5200	236 x 171	Y	N	Y	N	Y	Image dia. 23mm
7.5mm/5.6	A	9/6	180	22	Fixed focus	Built-in	N/A	315	82 x 80	N	N	N	N	N	Image dia. 23mm
8mm/8	A	9/5	180	22	Fixed focus	Built-in	N/A	300	89 x 80	N	N	N	N	N	Image dia. 24mm
8mm/2.8	C	10/8	180	22	0.3	Built-in	N/A	1000	123 x 140	Y	N	Y	N	Y	Image dia. 23mm
8mm/2.8	Ai-S	10/8	180	22	0.3	Built-in	N/A	1000	123 x 140	Y	N	Y	N	Y	Image dia. 23mm
10mm/5.6	A	9/6	180	22	Fixed focus	Built-in	N/A	400	84 x 105	N	N	N	N	N	Image dia. 20mm
13mm/5.6	K	16/12	118	22	0.30	39	Built-in	1200	115 x 99	Y	N	Y	N	N	CRC
13mm/5.6	Ai-S	16/12	118	22	0.30	39	Built-in	1200	115 x 99	Y	N	Y	N	N	CRC
15mm/5.6	C	15/12	110	22	0.30	Built-in	Built-in	560	82 x 85.5	Y	N	Y	N	N	
15mm/5.6	K	15/12	110	22	0.30	Built-in	Built-in	560	82 x 85.5	Y	N	Y	N	N	
15mm/3.5	N	14/11	110	22	0.30	39	Built-in	630	90 x 94	Y	N	Y	N	N	CRC
15mm/3.5	Ai-S	14/11	110	22	0.30	Bayonet	Built-in	630	90 x 94	Y	N	Y	N	N	CRC
16mm/3.5	C	8/5	170	22	0.30	Built-in	Built-in	330	68 x 60.5	Y	N	Y	N	N	
16mm/3.5	K	8/5	170	22	0.30	Built-in	Built-in	330	68 x 60.5	Y	N	Y	N	N	
16mm/2.8	N	8/5	180	22	0.30	39	Built-in	310	63.5 x 62.5	Y	N	Y	N	Y	
16mm/2.8	Ai-S	8/5	180	22	0.30	39	Built-in	310	63.5 x 62.5	Y	N	Y	N	Y	
18mm/4	K	13/9	100	22	0.3	82	HN-15	390	89 x 58.5	Y	N	Y	N	N	

Lens	Type of Bayonet	Elements/Groups	Angle of view	Minimum aperture	Min. focus distance	Filter size (mm)	Lens hood	Weight (g)	Dia./Length (mm)	TC-201	TC-301	TC-14A	TC-14B	TC-16A	Remarks
18mm/3.5	Ai-S	11/10	100	22	0.25	72	HK-9	350	75 x 72	Y	N	Y	N	N	CRC
20mm/3.5	C	11/9	94	22	0.3	72	HN-9	390	75 x 69	Y	N	Y	N	N	
20mm/4	K	10/8	94	22	0.3	52	HN-14	210	63.5 x 47	Y	N	Y	N	N	
20mm/3.5	N	11/8	94	22	0.3	52	HK-6	235	63.5 x 50.5	Y	N	Y	N	N	
20mm/3.5	Ai-S	11/8	94	22	0.3	52	HK-6	235	63.5 x 50.5	Y	N	Y	N	N	
20mm/2.8	Ai-S	12/9	94	22	0.25	62	HK-14	260	65 x 64	Y	N	Y	N	N	CRC
21mm/4	A	8/4	92	16	0.9	52	HN-14	135	63.5 x 50	N	N	N	N	N	Optical viewfinder
24mm/f2	N	11/10	84	22	0.3	52	HK-2	305	63 x 61	Y	N	Y	N	Y	CRC
24mm/f2	Ai-S	11/10	84	22	0.3	52	HK-2	305	63 x 61	Y	N	Y	N	Y	CRC
24mm/2.8	C	9/7	84	16	0.3	52	HN-1	290	64.5 x 59	Y	N	Y	N	Y	CRC
24mm/2.8	K	9/7	84	22	0.3	52	HN-1	280	63.5 x 59	Y	N	Y	N	Y	CRC
24mm/2.8	N	9/9	84	22	0.3	52	HN-1	280	63.5 x 59	Y	N	Y	N	Y	CRC
24mm/2.8	Ai-S	9/9	84	22	0.3	52	HN-1	250	63 x 57	Y	N	Y	N	Y	CRC
28mm/4 PC	K	10/8	74	22	0.3	72	HN-9	410	78 x 67.5	Y	N	Y	N	N	Max. shift 11mm
28mm/3.5 PC	Ai-S	9/8	74	22	0.3	72	HN-9	380	78 x 69	Y	N	Y	N	N	Max. shift 11mm
28mm/3.5	A	6/6	74	16	0.6	52	HN-2	215	62.5 x 54	Y	N	Y	N	N	
28mm/3.5	C	6/6	74	16	0.6	52	HN-2	215	62.5 x 54	Y	N	Y	N	N	
28mm/3.5	K	6/6	74	22	0.3	52	HN-2	230	63.5 x 54	Y	N	Y	N	N	
28mm/3.5	N	6/6	74	22	0.3	52	HN-2	230	63.5 x 54	Y	N	Y	N	N	
28mm/3.5	Ai-S	6/6	74	22	0.3	52	HN-2	220	63 x 54	Y	N	Y	N	N	
28mmf2.8	K	7/7	74	22	0.3	52	HN-2	240	63 x 54	Y	N	Y	N	Y*	* NO. 500001
28mmf2.8	Ai-S	8/8	74	22	0.2	52	HN-2	250	63 x 59	Y	N	Y	N	Y	CRC
28mmf2.8E	Ai-S	5/5	74	22	0.3	52	HR-6	150	62.5 x 44.5	Y	N	Y	N	Y	
28mm/2	C	9/8	74	22	0.3	52	HN-1	345	64.5 x 70	Y	N	Y	N	N	CRC
28mm/2	K	9/8	74	22	0.3	52	HN-1	355	64.5 x 68.5	Y	N	Y	N	Y*	CRC* NO. 540021
28mm/2	Ai-S	9/8	74	22	0.25	52	HN-1	360	63 x 68.5	Y	N	Y	N	Y	CRC
35mm/3.5 PC	A	6/6	62	32	0.3	52	HN-1	290	73 x 55	Y	N	Y	N	N	Max. shift 11mm
35mm/2.8 PC	C	8/7	62	32	0.3	52	HN-1	335	70 x 66.5	Y	N	Y	N	N	Max. shift 11mm
35mm/2.8 PC	K	8/7	62	32	0.3	52	HN-1	330	66.5 x 6	Y	N	Y	N	N	Max. shift 11mm
35mm/2.8 PC	Ai-S	7/7	62	32	0.3	52	HN-1	320	62 x 66	Y	N	Y	N	N	Max. shift 11mm
35mm/2.8	A	7/6	62	16	0.3	52	HN-3	200	62.5 x 57	Y	N	Y	N	N	
35mm/2.8	K	6/6	62	22	0.3	52	HN-3	240	63.5 x 54	Y	N	Y	N	N	
35mm/2.8	N	5/5	62	22	0.3	52	HN-3	240	63.5 x 54	Y	N	Y	N	N	
35mm/2.8	Ai-S	5/5	62	22	0.3	52	HN-3	240	63.5 x 54	Y	N	Y	N	Y*	* NO. 880001
35mm/2.5E	Ai-S	5/5	62	22	0.3	52	HN-3	150	63.5 x 54	Y	N	Y	N	Y	
35/2	A	8/6	62	22	0.3	52	HN-3	285	63.5 x 61	Y	N	Y	N	N	
35/2	C	8/6	62	22	0.3	52	HN-3	285	63.5 x 61	Y	N	Y	N	N	
35/2	K	8/6	62	22	0.3	52	HN-3	280	63.5 x 61	Y	N	Y	N	Y*	* No. 931001
35/2	Ai-S	8/6	62	22	0.3	52	HN-3	280	63.5 x59.5	Y	N	Y	N	Y	
35mm/1.4	C	9/7	62	22	0.3	52	HN-3	415	66.5 x 74.5	Y	N	Y	N	N	
35mm/1.4	K	9/7	62	22/16	0.3	52	HN-3	410	67.5 x 74	Y	N	Y	N	N	
35mm/1.4	Ai-S	9/7	62	16	0.3	52	HN-3	415	67.5 x 74	Y	N	Y	N	Y	

Lens	Type	Elem/Grp					Hood	Weight	Dimensions						Notes
45mm/2.8 GN	C	4/3	50	32	0.8	52	HN-4	155	64 x 32	Y	N	Y	N	N	Focus ring - aperture synchronisation
45mm/2.8P	Ai-P	4/3	50	22	0.45	52	HN-35	120	63 x 17	N	N	N	N	N	Has P-type CPU for Auto Exp. modes
50mm/2	A	6/4	46	16	0.6	52	HN-5	205	64 x 48	Y	N	Y	N	N	
50mm/2	C	6/4	46	16	0.6	52	HS-2	205	64 x 50.5	Y	N	Y	N	N	
50mm/2	K	6/4	46	16	0.6	52	HS-6	205	64 x 53	Y	N	Y	N	Y*	* No. 3640001
50mm/1.8	N	6/5	46	22	0.45	52	HS-6	220	63.5 x 48	Y	N	Y	N	Y	
50mm/1.8	Ai-S	6/5	46	22	0.45	52	HS-11	220	63.5 x 48	Y	N	Y	N	Y	
50mm/1.8 N	Ai-S	6/5	46	22	0.6	52	HR-4	220	63.5 x 27.5	Y	N	Y	N	Y	
50mm/1.8 E	Ai-S	6/5	46	22	0.6	52	HR-4	220	63.5 x 36.5	Y	N	Y	N	Y	
50mm/1.4	A	7/5	46	16	0.6	52	HS-1	325	67 x 56.5	Y	N	Y	N	N	
50mm/1.4	C	7/5	46	16	0.6	52	HN-5	325	67 x 56.5	Y	N	Y	N	N	
50mm/1.4	K	7/5	46	16	0.45	52	HN-5	325	67 x 56.5	Y	N	Y	N	N	
50mm/1.4	N	7/6	46	16	0.45	52	HR-1	260	64 x 49	Y	N	Y	N	Y*	* No. 3980001
50mm/1.4	Ai-S	7/6	46	16	0.45	52	HS-9	250	64 x 50	Y	N	Y	N	Y	
50mm/1.2	N	7/6	46	16	0.5	52	HS-12	390	70 x 59	Y	N	Y	N	Y	
50mm/1.2	Ai-S	7/6	46	16	0.5	52	HR-2	390	70 x 59	Y	N	Y	N	Y	
55mm/3.5 Micro	A	5/4	43	32	0.24	52	HN-3	235	66.5 x 64.5	Y	N	Y	N	N	
55mm/3.5 Micro	C	5/4	43	32	0.24	52	HN-3	235	66.5 x 64.5	Y	N	Y	N	N	
55mm/3.5 Micro	K	5/4	43	32	0.24	52	HN-3	245	66 x 64.5	Y	N	Y	N	N	
55mm/2.8 Micro	Ai-S	6/5	43	32	0.25	52	HN-3	290	63.5 x 70	Y	N	Y	N	Y	CRC
55mm/1.2	C	7/5	43	16	0.6	52	HR-2	420	73.5 x 58.5	Y	N	Y	N	Y	
55mm/1.2	K	7/5	43	16	0.5	52	HS-7	410	72 x 58.5	Y	N	Y	N	Y	
58mm/1.2 Noct	N	7/6	40/50	16	0.5	52	HS-7or HR-2	485	74 x 63	Y	N	Y	N	Y	ASP
58mm/1.2 Noct	Ai-S	7/6	40/50	16	0.5	52	HS-7 or HR-2	485	74 x 63	Y	N	Y	N	Y	ASP
58mm/1.4	A	7/6	40/50	16	0.6	52	HS-7	365	69 x 63	Y	N	Y	N	N	
85mm/2	N	5/5	28/30	22	0.85	52	HS-10	310	63.5 x 61	Y	N	Y	N	Y	
85mm/2	Ai-S	5/5	28/30	22	0.85	52	HS-10	310	63.5 x 61	Y	N	Y	N	Y	
85mm/1.8	C	6/4	28/30	22	1.0	52	HN-7	420	72 x 70	Y	N	Y	N	N	
85mm/1.8	K	6/4	28/30	22	0.85	52	HN-7	430	70 x 70	Y	N	Y	N	N	
85mm/1.4	Ai-S	7/5	28/30	16	0.85	72	HN-20	620	80 x 72	Y	N	Y	N	Y	CRC
85mm/2.8D PC-Micro	AF-D	6/5	28/30	45	0.39	77	HB-22	770	83.5 x 109.5	N	N	N	Y	N	Manual focus only 'D' CPU
100mm/2.8E	Ai-S	4/4	24/30	22	1.0	52	HR-5	215	63 x 58	Y	N	Y	N	Y	
105mm/4.5 UV	Ai-S	6/6	23/20	32	0.45	52	Built-in	525	69 x 116	Y	N	N	Y	N	Extended UV transmission
105mm/4	A	5/3	23/20	32	N/A	52	HN-8	230	64 x 55	N/A	N/A	N/A/A	N/A	N/A	Lens head only for bellows unit
105mm/4 Micro	K	5/3	23/20	32	0.47	52	Built-in	500	74.5 x 104	Y	Y	Y	Y	N	
105mm/4 Micro	Ai-S	5/3	23/20	32	0.47	52	Built-in	500	68.5 x 104	Y	Y	Y	Y	N	
105mm/2.8 Micro	Ai-S	10/9	23/20	32	0.41	52	HS-10	515	66.5 x 91.5	Y	N	Y	N	Y	CRC
105mm/2.5	A	5/3	23/20	22	1.2	52	HS-4	435	66 x 78	Y	N	Y	N	Y	
105mm/2.5	C	5/4	23/20	22	1.0	52	HS-8	435	66 x 78	Y	N	Y	N	Y	
105mm/2.5	K	5/4	23/20	22	1.0	52	HS-8	435	66 x 78	Y	N	Y	N	Y	
105mm/2.5	Ai-S	5/4	23/20	22	1.0	52	Built-in	435	64 x 77.5	Y	N	Y	N	Y	
105/1.8	Ai-S	5/5	23/20	22	1.0	52	Built-in	580	78.5 x 88.5	Y	N	Y	N	Y	
120mm/4 Medical	Ai-S	9/6	18/50	32	0.35	49	N/A	890	98 x 150	N	N	Y	Y	N	Built-in flash Close-up filters
135mm/4	A	4/3	18	22	N/A	43	N/A	250	57 x 94	N/A	N/A	N/A	N/A	N/A	Lens head only for bellows unit
135mm/3.5	A	4/3	18	32	1.5	52	HS-4	460	66 x 93.5	Y	N	Y	Y	N	
135mm/3.5	C	4/3	18	32	1.5	52	HS-8	460	66 x 93.5	Y	N	Y	Y	N	

NIKON LENS DATA

Lens	Type of Bayonet	Elements/Groups	Angle of view	Minimum aperture	Min. focus distance	Filter size (mm)	Lens hood	Weight (g)	Dia./Length (mm)	TC-201	TC-301	TC-14A	TC-14B	TC-16A	Remarks
135mm/3.5	K	4/3	18	32	1.5	52	Built-in	400	65 x 98.5	Y	N	Y	Y	N	
135mm/3.5	N	4/4	18	32	1.3	52	Built-in	400	65 x 89.5	Y	N	Y	Y	N	
135mm/3.5	Ai-S	4/4	18	32	1.3	52	Built-in	400	65 x 89.5	Y	N	Y	Y	N	
135mm/2.8	C	4/4	18	22	1.5	52	Built-in	620	72 x 104	Y	N	Y	N	Y*	* Only • to 1.7m
135mm/2.8	K	4/4	18	22	1.5	52	Built-in	620	72 x 104	Y	N	Y	N	Y*	* Only • to 1.7m
135mm/2.8	N	5/4	18	32	1.3	52	Built-in	430	64.5 x91	Y	N	Y	N	Y*	* Only • to 1.7m
135mm/2.8	Ai-S	5/4	18	32	1.3	52	Built-in	430	64.5 x91	Y	N	Y	N	Y*	* Only • to 1.7m
135mm/2.8E	Ai-S	4/4	18	32	1.5	52	Built-in	395	62.5 x88.5	Y	N	Y	N	Y*	* Only • to 1.7m
135mm/2	N	6/4	18	22	1.3	72	Built-in	860	81 x 103	Y	N	Y	N	Y	
135mm/2	Ai-S	6/4	18	22	1.3	72	Built-in	860	81 x 103	Y	N	Y	N	Y	
180mm/2.8	C	5/4	13/40	32	1.8	72	Built-in	830	81 x 141	Y	N	Y	N	Y*	* Only • to 2.5m
180mm/2.8	K	5/4	13/40	32	1.8	72	Built-in	830	81 x 141	Y	N	Y	N	Y*	* Only • to 1.7m
180mm/2.8 ED	Ai-S	5/5	13/40	32	1.8	72	Built-in	800	78.5 x 138	Y	N	Y	N	Y*	* Only • to 1.7m
200mm/5.6 Medical	A	4/4	12/20	45	N/A	N/A	N/A	670	80 x 176	N/A	N/A	N/A	N/A	N/A	Built-in flash 4-pin
200mm/5.6 Medical	N	4/4	12/20	45	N/A	N/A	N/A	670	80 x 176	N/A	N/A	N/A	N/A	N/A	Built-in flash 6-pin
200mm/4 Micro	N	9/6	12/20	32	0.71	52	Built-in	740	66 x180	Y	Y	Y	Y	N	
200mm/4 Micro	Ai-S	9/6	12/20	32	0.71	52	Built-in	740	66 x180	Y	Y	Y	Y	N	
200mm/4	A	4/4	12/20	32	2.0	52	Built-in	630	72 x 163	Y	N	Y	N	N	
200mm/4	C	4/4	12/20	32	2.0	52	Built-in	630	72 x 163	Y	N	Y	N	N	
200mm/4	K	5/5	12/20	32	2.0	52	Built-in	530	68 x 126	Y	N	Y	N	N	
200mm/4	Ai-S	4/4	12/20	32	2.0	52	Built-in	510	65 x 124	Y	N	Y	N	N	
200mm/2 IF-ED	N	10/8	12/20	22	2.5	122	Built-in	2300	128 x 214	Y	Y	Y	Y	Y	IF
200mm/2 IF-ED	Ai-S	10/8	12/20	22	2.5	122	Built-in	2300	128 x 222	Y	Y	Y	Y	Y	IF
200mm/2 N IF-ED	Ai-S	10/8	12/20	22	2.5	39	Built-in HE-4	2550	132 x 225.5	Y	Y	Y	Y	Y	IF
300mm/4.5	C	6/5	8/10	22	4.0	72	Built-in	1110	80 x 203	Y	Y	N	Y	N	
300mm/4.5	K	6/5	8/10	22	4.0	72	Built-in	1140	78 x 203	Y	Y	N	Y	N	
300mm/4.5	Ai-S	6/5	8/10	32	3.5	72	Built-in	1140	78 x 203	Y	Y	N	Y	N	
300mm/4.5 ED	K	6/4	8/10	22	4.0	72	Built-in	1100	78 x 203	Y	Y	N	Y	N	
300mm/4.5 IF-ED	N	7/6	8/10	22	2.5	72	Built-in	990	80 x 200	N	Y	N	Y	N	IF
300mm/4.5 IF-ED	Ai-S	7/6	8/10	32	2.5	72	Built-in	990	80 x 200	N	Y	N	Y	N	IF
300mm/2.8	C	6/5	8/10	32	4.0	122	Built-in	2600	125 x 251	N	Y	N	Y	N	IF
300mm/2.8 IF-ED	N	8/6	8/10	22	4.0	39 / 122	Built-in	2500	138 x 249	N	Y	N	Y	Y	IF
300mm/2.8 IF-ED	Ai-S	8/6	8/10	22	4.0	39 / 122	Built-in	2500	138 x 249	N	Y	N	Y	Y	IF
300mm/2.8 N IF-ED	Ai-S	8/6	8/10	22	3.0	39	Built-in HE-4	2400	132 x 263	N	Y	N	Y	Y	IF
300mm/2 IF-ED	Ai-S	11/8	8/10	16	4.0	52	HE-1	7100	183 x 339	N	Y	N	Y	Y	Supplied with TC-14C (1.4x)
400mm/5.6	C	5/3	6/10	32	5.0	72	Built-in	1400	85 x 262	N	Y	N	Y	N	
400mm/5.6 ED	K	5/3	6/10	32	5.0	72	Built-in	1400	85 x 262	N	Y	N	Y	N	
400mm/5.6 IF-ED	N	7/6	6/10	32	4.0	72	Built-in	1200	85 x 262	N	Y	N	Y	N	IF
400mm/5.6 IF-ED	Ai-S	7/6	6/10	32	4.0	72	Built-in	1200	85 x 262	N	Y	N	Y	N	IF
400mm/4.5	C	4/4	6/10	22	5.0 / 5.5*	122 / 52*	Built-in	3100 / 3300*	135 x 472	N/A	N/A	N/A	N/A	N/A	Lens head only Use Focus Unit CU-1 or, AU-1*

400mm/3.5 IF-ED	N	8/6	6/10	22	4.5	39 / 122	Built-in	2800	134 x 304	N	Y	N	Y	N	IF	
400mm/3.5 IF-ED	Ai-S	8/6	6/10	22	4.5	39 / 122	Built-in	2800	134 x 304	N	Y	N	Y	N	IF	
400mm/2.8 IF-ED	Ai-S	8/6	6/10	22	4.0	52	Built-in + HE-3	5150	172 x 432	N	Y	N	Y	N	IF	
500mm/8 Reflex	C	5/3	5	8	4.0	39	Y	1000	93 x 142	Y	N	Y	Y	N	Fixed aperture	
500mm/8 N Reflex	Ai-S	6/6	5	8	1.5	39	HN-27	840	89 x 116	Y	N	Y	Y	N	Fixed aperture	
500mm/5 Reflex	A	5/4	5	5	15.0	39	Y	1600	125 x 197	N	Y	N	Y	N	Fixed aperture	
500mm/4 P IF-ED	Ai-S	8/6	5	22	5.0	39	HK-17	2950	138 x 387	N	Y	N	Y	N	Has P-type CPU for Auto Exp. modes	
600mm/5.6	C	5/4	4/10	22	11.0 11.0*	122 52*	Built-in	3600 4800*	135 x 517	N/A	N/A	N/A	N/A	N/A	Lens head only Use Focus Unit CU-1 or, AU-1*	
600mm/5.6 ED	K	5/4	4/10	22	11.0 11.0*	122 52*	Built-in	3500 4700*	133 x 515	N/A	N/A	N/A	N/A	N/A	Lens head only Use Focus Unit CU-1 or, AU-1*	
600mm/5.6 IF-ED	N	7/6	4/10	32	5.5	39 /122	Built-in	2700	134 x 382	N	Y	N	Y	N	IF	
600mm/5.6 IF-ED	Ai-S	7/6	4/10	32	5.5	39 /122	Built-in	2700	134 x 382	N	Y	N	Y	N	IF	
600mm/5.6 N IF-ED	Ai-S	7/6	4/10	32	5.5	39	Built-in + HE-4	2700	134 x 382	N	Y	N	Y	N	IF	
600mm/4 IF-ED	N	8/6	4/10	22	6.5	39 /160	Built-in	6300	177 x 460	N	Y	N	Y	N	IF Supplied with TC-14 (1.4x)	
600mm/4 IF-ED	Ai-S	8/6	4/10	22	6.5	39 /160	Built-in	6300	177 x 460	N	Y	N	Y	N	IF	
600mm/4 N IF-ED	Ai-S	8/6	4/10	22	6.5	39	HE-5	5650	173 x 473	N	Y	N	Y	N	IF	
800mm/8	C	5/5	3	22	19.0 20.0*	122 52*	Built-in	3500 4700*	135 x 712	N/A	N/A	N/A	N/A	N/A	Lens head only Use Focus Unit CU-1 or, AU-1*	
800mm/8 ED	K	5/4	3	22	19.0 20.0*	122 52*	Built-in	4100 5300*	133 x693	N/A	N/A	N/A	N/A	N/A	Lens head only Use Focus Unit CU-1 or, AU-1*	
800mm/8 IF-ED	N	9/7	3	22	10.0	39 / 122	Built-in	3300	134 x 460	N	Y	N	Y	N	IF	
800mm/8 IF-ED	Ai-S	9/7	3	22	10.0	39 / 122	Built-in	3300	134 x 460	N	Y	N	Y	N	IF	
800mm/5.6 IF-ED	Ai-S	8/6	3	32	8.0	52	Built-in HE-3	5450	163 x 554	N	Y	N	Y	N	IF	
1000mm/6.3 Reflex	A	3/2	2/30	6.3	30.0	Built-in	N/A	9900	238 x 500	N	Y	N	Y	N		
1000mm/11 Reflex	C	5/5	2/30	11	8.0	Built-in	Y	1900	117 x 238	N	Y	N	Y	N		
1000mm/11 Reflex	K	5/5	2/30	11	8.0	39	Built-in	1900	119 x 241	N	Y	N	Y	N		
1200mm/11	C	5/5	2	64	43.0 50.0*	122 52*	Built-in	4300 5500*	135 x 922	N/A	N/A	N/A	N/A	N/A	Lens head only Use Focus Unit CU-1 or, AU-1*	
1200mm/11 ED	K	5/5	2	64	43.0 50.0*	122 52*	Built-in	4900 6100*	133 x 898	N/A	N/A	N/A	N/A	N/A	Lens head only Use Focus Unit CU-1 or, AU-1*	
1200mm/11 IF-ED	N	9/8	2	32	14.0	39 / 122	Built-in	3900	134 x 577	N	Y	N	Y	N	IF	
1200mm/11 IF-ED	Ai-S	9/8	2	32	14.0	39 / 122	Built-in	3900	134 x 577	N	Y	N	Y	N	IF	
2000mm/11 Reflex	C	5/5	1/10	11	18.0	Built-in	Built-in	7500	262 x 600	N	Y	N	Y	N		

Manual Focus Zoom-Nikkor Lenses

Lens	Type of Bayonet	Elements/Groups	Angle of view	Minimum aperture	Min. focus distance	Filter size (mm)	Lens hood	Weight (g)	Dia. /Length (mm)	TC-201	TC-301	TC-14A	TC-14B	TC-16A	Remarks
25-50/4	N	11/10	80 - 48	22	0.6	72	HK-7	600	75.0 x 122.0	Y	N	Y	N	N	
25-50/4	Ai-S	11/10	80 - 48	22	0.6	72	HK-7	600	75.0 x 122.0	Y	N	Y	N	N	
28-45/4.5	K	11/7	74 - 50	22	0.6	72	HK-1	440	75.0 x 91.0	Y	N	Y	N	N	
28-50/3.5	Ai-S	9/7	74 - 96	22	0.6	52	HK-12	395	68.5 x 75.0	Y	N	Y	N	N	Max. RR 1:5.1
28-85/3.5-4.5	Ai-S	15/11	74 – 28/30	22	0.8	62	HK-16	510	67.0 x 97.5	Y	N	Y	N	N	Max. RR 1:3.4
35-70/3.5	N	10/9	62 – 34/20	22	1.0	72	HK-4	550	75 .0 x 101.0	Y	N	Y	N	N	
35-70/3.5	Ai-S	10/9	62 – 34/20	22	0.7	62	HN-22	550	66 .0 x 105.0	Y	N	Y	N	N	Max. RR 1:3.9
36-72/3.5E	Ai-S	8/8	62 – 33/30	22	1.2	52	HK-8	380	67.0 x 71.0	Y	N	Y	N	N	
35-70/3.3-4.5	Ai-S	8/7	62 – 34/20	22	0.35	52	HN-2	255	63.0 x 69.0	Y	N	Y	N	N	Max. RR 1:4.4
35-105/3.5-4.5	Ai-S	16/12	62 – 23/20	22	1.4	52	HK-11	510	54.0 x 95.0	Y	N	Y	N	N	Max. RR 1:4
35-135/3.5-4.5	Ai-S	15/14	62 - 18	22	1.5	62	HN-22	600	68.0 x 112.0	Y	N	Y	N	N	Max. RR 1:3.5
35-200/3.5-4.5	Ai-S	17/13	62 – 12/20	22	1.3	62	HK-15	740	70.0 x 128.0	Y	N	N	N	N	Max. RR 1:4
43-86/3.5	C	9/7	53 – 38/20	22	1.2	52	HN-3	410	65.0 x 78.0	Y	N	Y	N	N	
43-86/3.5	K	11/8	53 – 38/20	22	1.2	52	HN-3	450	66.0 x 81.5	Y	N	Y	N	N	
50-135/3.5	Ai-S	16/13	46 - 18	32	1.3	62	HK-10	700	71.0 x 133.0	Y	N	Y	N	N	Max. RR 1:9.3
50-300/4.5	C	20/13	46 – 8/10	22	2.5	95	HN-11	2300	98.0 x 292.0	Y	N	Y	N	N	
50-300/4.5	K	20/13	46 – 8/10	22	2.5	95	HN-11	2300	98.0 x 292.0	Y	N	Y	N	N	
50-300/4.5	N	15/11	46 – 8/10	32	2.5	95	HK-5	2200	98.0 x 247.0	Y	N	Y	N	N	
50-300/4.5	Ai-S	15/11	46 – 8/10	32	2.5	95	HK-5	1950	98.0 x 239.0	Y	N	Y	N	N	
70-210/4 E	Ai-S	13/9	34/20 – 11/50	32	1.5	62	HN-24	730	72.5 x 156	Y	N	Y	N	N	Max. RR 1:5.5
70-210/4.5-5.6	Ai-S	11/8	34/20 – 11/50	32	1.5	52	HR-1	375	64.0 x 104.0	Y	N	Y	N	N	
75-150/3.5 E	Ai-S	12/9	31/40 - 17	32	1.0	52	HN-21	520	65.0 x 125.0	Y	N	Y	N	N	
80-200/4.5	A & C	15/10	30 -12	32	1.8	52	HN-7	830	74.5 x 162	Y	N	Y	N	N	
80-200/4.5	K	15/10	30 -12	32	1.8	52	HN-7	830	74.5x 162	Y	N	Y	N	N	
80-200/4.5	N	12/9	30 -12	32	1.8	52	HN-7	750	73.0 x 162	Y	N	Y	N	N	
80-200/4	Ai-S	13/9	30 -12	32	1.2	62	HN-23	810	73.0 x 162	Y	N	Y	N	N	
80-200/2.8 ED	Ai-S	15/11	30 -12	32	2.5	95	HN-25	1900	99.0 x 231	Y	N	Y	N	Y	
85-250/4-4.5	A	16/9	28/30 - 10	16	4.0	82 Series 9	Yes	2010	89.0 x 305	N	Y	N	Y	N	
85-250/4-4.5	A	16/9	28/30 - 10	16	4.0	82 Series 9	Yes	2000	89.0 x 305	N	Y	N	Y	N	
85-250/4	C	16/9	28/30 - 10	16	4.0	82 Series 9	Yes	1900	89.0 x 305	N	Y	N	Y	N	
100-300/5.6	Ai-S	14/10	24 - 8	32	2.0	62	HN-24	930	74.0 x 199	Y	N	Y	Y	N	Max. RR 1:4.4
180-600/8 ED	K	18/11	13/40 – 4/10	32	2.5	95	HN-16	3400	105.0 x 403.0	N	Y	N	Y	N	
180-600/8 ED	Ai-S	18/11	13/40 – 4/10	32	2.5	95	HN-16	3600	105.0 x 403.0	N	Y	N	Y	N	
200-400/4 ED	Ai-S	15/10	12 - 6	32	4.0	122	HE-2	3650	144.0 x 338.0	N	Y	N	Y	N	
200-600/9.5-10.5	A	19/12	12/20 – 4/10	32	4.0	82 Series 9	HN-10	2300	89.0 x 382	N	Y	N	Y	N	
200-600/9.5	C	19/12	12/20 – 4/10	32	4.0	82 Series 9	HN-10	2300	89.0 x 382	N	Y	N	Y	N	
200-600/9.5	N	19/12	12/20 – 4/10	32	4.0	82 Series 9	HN-10	2400	89.0 x 382	N	Y	N	Y	N	
200-600/9.5	Ai-S	19/12	12/20 – 4/10	32	4.0	82 Series 9	HN-10	2500	89.0 x 382	N	Y	N	Y	N	
360-1200/11 ED	K	20/12	6/50 - 2	32	6.0	122	HN-17	7100	125.0 x 704.0	N	Y	N	Y	N	
360-1200/11 ED	Ai-S	20/12	6/50 - 2	32	6.0	122	HN-17	7900	125.0 x 704.0	N	Y	N	Y	N	
1200-1700/5.5-8 P IF-ED	Ai-S	18/13	2 – 1/30	22	10	52	Built-in	16000	237 x 880	N	N	N	N	N	

Fixed Focal Length Auto Focus Nikkor Lenses

Lens	Type of Bayonet	Elements/Groups	Angle of view	Minimum aperture	Min. focus distance	Filter size	Lens hood	Weight (g)	Dia./Length (mm)	TC-201	TC-301	TC-14A	TC-14B	TC-14E I/II	TC-20E i/II	Remarks
14mm/2.8D AF ED	AF-D	12/14	114	22	0.2	N/A	Built-in	670	87 x 86.5	Y (MF)	N	Y (MF)	N	N	N	RF ASP
16mm/2.8D AF F/eye	AF-D	5/8	180	22	0.25	39	Built-in	290	63 x 57	Y (MF)	N	Y (MF)	N	N	N	CRC
18mm/2.8D AF	AF-D	10/13	100	22	0.25	77	HB-8	380	82 x 58	Y (MF)	N	Y (MF)	N	N	N	RF ASP
20mm/2.8 AF	AF	9/12	94	22	0.25	62	HB-4	260	69 x 42.5	Y (MF)	N	Y (MF)	N	N	N	CRC
20mm/2.8D AF	AF-D	9/12	94	22	0.25	62	HB-4	270	69 x 42.5	Y (MF)	N	Y (MF)	N	N	N	CRC
24mm/2.8 AF	AF	9/9	84	22	0.3	52	HN-1	270	64.5 x 46	Y (MF)	N	Y (MF)	N	N	N	CRC
24mm/2.8 AF-N	AF	9/9	84	22	0.3	52	HN-1	270	64.5 x 46	Y (MF)	N	Y (MF)	N	N	N	CRC
24mm/2.8D AF	AF-D	9/9	84	22	0.3	52	HN-1	270	64.5 x 46	Y (MF)	N	Y (MF)	N	N	N	CRC
28mm/2.8 AF	AF	5/5	74	22	0.3	52	HN-2	195	65 x 48.7	Y (MF)	N	Y (MF)	N	N	N	
28mm/2.8 AF-N	AF	5/5	74	22	0.3	52	HN-2	195	65 x 48.7	Y (MF)	N	Y (MF)	N	N	N	
28mm/2.8D AF	AF-D	6/6	74	22	0.25	52	HN-2	210	65 x 44.5	Y (MF)	N	Y (MF)	N	N	N	
28mm/1.4D AF-D	AF-D	8/11	74	16	0.35	72	HK-7	520	75 x 77.5	N	N	Y (MF)	N	N	N	RF CRC ASP
35mm/2 AF	AF	5/6	62	22	0.25	52	HN-3	205	64.5 x 43.5	Y (MF)	N	Y (MF)	N	N	N	
35mm/2D AF	AF-D	5/6	62	22	0.25	52	HN-3	205	64.5 x 43.5	Y (MF)	N	Y (MF)	N	N	N	
50mm/1.8 AF	AF	5/6	46	22	0.45	52	HR-2	210	65 x 48	Y (MF)	N	Y (MF)	N	N	N	
50mm/1.8 AF-N	AF	5/6	46	22	0.45	52	HR-2	155	65 x 43	Y (MF)	N	Y (MF)	N	N	N	
50mm/1.8D AF-D	AF-D	5/6	46	22	0.45	52	HR-2	155	63.5 x 39	Y (MF)	N	Y (MF)	N	N	N	
50mm/1.4 AF	AF	6/7	46	16	0.45	52	HR-2	255	65 x 42	Y (MF)	N	Y (MF)	N	N	N	
50mm/1.4 AF-N	AF	6/7	46	16	0.45	52	HR-2	255	65 x 42	Y (MF)	N	Y (MF)	N	N	N	
50mm/1.4D AF-D	AF-D	6/7	46	16	0.45	52	HR-2	230	64.5 x 42.5	Y (MF)	N	Y (MF)	N	N	N	
80mm/2.8 AF	AF	4/6	30/20	32	1.0	52	HS-7	390	69 x 78	Y (MF)	N	Y (MF)	N	N	N	F3 AF only
85mm/1.8 AF	AF	6/6	28/30	16	0.85	62	HN-23	380	71.5 x 58.5	Y (MF)	N	Y (MF)	N	N	N	RF
85mm/1.8D AF-D	AF-D	6/6	28/30	16	0.85	62	HN-23	380	71.5 x 58.5	Y (MF)	N	Y (MF)	N	N	N	RF
85mm/1.4D AF-D	AF-D	8/9	28/30	16	0.85	77	HN-31	550	80 x 72.5	Y (MF)	N	Y (MF)	N	N	N	IF
105mm/2D AF-D DC	AF-D	6/6	23/20	16	0.9	72	Built-in	640	79 x 111	N	N	N	N	N	N	RF DC
135mm/2 AF DC	AF	6/7	18	16	1.1	72	Built-in	815	79 x 120	N	N	Y (MF)	N	N	N	RF DC
135mm/2D AF-D DC	AF-D	6/7	18	16	1.1	72	Built-in	815	79 x 120	N	N	Y (MF)	N	N	N	RF DC
180mm/2.8 AF	AF	6/8	13/40	22	1.5	72	Built-in	720	78.5 x 138	Y (MF)	Y (MF)	N	N	N	N	IF
180mm/2.8 AF-N	AF	6/8	13/40	22	1.5	72	Built-in	750	78.5 x 144	Y (MF)	Y (MF)	N	N	N	N	IF
180mm/2.8D AF-D	AF-D	6/8	13/40	22	1.5	72	Built-in	760	78.5 x 144	Y (MF)	Y (MF)	N	N	N	N	IF
200mm/3.5 AF IF-ED	AF	6/8	12/20	32	2.0	62	Built-in	870	80 x 157	Y (MF)	Y (MF)	Y (MF)	Y (MF)	N	N	IF F3AF only
300mm/4 AF	AF	6/8	8/10	32	2.50	39/82	Built-in	1330	89 x 219	N	Y (MF)	N	Y (MF)	N	N	IF
300mm/4D AF-S IF-ED	AF-D	6/10	8/10	32	1.45	77	Built-in	1440	90 x 222.5	N	Y (MF)	N	Y (MF)	Y (AF)	Y (MF)	SWM
300mm/2.8 AF IF-ED	AF	6/8	8/10	22	3.0	39	Built-in + HE-6	2700	133 x 255	Y (MF)	Y (MF)	Y (MF)	Y (MF)	N	N	IF
300mm/2.8D AF-I IF-ED	AF-D	9/11	8/10	22	2.5	39	HK-19	2900	124 x 241	N	Y (MF	N	Y (MF)	Y (AF)	Y (AF)	Internal AF motor
300mm/2.8D AF-S IF-ED	AF-D	8/11	8/10	22	2.5	52	HK-22	3000	124 x 269	N	Y (MF	N	Y (MF)	Y (AF)	Y (AF)	Type I SWM
300mm/2.8D AF-S IF-ED	AF-D	8/11	8/10	22	2.3	52	HK-26	2580	124 x 268.5	N	Y (MF	N	Y (MF)	Y (AF)	Y (AF)	Type II SWM

337

NIKON LENS DATA

Lens	Type of Bayonet	Elements/Groups	Angle of view	Minimum aperture	Min. focus distance	Filter size	Lens hood	Weight (g)	Dia./Length (mm)	TC-201	TC-301	TC-14A	TC-14B	TC-14E I/II	TC-20E i/II	Remarks
400mm/2.8D AF-I IF-ED	AF-D	7/10	6/10	22	3.3	52	HK-20	3300	158 x 374	N	Y (MF)	N	Y (MF)	Y (AF)	Y (AF)	Internal AF motor
400mm/2.8D AF-S IF-ED	AF-D	9/11	6/10	22	3.8	52	HK-25	4800	160 x 352	N	Y (MF)	N	Y (MF)	Y (AF)	Y (AF)	Type I SWM
400mm/2.8D AF-S IF-ED	AF-D	9/11	6/10	22	3.5	52	HK-25	4400	159.5 x 351.5	N	Y (MF)	N	Y (MF)	Y (AF)	Y (AF)	Type II SWM
500mm/4D AF-I IF-ED	AF-D	7/9	5	22	5	39	HK-21	4170	137.5 x 365	N	Y (MF)	N	Y (MF)	Y (AF)	Y (MF)	Internal AF motor
500mm/4D AF-S IF-ED	AF-D	9/11	5	22	5	52	HK-24	3700	140 x 394	N	Y (MF)	N	Y (MF)	Y (AF)	Y (MF)	Type I SWM
500mm/4D AF-S IF-ED	AF-D	9/11	5	22	4.6	52	HK-24	3430	139.5 x 394	N	Y (MF)	N	Y (MF)	Y (AF)	Y (MF)	Type II SWM
600mm/4D AF-I IF-ED	AF-D	7/9	4/10	22	6	39	HK-18	6050	166 x 417	N	Y (MF)	N	Y (MF)	Y (AF)	Y(MF)	Internal AF motor
600mm/4D AF-S IF-ED	AF-D	7/10	4/10	22	6	52	HK-23	5800	166 x 445	N	Y (MF)	N	Y (MF)	Y (AF)	Y (MF)	Type I SWM
600mm/4D AF-S IF-ED	AF-D	7/10	4/10	22	5.6	52	HK-23	4850	166 x 430.5	N	Y (MF)	N	Y (MF)	Y (AF)	Y (MF)	Type II SWM

Auto Focus Zoom-Nikkor Lenses

Lens	Type of Bayonet	Elements/Groups	Angle of view	Minimum aperture	Min. focus distance (Macro)	Filter size	Lens hood	Weight (g)	Dia./Length (mm)	TC-201	TC-301	TC-14A	TC-14B	TC-14E I/II	TC-20E I/II	Remarks
12-24/4G AF-S DX IF-ED	AF-D	11/7	99 – 61(DX)	22	0.3	77	HB-23	485	82.5 x 90.0	N	N	N	N	N	N	IF ASP SWM G-type
17-35/2.8D AF-S IF-ED	AF-D	13/10	104 - 62	22	0.9	77	HB-23	745	82.5 x106.0	Y (MF)	N	Y (MF)	N	N	N	IF ASP SWM
18-35/3.5-4.5D AF-D IF-ED	AF-D	11/8	100 - 62	22	1.1	77	HB-23	370	82.7 x82.5	Y (MF)	N	Y (MF)	N	N	N	IF ASP
20-35/2.8D AF-D IF	AF-D	14/11	94 - 62	22	1.7	77	HB-8	585	82.0 x 94.0	Y (MF)	N	Y (MF)	N	N	N	IF ASP

Lens	Type	Elem/Grp	Angle	f	Dist	Filter	Hood	Weight	Dimensions							Notes
24-50/3.3-4.5 AF	AF	9/9	84 – 46	22	0.5	62	HB-3	375	70.5 x 75.5	Y (MF)	N	Y (MF)	N	N	N	
24-50/3.3-4.5D AF-D	AF-D	9/9	84 – 46	22	0.6 (0.5)	62	HB-3	355	67.5 x 74.1	Y (MF)	N	Y (MF)	N	N	N	
24-85/2.8-4D AF IF	AF-D	15/11	84 – 28/30	22	0.5 (0.21)	72	HB-25	545	78.5 x 82.5	Y (MF)	N	Y (MF)	N	N	N	
24-85/3.5-4.5G AF-S IF-ED	AF-D	15/12	84 – 28/30	22	0.38	67	HB-28	415	73.0 x 72.5	N	N	N	N	N	N	IF ASP SWM G-type
24-120/3.5-5.6D AF IF	AF-D	15/11	84 – 20/30	22	0.5	72	HB-11	550	79.0 x 80.0	Y (MF)	N	Y (MF)	N	N	N	IF
24-120/3.5-5.6G AF-S VR IF-ED	AF-D	15/13	84 – 20/30	22	0.5	72	HB-25	575	77.0 x 94.0	N	N	N	N	N	N	IF SWM G-type VR
28-70/3.5-4.5 AF	AF	8/7	74 – 34/20	22	0.5 (0.39)	52	HB-6	350	67.5 x 71.0	Y (MF)	N	Y (MF)	N	N	N	
28-70/3.5-4.5D AF-D	AF-D	8/7	74 – 34/20	22	0.5 (0.39)	52	HB-6	355	67.5 x 71.0	Y (MF)	N	Y (MF)	N	N	N	
28-70/2.8D AF-S	AF-D	15/11	74 – 34/20	22	0.7 (0.5)	77	HB-19	935	86.5 x 121.5	Y (MF)	N	Y (MF)	N	N	N	IF ASP SWM
28-80/3.3-5.6G AF-D	AF-D	6/6	74 – 30/10	22	0.35	58	HB-20	195	66.5 x 64.0	N	N	N	N	N	N	ASP G-type
28-80/3.5-5.6D AF-D	AF-D	8/8	74 – 30/10	22	0.4	58	HB-20	265	65.0 x 79.5	Y (MF)	N	Y (MF)	N	N	N	
28-85/3.5-4.5 AF	AF	15/11	74 – 28/30	22	0.8 (0.23)	62	HB-1	540	71.0 x 89.0	Y (MF)	N	Y (MF)	N	N	N	
28-85/3.5-4.5 AF-N	AF	15/11	74 – 28/30	22	0.8 (0.23)	62	HB-1	540	71.0 x 89.5	Y (MF)	N	Y (MF)	N	N	N	
28-100/3.5-5.6G AF-D	AF-G	8/6	74 – 24/20	22	0.56	62	HB-27	245	68.0 x 80.0	N	N	N	N	N	N	ASP G-type
28-105/3.5-4.5D AF-D IF	AF-D	16/12	74 – 23/20	22	1.7 (0.7)	62	HB-18	455	73.0 x 81.5	Y (MF)	N	Y (MF)	N	N	N	IF ASP
28-200/3.5-5.6D AF-D IF	AF-D	16/13	74 – 12/20	22	2.0 (0.85)	72	HB-12	520	78.0 x 86.5	Y (MF)	N	Y (MF)	N	N	N	IF ASP
28-200/3.5-5.6G AF-D IF-ED	AF-G	12/11	74 – 12/20	22	0.44	62	HB-30	360	69.5 x 71.0	N	N	N	N	N	N	IF ASP G-type
35-70/3.3-4.5 AF	AF	8/7	62 – 34/20	22	0.5 (0.35)	52	HN-2	275	69.0 x 70.0	Y (MF)	N	Y (MF)	N	N	N	
35-70/3.3-4.5 AF-N	AF	8/7	62 – 34/20	22	0.5 (0.35)	52	HN-2	240	66.5 x 65.5	Y (MF)	N	Y (MF)	N	N	N	
35-70/2.8 AF	AF	15/12	62 – 34/20	22	0.6 (0.28)	62	HB-1	665	71.5 x 94.5	Y (MF)	N	Y (MF)	N	N	N	
35-70/2.8D AF-D	AF-D	15/12	62 – 34/20	22	0.6 (0.28)	62	HB-1	665	71.5 x 94.5	Y (MF)	N	Y (MF)	N	N	N	
35-80/4-5.6D AF-D	AF-D	8/7	62 – 30/10	22	0.35	52	HN-3	180	66.0 x 67.5	Y (MF)	N	Y (MF)	N	N	N	
35-105/3.5-4.5 AF	AF	16/12	62 – 23/20	22	1.4 (0.27)	52	HB-2	460	69.0 x 95.5	Y (MF)	N	Y (MF)	N	N	N	
35-105/3.5-4.5 AF-N	AF	16/12	62 – 23/20	22	1.4 (0.27)	52	HB-7	510	70.0 x 87.0	Y (MF)	N	Y (MF)	N	N	N	One-ring
35-105/3.5-4.5D AF-D IF	AF-D	13/10	62 – 23/10	22	0.85	52	HB-5	410	68.5 x 72.5	Y (MF)	N	Y (MF)	N	N	N	IF
35-135/3.5-4.5 AF	AF	15/12	62 - 18	22	1.5 (0.3)	62	HB-1	630	72.0 x 117.0	Y (MF)	N	Y (MF)	N	N	N	
35-135/3.5-4.5 AF-N	AF	15/12	62 - 18	22	1.5 (0.3)	62	HB-1	685	72.5 x 109	Y (MF)	N	Y (MF)	N	N	N	
70-210/4 AF	AF	13/9	34 /20 –11/50	32	1.1	62	HN-24	760	76.5 x 156.0	Y (MF)	N	Y (MF)	N	N	N	
70-210/4-5.6 AF	AF	12/9	34 /20 –11/50	32	1.5 (1.2)	62	HN-24	590	73.5 x 108.0	Y (MF)	N	Y (MF)	N	N	N	
70-210/4-5.6D AF-D	AF-D	12/9	34/20 –11/50	32	1.5 (1.2)	62	HN-24	600	73.5 x 108.0	Y (MF)	N	Y (MF)	N	N	N	
70-300/4-5.6D AF-D	AF-D	13/9	34/20 – 8/10	32	1.5	62	HB-15	505	74.0 x 116.0	Y (MF)	N	Y (MF)	N	N	N	
70-300/4-5.6G AF-G	AF-G	13/9	34/20 – 8/10	22	1.5	62	HB-26	470	74.0.0 x 116.5	N	N	N	N	N	N	G-type
75-300/4.5-5.6 AF	AF-D	13/11	31/40 – 8/10	32	3 (1.5)	62	HN-24	860	72 x 166.0	Y (MF)	N	Y (MF)	N	N	N	
70-200/2.8G AF-S IF-ED	AF-G	21/15	34/20 – 12/20	22	1.5	77	HB-29	1470	87.0 x 215.0	N	N	N	N	Y (AF)	Y (AF)	IF SWM G-type VR
80-200/2.8 AF ED	AF	16/11	30/10 –12/20	22	1.8 (1.5)	77	HN-28	1280	85.5 x 176.0	Y (MF)	N	Y (MF)	N	N	N	One-ring
80-200/2.8D AF-D ED	AF-D	16/11	30/10 – 12/20	22	1.8 (1.5)	77	HB-7	1300	87.0 x 187.0	Y (MF)	N	Y (MF)	N	N	N	One-ring
80-200/2.8D N AF-D ED	AF-D	16/11	30/10 – 12/20	22	1.8 (1.5)	77	HB-7	1300	87.0 x 187.0	Y (MF)	N	Y (MF)	Y (MF)	N	N	Two-ring
80-200/2.8D AF-S IF-ED	AF-D	18/14	30/10 – 12/20	22	1.5	77	HB-17	1580	88.0 x 207.0	Y (MF)	N	N	Y (MF)	Y (AF)	Y (AF)	IF SWM
80-400/4.5-5.6D AF-D ED VR	AF-D	17/11	30/10 – 6/10	32	2.3	77	HB-24	1340	91.0 x 171.0	Y (MF)	N	Y (MF)	N	N	N	VR

Special Purpose Auto Focus Nikkor Lenses

Lens	Type of Bayonet	Elements/Groups	Angle of view (Deg/Min)	Minimum aperture	Min. focus distance (m)	Filter size	Lens hood	Weight (g)	Dia./Length (mm)	TC-201	TC-301	TC-14A	TC-14B	TC-14E I/II	TC-20E i/II	Remarks
55mm/2.8 AF-Micro	AF	5/6	43	32	0.23	62	HN-22	420	74 x 82	Y (MF)	N	Y (MF)	N	N	N	CRC
60mm/2.8 AF-Micro	AF	7/8	39/40	32	0.219	62	HN-22	440	70 x 74.5	Y (MF)	N	Y (MF)	N	N	N	CRC
60mm/2.8D AF-Micro	AF-D	7/8	39/40	32	0.219	62	HN-22	440	70 x 74.5	Y (MF)	N	Y (MF)	N	N	N	CRC
105mm/2.8 AF-Micro	AF	8/9	23/20	32	0.314	52	HS-7	560	75 x 104.5	Y (MF)	N	N	N	N	N	CRC
105mm/2.8D AF-Micro	AF-D	8/9	23/20	32	0.314	52	HS-7	560	75 x 104.5	Y (MF)	N	N	N	N	N	CRC
200mm/4D IF-ED AF-Micro	AF-D	8/13	12/20	32	0.5	62	HN-30	1190	76 x 193	N	N	N	N	N	N	IF CRC
70-180mm/4.5-5.6D ED AF-Micro	AF-D	14/18	34/20 – 13/40	32	0.37	62	HB-14	1010	75 x 167	Y (MF)	N	Y (MF)	N	N	N	

Notes:

1. Y = Usable
2. N = Not Usable
3. MF = Manual Focus
4. AF = Auto Focus
5. RR = Reproduction Ratio
6. Angle-of-View = Degrees/Minutes
7. Using TC-14A, TC-4B, TC-201, and TC-301 may cause vignetting with AF lenses longer than 50mm, or uneven exposure with high shutter speeds at f/11, or less.
8. CRC = Close Range Correction system
9. IF = Internal Focusing system
10. RF = Rear Focusing system
11. DC = Defocus Control system
12. ED = Extra-low Dispersion glass
13. ASP = Aspherical lens element(s)
14. SWM = Silent Wave Motor for auto focus system
15. Ai-S P = Manual focus lens that has a P-type CPU, which permits use of auto-exposure modes
16. AF-N = Lens redesigned with wider rubber faced focus ring
17. AF-D = Lens CPU relays focus distance information to camera
18. AF-I = Lens with internal motor for auto focus operation
19. AF-S = Lens with silent wave motor for auto focus operation
20. AF-G = Lens has no aperture ring
21. AF-I & AF-S = AF function will only operate with F5, F4, F100, F90X, F90, F80, F75, F70, F65, D1-series, and D100 cameras
22. VR = Vibration Reduction function will only operate with F5, F100, F80, F75, F65, D1-series, and D100 cameras
23. G-type Nikkor:

These lenses are compatible with all exposure modes on F5, F100, F80, F75, F65, F60, F50, F-401-series, D1-series and D100 cameras

These lenses are compatible with the Shutter Priority & Program exposure modes on F4, F90-series, F70, F-801-series, and F601M cameras

They are incompatible with all other cameras.

Nikon manual focus cameras / Nikkor lens & metering compatibility

Camera	Lens type						
	Pre-AI	AI & AI converted	AI-S	AI-P	E-series	AF & AFD	AF-I & AF-S
F Photomic, T, TN, FTN	Y	Y	Y	Y	Y 1	Y 1	Y 1
Nikkormat FT, FS, FT2, FTN	Y	Y	Y	Y	Y 1	Y 1	Y 1
Nikkormat EL, ELW	Y	Y	Y	Y	Y 1	Y 1	Y 1
Nikkormat FT3, EL2	Y 1	Y	Y	Y	Y	Y	Y
F2 Photomic, S, SB	Y	Y	Y	Y	Y 1	Y 1	Y 1
F2A, F2AS	Y 1	Y	Y	Y	Y	Y	Y
FM, FE	Y 1	Y	Y	Y	Y	Y	Y
F3, F3HP, F3P	Y 1	Y	Y	Y	Y	Y	Y
EM, FG, FG-20	N	Y	Y	Y	Y	Y	Y
FE2, FA	N	Y	Y	Y	Y	Y	Y
FM2, FM2N, FM3A	N	Y	Y	Y	Y	Y	Y
F301	N	Y	Y	Y	Y	Y	Y
F601M	N	Y	Y	Y	Y	Y	Y
FM10, FE10	N	Y	Y	Y	Y	Y	Y

Y = Compatible
N = Not compatible

Notes:
1. Compatible but full aperture metering does not function. Use stop-down method.
2. All G-series AF Nikkor lenses are incompatible with manual focus cameras since they do not have an aperture ring.
3. The VR function of the AF Nikkor VR 80-400mm f4.5-5.6D lens will not operate with manual focus cameras
4. The F2H and F3H cameras can only perform stop down metering regardless of lens type.

Nikon auto focus camera / Nikkor lens & metering compatibility

Camera	Lens type						
	Pre-AI	AI & AI-S E-series	AI-P	AF	AF-D	AF-I & AF-S	AF-G
F5	N	Y 4	Y 6	Y	Y 8	Y	Y
F4	Y 1, 2	Y 1, 2, 3	Y 6	Y	Y 7	Y	N
F100	N	Y 4	Y 6	Y	Y 8	Y	Y
F90, F90X	N	Y 4	Y 6	Y	Y 8	Y	N
F80	N	Y 5	Y 6	Y	Y 8	Y	Y
F75	N	Y 5	Y 6	Y	Y 8	Y	Y
F70	N	Y 4	Y 6	Y	Y 8	Y	N
F65	N	Y 5	Y 6	Y	Y 8	Y 10	Y
F60	N	Y 5	Y 6	Y	Y 8	Y 10	Y
F55	N	Y 5	Y 6	Y	Y 8, 9	Y 10	Y
F50	N	Y 5	Y 6	Y	Y 8, 9	Y 10	Y
F801, F801S	N	Y 4	Y 6	Y	Y 7	Y 10	N
F601	N	Y 4	Y 6	Y	Y 7	Y 10	N
F501	N	Y 4	Y 6	Y	Y 7	Y 10	N
F401s	N	Y 5	Y 6	Y	Y 7	Y 10	N
F401x	N	Y 5	Y 6	Y	Y 7	Y 10	N

Y = Compatible N = Not compatible

Notes:
1. Compatible but full aperture metering does not function. Use stop-down method.
2. Shutter speed priority and Program exposure modes not available.
3. Matrix metering will not operate with AI converted lenses.
4. Matrix metering will not operate. Spot and Centre Weighted will as available on body. Manual and Aperture priority exposure control operates, but Shutter speed priority and Program do not operate.
5. Lens will mount but camera meter does not operate, because these lens types lack a CPU. Use manual exposure mode.
6. AI-P lenses provide manual focus with electronic rangefinder and full meter operation available on body.
7. 3D metering function does not operate as camera body lacks appropriate electronics.
8. 3D metering performed.
9. 3D metering performed for ambient light measurement only.
10. AF does not operate, because camera lacks electrical connections to drive AF motor in lens. Use manual focus.
11. All AF-I, AF-S, and AF-G series lenses offer 3D metering where available on the camera body.

Compatibility of non-CPU lens / accessory with the AF Nikon F-mount.

Despite the broad compatibility of the original Nikon F-mount, which dates from 1959, through the evolution of the Nikon AF systems to the present day, there are some lenses and accessories that cannot be used with Nikon auto-focus camera models. Attaching any of the following to an AF camera may cause damage to the camera, lens, or accessory.

- Pre-Automatic Indexing (AI) lenses
- 400mm f4.5, 600mm f5.6, 800mm f8, and 1200mm f11 lens heads with Focusing Unit AU-1
- Fisheye lenses, 6mm f5.6, 7.5mm f5.6, 8mm f8, and OP 10mm f5.6
- Early type 21mm f4
- Early type Perspective Control 35mm f3.5
- Early type Reflex 1000mm f6.3
- AF 80mm f2.8, AF 200mm f3.5, and TC16 teleconverter for F3 AF
- 200-600mm f9.5 (serial no. 280001 – 300490)
- 180-600mm f8 ED (Serial no. 174041 – 174180)
- 360-1200mm f11 ED (Serial no. 174031 – 174127)
- Reflex 2000mm f11 (Serial no. 200111 – 200310)
- Reflex 1000mm f11 (Serial no. 142361 – 143000)
- PC 35mm f2.8 (Serial no. 851001 – 906200)
- PC 28mm f4 (Serial no. 180900 or lower)
- Extension ring K1 and K2
- Auto-extension ring PK-1, and PK-11
- Reversing ring BR-2
- Semi-auto diaphragm ring BR-4
- TC-16A Teleconverter

Exposure Value (EV): Shutter Speed / Lens Aperture combinations

	1	1.4	2	2.8	4	5.6	8	11	16	22	32
4	-2	-1	0	1	2	3	4	5	6	7	8
2	-1	0	1	2	3	4	5	6	7	8	9
1	0	1	2	3	4	5	6	7	8	9	10
1/2	1	2	3	4	5	6	7	8	9	10	11
1/4	2	3	4	5	6	7	8	9	10	11	12
1/8	3	4	5	6	7	8	9	10	11	12	13
1/15	4	5	6	7	8	9	10	11	12	13	14
1/30	5	6	7	8	9	10	11	12	13	14	15
1/60	6	7	8	9	10	11	12	13	14	15	16
1/125	7	8	9	10	11	12	13	14	15	16	17
1/250	8	9	10	11	12	13	14	15	16	17	18
1/500	9	10	11	12	13	14	15	16	17	18	19
1/1000	10	11	12	13	14	15	16	17	18	19	20
1/2000	11	12	13	14	15	16	17	18	19	20	21
1/4000	12	13	14	15	16	17	18	19	20	21	22

Lens Hoods

HOOD	LENS
Bayonet Type	
HB-1	AF 28-85, AF 35-70/2.8, AF 35-135/3.5-4.5
HB-2	AF 35-105/3.5-4.5
HB-3	AF 24-50/3.3-4.5
HB-4	AF 20/2.8
HB-5	AF 35-105/3.5-4.5
HB-6	AF28-70/3.5-4.5D
HB-7	AF 80-200/2.8D (Type II & III)
HB-8	AF 20-35/2.8D, AF 18/2.8D
HB-10	AF 28-80/3.5-5.6D
HB-11	AF 24-120/3.5-5.6D
HB-12	AF 28-200/3.5-5.6D
HB-14	AF Micro 70-180/4.5-5.6D ED
HB-15	AF 70-300/4.5-5.6D ED
HB-17	AF-S 80-200/2.8
HB-18	AF 28-105/3.5-4.5D
HB-19	AF-S 28-70/2.8D
HB-20	AF 28-80/3.3-5.6G
HB-22	PC Micro 85/2.8D
HB-23	AF-S 17-35/2.8, AF 18-35/3.5-4.5, AF DX 12-24/4
HB-24	AF VR 80-400/4.5-5.6D
HB-25	AF 24-85/2.8-4, AF VR 24-120/3.5-4.5
HB-26	AF 70-300/4.5-5.6G
HB-27	AF 28-100/3.5-5.6G
HB-28	AF-S 24-85/3.5-4.5G
HB-29	AF-S VR 70-200/2.8G
HB-30	AF 28-200/3.5-5.6G
Extension Hood	
HE-1	Lens hood extension for 300/2
HE-2	Lens hood extension for 200-400/4
HE-3	Lens hood extension for 400/2.8 & 800/5.6
HE-4	Lens hood extension for 200/2, 300/2.8, 600/5.6
HE-5	Lens hood extension for 600/4
HE-6	Lens hood extension for AF 300/2.8
Slip-on Type	
HK-1	28-45/4.5
HK-2	24/2
HK-3	20/4, 28-50/3.5
HK-4	35-70/3.5

HK-5	50-300/4.5 ED
HK-6	20/3.5
HK-7	25-50/4, AF 28/1.4D
HK-8	36-72/3.5 E
HK-9	18/3.5
HK-10	50-135/3.5
HK-11	35-105/3.5-4.5
HK-12	28-50/3.5
HK-14	20/2.8
HK-15	35-200/3.5-4.5
HK-16	28-85/3.5-4.5
HK-17	500/4 P
HK-18	AF-I 600/4D
HK-19	AF-I 300/2.8D
HK-20	AF-I 400/2.8D
HK-21	AF-I 500/4D
HK-22	AF-S 300/2.8 (Type I)
HK-23	AF-S 600/4 (Type I&II)
HK-24	AF-S 500/4 (Type I&II)
HK-25	AF-S 400/2.8 (Type I&II)
HK-26	AF-S 300/2.8 (Type II)

Screw-in (Metal)

HN-1	24/2.8, 28/2, 35 PC
HN-2	28/2.8 & 35-70/3.3-4.5
HN-3	35/1.4, 35/2, 35/2.8, 55/2.8
HN-4	45/2.8 GN
HN-5	50/1.4
HN-6	55/1.2
HN-7	85/1.8 & 80-200/4.5
HN-8	105/2.5
HN-9	28/3.5 PC
HN-10	200-600/9.5
HN-11	50-300/4.5
HN-12	52mm polarizing filter
HN-13	72mm polarizing filter
HN-14	20/4
HN-15	18/4
HN-16	180-600/8
HN-17	360-1200/11
HN-20	85/1.4
HN-21	75-150/3.5 E
HN-22	35-135/3.5-4.5, 35-70/3.5, AF 55/2.8 & 60/2.8
HN-23	80-200/4, AF 85/1.8
HN-24	AF 70-210/4-5.6, 100-300/5.6, AF 75-300/4.5-5.6
HN-25	80-200/2.8 ED
HN-26	62mm polarizing filter

HN-27	Reflex 500/8
HN-28	AF 80-200/2.8 (Type I)
HN-30	AF Micro 200/4D
HN-31	AF 85/1.4
HN-34	77mm polarizing filter
HN-35	45/2.8 P
HN-36	AF-3 & AF-4 Gelatin filter holders

Screw-in (Rubber)

HR-1	Lens hood for 50/1.4
HR-2	Lens hood for 50/1.2
HR-4	Lens hood for 35/2.5E, 50/1.8E, 50/1.8
HR-5	Lens hood for 100/2.8 E
HR-6	Lens hood for 28/2.8

Snap-on

HS-1	Lens hood for non-AI 50/1.4
HS-2	Lens hood for non-AI 50/2
HS-3	Lens hood for non-AI 55/1.2
HS-4	Lens hood for AI 105/2.5
HS-5	Lens hood for 50/1.4 K
HS-6	Lens hood for AI 50/1.8 & 50/2
HS-7	Lens hood for AF 50/1.4
HS-8	Lens hood for non-AI 105/2.5, non-AI 135/3.5
HS-9	Lens hood for AI-S 50/1.4
HS-10	Lens hood for AI-S 85/2
HS-11	Lens hood for AI-S 50/1.8
HS-12	Lens hood for AI-S 50/1.2
HS-14	Lens hood for AI-S 105/2.8 Micro

Flash Data

Guide Numbers

The Guide Number (GN) is the most useful specification to know about a flash unit. It is an expression of how much light the flash is capable of producing. The higher the GN the higher the light output from the flash. The value of a GN will be determined by ISO sensitivity, unit of distance, and angle-of-coverage of the flash reflector.

All Guide Numbers in this book are specified in the form GN X: (ISO100, m) and are stated for the coverage equivalent to a 35mm film camera lens, unless stated otherwise.

GN Calculations

If you know the GN of your flash unit and the distance between it and the subject you can calculate the lens aperture to give a proper exposure. Remember that if the light from the flash is the only, or principle component of the light illuminating the subject the camera shutter speed will have no effect on the exposure, provided it is equal to or less than the maximum flash synchronisation speed.

For example assume you are using ISO100 film, or a digital camera with the sensitivity set to the equivalent of ISO100, the flash unit has a GN36 (ISO100, m), and the subject is 9m from the flash. The "correct" aperture is given by the formula:

GN / Distance = Lens Aperture, (e.g. 36 / 9 = 4)

So in this example, with the flash emitting its full power output, an aperture of f/4 would render a "correctly" exposed flash picture.

Alternatively if you know the GN and want to work at a pre-determined aperture you can calculate the required flash-to-subject distance to render the subject as "correctly" lit. For example assume you are using ISO100 film, or a digital camera with the sensitivity set to the equivalent of ISO100, the flash unit has a GN48 (ISO100, m), and you have set an aperture of f/8 on the lens. The "correct" aperture is given by the formula:

GN / Aperture = Distance, (e.g. 48 / 8 = 6)

So in this example using the full output of the flash at an aperture of f/8 you will need to place the flash 6m from the subject to ensure "correct" exposure.

It is important to remember that Guide Numbers are calculated on the distance between the flash and the subject, and not the distance between the camera and the subject, and assume the flash to be in the same axis as the lens. This becomes particularly relevant when the flash unit is taken off the camera and triggered via a lead or slave cell. At an angle of 30° or more off the lens axis the effective Guide Number of a flash unit is reduced, and it is necessary to compensate your exposure calculations. The following values should be taken as a general guide.

At 45° off lens-subject axis increase open the aperture + 1/2 stop.

At 60° off lens-subject axis increase open the aperture + 1 stop.

At 75° off lens-subject axis increase open the aperture + 2 stop.

All flash unit manufacturers calculate GN values on the assumption that the unit will be used indoors where there will reflective surfaces such as walls, ceilings, and floors. Outdoors it is unlikely that any light from the flash will be reflected from nearby surfaces so the effective GN value should be reduced by approximately a third. Either multiply the standard GN value by 0.7, or calculate the aperture with the standard GN value and then open the lens aperture by 1/3 stop.

If you wish to use a film with a different sensitivity rating than ISO 100, or a digital camera like the D100 that has a base sensitivity value equivalent to ISO 200 it will be necessary to re-calculate the GN value. Use the factors listed in the following table.

ISO Sensitivity	GN Multiplication Factor
25	0.50
32	0.56
40	0.63
50	0.70
64	0.80
80	0.90
100	1.00
125	1.12
160	1.25
200	1.40
250	1.60
320	1.80
400	2.00
500	2.25
640	2.50
800	2.80
1000	3.15
1250	3.55
1600	3.95

If you assume the use of an ISO 400 film in place of one rated at ISO 100, with a flash unit of GN20, at a flash to subject distance of 5m. To calculate the aperture use the following formula:

(GN x ISO Multiplier) / Distance = Aperture
(e.g. [20 x 2] / 5 = 8)

So in this example using the full output of the flash with ISO 400 film at a distance of 5m you will need to set an aperture of f/8 to achieve a "correct" exposure.

The following table provides the standard GN values for the various levels of coverage of the Nikon Speedlight range. The coverage is equivalent to the angle of view of the lens focal length (35m film) listed.

Nikon Speedlight Guide Number1 (ISO100, Metres) Data

	14mm	17mm	18mm	20mm	24mm	28mm	35mm	50mm	70mm	85mm	105mm
SB-1	-	-	-	-	-	-	28	-	-	-	-
SB-2	-	-	-	-	-	18	25	-	-	-	-
SB-3	-	-	-	-	-	18	25	-	-	-	-
SB-4	-	-	-	-	-	-	16	-	-	-	-
SB-5	-	-	-	-	-	32	-	-	-	-	-
SB-6	-	-	-	-	-	-	45	-	-	-	-
SB-7E	-	-	-	-	-	18	25	-	-	-	-
SB-8E	-	-	-	-	-	18	25	-	-	-	-
SB-9	-	-	-	-	-	-	14	-	-	-	-
SB-10	-	-	-	-	-	18	25	-	-	-	-
SB-11	-	-	-	-	-	25	36	-	-	-	-
SB-12	-	-	-	-	-	18	25	-	-	-	-
SB-14	-	-	-	-	22	32	-	-	-	-	-
SB-140	-	-	-	-	22	32	-	-	-	-	-
SB-15	-	-	-	-	-	18	25	-	-	-	-
SB-16A/B	-	-	-	-	19	27	32	38	-	42	-
SB-17	-	-	-	-	-	18	25	-	-	-	-
SB-18	-	-	-	-	-	-	20	-	-	-	-
SB-19	-	-	-	-	-	-	20	-	-	-	-
SB-20	-	-	-	-	-	22	35	-	-	-	-
SB-22	-	-	-	-	-	18	25	-	-	-	-
SB-22s	-	-	-	-	-	20	28	-	-	-	-
SB-23	-	-	-	-	-	-	20	-	-	-	-
SB-24	-	-	-	-	30	32	36	42	48	50	-
SB-25	-	-	-	22	30	32	36	42	48	50	-
SB-26	-	-	20	22	30	32	36	42	48	50	-
SB-27	-	-	-	-	25	27	30	34	342		-
SB-28			20	22	30	32	36	42	48	50	-
SB-28DX	-	-	20	22	30	32	36	42	48	50	-
SB-30	-	10	-	-	-	16	-	-	-	-	-
SB-50DX	12	-	-	-	18	20	22	26	-	-	-
SB-80DX	17	19	-	-	32	34	38	44	50	53	56

Notes:
1. The Guide Numbers (ISO100, m) listed are for the flash head setting NOT the focal length of the lens in use.
2. Flash head in vertical orientation.

Nikon Speedlight Data

Model / Attachment	Guide Number [1]	Battery (size / type)	External Battery + (AC Unit)	Recycle time (sec) [2]	Number flashes [2]	Flash duration [3]	Coverage Hori./ Vert. (Degrees) [8]	Head tilts	Head rotates	TTL Mode	Non-TTL Auto Mode	Man. power levels	Wide-angle Adapter	AF Assist light	PC Socket	Multi-flash socket	Repeating flash	High-speed Synch.	Rear curtain	Weight (g)	Dimensions (HxWxD) (mm)
SB-1 (Grip-type)	38	SN-1 (NiCd)	SD-2 / SD-3 (SA-1)	4	80	1/2000	56/40	Y	N	N	N	1	N	N	Y	N	N	N	N	670[7]	238.0x 80.0x50.0
SB-2 (F2-type)	25	4x LR6	(SA-2)	8	140	1/1200	56/40	N	Y	N	Y	1	N	N	Y	N	N	N	N	430	40.0x 110.0x104.0
SB-3 (ISO foot)	25	4x LR6	(SA-2)	8	140	1/1200	56/40	N	Y	N	Y	1	N	N	Y	N	N	N	N	430	40.0x 110.0x104.0
SB-4 (ISO foot)	16	2x LR6	N/A	9	140	1/800	56/40	N	N	N	Y	1	N	N	N	N	N	N	N	180	75.0x 70.0x40.0
SB-5 (Grip-type)	32	SN-2 (NiCd)	SD-4	2.6	75	1/1000	67/48	Y	N	N	Y	3 [4]	N	N	N	N	N	N	N	900[7]	252.0x 93.0x125.0
SB-6 (F/F2-type)	45	SN-3 (NiCd)	SD-5 (SA-3)	N/A	N/A	1/440	56/40	N	N	N	Y	2 4	N	N	N	N	Y	N	N	1100	128.0x190.0
SB-7E (F2-type)	25	4x LR6	N/A	8	160	N/K	56/40 (67/48)	N	Y	N	Y	1	Y (SW-2)	N	Y	N	N	N	N	300	37.0x 110.0x79.0
SB-8E (ISO foot)	25	4x LR6	N/A	8	160	N/K	56/40 (67/48)	N	Y	N	Y	1	Y (SW-2)	N	Y	N	N	N	N	270	37.0x 110.0x79.0
SB-9 (ISO foot)	14	2x LR6	N/A	9	55	N/K	56/40	N	N	N	Y	N	N	N	N	N	N	N	N	87	99.0x 56.0x24.0
SB-E (ISO foot)	17	2x LR6	N/A	9	80	N/K	56/40	N	N	N	Y	N	N	N	N	N	N	N	N	130	110.0x 55.0x33.0
SB-10 (ISO foot)	25	4x LR6	N/A	8	160	N/K	56/40 (70/53)	N	N	N	Y	1	Y (SW-2)	N	Y	N	N	N	N	270	37.0x 110.0x79.0
SB-11 (Grip-type)	36	8x LR6	SD-7 / SD-8A [6]	8	150	1/800	56/40 (70/53)	Y	N	N	Y	1	Y (SW-3)	N	Y	Y	N	N	N	860[7]	276.0x 104.0x118.0
SB-12 (F3-type)	25	4x LR6	N/A	8	160	N/K	56/40 (70/53)	N	Y	Y	N	1	Y (SW-4)	N	Y	N	N	N	N	350	40.0x 105.0x85.0
SB-14 (Grip-type)	32	SD-7	SD-7 / SD-8A [6]	9.5	270	1/800	67/48 (78/60)	Y	Y	N	Y	1	Y (SW-5)	N	Y	Y	N	N	N	515[7]	217.0x94.0x91.0
SB-140[2] (Grip-type)	32	SD-7	SD-7 / SD-8A [6]	9.5	270	N/K	67/48 (78/60)	Y	Y	N	Y	1	Y [5] (SW-5)	N	Y	Y	N	N	N	515[7]	217.0x 94.0x91.0
SB-15 (ISO foot)	25	4x LR6	N/A	8	160	N/K	60/45 (70/53)	Y	Y	Y	Y	2 [4]	Y (SW-6)	N	Y	N	N	N	N	270	42.5x 101.0x90.0
SB-16A (F3-type)	32	4x LR6	N/A	11	100	1/1250	60/45 (70/53)	Y	Y	Y	Y	2 [4]	Y (SW-7)	N	Y	Y	N	N	N	485	165.5x 100.0x82.0
SB-16B (ISO shoe)	32	4x LR6	N/A	11	100	1/1250	60/45 (70/53)	Y	Y	Y	Y	2 [4]	Y (SW-7)	N	Y	Y	N	N	N	445	144.0x 100.0x82.0
SB-17 (ISO foot)	25	4x LR6	N/A	8	160	1/1400	60/45 (70/53)	Y	Y	Y	Y	2 [4]	Y (SW-6)	N	Y	N	N	N	N	300	43.0x 101.0x90.0
SB-18 (ISO foot)	20	4x LR6	N/A	6	250	N/K	60/45	N	N	Y	Y	N/A	N	N	N	N	N	N	N	150	113.0x 66.0x42.0

SB-19	20	4x LR6	N/A	7	250	N/K	60/45	N	N	N	Y	N/A	N	N	N	N	N	N	N	170	116.0x 66.0x46.0
SB-20	30	4x LR6	SD-7 / SD-8A [6]	7	150	1/1200	60/45	Y	N	Y	Y	1	N	Y	Y	N	N	N	N	260	110.0x 71.0x70.0
SB-22	25	4x LR6	SD-7 / SD-8A ^	4	200	1/1700	70/53	Y	N	Y	Y	1	Y	Y	Y	N	N	N	N	250	105.0x 68.0x80.0
SB-22s	28	4x LR6	SD-7 / SD-8A [6]	5	230	1/1100	70/53	Y	N	Y	Y	1	Y	Y	Y	N	N	N	N	210	105.0x 68.0x80.0
SB-23	20	4x LR6	N/A	2	400	1/2000	60/45	N	N	Y	N	1	N	Y	N	N	N	N	N	140	67.0x 64.0x84.0
SB-24	36	4x LR6	SD-7 / SD-8A [6]	7	100	1/1000	78/60	Y	Y	Y	Y	5	N	Y	Y	Y	Y	N	Y	380	131.0x 0.0x100.0
SB-25	36	4x LR6	SD-7 / SD-8A [6]	7	100	1/1000	98/85	Y	Y	Y	Y	7	Built-in (20mm)[9]	Y	Y	Y	Y	Y	Y	380	135.0x 79.0x101.0
SB-26	36	4x LR6	SD-7 / SD-8A [6]	7	150	1/1000	102/90	Y	Y	Y	Y	7	Built-in (18mm)[9]	Y	Y	Y	Y	Y	Y	390	135.0x 79.0x101.0
SB-27	30	4x LR6	SD-7 / SD-8A [6]	5	140	1/1000	78/60	N	Y	Y	Y	5	Built-in (24mm)[9]	Y	Y	N	N	N	Y [10]	340	70.0x 107.0x97.0
SB-28	36	4x LR6	SD-7 / SD-8A [6]	6.5	150	1/1000	102/90	Y	Y	Y	Y	7	Built-in (18mm)[9]	Y	Y	Y	Y	Y	Y [10]	335	127.0x 68.0x91.0
SB-28DX	36	4x LR6	SD-7 / SD-8A [6]	6.5	150	1/1000	102/90	Y	Y	Y	Y	7	Built-in (18mm)[9]	Y	Y	Y	Y	Y	Y [10]	335	127.0x 68.0x91.0
SB-30	16	1x CR123A	N/A	4	250	1/2800	110/100	Y	N	Y	Y	3	Built-in (17mm)[9]	N	N	N	N	N	Y [10]	92	83.5x 58.5x36.0
SB-50DX	22	2x CR123A	N/A	3.5	260	1/1800	120/110	Y	N	Y	Y	1	Built-in (14mm)[9]	Y	N	N	N	Y	Y [10]	235	107.0x 63.0x105.0
SB-80DX	38	4x LR6	SD-7 / SD-8A [6]	6	150	1/1050	120/110	Y	Y	Y	Y	8	Built-in (14mm)[9]	Y	Y	Y	Y	Y	Y [10]	335	127.5x 70.5x91.5

Notes:

1. All Guide Numbers are quoted for the coverage of a 35mm lens, with an ISO sensitivity of 100 in Metres, unless stated otherwise.
2. Performance is quoted for fresh Alkaline-manganese batteries at 20°C.
3. Flash duration is given for full power output.
4. Includes a Motor Drive (MD) mode (manual output at reduced power): neither TTL nor Automatic flash output control are available
5. The SB-140 can use the SW-5 (Visible light), and the SW-5 (UV) & SW-5(IR) adapters. Unit can only operate in Manual mode with the latter two.
6. The SD-7 is not available in European countries.
7. Weight of flash unit only. Does not include bracket: SK-2/SB-1, SK-3/SB-5, SK4/SB-11, & SK5/SB-14/SB-140.
8. The angle of coverage represents the maximum available. Values given in brackets are for the appropriate wide-angle adapter.
9. Minimum focal length covered by diffuser.
10. Rear Curtain sync must be set from an appropriate camera body as this option is not available on the flash unit.

Nikon Macro-Speedlight & Medical-Nikkor Flash Unit Data

Model / Attachment	Guide Number	Battery power	Mains AC Power	Recycle time (sec) [5]	Number flashes [5]	Flash duration [6]	Max. coverage (Hori./Vert.)	Head tilts	Head rotates	TTL	Man. power levels	Wide-angle Adapter	Focus Assist Light	PC Socket	Multi-flash socket	Repeating flash	High-speed Synch.	Rear curtain	Weight (g)	Dimensions Flash (mm) HxWxD	Dimensions Control Unit HxWxD
SR-2 [1]	16	LD-1	LA-1	12	600	1/500	65	N/A	N/A	N	2	N/A	N/A	N	N	N	N	N	200	140.0x 106.0x 24.0	N/A
SM-2 [2]	N/A [3]	LD-1	LA-1	12	600	1/500	N/A	N/A	N/A	N	2	N/A	N/A	N	N	N	N	N	185	100.0x 70.0x 35.0	N/A
Medical-Nikkor 200/4 [4]	11	LD-1	LA-2	9	110	1/500	N/A	N/A	N/A	N	N	N/A	Y	N	N	N	N	N	N/A [4]	N/A [4]	N/A
Medical-Nikkor 120/4 [4]	16	LD-2	LA-2	9	90	1/500	N/A	N/A	N/A	N	N	N/A	Y	N	N	N	N	N	N/A [4]	N/A [4]	N/A
SB-21A (F3-type)	12 [8]	4x LR6 or, LD-2	LA-2	8	200	1/2000	65/85 [7]	N/A	N/A	Y	3	Y (SW-8)	Y	N	Y	N	N	N	145 [9] + 280 [10]	130.0x 120.0x 21.0	41.5x 100.0x 90.0
SB-21B (ISO foot)	12 [8]	4x LR6 or, LD-2	LA-2	8	200	1/2000	65/85 [7]	N/A	N/A	Y	3	Y (SW-8)	Y	N	Y	N	N	N	145 [9] + 250 [10]	130.0x 120.0x 21.0	41.5x 100.0x 90.0
SB-29 (ISO foot)	11 [8]	4x LR6	N/A	3	300	1/1400	90/102 [7]	N/A	N/A	Y	2	N/A	Y	Y	Y	N	N	N	410 [11]	133.0x 119.0x 28.5	69.0x 106.5x 88.5
SB-29s (ISO foot)	11 [8]	4x LR6	N/A	3	300	1/1400	90/102 [7]	N/A	N/A	Y	3	N/A	Y	Y	Y	N	N	N	410 [11]	133.0x 119.0x 28.5	69.0x 106.5x 88.5

Notes:

1. SR-2 has a 52mm thread for attachment to the front filter ring of a lens.
2. SM-2 has a bayonet mount to attach to a lens mounted in the reversed position.
3. Nikon did not quote a guide number for the SM-2 due to the very short working distances involved with a reversed lens.
4. The flash units of the Medical-Nikkor lenses are built-in.
5. Assumes fresh batteries and an ambient operating temperature of 20°C.
6. Duration quoted for maximum output level.
7. Assumes flash module set with tubes in vertical orientation at a distance of 1m with 35mm film camera.
8. Assumes both flash tubes are used.
9. Weight of SB-21 flash unit only.
10. Weight of AS-12 (F3) & AS-14 (ISO) controller units only.
11. Combined weight of SB-29/s flash unit & controller unit.

To calculate a maximum working aperture when using SB-21A/B & SB-29/s with a lens in the reverse mounted position, or at a magnification ratio larger than 1:1 use the following formula:

Aperture = Coefficient / Flash-to-Subject Distance (m)

Where the coefficient is:

ISO25 - 100	2
ISO 125 - 400	4
ISO ≥ 500	5.6

Close-up & Macro Photography

Reproduction Ratios

Magnification	Reproduction Ratio	Subject Size 1 (mm)
0.25x	1:4	96 x 144
0.50x	1:2	48 x 72
1.0x [2]	1:1 [2]	24 x 36
2.0x	2:1	12 x 18
3.0x	3:1	8 x 12
4.0x	4:1	6 x 9
5.0x	5:1	4.8 x 7.2
6.0x	6:1	4 x 6
7.0x	7:1	3.4 x 5.1

Notes:

1. Assumes use of 35mm film.
2. Usually referred to as life-size.
3. At high magnifications avoid use of small lens apertures because the effect of diffraction will impair image quality.
4. To reduce the effect of diffraction at a magnification of 2.0x use \geq f/8, at 1.0x use \geq f/11, and at 0.5x use \geq f/16.

Nikon Close-up Lenses

A cost effective way of achieving a modest magnification is to use a close-up lens. These lenses, which are also called close-up filters, fit to the front attachment thread of the principle lens. As they do not cause any additional lens extension they do not affect the exposure value or the TTL metering system. Nikon currently produce a range of seven different close-up lenses for a variety of focal length lenses in both 52mm and 62mm threads.

Close-up Lens	Filter Thread	Dioptre Value
0	52	+ 0.7
1	52	+ 1.5
2	52	+ 3.0
3T	52	+ 1.5
4T	52	+ 2.9
5T	62	+ 1.5
6T	62	+ 2.9

Notes:

1. There is no change in exposure (filter factor) with close-up lenses.
2. To optimise image quality always use a mid-range aperture (f/5.6 – f/11) when using close-up lenses.
3. Avoid stacking close-up lenses. If you do combine two always position the strongest closest to the principle lens.
4. Number 0, 1, & 2 are recommended for lenses with a focal length up to 55mm.
5. Number 3T & 4T are recommended for lenses with a focal length between 85 – 200mm.
6. Number 5T & 6T are recommended for lenses with a focal length between 70 –210mm.

No. 0 Close-up Lens

Lens	Lens-to-Subject Distance (mm)	Reproduction Ratio	Subject field size (mm x mm)
24/2	1520 – 2790	1:57.6 – 1:7.6	1380 x 2070 – 183 x 274
24/2.8	1510 – 2770	1:57.9 – 1:7.8	1390 x 2080 – 186 x 279
28/2	1520 – 2410	1:49 – 1:4.9	1180 x 1780 – 118 x 177
28/2.8	1510 – 1960	1:49 – 1:3.7	1180 x 1780 – 88 x 132
35/1.4	1530 – 2780	1:39 – 1:4.8	941 x 1410 – 115 x 172
35/2	1520 – 2750	1:39 – 1:4.9	941 x 1410 – 118 x 176
35/2.8	1510 – 2770	1:39.2 – 1:5	941 x 1410 – 120 x 179
50/1.2	1510 – 4160	1:27.4 – 1:6.2	657 x 985 – 148 x 222
50/1.4	1500 – 3810	1:27 – 1:5.5	657 x 985 – 131 x 196
50/1.8	1500 – 3810	1:27.4 – 1:5.4	657 x 985 – 129 x 193
AF 24/2.8	1510 – 2770	1:58 – 1:7.8	1390 x 2080 – 186 x 279
AF 28/2.8	1500 – 2740	1:49 – 1:6.6	1180 x 1770 – 159 x 238
AF 35/2	1510 – 2370	1:39 – 1:3.8	941 x 1410 – 92 x 138
AF 50/1.4	1510 – 3810	1:27 – 1:5.4	656 x 984 – 131 x 196
AF 50/1.8	1500 – 3810	1:27 – 1:5.3	656 x 984 – 128 x 191

No. 2 Close-up Lens

Lens	Lens-to-Subject Distance (mm)	Reproduction Ratio	Subject field size (mm x mm)
24/2	447 – 233	1:14 – 1:5.5	332 x 497 – 133 x 199
24/2.8	441 – 230	1:13.9 – 1:5.6	333 x 499 – 134 x 202
28/2	454 – 216	1:12 – 1:3.9	284 x 426 – 93 x 140
28/2.8	440 – 182	1:12 – 1:3.1	284 x 426 – 74 x 111
35/1.4	457 – 239	1:9.4 – 1:3.6	226 x 338 – 86 x 128
35/2	446 – 234	1:9.4 – 1:3.7	226 x 338 – 87 x 131
35/2.8	441 – 232	1:9.4 – 1:3.6	226 x 338 – 87 x 131
50/1.2	443 – 292	1:6.6 – 1:3.7	157 x 236 – 88 x 132
50/1.4	435 – 275	1:6.6 – 1:3.4	157 x 236 – 81 x 121
50/1.8	432 – 273	1:6.6 – 1:3.3	157 x 236 – 79 x 119
AF 24/2.8	441 – 230	1:14 – 1:5.6	333 x 499 – 134 x 202
AF 28/2.8	434 – 226	1:12 – 1:4.8	282 x 423 – 114 x 171
AF 35/2	439 – 209	1:9.4 – 1:3	226 x 338 – 71 x 107
AF 50/1.4	437 – 277	1:6.6 – 1:3.4	157 x 236 – 81 x 121
AF 50/1.8	434 - 275	1:6.6 – 1:3.3	157 x 236 – 79 x 118

No. 1 Close-up Lens

Lens	Lens-to-Subject Distance (mm)	Reproduction Ratio	Subject field size (mm x mm)
24/2	783 – 261	1:27.5 – 1:6.8	659 x 989 – 162 x 244
24/2.8	778 – 258	1:27.6 – 1:6.9	662 x 993 – 165 x 247
28/2	790 – 231	1:24 – 1:4.5	565 x 847 – 109 x 163
28/2.8	776 – 191	1:24 – 1:3.4	565 x 847 – 83 x 124
35/1.4	794 – 263	1:19 – 1:4.3	449 x 673 – 103 x 154
35/2	783 – 261	1:19 – 1:4.4	446 x 672 – 106 x 160
35/2.8	778 – 259	1:18.7 – 1:4.4	449 x 673 – 106 x 159
50/1.2	779 – 359	1:13 – 1:5	313 x 469 – 120 x 180
50/1.4	771 – 334	1:13 – 1:5	313 x 470 – 108 x 162
50/1.8	769 - 333	1:13 – 1:4.4	313 x 470 – 106 x 159
AF 24/2.8	778 – 258	1:28 – 1:6.9	662 x 993 – 165 x 247
AF 28/2.8	771 – 255	1:23 – 1:5.8	561 x 842 – 140 x 211
AF 35/2	775 – 227	1:19 – 1:3.5	449 x 673 – 84 x 126
AF 50/1.4	774 – 335	1:13 – 1:4.5	313 x 469 – 108 x 162
AF 50/1.8	771 - 334	1:13 – 1:4.4	313 x 469 – 105 x 158

No. 3T Close-up Lens

Lens	Lens-to-Subject Distance (mm)	Reproduction Ratio	Subject field size (mm x mm)
85/2	770 – 460	1:7.8 – 1:3.8	186 x 280 – 90 x 137
105/2.5	780 – 510	1:6.3 – 1:3.3	150 x 227 – 80 x 120
Micro 105/2.8	796 – 346	1:6.3 – 1:5.1	151 x 227 – 36 x 54
AF-Micro 105/2.8	819 – 293	1:6.3 – 1:1.2	152 x 228 – 20 x 30
135/2.8	800 – 570	1:4.9 – 1:2.7	117 x 176 – 65 x 100
135/3.5	800 – 570	1:4.9 – 1:2.7	117 x 176 – 65 x 100
200/4	830 – 680	1:3.3 – 1:1.2	80 x 120 – 48 x 72
Micro 200/4	885 – 503	1:3.3 – 1:1.15	79 x 118 – 27 x 41

No. 4T Close-up Lens

Lens	Lens-to-Subject Distance (mm)	Reproduction Ratio	Subject field size (mm x mm)
85/2	440 – 350	1:4 – 1:2.5	60 x 90 – 9.5 x 14.2
105/2.5	460 – 380	1:3.2 – 1:2.2	52 x 78 – 77 x 116
Micro 105/2.8	470 – 307	1:3.2 – 1:1.2	78 x 117 – 17 x 26
AF-Micro 105/2.8	495 – 278	1:3.2 – 1:1.4	78 x 117 – 17 x 26
135/2.8	470 – 410	1:2.5 – 1:1.7	60 x 90 – 41 x 61
135/3.5	470 – 410	1:2.5 – 1:1.7	60 x 90 – 41 x 61
200/4	510 – 480	1:1.7 – 1:1.2	41 x 61 – 28 x 42
Micro 200/4	561 – 422	1:1.7 – 1:1.22	40 x 60 – 19 x 29

No. 5T Close-up Lens

Lens	Focal Length(mm)	Lens-to-Subject Distance (mm)	Reproduction Ratio	Subject field size (mm x mm)
AF 85/1.8	85	775 - 461	1:7.8 – 1:4.3	188 x 282 – 104 x 156
AF 28 – 85/3.5-4.5	28	829 – 499	1:23.1 – 1:12.5	554 x 831 – 300 x 449
	35	820 – 489	1:19 – 1:10.3	465 x 684 – 246 x 370
	50	809 – 479	1:13.3 – 1:7.2	319 x 479 – 173 x 259
	85	806 - 476	1:8 – 1:4.3	192 x 288 – 104 x 156
AF 35 – 70/2.8	35	833 – 444	1:18.5 – 1:8.6	444 x 665 – 206 x 309
	50	818 – 429	1:13.2 – 1:6.2	319 x 479 – 148 x 222
	70	811 – 422	1:9.7 – 1:4.5	233 x 350 – 108 x 162
	Macro Setting	314 - 265	1:4.6 – 1:3.5	83 x 125 – 111 x 166
AF 35 – 135/3.5-4.5	35	825 – 609	1:18.4 – 1:11.8	441 x 662 – 282 x 424
	50	833 – 617	1:13.3 – 1:8.5	319 x 479 – 204 - 306
	70	842 – 625	1:9.5 – 1:6.5	228 x 342 – 146 x 219
	135	854 – 637	1:5.1 – 1:3.2	122 x 183 – 78 x 117
	Macro Setting	609 - 278	1:11.8 – 1:3.4	282 x 424 – 81 x 121
AF 70 – 210/4-5.6	70	824 – 608	1:9.3 –1:5.7	223 x 335 – 136 x 204
	85	833 – 617	1:7.8 – 1:4.8	188 x 282 – 114 x 171
	105	843 – 627	1:6.3 – 1:3.9	152 x 228 – 93 x 139
	135	852 – 636	1:4.9 – 1:3	118 x 177 – 72 x 108
	210	871 – 655	1:3.3 – 1:2	78 x 117 – 47 x 71
	Macro Setting	577 - 624	1:5.1 – 1:1.8	123 x 184 – 43 x 64
AF 75 – 300/4.5-5.6	75	882 – 760	1:8.7 – 1:6.7	208 x 313 – 160 x 240
	100	890 – 768	1:6.6 – 1:5.1	160 x 240 – 123 x 184
	135	898 – 776	1:4.9 – 1:3.8	118 x 177 – 91 x 136

NIKON CLOSE-UP/MACRO ACCESSORY DATA

Lens	Focal Length(mm)	Lens-to-Subject Distance (mm)	Reproduction Ratio	Subject field size (mm x mm)
	200	908 – 785	1:3.3 – 1:2.6	80 x 120 – 61 x 92
	300	912 – 790	1:2.3 – 1:1.7	54 x 82 – 42 x 63
	Macro Setting	697 – 667	1:5.1 – 1:1.3	122 x 183 – 32 x 48
105/1.8	105	766 – 495	1:6.7 – 1:3.4	160 x 240 – 80 x 120
80 – 200/4	80	870 – 620	1:8.3 – 1:4.4	190 x 300 – 110 x 160
	105	870 – 620	1:6.3 – 1:3.3	150 x 230 – 80 x 120
	135	870 – 620	1:4.9 – 1:2.6	120 x 180 – 62 x 94
	200	870 – 620	1:8 – 1:3.4	80 x 120 – 43 x 65

No. 6T Close-up Lens

Lens	Focal Length(mm)	Lens-to-Subject Distance (mm)	Reproduction Ratio	Subject field size (mm x mm)
AF 85/1.8	85	451 - 344	1:4 – 1:2.9	97 x 145 – 69 x 104
AF 28 – 85/3.5-4.5	28	505 – 392	11.8 – 8.5	284 x 427 – 203 305
	35	496 – 382	1:9.7 – 1:7	234 x 351 – 167 x 251
	50	485 – 372	1:6.8 – 1:4.9	164 x 246 – 117 x 175
	85	482 – 369	1:4.1 – 1:2.9	98 x 148 – 70 x 110
AF 35 – 70/2.8	35	510 – 369	1:9.5 – 1:6.2	227 x 341 – 148 x 222
	50	494 – 354	1:6.8 – 1:4.4	164 x 246 – 107 x 160
	70	487 – 346	1:5 – 1:3.2	120 x 180 – 78 x 117
	Macro Setting	290 - 255	1:3.8 – 1:3.1	92 x 138 – 73 x 110
AF 35 – 135/3.5-4.5	35	501 – 436	1:9.4 – 1:7.2	226 x 340 – 173 x 259
	50	509 – 444	1:6.8 – 1:5.2	164 x 246 – 125 x 187
	70	518 – 452	1:4.9 – 1:3.7	117 x 175 – 89 x 134
	135	530 – 465	1:2.6 – 1:2	63 x 94 – 48 x 71
	Macro Setting	436 - 264	1:7.2 – 1:2.9	173 x 259 – 70 x 105
AF 70 – 210/4-5.6	70	500 – 439	1:4.8 – 1:3.5	115 x 172 – 84 x 125
	85	510 - 449	1:4 –1:2.9	96 x 145 – 70 x 105
	105	519 – 458	1:3.2 – 1:2.4	78 x 117 – 57 x 85
	135	529 – 468	1:2.5 – 1:1.8	61 x 91 – 44 x 66
	210	547 – 486	1:1.7 – 1:1.2	40 x 60 – 29 x 44
	Macro Setting	429 - 476	1:3.2 – 1:1.1	78 x 117 – 27 x 41
AF 75 – 300/4.5-5.6	75	558 – 528	1:4.5 – 1:3.8	107 x 161 – 91 x 136
	100	566 – 535	1:3.4 – 1:2.9	82 x 123 – 70 x 105
	135	575 – 544	1:2.5 – 1:2.1	61 x 91 – 51 x 77
	200	584 – 553	1:1.7 – 1:1.4	41 x 61 – 35 x 52
	300	588 – 558	1:1.2 – 1:1	28 x 42 – 24 x 36
	Macro Setting	501 - 531	1:3.1 – 1.25:1	76 x 113 – 20 x 30
105/1.8	105	442 – 361	1:3.4 – 1:2.2	82 x 123 – 53 x 79
80 – 200/4	80	540 – 470	1:4.3 – 1:2.2	100 x 150 – 67 x 100
	105	540 – 470	1:3.2 – 1:2.1	80 x 120 – 50 x 75
	135	540 – 470	1:2.5 – 1:1.7	60 x 90 – 40 x 60
	200	540 - 470	1:1.8 – 1:1.1	43 x 65 – 26 x 40

Reversing Rings

Reverse mounting a lens is a quick and cost effective way of achieving greater magnification compared with supplementary close-up lenses and extension tubes. It also optimises the optical performance of the lens. The Reproduction Ratio (RR) of some popular Nikkor lenses (set at infinity) and reversed mounted with the BR-2A / BR-5 adapter rings are given in the tables below.

AF-Nikkor Lenses

Lens	Reproduction Ratio
20mm f/2.8D / f/2.8	3.4:1
24mm f/2.8D / f/2.8	2.5:1
28mm f/2.8D / f/2.8	2.0:1
35mm f/2D / f/2	1.4:1
50mm f/1.4 / f/1.4	1:1.1
50mm f/1.8 (N)	1:1.4
Micro 55mm f/2.8	1.2:1
Micro 60mm f/2.8D / f2.8	1:1.2
24-50mm f/3.3-4.5D / f/3.3-4.5	3:1 – 1:1
28-70mm f/3.5-4.5D / f/3.5-4.5	2.2:1 – 1:5.6
28-85mm f/3.5-4.5 (N)	3:1 – 1:27.5
28-105mm f/3.5-4.5 / f/3.5-4.5	2.8:1 – 1:1.8
35-70mm f/2.8D / f/2.8	2.3:1 – 1:1.9
35-70 f/3.3-4.5 (N)	2.1:1 – 1:6.1
35-80 f/4-5.6	1.5:1 – 1:1.4
35-105mm f/3.5-4.5D IF	1.8:1 – 1:33.6
35-105mm f/3.5-4.5	1.8:1 – 1:6.1
35-135mm f/3.5-4.5 (N)	2.2:1 – 1:31.7

Manual Focus Nikkor Lenses

Lens	Reproduction Ratio
20mm f/2.8	3.4:1
24mm f/2	2.6:1
24mm f/2.8	2.6:1
28mm f/2	2.2:1
28mm f/2.8	2.1:1
35mm f/1.4	1.8:1
35mm f/2	1.6:1
35mm f/2.8	1.5:1
35mm f/2.8 PC	1.6:1
50mm f/1.2	1.1:1
50mm f/1.4	1:1.1
50mm f/1.8	1:2
Micro 55mm f/2.8	1:1.1
Noct 58mm f/1.2	1:1.2
28-85mm f/3.5-4.5	2.9:1 – 1:35.8
35-70mm f/3.5-4.5	2.1:1 – 1:6.1
35-105mm f/3.5-4.5	1.8:1 – 1:6
35-135mm f/3.5-4.5	2.2:1 – 1:14.9
35-200mm f/3.5-4.5	2.2:1 – 1:∞

Notes:

1. The BR-2 adapter ring must not be used on Nikon AF cameras. Use the BR-2A instead.
2. The BR-2 / BR-2A adapter rings are compatible with lenses that have a 52mm front attachment thread.
3. The BR-5 adapter ring is required for any lens with a 62mm front attachment thread.
4. The BR-3 adapter ring can be attached to the bayonet mount of a reversed lens to provide a 52mm thread for filters and lens hoods.

Nikon PK-Extension Ring Data

The following tables contain data concerning the use of the current range of Nikon PK-type extension tubes in combination with a number of popular Nikkor lenses. Note that auto focus operation will not function with AF-Nikkor lenses, and there are restrictions on exposure measurement with some AF camera bodies.

Extension Ring(s)	Extension (mm)
PK-11A	8.0
PK-12	14.0
PK-11A + PK-12	22.0
PK-13	27.5
PK-11A + PK-13	35.5
PK-12 + PK-13	41.5
PK-11A + PK-12 + PK-13	49.5
PN-11	52.5

Notes:
1. The PK-11 Extension Tube must not be used with AF-Nikkor lenses. Use the PK-11A instead.
2. Extension will result in a lower light level at the film plane but TTL metering will account for this automatically.
3. On AF cameras auto focus will not work. Use manual focus instead.
4. Matrix metering (except F4) will not work with these extension tubes. Use centre-weighted / spot metering.
5. Shutter Priority & Program exposure modes will not work with these extension tubes. Use Manual / Aperture Priority exposure modes.

Nikkor Ai-S 20mm f/2.8

Extension Ring	Reproduction Ratio	Size of Subject Field (mm)	Subject to Film Distance (mm)
None	1: ∞ - 1:8	∞ - 18.9x28.4	∞ - 250
PK-11A	1:2.6 – 1:2	61x92 – 46x70	137 – 127
PK-12	1:1.5 – 1:1.2	35x53 – 30x44	121 – 118
PK-11A + PK-12	1.1:1 – 1.2:1	22x34 – 20x30	118 – 118
PK-13	1.3:1 – 1.5:1	18x27 – 16x25	119 – 121
PK-11A + PK-13	1.7:1 – 1.9:1	14x21 – 13x19	124 – 126
PK-12 + PK-13	2:1 – 2.2:1	12x18 – 11x17	128 – 130
PK-11A + PK-12 + PK-13	2.4:1 – 2.5:1	10x15 – 9.5x14	134 – 137

AF-Nikkor 28mm f/2.8D

Extension Ring	Reproduction Ratio	Size of Subject Field (mm)	Subject to Film Distance (mm)
None	1: ∞ - 1:7.6	∞ - 18.2x27.4	∞ - 300
PK-11A	1:3.6 – 1:2.4	86x130 – 59x88	190 – 160
PK-12	1:2.1 – 1:1.6	49x74 – 39x58	151 – 142
PK-11A + PK-12	1:1.3 – 1:1.1	31x47 – 27x40	138 – 136
PK-13	1:1 - 1.1:1	25x38 – 22x33	136 – 136
PK-11A + PK-13	1.2:1 – 1.4:1	19x29 – 18x26	137 – 138
PK-12 + PK-13	1.4:1 – 1.6:1	17x25 – 15x23	139 – 142
PK-11A + PK-12 + PK-13	1.7:1 – 1.9:1	14x21 – 13x19	144 – 147

AF-Nikkor 24mm f/2.8D & Nikkor Ai-S 24mm f/2.8

Extension Ring	Reproduction Ratio	Size of Subject Field (mm)	Subject to Film Distance (mm)
None	1: ∞ – 1:8.8	∞ – 212x318	∞ – 300
PK-11A	1:3 – 1:2.3	73x110 – 54x82	164 – 148
PK-12	1:1.7 – 1:1.5	42x63 – 35x52	138 – 134
PK-11A + PK-12	1.1:1 – 1:1	27x40 – 24x36	131 – 131
PK-13	1.1:1 – 1.2:1	21x32 – 19x29	131 – 132
PK-11A + PK-13	1.5:1 – 1.6:1	16x24 – 15x23	134 – 136
PK-12 + PK-13	1.7:1 – 1.8:1	14x21 – 13x20	138 – 140
PK-11A + PK-12 + PK-13	2:1 – 2.1:1	12x18 – 11x17	143 – 145

Nikkor Ai-S 50mm f/1.2, 50mm f/1.4

Extension Ring	Reproduction Ratio	Size of Subject Field (mm)	Subject to Film Distance (mm)
None	1: ∞ – 1:6.7	∞ – 161x241	∞ – 450
PK-11A	1:6.4 – 1:3.3	155x232 – 79x118	438 – 282
PK-12	1:3.7 – 1:2.4	88x133 – 57x86	300 – 240
PK-11A + PK-12	1:2.3 – 1:1.7	56x84 – 43x63	239 – 215
PK-13	1:1.9 – 1:1.5	45x68 – 36x54	220 – 207
PK-11A + PK-13	1:1.5 – 1:1.2	36x54 – 30x45	207 – 201
PK-12 + PK-13	1:1.2 – 1:1	30x45 – 24x36	202 – 199
PK-11A + PK-12 + PK-13	1:1 – 1.1:1	24x36 – 22x32	200 – 199

Nikkor Ai-S 35mm f/1.4, 35mm f/2, 35mm f2.8

Extension Ring	Reproduction Ratio	Size of Subject Field (mm)	Subject to Film Distance (mm)
None	1: ∞ – 1:5.5	∞ – 133x199	∞ – 300
PK-11A	1:4.5 – 1:2.5	108x162 – 60x89	263 – 197
PK-12	1:2.6 – 1:1.8	62x93 – 42x63	200 – 177
PK-11A + PK-12	1:1.6 – 1:1.3	39x59 – 30x45	174 – 167
PK-13	1:1.3 – 1:1.1	31x47 – 25x38	168 – 165
PK-11A + PK-13	1:1 – 1.2:1	24x36 – 21x31	165 – 166
PK-12 + PK-13	1.2:1 – 1.3:1	21x31 – 18x27	166 – 168
PK-11A + PK-12 + PK-13	1.4:1 – 1.6:1	17x26 – 15x23	169 – 172

Nikkor Ai-S 50mm f/1.8, AF-Nikkor 50mm f/1.8

Extension Ring	Reproduction Ratio	Size of Subject Field (mm)	Subject to Film Distance (mm)
None	1: ∞ – 1:6.6	∞ – 159x238	∞ – 450
PK-11A	1:6.5 – 1:3.3	155x232 – 79x118	440 – 284
PK-12	1:3.7 – 1:2.4	88x133 – 57x86	304 – 243
PK-11A + PK-12	1:2.4 – 1:1.7	56x84 – 43x63	243 – 219
PK-13	1:1.9 – 1:1.5	45x68 – 36x54	224 – 210
PK-11A + PK-13	1:1.5 – 1:1.2	36x54 – 30x45	201 – 204
PK-12 + PK-13	1:1.2 – 1:1	30x45 – 24x36	205 – 203
PK-11A + PK-12 + PK-13	1:1 – 1.1:1	24x36 – 22x32	203 – 103

Micro-Nikkor Ai-S 55mm f/2.8

Extension Ring	Reproduction Ratio	Size of Subject Field (mm)	Subject to Film Distance (mm)
None	1:∞ - 1:1.9	∞ - 46x69	∞ - 250
PK-11A	1:6.9 - 1:1.5	165x248 – 36x54	497 – 235
PK-12	1:3.9 - 1:1.3	94x141 – 37x56	341 – 229
PK-11A + PK-12	1:2.5 - 1:1.1	60x90 – 27x40	271 – 225
PK-13	1:2 - 1:1	48x72 – 24x36	249 – 225
PK-11A + PK-13	1:1.5 - 1:1.1	36x54 – 21x32	232 – 226
PK-12 + PK-13	1:1.3 – 1.2:1	32x48 – 19x29	225 – 227
PK-11A + PK-12 + PK-13	1:1.1 – 1.4:1	27x40 – 17x26	222 – 231

Nikkor Ai-S 85mm f/2, 85mm f/1.4

Extension Ring	Reproduction Ratio	Size of Subject Field (mm)	Subject to Film Distance (mm)
None	1:∞ - 1:8.1	∞ - 194x290	∞ - 850
PK-11A	1:10.6 - 1:4.6	255x382 – 110x165	1060 – 562
PK-12	1:6.1 - 1:3.5	146x219 – 83x125	684 – 473
PK-11A + PK-12	1:3.9 - 1:2.6	93x139 – 63x94	304 – 408
PK-13	1:3.1 - 1:2.2	74x111 – 54x80	444 – 382
PK-11A + PK-13	1:2.4 - 1:1.8	57x86 – 44x66	393 – 357
PK-12 + PK-13	1:1.2 - 1:1.6	49x74 – 39x59	369 – 345
PK-11A + PK-12 + PK-13	1:1.7 - 1:1.4	41x62 – 34x51	349 – 334

AF Micro-Nikkor 60mm f/2.8D

Extension Ring	Reproduction Ratio	Size of Subject Field (mm)	Subject to Film Distance (mm)
None	1:∞ - 1:1	∞ - 24x36	∞ - 219
PK-11A	1:7.5 - 1:1.2	180x270 – 20x30	585 – 221
PK-12	1:4.3 - 1.4:1	103x154 – 18x27	398 – 223
PK-11A + PK-12	1:2.7 - 1:1.5	65x98 – 16x24	312 – 227
PK-13	1:2.2 - 1.6:1	52x79 – 15x22	285 – 231
PK-11A + PK-13	1:1.7 - 1:8.1	41x61 – 13x20	263 – 236
PK-12 + PK-13	1:1.4 - 1.9:1	35x52 – 13x19	255 – 240
PK-11A + PK-12 + PK-13	1:1.2 - 2.1:1	29x44 – 12x17	249 – 246

Nikkor Ai-S 105mm f2.5, 105mm f1.8

Extension Ring	Reproduction Ratio	Size of Subject Field (mm)	Subject to Film Distance (mm)
None	1:∞ - 1:8.3	∞ - 200x300	∞ - 1000
PK-11A	1:13.1 - 1:5.1	315x473 – 122x183	1570 – 735
PK-12	1:7.5 - 1:3.9	180x270 – 95x142	981 – 620
PK-11A + PK-12	1:4.8 - 1:3	115x172 – 73x109	702 – 532
PK-13	1:3.8 - 1:2.6	92x137 – 63x94	608 – 494
PK-11A + PK-13	1:3 – 1:2.2	73x109 – 52x79	525 – 456
PK-12 + PK-13	1:2.5 - 1:1.9	61x91 – 47x70	486 – 437
PK-11A + PK-12 + PK-13	1:2.1 - 1:1.7	51x76 – 41x61	451 – 419

Micro-Nikkor 105mm f/2.8

Extension Ring	Reproduction Ratio	Size of Subject Field (mm)	Subject to Film Distance (mm)
None	1:∞ – 1:2	∞ – 200x300	∞ – 1000
PK-11A	1:13 – 1:1.7	315x473 – 40x60	1620 – 391
PK-12	1:7.5 – 1:1.5	180x270 – 36x54	1030 – 382
PK-11A + PK-12	1:4.8 – 1:1.3	115x172 – 31x47	753 – 374
PK-13	1:3.8 – 1:1.2	92x137 – 29x43	659 – 371
PK-11A + PK-13	1:3 – 1:1.1	73x109 – 26x39	576 – 369
PK-12 + PK-13	1:2.5 – 1:1	61x91 – 24x36	537 – 368
PK-11A + PK-12 + PK-13	1:2.1 – 1.1:1	51x76 – 22x33	502 – 369

Nikkor Ai-S 135mm f/2, 135mm f/2.8, 135mm f3.5

Extension Ring	Reproduction Ratio	Size of Subject Field (mm)	Subject to Film Distance (mm)
None	1:∞ – 1:7.5	∞ – 180x270	∞ – 1300
PK-11A	1:16.9 – 1:5.2	405x607 – 125x187	2560 – 998
PK-12	1:9.6 – 1:4.2	231x347 – 101x152	1590 – 873
PK-11A + PK-12	1:6.1 – 1:3.4	147x221 – 81x122	1120 – 767
PK-13	1:4.9 – 1:3	118x177 – 71x107	629 – 321
PK-11A + PK-13	1:3.8 – 1:2.5	91x137 – 61x91	820 – 666
PK-12 + PK-13	1:3.3 – 1:2.3	78x117 – 54x82	752 – 639
PK-11A + PK-12 + PK-13	1:2.7 – 1:2	65x98 – 48x72	689 – 609

AF Micro-Nikkor 105mm f/2.8

Extension Ring	Reproduction Ratio	Size of Subject Field (mm)	Subject to Film Distance (mm)
None	1:∞ – 1:1	∞ – 24x36	∞ – 314
PK-11A	1:13.1 – 1.1:1	315x473 – 22x32	1590 – 315
PK-12	1:7.5 – 1.2:1	180x270 – 20x30	1000 – 316
PK-11A + PK-12	1:4.8 – 1.3:1	115x172 – 18x28	724 – 319
PK-13	1:3.8 – 1.4:1	92x137 – 17x26	629 – 321
PK-11A + PK-13	1:3 – 1.5:1	73x109 – 16x24	547 – 326
PK-12 + PK-13	1:2.5 – 1.6:1	61x91 – 15x23	508 – 329
PK-11A + PK-12 + PK-13	1:2.1 – 1.7:1	51x76 – 14x22	473 – 334

AF Nikkor 180mm f/2.8 IF-ED

Extension Ring	Reproduction Ratio	Size of Subject Field (mm)	Subject to Film Distance (mm)
None	1:∞ – 1:6.4	∞ – 154x232	∞ – 1556
PK-11A	1:22.5 – 1:5	540x810 – 120x180	4400 – 1307
PK-12	1:12.8 – 1:4.3	309x463 – 103x154	2671 – 1184
PK-11A + PK-12	1:8.2 – 1:3.6	196x295 – 86x130	1837 – 1069
PK-13	1:6.5 – 1:3.2	157x236 – 78x117	1548 – 1010
PK-11A + PK-13	1:5.1 – 1:2.8	122x183 – 68x102	1910 – 945
PK-12 + PK-13	1:4.3 – 1:2.6	104x156 – 62x93	1165 – 907
PK-11A + PK-12 + PK-13	1:3.6 – 1:2.3	87x131 – 56x84	1047 – 867

Micro-Nikkor 200mm f/4 IF

Extension Ring	Reproduction Ratio	Size of Subject Field (mm)	Subject to Film Distance (mm)
None	1: ∞ - 1:2	∞ - 48x72	∞ - 710
PK-11A	1:25 – 1:1.8	600x900 – 43x65	538 – 690
PK-12	1:14.3 – 1:1.7	343x514 – 40x61	325 – 678
PK-11A + PK-12	1:9.1 – 1:1.5	218x327 – 37x56	222 – 665
PK-13	1:7.3 – 1:1.5	175x262 – 35x53	186 – 658
PK-11A + PK-13	1:5.6 – 1:1.4	135x203 – 33x49	154 – 651
PK-12 + PK-13	1:4.8 – 1:1.3	116x173 – 31x46	138 – 646
PK-11A + PK-12 + PK-13	1:4 – 1:1.2	97x145 – 29x43	123 – 642

Nikkor 300mm f/4.5 IF-ED

Extension Ring	Reproduction Ratio	Size of Subject Field (mm)	Subject to Film Distance (mm)
None	1: ∞ - 1:7.2	∞ - 172x258	∞ - 2510
PK-11A	1:37.5 – 1:5.9	899x135 – 141x211	1189 – 218
PK-12	1:21.4 – 1:5.2	514x771 – 124x186	708 – 200
PK-11A + PK-12	1:13.6 – 1:4.5	327x490 – 107x161	476 – 183
PK-13	1:10.9 – 1:4.1	262x392 – 98x147	395 – 173
PK-11A + PK-13	1:8.4 – 1:3.6	203x304 – 87x130	322 – 162
PK-12 + PK-13	1:7.2 – 1:3.3	173x260 – 80x120	286 – 155
PK-11A + PK-12 + PK-13	1:6.1 – 1:3	145x218 – 72x108	123 – 642

Bellows Units

Bellows units offer the maximum level of magnification and greatest versatility for close-up and macro photography. The following tables set out the relevant data for the current PB-6 and PB6E models using lenses in their normal mounted position and in a reverse mounted position. The latter is often preferable, particularly at high magnification, to optimise optical quality.

Nikon PB-6 Bellows Unit Data

Focal Length	Mounting Position	Reproduction Ratio	Extension (mm)	Working Distance (mm)
20mm	Reversed	4.5:1 – 11:1	78 - 208	38 – 35.5
24mm	Reversed	3.9:1 – 9:1	83 -208	39.8 – 36.2
28mm	Normal	1.7:1 – 2.9:1	48 - 84	7.3 - 0
28mm	Reversed	3.3:1 – 7.6:1	83 - 208	42.3 – 37.3
35mm 1	Normal	1.3:1 – 4.3:1	48 - 154	18.6 – 0
35mm 1	Reversed	2.6:1 – 5.9:1	89 - 208	47.5 – 39.6
50mm	Normal	1:1.1 – 4:1	48 - 208	68.6 – 25.9
50mm	Reversed	1.4:1 – 4:1	73.6 - 208	71.6 – 46.5
55mm	Normal	1:1.1 – 3.8:1	48 - 208	65.4 – 16.9
55mm	Reversed	1.5:1 – 3.5:1	99 - 208	70.9 – 49.4
85mm	Normal	1:1.8 – 2.4:1	48 - 208	210 – 90
85mm	Reversed	1:3 – 1.7:1	90 - 208	290 - 83
105mm	Normal	1:2.2 – 2:1	48 - 208	300 - 120
105mm	Reversed	1:6.1 – 1:1.1	133 - 208	670 - 150
135mm	Normal	1:2.8 – 1.5:1	48 - 208	520 - 230
135mm	Reversed	1: ∞ – 1:4.8	180 - 208	∞ - 680
180mm	Normal	1:3.8 – 1.2:1	48 - 208	830 - 310
200mm	Normal	1:4.2 – 1:1	48 - 208	990 - 349

Nikon PB-6 + PB6E Bellows Unit Data

Focal Length	Mounting Position	Reproduction Ratio	Extension (mm)	Working Distance (mm)
20mm	Reversed	11:1 – 23:1	208 - 438	35.3 – 34.4
24mm	Reversed	9:1 – 19:1	208 - 438	36.2 – 34.8
28mm	Reversed	7.5:1 – 15:1	208 - 438	37.3 – 35.3
35mm	Reversed	5.8:1 – 12:1	208 - 438	3.4 – 0.1
50mm	Normal	4:1 – 8.5:1	208 - 438	21.3 – 14.6
50mm	Reversed	4:1 – 8.5:1	208 - 438	46.5 – 39.6
55mm	Normal	3.8:1 – 8:1	208 - 438	16.1 – 8.5
55mm	Reversed	3.5:1 – 7.8:1	208 - 438	48.8 – 43.6
85mm	Normal	2.5:1 – 5.5:1	208 – 438	90 – 71
85mm	Reversed	1.8:1 – 4.5:1	208 - 438	83 - 53
105mm	Normal	2:1 – 4.5:1	208 – 438	120 – 92
105mm	Reversed	1:1.7 – 3.5:1	208 – 438	150 -68
135mm	Normal	1.5:1 – 3.5:1	208 – 438	230 –190
135mm	Reversed	1:5 – 1.5:1	208 – 438	680 - 100
180mm	Normal	1.2:1 – 2.5:1	208 – 438	310 -230
200mm	Normal	1:1 – 2.5:1	208 - 438	520 -420

Note:
1. With 35mm f/2 type lens.

Nikon Camera Software

Nikon Data Link System

Once cameras such as the Nikon F90 became available, with so many functions controlled by its microprocessor, Nikon realised that photographers could benefit from further customized control of their camera. The aptly named Data-Link system was introduced, and in place of the earlier two-pin remote terminal, a new ten-pin remote socket, located on the front of the camera, was fitted to allow the connection of the Sharp IQ-8000/IQ-9000 series electronic organizers, via the MC-27 lead, to enable data transfer. Nikon released the AC-1E Data-link card that was compatible with the organizers and provided a whole host of remote control and customized operations beyond those offered by the MF-26 Multi-Control back. Following the release of the F90X camera Nikon introduced a second Data Link card, the AC-2E. The functions include: downloading shooting data recorded by the F90/F90X, the ability to develop and store up to five individual program curves, and the organizer can serve as a remote display.

Nikon Photo Secretary System

As more and more photographers embraced personal computers Nikon introduced the Photo Secretary System software that links the F90/90X, F100, and F5 cameras to a computer to provide an even greater degree of control than the earlier Data Link system for the F90/F90X.

The first software system known as the AC-PW-E for the F90/90X can be used on a personal computer running Windows 95, Windows NT 3.51 or later, and Windows 3.1. It requires the MC-31 connecting lead to link the camera to the computer. Given the dynamic nature of computer software design these are rather dated programs but still operable on some machines. The Photo Secretary allows the photographer to store and manage shooting data from the camera for cross referencing with the images but also to perform a variety of camera settings and other operation directly from the PC. Nikon have never provided a version for any versions of the Apple Macintosh operating system.

In deference to the professional status of the F5 two versions of the Photo Secretary software were introduced for the camera: the AC-1WE for Windows 95 and the AC-1ME for Apple Macintosh OS 7.0 –7.6. The camera is connected to the computer via the MC-33 lead for a PC and the MC-34 for a Mac, and in both instances requires a serial port connection on the computer. Like the AC-PW-E software for the F90/90X the appropriate software for the F5 allows you to store and manage shooting data from the camera and perform a variety of camera control functions and other operation directly from the computer.

The most recent version of the Photo Secretary software is the AC-2WE for the F100 camera. It is only available for the PC platform and is compatible with Windows 95, 98 and NT 4.0. The camera can be connected by either the MC-31, or MC-33 lead. Functions and features are similar to those offered by the software for the F90X and F5.

It would appear that the proliferation of third party software to perform a similar function seems to have deterred Nikon from keeping their Photo Secretary product up-to-date with current operating systems, although Nikon continue to list the programs as still being available.

Nikon View

The advent of the digital SLR in the form of the D1 heralded a new era in the software available from Nikon. It was designed to allow a photographer to enhance the operation of their camera as never before. Nikon have produced two principle programs, which have constantly evolved since their introduction. The first is Nikon View, currently in version 6, which is designed to facilitate the transfer of image files from the camera or storage media to a computer. It allows you to browse the images, view them, and make minor adjustments. The program also offers direct print and e-mail output. This software is available free from Nikon and is bundled with all their digital cameras.

The principle features of Nikon View 6:

- Rapid and easy transfer of image files to computer
- Browsing of image files with variable thumbnail size
- View each image alongside the shooting data.
- Automatic adjustment of contrast and colour
- Image crop and re-size functions
- Manual control of colour brightness, contrast, and colour balance
- Exposure and white balance correction of NEF RAW files
- Print, e-mail, and slideshow output of images

Nikon Capture

The second is Nikon Capture, currently at version 3.5, which is a powerful post capture production tool and camera control software suite. Its two distinct functions to allow a photographer to get the most out of the D1-series and D100 SLR cameras across both the PC and Mac computer platforms. It is available as an optional accessory.

Nikon Capture Editor

Nikon Capture Editor provides a broad variety of image enhancement tools, including control of brightness, contrast, colour balance, image size and resolution, and an unsharp mask tool. There is a noise reduction facility to assist with the electronic noise that can affect images, particularly those shot at high sensitivity ratings and/or in low-light conditions. This array of features can be applied to all image files regardless of format and quality mode.

If you choose to shoot Nikon Electronic File (NEF) format images in RAW mode Nikon Capture provides the opportunity to alter or correct many of the attributes of these files post capture. White Balance, Exposure Compensation, Sharpening, Tone Compensation, Colour Mode, Hue Adjustment and Saturation Compensation can all be adjusted after the original image has been captured providing a very high degree of control over the final image quality. All of these controls can be applied in a batch process function when a series of images have been taken under similar conditions to improve workflow. If the adjusted RAW image files is finally saved in the NEF format the image enhancement and adjustment setting are saved independently of the original file data. This allows the photographer to change settings at any stage in the future without affect the quality of the original image file.

Nikon Capture Control

The Control component of Nikon capture allows you to control virtually every aspect of an appropriate digital SLR camera from your computer, including the release of the shutter.

Using the D1-series cameras the connection is via an IEEE 1394 (Firewire) interface and for the D100 camera it is via the USB interface. Pictures taken on the camera are stored directly to the computer hard drive as opposed to the storage media on board the camera. This provides a high volume storage capacity for extended shooting situations.

The principle features of Nikon Capture 3.5:

- A fully colour managed image editing system
- Remote camera control
- 3 stops exposure correction control with NEF Raw
- Full post exposure corrections of white balance post image capture
- Dual destination of batch process files
- One original NEF file, all adjustments and alterations remain separate
- 10Mp output option from D1X
- Vignette control for images shot with an ultra wide-angle lens

The accompanying tables show the compatibility with various computer operating systems and the inter-compatibility between the different versions of Nikon View and Nikon Capture programs.

Nikon View - Operating System Compatibility

Compatible Products	View DX	View 3	View 4.3.x Coolpix cameras 3	View 4.3.x SLR cameras	View 5.0.1	View 5.1.x	View 5.5 (Mac OS only)	View 6.0
	D1	700, 800, 900, 950 (880, 990)[2]	775, 880, 885, 990, 995	D1 / D1X / D1H	All USB Coolpix D1-series	All USB Coolpix D1-series, D100	All USB Coolpix D1-series, D100	All USB Coolpix D1-series, D100
Windows 95	Yes	Yes	No	No	No	No	No	No
Windows 98	Yes	Yes	Yes	No	No	No	No	No
Windows 98SE	Yes	Yes	Yes	Yes	Yes	Yes	No	Yes
Windows ME	Yes	Yes	Yes	Yes	Yes	Yes	No	Yes
Windows NT4.0	Yes	Yes	No	No	No	No	No	No
Windows 2000	Yes	Yes	Yes	Yes	Yes	Yes	No	Yes
Windows XP	No	No	Yes [4]	Yes [4]	Yes	Yes	No	No
Mac OS8.5	No	Yes	No	No	No	No	No	No
Mac OS8.6	Yes	Yes	Yes	Yes	No	No	No	No
Mac OS9.0	Yes	Yes	Yes	Yes	Yes	Yes	No	Yes
Mac OS9.0.4	Yes	Not Tested	Not Tested	Yes	Yes	Yes	Yes	Yes
Mac OS9.1	Yes [1]	Not Tested	Yes	Yes	Yes	Yes	Yes	Yes
Mac OS9.2.1	Not Tested	Not Tested	Yes	Yes	Yes	Yes	Yes	Yes
Mac OS10.1	No	No	No	No	Yes	Yes	Yes	Yes [6]
Mac OS10.2	No	No	No	No	No	Yes [5]	Yes	Yes

Notes:

1. Mac Powerbook G3/400MHz & the Keyspan FCB-1 (IEEE 1394) card are incompatible.
2. Using serial connection
3. Using USB connection
4. Requires v 4.3.1, or later (v4.3.0 can be used with restrictions).
5. Requires v5.1.3, or later.
6. Requires v10.1.2, or later.

Nikon View / Nikon Capture Compatibility

	Capture 1.x	Capture 2.x	Capture 2.0.4	Capture 3.0x	Capture 3.5
View 3.x	Yes	No	No	No	No
View 4.x	Yes	Yes	Yes	No	No
View 5.x	No	Yes	Yes [1]	Yes	Yes
View 6.x	No	Yes	Yes	Yes	Yes

Notes:

1. Requires Nikon View v5.1.4, or later.

Nikon Capture - Operating System Compatibility

	apture 1.x	Capture 2.0x	Capture 2.0.3	Capture 2.0.41	Capture 3.0x	Capture 3.5
Compatible Products	D1	D1 / D1X / D1H	D1 / D1X / D1H	D1 / D1X / D1H	D1 / D1X / D1H, D100 [2]	D1 / D1X / D1H, D100 [3]
Windows 95	Yes	No	No	No	No	No
Windows 98		No	No	No	No	No
Windows 98SE	Yes	Yes	Yes	Yes	Yes	Yes
Windows ME	Yes	Yes	Yes	Yes	Yes	Yes
Windows NT4.0	Yes	No	No	No	No	No
Windows 2000	Yes	Yes [4]	Yes	Yes	Yes	Yes
Windows XP	No	Yes	Yes	Yes	Yes	Yes
Mac OS8.5	No	No	No	No	No	No
Mac OS8.6	Yes	Yes	Yes	No	No	No
Mac OS9.0	Yes	Yes	Yes	No	No	No
Mac OS9.0.4	Yes	Yes	Yes	Yes	Yes	Yes
Mac OS9.1	Yes	Yes	Yes	Yes	Yes	Yes
Mac OS9.2.1	Not Tested	Yes [4]	Yes	Yes	Yes	Yes
Mac OS10.1	No	No	No	No	Yes 5	Yes [5]
Mac OS10.2	No	No	No	No	No	Yes

Notes:

1. To use Nikon Capture version 2.0.4 in combination with Nikon View 5 ensue version 5.1.4, or later is installed first.

2. Nikon Capture – Control will not work with D100.

3. Nikon Capture – Control will only work with D100 on Mac OS if camera has Firmware v.2.0, or later.

4. Requires Nikon Capture v2.0.2, or later.

5. For Nikon Capture – Control to work with D1, D1X, and D1H requires Mac OS 10.1.5, or later.

Battery Types

Currently there are five principle types of battery chemistry in use and I have described the important features of each type below.

For general photography rechargeable NiCd and NiMH types offer a good compromise between cost and performance, with the advantage that they cause proportionally less harm to the environment compared to non-rechargeable alkaline types. If weight and/or performance in low temperature are critical then opt for Lithium types.

Non-Rechargeable Carbon-zinc

This is a relatively old battery technology, which in my opinion should be avoided. The low cost of these batteries represents a false economy as they have a short shelf life, lose their charge in a relatively short period of time, and suffer a significant reduction in performance in low temperatures. The chemistry used in them is an environmental toxin, and they are unstable being prone to rupture and leakage.

Non-Rechargeable Alkaline-manganese

I am sure all photographers will be familiar with the ubiquitous non-rechargeable alkaline battery, which come in many shapes and sizes. They have two principle advantages: low cost and wide availability. However, this is offset by their variable performance, especially in a device like a camera or flash unit, which has a high power demand. Provided they are fresh alkaline batteries will begin their output at a specified voltage and as power is drawn during use this will gradually reduce this until the cell is exhausted, as a consequence the performance of the device they are powering will also gradually diminish. For instance flash re-cycling times will become extended with use. Low temperatures further impair their performance and below freezing they will often cease to work.

They also exhibit loss of charge with time even when not in use so have a limited shelf life, and the residual chemistry damages the environment following their disposal.

Rechargeable Nickel Cadmium (NiCd) Batteries

NiCd, or Nicad as they are often called, is a type of rechargeable battery that fully charged, starts off at a stated voltage, which is more or less maintained until suddenly becoming exhausted. This has the advantage of sustaining the performance of the device they power as the battery is used, however, there comes a point when it will cease to work suddenly and without warning. A NiCd battery can often withstand several hundred recharge cycles, which helps off set their higher initial cost. They have a slightly better low temperature performance and lower internal resistance compared with alkaline

types so are better suited to motor drives and flash units. However, they do exhibit a loss of charge in a relatively short time so always charge them before use.

Although NiCd batteries have been around for many years they have never been particularly popular with either photographers, or equipment manufacturers. Compared to non-rechargeable systems they suffer a key drawback; they develop a 'charge memory' if they are only partially discharged and recharged repeatedly. This 'memory' effect causes a reduction in battery performance leading eventually to its total failure, and is due to the battery only using those cells that have been fully discharged and charged on a regular basis. The battery 'forgets' it has further capacity to discharge so performance becomes impaired and life expectancy is shortened.

Rechargeable Nickel Metal Hydride (NiMH) Batteries

In many ways NiMH is superior to the older technology of NiCd type batteries. They can hold a higher initial charge and can sustain a device for up to 40% longer. NiMH batteries are far less prone to the loss of charge effect and offer a marginally better performance in low temperatures compared to NiCd types. To extract the most from NiMH it is important to pre-condition a new battery properly. This requires it to be put through three full cycles of discharge-charge before use. Once conditioned in this way it is imperative that the NiMH battery receives a regular 'refresh cycle' of full discharge followed by charging to maintain its performance. Giving a 'top-up' charge of a partially discharged battery will not affect it adversely as they do not suffer the 'memory' effect of NiCd types, but you should take care not to over charge NiMH batteries extensively as this may damage them.

Note:

Always check the rating of batteries. For example many LR6 (AA) size NiMH/NiCd batteries are generally rated at 1.2 – 1.25V, compared with the 1.5V of alkaline and Lithium types. In a device such as the MB-D100 battery pack for the D100 camera, which requires 7.4V to operate, six rechargeable NiMH/NiCd batteries only provide 7.2V so they will quickly drop below the threshold voltage of the camera and it will stop functioning. NiMH/NiCd are suited to use in a flash units, because they provided a better performance in devices that require frequent high-level power output.

Non-Rechargeable Lithium Batteries

Lithium is a lightweight and highly conductive material making it very suitable for batteries. Lithium batteries offer a weight saving of about 30% over other battery types, and have exceptionally good charge retention properties. The most important attribute of Lithium batteries is their performance in very low temperatures. A battery's tolerance to low tempera-

ture is a significant consideration since all chemical reactions are inhibited by a decrease in temperature, and batteries are no exception. I have experienced situations when a fresh set of alkaline cells have become exhausted after only a couple of films when working in temperatures of 0°C!

The only disadvantage to using Lithium batteries is that they do not react well to a sudden demand for a high power surge. So I would not recommend their use in flash units, especially if you will require a rapid series of high output level flashes. In this respect a high capacity NiMH battery is a better option.

Rechargeable Lithium-ion (Li-Ion) Batteries

Rechargeable Li-ion batteries are a relatively new technology, which offers several advantages over NiCd and NiMH types. Li-ion batteries are typically 25-35% lighter and can provide 10-20% better performance than a NiMH battery with an equivalent milli-Ampere per hour (mAh) rating. Most important of all Li-ion batteries are not susceptible to the 'memory' effect associated with NiCd types, and can safely receive a 'top-up' charge at any level of discharge. Although Li-ion batteries will benefit from an initial conditioning by allowing the battery to fully discharge after each of the first three charge cycles.

Battery Designations

The table below lists some common battery types by their International Electro-technical Commission (IEC) designation, their U.S. equivalents (were applicable), and the product codes for three popular brand manufacturers.

IEC	U.S.	Duracell	Energiser	Varta
LR6	AA	MN1500	E91	V1500PX
LR03	AAA	MN2400	E92	V2400PX
LR14	C	MN1400	E93	4014
LR20	D	MN1300	E95	4020
LR61	PP3	MN1604	522	4022
LR44	-	LR44	A76	V13GA
LR9	-	PX625	E625G	V625U
4SR44	-	PX28	544	V28PX
CR1/3N	-	DL1/3N	2L76	CR1/3N
CR-P2	-	DL223	EL223	CRP2
CR2025	-	DL2025	E CR2025	CR2025
CR2032	-	DL2032	E CR2032	CR2032
CR2	-	CR2	E CR2	CR2
CR123A	-	DL123A	EL123A	CR123A
2CR5	-	DL245	E 2CR5	2CR5

Battery Requirements for Nikon Cameras and Accessories

Camera	IEC Designation	Number Required
F Photomic, T, TN, FTN	LR9	2
F2 Photomic, S, SB, A, AS	CR1/3N	1
F2 Photomic, S, SB, A, AS	LR44	2
F3, F3 HP, F3 P	CR1/3N	1
F3, F3 HP, F3 P	LR44	2
F3 AF	CR1/3N + LR03	1 2
F3 AF	LR44 + LR03	2 2
F4	LR6	4
F4S, F4E	LR6	6
F5	LR6	8
Nikkormat FT, FTN, FT-2, FT-3	LR44	2
Nikkormat EL, ELW, EL-2	4SR44	1
FM, FM2N, FE, FE2, FA, FM3A	CR1/3N	1
FM, FM2N, FE, FE2, FA, FM3A	LR44	2
EM, FG, FG-20	CR1/3N	1
EM, FG, FG-20	LR44	2
FM10	LR44	2
FE10	LR44	2
F-301, F501	LR03	4
F-301, F501 (with MB-3)	LR6	4
F-401, F-401S, F-401X	LR6	4
F-401, F-401S, F-401X (QD types)	LR6 + CR2025	4 1
F-601, F-601M	CR-P2	1
F-601 QD	CR-P2 + CR2025	1 1
F-801, F-801S	LR6	4
F90, F90X	LR6	4
F50	2CR5	1
F70	CR123A	2
F60	CR123A	2
F100	LR6	4
F80	CR123A	2
F65	CR2	2
F55	CR2	2
F75	CR2	2
Nikonos IVA, V	CR1/3N	1
Nikonos IVA, V	LR44	2
Nikonos RS	CR-P2	1

BATTERY – TYPES/DESIGNATIONS/REQUIREMENTS

Accessory	IEC Designation	Number Required
AW-1	LR6	6
DB-1	LR14	4
DB-2	LR6	2
DB-3, DB-4	LR03	2
DB-5	LR6 + CR2025	1 1
DB-6	LR20	6
DL-1	LR9	1
DX-1	LR03	2
F-36 Cordless Pack	LR6	8
F-36 External Pack	LR14	8
LD-1	LR20	8
LD-2	LR6	8
MB-1	LR6	10
MB-2	LR6	8
MB-3	LR6	4
MB-4	LR03	4
MB-10	LR6	4
MB-15	LR6	6
MB-16	LR6	4
MB-17	LR6	4
MB-18	LR6	4
MB-20	LR6	4
MB-21, MB-23	LR6	6
MB-100	LR6	20
MB-D100	LR6	6
MC-20	CR2032	1
MD-4, MD-11, MD-12, MD-14, MD-15	LR6	8
MD-E	LR03	6
MF-10	LR6	2
MF-11	LR6	4
MF-12, MF-14, MF-15, MF-16, MF-18, MF-19, MF-23	LR44	2
MF-20, MF-22, MF-25, MF-27, MF-29	CR2025	1
MF-21, MF-24, MF-26	CR2025	2
MF-17	LR6	6
ML-1 Transmitter	LR6	4
ML-1 Receiver	LR61	1
ML-2 Transmitter/Receiver (each)	LR6	4
ML-3 Transmitter	LR09	2
MS-11 (for MB-10)	CR123A	2
MS-23 (for MB-23)	LR6	6
MT-1/2	LR6	4
MW-1 Transmitter/Receiver (each)	LR6	8
MW-2 Transmitter/Receiver (each)	LR6	4

	IEC Designation	Number Required
R8	LR6 + LR9	6 2
R10	LR6	6
SB-2, SB-3	LR6	4
SB-4	LR6	2
SB-7, SB-8	LR6	4
SB-9	LR6	2
SB-10	LR6	4
SB-11	LR6	8
SB-12, SB15, SB-17, SB-18, SB-19, SB-20, SB-22, SB-24, SB-25, SB-26, SB-28, SB-28DX	LR6	4
SB-16 A/B, SB-22s, SB-23, SB-27	LR6	4
SB-21 A/B	LR6	4
SB-29, SB-29s	LR6	4
SB-30	CR123A	1
SB-50DX	CR123A	2
SB-80DX	LR6	4
SB-101	LR6	8
SB-102	LR14	6
SB-103	LR6	4
SB-E	LR03	4
SD-2	LR20	6
SD-6	LR6	6
SD-7, SD-7A	LR14	6
SD-8, SD-8A	LR6	6
SK-6, SK-6A	LR6	6

Camera/Accessory	Dedicated Nikon Battery	Number required
D1, D1X, D1H	EN-4	1
D100	EN-EL3	1

Nikon Product Codes

A

A2	Filter for colour photography
A12	Filter for colour photography
AC-1E	Data-link card for F90 to Sharp PDA
AC-1ME	Photo Secretary software for F5 - Mac
AC-1WE	Photo Secretary software for F5 - PC
AC-2E	Data-link card for F90/F90X to Sharp PDA
AC-2WE	Photo Secretary software for F90/X/F100 - PC
ACT	Case for Nikon F with Action Finder/50mm lens
AE-1	Connecting lead with release button
AE-2	Connecting lead with crocodile clips
AE-3	Connecting lead with twin plugs
AE-4	Connecting lead with mini plugs
AE-5	Connecting lead with banana plugs
AF-D	AF-Nikkor with distance information CPU
AF-G	AF-Nikkor without aperture ring
AF-I	AF-Nikkor with integral focusing motor
AF-Nikkor	Auto focus Nikkor lens
AF-S	AF-Nikkor with Silent Wave focusing motor
AF-1	Gelatin/Polyester filter holder 52mm dia.
AF-2	Gelatin/Polyester filter holder 72mm dia.
AF-3	Gelatin/Polyester filter holder 52-77mm dia.
AF-4	Gelatin/Polyester filter holder 52-95mm dia.
AH-1	Hand-strap for F2 with MD-2
AH-2	Tripod adapter for MD-4/11/12/14/15
AH-3	Tripod adapter for MD-4/11/12/14/15, F301/F-501
AH-4	Hand-strap for F4/F-401/F-601/F-801/F90/F100
AH-5	Tripod mounting spacer for PC-Micro 85/2.8
AI	Automatic indexing – lens mount standard
AI-S	Automatic indexing – lens mount standard
AM-1	Film cassette for F2 (for 36 exposures)
AN-1	Neck strap, leather
AN-2	Neck strap, leather
AN-3	Neck strap, leather
AN-4B	Neck strap, leather
AN-4Y	Neck strap, nylon, black
AN-5W	Neck strap, nylon, yellow
AN-5Y	Neck strap, nylon, red
AN-6W	Neck strap, nylon, yellow
AN-6Y	Neck strap, nylon, red
AN-7	Neck strap, nylon, black
AN-10	Neck strap, nylon, brown-beige
AN-11	Neck strap, nylon

AN-12	Neck strap, nylon
AN-17	Neck strap, nylon
AP-2	Panorama head
AR-1	Soft shutter-release button for Leica-type thread
AR-2	Cable release for Leica-type thread
AR-3	Cable release for ISO-type thread
AR-4	Double cable release for ISO/Leica-type thread
AR-5	Cable release for pistol grip/Leica-type thread
AR-6	Cable release for ISO-type thread
AR-7	Double cable release (ISO-type)
AR-8	Adapter Leica thread to ISO-type thread
AR-9	Soft shutter-release button for ISO-type thread
AR-10	Double cable release (ISO-type to 2-pin electrical)
AS-1	Flash adapter provides ISO shoe on F/F2
AS-2	Flash adapter ISO - SB-2/SB-7E
AS-3	Flash adapter F3 - SB2/SB-7E
AS-4	Flash adapter ISO - F3
AS-5	Flash adapter F2 (SB-12/17/16A/21A)
AS-6	Flash adapter provides ISO shoe on F3
AS-7	Flash adapter TTL for F3/non-TTL ISO shoe
AS-8	F3-type adapter for SB-16
AS-9	ISO-type adapter for SB-16
AS-10	ISO-type shoe TTL connector
AS-11	F3-type multi-flash TTL connector
AS-12	F3-type controller for SB-21
AS-14	ISO-type controller for SB-21
AS-15	ISO-type adapter provides PC-type sync socket
AS-17	Flash adapter ISO TTL shoe to F3
AU-1	Later focusing unit for 400mm/1200mm lens heads
AW-1	Auto-winder for Nikkormat ELW and EL-2
AY-1	Yoke mount for Reflex-Nikkor 2000mm/11

B

B2	Filter for colour photography
B8	Filter for colour photography
B12	Filter for colour photography
BCB-I	Flash bulb unit for Nikon M and S cameras
BCB-II	Flash bulb unit for Nikon M and S cameras
BC-3	Flash bulb unit for Nikon S and S2 cameras
BC-4	Collapsible fan reflector flash unit S2/S3/S4/SP
BC-5	Collapsible fan reflector flash unit S2/S3/S4/SP
BC-6	ISO-type flash bulb unit with fixed reflector
BC-7	Collapsible fan reflector bulb-flash unit F/F2
BCT	Blimp case for Nikon F
BD-1	Case for BC-7
BD-2	Sync-cord for BC-7
BF-1	Body cap (non-AF SLR)

NIKON PRODUCT CODES

BF-1A	Body cap (AF SLR)
BF-2	Front cap for TC-300/301
BF-3	Front cap for TC-14/14B/14C
BF3A	Front cap for TC-14E/20E (Type AF-I and AF-S)
BR-1	Adapter for 135mm/4.0 on PB-type bellows units
BR-2	Retro-ring 52mm thread (non-AF SLR)
BR-2A	Retro-ring 52mm thread (AF SLR)
BR-3	Bayonet adapter ring with 52mm filter thread
BR-4	Auto-diaphragm adapter for retro-mounted lenses (not AF SLR)
BR-5	Adapter ring for BR-2A (52mm to 62mm thread)
BR-6	Auto-diaphragm adapter for retro mounted lenses (use with BR-2A f or AF lenses)

C

CA-1	Filter case for 6 x 52mm
CA-2	Filter case for 6 x 39mm
Calypso	Nikonos underwater camera model
CB-1	Shoulder case (red-blue)
CB-2	Shoulder case (green)
CB-3	Shoulder case (beige)
CE-2	Lens case for 50-300/4.5 plus body
CE-3	Lens case for 200-600/9.5 plus body
CE-5	Lens case for lens head 600/5.6
CE-6	Lens case for lens head 800/8
CE-7	Lens case for lens head 1200/11
CE-8	Lens case for lens head 400/4.5
CF-1	Case, semi-soft, for F2 + 50/1.4
CF-2	Case, semi-soft, for F2 + 105/2.5
CF-4	Case, semi-soft, for FTN - FT-3 + 50/1.4, 50/2
CF-5	Case, semi-soft, for FT-3 + 105/2.5
CF-6	Action case, semi-soft (replaced by CF-34)
CF-7	Case, semi soft, for FM/FE + 50/1.4
CF-8	Case, semi soft, for FM/FE + 105/2.5
CF-8A	Front part CF-8 for 35-70/3.5
CF-9	Case, semi soft, for FM/FE + MD + 50/1.4
CF-11	Case, semi soft, for EM + 50/1.8
CF-12	Case, semi soft, for EM + 100/2.8 E
CF-14	Case, semi soft, for EM + 36-72/3.5 E
CF-15D	Case rear part for FM/2/FE/2 with MD-11/12
CF-16	Case, semi soft, for EM + MD-E + 36-72/3.5 E
CF-17	Case, semi soft, for FG + 50/1.8 E
CF-18	Case, semi soft, for FG + 36-72/3.5 E
CF-18A	Front part CF-18 for 35-70/3.5
CF-19D	Case rear part for FG + MF-15
CF-20	Case, semi soft, for F3 + 50/1.4, 50/1.8
CF-21	Case, semi soft, for F3 + 35-105/3.5-4.5
CF-21A	Front part CF-21 for 35-70/3.5

CF-22	Case, semi soft, for F3 HP + 50/1.4, 50/1.8
CF-23D	Case rear part for F3 + MF-14
CF-24	Case, semi soft, for F3 AF + 80/2.8
CF-27	Case, semi soft, for FM/FE-2 + 50/1.4, 50/1.8
CF-27D	Case rear part for FM/FE-2 + MF
CF-27S	Case, semi soft, for FM3A + 50/1.4, 50/1.8
CF-28	Case, semi soft, for FM/2/3AFE-2 + 35-70/3.3-4.5
CF-28A	Front part CF-28 for 35-70/2.8
CF-28D	Front part CF-27 for 35-200/3.5-4.5
CF-29	Case, semi soft, for FM/2/3A/FE-2 + MD + 50/1.4
CF-29S	Case, semi soft, for FM3A + 18-35/3.5-4.5
CF-30	Case, semi soft, for FA + 50/1.4
CF-30D	Case rear part for FA + MF
CF-31	Case, semi soft, for FA + 35-70/3.5
CF-32	Case, semi soft, for FG-20 + 50/1.4
CF-33	Case, semi soft, for FG-20 + 35-70/3.3-4.5
CF-34	Action case, semi-soft, for SLR + 80-200mm
CF-35	Case, semi soft, for F-301/501 + 35-70/3.3-4.5
CF-35D	Case rear part for F-301/501
CF-36	Case, semi soft, for F-301/501 + 35-70/2.8
CF-36A	Front part CF-35 for 35-105mm
CF-37	Case, semi soft, for F-401 + 35-70/3.3-4.5
CF-37 QD	Case, semi soft, for F-401QD + 35-70/3.3-4.5
CF-38A	Front part CF-37 for 35-105/3.5-4.5
CF-39	Case, semi soft, for F-801 + 50/1.4, 50/1.8
CF-39D	Camera case rear part for F-801
CF-40	Case, semi soft, for F-801 + AF 35-135/3.5-4.5
CF-41	Case, semi soft, for F4 + AF 35-70/3.3-4.5
CF-42	Case, semi soft, for F4S + 135/2.8
CF-43	Case, semi soft, for F4S + 35-70/3.3-4.5
CF-45	Case, semi soft, for F-601 + 50/1.4
CF-46	Case, semi soft, for F-601 + 35-105/3.5-4.5
CF-47	Case, semi soft, for F90X + 50/1.4
CF-47D	Camera case rear part for F90X
CF-48A	Front part CF-47 for 24-120/3.5-5.6
CF-49	Case, semi soft, for F50/F60 + AF 50/1.8
CF-50	Case, semi soft, for F50/F60 + AF 18-35/3.5-4.5
CF-51	Case, semi soft, for F70 + AF 50/1.8
CF-52	Case, semi soft, for F70 + AF 18-35/3.5-4.5
CF-53	Case, semi soft, for F5 + AF 50/1.4
CF-54	Case, semi soft, for F5 + AF 28-70/2.8
CF-57	Case, semi soft, for F100 + AF 50/1.4
CF-58	Case, semi soft, for F100 + AF 28-70/2.8
CF-59	Case, semi soft, for F80 + AF 50/1.8
CF-60	Case, semi soft, for F80 + AF 18-35/3.5-4.5
CF-61	Case, semi soft, for F65 + AF 50/1.8
CF-62	Case, semi soft, for F55 + AF 50/1.8
CF-63	Case, semi soft, for F75 + AF 50/1.8

CF-D100	Case, semi soft, for D100 + AF-S 24-85/3.5-4.5G
CH-1	Camera case, hard, for F2 + 50mm
CH-2	Camera case, hard, for F2 + 105/2.5
CH-3	Camera case, hard, for EL + 50mm
CH-4	Camera case, hard, for F2 + 50mm
CH-5	Camera case, hard, for F2 + 105/2.5
CH-6	Case, hard, for Nikkormat FTN-FT3 + 50/1.4
CH-7	Case, hard, for Nikkormat FTN-FT3 + 43-86/
CH-8	Case, hard, for Nikkormat EL2 + 50/1.4
CH-9	Case, hard, for Nikkormat EL2 + AW-1 + 50/1.4
CH-10	Case, hard, for Nikkormat EL2 + AW-1 + 105.2.5
CH-11	Camera case, hard, for F2 + DS + 105/2.5
CL-4	Leather lens case for 10/5.6 OP
CL-11	Leather lens case for 8/2.8
CL-12	Leather lens case for 180/2.8
CL-13	Leather lens case for 200/4
CL-14	Leather lens case for 13/5.6
CL-15	Leather lens case for 135/2
CL-15S	Leather lens case for AF 70-210/4, AF 105/2.8
CL-17	Leather lens case for 15/3.5 & 85/1.4
CL-20	Leather lens case for 300/4.5
CL-23	Leather lens case for 500/8 C
CL-24	Leather lens case for 1000/11 C
CL-26	Leather lens case for 15/5.6
CL-27	Leather lens case for 400/5.6
CL-28	Leather lens case for 18/4
CL-29	Leather lens case for Reflex 1000/11
CL-30	Leather lens case for 50/1.4 & TC-201
CL-30S	Leather lens case for AF 50/1.4, AF 50/1.8
CL-31	Leather lens case for 58/1.2 & 55/2.8
CL-31S	Leather lens case for 50/1.2
CL-32	Leather lens case for 135/2.8
CL-32S	Leather lens case for AF-S 28-70/2.8
CL-33	Leather lens case for 35-135 + TC-301
CL-33S	Leather lens case for AF 35-105
CL-34	Leather lens case for 28 PC
CL-34A	Leather lens case for AF 24/2.8, AF 28/2.8
CL-35	Leather lens case for 80-200/4
CL-36	Leather lens case for 300/4.5 IF-ED
CL-37	Leather lens case for 18/3.5, AF 20/2.8
CL-38	Leather lens case for AF 180/2.8, AF 135DC
CL-39	Leather lens case for 500/8
CL-40	Leather lens case for 100-300/5.6
CL-41	Leather lens case for AF 35-135
CL-42	Leather lens case for AF 300/4
CL-43	Leather lens case for AF 80-200/2.8
CL-43A	Leather lens case for AF 80-200/2.8D
CL-44	Leather lens case for AF 85/1.4

CL-45	Leather lens case for AF Micro 200/4
CL-49	Leather lens case for 24-120/3.5-5.6 (
CL-50	Leather lens case for 28/3.5 & 35/2.5 UW
CL-51	Leather lens case for 80/4 UW
CL-61	Leather lens case for 400/3.5 IF-ED
CL-62	Leather lens case for 600/5.6 IF-ED
CL-63	Leather lens case for 300/2.8 IF-ED
CL-64	Leather lens case for 50-300/4.5 ED
CL-65	Leather lens case for 200-600/9.5
CL-66	Leather lens case for 80-200/2.8
CL-71	Leather lens case for AF Micro 70-180/4.5-5.6
CL-72	Leather lens case for AF 70-300/4.5-5.6
CL-73	Leather lens case for AF-S 80-200/2.8
CL-76	Leather lens case for AF-S 17-35/2.8
CL-L1	Nylon lens case for AF-S 300/2.8
CL-L2	Nylon lens case for AF-S 400/2.8, 500/4, 600/4
CL-M1	Nylon lens case for AF VR 80-400/4.5-5.6
CL-M2	Nylon lens case for AF-S 80-200/2.8, AF-S 300/4
CL-S1	Cloth lens pouch (AF 18-35/3.5-4.5)
CL-S2	Cloth lens pouch (AF 35-70/2.8)
CL-S3	Cloth lens pouch (AF-S 17-35/2.8)
CL-S4	Cloth lens pouch (AF 70-300/4.5-5.6)
CP-1	Plastic lens case for 85/1.8
CP-2	Plastic lens case for 135/2.8
CP-3	Plastic case for 52mm filter
CP-4	Plastic case for 52mm polarizing filter
CP-5	Plastic case for 72mm filter
CP-6	Plastic case for 62mm filter
CP-7	Plastic case for AM-1
CP-8	Plastic case for 85/2
CP-9	Plastic case for 135/2.8
CS-1	Soft camera case for F + 50mm
CS-2	Soft camera case for F + 135mm
CS-3	Soft camera case for F + 200mm
CS-4	Soft camera case for F2 + 50mm
CS-5	Soft camera case for F2 + 135mm/2.8
CS-6	Soft camera case for F2 + 200mm/4
CS-7	Soft camera case for SLR + 50mm
CS-8	Soft camera case for SLR + 50mm
CS-9	Soft camera case for SLR + 135/2.8
CS-10	Soft camera case for SLR + 80-200mm/4
CS-11	Soft camera case for EL + 50mm
CS-12	Soft camera case for F2 + 50mm
CS-13	Blimp case for insulation of shutter noise
CS-15	Soft camera case for F3 + 50mm
CS-16	Soft camera case for FM/FA + 35-70mm/3.3-4.5
CS-17	Soft camera case for FM2 + 50mm
CS-18	Soft camera case for FM2 + 35-105mm

NIKON PRODUCT CODES

CS-19	Soft camera case for SLR + 50mm
CS-20	Soft camera case for SLR + 35-105mm
CS-21	Soft camera case for F4E + 50mm
CS-22	Soft camera case for F4E + 35-70mm/2.8
CS-23	Soft camera case for F4 + 50mm
CS-24	Soft camera case for F4 + 35-70mm/2.8
CS-25	Soft camera case for F4s + 50mm
CS-26	Soft camera case for F4s + 35-70mm/2.8
CT-200	Trunk case for 200/2
CT-300	Trunk case for 300/2
CT-302	Trunk case for 300/2.8
CT-303	Trunk case for 300/2.8 AF
CT-305	Trunk case for AF-S 300/2.8
CT-400	Trunk case for 400/2.8
CT-402	Trunk case for AF-S 400/2.8
CT-500	Trunk case for 500/4 P
CT-502	Trunk case for AF-S 500/4
CT-601	Trunk case for 600/4 (early type)
CT-602	Trunk case for 600/4 (new)
CT-603	Trunk case for 600/5.6
CT-604	Trunk case for AF-I 600/4 IF-ED
CT-606	Trunk case for AF-S 600/4
CT-800	Trunk case for 800/5.6
CT-1203	Trunk case for 800/8, 1200/11
CT-M	Hard camera case for F + 50/1.4
CT-M2	Hard camera case for FTN + 50/1.4
CT-MZ	Hard camera case for FTN + 43-86/3.5
CT-TZ	Hard camera case for F Photomic + 135/3.5
CT-Z	Hard camera case for F + 105/2.5
CU-1	1st type focusing unit for 600/5.6, 800/8, 1200/11
CZ-1860	Trunk case for 180-600/8
CZ-3612	Trunk case for 360-1200/11

D

D Nikkor	Lens with CPU that provides focus distance info.
DA-1	Action finder for F2
DA-2	Action finder for F3
DA-20	Action finder for F4/S/E
DA-30	Action finder for F5
DB-1	External battery compartment for DS-units
DB-2	External battery compartment for SLR using LR44
DB-3	External battery compartment for MF-12
DB-4	External battery compartment for DX-1
DB-5	External battery compartment for F-801
DB-6	External battery compartment for F4/F90/90X
DC Nikkor	Lens with defocus control feature
DE-1	Prism finder for F2

DE-2	Prism finder for F3
DE-3	Prism finder for F3 HP
DE-4	Prism finder for F3 T
DE-5	Prism finder for F3 P with ISO shoe
DF-1	Viewfinder for fisheye 6/5.6 & 10/5.6 OP
DF-10	Finder for UW-80/4
DF-11	Finder for UW-15/2.8
DF-12	Finder for UW-20/2.8
DG-2	Viewfinder magnifier
DH-1	Charging unit for DN-1
DK-1	Adapter ring for large to small diameter eyepiece accessories (replaced by DK-13)
DK-2	Eyecup for F3 HP/F4/F5/D1-series
DK-3	Eyecup for FM to FA cameras
DK-4	Eyecup for F2 and F3 cameras
DK-5	Eyepiece cover for EM to F-601/QD/M
DK-6	Eyecup for F-801/s/F90/x
DK-7	Adapter ring for small to large diameter eyepiece accessories (F3HP/F4/F5/F00/D1)
DK-8	Eyepiece cover for HP finders (F-801/s – F100)
DK-13	Adapter ring for large to small diameter eyepiece accessories (FM2/FE2/FM3A/F3)
DK-100	Eyepiece cap for Nikonos RS
DL-1	Illuminator for DP-1/DP-11/Photomic FTN
DM-1	Connecting cord MA-4 to DS-units
DN-1	NiCd-type rechargeable battery for DS-units
DP-1	Metering finder for F2 Photomic
DP-2	Metering finder for F2 S
DP-3	Metering finder for F2 SB
DP-11	Metering finder for F2 A
DP-12	Metering finder for F2 AS
DP-20	Metering finder for F4
DP-30	Metering finder for F5
DR-2	Right-angle finder attachment
DR-3	Right-angle finder attachment
DR-4	Right-angle finder attachment
DS-1	Automatic aperture control unit for F2
DS-1H	Case for DS unit
DS-2	Automatic aperture control unit for F2
DS-12	Automatic aperture control unit for F2 (AI lens)
DW-1	Waist-level finder for F2
DW-2	6x Magnification finder for F2
DW-3	Waist-level finder for F3
DW-4	6x Magnification finder for F3
DW-20	Waist-level finder for F4
DW-21	6x Magnification finder for F4
DW-30	Waist-level finder for F5
DW-11	6x Magnification finder for F5

DX-1	Auto-focus viewfinder for F3 AF

E

E2	Extension tube for Nikon F camera system
E-Series	Series of economically priced Nikkor lenses
ED	Extra-low dispersion glass
ED-IF	Extra-low dispersion glass & Internal Focusing
EL	SLR camera
EL-2	SLR camera
ELW	SLR camera
EM	SLR camera
ES-1	Slide-copying adapter
Eyepiece Adpt.	Adapter for square eyepiece to circular thread

F

F	SLR camera
F Photomic	SLR camera with metering finder (T/TN/FTn)
F2	SLR camera
F2 Photomic	SLR camera with DP-1 head
F2 S	SLR camera with DP-2 head
F2 SB	SLR camera with DP-3 head
F2 A	SLR camera with DP-11 head
F2 AS	SLR camera with DP-12 head
F2 H	High-speed version of F2 (10fps)
F2 T	Titanium version of Nikon F2
F-250	Bulk-film magazine with motor-drive for Nikon F
F3	SLR camera (DE-2 head)
F3H	High-speed version of F3 (13fps)
F3HP	SLR camera (High eye-point DE-3 head)
F3 T	Titanium version of Nikon F3
F3 AF	AF version of Nikon F3
F3 P	Special version of F3 (ISO shoe on head)
F-36	Motor-drive for Nikon F
F4	AF-SLR camera
F4S	AF-SLR camera with MB-21
F4E	AF-SLR camera with MB-23
F5	AF-SLR camera
F50	AF-SLR camera
F55	AF-SLR camera
F60	AF-SLR camera
F65	AF-SLR camera
F70	AF-SLR camera
F75	AF-SLR camera
F75D	AF-SLR camera (F-75 data version)
F80	AF-SLR camera
F80D	AF-SLR camera (F80 data version)

F100	AF-SLR camera
F-301	SLR camera
F-401	AF-SLR camera
F-401 QD	AF-SLR camera (F-401 data version)
F-401s	AF-SLR camera
F-401s QD	AF-SLR camera (F-401s data version)
F-401x	AF-SLR camera
F-401x QD	AF-SLR camera (F-401x data version)
F-501	AF-SLR camera
F-601	AF-SLR camera
F-601M	SLR camera
F-601 QD	AF-SLR camera (F-601 data version)
F-801	AF-SLR camera
F-801s	AF-SLR camera
F90	AF-SLR camera
F90D	AF-SLR camera (F90 data version)
F90S	AF-SLR camera (F90 multi-function back version)
F90X	AF-SLR camera
FA	SLR camera
FB-3	Compartment case
FB-4	Compartment case
FB-5	Compartment case
FB-6	Compartment case
FB-7	Compartment case
FB-8A	Compartment case
FB-9	Compartment case
FB-10	Compartment case
FB-11A	Compartment case
FB-12	Compartment case
FB-13	Compartment case
FB-14	Compartment case
FB-15	Compartment case
FB-16	Compartment case
FB-17	Compartment case
FB-E	Compartment case (E-series system)
FE	SLR camera
FE-2	SLR camera
FG	SLR camera
FG-20	SLR camera
FM	SLR camera
FM-2	SLR camera
FM-2N	SLR camera
FM-3A	SLR camera
FS	SLR camera
FT	SLR camera
FT-2	SLR camera
FT-3	SLR camera
FTn	SLR camera

NIKON PRODUCT CODES

H

HB	Lens hood with bayonet mount
HB-1	AF 28-85, AF 35-70/2.8, AF 35-135/3.5-4.5
HB-2	AF 35-105/3.5-4.5
HB-3	AF 24-50/3.3-4.5
HB-4	AF 20/2.8
HB-5	AF 35-105/3.5-4.5
HB-6	AF28-70/3.5-4.5D
HB-7	AF 80-200/2.8D (Type II & III)
HB-8	AF 20-35/2.8D, AF 18/2.8D
HB-10	AF 28-80/3.5-5.6D
HB-11	AF 24-120/3.5-5.6D
HB-12	AF 28-200/3.5-5.6D
HB-14	AF Micro 70-180/4.5-5.6D ED
HB-15	AF 70-300/4.5-5.6D ED
HB-17	AF-S 80-200/2.8
HB-18	AF 28-105/3.5-4.5D
HB-19	AF-S 28-70/2.8D
HB-20	AF 28-80/3.3-5.6G
HB-22	PC Micro 85/2.8D
HB-23	AF-S 17-35/2.8, AF 18-35/3.5-4.5, AF DX 12-24/4
HB-24	AF VR 80-400/4.5-5.6D
HB-25	AF 24-85/2.8-4, AF VR 24-120/3.5-4.5
HB-26	AF 70-300/4.5-5.6G
HB-27	AF 28-100/3.5-5.6G
HB-28	AF-S 24-85/3.5-4.5G
HB-29	AF-S VR 70-200/2.8G
HB-30	AF 28-200/3.5-5.6G
HE	Extension lens hood
HE-1	Lens hood extension for 300/2
HE-2	Lens hood extension for 200-400/4
HE-3	Lens hood extension for 400/2.8 & 800/5.6
HE-4	Lens hood extension for 200/2, 300/2.8, 600/5.6
HE-5	Lens hood extension for 600/4
HE-6	Lens hood extension for AF 300/2.8
HK	Lens hood with slip-on mount and locking screw
HK-1	28-45/4.5
HK-2	24/2
HK-3	20/4, 28-50/3.5
HK-4	35-70/3.5
HK-5	50-300/4.5 ED
HK-6	20/3.5
HK-7	25-50/4, AF 28/1.4D
HK-8	36-72/3.5 E
HK-9	18/3.5
HK-10	50-135/3.5
HK-11	35-105/3.5-4.5

HK-12	28-50/3.5
HK-14	20/2.8
HK-15	35-200/3.5-4.5
HK-16	28-85/3.5-4.5
HK-17	500/4 P
HK-18	AF-I 600/4D
HK-19	AF-I 300/2.8D
HK-20	AF-I 400/2.8D
HK-21	AF-I 500/4D
HK-22	AF-S 300/2.8 (Type I)
HK-23	AF-S 600/4 (Type I&II)
HK-24	AF-S 500/4 (Type I&II)
HK-25	AF-S 400/2.8 (Type I&II)
HK-26	AF-S 300/2.8 (Type II)
HN	Lens hood with screw-in mount (metal)
HN-1	24/2.8, 28/2, 35 PC
HN-2	28/2.8 & 35-70/3.3-4.5
HN-3	35/1.4, 35/2, 35/2.8, 55/2.8
HN-4	45/2.8 GN
HN-5	50/1.4
HN-6	55/1.2
HN-7	85/1.8 & 80-200/4.5
HN-8	105/2.5
HN-9	28/3.5 PC
HN-10	200-600/9.5
HN-11	50-300/4.5
HN-12	52mm polarizing filter
HN-13	72mm polarizing filter
HN-14	20/4
HN-15	18/4
HN-16	180-600/8
HN-17	360-1200/11
HN-20	85/1.4
HN-21	75-150/3.5 E
HN-22	35-135/3.5-4.5, 35-70/3.5, AF 55/2.8 & 60/2.8
HN-23	80-200/4, AF 85/1.8
HN-24	AF 70-210/4-5.6, 100-300/5.6, AF 75-300/4.5-5.6
HN-25	80-200/2.8 ED
HN-26	62mm polarizing filter
HN-27	Reflex 500/8
HN-28	AF 80-200/2.8 (Type I)
HN-30	AF Micro 200/4D
HN-31	AF 85/1.4
HN-34	77mm polarizing filter
HN-35	45/2.8 P
HN-36	AF-3 & AF-4 Gelatin filter holders
HR	Lens hood with screw-in mount (rubber)
HR-1	50/1.4

HR-2	50/1.2
HR-4	35/2.5E, 50/1.8E, 50/1.8
HR-5	100/2.8 E
HR-6	28/2.8
HS	Lens hood with snap-on mount
HS-1	50/1.4 (pre-AI)
HS-2	50/2 (pre-AI)
HS-3	55/1.2 (pre-AI)
HS-4	105/2.5 (AI)
HS-5	50/1.4 (AI)
HS-6	50/1.8 & 50/2 (AI)
HS-7	AF 50/1.4
HS-8	105/2.5, 135/3.5 (pre-AI)
HS-9	50/1.4 (AI-S)
HS-10	85/2 (AI-S)
HS-11	50/1.8 (AI-S)
HS-12	50/1.2 (AI-S)
HS-14	105/2.8 Micro (AI-S)

G

GN-Nikkor	Lens with GN coupling for flash photography

K

K1	K-series extension ring No.1 for Nikon F camera
K2	K-series extension ring No.2 for Nikon F camera
K3	K-series extension ring No.3 for Nikon F camera
K4	K-series extension ring No.4 for Nikon F camera
K5	K-series extension ring No.5 for Nikon F camera

L

L1A	Skylight filter
L1BC	Skylight filter
L39	UV filter
L39C	UV filter
LA-1	AC/DC-unit Medical-Nikkor 200/5.6 & SM-2/SR-2
LA-2	AC/DC-unit for Medical-Nikkor 120/4 & SB-21
LD-1	Battery case Medical-Nikkor 200/5.6 & SM-2/SR-2
LD-2	Battery case for Medical-Nikkor 120/4 & SB-21
LF-1	Rear lens cap
LF-2	Rear lens cap for 6/5.6 & 10/5.5
LN-1	Wide strap for heavy telephoto lenses
LW-Nikkor	Nikonos lens

M

M Ring	Extension ring 27.5mm (No meter coupling)
M2 Ring	Extension ring 27.5mm (No meter coupling)
MA-1	AC/DC-unit for F-36 motor
MA-2	AC/DC-unit for MD-1/2/3 motor
MA-3	Cold weather jacket for MB-1 battery pack
MA-4	AC/DC-unit - MD-1/2/3/4 & DS aperture control unit
MB-1	Battery pack for MD-1/2/3
MB-2	Battery pack for MD-1/2/3
MB-3	Battery pack for F-301/501
MB-4	Battery pack for F-301/501
MB-10	Battery pack with vertical release for F90X
MB-15	Battery pack with vertical release for F100
MB-16	Battery pack for F80
MB-17	Battery pack for F65
MB-18	Battery pack with vertical release for F75
MB-20	Battery pack for F4
MB-21	Battery pack for F4S
MB-21G	Grip section of MB-21
MB-22	Battery pack for external power supply for F4/F4S
MB-22B	Base unit of MB-21
MB-23	Battery compartment for F4E
MB-D100	Multi function battery pack for D100
MB-100	Battery compartment for F2H - MD-100 (30v)
MC-1	Remote control lead for MD-1/2
MC-2	Connecting lead MA-2/4 to MD-1/2/3
MC-3	Connecting lead Pistol grip II MD-1/2/4/11/12/15
MC-3A	Lead Pistol grip II - F-301/501/801/s/F4S/E
MC-4	Lead with banana plugs - MD-1/2/3/4/11/12/15
MC-4A	Lead with banana plugs - F-301/501/801/F4S
MC-5	Connecting lead MT-1 - MD-1/2/3/4/11/12
MC-6	Triggering lead for MF-10/11
MC-7	Connecting lead MD-1/2/3 MB-1/2
MC-8	Connecting lead ML-1, MD-1/2/3/4/11/12
MC-8A	Connecting lead ML-1, F-301/501/801/F4S
MC-9	Connecting lead SB-6 F-36
MC-10	Remote control cord for MD-3/11/12
MC-11	Connecting lead MA-4 MD-4
MC-11A	Connecting lead MA-4 MD-4
MC-12	Remote control lead for MD 3/4/11/12/15, F-301/501/801/F4S
MC-12A	Remote control lead for MD-3/4/11/12/15, F-301/501/801/F4S
MC-12B	Remote control lead for MD-4/12, F4S/E/F70
MC-14	Triggering lead for MF-4
MC-15	Connecting lead external power supply MF-17

NIKON PRODUCT CODES

MC-16	Connecting lead MT-2 MD-1/2/3/4/11/12/15
MC-16A	Connecting lead MT-2 F-301/501/801/F4
MC-17	Connecting lead for simultaneous release MD-3/4/11/12/15 & F-301/501/801/F4S
MC-17S	Connecting lead for simultaneous release MD-3/4/11/12/15 & F-301/501/801/F4S
MC-18	Connecting lead for MW-2
MC-20	Remote control lead with timer for 10-pin socket
MC-21	Extension lead for MC-20/MC-22/MC-30
MC-22	Lead with banana plugs to 10-pin socket
MC-23	Lead for simultaneous release of cameras with 10-pin accessory socket
MC-25	Adapter lead for 2-pin accessory to 10-pin socket
MC-26	Adapter lead for 10-pin accessory to 2-pin socket
MC-27	Lead to connect F90/X to a Sharp PDA
MC-28	Connecting lead from DB-6 to F4E
MC-29	Connecting lead from DB-6 to F90/x
MC-30	Remote control lead (o.8m) for 10-pin socket
MC-31	Lead to connect F90X/100 to a computer (PC)
MC-32	External power lead with banana plugs for F5
MC-33	Lead to connect F5 to a computer (PC)
MC-34	Lead to connect F5 to a computer (Mac)
MD-1	Motor-drive for F2
MD-2	Motor-drive for F2
MD-3	Motor-drive for F2
MD-4	Motor-drive for F3
MD-4H	Motor-drive fro F3 High Speed
MD-11	Motor-drive for FM, FE, FA
MD-12	Motor-drive for FM, FE, FA
MD-14	Motor-drive for EM, FG-20, FG
MD-15	Motor-drive for FA
MD-100	Motor-drive for F2 High Speed
MD-E	Motor-drive for EM, FG-20, FG
Medical-Nikkor	Macro lens with built-in ring-flash
MF-1	Bulk-film magazine (250 exp.) for F2
MF-2	Bulk-film magazine (750 exp.) for F2
MF-3	Rewind stop-back for MD-2
MF-4	Bulk-film magazine (250 exp.) for F3
MF-6	Rewind stop-back for MD-4 (early version)
MF-6B	Rewind stop-back for MD-4 (late version)
MF-10	Data-back for F2 Data
MF-11	Bulk-film and data-back for F2
MF-12	Data-back for FM/FE
MF-14	Data-back for F3
MF-15	Data-back for FG
MF-16	Data-back for FM-2, FE-2, FA
MF-17	Bulk-film and data-back for F3
MF-18	Data-back for F3 with MD-4

MF-19	Multi-control back for F-301/501
MF-20	Data-back for F-801/s
MF-21	Multi-control back for F-801/s
MF-22	Data-back for F4/S/E
MF-23	Multi-control back for F4/S/E
MF-24	Bulk-film and data-back for F4
MF-25	Data-back for F90X
MF-26	Multi-control back for F90X
MF-27	Data-back for F5
MF-28	Multi-control back for F5
MF-29	Data-back for F100
MH-1	Charging unit for 2 x MN-1
MH-2	Charging unit for 1 x MN-2
MH-15	Charging unit for MN-15, EN-4
MH-16	Charging unit EN-4
MH-17	Charging unit EN-4 (12V DC)
MH-18	Charging unit for EN-EL3
MH-19	Charging unit for EN-4, EN-EL3, MN-15, MN-30
MH-20	Charging unit for MN-20
MN-30	Charging unit for MN-30
MH-100	Charging unit for 4 x MN-1
Micro-Nikkor	Special lens for close-up/macro photography
MK-1	Firing rate converter for MD-4
ML-1	Wireless remote control unit (2-pin)
ML-2	Wireless remote control unit (2-pin)
ML-3	Wireless remote control unit (10-pin)
MN-1	NiCd-battery unit for MB-1/2
MN-2	NiCd-battery unit for MD-4
MN-15	NiMH battery unit for MB-15
MN-20	NiCd battery unit for MB-23
MN-30	NiMH battery unit for F5
MR-1	Terminal release (Leica-type thread)
MR-2	Terminal release (Leica-type thread)
MR-3	Terminal release (ISO)
MS-1	Battery holder for MB-1
MS-2	Battery holder for MB-2, SB-2/3/7/8/10
MS-3	Battery holder for MD-4
MS-4	Battery holder for MD-14/15
MS-5	Battery holder for SB-16/103
MS-6	Battery holder for SB-15/17
MS-7	Battery holder for F-801/s
MS-8	Battery holder for F90/90X
MS-10	Battery holder for MB-10 (AA size battery)
MS-11	Battery holder for MB-10 (Lithium)
MS-13	Battery holder for F100 (Lithium)
MS-21	Battery holder for MB-21
MS-23	Battery holder for MB-23
MS-30	Battery holder for F5 (AA size battery)

MT-1	Intervalometer for timed release of camera
MT-2	Intervalometer for timed release of camera
MW-1	Radio control unit for remote control of camera
MW-2	Radio control unit for remote control of camera
MZ-1	Film cassette for MF-1/4/11/17/24 (10.5m)
MZ-2	Film cassette for MF-1/4/11/17/24 (30m)

N

N2000	F-301 (for N. American market)
N2020	F-501 (for N. American market)
N4004	F-401 (for N. American market)
N4004s	F-401s (for N. American market)
N5005	F-401x (for N. American market)
N6000	F-601 (for N. American market)
N6006	F-601M (for N. American market)
N8008	F-801 (for N. American market)
N8008s	F-801s (for N. American market)
N50	F50 (for N. American market)
N55	F55 (for N. American market)
N60	F60 (for N. American market)
N65	F65 (for N. American market)
N70	F70 (for N. American market)
N75	F75 (for N. American market)
N80	F80 (for N. American market)
N90	F90 (for N. American market)
N90s	F90X (for N. American market)
NB-100	NiCd battery pack for MB-10
NC-100	Charger unit for NB-100
ND2	Neutral density filter - 1EV
ND4	Neutral density filter - 2EV
ND8	Neutral density filter - 3EV
ND400	Neutral density filter - 10EV
N-F Adapter	Adapter rangefinder lenses to F-bayonet
NIC	Proprietary Nikon lens coating
Nikkor	Brand name for lenses manufactured by Nikon
Nikkormat	SLR camera (EL/2, ELW, FS, FT, FT-2/3, FTN)
Nikonos	Underwater cameras (models I, II, III, IVA, V, RS)
No.0	Close-up lens 0.7 dpt. (52mm)
No.1	Close-up lens 1.5 dpt. (52mm)
No.2	Close-up lens 3.0 dpt. (52mm)
No.3T	Close-up lens 1.5 dpt. (52mm)
No 4T	Close-up lens 2.9 dpt. (52mm)
No.5T	Close-up lens 1.5 dpt. (62mm)
No.6T	Close-up lens 2.9 dpt. (62mm)
No.51	Soft lens pouch for up to 55/1.2
No.52	Soft lens pouch for up to 135/2.8

No.53	Soft lens pouch for up to 200/4
No.54	Soft lens pouch for up to 55/1.2
No.55	Soft lens pouch for up to 135/2.8
No.57	Front lens cap 300/2.8 - 600/5.6
No.58	Front lens cap 200 - 400/4
No.59	Front lens cap 400/2.8
No.61	Soft lens pouch for 85/2 or TC-201
No.62	Soft lens pouch for 35-70/3.6 or TC-301
No.63	Soft lens pouch for 80-200/4
Noct-Nikkor	Special lens for available-light photography

O

O56	Orange filter
O57	Orange filter supplied with 8mm/8 Fisheye
OM-9	Compartment case
OM-10	Compartment case
OP-Nikkor	Orthographic Projection lens

P

PA-1	Wooden case for reproduction unit PF-2
PA-2	Baseboard for PF-2
PA-3	Table clamp for PF-2
PA-4	Camera adapter for F-801 and PF-4
PB-1	Bellows unit
PB-2	Bellows unit
PB-3	Bellows unit
PB-4	Bellows unit
PB-5	Bellows unit
PB-6	Bellows unit
PB-6D	Bellows spacer
PB-6E	Bellows extension unit
PB-6M	Macro copy stand
PC-3	Table clamp for PF-3/4
PC-Nikkor	Shift lens for perspective control
PF-1	Reproduction stand
PF-2	Reproduction stand
PF-3	Reproduction stand
PF-4	Reproduction stand
PG-1	Focusing stage
PG-2	Focusing stage
PH-3	Camera cradle for PF-3
PH-4	Camera cradle for PF-3/4
PK-1	Automatic extension ring 8mm
PK-2	Automatic extension ring 14mm
PK-3	Automatic extension ring 27.5mm
PK-11	Automatic extension ring (AI) 8mm

NIKON PRODUCT CODES

PK-11A	Automatic extension ring (AI) 8mm for AF SLR
PK-12	Automatic extension ring (AI) 14mm
PK-13	Automatic extension ring (AI) 27.5mm
PL-3	Illumination unit for PF-3/4
PL-3A	Attachment adapter for PL-3
PN-1	Automatic extension ring 52.5mm
PN-11	Automatic extension ring (AI) 52.5mm
PS-4	Slide copying adapter for PB-4/5
PS-5	Slide copying adapter for PB-5
PS-6	Slide copying adapter for PB-6

R

R60	Red filter

S

S-36	Motor drive for SP/S3 rangefinder cameras
S-72	Motor drive for S3M rangefinder camera
S-250	Motor drive for rangefinder cameras
SA-1	AC/DC power unit for SB-1
SA-2	AC/DC power unit for SB-2/3
SA-3	AC/DC power unit for SB-6
SB-1	Grip-type flash unit GN36, lead connected
SB-2	Flash unit, GN25, for F/F2
SB-3	Flash unit, GN25, ISO-foot
SB-4	Flash unit, GN16, ISO-foot
SB-5	Grip-type flash unit, GN32, lead connected
SB-6	Stroboscopic flash unit, GN45, lead connected
SB-7E	Flash unit, GN25, for F/F2
SB-8E	Flash unit, GN25, ISO-foot
SB-9	Flash unit, GN14, ISO-foot
SB-10	Flash unit, GN25, ISO-foot
SB-11	TTL flash unit, GN36, lead connected
SB-12	TTL flash unit, GN25, for F3
SB-14	TTL flash unit, GN32, lead connected
SB-15	TTL flash unit, GN25, ISO-foot
SB-16A	TTL flash unit, GN32, for F3
SB-16B	TTL flash unit, GN32, ISO-foot
SB-17	TTL flash unit, GN25, for F3
SB-18	TTL flash unit, GN20, ISO-foot
SB-19	Flash unit, GN20, ISO-foot
SB-20	AF-TTL flash unit, GN30, ISO-foot
SB-21A	TTL-Macro-flash unit, GN16, for F3
SB-21B	TTL-Macro-flash unit, GN16, ISO-foot
SB-22	AF-TTL flash unit, GN25, ISO-foot
SB-22s	AF-TTL flash unit, GN28, ISO-foot
SB-23	AF-TTL flash unit, GN20, ISO-foot

SB-24	AF-TTL flash unit, GN36, ISO-foot
SB-25	AF-TTL flash unit, GN36, ISO-foot
SB-26	AF-TTL flash unit, GN36, ISO-foot
SB-27	AF-TTL flash unit, GN30, ISO-foot
SB-28	AF-TTL flash unit, GN36, ISO-foot
SB-28DX	AF-TTL flash unit, GN36, ISO-foot for D-SLR
SB-29	TTL macro-flash unit, GN11, ISO-foot
SB-29s	TTL macro-flash unit, GN11, ISO-foot
SB-30	TTL flash unit, GN16, ISO-foot
SB-50DX	AF-TTL flash unit, GN22, ISO-foot for D-SLR
SB-80DX	AF-TTL flash unit, GN38, ISO-foot for D-SLR
SB-101	UW-flash unit, GN32, for Nikonos III, IVa
SB-102	TTL-UW-flash unit, GN32, for Nikonos III, IVa, V
SB-103	TTL-UW-flash unit, GN20, for Nikonos V
SB-104	TTL-UW-flash unit, GN16, for Nikonos RS
SB-105	TTL-UW-flash unit, GN20, for Nikonos IVa, V, RS
SB-140	UV/IR-flash unit, GN30, lead connection
SB-E	Flash unit, GN17, ISO-type mount
SC	Connecting lead for F-36 motor drive
SC-1	Sync-lead for SB-1 to Nikon F
SC-1 (U.S.)	Remote release for MD-1 motor drive
SC-2	Extension sync-lead for SC-1 (1.0m)
SC-3	Coiled sync-lead for SB-1
SC-4	Flash-ready light adapter for F2 Photomic -SB-2/3
SC-5	Sync-lead SB-2/3/5/6 (0.15m)
SC-6	Sync-lead (1m)
SC-7	Adapter lead SB-2/3/5/6 (0.25m)
SC-8	Adapter cord SBA cord
SC-9	Extension lead for SU-1
SC-10	Adapter lead SB unit to Nikkormat FT/FTN
SC-11	Sync-lead (0.3m)
SC-12	TTL-connecting lead SB-11/14/140
SC-13	Extension lead SU-2/3
SC-14	TTL-extension lead for SB-16A/17 with F3
SC-15	Sync-lead (1m)
SC-16	Sync-lead (1m)
SC-17	Multi-flash TTL lead with ISO type shoe and foot
SC-18	Multi-flash TTL connecting lead (1.5m)
SC-19	Multi-flash connecting lead (3m)
SC-20	Sync-lead for Medical 120/4
SC-21	Power lead for Medical and SB-21 - LA-2/LD-2
SC-22	Sync-lead Medical 120/4 for ISO type foot
SC-23	TTL sync-lead with ISO-type foot for SB-11/14/140
SC-24	TTL sync-lead for terminal on DW-20/21/30/31
SC-100	Double TTL sync-lead for SB-102/103/104
SC-101	TTL sync-lead for SB-104/105 with Nikonos V/RS
SC-102	Double TTL sync-lead SB-104/105 with V/RS
SC-103	Extension TTL sync-lead SB-103/104

SD-2	External battery pack for SB-1		SS-21	Soft case for SB-21	
SD-3	External battery for SB-1		SS-22	Soft case for SB-22	
SD-4	External battery for SB-5		SS-23	Soft case for SB-23	
SD-5	External power unit for SB-6 (includes SN-3 NiCd)		SS-24	Soft case for SB-24	
SD-6	External battery for SB-11/14/140		SS-25	Soft case for SB-25	
SD-7	External battery pack for SB-11/14/20/22/24/140		SS-26	Soft case for SB-26	
SD-8	External battery pack for SB-20 to SB-80DX		SS-27	Soft case for SB-27	
SD-8A	As for SD8 (for European Union standard)		SS-28	Soft case for SB-28/SB-28DX	
SE-2	Extension cord for SB-1/2/3/7/8 (5m)		SS-29	Rigid equipment case for SB-29/SB-29s	
SF-1	Flash-ready light for SB-1/2/3/5/6/7/8, SR-1/2		SS-30	Soft case for SB-30	
SH-1	Charging unit for SN-1		SS-50	Soft case for SB-50DX	
SH-2	Charging unit for SN-2		SS-80	Soft case for SB-80DX	
SH-3	Charging unit for SN-3		SS-101	Soft case for SB-101/102/103	
SH-104	Charging unit for SN-4		SU-1	External sensor for SB-5/6	
SK-2	Bracket for SB-1		SU-2	External sensor for SB-11/14	
SK-3	Bracket for SB-5		SU-3	External sensor for SB-11/14/140	
SK-4	Bracket for SB-11		SU-4	Wireless TTL flash controller	
SK-5	Bracket for SB-14/140		SU-101	External sensor for SB-101/102	
SK-6	Power bracket for SB-26 - SB-80DX		SW-1	Wide adapter for SB-2/3	
SK-6A	As SK-6 (for European Union standard)		SW-2	Wide adapter for SB-7/8E/10	
SK-7	Bracket for TTL flash unit (requires SC-17 lead)		SW-3	Wide adapter for SB-11	
SK-101	Bracket for SB-101		SW-4	Wide adapter for SB-12	
SK-104	Bracket set for SB-104		SW-5	Wide adapter for SB-14	
SK-104A	Flash-head mounting arm for SB-104		SW-6	Wide adapter for SB-15/17	
SK-104B	Bracket for SB-104		SW-7	Wide adapter for SB-16A/B	
SK-104C	Flash-head mounting arm for SB-102/103		SW-8	Wide adapter for SB-21A/B	
SK-104E	Extension arm for SB-104		SW-10H	Diffusion dome for SB-80DX	
SK-104W	Double bracket for SB-104		SW-91R	Infrared filter for SB-50DX	
SL-1	Focus-stop ring for AF-lenses 52mm dia.		SW-101	Wide adapter for SB-101	
SL-2	Focus-stop ring for AF-lenses 62mm dia.		SW-102	Wide adapter for SB-102	
SM-1	Ring-light for retro-mounted lenses		SW-103	Wide adapter for SB-103	
SM-2	Ring-light for retro-mounted lenses		SW-104	Wide adapter for SB-104	
SN-1	Rechargeable NiCd-battery for SB-1 Speedlight				
SN-2	Rechargeable NiCd-battery for SB-5 Speedlight				
SN-3	Rechargeable NiCd-battery for SD-5 Battery Unit				

T

TC-1	2x Tele-Converter
TC-2	2x Tele-Converter
TC-14	1.4x Tele-Converter (AI)
TC-14A	1.4x Tele-Converter (AI-S)
TC-14B	1.4x Tele-Converter (AI-S)
TC-14C	1.4x Tele-Converter (300/2 lens)
TC-14E	1.4x AF Tele-Converter (AF-I & AF-S lenses)
TC-14E II	1.4x AF Tele-Converter (AF-I & AF-S lenses)
TC-16	1.6x AF Tele-Converter (F3 AF only)
TC-16A	1.6x AF Tele-Converter
TC-20E	2x AF Tele-Converter (AF-I & AF-S lenses)
TC-20E II	2x AF Tele-Converter (AF-I & AF-S lenses)
TC-200	2x Tele-Converter (AI)

SN-4 | Rechargeable NiCd-battery for SB-104
SR-1 | Ring-light, GN16, cord connected
SR-2 | Ring-light, GN16, cord connected
SS-1 | Soft case for SB-1
SS-2 | Soft case for SB-2/3
SS-3 | Soft case for SB-4
SS-7 | Soft case for SB-7/8
SS-9 | Soft case for SB-9
SS-15 | Soft case for SB-15
SS-16 | Soft case for SB-16 A/B
SS-17 | Soft case for SB-17/AS-12/14
SS-18 | Soft case for SB-18/19
SS-20 | Soft case for SB-20

NIKON PRODUCT CODES

TC-201	2x Tele-Converter (AI-S)
TC-300	2x Tele-Converter (AI)
TC-301	2x Tele-Converter (AI-S)

U

UR-1	Adapter 72-62mm
UR-2	Adapter for UV-Nikkor 105/4.5
UR-3	Adapter ring SB-21 - 60/2.8 AF
UV-Nikkor	Special lens for Ultra-violet light photography
UW-Nikkor	Underwater lens for Nikonos camera system

X

X0	Light green filter
X1	Dark green filter

Y

Y44	Light yellow filter
Y48	Medium yellow filter
Y52	Dark yellow filter

Glossary

A

AE Lock

A function that temporarily stores the exposure setting determined by the camera. After measuring the light from a specific area of the subject the exposure reading can be maintained by activation of the AE Lock function allowing the camera position to be changed to recompose the picture without affecting the exposure settings.

Angle-of-View

Angle-of-View refers to the amount of coverage of a subject that a particular focal length provides. The shorter the focal length the greater the angle-of-view, and the longer the focal length the narrower the angle-of-view becomes. The 50mm focal length for 35mm film cameras is referred to as a 'normal' because its 46° angle-of-view approximates to that of the human eye.

Anti-Aliasing Filter

In a digital camera this filter is placed in front of the Colour Filter Array and CCD sensor array. Its purpose is to remove the sharp edges and detail from the image projected by the lens so that each photodiode on the CCD sensor receives light of a lower contrast with a more gradual change between two distinct areas of colour or detail.

Aperture-Priority Auto Exposure

This is an automated exposure system that calculates an appropriate shutter speed for a pre-selected lens aperture.

B

Barrel Distortion

An optical aberration; it causes straight lines in an image to apparently bend outwards towards the edges of the frame.

Bayer Pattern

The most common form of Colour Filter Array used over a CCD sensor is the Bayer Pattern, named after the Kodak engineer who designed it. It features twice as many green filters as red and blue to mimic the human eye's greater sensitivity to this colour, which leads to a higher degree of colour accuracy.

Blank Exposure

Cameras with manual film advance require the film to be wound forward and the shutter to be cocked and released several times before the film counter indicates the first frame has been reached. These initial shutter cycles are referred to as blank exposures.

Bracketing

Making a sequence of exposures where one or more factors are altered with each successive frame. For example the shutter speed may be altered by a predetermined increment, or alternatively the output of a flash unit may be varied. It is particularly useful for transparency films that have very narrow exposure latitude.

C

Cable Release

A shutter release accessory that obviates the need to touch the camera's own release button and therefore eliminates the risk of vibration affecting image sharpness. They are either mechanical or electrical in operation depending on the type of camera to which they are connected.

CCD

A Charge-Coupled Device is a very small photodiode (electronic light sensor). Sometimes referred to as a 'photo site' the sensor is sensitised by the application of an electrical charge prior to exposure. The CCD sensor used in Nikon cameras comprises a two dimensional array of CCDs.

Centre-weighted Metering

Light is measured with the emphasis placed on the central image area. Influence on the light meter gradually decreases towards the edge of the frame area.

Chromatic Aberration

An optical aberration; it causes light of different wavelengths to be brought to different points of focus with the effect of creating a secondary spectrum, which degrades image quality.

Colour Filter Array

The CCD sensor used in digital cameras is panchromatic. In order to make each photodiode (photo site) responsible for the detection of a particular colour a CFA is placed over the CCD. The CFA is composed of an array of red, green, and blur filters with each filter covering one single photodiode.

Coma

An optical aberration; it causes bright highlights, usually point sources of light, to appear as though they have a comet-like tail radiating outwards towards the edges of the frame area.

Correct Exposure

An exposure value determined by the camera, which it deems will offer the best rendition of the prevailing light conditions from darkest shadow to brightest highlight. This may of course not concur with your pre-visualised result and therefore can only be taken as a guide upon which you can apply alterations.

CPU

Central Processing Unit: The electronic component that controls the functions of an electronic device. For example all AF and Ai-P Nikkor lenses have a CPU built-in. It facilitates the communication of data between the lens and the camera, and the control of the lens functions such as focus and aperture.

D

Depth-of-Field

Depth-of-Field (DoF) is the zone in front of and behind the plane of focus in which the subject will appear to be 'in-focus' and therefore perceived to be sharp by the viewer. It varies according to camera-to-subject distance, focal length, and lens aperture. Smaller apertures (larger f number) will render a deeper zone; larger apertures (smaller f number) will render a shallower zone. As a rule of thumb for general photography the DoF zone will extend one third of the way in front of the subject and two thirds behind it. In close-up and macro photography this changes so that the DoF zone is split evenly in front and behind the plane of focus.

DX Code

The bar code system on film cassettes developed by Kodak; the bar code carries information about the film type, sensitivity, and number of frames. Cameras that can read the DX code may be set to automatically adjust functions according to the information carried in the DX code.

D-Nikkor

An AF-Nikkor lens that has additional functionality in its CPU; this is used to pass focus distance information to the camera for inclusion in exposure calculations.

E

EV

Exposure Value (EV) indicates the available combinations of shutter speed and lens aperture that will provide the same exposure under conditions of the same scene brightness and ISO sensitivity. At ISO100, the combination of a 1 second shutter speed and an aperture of f/1.4 is defined as having an EV of 1, which is expressed as EV1.

Exposure

The exposing of either film or a light sensitive sensor, as used in a digital camera, to light with a particular combination of shutter speed and lens aperture. The aperture is used to control the amount of light that passes through the lens whilst the shutter speed determines how long the film or light sensor are exposed to the light.

Exposure Compensation

The intentional application of a compensation factor to the exposure value settings determined by the exposure meter in a camera. Increasing the exposure is referred to as a positive compensation, and decreasing the exposure is referred to as a negative compensation. Either may be required to achieve a specific result or offset the effects of particular lighting conditions, which might other wise lead to exposure error.

F

File Format

Digital images are stored as digital files. Each file is saved in a particular format in order that it can be recognised and read on different devices. The file format is described by the file extension name it is assigned when saved. The common file formats used by in Nikon digital cameras are JPEG (.jpg), TIFF (.tiff), and NEF (.nef).

Fill-flash

A technique that mixes flash with ambient light; the ambient light is the principle light source and the output from the flash provides a supplementary light to help reduce contrast and reveal detail in shadow areas.

Flash-exposure compensation

Similar to exposure-compensation this involves the intentional application of compensation factor to change the automatically determined output of a flash unit. Increasing the output is referred to as a positive compensation, and decreas-

ing the output is referred to as a negative compensation.

Flash Shooting Distance

The range of distances within which the flash can output sufficient light to achieve a correct exposure; the range will be extended with higher ISO sensitivity, and larger lens apertures. It will be reduced with lower ISO sensitivity and smaller lens apertures.

Flash Synchronisation Speed

Often abbreviated to Sync Speed this is the faster shutter speed at which the entire film/sensor area will receive a full exposure to the output of the flash unit. If a shutter speed higher than the sync speed is selected a proportion of the image will not receive light from the flash unit because the second shutter curtain or blades will already be travelling across the image area before the flash output has completed its cycle.

Flexible Program

Flexible Program, sometimes called Vari-Program, temporarily shifts the automatically selected combination of shutter speed/aperture while maintaining the same overall exposure value. This will be done according to the specific priorities of a particular Program mode. For example the program may place the emphasis on maintaining the highest possible shutter speed when the risk of camera shake and/or subject motion might reduce sharpness.

Full Aperture

The widest available aperture (smallest f number); at this setting the maximum amount of light passes through the lens.

f-number

The f-number represents the lens aperture value and is calculated by dividing the focal length of the lens by the effective size of the aperture opening. The smallest f-number represents the widest/largest aperture available on the lens. A lens that is described as being a

'fast lens' is one that has a small f-number usually equal to or less than f/2.8. The largest f-number represents the narrowest/smallest aperture available on the lens. Typically on most current Nikkor lenses this is f/22, however, on some Zoom-Nikkors and all Micro-Nikkors it is f/32, and f/45 in the case of the PC Micro-Nikkor 85mm f/2.8D.

Focal Length

The distance between the optical centre of a lens and its point of focus, which in the case of a camera lens is the film/senor plane, when the lens is focused at infinity.

Focus Tracking

A system that allows a camera's auto focus mechanism to analyse the speed and direction of a moving subject from the focus data; the system uses this information to anticipate the subject's position at the precise moment of exposure.

Front-curtain Flash Sync

The flash fires immediately after the first set of shutter blades or curtain have completely opened. It may also be referred to as Normal Flash Sync.

Full-aperture Metering

This system keeps the lens aperture open at its maximum to facilitate viewing through the camera by providing the brightest viewfinder image, whilst calculating the exposure settings for the preselected shooting aperture value.

G

G-Nikkor

The latest type of Nikkor; these do not have a conventional aperture ring and are only compatible with those cameras that allow the aperture to be selected from the camera body.

Guide Number

A Guide Number (GN) represents the maximum power output of a flash unit in relation to the ISO sensitivity. It is usually expressed in the form of GN (ISO, Distance) for a particular focal length of lens (angle-of-view), and unless otherwise stated in this book is given as GN (ISO100, m) for a 35mm lens (film).

I

Interpolation

A computing process that uses the values of existing data to estimate the values of unknown data. In simple terms is a process of 'invention'. In a digital image interpolation merely creates new pixels based on the average values of those pixels that exist in the surrounding area of the original image and hence no new information is added to the final image.

ISO Sensitivity

International Standards Organisation (ISO); the ISO rating represents the sensitivity with regard to film and digital camera sensors. The higher the ISO number the greater the sensitivity. A film or sensor with a rating of ISO200 is twice as sensitive as one with an ISO rating of ISO100, and half as sensitive as one with an ISO rating of ISO400.

M

Manual Exposure

In this mode the photographer must set the shutter speed and lens aperture manually based on the light meter reading. They will remain at these values regardless of any change in the exposure conditions.

Matrix Metering

This metering system divides the image area into distinct sections and then assesses the light in each before combining these multiple readings to give an averaged value for the overall exposure settings.

Matrix Balanced Fill-Flash

This system combines the Matrix metering system for the ambient light with the TTL-flash metering system to provide a fill-flash output that is balanced with the ambient light reading.

Mechanical Shutter

A shutter system that mechanically controls the shutter speed; the advantage is that it does not rely on electrical power to operate. This can be an advantage when shooting for protracted periods in very low temperatures, in remote areas where availability of batteries is unlikely, in very damp conditions such as high humidity, or for very long time exposures.

Multiple-exposure

A technique that involves making more than one exposure on a single frame of film.

Multi-sensor Metering

Similar to Matrix Metering this system uses a series of sensors to evaluate the light in different areas of the scene before combining the readings to give an overall exposure value. The priority assigned to each sensor will alter depending on it s position and the level of light that it detects in relation to the surrounding sensors.

N

NEF

Nikon Electronic File format; this is the proprietary file format for RAW data files saved by a Nikon digital camera.

Neutral Density (ND) Filter

Neutral Density filters reduce the overall level of light that they pass without affecting any specific wavelength. They can be useful if you require a low shutter speed in bright light conditions, or wish to shoot at a wide aperture

O

Overexposure

A level of exposure that renders the image with a brighter and lighter appearance; as the level of overexposure is raised highlight areas in the image will become increasingly devoid of detail and shadow areas will lack depth.

P

Perspective

Perspective is the relative size and apparent separation of subject elements within a two dimensional image; that is to say, how far the foreground and background appear to be separated from each other, and the relationship between these areas an the main subject, and is wholly determined by the camera-to-subject distance.

Pin Cushion

An optical aberration; it causes straight lines in an image to apparently bend inwards towards the centre of the frame.

Program Exposure Mode

This is an automated exposure system that calculates an appropriate combination of both lens aperture and shutter speed.

R

Rangefinder

A focusing system used in non-SLR type cameras. It does not offer the what-you-see-is-what-you-get viewfinder image of an SLR but has an indirect viewing system. Rangefinder focusing is particularly effective for wide-angle lenses and in low light but has limitations at close distances and with long focal length lenses.

Rear-curtain Flash Sync

The flash unit fires an instant before the second (rear) set of shutter blades of a focal p-lane shutter begin to close at the end of an exposure. Used in combination with a slow shutter speed it allows the ambient light on the subject to record before the flash output. This gives the characteristic mix of blur behind a moving subject, which is rendered sharp by the brevity of the flash pulse.

Red-Eye Reduction

A system that uses a small lamp built-in to either the camera or flash unit to light in advance of the flash output. It has the effect of causing the eye pupil to contract, thus helping to reduce the risk of retinal reflections that appear as 'red-eye'.

Repeating Flash

A rapid series of light pluses from a flash unit that are recorded in a single exposure; this stroboscopic effect can be used for scientific or creative purposes. Generally it works best with the subject placed against a dark background.

Reproduction Ratio

The Reproduction Ratio (RR) represents the relationship between subject size and the size of the subject's image film/sensor. It is determined by the distance from the subject to the film/sensor plane and by the focus setting on the lens. For example, if the image formed on the film or sensor is the same size as the subject the RR is said to be in the ratio of 1:1. If the image is twice the size as the subject the RR is 2:1 or 2x. If the image is only a quarter the size of the subject the RR is 1:4 or 1/4x.

S

Shutter Speed

This is the length of time that the shutter blades or curtains remain open to expose the film or sensor to the light passing through the lens.

Shutter Speed Priority Exposure Mode

This is an automated exposure system that calculates an appropriate lens aperture for a pre-selected shutter speed.

Slow Flash Sync

A flash technique that combines flash with a slow shutter speed, and is particularly useful when the level of ambient light is very low and you wish this to be recorded as well as the flash lit component. For example it helps to prevent a dark background being recorded as a featureless shadow area that lacks detail.

SLR

Single Lens Reflex: a camera viewing system that projects an image onto a focusing screen via a reflex mirror. It has the advantage of providing an identical view if the scene to the one that is projected onto the film or sensor.

Spot Metering

This metering system takes a reading from a very small proportion of the total image area. It allows precise measurement of light from a specific part of the subject.

T

TTL Metering

Through the Lens is a method by which the light level is read by the light metering system built-in to a camera. It has the advantage that the light reaching the metering sensors is the same as that used for the final exposure.

TTL Flash

An adaptation of the TTL system for ambient light; the flash light reflected from the subject is monitored during the exposure and the output is quenched as soon as the camera determines that sufficient light has been emitted from the flash unit.

U

Underexposure

A level of exposure that renders the image with a darker and dimmer appearance: as the level of underexposure is raised shadow areas in the image will become increasingly devoid of detail

and highlight areas will have greater density leading to a loss of overall contrast.

V

Vignetting

Vignetting is the progressively diminished level of illumination from the centre of an image area towards the corners and edges of the frame. It can be caused by an optical aberration of the lens, or alternatively by the inappropriate use of filters or accessories such as a lens hood.

W

Working Distance

The distance between the front of a lens to the subject: in general photography it is rarely significant, however, for macro and close-up photography it is an important consideration due to the proximity of the lens to the subject. This can impede the positioning of lighting accessories and in the case of live specimens cause them distress. The solution is to use a longer focal length lens as this will offer a greater free working distance.

Index

INDEX

A Selection of our Collector Books

ZEISS

COMPENDIUM
East and West – 1940-1972

Charles M. Barringer
and Marc James Small

Nikon

COMPENDIUM
Nikon System from 1917

Simon Stafford
Hillebrand & Hauschild

HASSELBLAD
SYSTEM COMPENDIUM

Richard Nordin

Leica
The First 70 YEARS

HOVE COLLECTORS BOOKS by Gianni Rogliatti

Leica
COLLECTORS GUIDE

HOVE COLLECTORS BOOKS DENNIS LANEY

Leica
HOVE BOOKS

LEICA LENS
COMPENDIUM

Erwin Puts

The Collector's
Guide to
CINE
CAMERAS

John Wade

The Collector's
Guide to
CLASSIC
CAMERAS
1945-1985

John Wade

THE HOVE INTERNATIONAL
BLUE BOOK
14TH EDITION

• Overview on
 collecting
• Internet collecting
• Dating and
 identifying
• Restoration and
 storage advice
• Tomorrow's
 collectables
• Landmark cameras

PRICE GUIDE & HANDBOOK
FOR COLLECTABLE CAMERAS

388

Get the MOST out of your

Nikon

camera.

in the most prestigious photographic club in the world

ikon Owners' Club International

ENEFITS OF MEMBERSHIP

e NIKON OWNERS' CLUB INTERNATIONAL is a worldwide club with the purpose of uniting Nikon ners and bringing them unique benefits that will increase their skill and interest in otography and Nikon equipment. As a member you not only get an array of ecial discounts and services but also become part of the most prestigious camera b in the world. The benefits of membership are:

Interactive members-only website: www.nikonownersclub.com ich offers a technical helpline, members' message board, members' gallery st your own images), the latest press releases from Nikon, Kodak and Fuji, hnical equipment reviews, members' equipment reviews, club events, ecial prizes and much, much more.

■ *Nikon Owner* magazine. You'll stay well informed with your subscription to **Nikon Owner.** The magazine features spectacular photography and in-depth articles by some of the world's greatest photographic writers. It also includes write-ups on the latest Nikon cameras, Heather Angel's wildlife articles, Simon Stafford's equipment reviews, technique features, portfolios, advice, members' articles and Gray Levett's *History of Nikon.* Learn how to take better pictures with our helpful articles, read about other Nikon users, take part in our photo competitions.

- 10% discount off your developing & printing from the one of the best photographic labs in London***
- 10% discount off Lowepro bags and accessories*
- 10% discount off Snappy Snaps processing & digital services*****
- Priority service and 10% discount on Nikon servicing and repairs*
- 10% discount on Hasselblad servicing**
- Discounted insurance on Nikon and other brands of cameras****
- FREE 3-year warranty when you buy new Nikon (worth £40.00)*
- Special photographic workshops and overseas safaris
- FREE estimates for your Nikon servicing and repairs*
- FREE insurance valuation service*
- FOR A LIMITED TIME ONLY YOU CAN GET YOUR MEMBERSHIP FOR JUST £59.00. JOIN TODAY!

*Available at Grays of Westminster
**Available from Hasselblad U.K. Limited
***Available from Sky Photographic Services
****Available from Golden Valley Insurance
***** Available from participating Snappy Snaps in the U.K.

Simon Stafford is the technical editor of **Nikon Owner** magazine and writes in every issue.

JOIN THE CLUB FOR £59.00 TODAY!

Membership couldn't be easier just choose one of the following options:

1 Send a cheque made payable to: **Nikon Owners' Club International**
(overseas send an international money order in pounds sterling drawn and made payable through a U.K. Bank)
Send to: **Club Secretary, Nikon Owners' Club International, 40 Churton Street, London SW1V 2LP, England**
Please ensure that you include your full postal address, telephone number (and e-mail address where available).

2 Call +44 (0)20-7592 9282 and pay by credit card
We accept the following major credit cards (as well as Connect cards)

3 Or, for instant membership, join online at: www.nikonownersclub.com

elephone: 020-7592 9282. International telephone: +44 20-7592 9282
ax: 020-7976 5783. International Fax: +44 20-7976 5783. e-mail: info@nikonownersclub.com